18 Nov. '04

For Jerry —
With All Best Wishes,

France and the Holy Land

PARALLAX
Re-visions of Culture and Society

Stephen G. Nichols, Gerald Prince & Wendy Steiner
Series Editors

FRANCE

and the

HOLY LAND

Frankish Culture
at the End of the Crusades

Edited by

Daniel H. Weiss & Lisa Mahoney

THE JOHNS HOPKINS UNIVERSITY PRESS
BALTIMORE & LONDON

© 2004 The Johns Hopkins University Press
All rights reserved. Published 2004
Printed in the United States of America on acid-free paper
9 8 7 6 5 4 3 2 1

The Johns Hopkins University Press
2715 North Charles Street
Baltimore, Maryland 21218-4363
www.press.jhu.edu

Library of Congress Cataloging-in-Publication Data

France and the Holy land : Frankish culture at the end of the crusades / edited by
Daniel H. Weiss, Lisa Mahoney.
 p. cm. — (Parallax)
Includes bibliographical references and index.
 ISBN 0-8018-7823-3 (hard. : alk. paper)
 1. Crusades. 2. Franks—Mediterranean Region—History. 3. Jerusalem—
History—Latin Kingdom, 1099-1244. 4. France—History—Medieval period,
987-1515. 5. Christianity and other religions. 6. Civilization, Medieval.
I. Weiss, Daniel H. II. Mahoney, Lisa. III. Parallax (Baltimore, Md.)
D161.5.F7F73 2004
956.94'503—dc21 2003012880

A catalog record for this book is available from the British Library.

Contents

Contents

Illustrations

Illustrations

Preface

THE ESSAYS COLLECTED in this volume explore the interchange of ideas between France and societies in the Holy Land and the Mediterranean East during the latter part of the crusader period. The original conception for this project emerged in discussions with my colleagues Anne Derbes and Mark Sandona on the topic of thirteenth-century crusader manuscript illumination in the city of Acre and its curious relationship to contemporary developments in Paris. To examine the larger topic of cultural exchange in the eastern Mediterranean during the crusades, the three of us organized a conference at the Johns Hopkins University in March 2000 entitled "Frankish Culture at the End of the Crusades: France and the Holy Land." All but one of the papers from that conference have been included in this volume and they have been supplemented by the important contribution of Anthony Cutler on artistic exchange between crusaders and Muslims. Harvey Stahl, who presented an outstanding paper on the Psalter of Saint Louis, was sadly unable to prepare his essay for publication before his death in 2002. I am grateful to all of the contributors for their participation in the conference and for their continued support of this project through the publication of this volume.

The Hopkins conference provided an exceptional opportunity for scholars in diverse disciplines—historians, literary scholars, art historians, and archaeologists—to exchange ideas and discuss various approaches to the study of crusader culture and the Latin East. The conference was made possible with funds from the International Center of Medieval Art, the Maryland Humanities Council through a grant from the National Endowment for the Humanities, the Zanvyl Krieger School of Arts and Sciences at Johns Hopkins, and Hood College. The publication of this volume was aided by an additional grant from Johns Hopkins.

I would like to thank my original collaborators, Anne Derbes and Mark Sandona, for helping to make the conference a reality and for supporting this publication in numerous ways. They have been superb and delightful colleagues every step of the way. More recently, I have been joined in this project by Lisa Mahoney,

an advanced graduate student in the History of Art Department at Hopkins, who agreed to serve as co-editor of the volume when my administrative duties at Hopkins made it difficult for me to proceed with the project on my own. Lisa has made essential contributions throughout the project and she has been a splendid colleague. I am grateful to her for her assistance. Without it, this publication would have not have been possible. As always, I am grateful to my assistant Pat Piraino, who helped on this project in myriad ways.

The field of medieval studies was sadly diminished by the untimely deaths of Harvey Stahl and Michael Camille in 2002. This volume is dedicated to their memory.

DANIEL WEISS

Introduction

THE CRUSADES to the Holy Land were one of the most extraordinary and consequential movements of the Middle Ages. The march of the Seljuk Turks through the East terrified many in western Europe, who imagined—or were led to imagine—the atrocities perpetrated against Christians. To be sure, in launching the First Crusade in 1095, Pope Urban II conjured horrific images of the desecration of Christian holy places by the enemies of God. Inspired by these words to an extent unforeseen by anyone, including Urban himself, thousands of Europeans fought to "liberate" Jerusalem from the Turks and, remarkably, by 1099 they had succeeded. After the success of the First Crusade, men and women from western Europe, called "Franks" by the people of the eastern Mediterranean, settled in the newly conquered territory, which extended at its height from Armenian Cilicia and the County of Edessa in the north (parts of modern Turkey, Syria, and Iraq) to the Kingdom of Jerusalem in the south (the southern tip of modern Israel). The Franks occupied the region, with ever diminishing authority and confidence, until the fall of Acre, capital of the Latin Kingdom of Jerusalem, in 1291.

Despite the chronic, and ultimately futile, struggle to hold the occupied lands, the settlers created for themselves a rich intellectual and cultural life. They wrote poetry and histories of their experiences, erected churches and castles, and commissioned illuminated manuscripts, frescoes, mosaics, sculpture, ivory carvings, icons, and more. The majority of the crusaders and settlers were French, and the art and culture of Paris were of abiding importance to them. But the settlers did not merely transfer French artistic forms to the Levant; rather, they appropriated ideas and images from Byzantine and Islamic neighbors, producing a fascinating visual culture that is neither Eastern nor Western but a distinctive mélange of both. Moreover, the Franks interacted with these disparate cultures in the Levant and left their mark on them as well.

Ironically, the fullest flowering of the intellectual and cultural life of the Latin Kingdom came in the decades just preceding the fall of Acre in 1291. Such a creative fluorescence, remarkable in large part for its stark contrast to the declining

political state, remains largely unexplored as a historical phenomenon. Material evidence suggests the crusader workshop in Acre alone saw the production of twenty manuscripts, including several copies of William of Tyre's *Histoire d'Outremer* as well as the first illuminated copies of the *Histoire Universelle,* an unusual combination of biblical, mythological, and historical narrative texts first compiled for Roger of Lille early in the thirteenth century. These manuscripts embody the characteristics of much art produced in the crusader capital during the second half of the thirteenth century: the employment of pictorial references to the Mediterranean environment clearly reflects the unusual cultural milieu in which they were produced and the appropriation of subject matter reveals that the manuscripts' creators were equally engaged with contemporary artistic and historiographical developments in Paris notwithstanding the imposing geographical distance or political instability in the Holy Land.

Equally, military involvement in and tentative occupation of the Mediterranean East could not help but affect Frankish culture outside of the Holy Land, in both France itself and its territories in Italy and Cyprus. The Crusader Kingdom thus facilitated transformations of theological and social attitudes just as it fueled political ambitions. Historical, literary, and pictorial sources document these transformations, commenting on the nature of crusading and, often, justifying its costs.

The importance of exploring the full impact of this significant historical period, in both the East and the West, led Anne Derbes, Mark Sandona, and Daniel Weiss to organize a conference entitled "Frankish Culture at the End of the Crusades: France and the Holy Land," which took place at the Johns Hopkins University, 24–25 March 2000. As the title implies, the particular emphasis of the symposium was on the period of Frankish occupation of the Holy Land. The papers presented focused on the repercussions this involvement had in the development and transmission of social, political, and artistic ideologies related to the crusading endeavor, but also on the preconditions and consequences of that endeavor. All but one of the papers from that conference have been compiled in this volume and they have been supplemented by the important contribution of Anthony Cutler on artistic exchange between crusaders and Muslims. Harvey Stahl, who presented an outstanding paper on the Psalter of Saint Louis, was sadly unable to prepare his essay for publication before his untimely death in 2002. Together, these essays, because of their consideration of varied crusader material from the perspective of diverse disciplines and methodologies, offer new evidence and a new approach to the study of the crusades.

The volume is organized in five sections. In Part I, "Art and Poetry in Crusader Paris," two chapters explore cultural production in France related to the enterprise

of crusading. Daniel Weiss argues that the form and structure of the Old Testament illustrations of the Morgan Picture Bible were manipulated for the purposes of effective storytelling in a manner comparable to contemporary rhetorical treatises dedicated to the same end. Considering such basic rhetorical devices as amplification and repetition, Weiss investigates the moments at which narratives are expanded and specific themes, compositions, and motifs are repeated in the Morgan Bible. Coupled as these moments are with contemporary details, he suggests that the story here being told reflects particular contemporary interests concerning the Holy Land. In so doing, Weiss associates this work with the rise of a specifically crusader community in France during the second half of the thirteenth century.

Stephen Nichols takes up the subject of lyric poetry in the twelfth and thirteenth centuries, exposing the manner in which the traditional form and theme of courtly love poetry was adapted by poets such as Bertran de Born for the purpose of creating crusade polemics. At a time of apparent public optimism, these lyric poems reveal a growing disillusionment with the crusades, offering a critique of the reality of crusading and the propaganda used in preaching the crusades. By understanding specific lyric poems as responses to historical events linked to the Holy Land, Nichols opens up new territory for interpreting poetry during this period and, in so doing, proposes hidden significance and meaning that reflect the political atmosphere in which they were produced.

The three chapters in Part II, "Frankish Presence in the Levant," consider the political, social, and artistic relationship between France and communities in the Holy Land. Jonathan Riley-Smith investigates the involvement of the French crown in the Holy Land during three distinct phases. The level of French commitment and its direction is explored in relation to the reigns of three successive French kings—Louis IX, Philip III, and Philip IV—and their respective political motivations. To this end, Riley-Smith examines the evidence of aid offered to the Holy Land, especially in mercenary troops, and the designated French representative in the Holy Land during each of these reigns.

Gustav Kühnel then investigates the sources and pictorial traditions of representations of the Byzantine Emperor Heracles. By contrasting the crusader and Western representations of Heracles to those in Byzantine images, Kühnel exposes the position this specific emperor held in the respective cultures and provides an explanation for puzzling discrepancies in his presentation. Through this comparison, Kühnel establishes that it is Heracles's role as a savior of Christ's relics that is emphasized in the West. According to Kühnel, it is this role that made Heracles a potent precursor and model for Louis IX and that allowed Heracles to contribute to the realization of Paris as a new *locus sanctus,* a new Holy Land, and a new Jerusalem.

In his analysis of technique versus style, Robert Ousterhout reveals the extent to which the French Gothic influenced architecture in the Holy Land. Ousterhout focuses specifically on the use of the ribbed groin vault in the Levant, one of the defining characteristics of French Gothic architecture. In doing so, he demonstrates that, whereas a French Gothic *style* is evident in architecture built in the Holy Land, the construction of the buildings themselves remained in keeping with local building traditions. Therefore, the French Gothic, as witnessed in the ribbed groin vault, influenced architectural elements only superficially and was in no way integral to the building itself, as it was in the West. Ousterhout concludes that these architectural elements can best be understood as cultural signifiers of interest to a patron that remained a matter of style alone.

In Part III, "Acre as a Cultural Center," the two chapters focus on material evidence for the key role Acre played in the Holy Land as a site of intellectual and artistic development. David Jacoby examines the social, cultural, and artistic evolution of Acre during the two centuries of crusader occupation in the Levant. His essay considers the complicated relationship between the Western and indigenous residents of the Holy Land and the influx of crusaders, merchants, clergy, artists, and both Western and Byzantine pilgrims, assessing specifically the influence these groups had on artistic production in terms of trade, market demands, patronage, and the introduction and transmission of both Western and Eastern artistic trends.

In his essay, Jaroslav Folda seeks to establish the existence of a major artistic center in Acre before the arrival of Louis IX in 1250, an event traditionally considered by scholars to mark the beginning of rigorous artistic production in the capital. Folda's discussion considers the years between 1191 and 1244, when the Western presence in the Holy Land was predominantly German. By focusing on three objects of painting associated with the Levant, Folda argues that in both style and iconography, these works reveal the existence of specifically German artists and German patrons in Acre during the first half of the thirteenth century. More important, each of them gestures to the existence of greater artistic activity and patronage during this period than has previously been assumed.

The three chapters in Part IV, "The Uses of Secular History," are dedicated to investigating the surprising importance and new popularity of history writing and interpretation within the crusader community in the East and West. Bianca Kühnel treats two manuscripts made in Acre, the *Histoire Universelle* and William of Tyre's *Histoire d'Outremer*, during the final decades of Latin occupation in the Holy Land. By way of these manuscripts, Kühnel examines the manner in which secular histories were adapted to reflect and ultimately strengthen the position of the Latin Kingdom. Her close examination of unusual iconography and imagery

reveals a calculated and complicated visual link between past and present in these manuscripts, intended to emphasize, in particular, the authority, legitimacy, and continuity of Acre kingship during a period marked by political instability.

Examining editions of the *Histoire Universelle* made in the second half of the thirteenth century, Anne Derbes and Mark Sandona consider the sections of their narrative cycles devoted to the Amazons. By comparing representations of these women in Western examples of this manuscript with those made in Acre, Derbes and Sandona reveal the ideological implications of their presence. Their study reveals that the Amazons are not only depicted more often in the manuscripts produced in the Holy Land, but that these women are also consistently represented in a uniquely sympathetic light. Looking at the Acre manuscripts as a group, Derbes and Sandona propose that this phenomenon reflects the very real involvement of women in the crusades. The particularly strong emphasis on Amazons as well as other historical and biblical female figures found in one of these manuscripts in particular (Paris MS. fr. 20125) allows Derbes and Sandona to suggest the influence of a woman in this specific manuscript's commission.

Moving outside of the Levant and to its influence abroad, Rebecca Corrie focuses on the Chantilly *Histoire ancienne*. Her stylistic analysis of this manuscript allows her to establish more firmly the history of an atelier in southern Italy during the second half of the thirteenth century. To this end, she looks at the Chantilly manuscript as part of a larger group of stylistically related manuscripts, exploring issues of patronage, stylistic development, and artistic collaboration in this area and during this period. More important, however, Corrie discusses the transmission of this particular text from the Holy Land to Angevin Naples, where, she proposes, the Chantilly *Histoire ancienne* was made for a member of the court of Charles I. Corrie concludes that, because of its implicit connection to the Holy Land, the *Histoire ancienne* was recognized as a powerful site for the expression of personal political ambitions and was, in the case of the Chantilly manuscript, used to express those of the Angevin court.

In the final section, Part V, "Cultural Exchange in the Age of the Crusades," three chapters explore the mechanisms of cultural exchange between disparate cultures during the thirteenth century and following the loss of the crusader kingdom. In his essay, Anthony Cutler explores the character of Muslim influences on crusader art. He asserts that the transmission of Muslim imagery and artistic technique across borders was made possible by the social, economic, and diplomatic conditions in the Holy Land, and this primarily through gift exchange and loot. Cutler's close analysis of two objects made in this context, a metal bowl and a pilgrimage token, reveals the very subtle nature of Islamic influence in the iconog-

raphy and themes of Christian art. Furthermore, these objects suggest that works produced in this multicultural atmosphere cannot be understood as the creations of a single culture, but as the hybrid products of an environment wherein artistic exchange was inevitable.

Scott Redford focuses on Port Saint Symeon pottery shards, named after the port of Antioch where scholars have traditionally believed such ceramics were produced. Through an analysis of subsequent archaeological findings of similar pottery shards, however, Redford maintains that this type of ceramic was in fact not widely exported throughout the Mediterranean, but produced in multiple centers. This evidence suggests that these ceramics were not luxury wares, as previously assumed, but objects of mass production, standardized in form and appealing to the diverse inhabitants of the Mediterranean.

Annemarie Weyl Carr's essay concludes the volume with an examination of a group of Kykkotissa icons that first appeared on Cyprus between 1359 and 1430. During this period, the foreign rulers of Cyprus, the French Lusignans, embraced Palaeologan, Gothic, and Mamluk artistic styles in an effort to solidify their position in the Mediterranean. Within this atmosphere, explicitly Greek Cypriot objects, such as these icons, became an intrinsic part of Lusignan politics, deeply embedded in court and public ritual. Carr suggests that the development of this cult of icons among Latin rite Christians was funded by the Lusignan court in order to establish their power within a traditionally Orthodox context, while simultaneously picturing the unity of its kingdom.

Given the interdisciplinary character of these essays, *France and the Holy Land* offers a new approach to the study of crusader culture. Specifically, the traditional understanding of this period is here complicated and enriched by historians, literary scholars, art historians, and archaeologists in dialogue with one another, utilizing the evidence peculiar to their respective disciplines. Our aim has been to focus on the complex and dynamic relationship between France and the Holy Land in the second half of the thirteenth century, and to determine the issues fundamental to its consideration. Thus, the essays compiled in this volume promise to facilitate further scholarly discussion by identifying new relationships and contexts and, in so doing, to contribute to our understanding of the crusading period.

PART I

ART AND POETRY
IN CRUSADER PARIS

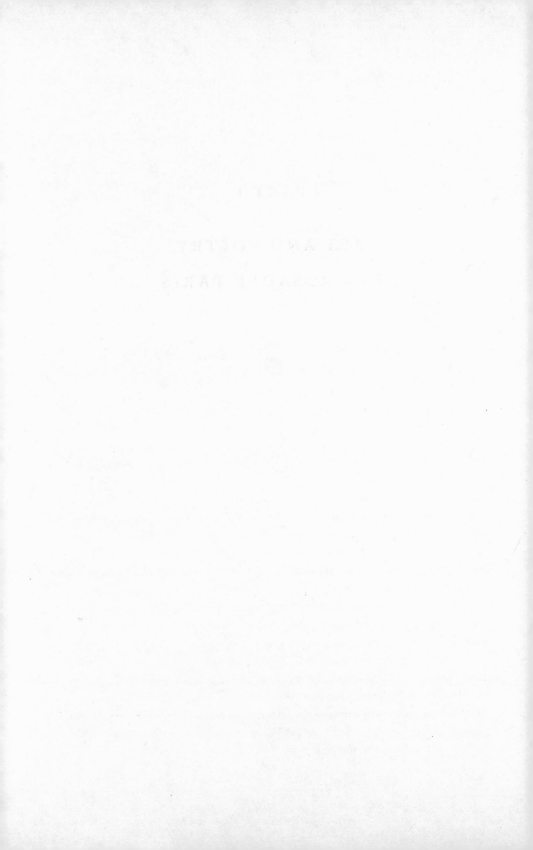

CHAPTER I

The Old Testament Image and the Rise
of Crusader Culture in France

Daniel H. Weiss

If the second half of the thirteenth century witnessed the inexorable destruction of the crusader states in Outremer, it also—and quite paradoxically— witnessed the greatest flowering of crusader art in its 200-year history.[1] Indeed, the surviving material produced in the Levant during the past four decades—consisting of some 120 icons and nearly two dozen illuminated manuscripts—attests above all to the importance of material culture for a community contending with an increasingly enfeebled and vulnerable military enterprise. Intriguingly, the manuscripts are for the most part not standard service books and Gospels but rather illustrated works of epic history—William of Tyre's account of the Latin Kingdom (with continuations), the *Histoire ancienne jusqu'à César,* or *Histoire Universelle,* as well as two excerpted Old Testaments.[2] The remarkable presence of these disparate historical works must reflect, at least in part, a desire by members of the crusader community to reconcile all that loss and failure. More specifically, I would argue that the books help to broaden the scope by providing a context for the crusaders' lived experience while, at the same time, commemorating their sojourn in the Holy Land, grim though it may have been.[3]

The impulse to create works of art associated with the crusades to the Holy Land was pursued with equal zeal at their places of origin in the West, even if many of the works themselves are decidedly different in appearance. In Paris, King Louis IX commissioned works overwhelmingly concerned with the thematics of biblical historiography—derived particularly from Old Testament narratives— and dedicated equally to the presentation of the Franks as the new leaders of the

3

Christian world, the new "Chosen People."[4] Under the leadership of Saint Louis, the most expansive and ambitious crusading king of them all, monuments like the Sainte-Chapelle were designed to affirm the continuity of sacred history into the present even while asserting France's political and spiritual preeminence.[5] Such a vision is pictured within the stained glass of the chapel, where, following extended narratives from the Old and New Testaments, the acquisition of the Passion relics is presented in the northwest bay. Here, in an extraordinary gesture of uninhibited royal confidence, Louis brings Christian history current with an image of himself, indistinguishable from the great biblical kings, presiding over the acquisition and worship of the sacred relics (fig. 1.1).[6] Frankish pretensions of Christian preeminence were also made explicit in contemporary texts, including that of the archbishop of Sens, who claimed that, with the acquisition of the Passion relics, France now enjoyed privileged status in the eyes of God, equal to that enjoyed by the Byzantines for nearly a millennium.[7]

Produced in the years leading up to Louis's disastrous First Crusade, the Sainte-Chapelle helped to define the critical parameters of crusade-inspired art in France: biblical narratives adapted and reinterpreted to speak in contemporary terms on such relevant themes as holy war, idolatry, and sacred kingship, among others.[8] Later works, such as the magnificent psalter made for the king after his return from the Holy Land (Paris, Bibliothèque Nationale, MS. lat. 10525), affirm the enduring importance of the Old Testament in the spiritual and political world of the "Most Christian" king.[9]

My focus in this essay is on one of the more intriguing and enigmatic works of French illumination created within this context: the Morgan Picture Bible (New York, Pierpont Morgan Library, MS. M 638).[10] My interest is in exploring the actual structure of the Old Testament narratives and in discerning, to the extent we can, precisely how biblical subject matter has been thematized to serve the particular interests of the crusader community in France. That is, how might we actually read these images and in what ways do they contribute to the rise of a crusader culture in France during the last, fateful years of the enterprise in the thirteenth century?

Before turning to such fundamental questions, some preliminary information is in order. The Old Testament manuscript, containing some 340 episodes on both sides of forty-six parchment leaves, is known to have been in the possession of Cardinal Bernard Maciejowski of Cracow at the beginning of the seventeenth century and was subsequently conveyed by papal emissaries to Shah Abbas the Great in 1608.[11] The Bible was acquired by Pierpont Morgan from a dealer in London in 1916 and since that time has been housed in the Morgan Library in New York. Al-

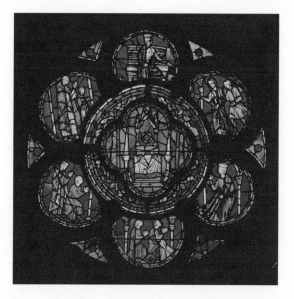

Fig. 1.1. Paris, Sainte-Chapelle, upper chapel stained glass, King Louis IX presiding over the worship of the Crown of Thorns

though the margins of the manuscript are now crowded with a variety of inscriptions—including Latin, Persian, and Judeo Persian—the Old Testament cycle was originally devoid of any accompanying text, making it one of the earliest and most impressive picture books of its era. The diverse inscriptions are all later additions—the Latin from the fourteenth century, the Persian from the seventeenth, and the Judeo Persian from the eighteenth.[12]

As currently constituted, the manuscript may not be complete. Beginning with the first chapters of Genesis, the excerpted cycle concludes abruptly and illogically with the story of Joab and Sheba from 2 Samuel. It is therefore possible that the manuscript originally contained an additional quire incorporating scenes illustrating the death of David and rise of Solomon. It is also possible that the extensive pictorial cycle was not autonomous, but was prefatory to a psalter text, as is the case with the seventy-eight illustrated leaves in the Saint Louis Psalter. Given the size of the Morgan manuscript (390 mm × 300 mm), the sophistication of its images, and the lack of codicological evidence to the contrary, I am inclined to agree with scholarly consensus that the manuscript was conceived as an independent picture book.[13]

Certainly more problematic is the question of the manuscript's origin. There is no real consensus among scholars on this issue, largely because there is inade-

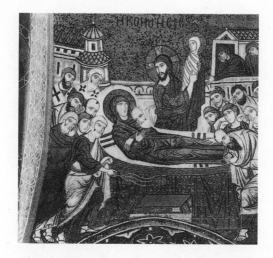

Fig. 1.2. Palermo, Church of the Martorana, mosaic of the Dormition of the Virgin

quate comparative material to support any clear attribution on the basis of style.[14] However, on other grounds I am inclined to believe that the Morgan Picture Bible was produced in Paris for the court of Saint Louis. In its conception and format, the manuscript is closely related to two works that are known to have been made for Louis: the Sainte-Chapelle and the previously mentioned psalter. These works, collectively representing the largest group of Old Testament cycles produced during the Middle Ages, share a new emphasis on presenting sacred history primarily in images, rich in narrative detail with an overarching emphasis on holy war and the special responsibilities of sacred kingship. All transform the stories of scripture into epic narratives in a manner evocative of French chivalric romance.

To be sure, the lack of more precise documentary or stylistic evidence precludes definitive resolution of the issue of the manuscript's origin. Yet the preponderance of available evidence, including especially the strong thematic connections to the art of Saint Louis, would suggest that the manuscript was created within the auspices of the royal court, and probably in Paris. It is, in any event, clearly a product of the crusading culture of the Frankish Court, produced during the years of Louis's First Crusade, that is, around mid-century.

The Old Testament narratives of the Morgan Picture Bible, like those of the Sainte-Chapelle and psalter, are imaginative and remarkably contemporary images, but the practice of transforming biblical subject matter into a political or exegetical statement was a long-standing one, having been established during the first centuries of the Christian era. As early as the fifth century, in the great

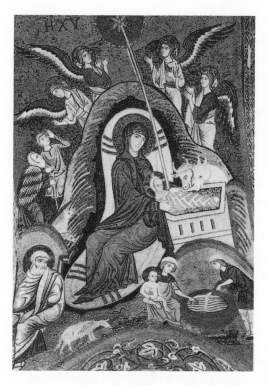

Fig. 1.3. Palermo, Church of the Martorana, mosaic of the Nativity of Christ

churches of Rome—Old St. Peter's, St. Paul's, and Sta. Maria Maggiore—biblical history had been presented not only as straightforward narrative but also as theology, as Herbert Kessler has shown.[15] Through the structure and arrangement of the narratives and the use of such pictorial devices as symbolism and patterning, these cycles expressed, in purely visual terms, complex theological ideas that resembled, as Kessler argues, "the contemporary biblical homilies of Ambrose, Augustine, and Leo the Great. They were a form of preaching, designed to illuminate scripture through the interpretation of history."[16]

In Byzantium, as Henry Maguire has convincingly shown, complex religious narratives were often modeled on well-established literary and rhetorical practice.[17] For example, the Byzantine rhetorical form of antithesis provides us with a basis for understanding the full paradoxical significance of the Nativity and Dormition scenes on opposing walls of the Martorana in Palermo, a society deeply indebted to Byzantine culture (figs. 1.2 and 1.3).[18] These mosaics visualize the sentiment expressed by John of Damascus in his hymn on the Feast of the Dormition, "hav-

ing brought forth the True life you depart to the life which is divine."[19] Or to cite another example, the more explicit version of Emperor Leo VI, "because you held God when he was invested with flesh, you are held in the hands of God when you are divested of flesh."[20] As Maguire demonstrates, these images are not mere illustrations of a text, but rather they operate within an independent formal language that enables the exploration of new dimensions and interpretive possibilities, which in turn contribute to the formulation of new modes of representation and iconographic patterns.

In her recent pathbreaking study on the Sainte-Chapelle glass, Alyce Jordan has discerned a similar relationship between the Old Testament narratives within the Gothic chapel and rhetorical treatises, such as Geoffrey of Vinsauf's *Poetria Nova,* written in 1210 and dedicated to explicating various techniques of storytelling.[21] The fundamental premise of Geoffrey's treatise, as Jordan points out, is that form and structure generate narrative meaning. Whereas the narrative material itself might be common knowledge and finite in scope, the discursive possibilities were most effectively developed through manipulation of the formal elements. Thus, Geoffrey recommends the use of a technique he calls *amplificatio,* in which selected aspects of a narrative are expanded in various ways. As Geoffrey observes, "a statement merely hops through the ears if the expression of it be abrupt, a substitute phrasing is made for it in the form of a long sequence of statements . . . so as to spin out the various ways of expressing a thing."[22]

Jordan's work on the Sainte-Chapelle glass has been of fundamental importance in recognizing that the *seemingly* repetitive, iconographically impoverished Old Testament narratives are actually sophisticated, highly particularized statements of royal concerns. Whereas scholars have long been cognizant of the clear resonances between the biblical cycles and the court of Saint Louis, Jordan's research has begun to disclose the structural basis and narrative mechanisms of the stained glass program.

In the illustrations of the Morgan Picture Bible, we can discern a comparable approach to narrative. To be sure, the correspondence between the Old Testament images in the Picture Bible and rhetorical treatises like Geoffrey's is not direct, but rather the paintings reveal a common approach or sensibility. Throughout the Morgan cycle, the Old Testament stories have been thematized and transformed into contemporary allegories through the manipulation of the structure, design, and level of detail in the narrative in a manner comparable to that employed in the Sainte-Chapelle and the *Poetria Nova.*

Undoubtedly, the most consistent—and repetitive—event portrayed in the Morgan Bible is that of military conflict. Of the ninety-two illuminated pages,

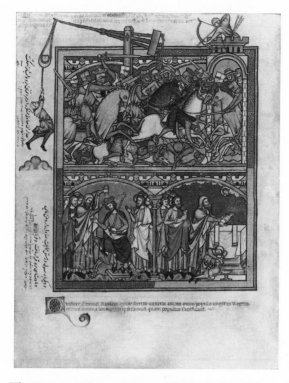

Fig. 1.4. The Pierpont Morgan Library, New York, MS. M.638, fol. 23v,
Saul destroying Nahash

fully half contain epic depictions of battle (figs. 1.4 and 1.5). From this gruesome and repetitious spectacle, one is led to recall Geoffrey's advice, "let one and the same thing be disguised in multiple forms; be various and yet the same."[23] The gifted painters of the Morgan Bible have indeed been various, for each depiction is a unique, highly complex, and utterly startling composition. In turning the pages of this picture book, one is inevitably and repeatedly encouraged to contemplate the nature of war: the vicissitudes of actual combat, the appalling waste, and, above all, the historical sweep and epic human struggle of holy wars.

A second theme extracted from the Old Testament narrative, and cultivated in the pages of the Morgan Picture Bible, is that of sacrifice, one of the abiding rituals of Hebrew worship and harsh realities of crusading.[24] Through sheer repetition of scenes of sacrifice—there are no fewer than twenty depicted in the manuscript—and distinctive compositional juxtapositions, the human cost of sacrifice is recounted with especially poignant results.

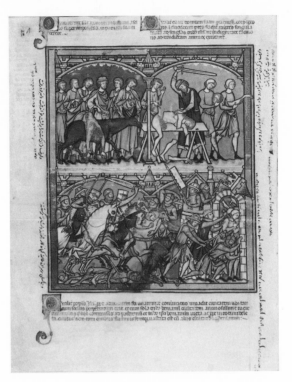

Fig. 1.5. The Pierpont Morgan Library, New York, MS. M.638, fol. 16v, the slaughter of the Benjaminites

For example, on folio 13v the tragic story of Jephthah's sacrifice is juxtaposed with the grim tale of Abimelech slaying his brethren (fig. 1.6). The Jephthah story is recounted in three scenes. On the upper left, the leader of the Israelite army is shown returning home, fresh from his victory over the Ammonites. His gesture of remorse recalls his fateful vow to the Lord taken just before the battle, "If you will give the Ammonites into my hand, then whoever comes out of the doors of my house to meet me, when I return victorious from the Ammonites, shall be the Lord's, to be offered up by me as a burnt offering" (Judg. 11:30–31).

The actual event depicted is recounted in Judges 11:34: "Then Jephthah came to his home at Mizpah; and there was his daughter coming out to meet him with timbrels and dancing. She was his only child; he had no son or daughter except her. When he saw her, he tore his clothes, and said, 'Alas my daughter you have brought me very low . . . for I have opened my mouth to the Lord, and I cannot take back my vow.'" The following scene elaborates further on the story; Jeph-

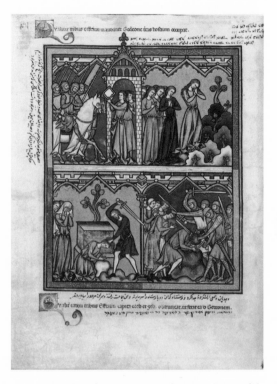

Fig. 1.6. The Pierpont Morgan Library, New York, MS. M.638, fol. 13v, scenes from
Jephthah and Abimelech

thah's daughter is shown wandering in the mountains bewailing her fate before
she is to be sacrificed.

On the lower register, the sacrifice itself is juxtaposed with the scene of Abim-
elech slaying his brethren. The Abimelech story, on the right, is derived from
Judges 9:3–6 and therefore should precede the Jephthah cycle, but most likely has
been moved out of its proper sequence to strengthen the pictorial contrast between
apparently similar events. Jephthah, in fulfilling his vow, is shown holding his
daughter by the hair as he prepares to sever her head before a two-tiered altar
(which is not mentioned in the text). Abimelech, wearing a red tunic over his
chain mail, is shown to the right in a pose echoing that of Jephthah as he cleaves
the head of one of his brethren upon a stone. These two images thus compare dis-
parate examples of killing within families: Jephthah's wrenching sacrifice to keep
his word to the Lord versus Abimelech's heinous crime of fratricide to advance his
own interests. The initial theme of sacrifice is then resumed on the next page

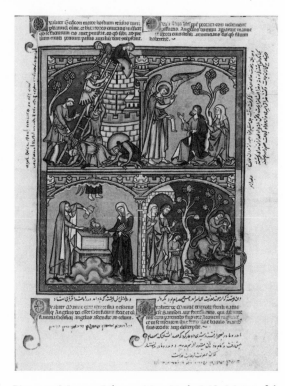

Fig. 1.7. The Pierpont Morgan Library, New York, MS. M 638, fol. 14r, death of
Abimelech, story of Samson

where, in the place of the Jephthah scene on the lower left, Manoah and his wife
are shown offering a kid upon a two-tiered altar resembling the one used by Jeph-
thah on the previous page (fig. 1.7). However, the biblical text states that the offer-
ing was placed on a rock (Judg. 13:15–20). Manoah and his wife are expressing
gratitude for the Lord's promise that they will have a son; the loss of Jephthah's
daughter is thus contrasted with the prophecy of Samson's birth.

Throughout the Morgan Crusader Bible, repetition of particular compositions
or the use of recurring motifs serve to transform the biblical narratives into con-
temporary allegories of interest to crusaders. One of the most distinctive uses of
recurring motifs in the Morgan manuscript may be found on facing pages re-
counting the early events from the story of Joseph (fols. 5r–5v, figs. 1.8 and 1.9).
To develop the theme of Joseph's triumph over adversity in Egypt, the Morgan
illuminators have structured a sequence around recurring depictions of his coat.
On the upper left of the first page, Joseph is shown being cast into the pit as his

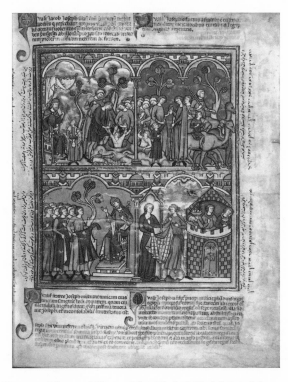

Fig. 1.8. The Pierpont Morgan Library, New York, MS. M.638, fol. 5r, story of Joseph

gray coat is held aloft by the extended sleeves by one of his brothers. Just below this scene, the same coat, now depicted in blue and covered in kid's blood, is offered to Jacob by one of his brothers, who holds it in the same extended-sleeve manner as in the image above.

The motif of the coat is continued in the next scene on the lower right, where we see Joseph accosted by Potiphar's wife, who grasps and removes his orange mantle as he turns to flee. He is then imprisoned on the far right with the butler and baker. Joseph's ultimate vindication is again signaled with the use of a coat. In the lower right quadrant on the facing page (upper portion), Joseph is honored by Pharaoh with a signet ring and a garment of fine linen, now pictured in blue, which is being placed upon his shoulders by an attendant. The variations in the color of Joseph's coat in each appearance serve to elevate the significance of the garment in cueing a reading of the narrative sequence. Joseph's new prominence as governor of Egypt is further signaled in the scene below where his pose, gesture, and garment echo that of Pharaoh, who is situated directly above.

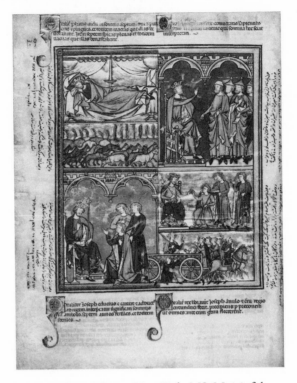

Fig. 1.9. The Pierpont Morgan Library, New York, MS. M.638, fol. 5v, story of Joseph

Perhaps the most complex example of narrative expansion and elaboration concerns an extended allegory on sacred kingship as enacted in the conflict between Saul and David. Within the pages of the Morgan manuscript, Saul is shown presiding as king from his throne no fewer than twenty-four times, in fifteen of which he is actively engaged with David. To examine just one brief segment of this narrative, we might consider four images of Saul confronting David beginning on folio 28v (fig. 1.10). In the series, Saul is consistently shown enthroned, employing a spear or scepter in confronting David. In the first such scene, in the lower left section of folio 28v, David kneels before Saul as he presents the head of Goliath to his king. Saul, in turn, offers his scepter to David, a gesture that is not described in this biblical story but can be understood as an expression of royal favor. In the scene on the next page, again in the lower left section, Saul is shown "as he raved within the house, while David was playing the lyre as he did day by day. Saul had his spear in his hand; and Saul threw the spear for he thought, I will pin David to the wall. But David eluded him twice" (1 Sam. 18:10–11; fig. 1.11).

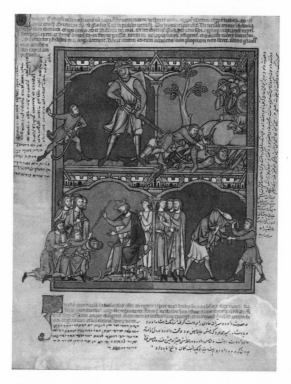

Fig. 1.10. The Pierpont Morgan Library, New York, MS. M.638, fol. 28v,
David before Saul

The sequence continues in the lower right section of the same page, where Saul
again offers his scepter to a kneeling David who is being made a captain over a
thousand men. Like the first depiction of David kneeling before Goliath, the pres-
entation of the scepter to David in this scene is not based on the biblical text. This
sequence of confrontations between Saul and David then concludes on folio 30v,
where Saul again attempts to injure David with his spear (fig. 1.12). In each of these
scenes an enthroned Saul is shown using his spear or scepter to dominate and con-
trol David, the scepter as a symbol of respect and the spear of anger. The repeated
use of this composition and motif offers a pictorial gloss on the conflicted rela-
tionship Saul had with David and it suggests that the ill-fated king's use of his
power was capricious and often self-serving. By repeating the essential elements
of the composition in each scene and adding details not mentioned in the bibli-
cal text, the designer of the program was able to construct a pictorial sermon on
the theme of royal pride and its consequences.[25]

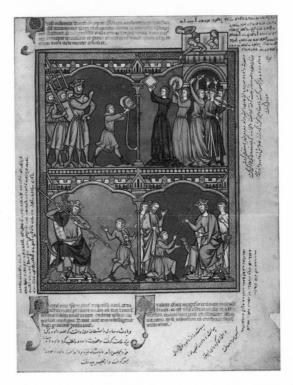

Fig. 1.11. The Pierpont Morgan Library, New York, MS. M.638, fol. 29r,
Saul and David

Throughout the Morgan manuscript, sophisticated compositions tell biblical stories in a new way. Without the support or limitations of an accompanying text, these remarkably inventive images present the biblical narratives in a dramatic and engaging style while subtly exploring a wide variety of contemporary themes, relevant most of all to a culture dedicated to crusading. These include the historical inevitability of war, the nature of sacrifice and the unpredictability of God's will, and the responsibilities of sacred kingship.

The wealth of naturalistic and observational details present in the Old Testament narratives serves only further to enhance the relevance of the stories for a contemporary audience. The pictorial naturalism is in many places remarkable for a work of the thirteenth century. For example, in the scene of Rechab and Baanah entering Ishbaal's house from 2 Samuel, the woman seated beside the door is among the most finely observed and drawn figures in medieval painting (fig. 1.13). Seated on the ground with her knees drawn to her chest and resting her head in

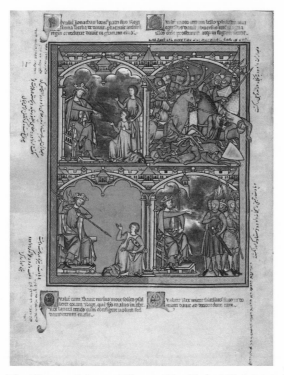

Fig. 1.12. The Pierpont Morgan Library, New York, MS. M.638, fol. 30v,
Saul assaulting David

the crook of her right arm, the sleeping woman leans against the wall of the brick
house. She has before her a winnowing fan, presumably indicating the task she
was engaged in before falling asleep.

Greatest emphasis, however, is given to representations of war. Scenes of battle
provided the illuminators with limitless opportunity for designing complex fig-
ural arrangements and depicting weaponry in action. One such example can be
found in the depiction of the Battle of Hai from the Book of Joshua (fig. 1.14).
The biblical text describing the conflict with the king of Hai sets out the main
lines of the story and establishes the metaphorical significance of Joshua as the
sword of God:

> Then the Lord said to Joshua, "Stretch out the sword that is in your hand to-
> ward Hai; for I will give it into your hand." And Joshua stretched out the sword
> that was in his hand toward the city . . . When Israel had finished slaughtering
> all the inhabitants of Hai in the open wilderness where they had pursued them,
> and when all of them to the very last had fallen by the edge of the sword, all Is-

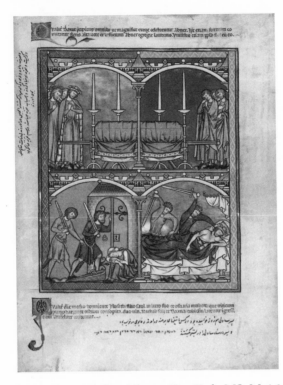

Fig. 1.13. The Pierpont Morgan Library, New York, MS. M.638, fol. 38r,
slaying of Ishbosheth

rael returned to Hai, and attacked it with the edge of the sword. The total of
those who fell that day, both men and women, was twelve thousand—all the
people of Hai. For Joshua did not draw back his hand, with which he stretched
out the sword, until he had utterly destroyed all the inhabitants of Hai . . . And
he hanged the King of Hai on a tree until evening. (8:18–29)

The Morgan illuminator elaborated on narrative and metaphor by manipu-
lating the formal elements of the composition and incorporating a wealth of pic-
torial details not present in the text. Joshua dominates the scene, entering the com-
position from the left astride a bay horse caparisoned in white as he runs a massive
sword through a warrior covered in chain mail who spills his viscera as he tumbles
from his horse. In the right foreground, a kneeling figure wearing chain mail under
a pink sleeveless surcoat fires a crossbow into the chest of the enemy, a man stand-
ing in the tower preparing to hurl a stone. At the base of the tower, an Israelite
soldier works at the gates with a pickax, taking cover beneath his shield. The king

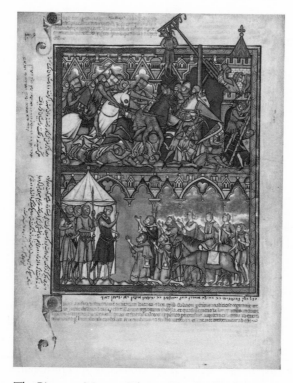

Fig. 1.14. The Pierpont Morgan Library, New York, MS. M.638, fol. 10v, conquest of Hai

of Hai is shown at the top of the composition suspended, not from a tree as described in the biblical passage, but from an engine of war consisting of a rakelike head with six hooks balanced on a large pier by a counterweight.

In this battle scene, as in many of the manuscript's images, the unique sensibility of crusader-inspired art is everywhere apparent: the epic sweep of battle; the myriad soldiers, horses, and diverse weapons; the decisive moment of resolution; and, above all, the meticulous presentation of military brutality. If the structure and content of the narrative was drawn from the Old Testament passage, the formal aspects of the composition were inspired by the aspirations of a culture dedicated to the ideal of the crusade. It is therefore not surprising for us to observe that the art of the Morgan Picture Bible resonates so fully with the poetic sensibility of such writers as Bertran de Born. In his twelfth-century lyric on the exploits of Kings Alfonso of Castile and Richard the Lionheart during the Third Crusade, Bertran described his vision of the ideal crusade: "If both kings are noble

and courageous, we shall soon see fields strewn with pieces of helmets and shields and swords and saddlebows and men split through their trunks down to their breeches; we shall see horses running wild, and many a lance through sides and chests, and joy and tears and grief and rejoicing. The loss will be great, and the gain will be greater."[26]

Notes

1. On the art of the crusader kingdom, see Hugo Buchthal, *Miniature Painting in the Latin Kingdom of Jerusalem* (Oxford, 1957); Jaroslav Folda, *The Art of the Crusaders in the Holy Land, 1098–1187* (Cambridge, 1995); idem, *Crusader Manuscript Illumination at Saint-Jean d'Acre, 1275–1291* (Princeton, 1976); and Daniel H. Weiss, *Art and Crusade in the Age of Saint Louis* (Cambridge, 1998).

2. See Buchthal, *Miniature Painting*, 48–93; and Folda, *Crusader Manuscript Illumination*. On the *Histoire Universelle*, see also in this volume Anne Derbes and Mark Sandona, "Amazons and Crusaders: The *Histoire Universelle* in Flanders and the Holy Land."

3. See Weiss, *Art and Crusade*, 210–15.

4. This idea is developed in Harvey Stahl, "Old Testament Illustration during the Reign of Saint Louis: The Morgan Picture Book and the New Biblical Cycles," in *Il medio oriente e l'occidente nell'arte del XIII secolo*, Atti del XXIV Congresso Internazionale di Storia dell'Arte, ed. Hans Belting (Bologna, 1982), 79–93; Alyce Jordan, *Visualizing Kingship in the Windows of the Sainte-Chapelle* (Turnhout, 2002); and Beat Brenk, "The Sainte-Chapelle as a Capetian Political Program," in *Artistic Integration in Gothic Buildings*, ed. Virginia C. Raguin, Kathryn Brush, and Peter Draper (Toronto, 1995), 195–213.

5. Weiss, *Art and Crusade*, 11–77.

6. Ibid., pl. V.

7. "Sicut igitur Dominus Iesus Christus as sue redemptionis exhibenda mysteria Terram promissionis elegit, sic as passionis sue triumphum devotius venerandum nostrum Galliam videtur & creditur specialiter elegisse, ut ab ortu solis ad occasum laudetur nomen Domini, dum a climate Grecie, que vicinior dicitur Orienti, in Gallium, partibus Occidentus contiguam aut confinem, ipse Dominus as Redemptor noster sue sacratissime passionis sancta transmitteret instrumenta; & sic, veluti compartitis honoribus, terre alteri alteram adequavit." Gautier Cornut, *Historiae susceptionis Coronee spinee*, in C. de Riant, *Exuviae Sacrae Constantinopolitanae* (Geneva, 1877), 1:47.

8. See especially A. Jordan, *Visualizing Kingship*.

9. On the Saint Louis Psalter, see William C. Jordan, "The Psalter of Saint Louis (BN MS lat. 10525): The Program of the Seventy-Eight Full Page Illustrations," *Acta: The High Middle Ages* 7 (1983): 65–91; and Marcel Thomas, *Le Psautier de Saint Louis* (Graz, 1970).

10. See Sydney C. Cockerell and John Plummer, *Old Testament Miniatures* (New

York, 1969); Stahl, "The Iconographic Sources of the Old Testament Miniatures, Pierpont Morgan Library, M.638" (Ph.D. diss., New York University, 1974); Weiss, *The Morgan Crusader Bible: Commentary* (Luzern, 1999); and William Noel and Daniel Weiss, eds., *The Book of Kings: Art, War, and the Morgan Library's Medieval Picture Bible* (London, 2002).

11. This history is recounted in Cockerell and Plummer, *Old Testament Miniatures,* 5–14; Weiss, *Morgan Crusader Bible,* 225–29; and Marianna Shreve Simpson, "Shah Abbas and His Picture Bible," in *The Book of Kings,* 120–41.

12. On the Latin, Persian, and Judeo Persian texts, see the translations by Eran Lupu, Sussan Babaie, and Vera Basch Moreen in Weiss, *Morgan Crusader Bible,* 299–376.

13. Cockerell and Plummer, *Old Testament Miniatures,* 5–6.

14. The attribution to Paris includes Weiss, *Morgan Crusader Bible,* 236; Cockerell and Plummer, *Old Testament Miniatures,* 6; Buchthal, *Historia Troiana: Studies in the History of Medieval Secular Illustration* (London, 1971), 11; and H. W. Stork, *The Bible of Saint Louis: Complete Facsimile Edition in the Original Format of MS 240 from the Pierpont Morgan Library, New York* (Graz, 1996), 23. Robert Branner proposed an English origin for the manuscript, *Manuscript Painting in Paris during the Reign of Saint Louis* (Berkeley, 1977), ix and 139. Alison Stones has argued that the manuscript is of northern French origin, "Sacred and Profane Art: Secular and Liturgical Book-Illumination in the Thirteenth Century," in *The Epic in Medieval Society,* ed. Harold Scholler (Tübingen, 1977), 105ff., and more recently she has suggested Flanders or Hainaut, "Illustrating Lancelot and Guinevere," in *Lancelot and Guinevere: A Casebook*, ed. Lori J. Walters (New York, 1996), n. 18.

15. Herbert L. Kessler, "Pictures as Scripture in Fifth-Century Churches," *Studia Artium Orientalis et Occidentalis* 2, no. 1 (1985): 17–31.

16. Ibid., 27.

17. Henry Maguire, *Art and Eloquence in Byzantium* (Princeton, 1981).

18. Ibid., 59–68.

19. Ibid., 60.

20. Ibid.

21. A. Jordan, *Visualizing Kingship,* 10–14.

22. Ibid., 12; and Geoffrey of Vinsauf, *The New Poetics,* trans. Jane Baltzell Kopp, in *Three Medieval Rhetorical Arts,* ed. James J. Murphy (Berkeley, 1971), 42.

23. A. Jordan, *Visualizing Kingship;* 13; and Vinsauf, *The New Poetics,* 41–42.

24. Sacrifice was also a recurring theme in crusader sermons. See, for example, Penny J. Cole, *The Preaching of the Crusades to the Holy Land, 1095–1270* (Cambridge, Mass., 1991).

25. On pictorial sermons in the court of Louis IX, see also Weiss, "Biblical History and Medieval Historiography: Rationalizing Strategies in Crusader Art," *Modern Language Notes* 108 (1993): 710–37.

26. On the writings of Betran de Born, see the essay by Stephen Nichols in this volume, "Urgent Voices: The Vengeance of Images in Medieval Poetry."

Urgent Voices: The Vengeance of Images in Medieval Poetry

Stephen G. Nichols

Reflections on Crusader Poetry

Troubadours and trouvères, the composers of courtly lyric in the Middle Ages, tend to be associated more with *fin'amors* (courtly love) than with warfare. While the minstrel Taillefer may be portrayed in the Bayeux tapestry as singing to William the Bastard's warriors at the Battle of Hastings—or perhaps celebrating their exploits—no one accuses him of having started the battle. But when it comes to the crusades, poets *were* intensely implicated, not simply with celebrating the events, after the fact, but with inciting them, even, in a certain sense, giving them moral definition. Poetry in the twelfth and thirteenth centuries could be aggressively political, fiercely engaged. But just *how* did it engage, and what were the motivations that led lyric poetry to cross over from Eros to Mars—if, indeed, the two domains have ever been so very separate?

The question is subtle, for it strikes at the heart of lyric poetry's intervention in history at the time. Why has the crusade genre of troubadour lyric not been perceived as a lyric mode that, more than others, perhaps, demonstrates the passionate engagement of these poets with a movement that brings out, even for contemporaries, the glaring contradiction of religion, politics, and geography? Why has this lyric been perceived generally as unproblematic, a more or less straightforward didactic genre? For two centuries now, we have known—or thought we did—what the lyrics are and what their purpose is. Following the lead of the troubadours and trouvères themselves, we have accepted their generic identifications.

Such views follow naturally upon an approach to lyric that takes the corpus itself as a starting point: a chronology of poets and a repertory of different genres and their evolution. However, if one plots crusade lyric on a grid of historical co-ordinates, a rather different view and understanding of the genre emerges.

For one thing, it turns out to have an asymmetrical chronological distribution as compared with most troubadour lyric genres. Whereas other forms of the lyric tend to be more or less evenly distributed from the early troubadours to the third quarter of the thirteenth century (when the "active" phase of troubadour lyric ends), the crusade lyric clumps in response to precise historical events. This is the more anomalous given the fact that the eight recognized crusades between the end of the eleventh century and the last quarter of the thirteenth coincide almost exactly with the activity of the troubadours themselves.[1]

Yet if troubadour lyric and the crusades are almost coextensive, the extant crusade songs do not reflect this balance. In a forthcoming article, Jaye Puckett has shown that of the fifty-two extant crusade songs, a significant group (sixteen) cluster around the Third Crusade.[2] This relative outpouring—compared with later crusades, which vary from four songs for the Seventh Crusade, to a high of six for the Fifth and Eighth—suggests the fervor and optimism with which Europe greeted the Third Crusade. While it is true that this crusade coincided with the height of the troubadour culture, it is also the case that Europe reacted to the capture of Jerusalem by Saladin in 1189 with determination and optimism. That resolve, the optimism that fueled it, and the frustrations at delays that slowed it ring unambiguously in songs for this crusade.

But retaking Jerusalem proved an elusive goal, particularly as the very different perspectives of naïve unrealism in Europe and the realistic but badly coordinated appeals from crusaders in the Holy Land reveal the contradictions of the enterprise. Later crusade songs register a growing pessimism, the discouragement and bitter criticism of what they perceive as an ever-growing gap between crusade rhetoric and what princes were, in fact, prepared to deliver. Here, at least in the first third of the thirteenth century, crusade songs stand at variance with prevailing public sentiment. The crusader movement was positively viewed at the time. So the songs may be taken as early warning signs of disillusion to come.

The thematic of space in these songs offers an analytic tool by which to figure the contradictions inherent in the crusade enterprise. Space joins with visual image to make crusade songs different from other lyric genres. Through adroit use of topographical references, crusade songs join contemporary events to a semiotically charged geography that Europeans have previously associated with the biblical far past, the *in illo tempore* of Christian narrative. Accounts of pilgrimage journeys to

Palestine routinely evoke the spiritual value of the far past to justify the trouble the pilgrims take to view the biblical sites. The symbolic current runs from past to present, in such instances, while the *locus sanctus* the pilgrim visits is metaphoric, a holy place in *name,* where it is the name that guarantees the link to the (far past) event.

By pointing to an event occurring in the Holy Land, now, in the present, crusade song overwrites the metaphoric/historical value of a holy place with a new literal account of actions undertaken by crusaders in the name of immemorial religious values. In other words, the holy site is now also a renewed site of suffering for the cross (at least in theory). Rather than simply representing the mythical space of the far past, the songs render past values in terms of present deeds and needs. Christ's Passion *redeviva,* as it were.

The specificity of sacred space as sign in this poetry activates a poetic voice unlike that found in other troubadour lyric genres, including the *sirventes,* or satiric song, which might seem closer in nature. We'll return to the *sirventes* in a moment. First, let's note how crusade lyric's treatment of sacred space sets it apart from the troubadour norm of a centripetal or self-referential discourse. Crusade lyric typically begins to deploy a normative poetic form. We can perhaps see this conventional inflection best in an early poem (c. 1138–47) by Marcabru, which is not strictly speaking a crusade lyric, but rather a *canso,* or love song, that has been transformed by the indirect presence of the crusade (in this case, the Spanish crusade).[3]

A la Fontana del vergier, "By the Orchard Fountain," begins as a typical lyric in which the poet/lover finds a lovely woman sitting beside a fountain.

> A la Fontana del vergier,
> on l'erb' es vertz josta'l gravier,
> a l'ombra d'un fust domesgier,
> en aiziment de blancas flors
> e de novel chant costumier,
> trobei sola, ses companhier,
> cela que no volc mon solatz.[4] (1–7)

[By the fountain in the orchard / where the grass is green down to the water's edge, / in the shade of a flowering fruit tree, / 'midst pleasant white blossoms / and the old hymn to a new season, / I found, alone, with no companion, / she who does not desire *my* words of solace.]

That the woman is alone, does not seek the solace of the poet/lover, would not necessarily debar the song from initiating the love dialogue we associate with pastourelle. In fact, the second stanza maintains this screen by describing the young woman as beautiful and high-born: "So fon donzel' ab son cors bel, / filha d'un senhor del castel" ["She was a young woman with a beautiful body, / the daugh-

ter of a lord of the château," 8–9]. Having drawn the reader in with one set of expectations, Marcabru now implements a differential contrast that implements another discourse entirely. This is not to be a love poem that isolates the lover and his mistress from the world in their poetic garden. The poet's blandishments or songs will not distract her from her fixed point of contemplation that she will enunciate in her own words in the third stanza.

> e quant eu cugei que l'auzel
> li fesson joi e la verdors,
> e pel dous termini novel,
> e que entendes mon favel,
> tost li fon sos afars camjatz. (10–14)

[and just when I thought that the birds / and the green bower would bring her joy, / in this soft new season, / and that she would gladly encourage my smooth talk, / her whole demeanor suddenly changed.]

Indeed, the second stanza, when coupled with the third and fourth, suggests the impotence, even fatuousness, of the conventions of *fin'amors* in the face of the outside world. The young girl's *amic* has gone off to fight the Saracens in Spain, and her only appropriate response, the female equivalent to taking the cross, must be an ascetic grief. Her grieving encompasses not simply her lover, but also—as her apostrophe to Christ makes clear—Christ's humiliation, his *anta,* "shame," caused by those who do not respect his holy places.

> Dels olhs ploret josta la fon
> e del cor sospiret preon
> 'Jhesus,' dis ela, 'reis del mon,
> per vos mi cries ma grans dolors,
> quar vostra anta mi cofon,
> quar li melhor de tot est mon
> vos van servir, mas a vos platz. (15–21)

[Her eyes wept with the fountain, / and she sighed from the depths of her heart, / "Jesus," she said, "King of the world, / on your account my great sorrow grows, / your humiliation confounds me, / for the best men in the whole world / go off to serve you, and that's your desire."]

Here, the garden ceases to resemble the *locus amoenus* of the typical love song, to become something more akin to a Gethsemane, and the woman to a sorrowing Virgin. For Marcabru, the ethical response to the intervention of history in one's life demands the suppression of *fin'amors* and its aesthetics. His poem thereby becomes an example of the crusader ascetics he advocates.

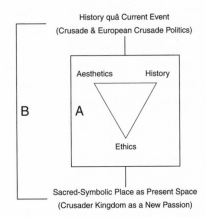

A. Troubadour poetry generally deploys a discourse in which form, problems of subjectivity, and behavior play out in a contrastive present-past scenario where past and present refer to that of an individual subject. The dynamics of aesthetics, history, and ethics tend to be personal and self-referential and thus centripetal. The crusade lyric also begins to deploy this dynamic. Using the same centripetal poetics initially, crusade lyric finds that the pressure of the external forces (B) that constitute—unlike other lyric forms—its subject matter dialogizes the dynamic interaction of the poetics (A) to the point of redirecting the discourse outward, or at least compromising its centripetal thrust.

B. Crusade lyric both activates and responds to external referential stimuli, the crusade event that motivates them and the historical and cultural symbolic value of the Christian Holy Land that it sees the crusade as reanimating. The "external" forces of "B," alter the dynamics of "A" in crusade lyric by rendering the sacred places literally the site of a new Passion, and by revealing the complex political reality of the crusades—fought in Palestine, but determined by the integrity (or lack thereof) of European princes. By stressing the bipartite "front" of these wars—Europe and the Holy Land—crusade lyric reveals the crusade as a ubiquitous current event, present history in every sense.

Fig. 2.1. Schematic representation of elements in crusader lyric

In so doing, of course, it both critiques and rejects *fin'amors*. The poetic discourse Marcabru advocates for crusade lyric turns resolutely away from the badinage of lovers, with its attendant ethics of immediate gratification, toward the kind of long-term spiritual reward that, on his account, must motivate and sustain both the crusader and the woman he leaves behind.

The final two stanzas implement a dialogue between poet and *domna* that is the hallmark of the pastourelle. In this case, however, the poet urges the ethics and ascetics of spiritual reward: "My beauty," said I, "there's no reason to despair so, / for he who makes the woods green with leaves / can give you ample joy."[5] Skeptically, she responds that while she has no doubt that God will reward her in the

other world, along with numbers of other sinners, in this one he has taken the only thing that can bring her joy, "but I can do little about it, / for he's gone too far away from me."[6]

With the final two stanzas Marcabru dialectizes the differential contrast between what will become crusader poetry and the conventional song of *fin'amors*. He represents the unbridgeable gap between the two modes in spatial terms. On the one hand, he sketches crusader space as a real world driven by an ethics of self-abnegation and acceptance of a historical imperative. Against this, he contrasts the closed garden, the castle orchard of the *canso*, where private erotic concerns and codified courtly ethics strive to remove the lovers from historical time and the obligations of a world beyond the garden's (or the song's) perimeter.

Marcabru holds these two modes suspended over the head of the young woman by way of dramatizing that they are real-life choices. And they are choices radically different from those usually faced by knights and ladies of courtly society. In this world, while knights did go off to fight, they rarely went far. Crusade service, however, changed the meaning of *alonhar*, "to go far away," encompassing distances not hitherto encountered in chivalric warfare. In addition, the warfare could not be more alien, or the rules less certain.

That the young woman in the song makes the "wrong" choice, though fully cognizant of the greater moral force of the alternative, drives home Marcabru's point that courtly ethos, the license to celebrate and be guided by one's comfort and erotic life, threatens the crusade enterprise much more than fear of the enemy, or economic factors. It is important to note that courtly lyric and crusader poetry share two key elements: aesthetics or poetic form; and the dramatis personae: the poet, the knight, and, often, the lady. Courtly lyric, then, comes to symbolize, for the crusade cause, the impediments of a "comfortable," known way of life whose pull, even at the height of crusader fervor, many of those who had taken the cross found difficult to shake off. Indeed, as we shall see, later troubadours seize precisely on the scenario Marcabru dramatizes so vividly.

Marcabru's beautiful and headstrong young woman stands, then, as an allegory for the courtly lyric itself, refusing to be displaced by the moral or historical arguments advanced by crusade advocates. Despite their shared aesthetics and characters, crusader poetry and the larger troubadour lyric respond to different historical and philosophical stimuli. Crusader poems often, as Marcabru does here, take their point of departure from familiar poetic forms from which they then diverge by way of marking more strongly the contrast between them.

By way of segue from these general remarks on crusader lyric into the next section, I offer the following diagram (fig. 2.1). It shows where crusader poetry over-

laps with the troubadour canon (A), as well as the external pressures (B) constituting its subject matter, its motivation, and its agency of difference. Paragraphs "A" and "B" (following the diagram notation) explain the external pressures.

The Vengeance of Images: Crusader Poetry and History

The preceding view of the crusader lyric is somewhat, or even considerably, at variance with traditional views of this genre. Scholars have rarely felt uncomfortable with following the lead of the troubadours in accepting generic identifications, particularly that of the *sirventes* or satiric song of provocation. They—we—have also accepted the identification of given poets with certain genres. Bernart de Ventadorn is the quintessential love poet in this view, for example, and Bertran de Born, the politically engaged warrior bard.[7]

In Bertran's case, this view comes with the imprimatur of no less an authority than Dante himself. Everyone recalls his memorable image of Bertran's torso holding its head before it like a lantern at *Inferno* 28:118–26, in the ninth and last *bolgia,* of the eighth circle of Hell, which is reserved for the sowers of discord.

> Io vidi certo, e ancor par ch'io 'l veggia,
> un busta sanza capo andar sì come
> andavan li ·altri de la trista greggia;
> e'l capo tronco tenea per le chiome,
> pesol con mano a guisa di lanterna:
> e quel mirava noi e dicea: "Oh me!"
> Di sé facea a sé stesso lucerna,
> ed eran due in uno e uno in due;
> com'esser può, quei sa che sì governa.

[Truly I saw, and seem to see it still, a trunk without the head going along as were the others of that dismal herd, and it was holding the severed head by the hair, swinging it in hand like a lantern, and it was gazing at us and saying: "Oh me!" Of itself it was making a lamp for itself, and they were two in one and one in two—how can this be, He knows who so ordains.[8]]

Elsewhere, in *De vulgari eloquentia* (2.2.9), Dante calls Bertran "the most illustrious vernacular poet of arms."[9] He also cites the troubadour as a paragon of liberality in the *Convivio* (4.II.14), the equal, in fact, of Alexander the Great, as well as of key crusader warriors, including Saladin.

William Paden and his co-editors of Bertran's poems argue that Dante's portrait of Bertran as a "sower of discord" does not necessarily correspond to historical reality. "Bertran in Hell," they note, "sounds not at all like the living poet."[10]

Because he did write about battles and crusades, Bertran had a reputation by the late thirteenth century as a poet of arms. At this juncture of *Inferno,* Dante needed a well-known and colorful figure to illustrate *contrapasso,* the term he borrows from Aquinas's commentary on Aristotle's *Ethics* that signifies "retaliation."

In Dante's view, Bertran's head severed from his trunk and carried, not Medusa-like, but as a beacon in front of him, illustrates condign retaliation for the sin of turning sons against father by stirring discord between Henry II of England and his sons, particularly Richard. Having severed son from father, the right arm from the head of the body politic, as it were, Bertran suffers divine retaliation by having his own head severed from his body. Naming himself to Dante-Pilgrim and Virgil as a figure of *contrapasso,* he represents his brand of just retribution, the governing principle for sinners in *Inferno.*[11] In short, Dante uses Bertran for his own ends.[12]

Modern literary historians have followed his lead. Accepting Dante's assessment of Bertran, Teodolinda Barolini disparages—in Dante's name—the troubadour. "Bertran," she says, "misused his position [as a political poet], and mishandled his responsibility . . . Bertran is a grotesque inversion of Virgil [full of] a self-sufficiency that is not strength but meaninglessness."[13] More illogically, given the importance Dante accords to Bertran's political sins, Barolini asserts that his poems "had little political impact."[14] To her summation of Dante's (and her own) treatment of Bertran, however, one can only assent. "In his presentation of Bertran," she says, "Dante definitely alters the historical record, and in such a way as to affect the poetic record as well: Bertran's poetic reputation was not enhanced by the *Comedy.*"[15]

Labels are convenient. They are doubly so when they link poets to their creations in a formalist classification that can then help to interpret particular poems. Poets do have their themes and their interests, Bertran no less than another. He does indeed write about war; and he certainly satirizes those who seem slow going into battle. It is the task of literary history to point out such things. Yet to conflate poet and formal production for heuristic purposes, as Dante does, inevitably limits the dialogic interaction between the poetry and its historical and contemporary moment. In short, it decontextualizes the poet, and flattens the variety of his oeuvre, exactly as Dante and Barolini do, however brilliantly, with Bertran. After *Inferno* 28, it has been difficult to see the troubadour as other than illustrating Dante's adaptation of Thomas Aquinas's gloss on *contrapassum* in his commentary on Aristotle's *Ethics.*[16]

Bertran de Born may be an extreme case, thanks to Dante, but troubadour and trouvère crusade poetry generally has tended to suffer from the syndrome of generic conflation. To identify a given lyric as a crusade song tells us little about the dialogics of polemical verse in the period. It tells us still less about the histor-

ical context that inspired poets to raise their voices urgently as part of a long and widespread debate about the propriety, efficacy, and moral justification for this movement, which seems so curiously irrational to modern eyes. Only by reinserting crusade poetry into this wider, political and philosophic context can we understand particular poems, especially those that have proved puzzling or recalcitrant to analysis.

It is significant that neither Dante nor Barolini mentions Bertran's role as a crusade poet. Would the terms *warmongering* and *sanguinary* have tripped off Barolini's pen in that case? And have Bertran's crusade poems been clearly understood in the larger context of the historical debate over the crusades and the concept of a *bellum iustum* in the eleventh and twelfth centuries? Let's look briefly at a couple of Bertran's crusade songs to see what they have to tell us not only about his poems, but also about the surprising elusiveness of the crusade genre in modern criticism.

William Paden's edition of Bertran's poetry places six of his songs in the period of the Third Crusade from 1188 to 1194. Four of these exhibit unique formal characteristics, including, in two cases, so truncated a structure that earlier scholars have taken them for fragments.[17] Another song, Paden's 37 (P-C 80:3) *Anc no 's poc far maior anta* ("She could never bring greater shame on herself"), exactly imitates the formal schema of Raimbaut d'Aurenga's *Ara non siscla ni chanta* ("The nightingale doesn't sing now," P-C 389:12).[18] Raimbaut (1147–73) wrote earlier than Bertran (1181–98), who often cites him, and they are the only two poets to use this particular schema.[19]

There is not the slightest doubt, then, but that Bertran deliberately produced a contrafaction, transforming Raimbaut's unambiguous love lyric into a crusade polemic against the inconstancy of those who woo a woman or a cause and then refuse to redeem their pledge. Nothing surprising here, for it is exactly the kind of transformation that the reflections in the first part of this chapter would lead us to expect. Indeed, Bertran's morphing of Raimbaut's love lyric into a crusade polemic simply plays upon the dual modal register that Marcabru uses so well in *A la Fontana del vergier.*

Both of these examples suggest the ease with which poets could adapt the register of *fin'amors* for the purposes of crusade polemic. They usually accomplish this by an allegorical shift in which the literal lady, the *domna,* or love object, now becomes a personified Holy Land, symbolically evoked as the *lavador* (baptismal font: Marcabru's *Pax in nomine Domini!*), or the *bressol,* "cradle," or *chambra* in Bertran's crusade poems. In such an allegorical transition, the love dialectic of the typical love lyric—that is, expressions of the lover's ardor and the *domna*'s resist-

ance—symbolically figure the inner struggle between the *croisé*'s higher and baser self, his lofty spiritual ideals, and the fear of material loss and hardship. It is no accident that Bertran turned to Raimbaut d'Aurenga as a model for his transformed love lyric.[20] Raimbaut was one of the early practitioners of *trobar clus,* the hermetic style of troubadour poetry that favored obscure metaphors and difficult allegorical flights.

Bertran and other crusade poets perceived the courtly ethos itself, as exemplified by the *fin'amors* of love songs, as one source of aristocratic reluctance to espouse the military ardors required by a spiritual commitment to the crusade. One solution envisaged attacking the courtly ethos from within by fighting rhetoric with rhetoric, *canso* with *sirventes.* Consequently, we find no shortage of the straightforward polemic against the *otium* of courtiers. Bertran himself speaks scathingly of those who delay their departure for the Holy Land every time they catch sight of their mistress. In the first of his apostrophic songs to Conrad of Montferrat, then defending Tyre against a siege by Saladin for which King Richard and King Philip had pledged assistance that they delayed in bringing, Bertran writes:

> Meser Conrat, a Jesu vos coman,
> qu'eu fora lai a Sur de Saladi,
> mas laisei m'en quar se tarzavan tan
> li comt'e 'ill duc, lli rei e li princi.
> Pois vi midonz bell'e bloia
> Per que s'anet mos cors aflebeian,
> q'eu fora lai, ben a pasat un an. (*Ara sai eu de pretz,* ll. 8–14)

[Sir Conrad, I commend you to Jesus; I would have been there at Saladin's Tyre, but I gave it up because the counts and the dukes, the kings and the princes were tarrying so. Then I saw my lady, beautiful and fair, and my heart went weak all over, otherwise I would have been there over a year ago.[21]]

Except for recognizing the bitter irony of his observations, this kind of rhetoric requires little interpretation. The sarcastic anger stands out as from the satiric epigrams of Martial (whom Bertran could have taken as a model). This kind of attack might well sting a knight guilty of indolence in prosecuting his crusade vows. It sets off in stark contrast the conflicting dimensions of his life: the materiality of courtly pleasure, on the one hand, and the rigor of spiritual commitment to defending the sacred space of Christendom, on the other.

The satiric images of Bertran's odes to Conrad of Montferrat evoke the same register of exemplarity that we find in hortatory sculptures on the portals of Romanesque churches. In their portrayal of the opposing registers of luxuriousness and asceticism, they precisely invoke the didactic juxtaposition of material blind-

ness and ascetic acuity conveyed by the story of Lazarus and Dives so popular in Romanesque art. Exquisite early examples may be found in the heart of troubadour country in the bas-reliefs carved on the portal of the Cluniac church at Moissac and on the Porte Miegeville at Saint-Sernin in Toulouse, for example.

Such direct invocations of the terms of the debate separating crusader advocates from their nonengaged neighbors clearly delineate the issues, but they cannot catch the noncrusader unaware. They cannot surprise him into perceiving that his preference for material pleasure directly contradicts his spiritual duty, constituting, in fact, the equivalent of a mortal moral failing. Rather than keeping the two domains separate by the kind of "pro and con" argument that we find, for instance, in Rutebeuf's debate poem between the *croisé* and the *décroisé,* written almost a century later for Saint Louis's Second Crusade of 1270, there needed to be a means of superposing the two worldviews. If the material could be represented vividly enough initially, only to have it contradict itself and yield before its ascetic alter ego, the two views could be dialogized within the same poetic structure. To represent the spiritual world as superposed on the physical accorded perfectly with medieval practice. Pilgrimage and crusade literature from the time of Constantine argued that all space was sacred because, as Cosmas Indicopleustès and others maintained, the physical world simply manifested in three-dimensional space the sacred universe symbolized by the biblical tabernacle.[22] The issue was not to demonstrate yet again this indisputable truth, but to make potential crusaders see its force for their own lives.

Several of Bertran's poems written around the time of the Third Crusade offer a strategy whereby the formal qualities of troubadour poetry coupled with the medieval practice of reading "vertically," as it were, to experience different levels of meaning would constrain the crusader reader to acknowledge his willful blindness to the reversal of priorities his lifestyle encouraged. In short, Bertran transforms the technique of *trobar clus* that he acquires from Raimbaut d'Aurenga and Arnaut Daniel to create a satirical allegory that appears as a straightforward evocation of the joys of feudal life: either those of amorous dalliance or of baronial warfare on one's neighbors. Dante and modern critics, including Bertran's editors, have taken these poems at face value, understandably, as they are vivid and provocative. But something more complex is really going on in them. Rather than contrasting the choices of courtly love and crusader commitment in the manner of Marcabru, Bertran uses the vehicle and language of *fin'amors* itself to demonstrate how it overlay and masked the hard core of moral commitment inherent in the crusading life.

The crusades and the *sirventes* were inevitable bedfellows so long as the gulf be-

tween saying and doing remained unbridged by the European princes. The four-teenth-century *Leys d'amors* (literally *Rules of Love,* where *amors* means poetry) that codified troubadour poetry defined the *sirventes* as follows. "The *sirventes* blames and reproaches the conduct of evil and crazy men. It may also treat mat-ters of war."[23] Another version adds a coda that makes the didactic and moral sense even clearer: "And the *sirventes* may also speak of deeds of war, to assure its proper progress; good reasons are the way to chide, lead, and teach people."[24]

Called *sirven,* or servant, because it was thought to be ancillary to the *canso,* or love lyric, from which it borrowed melody and form, the *sirventes* performed a moral purpose. Inherently the most political of troubadour genres, as satire gen-erally is, the *sirventes* often took the form of crusade songs, beginning with Mar-cabru's prototype of 1137, *Pax in nomine Domini!,* also known as the *Canso del lavador* or "Song of the washing place," from the lines where Marcabru uses the term *lavador* (literally "washing place," but here something like a spring or a bap-tismal font) to symbolize the war against the unbelievers. Mystically, God prepares in Spain—as he does in the Holy Land—a *lavador,* or font, where the sins of his soldiers can be cleansed, for, as he says, "God wants to test the bold and the weak in his washing place."[25]

Bertran knows the *sirventes* well, and often uses it to devastating effect in non-crusading causes. In *Ges de far sirventes no'm tartz* ("I'm not going to put off com-posing this *sirventes*"), he confidently asserts his talent for the genre:

> 1. Ges de far sirventes no 'm tartz,
> anz lo fauc senes totz affans,
> tant es sotils mos geins e m'artz.
> Que mes m'en sui en tal enans,
> e s'ai tant de sort
> qe ve'us m'en estort,
> qe comte ni rei
> no 'm forssan ni grei. (1–8)[26]

[I'm not slow at making *sirventes,* rather I do it with little effort, so subtle are my wit and my craft. I've got such an advantage, and so much luck that, see, I twist so that counts nor kings nor complaints bother me.]

Or again:

> 2. Volontiers fera sirentes,
> s'om bo volgues ausir chantar,
> que pretz es mortz, honors e bes,
> e se los en pogues venjar
> tanz n'i agra que mortz que pres

que si fins del mon no ·i vengues,
tanz no ·n pogran aigas negar
ni tuit li foc del mon cremar! (9–16)

3. Regisme son, mas rei no jes;
e contatz, mas non comt ni bar;
las marchas son, ma no ·il marqes;
e ·ill ric castel, e ·ill beill estar,
mas li castellan no i sso.
Et avers es plus c'an non fo;
pros an condutz e pauc manjar,
en colpa d'avol ric avar. (17–24)[27]

[2. I'll gladly make a *sirventes* if anyone wants to hear it, for valor (*pretz*) is dead, and honor, and worthiness, and if I could avenge their loss, there'd be so many killed and captured that, unless it were the end of the world, there'd not be sufficient water to drown them, nor fire to burn them. 3. There are kingdoms, but no kings; counties, but no counts or barons; marches but no marquesses; and rich castles and fine manors, but not a castellan among them. There's more wealth than ever; plenty of feasts (*condutz*), but little to eat, and all because of vile, rich misers.]

We should not be surprised to find that Bertran would turn to the *sirventes* when he wished to comment on the failed crusader obligations of princes and nobles at the time of the Third Crusade. In line with the idea that the crusader *sirventes* has a greater historical specificity and urgency than other forms, we might look at two short poems, so short, indeed that critics have taken one of them to be a fragment. In fact, they employ an epigrammatic form that Bertran himself calls a *miez sirventes,* a "half-*sirventes.*" By giving only two-and-a-half or three stanzas, Bertran distills the discursive force into epigrammatic form, rendering the poem the more scathing.

Since poetic genres were conventional, readers would normally expect a full six or seven stanzas (as in the two *sirventes* quoted above). Violating that norm by truncating the song gives the poet a way to signal a corresponding lack or failure in the world referenced by the poem. In effect, the truncated poem symbolically figures a corresponding diminution in the focus of discourse. In light of the Western princes' dilatory response to the crisis in the Holy Land, half the world, that of the Latin Kingdom in the Holy Land, has been eclipsed, severed from the West, or threatens to be.

The two half-*sirventes* present the crusading polemic as two panels of a diptych. In the first, Bertran projects the scene of desolation in the Holy Land, overrun

by Saladin and his forces. In the second, he portrays France, particularly the Midi, as a scene of destruction brought about by feuding princes who should have eyes only for the first scene. If the ideal of the epic hero is to be both a doer of deeds and a sayer of words, these heroes, like the poem that portrays them, are only half there.

The first poem, *Nostre seingner somonis el mezeis* ("Our Lord himself calls"), devotes the first stanza to evoking the crisis in the Holy Land.[28] The second describes Richard the Lionheart's response to the crisis in a full stanza that underlines Richard's dual response to the crisis. For half the stanza he enthusiastically embraces the crusader cause, and just as enthusiastically, in the second half, he embraces affairs that cause him to postpone his departure for the Holy Land. This stanza turns on the janus-line that falls in the center of the nine-line stanza. Applicable with equal irony to the first four lines, and to the last four, the fifth line oracularly states: *E c'el vol pretz, a las obras pareis* ("And it appears from his deeds that he wants honor," l. 14).

The dark irony of the line emerges when the extravagant praise of the third line of the stanza—*Qu'el voll mais pretz c'om de llas doas leis* ("He desires valor more than any man of either religion")—encounters its ominous homologue in the third line of the second half (line 8):

> Qu'el vol lo pretz del mal e ·l pretz del ben
> E vol tan pretz c'ambedos los rete. (ll. 17–18)

[He desires valor from evil as well as valor from good, he desires valor so much, in fact, that he'll keep both kinds.]

The pivotal line at the midpoint of the stanza—*e c'el vol pretz, a las obras pareis*—rhymes with the first line of praise: *Qu'el voll mais pretz c'om de llas doas leis*. The repetition of *pretz* at the epic caesura within the lines, and the rhyme *leis . . . pareis* assures the vertical parallel of the thought. Now look at the crushing conclusion in the final couplet with its cornucopia of repetitions of the word *pretz*. Not only does the couplet repeat the vertical superposition of *pretz* at the caesura of lines 12 and 14, it also deploys a horizontal sequence, *lo pretz del mal e ·l pretz del ben*, in line 17. *C'ambe dos los rete*—"he'll keep the two kinds"—of the last line, inevitably now makes the very first of the *pretz* lines—*Qu'el voll mais pretz c'om de llas doas leis* ("He desires valor more than any man of either religion")—resonate with a new and very somber connotation.

Keeping evil valor and good valor is like observing both religions, Christian and Muslim. Indeed, it drives home the supposition of the period that Muslims, like other heretics, believed in a radical separation of matter and spirit. Richard, like Ganelon, the traitor of the *Song of Roland* who betrays Roland and Charle-

magne, serves the two Laws, by delaying his departure for the crusade. Tradition-ally, from Charlemagne's time, the Christian king in Europe was "God's right arm," or the pope's. The *Song of Roland* reiterated this lesson for the twelfth century.

In light of this historical fact, let us look at the rhymes *reis, leis, pareis,* "king," "laws/religions," "appears," of the first half of the stanza. The first line announces that although Richard is presently duke, "he will be king": *e sera reis.* As king, he would have to uphold the one Law or *lei,* that is, Christianity. In other words, *reis* should not rhyme with *leis,* in the sense that the true king cannot uphold religion*s,* in the plural. How authentic a Christian king can Richard make? Bertran does not leave us in doubt. *Pareis,* the rhyme word of the pivotal line in the center of the stanza, means "it appears," but it also creates the homophone, *par reis,* "appears king," where *par* (from *parer*) is another form of "appears." Remember that the irony of the line as a whole—"It appears from his *obras* (works) that he desires valor"—suggests that his *obras* are sufficiently ambiguous to give the valor a dou-ble meaning. So when we hear *par reis,* we are meant to infer that his ambivalence toward the crusade makes him king only in appearance, not in deed.[29]

Space does not permit us to delve as deeply into the second panel of the diptych, the poem *Miez sirventes vueilh far dels reis amdos* ("I want to make a half-*sirventes* about both these kings"). Suffice it to say that here Bertran offers the other side of the picture: a vivid image of the petty feuds that keep Richard of England and Al-fonso of Castille at home, instead of departing for the crusade, as at least Richard had publicly sworn. The poem appears to bear out Dante's claim that Bertran was the warrior bard par excellence, and Teodolinda Barolini's qualification of him as "warmongering" and "sanguinary." Indeed the current editors cite the second and third stanzas as examples of Bertran's penchant for appropriating the more color-ful bits of epic battle description. At the literal level, there can be no doubt of the vividness of the battle description, especially in stanza 2, as this sample shows:

> 2. S'amdui li rei son pro ni coraios
> en brieu veirem camps joncatz de qartiers
> d'elms e d'escutz e de branz d'arços
> e de fendutz per bustz tro als braiers (9–12)[30]
> [. . .]

[If both kings are noble and courageous, we shall soon see fields strewn with shards of helmets and shields and swords and saddlebows and men split through their trunks down to their breeches . . .]

But to read this stanza literally would be to ignore the rest of the poem, and above all the other panel of the diptych, which we have just analyzed. Bertran there

revealed the ugly underside of courtly values, showing their propensity for dangerous ambiguity when he exposed the consequences of Richard's insatiable desire for *pretz* at any price. This second panel of the diptych demonstrates what he meant by the *pretz del mal* of the first poem. Richard's evil valor is the reckless waste of money evoked by lines 5–8 of stanza 1:

> Richarz metra a mueis e a sestiers
> Aur e argen, e ten s'a benanansa
> Metr' e donar, e non vol sa fianza.
> Anz vol gerra mais qe qaill' esparviers. (5–8)

[Richard will pour gold and silver by the barrel and bushel, feeling blessed to spend and give, and he won't keep his pledge. Rather, he wants war more than a hawk, quail.]

In other words, Richard's prodigality assures the slaughter of Christian by Christian so vividly described in stanzas 2 and 3.

That money and those lives, Bertran's mordant satire asserts, should better be spent in pursuing the *pretz del ben* in the Holy Land. Attention to the argument here permits us to follow the allegorical bent of the hypotyposis or graphic description in these stanzas. The scenes are allegorical because, like depictions of Hell in Last Judgment tympani of Romanesque churches—Autun, for example—the vivid description figures the suffering perpetrated by laudable ambitions gone awry. The more graphic and sanguinary the depiction, the more striking the allegory.

For later generations all the way up to Sir Walter Scott's 1825 novel of the Third Crusade called *The Talisman,* Richard symbolized the ideals of courtly *pretz,* or valor. Much closer to the scene of this ideal, Bertran perceives the double edge of courtly discourse. By turning it inward on itself, by revealing its contradictory codes, he seeks to embarrass, to ridicule, and thus to shame political leaders to perform in deeds the ideals they have espoused in words. Bertran does indeed represent the principle of *contrapassum:* but, *pace* Dante, he does not embody it; he wields it as a powerful poetic weapon. Lest we have any doubt of the reforming intent of this *sirventes,* we need only look at the last two couplets Bertran wrote by way of a *tornada.* They tell us what kind of a world he would like to live in, and what kind he hopes to be delivered from. They are his own version of a Last Judgment:

> 4. Mas se ·l reis ven ieu ai en Dieu fiansa
> qu'eu serai vius o serai per qartiers;
> 5. e si sui vius er mi grans benanansa,
> e se ieu mueir er mi grans seliuriers. (25–28)

[4. If the kings come and have the battles they long for, I trust in God that I'll be alive or in pieces. 5. And if I survive, it will be great luck, and if I die it will be a great deliverance.]

People tend not to miss the allegorical implications of Last Judgment scenes because they are typically carved into an interpretive context, that is, the ecclesiastical edifice. It is not the same with poetic stanzas like Bertran's vivid battle descriptions, which can be ripped out of context and misread, as we saw earlier. To do so does not simply trivialize the great crusader poet that Bertran de Born clearly was, it also rends the crusade song from a nearly millennial tradition of dialectic between the spiritual and the material life of the Christian laity. Within that tradition, crusade literature played a major role in defining and portraying the reforming values that motivated pilgrimage and crusade in the Latin West.

Notes

I would like to thank Daniel Weiss, then chair of art history at the Johns Hopkins University (now dean of the Krieger School of Arts and Sciences), for inviting me to participate in the colloquium, "Frankish Culture at the End of the Crusades: France and the Holy Land." Without his encouragement, I would not have written this study, or at least not in this form. Professor Sarah Kay of Cambridge University generously read and commented on an earlier version. She reads well and deeply; the current version owes much to her insights and our discussion.

1. The dates of the crusades to the Holy Land are: First Crusade, 1096–99; Second Crusade, 1147–49; Third Crusade, 1189–92; Fourth Crusade, 1202–4; Fifth Crusade 1217–19; Sixth Crusade, 1228–29; Seventh Crusade, 1248–54; Eighth Crusade, 1270. The first troubadour, Guilhem IX, wrote during the first quarter of the twelfth century, and certainly participated in the politics, though not the expedition itself, of the First Crusade. One of his poems has traditionally been interpreted as a farewell written for a crusade departure that did not occur. Guiraut Riquier composed the last known crusade lyric, *Karitatz et amor e fes* (January 1276). The active composition of troubadour songs ceased by the end of the thirteenth century, as did the fact, if not the cultural force, of crusading. Of course a crusade against heresy in the Midi of France, the Albigensian Crusade in the early thirteenth century, effectively ended the troubadour culture there, shifting its center to northern Italy, where it survived another half-century or so.

2. Of the fifty-two songs, forty-three deal with the crusades to the Holy Land, five with the Spanish Crusade (c. 1140–c. 1165), and four with the Albigensian Crusade (1218–29). No songs treat the First and Second Crusades, though Marcabru's two songs dealing with the Spanish Crusade (c. 1137 or 1149, and 1147), the earliest examples of the genre, certainly offered eloquent models for later poets. Sixteen songs address the Third Crusade; five, the Forth; six, the Fifth; five, the Sixth; four, the Seventh; six, the

Eighth; and one postdates the Eighth. For a complete list of the troubadours and their songs, as well as a penetrating analysis of the precocious understanding by the troubadours of the internal contradictions inherent in the crusade project from the outset, but revealed in the Fourth Crusade and the Albigensian expedition, see Jaye Puckett, "Troubadours and the Crusades," *Modern Language Notes* 116 (2001): 844–89.

3. The pull toward lyric conventionality, which constitutes an important aspect of the strategy of differential contrast in crusader lyric, works particularly well in Marcabru's case. We begin reading convinced of being in the presence of a variant of the pastourelle. Indeed, Anna G. Hatcher's article from 1964 argues the case for pastourelle. "Marcabru's *A la fontana del vergier,*" *Modern Language Notes* 79 (1964): 284–95.

4. Text from Karl Bartsch, *Chrestomathie Provençale,* 4e edition revue et corrigée (Elberfeld, 1880), cols. 49–51.

5. "Bela," fi m'eu, " . . . e no vos qual dezesperar, / que cel que fai lo bosc folhar / vos pot donar de joi assatz" (31, 33–35).

6. "Senher," dis ela, "ben o cre / que deus aja de mi merce / en l'autre segle per jasse, / quon assatz d'autres peccadors; / mas sai mi tol aquela re / don jois mi crec: mas pauc mi te, / que rop s'es de mi alonhatz" (36–42).

7. Teodolinda Barolini, to cite but one critic, refers to Bertran as "warmongering" and to his verse as "bloodthirsty and sanguinary." She sees him also as a fundamentally political poet. *Dante's Poets: Textuality and Truth in the Comedy* (Princeton, 1984), 159, 164, 169–70.

8. Dante Alighieri, *The Divine Comedy,* translated, with a commentary by Charles S. Singleton. I. *Inferno,* Italian Text and Translation. Bollingen Series 80 (Princeton, 1970), 300–301; *Inferno* 28:118–26.

9. *The Poems of the Troubadour Bertran de Born,* ed. William D. Paden Jr., Tilde Sankovitch, and Patricia H. Stäblein (Berkeley, 1986), 74.

10. Ibid., 76.

11. Ibid., 76–77.

12. He makes no secret of his purpose in theatralizing Bertran in this way, as the last four lines of the canto make clear. "Perch'io parti' così giunte persone, / partito porto il mio cerebro, lasso! / dal suo principio ch'è in questo troncone. / Cosi s'osserva in me lo contrapasso." [Because I parted persons thus united, I carry my brain parted from its source, alas! Which is this trunk. Thus is the retribution observed in me.] *Inferno* 28:139–42; Singleton, *Inferno,* I:1, 302–3.

13. Barolini, *Dante's Poets,* 169–70, 172.

14. Ibid., 172.

15. Ibid.

16. "Thomas Aquinas on *contrapassum* or, retribution. *Summa theologica,* II-II q. 61, a. 4 resp. '*I answer that,*' Retaliation (*contrapassum*) denotes equal passion repaid for previous action; and the expression applies most properly to injurious passions and actions, whereby a man harms the person of his neighbor; for instance if a man strike, that he be struck back. This kind of justice is laid down in the Law (Exod. xxi. 23, 24):

Reddet animam pro anima, oculum pro oculo, etc. [He shall render life for life, eye for eye, etc.]. And since also to take away what belongs to another is to do an unjust thing, it follows that secondly retaliation consists in this also, that whosoever causes loss to another, should suffer loss in his belongings. This just loss is also found in the Law (Exod. xxii.1). [*Et hoc quidem iustum damnum continetur in lege,* Exod. xxii.]" Singleton, *Inferno,* 2. Commentary (Princeton, 1970), 523.

17. The songs are Paden (*The Poems of the Troubadour Bertran de Born*) #s 36 (P-C 80:30) *Nostre seingner somonis el mezeis;* 38 (P-C 80:25) *Miez sirventes vueilh far dels reis amdos;* 40 (P-C 80:17) *Fuihetas, vos mi priatz qe ieu chan;* 41 (P-C 80:4) *Ara sai eu de pretz quals l'a plus gran.* The metrical form of *Miez sirventes . . .* (Frank 325:1) was subsequently imitated by five later troubadours, but was unique when Bertran composed it. Bertran uses the same metrical scheme (Frank 347: 1 and 2) for *Fuihetas,* and *Ara sai,* and is the only troubadour to do so. These crusade songs set themselves apart formally from the corpus.

18.
> Ara non siscla ni chanta
> rossigniols
> ni crida l'auriols
> en verger ni dinz forest,
> ni par flors groja ni blava,
> e si·m nais
> jois e chans
> e creis en veillans;
> car no·m ven com sol
> somnejans. (1–10)

[The nightingale doesn't sing or cry now, nor sounds the oriole in orchard or forest, and the flowers; don't seem yellow or blue, and yet in me are born joy and song and I grow older; for no longer do dreams come to me as they used to.]

19. On Bertran's predilection for Raimbaut, the only earlier troubadour who seems to have interested him, see the Introduction to Paden's edition, *The Poems of the Troubadour Bertran de Born,* 48–50.

20. In this respect, it is important to note that within this same cycle of six "crusade songs," written between 1188 and 1194, Bertran also did a contrafaction of one of the best-known troubadour tours de force, Arnaut Daniel's famous prototypical sestina, *Lo ferm voler* (P-C 29:14). Bertran's *Ben grans avoleza intra* (P-C 233:2, Paden, *The Poems of the Troubadour Bertran de Born,* #39), like his *Anc no·s pot far maior anta,* transforms a love lyric into a mordant satire. Arnaut's sestina is often cited as a typical example of *trobar clus,* in part because the rhyme words deployed in so intricate and difficult a pattern—the same rhyme words Bertran takes on as a challenge in his contrafaction—seem to make so bizarre a series: *intra, ongla, arma, verga, oncle, chambra* ("enters," "finger-/toenail," "soul," "rod," "uncle," "(bed)room"). Because of the equivocal denotations of the body parts, and the words *uncle, enters,* and *bedroom,* Arnaut's song has been taken as an exercise in sexual and/or queer *trobar clus.* Bertran's

polemic aims specifically at the paragons of *otium* or pleasure-lovers who make love rather than crusading.

21. Paden translation, *The Poems of the Troubadour Bertran de Born,* modified.

22. "Donc, descendu de la montagne, Moïse reçoit de Dieu l'ordre de construire le tabernacle qui était la réplique de ce qu'il avait vu sur la montagne, j'entends l'image de l'univers entier. . . . D'autre part, le bienheureux apôtre Paul a déclaré dans son *Épître aux Hébreux* que le premier tabernacle était la figure de ce monde-ci; il dit: « La première Alliance, elle aussi, avait des institutions culturelles, ainsi qu'un sanctuaire de ce monde-ci; un tabernacle, en effet, avait été dressé, le premier tabernacle, dans lequel était le chandelier, la table et les pains de proposition, et qu'on appelle Saint. » L'ayant qualifié de sanctuaire « de ce monde-ci », parce qu'il était la figure de ce monde, Paul ajouta: « Dans lequel il y avait le chandelier », ce qui veut dire les luminaires, « la table », c'est-à-dire la terre, et « les pains de proposition », pour désigner les fruits annuels de la terre; « lequel tabernacle s'appelle Saint », dit l'Apôtre, pour faire entendre le premier tabernacle." Cosmas Indicopleustès, *Topographie chrétienne,* ed. Wanda Wolska-Conus, Sources Chrétiennes, 159 (Paris, 1970), t. II, livre 5, ch. 20, 38–40.

23. "La difinitios de sirventes. . . . e deu tractar de reprehensio / o de maldig general / per castiar los fols e los malvatz. / o pot tractar quis vol / del fag d'alquna guerra." *Las flors del gay saber* estier dichas *Las leys d'amors,* ed. M. Gatien-Arnoult (Toulouse, 1849?), 340.

24. Anglade's reading is based on a different manuscript: "Tractans de mal dig general / Per castiar cels que fan mal; / E si de fag parla de guerra, / *En son proces per so non erra; / Am belas razos deu reprendre / Et enductivas ad aprendre.*" Joseph Anglade, *Las leys d'amors* (Toulouse, 1919), II:181.

25. "lo seingnorius celestiaus / probet de nos un lavador" (ll. 5–6), "Dieus vol los arditz e·ls suaus / assaiar a son lavador" (ll. 50–51). *Pax in nomine Domini!* (P-C 293:35). Text from Martín de Riqueur, *Los trovadores* (Barcelona, 1975), I:206–10.

26. Text from MS. A. Paden, *The Poems of the Troubadour Bertran de Born,* #19, 251.

27. Text from MS. I. Paden #42, 425. Note that in these two *sirventes,* Bertran does not lack for warm feelings and a robust rhetoric. There is also a general tendency, as one expects with the *sirventes,* to refer to conditions in the world. In the *sirventes* generally, however, such references lack both the spatial-spiritual dimension we associate with crusade lyric, and even the level of historical specificity that allows us to identify crusade lyric. *Volontiers fera sirventes* is a case in point. Paden et al. place it among Bertran's songs of the Third Crusade on the basis of the song's *envoi,* which addresses King Richard as "lion" and King Philip as "lamb." This is based on the strength of a chronicle of Richard I which asserts that the Sicilians used these terms when Richard and Philip were in Sicily awaiting embarkation for the Third Crusade. Given the time lapse between chronicle writing and the anecdote recounted, the evidence seems slim for making the dating of "spring or summer 1191" (422). But even admitting the *sirventes* to have been written at this time in Sicily, it evokes a general situation—as the editors themselves point out in citing the *ubi sunt . . .* topos—rather than a specific crusade theme.

28. Paden and Stimmung see a reference to Richard I in "nostre seingner." Antoine Thomas rightly identifies the term as evoking Christ. "Notre-Seigneur, c'est-à-dire Jhésus-Christ lui-même et non Richard Coeur-de-Lion comme l'a cru M. Stimmung" (*Poésies complètes de Bertran de Born* [Toulouse, 1888], 79, n. 1). It is a convention of crusade preaching to originate the call for a crusade with God, Christ, or a saint whose tomb was being menaced or desecrated by the Saracens. So the *Historia Karoli Magni* begins with St. James the Great's appearing to Charlemagne in a dream to summon him to Spain in order to free Santiago. Urban II, preaching the First Crusade at Clermont in November 1095, places the summons in God's mouth: "not I, but God exhorts you as heralds of Christ to repeatedly urge men of all ranks whatsoever, knights as well as foot-soldiers, rich and poor, to hasten to exterminate this vile race from our lands [*regionibus nostrorum*, i.e., the Holy Land] and to aid the Christian inhabitants in time." (Quoted from Fulcher of Chartres, *A History of the Expedition to Jerusalem, 1095–1127*, I, 3, iv [Knoxville, 1969], 66). Finally, the scriptural *loci classici* for having Christ himself issue the summons to take up the cross were Matthew 16:24; Mark 8:34; Luke 9:23. *Si quis vult post me venire, abnegat semetipsum et tollat crucem suam et sequatur me*, "Whoever wishes to follow me, let him renounce himself and let him take up his cross and follow me." This version is quoted in I,1 of the anonymous *Gesta Francorum et aliorum Hierosolimitanorum* (*History of the Franks and Other Pilgrims to Jerusalem*), completed by 1101, and thus the earliest contemporary account of the First Crusade. The *Gesta Francorum* was edited by Louis Bréhier and published in 1924 (2d ed., Paris, 1964).

29. The final cobla of this poem is itself half a stanza devoted to the French King Philip II. The fact that he merits only half a stanza suggests in the symbolic language of Bertran that he is only half-a-king, one who talks, but cannot act.

30. Text from MS. M (sole extant manuscript). Paden, *The Poems of the Troubadour Bertran de Born*, #38, 399.

PART II

FRANKISH PRESENCE
IN THE LEVANT

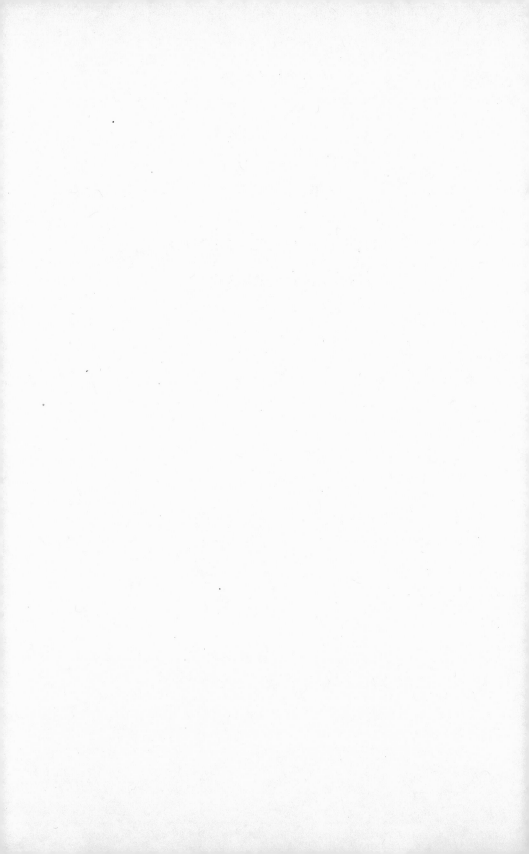

CHAPTER 3

The Crown of France and Acre, 1254–1291

Jonathan Riley-Smith

Of the secular powers in the West only England and France, and France's surrogate Sicily, were in the position to offer the Kingdom of Jerusalem and its chief city, Acre, effective assistance during the last four decades of Latin settlement. The significance of the decision of Lord Edward of England to lead his crusading contingent on to the Holy Land after the death of King Louis IX of France before Tunis in 1270 was not lost on contemporaries.[1] The courage Edward had shown is thrown into relief by Charles of Anjou's conviction that his brother, Alphonse of Poitiers, who did not join Edward in the Holy Land, was a "martyr by desire" simply because he had had to be dissuaded from proceeding there from North Africa.[2] Edward was committed to the interests of the Latin settlement for the rest of his life, although he was never able to organize another crusade.[3] The importance attached to his support is demonstrated by the fact that he was one of only two monarchs prayed for by name during Templar general chapters in the early fourteenth century.[4]

The other was the king of France, whose role was more considerable. In this chapter I will suggest that the history of French political involvement falls into three phases, which originated in the reigns of Louis IX, Philip III, and Philip IV, respectively, and reflects conscious decisions made by them or their counselors. The first involved direct intervention by means of a standing body of French mercenary troops, occasionally supplemented by crusaders. The *stipendarii* were probably withdrawn—perhaps early in 1270—to be integrated into Louis's crusade to Tunis. They returned to Acre in 1273, but a policy, probably initiated by Pope

Gregory X, of assuring the security of the Holy Land through its incorporation into an eastern Mediterranean empire ruled from Italy by Charles of Anjou may well have led in the second phase to the French troops being transferred into Charles's service in 1277. The third phase was marked by the abandonment in 1286 of the Angevin cause in Palestine, but not of the Holy Land itself, by Philip IV and by a return to the practice of maintaining a mercenary contingent in Acre led by a representative of the French king.

WHEN LOUIS IX SAILED from Acre for Europe in April 1254 he left there two physical memorials. The first comprised new fortifications. The eastern line of the walls of the old town appears to have been completed by the time he left. Although they have never been properly excavated—indeed exactly where they ran was until recently the subject of debate—the identification of a small section of them suggests that they were of the quality of those Louis had already constructed at Caesarea.[5] The walls of the suburb of Montmusard to the north were still being rebuilt and Eudes of Châteauroux, the papal legate, told John of Joinville that he intended to stay on in Palestine for another year and spend on these all his money—presumably church money collected for the crusade.[6] The work had been completed by 1264, when Pope Urban IV, who had been resident in the city before 1260 as patriarch of Jerusalem, wrote that he had heard how marvelous it was.[7]

The second memorial was the contingent of knights. The role this force played in the politics and military affairs of the Kingdom of Jerusalem has been described,[8] but no one, to my knowledge, has looked at its history from the point of view of the French crown. It originally consisted of 100 knights under the command of one of Louis's closest companions on crusade, Geoffrey of Sergines, who in this chapter will be entitled "the elder" to distinguish him from his son.[9] The contingent was presumably responsible for defending a stretch of the new walls, but we do not know where. Nor is it clear where inside or outside the town it was billeted. Some days before Henry of Cyprus arrived to claim the government in June 1286, Eudes Poilechien, who was representing the interests of Charles II of Anjou, brought "la gent dou roy de France" into the citadel, so it is certain that by then the citadel was not their normal barracks.[10] The contingent would have needed plenty of space at first, however, because it comprised more knights than those with which the Hospitallers of St. John envisaged garrisoning Crac des Chevaliers (sixty) and Mount Thabor (forty) in 1255[11] and than those in the Templar garrison of Safad (fifty) in 1260.[12] The knights would have constituted, of course, only a fraction of the personnel involved. There were also crossbowmen and sergeants serving with them.[13] Each knight, moreover, would have needed

supporters, such as grooms and squires. When the great French nobleman Eudes of Burgundy, count of Nevers and lord of Bourbon, died in Acre in July 1266 he was employing in his household four knights, three chaplains, seven squires, nine sergeants, thirty-two servants, five crossbowmen, and four turcopoles.[14] Ordinary knights would have had to do with much less, of course, but, assuming that each needed at least three supporters and that the contingent required some sort of headquarters staff and its own farriers and armorers, perhaps as many as 1000 persons may have been involved.

It occasionally suffered substantial losses—in Galilee in 1266;[15] to the northeast of Acre in 1269;[16] and in the fall of Tripoli in 1289[17]—and must have needed reinforcing, although it is not clear whether as many as 100 knights were stationed in Acre all the time. Louis was also spending money on crossbowmen and archers from the first.[18] Twenty-five knights and 800 crossbowmen arrived in 1273[19]—although this constituted a fresh start—and 100 horsemen (40 knights and 60 mounted sergeants) and 400 crossbowmen in 1275–76.[20] One has the impression that the force was still considerable in 1286.[21]

The "captains," who often, but not invariably, combined their post with the seneschalcy of the Kingdom of Jerusalem, seem to have been volunteers in the tradition, old by now, of *milites ad terminum,* who performed service in the Holy Land not for pay but as a religious duty.[22] Geoffrey of Sergines the elder seems to have held the appointment until his death in 1269, and service for God is a theme in Rutebeuf's *La complainte de monseigneur Joffroi de Sergines,* written 1255–56.[23] In 1263 Pope Urban IV described Geoffrey, who by then had also been regent of the Kingdom of Jerusalem, as someone who had devoted himself entirely to the service of Christ and had assumed the burden of supporting the Holy Land on his shoulders.[24] Two or three years later Pope Clement IV returned to this theme when he referred to the fact that Geoffrey had made a vow to commit himself totally to the interests of the Holy Land.[25] His probable successor Robert of Créseques, who was killed within a year,[26] was reported having come to Palestine to "die for God."[27] That the French knights were then withdrawn, perhaps in connection with Louis's crusade to Tunis, is implied in a letter written some years later on behalf of Pope John XXI. The letter recounted how John of Grailly took the cross and went to Acre—this must have been after the debacle at Tunis—where he met the future Gregory X, who had just heard he had been elected pope. Gregory persuaded John to remain in the East and promised that he—in other words, the Church—would provide for him.[28] This agreement would have been made early in 1272 and helps to explain why John was appointed seneschal of the kingdom at the time.[29] It suggests that the French force had left and that there was a need for alternative provision.

It is not easy to establish the costs envisaged by Louis himself at the outset. Although it is possible that some men in the contingent were, like the captains, volunteers rather than mercenaries proper, a surviving fragment of the king's accounts for the years 1250 to 1253 suggests that knights serving on his crusade without wages cost much the same as did those serving for pay, presumably because of the donations and subsidies they had to be given.[30] Each knight had put the king back by 7s and 6d a day (probably in *livres parisis*) or nearly 137 *livres* a year.[31] So to keep 100 knights at this rate of pay would have cost the French crown 13,687 *livres* 10s a year (17,109 in *livres tournois*) or nearly 7 percent of its average annual income (c. 250,000 *livres tournois*).[32] The generous subsidies recorded in Louis's accounts, however, are in keeping with those paid to knights when long-distance travel was involved. A contract between Louis and Edward of England in 1269 as part of the preliminaries to the crusade to Tunis seems to have specified a subsidy of 200 *livres tournois* per knight, at a time when a journey to and from Palestine was envisaged,[33] and in March 1285 Raes of Gavre and Gerard of Luxembourg agreed to serve the duke of Brabant for one year on the Aragonese Crusade, involving a journey from the Low Countries to Spain, each with four knights besides himself, for 3000 and 3500 *livres tournois,* respectively.[34] More modest sums were paid when knights were stationed in a semipermanent location. Eudes of Burgundy was paying his knights in Acre only 40 *livres tournois* a year (the equivalent of 32 *livres parisis*) in 1266[35] and six months after Eudes's death Louis himself, the pope, and the patriarch of Jerusalem were prepared to offer them an annual payment of 60 *livres tournois,* or under half what the crusading knights had cost the king in the 1250s.[36] Comparisons are very hard to make, of course, because there were so many imponderable elements that might or might not have been included in the figures: in 1266 the count of Nevers was providing additional living costs to each knight of between 3 and 13 *livres* a year (between 10 and 40 besants, which were each rated at one-third of a *livre tournois*)[37] and it may be that the figures from Palestine in the 1260s omit additional expenses—for armor and animals, for example—which were assessed separately.[38]

However confusing the figures, one cannot get away from the fact that Louis was prepared to dip deeply into his pocket. Professor Joseph Strayer stated, without giving a reference, that the French treasury later believed that between 1254 and 1270 the contingent had cost the king only an average of 4000 *livres tournois* a year (or 1.6 percent of his annual income).[39] Although this seems to be confirmed in the records that survive—4000 *livres tournois* and part of another 1000 in 1265;[40] 4400 *livres tournois* in 1266[41]—Geoffrey of Sergines estimated in 1267 that he needed the enormous sum of 10,000 *livres tournois* a year to retain his knights[42]

and in c. 1272, Pope Gregory X, writing about the *stipendarii,* stated that some 60,000 *livres tournois* sent by Louis to the Holy Land had been lost through the carelessness—doubtless a euphemism for the corruption—of officials.[43] The donation of funds to provide military forces for the defense of the Holy Land was a tradition that stretched back well into the twelfth century, when the value of reinforcing the military establishment in the East was already understood. As early as 1120 Count Fulk V of Anjou had paid for 100 knights to serve in Palestine for one year when he returned home at the end of his first crusade.[44] In his last testament of September 1222 Louis's grandfather, Philip II, had left the stupendous sum of 150,500 silver marks to provide for 300 knights for three years[45] and Count Raymond VII of Toulouse, who died before leaving on Louis's First Crusade, wanted in his will to provide fifty knights to serve for one year.[46] What was unusual about Louis's provision was that it was, as far as we know, open-ended;[47] indeed, whether this was intended or not, the knights were to remain in Acre for almost the rest of his life.

Payments by the French crown were supplemented, however, by monies provided by the Church, because, faced by the anxiety of Geoffrey of Sergines about cash—by 1267 he was threatening to sell his patrimony in France if he was not helped[48]—the papacy began to divert funds from the proceeds of church taxation. On 1 February 1263, Pope Urban IV, who was probably responding to an appeal from Louis, proposed that the proceeds of a tax on market transactions, which was put to pious uses, should be collected by suitable persons, with the backing of officials in the royal domain and in Champagne, and given to Geoffrey.[49] Meanwhile the pope had ordered the levying of a crusade hundredth for five years on the Church and had appointed Archbishop Giles of Tyre, a Breton whom Louis had nominated to the see of Damietta in Egypt during its brief occupation in 1249, and John of Valenciennes, the lord of Haifa, to be its executors.[50] The clergy in most countries never paid up, although the French, after a brief resistance, held an assembly at which they granted the aid, stating, however, that this was of their own volition.[51] In July 1264 the pope announced his intention to send cash from the hundredth in the following spring to finance repairs to the walls of Jaffa,[52] but by then he was dead and his successor, Clement IV, had decided to divert the money to meet the general needs of Geoffrey of Sergines.[53] This does not mean that it was going to be spent entirely on the French soldiers in Acre. Geoffrey was also lieutenant of the kingdom's regent, Hugh of Cyprus, and as the governor of Palestine was being given the freedom to decide what the priorities should be.[54] The point is that church money was now supplementing royal funding. And by 1267 it is clear that yet another source was being tapped. Writing to the Templar

commander in Paris and referring to a sum of 3000 *livres tournois* that he and the masters of the Temple and the Hospital had pledged, the patriarch of Jerusalem asked that this should be raised by the Templars in France, while the treasurer of the Temple in Paris should repay some merchants a further 1800 *livres tournois* borrowed by the patriarch to help retain forty-eight French knights in Acre.[55] So the French contingent was now being funded from three sources: the French crown, the pope (or rather the French Church) and the patriarch, and the military orders.

The proceeds of the five-year hundredth were, of course, intended mainly to help finance a new crusade to the East. In July 1264 the pope reported that this was in train and that there had already been a meeting in Paris of volunteers to choose a leader;[56] it looked for a time as if this was going to be the king's brother Alphonse of Poitiers.[57] There survive the financial accounts of a party of collectors of the hundredth, covering the period from 13 June to 2 October 1265.[58] On 21 June they gave 500 *livres* to a Geoffrey of Sergines "de bonis Terre Sancte."[59] This was not the Geoffrey who was struggling to hold things together in the East, but his son, who can be identified on the coming crusade, as we shall see. The accounts of the collectors also recorded the arrival on 11 July of a messenger from Eudes of Burgundy, who was to be one of the leaders of the small crusade that eventually departed.[60]

The needs of this crusade, however, must have conflicted with those relating to another, to be led by Charles of Anjou into southern Italy, the preaching of which was authorized by Urban in 1263 and was being organized in France by Simon of Brie, the future Pope Martin IV. In the accounts of the collectors 26 July was marked by the arrival of a messenger from Charles, who must have been hoping that money could be diverted to assist him.[61] In fact, yet another income tax, a three-year tenth, was levied on the French clergy for Charles's crusade.[62] It might be thought odd that Louis allowed this dissipation of effort, to say nothing of the strain on the Church in his dominions, particularly as the largest part of the crusade destined for the East was going to be led in the end by him. Although he was not in favor of the Sicilian venture at first, his only objections to it, which were overcome, seem to have concerned whether it was legal to deny the Hohenstaufen claims to Sicily.[63] The Italian crusade, moreover, was popular in France[64] and must have drawn many recruits away from the expedition to Palestine.

An early party of French crusaders, however, left for the East on the autumn passage of 1265. It comprised sixty knights "au servise de Dieu," led by Erard of Valéry and the counts of Nevers and Nanteuil.[65] That these crusaders came to represent not only themselves but also the French royal commitment to the Holy Land in another form was revealed by the patriarch in 1267, when he wrote that

the king of France and the pope had agreed that they could be retained until August 1268 and had established what their stipends were to be, subject to final letters of confirmation from the pope. In other words these crusaders were now to convert themselves into *stipendarii* in the service of the king, comprising a supplementary force to the French garrison. As crusaders, volunteers who had taken vows of a particular sort and were subject to the canon law that had developed with respect to crusading, they had of course been distinguished from the mercenary knights in the French contingent. They were treated separately by the patriarch of Jerusalem in his letter of 1267[66] and by Geoffrey of Sergines the elder and Erard of Valéry, who in letters to Louis of the same year referred to them as "chevaliers pelerins."[67] Their conversion into *stipendarii* was made relatively easy by the way greater lords were now often subsidizing their followers on crusade through the use of contracts for service.[68]

The count of Nevers, Eudes of Burgundy, had died in Acre on 6 July 1266. A remarkable document, comprising the accounts of his executors, Hugh of Augeront, one of his household knights, and Erard of Valéry, who was represented by Geoffrey of Sergines the younger, lists the stipends of Eudes's knights, esquires, and servants, the cost of their lodgings, and further outgoings to employees; miscellaneous payments made by the executors, including one for Eudes's tomb; cash assets, together with loose change, and what must be debited from them; inventories of goods, including jewelry, plate, precious cloth, armor, furniture in the count's chamber, pantry, kitchen and stables, food and wine, clothes, the furnishings of two chapels, including a reliquary of the True Cross and vestments; books, including a missal, a breviary, two *romans* (the *Roman des Loherains* and the *Roman de la terre d'Outremer*), and a *chansoners,* which, it has been suggested, would have been a collection of the songs of Thibaut of Champagne; bequests left to persons and churches in Acre; items bought from the count's estate by individuals and institutions in Acre; and those bits and pieces still unsold.[69]

The material provides a snapshot of a crusading contingent in Palestine in the 1260s. Eudes, who had a reputation for sanctity and whose tomb in Acre was to be the scene of healing miracles after his death,[70] was personally leading a force that consisted of his own knights and two smaller groups under knights called Regnaud of Précigné[71] and Robert of Juennesses. Whereas Eudes's household knights received 40 *livres tournois* a year, these two men were paid 300 and 235, respectively, which must mean that they had contracted with him to bring their own bodies of perhaps four and two knights with them.[72] From our point of view, of course, these crusaders, although technically volunteers, already looked like mercenaries through their subsidies from, and contracts of service with, Eudes, which

must have made their transformation into *stipendarii* a simple matter. They would hardly have noticed the difference themselves, although they may not have remained long in service in Palestine: of their leaders, Erard of Valéry fought at Tagliacozzo on 23 August 1268,[73] and Geoffrey of Sergines the younger died before Tunis in 1270 while serving as Charles of Anjou's seneschal.[74]

AFTER LOUIS IX'S DEATH on 25 April 1270, his body was dismembered. His heart was left with the army in Africa. His entrails were deposited in the cathedral of Monreale in Sicily at the request of Charles of Anjou. His bones were brought back to France by his son Philip III and were interred in the abbey of Saint-Denis on 21 May 1271. Miracles were reported in the year-long course of the cortège home and they multiplied at the tomb, to which the sick pilgrimaged in increasing numbers.[75] It is not surprising that the commitment of the new French king to Acre was renewed against this theatrical background and in 1272 a replacement force was reported to be on its way under the command of Oliver of Termes,[76] who had been on Louis's First Crusade[77] and had been associated with Geoffrey of Sergines in Acre in the mid-1260s.[78] Oliver was probably serving in the same voluntary manner as had Geoffrey; in July 1274 Pope Gregory X proposed to King Philip III that he should be persuaded to stay in the East, since he had been particularly useful.[79] He arrived in 1273, leading twenty-five mounted knights and 100 crossbowmen on foot, "paid for by the king of France,"[80] and he was almost immediately joined by 700 more crossbowmen, "paid for by the king of France and the church."[81] Two or three years later the 100 cavalry and 400 crossbowmen who reached Acre were "paid for by the church" and led "on behalf of the king of France" by William of Roussillon,[82] a replacement for Oliver of Termes, who had died in 1274.[83] In c. 1272 Pope Gregory had told Oliver that he could be granted cash to hire mercenaries "de pecunia Tunicii," which must have been the unexpended monies raised for the North African crusade,[84] and in 1274 he assured Philip III that he was aware of the sums the king was spending on the Holy Land and guaranteed some relief from the drain on his resources by drawing on a new crusade sexennial tenth, which had been decreed by the Second Council of Lyons and was now being collected in France.[85] Philip in fact made it easier still for the pope by renewing his commitment to the crusade vow, which he had not fulfilled after the withdrawal from Africa. Gregory promptly granted him the proceeds of the tenth collected not only throughout his kingdom, but also in some dioceses beyond the French frontiers.[86]

The relationship between the French crown and Acre was bound to be affected, however, by the assumption of power there by Philip's uncle, Charles of Anjou, to

whom the new king appears to have been devoted.[87] The establishment of the Angevin Kingdom of Sicily in the 1260s was to lead, as everyone knows, to a renewal of introspective crusading after the Sicilian Vespers of March 1282, not only in Italy, but also against Aragon. Philip was to accept the crown of Aragon for his second son, Charles of Valois, and was to die during the retreat from Gerona in October 1285. Meanwhile Charles of Anjou was recognized as king of Albania in 1271 and in 1278 took over direct rule of the Principality of Achaea. By then he was also claiming the throne of Jerusalem, which he had purchased in March 1277 from the pretender Maria of Antioch, with the approval of Pope John XXI. Charles sent a vicar-general to Acre, dividing what was left of the Kingdom of Jerusalem until 1286, when it was to be reunited under Henry of Cyprus.[88] Charles's rule of Acre badly needs further study. The present consensus is that his mind was constantly on Greece and the preservation of Achaea from the threat posed by the Byzantine emperor Michael VIII Palaeologos and that although he took the cross and claimed that the Sicilian Vespers had wrecked his plans for a major crusade to the East, his gaze was in fact focused on Constantinople.[89] But even a cursory glance at the reconstituted Angevin archives reveals that there was more to his government in Palestine than that.

His most recent biographer, Jean Dunbabin, portrays a man drawn, almost *par hazard,* into this adventure. She is particularly critical of the view that the purchase of the crown of Jerusalem was his initiative. It was Pope Gregory X, she maintains, whose idea this was.[90] Although the evidence is circumstantial she is probably right. Gregory, who had been living in Acre at the time of his election, as we have seen, may well have come to the conclusion that the only way the Christian beachheads in the Levant could be saved was through their incorporation into a larger unit that could provide the day-to-day investment in men and *materiel* needed for its defense.[91] As far as the French government was concerned the issue may simply have been one of supporting an important figure in the dynasty and a man whom Philip admired.

It is indicative that we know of no captain of the French contingent for almost a decade after a successor (named either Miles of Haifa or William of Picquigny)[92] took over briefly after William of Roussillon's death in 1277, the year of Charles's assumption of power in the Kingdom of Jerusalem. There are references in the Angevin archives to a stipendiary force employed in Acre by Charles himself and supplied by him.[93] In 1277 a French knight, Godfrey of *Summesot,* was made its captain, with the rank of vice-seneschal;[94] presumably Charles's vicar-general, Roger of San Severino, held the seneschalcy. In 1281 a Richard of Noblans was sent by Charles to be constable.[95] When in February 1283 Eudes Poilechien,

who had been made vice-marshal in 1277,[96] replaced Roger of San Severino as vicar-general,[97] he assumed the seneschalcy, with a French knight acting as marshal.[98] There are occasional references, therefore, to French knights in the service of Charles of Anjou, but there is, as far as I know, no hint for nine years that there were in Acre troops still employed by the French crown, until 1286, when Eudes Poilechien ordered "la gent du roy de France" into the citadel.[99] It may be significant that *Samaritanus patris,* an important general letter on crusading sent by Pope Nicholas III to France in December 1278 that touched on the raising of funds, contained no reference to French *stipendarii.*[100] They were probably still in Acre, but they must have passed into the employment of the Angevins. And it may be indicative that Marino Sanudo, writing, it is true, over two decades later, referred to Eudes Poilechien in 1286 combining the captaincy of the French mercenaries with his representative role on behalf of the government in Naples.[101] It is likely that the French crown had only just resumed paying for them and that Eudes had remained captain *pro tem.*

From 1273 on, however, the Capetians had another representative on the spot. The master of the Temple, William of Beaujeu (1273–91), was from a great Burgundian family with a long crusading tradition. They were related to the Capetians by marriage and William's kinship with them was recognized within his order[102] and by Charles of Anjou, to whom he was a "carissimus consanguineus."[103] It was probably because of this that he had served as provincial commander in the Kingdom of Sicily[104] and that in 1274 the pope sent him on a special mission to Philip III.[105] He is usually portrayed as being especially close to Charles, but it should not be forgotten that the prime loyalties of his family were to the crown of France. Three brothers had been on the Tunis crusade and one, who had held the marshalcy of France, had died there. The eldest, Humbert, had been constable of France and was to die on the Aragonese Crusade of 1285.[106] As the master of the Hospital wrote to the count of Flanders, William had been elected "por la reverence dou seignor roy de France et por le vostre."[107]

William certainly seems to have behaved as a French agent, pursuing a line of action that favored the Angevin claims, until he received instructions to the contrary, as we shall see. As soon as he returned to Acre in September 1275 he began to make life difficult for Hugh of Cyprus, the incumbent king about to be forced out by Charles, in a manner that reminds one of the spoiling tactics of the French contingent that had undermined the authority of Richard I of England in 1191.[108] William backed the resistance to Hugh of Isabella of Beirut,[109] entered into a fierce dispute with the king over a *borgesie* his order had bought without royal permis-

sion, and in 1276, when Hugh was threatening to leave the mainland, ostentatiously refrained from requesting him to stay, while a native client-confraternity of the Temple added to the anarchy by rioting in the streets.[110] When Charles's vicar-general arrived in 1277, he resided at first in the Templar convent and was helped financially by the order, which lent him money "in order to sustain him and our people," as Charles was to put it two years later.[111] After Hugh had tried unsuccessfully to recover Acre in 1279 he blamed the Templars for rallying opposition to him and in retaliation razed their castle at Gastria on Cyprus and vandalized their houses in Limassol and Paphos.[112] Documents from the Angevin archives illustrate how close William was to the vicar-generals and their assistants. As late as February 1283 he was still regarded in Naples as acting almost as co-ruler with Eudes Poilechien.[113]

The Sicilian Vespers of 1282, the capture of Charles's heir, Charles of Salerno, by the Aragonese in 1284, the deaths of Hugh of Cyprus in 1284 and Charles of Anjou in 1285, and, perhaps most significant of all, the death of Philip III later in the same year must have led the French to rethink their approach. It is clear that as soon as the seventeen- or eighteen-year-old Philip IV came to throne he or his advisers decided that policy toward Acre should change. There is circumstantial evidence that Philip was not very attached to the Angevin cause, not enough, at least, to have approved of the crusade against Aragon.[114] At any rate the decision seems to have been made to jettison the Angevins in Palestine and at the same time provide support for Henry of Cyprus, whose rule, the French government seems to have decided, was the only hope for the Latin settlement. There is a myth, which has been passed down from Georges Digard in the 1930s through Sylvia Schein in the 1980s to Norman Housley in the 1990s, that Philip then pulled out of Palestine completely.[115] This is based on a group of letters from Pope Nicholas IV, dated between 1 and 12 December 1290, which are preserved in the papal registers, although only calendared in the printed edition of them. The pope had offered Philip the "custodia Terre Sancte." With, he explained, the advice of his council, Philip had refused on the grounds that if the Christians were to be driven out of Palestine he would be implicated in the disaster. The pope's response was to press him to accept the burden until the next major crusade should reach the East and to assign him the crusade tenth promised to his father.[116] But this refusal of Philip's could not, and did not, indicate a withdrawal from Palestine. It is clear that by the "custodia Terre Sancte" the pope meant much more than the by now customary stationing of a body of troops in Acre. He was offering Philip the management of the Holy Land in its entirety and in refusing to assume such a burden the young king was only doing

what his great-great-grandfather Philip II and Henry II of England had done in 1185, when they had been offered Jerusalem by a delegation from the East.[117]

Although Philip, like Frederick II, is a tempting target for oversimplification he venerated the memory of his grandfather Louis IX and was always a dévot.[118] When on 27 June 1286, a message was delivered on behalf of Henry of Cyprus to the French knights who had been summoned into the citadel of Acre by Eudes Poilechien, they were informed that Henry knew that what they were doing was against the wishes of the king of France. Although Henry added that if it was learned that the king of France wished them to return to the citadel, they could do so,[119] he cannot have been bluffing. First, the Templars, who must have been following orders, had switched their support to Henry. William of Beaujeu joined the masters of the Hospitallers and Teutonic Knights in persuading Eudes Poilechien to surrender the citadel; his name also appears on the safe-conduct offered to the French by Henry.[120] It was reported that Robert of Artois, the regent of Naples, was so enraged by the support given to Henry by the Templars and Hospitallers that he confiscated their properties in Apulia.[121]

Second, a new captain for the French force in Acre, who was sympathetic to Henry, was posted out there. The reference to "la gent du roy de France" under the captaincy of Eudes Poilechien in June 1286 suggests that sometime before—perhaps only shortly before—Philip had resumed paying directly for these soldiers. With him, in fact, there was a return to the approach of Louis IX, even perhaps to the extent of combining the semipermanence of the French garrison with the temporary support provided by a small crusade. Alice of Brittany, the countess of Blois, came to Acre with a large force in 1287 and before her death there in the following year paid for improvements to the city's fortifications.[122] And in 1287 John of Grailly arrived in Acre as the new "capitaneus soldatorum regis Franciae."[123] John, who seems to have been another volunteer, had been one of a delegation from Acre to the papal curia, then at Lyons, which in 1274 had tried to block any discussion of Maria of Antioch's claim to the throne, and therefore of Charles of Anjou's purchase of it, arguing that the curia had no jurisdiction, because the only competent court was the high court of Jerusalem.[124] John's appointment must, therefore, have been one that was acceptable to Henry of Cyprus. And the French contingent was to fight heroically in the two great sieges that closed the history of the Latin settlements, those of Tripoli and Acre.[125]

Notes

1. Simon Lloyd, *English Society and the Crusade 1216–1307* (Oxford, 1988), 232.
2. Paul E. D. Riant, "Déposition de Charles d'Anjou pour la canonisation de Saint Louis," *Notices et documents publiés pour la société de l'histoire de France à l'occasion du cinquantième anniversaire de sa fondation* (Paris, 1884), 175–76.
3. It is curious that although Edward founded an English military confraternity, dedicated to St. Edward the Confessor, to man an English tower on the city walls he did not much patronize the English military order, St. Thomas of Acre, the headquarters of which was in the suburb of Montmusard. Lloyd, *English Society,* 240; Jonathan S. C. Riley-Smith, "A Note on Confraternities in the Latin Kingdom of Jerusalem," *Bulletin of the Institute of Historical Research* 44 (1971): 303; Alan J. Forey, "The Military Order of St. Thomas of Acre," *English Historical Review* 92 (1977): 492–96.
4. Jules Michelet, *Le procès des Templiers,* 2 vols. (Paris, 1841–51), 1:391.
5. See the excavation of 1976 described by Benjamin Z. Kedar, "The Outer Walls of Frankish Acre," *'Atiqot* 31 (1997): 175.
6. John of Joinville, *Vie de Saint Louis,* ed. Jacques Monfrin (Paris, 1998), 304.
7. Urban IV, *Registre,* ed. Jean Guiraud, 4 vols. (Paris, 1901–58), 1/2:421.
8. Jean Richard, *The Latin Kingdom of Jerusalem,* trans. Janet Shirley (Amsterdam, 1979), 377–79; idem, "Saint Louis dans l'histoire des croisades," *Bulletin de la société d'emulation du Bourbonnais* (1970): 243–44; Christopher J. Marshall, "The French Regiment in the Latin East, 1254–91," *Journal of Medieval History* 15 (1989): 301–7.
9. "L'Estoire de Eracles," *Recueil des historiens des croisades: historiens occidentaux* 2:441; "Le manuscrit de Rothelin," *Recueil des historiens des croisades: historiens occidentaux* 2:629. For Geoffrey of Sergines on Louis's crusade, see John of Joinville, 84, 150, 152, 182, 186, 214, 282.
10. The Templar of Tyre, *Cronaca del Templare di Tiro (1243–1314),* ed. Laura Minervini (Naples, 2000), 170.
11. Joseph Delaville Le Roulx, *Cartulaire général de l'ordre des Hospitaliers de St-Jean de Jérusalem (1100–1310),* 4 vols. (Paris, 1894–1906), 2:777–78.
12. *De constructione castri Saphet,* ed. Robert B. C. Huygens (Amsterdam, 1981), 41.
13. "Le manuscrit de Rothelin," 629.
14. A.-M. Chazaud, "Inventaire et comptes de la succession d'Eudes, comte de Nevers (Acre 1266)," *Mémoires de la société des antiquaires de France,* sér. 4, 2 (1871): 176–80.
15. "L'Estoire de Eracles," 455; The Templar of Tyre, 112.
16. "L'Estoire de Eracles," 458; The Templar of Tyre, 114–16.
17. The Templar of Tyre, 194, 198.
18. "Le manuscrit de Rothelin," 629.
19. "L'Estoire de Eracles," 463–64.
20. Ibid., 467; The Templar of Tyre, 142.
21. See Louis de Mas-Latrie, *Histoire de l'île de Chypre sous le règne des princes de*

la maison de Lusignan, 3 vols. (Paris, 1852–61), 3:671–73; "Bans et ordonnances des rois de Chypre," *Recueil des historiens des croisades: lois,* 2:357.

22. See Giuseppe Ligato, "Fra Ordine Cavallereschi e crociata: 'milites ad terminum' e 'confraternitates' armate," *Militia Christi e crociata nei secoli XI–XIII* (Milan, 1992), 645–97; Riley-Smith, *The First Crusaders* (Cambridge, 1997), 158–60.

23. Rutebeuf, "La complainte de monseigneur Joffroi de Sergines," ed. Julia Bastin and Edmond Faral, *Onze poèmes de Rutebeuf concernant la croisade* (Paris, 1946), 22–27. For Geoffrey's death, see The Templar of Tyre, 126; "L'Estoire de Eracles," 457.

24. Urban IV, *Registre,* 1/2:73–74. See also 19: a license to have a portable altar.

25. Clement IV, *Registre,* ed. Edouard Jordan (Paris, 1893–1945), 316–17.

26. "L'Estoire de Eracles," 458; The Templar of Tyre, 114–16. For Robert as seneschal, see *Regesta regni Hierosolymitani,* comp. Reinhold Röhricht (Innsbruck, 1893–1904), (henceforward *RRH*), nos. 1370–71.

27. The Templar of Tyre, 114.

28. John XXI, "Registre," ed. Jean Guiraud and Léon Cadier, *Les registres de Grégoire X (1271–1276) et de Jean XXI (1276–1277): recueil des bulles de ces papes,* one vol. and tables (Paris, 1892–1960), 3.

29. "L'Estoire de Eracles," 463; *RRH,* no. 1393.

30. "Dépenses de Saint Louis de MCCL à MCCLIII," *Recueil des historiens des Gaules et de la France,* 21:513–15.

31. Ibid., 513–15, especially 514. For the relationship between *livres parisis* and *tournois,* see Peter Spufford, *Handbook of Medieval Exchange* (London, 1986), 172.

32. See William C. Jordan, *Louis IX and the Challenge of the Crusade: A Study in Rulership* (Princeton, 1979), 78–79.

33. Lloyd, *English Society,* 116–17.

34. Serge Boffa, "Les soutiens militaires de Jean Ier, duc de Brabant, à Philippe III, roi de France, durant les expéditions ibériques (1276–1285)," *Revue du Nord* 78 (1996): 32–33.

35. Chazaud, "Inventaire," 176–77, 179–80.

36. Gustave Servois, "Emprunts de Saint Louis en Palestine et en Afrique," *Bibliothèque de l'école des Chartes,* sér. 4, 4 (1858): 292.

37. Chazaud, "Inventaire," 179–80.

38. This is illustrated in a dispute over *restor* of horses, settled by Louis on his crusade. Auguste Teulet, Jean de Laborde, Elie Berger, and Henri F. Delaborde, *Les layettes du Trésor des Chartes,* 5 vols. (Paris, 1863–1909), 3:171–72.

39. Joseph R. Strayer, "The Crusades of Louis IX," in *A History of the Crusades,* ed. Kenneth M. Setton , vol. 2, *The Later Crusades,* ed. R. L. Wolff and H. W. Hazard (Madison, 1969–89), 508.

40. Servois, "Emprunts," 123–26, 284–85.

41. Ibid., 126–31.

42. Ibid., 292.

43. Gregory X, "Registre," ed. Guiraud and Cadier, *Les registres de Grégoire X (1271–1276) et de Jean XXI (1276–1277),* "Appendice," 336.

44. William of Tyre, *Chronicon,* ed. Robert B. C. Huygens (Turnholt, 1986), 633.

45. Teulet et al., *Les layettes,* 1:549–50.

46. Ibid., 3:79.

47. Another example was Alexius IV's agreement with the Fourth Crusade in 1202 to provide 500 knights in the Holy Land for as long as he lived, but of course that promise was never kept; nor could it have been.

48. Servois, "Emprunts," 292. See also Clement IV, *Registre,* 317; Servois, "Emprunts," 129–30.

49. Urban IV, *Registre,* 1/2:73–74.

50. Ibid., 1/2:179–87. For Giles, see Bernard Hamilton, *The Latin Church in the Crusader States: The Secular Church* (London, 1980), 266.

51. William E. Lunt, *Financial Relations of the Papacy with England,* 2 vols. (Cambridge, Mass., 1939–62), 1:290–91.

52. Urban IV, *Registre,* 1/2:420–21.

53. Clement IV, *Registre,* 316–17.

54. See Riley-Smith, *The Feudal Nobility and the Kingdom of Jerusalem, 1174–1277* (London, 1973), 320.

55. Servois, "Emprunts," 292.

56. Urban IV, *Registre,* 1/2:420–21.

57. Teulet et al., *Les layettes,* 4:73, 108.

58. Léon L. Borrelli de Serres, "Compte d'une mission de prédication pour secours à la Terre Sainte (1265)," *Mémoires de la société de l'histoire de Paris et de l'Ile-de-France* 30 (1903): 243–80.

59. Borrelli de Serres, "Compte," 264. On the same day they received a delegation from Marseilles, which may well have been sent to discuss shipping cash or crusaders to the East, or Charles of Anjou's venture; he had left Marseilles for Italy at Easter.

60. Borrelli de Serres, "Compte," 269. On 23 July messengers arrived from the two executors of the hundredth. Ibid., 271.

61. Ibid., 272.

62. See Norman J. Housley, *The Italian Crusades* (Oxford, 1982), 175; Lunt, *Financial Relations,* 1:292–310.

63. See Richard, *Saint Louis* (Paris, 1983), 462–63.

64. Housley, *The Italian Crusades,* 148–49, 151–56.

65. The Templar of Tyre, 104; "L'Estoire de Eracles," 454.

66. Servois, "Emprunts," 292. Pope Clement IV ordered the archbishop of Tyre to consult with Louis on granting these crusaders subsidies from the hundredth. Teulet et al., *Les layettes,* 4:149; and see 163–64.

67. Servois, "Emprunts," 129.

68. See Lloyd, *English Society,* 116–25.

69. Chazaud, "Inventaire," 176–206. The document is often overlooked by crusade historians, because it was one of the few missed by the great scholar Reinhold Röhricht when he calendared the material relating to the Latin East. For a popular view of the bequests at the time, see The Templar of Tyre, 104.

70. Ibid. See "L'Estoire de Eracles," 455. For the year of his death, see Chazaud, "Inventaire," 169.

71. For Regnaud, see also Teulet et al., *Les layettes,* 2:629.

72. Chazaud, "Inventaire," 184.

73. William of Nangis, "Gesta Ludovici IX," *Monumenta Germaniae historica: scriptores* 26:661–62.

74. Jean Dunbabin, *Charles I of Anjou* (London, 1998), 59.

75. L.Carolus-Barré, "Les enquêtes pour la canonisation de Saint Louis—de Grégoire X à Boniface VIII—et la bulle *Gloria laus,* du 11 Août 1297," *Revue de l'histoire de l'église de France* 57 (1971): 20.

76. Gregory X, "Registre—Appendice," 337. See "L'Estoire de Eracles," 463.

77. John of Joinville, 8, 286, 288, 312.

78. "L'Estoire de Eracles," 449; The Templar of Tyre, 96; Servois, "Emprunts," 123–25. For the loss of two of his brothers, see Servois, "Emprunts," 124–25; "L'Estoire de Eracles," 458; The Templar of Tyre, 116 (called his nephews).

79. Gregory X, "Registre," 209.

80. "L'Estoire de Eracles," 463.

81. Ibid., 464.

82. Ibid., 467; The Templar of Tyre, 142.

83. "L'Estoire de Eracles," 466.

84. Gregory X, "Registre—Appendice," 335, 337.

85. Gregory X, "Registre," 209. See Lunt, *Financial Relations,* 1.311–46.

86. Gregory X, "Registre," 209–11, 213–15.

87. Dunbabin, *Charles I of Anjou,* 16.

88. Riley-Smith, *The Feudal Nobility,* 220–27; also Peter W. Edbury, *The Kingdom of Cyprus and the Crusades, 1191–1374* (Cambridge, 1991), 93–94. As early as 1269 the Muslims appear to have known that Hugh III of Cyprus was anxious about Charles's ambitions. Riley-Smith, *The Feudal Nobility,* 223. But it is unlikely that the opportunity of purchasing the crown from Maria had yet arisen: Louis IX was still alive and it is unlikely that a king with so rigid an attachment to legality would have approved of the sale of as yet unproved claims, even to his brother.

89. See Dunbabin, *Charles I of Anjou,* 95–96.

90. Ibid., 96–97.

91. See Riley-Smith, *The Crusades: A Short History* (London, 1987), 169, 178, 205.

92. "L'Estoire de Eracles," 478 (Miles of Haifa); "Annales de Terre Sainte," ed. Reinhold Röhricht and Gaston Raynaud, *Archives de l'Orient latin* 2 (1884): 456–57 (William of Picquigny, who seems to have been a leading vassal in the lordship of Tyre. *RRH,* nos. 1372, 1413).

93. Riccardo Filangieri et al., *I registri della cancelleria angioina,* 30 vols. (Naples, 1950–71), 18:31–32, 271; 19:23, 51, 76; 20:156; 22:114; 24:126.

94. Filangieri, *I registri,* 19:76.

95. Ibid., 24:123. See "L'Estoire de Eracles," 479.

96. Filangieri, *I registri,* 19:76.

97. Ibid., 26:96, 101, 207.

98. *RRH,* no. 1450. See The Templar of Tyre, 170.

99. The Templar of Tyre, 170; Marino Sanudo, "Liber secretorum fidelium crucis," ed. Jacques Bongars, *Gesta Dei per Francos,* 2 vols. (Hannau, 1611), 2:229.

100. Nicholas III, *Registre,* ed. Jules Gay and Suzanne Vitte (Paris, 1898–1938), 144–46.

101. Marino Sanudo, "Liber secretorum fidelium crucis," 229.

102. The Templar of Tyre, 142.

103. For example, Filangieri, *I registri,* 26:207.

104. Marie Luise Bulst-Thiele, *Sacrae Domus Militiae Templi Hierosolymitani Magistri* (Göttingen, 1974), 260.

105. Gregory X, "Registre—Appendice," 339.

106. Bulst-Thiele, *Sacrae Domus Militiae Templi,* 259–60.

107. Delaville Le Roulx, *Cartulaire,* 3:290.

108. See Riley-Smith, *The Feudal Nobility,* 117–20.

109. Ibn al-Furāt, *Tārīkh al-Duwal wa'l-Mulūk,* ed. and trans. Ursula and Malcolm C. Lyons, *Ayyubids, Mamlukes and Crusaders,* 2 vols. (Cambridge, 1971), 2:164.

110. "L'Estoire de Eracles," 474–75; The Templar of Tyre, 148; "Annales de Terre Sainte," 456 (according to which Hugh retaliated by wrecking the Templars' house in Limassol).

111. "L'Estoire de Eracles," 478–79; The Templar of Tyre, 150; "Annales de Terre Sainte," 456; Filangieri, *I registri,* 21:213.

112. The Templar of Tyre, 150; "Annales de Terre Sainte," 457; Francisco Amadi, *Chroniques de Chypre d'Amadi et de Strambaldi,* ed. René de Mas-Latrie, 2 vols. (Paris, 1891–93), 1:214; Florio Bustron, *Chronique de l'île de Chypre,* ed. René de Mas-Latrie (Paris, 1886), 116.

113. Filangieri, *I registri,* 26:101, 207.

114. Strayer, *The Reign of Philip the Fair* (Princeton, 1980), 10–11.

115. Georges Digard, *Philippe le Bel et le Saint-Siège,* 2 vols. (Paris, 1936), 1:123; Sylvia Schein, "Philip IV and the Crusade: A Reconsideration," in *Crusade and Settlement,* ed. Peter W. Edbury (Cardiff, 1985), 122; Housley, *The Later Crusades* (Oxford, 1992), 24.

116. Archivo Vaticano 45: Register of Pope Nicholas IV, fol. 176r and v. See Nicholas IV, *Registre,* ed. Ernest Langlois, 2 vols. (Paris, 1886–93), 1:642–43.

117. Hans E. Mayer, "Henry II of England and the Holy Land," *English Historical Review* 97 (1982): 732–33.

118. For his early attitude to crusading, see Jean Favier, *Philippe le Bel* (Paris, 1978), 8–9.

119. Mas-Latrie, *Histoire de l'île de Chypre,* 3:672–73.

120. The Templar of Tyre, 170; Francisco Amadi, *Chroniques de Chypre,* 216–17; Mas-Latrie, *Histoire de l'île de Chypre,* 3:671–73; "Bans et ordonnances des rois de Chypre," 357.

121. William of Nangis, *Chronique,* ed. P.H.J.F. Géraud, 2 vols. (Paris, 1843), 1:269–70.

122. "Annales de la Terre Sainte," 459–60; Marino Sanudo, "Liber secretorum fidelium crucis," 229.

123. "Annales de Terre Sainte," 460; Marino Sanudo, "Liber secretorum fidelium crucis," 229.

124. "L'Estoire de Eracles," 464. See also the reference to John of Grailly's responsibility for security at Lyons in John XXI, "Registre," 3.

125. The Templar of Tyre, 194–98, 218–20.

Heracles and the Crusaders: Tracing the Path of a Royal Motif

Gustav Kühnel

THE DECORATIVE PROGRAM of the Sainte-Chapelle in Paris is one of the most complex and sophisticated of mid-thirteenth-century French Gothic. Architecture and plastic arts join in a program whose main purpose is the realization in Paris of a new *locus sanctus,* the new Holy Land and the new Jerusalem, mirroring the political and religious aspirations of King Louis IX, the patron of the Sainte-Chapelle.[1] The spiritual authenticity of the new holy place in Paris was based on Saint Louis's acquisition of several of the most precious relics of Christianity. Among them, the most prominent were Christ's Crown of Thorns and the relic of the True Cross.[2]

These relics had been part of the sacred patrimony of the Byzantine Empire since Constantine the Great and Helena, through Heracles and until their acquisition by Louis IX. According to the new Capetian ideology of Saint Louis's period, the Sainte-Chapelle, built to house the relics, marked a decisive point in their history, especially that of the True Cross and the Crown of Thorns. Their acquisition was interpreted in Capetian religious-political thought as the moment of their succoring from disappearance and destruction, due to the incapacity of the Byzantines to preserve them for the benefit of the entire Christian world.[3] Saint Louis thus assumed the role of savior of the cross, in imitation of Constantine, Helena, and Heracles. In taking custody of these relics, the Capetian king took over a function of the Byzantine emperor. Louis IX thus became the direct successor of Constantine and Heracles.[4] At the same time, the Sainte-Chapelle, dedicated in 1248, was meant to surpass in its splendor and the prestige of its relics

the Byzantine chapel of the same name and function at the Boukoleon Palace in Constantinople.[5]

The political and religious program of this royal monument, manifest in the entire decoration, is most clearly expounded in the stained glass windows of the upper chapel. On the first window, to the right of the entrance (fig. 4.1, segment A), the following scenes are represented in narrative order: the story of Saint Louis's acquisition of the relics of the Passion; Saint Helena discovering the True Cross, in the lower field; then, the capture of the cross by the Persian king Chosroes and the victory of the Byzantine emperor Heracles over the Persian enemy, followed by the return of the cross to Jerusalem. Through their association on one window, these themes demonstrate a clear ideological filiation between Louis IX, Helena, and Heracles. The discovery of the cross through Helena, Constantine's mother, and its recovery from the infidel through Heracles, provide the iconographical paradigm to the deliverance of the sacred relics through their acquisition by Louis IX for France and the Christian West.

I do not intend in this chapter to deal with the window's program in general, but specifically with the figure and iconography of the emperor Heracles as precursor of and model for Louis IX. What were the immediate sources of the iconographical paradigm between Helena, Heracles, and Louis IX? How are we to define the memory or even the fame of Heracles in the West during Saint Louis's period or perhaps even earlier, during the First Crusade? Is the story of Heracles responsible for the idea of representing the deeds of a living monarch on behalf of the relics of the True Cross, and the past actions of Helena, Constantine, and Heracles associated with the cross in a common space, in the framework of a single window?

I shall attempt to suggest that one of the visual sources that may have stimulated the iconographical concept of the Sainte-Chapelle was the representation of the imperial portraits of Helena and Heracles on the walls of the Calvary Chapel of the Church of the Holy Sepulchre in Jerusalem.[6] This was an original twelfth-century crusader iconography, inspired by the proximity of the holy place of the Crucifixion. Its significance consists of the inclusion of Helena and Heracles as key, ideal figures of crusader ideology in the decoration of that particular holy place, in which the Passion of Christ and the Resurrection are united. Such features also appear in the Sainte-Chapelle. The spiritual authority of the Jerusalem *locus sanctus* and its unique iconography would have influenced the new *locus sanctus* in Paris and its iconography. The portraits of the imperial pair Helena and Heracles in the Jerusalem Calvary Chapel essentially evoke the same concept as the narrative representation of the two in the Sainte-Chapelle. The modes of expres-

Fig. 4.1. Sainte-Chapelle, upper chapel, the first window to the right of the entrance, Segment A (after Aubert, Lafond, and Verrier, *Les vitraux des Notre-Dame,* p. 75)

sion are different, the content is the same: in Jerusalem we have a frontal, isolated imperial portrait-type; in Paris, a narrative with the figure of the emperor as protagonist.

Seen from the crusader perspective, the iconographical concept of the Sainte-Chapelle is rooted in the tradition of crusader ideology, adopted and promoted by Louis IX, rather than in the iconography of the cross as formulated in the Golden Legend and articulated visually in representations of the Legend of the Cross.[7] In other words: the intention of the Sainte-Chapelle program to argue for the crusade and to emphasize its role in a divine scheme of salvation, in which Helena and Heracles are key figures and models of behavior for Louis IX, was shaped by a direct influence from the representations of Helena and Heracles in the crusader program of the Calvary Chapel in the Church of the Holy Sepulchre (fig. 4.2).

Neither the thirteenth-century stained glass of the Sainte-Chapelle with

1. KREUZIGUNG
9. KAISER HERAKLIOS
10. HL. HELENA
11. SALOMON
12. DAVID

13. DEESIS
14. ENGEL
15. ISAIAS
16. HABAKUK
17. AMOS

Fig. 4.2. Jerusalem, Church of the Holy Sepulchre, Calvary Chapel, plan with the distribution of the mosaics. Photo: author.

depictions of Saint Louis, Helena, and Heracles, nor the twelfth-century mosaics of the Calvary Chapel with the imperial portraits of Helena and Heracles have survived. The only survivor of the Calvary Chapel's crusader decoration is the figure of Christ from the Ascension scene.[8] However, the present windows in Paris are modern reconstructions of the thirteenth-century originals. This is the premise on which our work is based, in accord with the majority of scholars who have dealt with the Sainte-Chapelle decoration.

The existence of the Helena and Heracles portraits in the crusader decoration of the Calvary Chapel is securely documented by a series of sources, of which two have special weight: the depiction by Quaresmius in his *Elucidatio Terrae Sanctae* of 1639,[9] and that by Elzear Horn in his *Iconographiae locorum . . . terrae sanctae* from the first half of the eighteenth century, where the written depiction is ac-

companied by a watercolor copy of the double portrait, made by the author at the site.[10] It is quite likely that the portraits, as well as other remains of the original crusader decoration, were visible up to the fire of 1808.

Both written depictions are quite detailed, complementing each other. Quaresmius is very careful as to location and inscriptions: "Under the last, respectively western part of this most holy place, on the right respectively southern side Saint Helena is [represented], in royal habit and imperial diadem: in the right hand she has a long cross, like this illustrated here, and in her left [hand] a sphaerical globe with a red cross in the middle with [the following] inscription: HELENA REGINA. On the opposite, respectively northern side of the same arch, the Emperor Heraclius is [represented] dressed in imperial habit, with a diadem used by the Church only to ornate heads of Saints; and in his hands he has, like Helena, the Cross and the Orb, with the following inscription: ERACLIUS IMPERATOR."[11] Horn added precious information as to the technique and the state of preservation of the mosaic: "Helena is represented according to the ancient style in mosaic, as you can see in the frontispiece, that is, with small square stones closely knit together with mortar, some of which are of gilded glass and still exist; others are of earth, baked and of diverse colors, now almost completely black, so that I could scarcely make out of what colors they were."[12]

Horn's copy (fig. 4.3) shows that the portraits of Helena and Heracles were shaped according to older representations of the emperor-pair Constantine and Helena, whose earliest extant portraits are from the posticonoclastic period. The earliest Middle Byzantine representation of the True Cross flanked by the emperor Constantine and the empress Helena seems to be the mosaic in the room over the vestibule in Hagia Sophia, Istanbul,[13] which has been dated to the 870s.[14] Another formal parallel exists between the representations of Helena and Heracles and those of emperors on early Byzantine coins.[15] Various pairs of emperors are often represented flanking or holding together a cross elevated on a stepped base. Such, for example, are the solidi showing Emperor Heraclius and his brother Constans II (641–668), or Justinian II and his son Tiberius.[16] The emperors are represented frontally, holding cross and orb (fig. 4.4).[17]

The old hypothesis of Johann Georg, count of Saxonia, that it was Constantine and Helena who were represented in the Golgotha Chapel, cannot be sustained.[18] It is known that in the eleventh-century decoration of the tambour supporting the Anastasis dome, Constantine and Helena occupied a central place among the twelve apostles and prophets.[19] Whether a related iconography, placed in the same architectural complex of the Church of the Holy Sepulchre, influenced the emergence of a new scheme in which Heracles, the "new Constantine,"

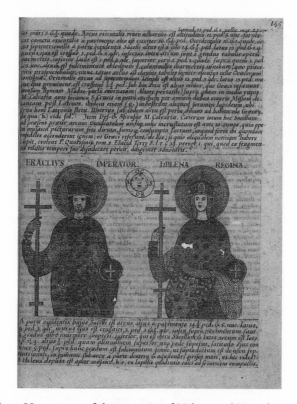

Fig. 4.3. Elzear Horn, copy of the portraits of Helena and Heracles in the Calvary Chapel (Vatican Library, Lat. 9233 II, fol. 146). Photo courtesy of the Biblioteca Apostolica Vaticana.

took the place of the emperor Constantine the Great beside Saint Helena, is a question that can be treated only speculatively. We may assume that a shift of emphasis from Constantine to Heracles could have taken place within the crusader ambiance at this holy place out of the aspiration to replace Byzantine imperial custody over the site itself and its most sacred relics. Since such a taking over of competence could not have been legitimized by the imperial tradition, this being a Byzantine prerogative, it had to be justified by the crusader tradition. Indeed, Western crusader tradition understood Heracles to be the forerunner of crusader monarchy. The chronicle of William of Tyre begins with Heracles,[20] while the text of his French translator and continuator has as title *L'estoire (livre/roman) d'Eracles*.[21]

Whatever the process of development, this much is certain: the representation of Heracles and Helena is an iconographical *novum,* elaborated by twelfth-century crusader art within the immediate context of the Crucifixion Chapel on Golgo-

Fig. 4.4. Byzantine coin with emperors flanking cross (after Wroth, *Catalogue,* vol. 2, p. 525, pl. LXII, 2)

tha. This iconographical novelty remains unique. It seems that after their joint appearance in the Golgotha Chapel, Heracles and Helena were never again represented as a pair, whether as iconic portrait depictions, or as an iconographical unit in a decorative program, as was the case with Constantine and Helena in monumental painting.[22]

At the Sainte-Chapelle, as we have seen, Heracles and Helena are depicted as part of a narrative dedicated to the Legend of the Cross. The ideas and political necessities that led to the genesis of this iconographical formula in the twelfth century seem to have had the same actuality during the thirteenth century in the case of Saint Louis. He preferred the narrative mode and the appeal to the Legend of the Cross, making possible an iconographical innovation with respect to Calvary: the twelfth-century crusader kings never allowed themselves to be represented in the Holy Sepulchre, especially not in the Calvary Chapel, where Christ wore the Crown of Thorns and suffered and died on the cross. In contrast, the king of France, Louis IX, felt himself emancipated from the pious sentiments of the Jerusalem kings, and was represented in his new Jerusalem, together with the holy relics and his divinely inspired deeds, side by side with Helena and Heracles.

The depiction of the imperial pair in the Calvary Chapel shows not only Saint Helena but also Heracles with a halo, indicating that the crusaders considered him a saint. In Byzantium, however, the emperor Heracles was never considered a saint. Moreover, because of his incestuous marriage with Martina, the daughter of his sister Maria, the Byzantine church considered him a sinner.[23] Byzantine art reacted accordingly: except for his appearance in the rendering of the Legend of the

Cross, he is not usually figured directly but represented symbolically through his deeds, or in an allusive and disguised manner. The most famous examples of such a disguised iconography are the so-called David plates in Nicosia and in the Metropolitan Museum of Art: a set of nine silver disks, produced during the reign of Heracles, that show scenes from David's life with allusions to the deeds of Heracles.[24]

Another example of a disguised Heracles iconography is offered by folio 4v of the Coptic Bible (Naples, Biblioteca Nazionale, MS. I B 18; fig. 4.5).[25] The manuscript is generally dated to the seventh century. The pen drawing we are referring to is located on the last folio of the Book of Job. Since this example is far less well known than the David plates, I shall go into some detail in describing it. The text of the Book of Job ends on the upper part of the page in question. Below the text, four full-length figures are represented frontally in a row: a man and three women. Only the man has a halo. His face reveals a decided character. The eyes are large, the nose rather straight, the lips well formed, the hair short, and the beard round. He wears a richly decorated crown set with three large oval gems and smaller pearls. The top of the crown is formed by three oblong precious stones. The curls on the forehead could indicate jewelry rather than coiffure. His broad-chested, strong body is clad in a cuirass and a short tunic with two decorative patches. Over the cuirass and tunic he wears the *paludamentum* fastened with a *fibula* on the right shoulder and carried over the left arm. He holds a scepter or a lance in his right hand and an orb, the Byzantine *sphaira*, in his left. An inscription naming the man in imperial garments is not omitted: following the end of the Book of Job, the name of the person portrayed is written in larger letters than those of the text, reading "Job the Just."

The three women are of smaller stature. They are almost identically clad in a long tunic with long narrow sleeves, over which is a *dalmatica*. On the two right-hand figures one can perhaps distinguish the *loros*, decorated with jewels around the neck and then falling vertically almost to the feet under a richly set belt. All three women wear the *maphorion*. The figure on the right has a decorated crown over her veil. The middle figure shows some signs of having a diadem, while the third has two crossed bands on her head.

The costumes and imperial attributes of the figures as well as the composition of this drawing, which was probably meant to be painted, remind us of the Justinian and Theodora panels in San Vitale, or of the Constantine IV (668–685) mosaic in Sant'Apollinare in Classe.[26] It is thus not surprising that the imperial features of the Naples miniature suggest a question about the identity of the figures as historical representations of Byzantine emperors. Thus, this might not be Job the pious sufferer, but a pious emperor who suffered like Job. Who could that em-

Fig. 4.5. Naples, Biblioteca Nazionale, MS. I B 18 (Coptic Bible), fol. 4v (after Delbrück, *Die Consulardiptychen,* no. 27, fig. 1)

peror be? Richard Delbrück suggested that the figure might be that of the emperor Heracles. His arguments were as follows: "There are no bearded Emperors before Phocas, who wore a pointed beard. Heraclius is the first emperor up to 630 who wore a circular beard. Most of his co-regents and successors followed this fashion. From 630 onwards, Heraclius wore the long flowing beard of a patriarch. Among this group of emperors, Heraclius is the only one who had daughters. The empress might be Martina, his niece and second wife, whom he married in 613; the older princess would be his sister and mother-in-law Epiphania the Elder, while the younger would be his daughter from his first marriage, Eudoxia, born in 611; this would date the miniature around 620."[27]

It is thus clear that the Naples miniature does not simply represent Job the pious sufferer, but contains an allusion to a pious emperor, compared, through his sufferings and trials, to the biblical figure. The incestuous marriage with Martina,

which made Heracles a sinner in the eyes of the Church and dealt a blow to his position in Byzantine society, in spite of his glorious undertakings for the salvation of the empire and the Holy Cross, makes him a serious candidate for the emperor figure in our miniature.[28]

Going back to the Calvary portrait, the most significant conclusion gained after reviewing the earlier allusive depictions is that the crusader representation renounced the disguised manner of referring to Heracles in previous Christian iconography. The emperor is here shown openly, side by side with Saint Helena, his aura gaining from the joint depiction. The *inventio* and *exaltatio crucis* are presented, at the appropriate holy place, as capital virtues.

Summing up our observations, we may say that the image of the emperor Heracles in Christian iconography took two distinct paths, reflecting two opposed interpretations: the earlier is proper to the Byzantine world and shows the emperor in a disguised way, his identity veiled, censured by subtle iconographical means. The second path, that taken by the crusaders in the twelfth century, reflects a positive attitude, not hindered by any moral reservations caused by the emperor's sin. His victories against the infidel are glorified, becoming models of crusader behavior; his personal conduct and moral profile were never, in the West, an impediment to his veneration.

The veneration of Heracles in the West began early, already in the Merovingian period, and can be followed continuously to Saint Louis and beyond. The period of Saint Louis represents the peak in the history of a long tradition of reverence for this emperor. The continuity can be followed in historiography, but also in the spirituality of the Middle Ages, as well as in liturgy and literature. The crusaders introduced two feasts relating to Heracles: 3 May for the *Inventio Crucis*, connected primarily to Helena, and 14 September for the *Exaltatio Crucis*. In the Western Church of Rome, the 14 September feast was dedicated to the recapture of the cross and its reinstallment in Jerusalem by Heracles, after being removed by the Persians in 614.

The best sign of Heracles's fame in the West is the *Roman d'Eracles* by Gauthier d'Arras, written in the second half of the twelfth century. The author depicts the entire *vita* of his hero, introduced as a legendary figure endowed with miraculous powers, who won the True Cross back from Chosroes.[29] This romance inspired Master Otte, in about 1210, to write a spiritual epic called *Eraclius*, where the story of Heracles is combined with the story of the finding of the True Cross by Helena.[30] This epic inspired the frescoes on the walls of the pilgrimage church at Fraurombach near Fulda from around the middle of the fourteenth century.[31]

Against the background of a continuing and special veneration of the emperor

Heracles in the West, the Calvary representation of his portrait does not appear as a surprising iconographical novelty, but as a natural outcome of the intensification of his cult with the success of the First Crusade, and as the result of Heracles being considered the model of the crusader kings. Saint Louis and the iconography of the Sainte-Chapelle windows subscribe to the same tradition: the representation of Heracles at the holy place in Jerusalem inspired the transfer of the equation Heracles-crusader king to the new holy place in Paris.

Notes

1. On the architecture and the decorative program of the Sainte-Chapelle as a new *locus sanctus,* a new Holy Land and a new Jerusalem, see Daniel H. Weiss, *Art and Crusade in the Age of St. Louis* (Cambridge, 1998), especially Part I, 11–77, with earlier bibliography.

2. On the history of the acquisition and transportation of the relics of the Passion, see the account of Gautier Cornut, archbishop of Sens, *Historiae susceptionis Corone spinee,* in C. de Riant, *Exuviae Sacrae Constantinopolitanae,* vol. 1 (Geneva, 1877), 45–56; *Recueil des historiens des Gaules et de la France,* vol. 22, 26–32; Weiss, *Art and Crusade,* 4–6.

3. For the role of Louis IX in "saving" the most precious relics of Christianity, see Weiss, *Art and Crusade,* 15 and n. 17.

4. For the figures of Helena and Heracles as models of Christian rulers for Louis IX, see Beat Brenk, "The Sainte-Chapelle as a Capetian Political Program," in *Artistic Integration in Gothic Buildings,* ed. Virginia C. Raguin, Kathryn Brush, and Peter Draper (Toronto, 1995), 206–7.

5. Weiss, *Art and Crusade,* 30f. See also Hans Belting, "Die Reaktion der Kunst des 13. Jahrhunderts auf den Import von Reliquien und Ikonen," in *Ornamenta Ecclesiae: Kunst und Künste der Romanik,* Katalog zur Ausstellung des Schnütgen-Museums, vol. 3 (Cologne, 1985), 173–80, esp. 174.

6. Gustav Kühnel, "Kreuzfahrerideologie und Herrscherikonographie: Das Kaiserpaar Helena und Heraklius in der Grabeskirche," *Byzantinische Zeitschrift* 90 (1997): 398–404; Jaroslav Folda, *The Art of the Crusaders in the Holy Land, 1098–1187* (Cambridge, 1995), 239. See also M. Müller, "Paris, das neue Jerusalem? Die Ste-Chapelle als Imitation der Golgatha-Kapellen," *Zeitschrift für Kunstgeschichte* 59 (1996): 325–35, on an association between the two from the point of view of architecture.

7. On the Golden Legend as a source for segment A's stained glass representations, see the excellent critical analysis by Alyce A. Jordan, "Narrative Design in the Stained Glass Windows of the Ste Chapelle in Paris" (Ph.D. diss., Bryn Mawr College, 1994), esp. 581–610. See also K. A. Wiegel, "Die Darstellungen der Kreuzauffindung bis zu Piero della Francesca" (Ph.D. diss., Cologne University, 1973), 252, n. 6.

8. G. Kühnel, "Das restaurierte Christusmosaik der Calvarienberg-Kapelle und

das Bildprogramm der Kreuzfahrer," *Römische Quartalschrift* 92 (1997): 45–71. For the Sainte-Chapelle's stained glass windows, see Marcel Aubert, J. Lafond, and J. Verrier, *Les vitraux des Notre-Dame et de Sainte-Chapelle de Paris* (Paris, 1950), 71–349 (by Louis Grodecki).

9. Franciscus Quaresmius, *Historica, theologica et moralis Terrae Sanctae elucidatio,* vol. 2, chap. 39 (Antwerpen, 1639), 459.

10. Elzear Horn, *Iconographiae monumentorum Terrae Sanctae (1724–1744),* 2d ed. of the Latin text with English version by E. Hoade and Preface and Notes by B. Bagatti (Jerusalem, 1962), 121.

11. My translation. Here the original: "Sub ultimo, & Occidentali parte huius sanctissimi loci, a parte dextra & Meridionali est sancta Helena in habitu Regio & Imperiali cum diademate: in dextera eius manu longa est crux ad instar hic descriptae, & in sinistra sphaericus globus; in cuius medio est rubea crux cum hac inscriptione: HELENA REGINA. E regione & Aquilonari parte eiusdem arcus est Heraclius Imperator habitu Imperialu indutus, cum diademate quo solet Ecclesia condecorare Sanctorum capita; & in manibus habet, ut Helena, Crucem & Orbem, cum sequenti inscriptione: ERACLIUS IMPERATOR" (Quaresmius, *Historica*).

12. Translation by Hoade, *Iconographiae monumentorum.* The original text: "Helena depicta est opere musaico, hoc est, ex lapillis quadratis calci ad se invicem compactis, quorum alii sunt vitrei inaurati, et adhuc durant; alii terrei, cocti et versicolores, nunc fere penitus apparent nigri, vixque cujus coloris fuerint discernere potui."

13. Natalia Teteriatnikov, "The True Cross Flanked by Constantine and Helena: A Study in the Light of the Post-Iconoclastic Re-evaluation of the Cross," *Deltion tes Christianikes archaiologikes etaireias* 19 (1995): 169–88, esp. 174.

14. Robin Cormack and Ernest J W. Hawkins, "The Mosaics of St. Sophia at Istanbul: The Rooms above the Southwest Vestibule and Ramp," *Dumbarton Oaks Papers* 31 (1977): 175–251, esp. 235–47, figs. 46, 47 and color pl. C. The fragment depicting Emperor Constantine is identified as such by an accompanying inscription. The identification of the second figure as St. Helena, indicated by the cuff of a garment, has been suggested by Cormack, especially because of her position as a pendant to the figure of the emperor. The two figures flank a cross, placed at the summit of the south window (Cormack and Hawkins, fig. 49). For the iconography of the emperor Constantine and the empress Helena with the Holy Cross, see also Klaus Wessel, "Konstantin und Helena," *Reallexikon der byzantinischen Kunst* 4 (1989), cols. 363ff. According to Wessel, the earliest extant exponents of this iconography are not earlier than the tenth century. For pre-iconoclastic images of Constantine, Helena, and the cross, see Teteriatnikov, "The True Cross," 174–76. See also H. von Heintze, "Ein spätantikes Mädchenporträt in Bonn: zur stilistischen Entwicklung des Frauenbildnisses im 4. und 5. Jahrhundert," *Jahrbuch für Antike und Christentum* 14 (1971): 65ff; and A. Frolow, *Les reliquaires de la vraie croix* (Paris, 1965), 223.

15. Frolow, *Les reliquaires,* 220f. and 223, n. 2.

16. André Grabar, *L'iconoclasme byzantin: dossier archéologique* (Paris, 1957), figs. 8,

17–19; Warwick Wroth, *Catalogue of the Imperial Byzantine Coins in the British Museum*, vol. 2 (London, 1908), pls. XXX, 19–21; XXXI, 13; XXXIII, 9–10; XXXV, 3 (Constans II); XXXVI, 1–3 and 8–10; XXXVII, 5–7 (Constantine IV, 668–685); XXXVIII, 15, 16, 20, 21 (Justinian II).

17. Wroth, *Catalogue,* vol. 2, 525, pl. LXII, 2.

18. Johann Georg Herzog zu Sachsen, "Konstantin der Grosse und die hl. Helena in der Kunst des christlichen Orients," in *Konstantin der Grosse und seine Zeit: Gesammelte Studien,* ed. Franz Dölger, Supplementheft der Römischen Quartalschrift, 19 (Freiburg, 1913), 257–58. See also Wessel, "Konstantin und Helena," col. 364; Frolow, *Les reliquaires,* 220; G. Kühnel, "Kreuzfahrerideologie," 397.

19. See the pilgrimage depiction by the monk Theoderich from the third quarter of the twelfth century in *Peregrinationes tres: Saewulf, John of Würzburg, Theodericus,* ed. Robert B. C. Huygens (Turnholt, 1994), 150.

20. *William of Tyre: Chronicon,* 1,1–2: *"Quod tempore Eraclii Augusti . . . quod tempore quo Eraclius Augustus Romanum administrabat imperium . . . ,"* ed. R.B.C. Huygens, Corpus Christianorum. Continuatio Mediaevalis, 53 (Turnholt, 1997), 105.

21. "L'Estoire de Eracles empereur et la conqueste de la Terre d'Outremer," in *Recueil des historiens des croisades: historiens occidentaux,* vol. 2 (Paris, 1859), 1–481; Margaret R. Morgan, *The Chronicle of Ernoul and the Continuations of William of Tyre* (Oxford, 1973); Janet Shirley, *Crusader Syria in the Thirteenth Century: The Rothelin Continuation of the History of William of Tyre with Part of the Eracles or Acre Text* (Aldershot, 1999).

22. It is possible that Heracles takes the place of Constantine on a sixteenth-century reliquary in Halle. See Frolow, *Les reliquaires,* 160, 218, and fig. 62. Frolow mentions a similar example, also from the sixteenth century, attributed to Cornelis Engelbrechtsz in the Munich Pinacoteca. These rare examples confirm the exceptional character of the crusader depiction in the Calvary Chapel.

23. Georgije Ostrogorsky, *History of the Byzantine State,* 2d ed. (New Brunswick, 1968); Warren Treadgold, *A History of the Byzantine State and Society* (Stanford, 1997), 289; See also Paul Speck, *Das geteilte Dossier* (Bonn, 1981), 41.

24. S. H. Wander, "The Cyprus Plates: The Story of David and Goliath," *Metropolitan Museum Journal* 8 (1973): 89–104; S. Spain Alexander, "Heraclius, Byzantine Imperial Ideology, and the David Plates," *Speculum* 52 (1977): 217–37; James Trilling, "Myth and Metaphor at the Byzantine Court," *Byzantion* 48 (1978): 249–63.

25. Dmitrii V. Ainalov, *The Hellenistic Origins of Byzantine Art* (1900; reprint, New Brunswick, 1961), 66–68, fig. 33; Richard Delbrück, *Die Consulardiptychen und verwandte Denkmäler,* Studien zur spätantiken Kunstgeschichte, 2 (Berlin, 1929), 270–74, no. 27, fig. 1; O. Kurz, "An Alleged Portrait of Heraclius," *Byzantion* 16 (1942–43): 162–64; *Mostra storica nazionale della miniatura: Palazzo Venezia, Roma,* Catalogo, 2d ed. (Florence, 1954), no. 1; Jules Leroy, *Les manuscrits coptes et coptes-arabes illustrés* (Paris, 1974), 181–84, pl. III; Iohannis Spatharakis, *The Portrait in Byzantine Illuminated Manuscripts* (Leiden, 1976), 14–20, fig. 5; J. D. Breckenridge, "Drawing of Job

and his Family Represented as Heraclius and his Family," in *Age of Spirituality: Late Antique and Early Christian Art, Third to Seventh Century,* ed. Kurt Weitzmann (New York, 1979), 35–36, fig. 29.

26. Friedrich W. Deichmann, *Ravenna: Hauptstadt des spätantiken Abendlandes,* vol. 1, *Geschichte und Monumente* (Wiesbaden, 1969), 241ff. and pls. 358, 359 (San Vitale), 123, 342–43 (Sant'Apollinare in Classe); vol. 2 (Wiesbaden, 1976), 273–79 and pls. 404–6 (the Granting of the Autokephalia mosaic in Sant'Apollinare in Classe). See also Otto G. von Simson, *Sacred Fortress: Byzantine Art and Statecraft in Ravenna* (Princeton, 1987), 27ff., pls. 2, 18, for the representations of Justinian and Theodora with their retinues in San Vitale, and 59f., pl. 27, for the *"Privilegia"* mosaic in Sant'Apollinare in Classe.

27. Delbrück, *Die Consulardiptychen,* 272.

28. See the conclusive remarks of Breckenridge, "The Drawing of Job," 36: "The Coptic monk who added this picture to the manuscript symbolized his biblical king in terms of his own ruler . . . the Coptic artist may well have known of the terrible trials the same emperor underwent later in life—largely due to foreign invasions, but also in the public unpopularity due to his incestuous second marriage. The choice of Heraclius to represent Job may have been more than just fortuitous."

29. Gautier d'Arras, *Eracle,* ed. Guy Raynaud de Lage, Les classiques français du Moyen Age (Paris, 1976), esp. verse 5093ff.; see also the Introduction, xv.

30. Wolfgang Stammler, ed., *Deutsche Philologie im Aufriss,* vol. 3, 2d ed. (Berlin, 1962), 641.

31. R. Kautzsch, "Die Herakliusbilder zu Fraurombach," in *Studien aus Kunst und Geschichte: Friedrich Schneider zum 70. Geburtstag,* ed. Joseph Sauer (Freiburg im Breisgau, 1906), 509ff.; Wiegel, "Die Darstellungen der Kreuzauffindung," 343, pl. VII, 1.

CHAPTER 5

The French Connection?
Construction of Vaults and Cultural Identity
in Crusader Architecture

Robert Ousterhout

In memory of Larry Hoey, who understood these things

THE STUDY OF Byzantine architecture has taught me two important rules
of thumb.[1] In this chapter, I will try to apply them to the analysis of crusader ar-
chitecture. The first rule is that architectural style and construction technique are
two different things, although they are often confused. Traditional art history,
based on formal analysis and dealing with influences and appropriations, normally
addresses style rather than technical concerns. The outward appearance of a build-
ing, its decorative aspects, can be discussed without a specific knowledge of how
it was built. The same holds true for medieval architectural practices: formal ele-
ments could have been seen and imitated long after a building was completed. But
construction technique is a different matter, for it is based on specialized knowl-
edge that could only be transmitted through the active participation in a work-
shop. This is not to say that building technology was privileged information—the
so-called secret of the master masons; but simply that many critical details of con-
struction were no longer visible when a building was completed, and thus they
could not have been learned from observation alone. This is why architectural his-
torians like myself appreciate partially collapsed buildings: they are much more
instructive when we can see beyond the finished surfaces. Medieval architectural
technology was passed on through a program of apprenticeship, of "learning by
doing," and disseminated by traveling masons.[2] In a professionally illiterate so-

ciety, the transfer of specialized knowledge required human beings as the vehicles.

The second rule is that the cultural experience of the patron is not necessarily the same as that of the artisan. The history of medieval art and architecture is often written as a history of patronage because the sources tell us about the patrons, not about the artists or builders. But we should *not* assume that because a patron was familiar with the monuments of Paris or of Constantinople that his masons came equipped with the same knowledge. For architecture, patrons could dictate certain things, such as budget, scale, appropriate materials, and liturgical necessities, but in the end, it was up to the masons to translate the patron's wishes into architectural form. A careful reading of relevant documents may thus provide us with a part of the picture, but only a part. It can never replace the close analysis of the building itself.

For the purposes of this study, my test case for the application of these rules of thumb to crusader architecture is the ribbed groin vault. It is the quintessential element of French Gothic architecture, in fact, one of its defining characteristics. The development of the ribbed groin vault was critical for the great technical advancements of the late Middle Ages, allowing for lighter, taller, and more open construction and more spacious interiors.

The construction of groin vaults and of ribbed groin vaults in masonry is perhaps of more interest to specialists in architecture than to historians and art historians, but the details of construction will become important to our discussion. Unribbed groin vaults were used commonly in Roman and subsequently in Romanesque architecture to cover square or rectangular spaces, as, for example, the side aisle or nave bays of a church.[3] Technically, a groin vault was created by the intersection of two barrel vaults, the curvature of which was defined by arches on the four sides of the bay. The groin vault provided a versatile structural form that adjusted the weight of the vault to the corners of the bay and did not require thick walls for support. Because of its versatility, the groin vault could be easily used in series, as a modular space covering. When used to cover the nave of a church, for example, the groin vault used in series provided a continuous, flowing space of an even height along the main axis of the building, while allowing for large, open clerestory windows along its flanks. When built on a large scale, however, the groin vault would have required substantial formwork or centering to support its weight during the process of construction, until the mortar had set.[4]

With the construction of groin vaults, one of the critical details was the groins—the diagonal intersections of the vault compartments. In terms of pure geometry, if the diagonal arches formed semicircles, they would have a greater diameter than the arches defining the bay, and the resulting vault would have a

slightly domical form.[5] If the diagonals were flattened to correspond to the height of the other arches, the geometry would be more difficult to calculate.[6] In either case, it was problematic to construct an unribbed groin vault in which the diagonal junctures formed smooth lines, and most medieval examples of the unribbed groin vault look a bit wobbly as a result.[7] By the late eleventh century, ribs were introduced into vault construction, perhaps originally as a simple visual correction to this problem, providing a smooth delineation of the groin, as well as a clear articulation to the structural system.[8] Over the course of the following century, builders learned that the ribbed groin vault could be exploited to structural advantage, that the ribs could provide stabilization during the critical early stages as the mortar set and the building settled. Perhaps more important, the ribs would have simplified the construction process, functioning as a part of the centering, and they could have supported additional formwork as the webs of the vault were constructed.[9] Visually, structurally, and constructionally, then, the ribs formed a key component in a Gothic system of vaulting.

Numerous permutations of the ribbed groin vault developed, and the literature on Gothic vaulting technology is voluminous. In the areas where we witness the dissemination of French Gothic architectural style and technology, we find the ribbed groin vault. The history of Gothic architecture in England, Germany, Italy, Bohemia, Spain, and elsewhere begins with the major impetus coming from France, followed by distinctive regional developments that affect both the architectural style and the related building technology.

That said, when we consider the Frenchness of the crusades, it is surprising just how seldom we find ribbed groin vaults in the architecture of the Holy Land. One good reason is, of course, that many crusader buildings were begun before the widespread use of ribbed groin vaulting by the middle of the twelfth century, and we might assume a time lag in the transfer of technology. On the other hand, examination of architectural sculptures often indicates that during the construction process, the decorative programs of crusader buildings were updated according to new trends on the Continent. This is the case, for example, at the Cathedral at Tortosa, where a stylistic progression has been noted in the nave sculptures.[10] The foliate capitals shift from a stylized flat leaf pattern to more naturalistic forms. Should we not expect a similar updating of the structural system? As a building rose, the high vaults would have been the last part to have been completed. Although the building activity at Tortosa apparently extended into the thirteenth century, the nave was covered by a slightly pointed, banded barrel vault. The form corresponds to the high vault of the great abbey church of Cluny, of a century earlier, but it is clearly less sophisticated than the contemporaneous ribbed groin vaults

Fig. 5.1. Jerusalem, Church of the Holy Sepulchre, view of north transept, showing ribbed high vault and unribbed vauting in the gallery, mid-twelfth century. Photo: author.

of the High Gothic. That is to say, the vaulting of Tortosa would have seemed an anachronism by French standards at the time the church was completed.

The first appearance of the ribbed groin vault in crusader architecture is probably in the high vaults of the Church of the Holy Sepulchre in Jerusalem (fig. 5.1).[11] The church was reconstructed toward the middle of the twelfth century, at a point in time that coincided with the transition from Romanesque and the early development of Gothic architecture in France. Although they must have been very much *au courant* at the time of its construction, the ribbed groin vaults of the Holy Sepulchre are never mentioned in the historical sources. Obviously, medieval visitors to the church were more concerned with its antiquity than with its novelty.

A careful analysis of the structural system of the Holy Sepulchre suggests that the ribbed groin vaults were afterthoughts, the result of changes in design that came about only *after* the construction was well under way. They appear *only* in the high vaults; the lower vaults are consistently unribbed groin vaults. What is more, the pier sections give no indication that ribs were intended. In the Gothic style, there is normally a pilaster or engaged colonnette of some sort to relate the vaulting rib to the elevation—that is, part of a system of the visual expression of structure, characteristic of late Romanesque and Gothic architecture. The ap-

pearance of the ribbed groin vault should be viewed as one of any number of design changes that occurred during the crusaders' reconstruction of the Holy Sepulchre.[12] This stands in contrast to what occurred, or more correctly, what did *not* occur at Tortosa. But in terms of crusader architecture, the Church of the Holy Sepulchre was an anomaly in almost every way.

The impetus for this particular design change at the Holy Sepulchre must have been the importation of new architectural ideas from France, possibly from the Ile-de-France, at mid-century. Unfortunately, we lack the documents that might tell us by whom and how this feature was introduced, but it was *not* a local development. There is nothing comparable in the prior architecture of the region. The simple rib profile might be best compared with slightly earlier Western examples, such as the side aisle vaults of St.-Etienne at Beauvais (c. 1130–40).[13] What is critical to our interpretation of the Holy Sepulchre, and of later crusader examples, is how the ribbed groin vault was used. The crusader vaults reveal little of the structural revolution that characterizes Abbot Suger's additions to the Abbey Church of Saint-Denis and its progeny. The stability of the Holy Sepulchre relied on its massiveness, not on its structural design; in spite of the introduction of ribbed groin vaults, it remained solidly a Romanesque building.

Two other early examples are also problematic. At the Cenacle, probably constructed shortly before the fall of Jerusalem in 1187, the interior of the Upper Room is covered by a systematic series of ribbed groin vaults (fig. 5.2).[14] The vaults rest on a row of freestanding columns at the center of the space, creating a sense of openness in the interior. Nevertheless, the whole is enveloped by thick masonry walls that betray little of the lightness inside. Nor, it seems, have the masons taken advantage of the skeleton of ribbing to reduce the mass of the vault.

The system of vaulting employed here may not be related directly to the developments in ecclesiastical architecture but to the developments in monastic architecture. Peter Fergusson has made the compelling argument that the Cenacle served as the model for certain refectories of the Augustinian order in the British Isles.[15] In Jerusalem, the Austin Canons were responsible for Sion and the Cenacle, and this important charge provides both the means and the motivation behind the transmission of forms. The association emphasized the symbolic relationship of the gathering of the monks for common meals with the gathering of the apostles for the Last Supper. This might explain the upstairs location of some monastic refectories, as at Easby Abbey, but these spaces were usually unvaulted. On the other hand, there were also—prior to the construction of the Cenacle— other monastic spaces that were two bays wide, covered by ribbed groin vaults used in series, as, for example, chapterhouses. The Cistercian chapterhouses at Fonte-

Fig. 5.2. Jerusalem, Cenacle, view of ribbed vaulting, before 1187. Photo: author.

nay and Senanque offer useful comparisons that look suspiciously like the Cena-
cle.[16] We might suggest that the gathering of monks at chapter could be compared
with the gathering of the apostles at Pentecost in the Cenacle. In fact, this may
have been a two-way symbolic relationship—that is, the Cenacle, with its monas-
tic associations, was modeled after familiar monastic spaces, incorporating the type
of vault construction associated with them. Subsequently, the new form of the
Cenacle exerted an influence on the layout of monasteries, as Fergusson proposes,
but without a transfer of technology. The upper-level setting was replicated but the
vaulting was not. As with the crusader Holy Sepulchre, the transfer of ideas from
the West to the Holy Land involved elements of both architectural planning and
technology, while the transfer from the Holy Land to the West was on a symbolic
level, involving only a generalized replication of significant architectural forms.[17]

A second example of the early ribbed groin vault, the Cathedral of St. John at
Sebaste, is now in a ruined state, but various scholars have attempted to recon-
struct it with the nave covered by sexpartite vaults above an alternating support

Fig. 5.3. Sebaste, Cathedral of St. John, plan, mid-twelfth century. After Pringle.

system (fig. 5.3).[18] This system of vaulting, common in late-twelfth-century France, would have been virtually unique in crusader architecture, but it seems entirely plausible, based on the surviving evidence of the piers and capitals. Nurith Kenaan-Kedar has attempted to connect the appearance of the sexpartite vaults here with the well-documented patronage and support from France, including that of William of Sens in the 1170s.[19] The nave of the Cathedral of Sens, of course, is one of the great early examples of the sexpartite Gothic vault.[20]

I believe the issue is a bit more complex and should be reevaluated, for the plans of the two buildings are not at all alike. In fact, their *only* similarity is, possibly, the form of the vault. As I suggested earlier, patrons of churches might be familiar with the liturgical organization of space—and one might expect this to be one of their major concerns—but they rarely arrive on the scene with a sophisticated knowledge of engineering. With the exception of the sexpartite vaulting and the alternating support system with doubled columns, the planning and construction details do not correspond. Importantly, with the exception of the Holy Sepulchre, crusader churches in the Holy Land never replicate the French chevet but favor a simple three-apsed termination instead.

Let us now turn to some different, if related, problems and move gradually to architectural developments of the thirteenth century. Ribbed vaulting appears in several spaces of the Compound of the Knights of St. John at Acre, from the end of the twelfth century.[21] In the latrine, however, the ribs have fallen, with the ex-

Fig. 5.4. Acre, Compound of the Knights of St. John, vault of latrine, showing springer and exposed arris where rib has fallen, end of twelfth century. Photo: author.

ception of surviving corbelled springers, still bonded in the corners of the room. Above this level, the vaults have smooth arrises, and there is virtually no trace left of the missing ribs (fig. 5.4). Without the bonded springers, it would have been virtually impossible to tell that the vault was ribbed. In the nearby Hall of the Knights, identical ribbed groin vaults were employed, rising from their bonded springers on heavy cylindrical piers. A close examination of the vaults similarly indicated that the ribs were *not* bonded to the webs. In several places, the ribs have fallen, but the vault has remained intact (fig. 5.5). This indicates that in terms of structure, the ribs and the vault proper functioned separately, and that the ribs were not providing any structural reinforcement for the vaults.

The distinction between the rib and the web of the vault is significant, for in French Gothic architecture the two functioned as a unit, either bonded together during construction or with the rib securely attached to the vault with mortar.[22] Moreover, if the vault was damaged and suffered partial collapse, it was normally the web that fell and not the rib. This is evident in the ruined church at Ourscamp

Fig. 5.5. Acre, Compound of the Knights of St. John, view of hall, showing springing of ribbed vaults, end of twelfth century. Photo: author.

in Oise, where the ribs are heavy and deep in section; they have remained in place long after the vault deteriorated.[23] Photographs of the collegiate church of St.-Quentin (c. 1220–57) and of Cologne Cathedral (c. 1270–1320) taken after bombardment in World War I show that the skeletal system of the ribs often withstood devastation when other parts of the vaults fell.[24] In examples where the ribs fell during the bombardment, it was normally the result of severe destruction in a building with fairly sophisticated ashlar construction of the vault webs. In the French examples, the ribs allowed for the construction of thin vaults, and, as Robert Mark has demonstrated, under normal circumstances the ribs were unnecessary once the mortar had set.[25] Nevertheless, they provided additional stability during crisis situations, such as earthquakes, high winds, and aerial bombardments. In contrast, the crusader vaults are considerably more massive, retaining their heavy character in spite of the added ribs.

Several explanations can be put forward for the distinction. Crusader architecture might have relied on massiveness as part of its symbolic expression—that is, part of a language of power, similar to the massiveness of Anglo-Norman architecture at the turn of the twelfth century. The heavy character might also be related to the threat of seismic activity in the region. But it may just as well have been the result of a general conservatism in crusader architecture. One possible

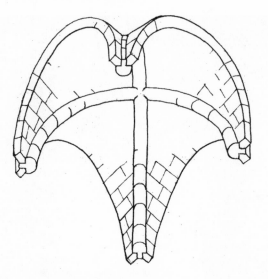

Fig. 5.6. Diagram of a ribbed groin vault showing construction with rib stem and rebated shelves. Drawing: author.

reason for the separate construction of the ribs in crusader vaults is that their primary function was *constructional*—that is, they acted as formwork to brace and shape the vault during its construction and to help to support its weight until the mortar had set. A similar interpretation has been proposed for the use of ribs in French Gothic architecture, in spite of their difference in thickness.[26] Although the crusader ribs may have served functions identical to their French counterparts during the process of construction, structurally they behaved differently afterward. In the French examples, once completed the ribs acted in combination with the vault. In many twelfth-century examples, the ribs were constructed with a rib stem flanked by rebated shelves on the backside, into which the webs were bonded (fig. 5.6).[27] The webs of the vault were thus connected directly to the ribs, but in fact, the ribs also separated the webs one from another. This type of vault construction appeared in the side aisle vaults at St.-Etienne at Beauvais, for example.[28] It also may be seen in the high vaults of the Holy Sepulchre (fig. 5.7).[29] This detail, visible in the extrados during recent repairs, would have been invisible in the completed building, a fact that emphasizes the technical indebtedness of the Holy Sepulchre's vaulting to new developments from France. I have not observed this detail in any other crusader building. In French Gothic architecture, the system of rib stems and rebated shelves was rarely used for the diagonals in rectangular vaults, and the system seems to have been gradually abandoned with the greater technical mas-

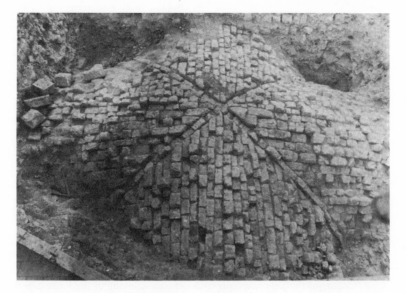

Fig. 5.7. Jerusalem, Holy Sepulchre, extrados of transept vault during repair, showing rib stems between vault compartments. Photo: Virgilio Corbo.

tery of vault construction in the thirteenth century. Nevertheless, either the greater stress or perhaps the strength of the mortar served effectively to unify the ribs and the vault. In contrast, the ribs of the crusader vaults at Acre appear neither rigid nor firmly attached. They could fall off without compromising the integrity of the vault, the stability of which was provided by its massiveness.

We see much the same sort of thing in a variety of thirteenth-century vaults. At Montfort Castle, constructed between c. 1226 and 1240, the hall of the guesthouse was covered by quadripartite ribbed groin vaults, but the ribs have fallen in the east bays.[30] Although the diagonal ribs of square bays could easily have been constructed with penetrating stems, Denys Pringle has noted the lack of bonding in the ribs, with smooth arrises at the groins. Similarly, in the east gate at Caesarea, completed by 1252, the ribs appear to be separate from the vault.[31] Several stones of the ribs seem to have been restored, apparently without disturbing the vault behind them. And, in the Grotto of the Annunciation at Nazareth, the seventeenth-century illustration by Cornelius de Bruyn shows the elegant, triple-moldings of the Gothic ribbed vaults (fig. 5.8).[32] It appears that several of the ribs have fallen, and the artist has depicted the setting of the ribs on the arrises (and not the ribs themselves), above the surviving tas-de-charges. Again, the ribs have fallen, the vault has not. In fact, without understanding this phenomenon, the

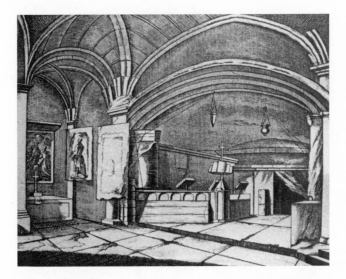

Fig. 5.8. Cornelius de Bruyn, seventeenth-century drawing of the Grotto of the Annunciation, showing tas-de-charges and exposed arrises where ribs have fallen

vaulting in de Bruyn's illustration would make no sense at all. This lack of bonding characterizes later architecture on Cyprus as well, as, for example, in a hall at Famagusta.[33] The same is seen in the vaults of the refectory at Crac des Chevaliers, from the mid-thirteenth century.[34] Here the windows of the portico have elegant bar tracery, and the groin vaults have thin, profiled ribs (figs. 5.9 and 5.10). But, like the vaults at Acre, some of the ribs have fallen, and it is clear they were not bonded.

Can the ribbed groin vault serve as a cultural signifier for crusader architecture? I think it can, if properly read, and here I recall the principles set out at the beginning. In fact, the refectory at Crac des Chevaliers provides a very instructive disjunction between architectural style and construction technology. The ribs and the tracery are elements of style, but in other aspects the actual vault construction has more in common with the traditional architecture of the Middle East than with the Gothic architecture of western Europe.

From the eleventh century on, the standard vault form used in the Middle East area was a rather heavy, unribbed groin vault, built above slightly pointed arches. Normally, the arches and the springers framing the vault were of ashlar construction, but the vault itself was more irregular, often of mortared rubble. This type of vault was used in precrusader architecture, as, for example, at the mid-eleventh-century Monastery of the Cross, outside Jerusalem (fig. 5.11).[35] During the cru-

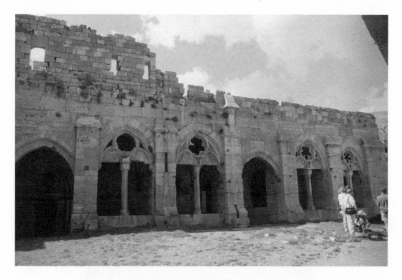

Fig. 5.9. Crac des Chevaliers, refectory façade, showing Gothic tracery, mid-
thirteenth century. Photo: author.

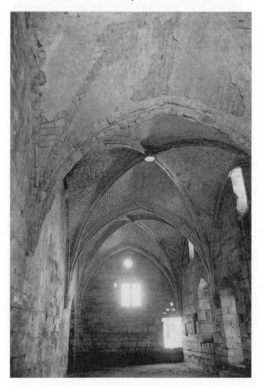

Fig. 5.10. Crac des Chevaliers, interior of refectory, showing ribbed vaults,
mid-thirteenth century. Photo: author.

Fig. 5.11. Jerusalem, Monastery of the Cross, interior of katholikon, showing groin vaulting, mid-eleventh century. Photo: author.

sader period, it appears frequently, as, for example, at Crac des Chevaliers and Acre (fig. 5.12).[36] We still find variations of this type of vault used during the Mamluk period, as in the Suq el-Qattanin in Jerusalem, with a rough vault rising above neat ashlar quoins at the springing.[37] Out of context, these vaults are almost impossible to date. In parts of the Church of the Holy Sepulchre, for example, it is impossible to tell the eleventh-century Byzantine vaulting from the twelfth-century crusader construction.[38] All of this points to a well-developed local tradition of construction—one capable of withstanding dramatic changes of rulership and patronage.

The crusader ribbed vaults, just discussed, fit into this picture. Except for the ribs, the vaults are for the most part typical regional creations. We might compare the bonding of the corbelled springers with the ashlar springers at the corners of the unribbed vaults. Both serve to define the shape of the vault. Here we may be witnessing a continuation of local construction practices, onto which the signature elements of French Gothic style have been superimposed. With rare excep-

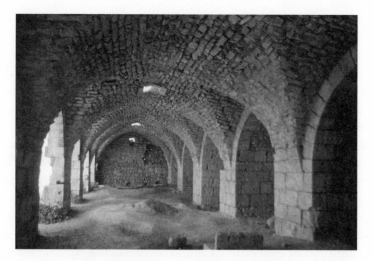

Fig. 5.12. Crac des Chevaliers, vaulting of undercroft. Photo: author.

tion, the construction is heavy and massive for both walls and vaults, and the windows remain small. Crusader buildings still appear massive, even when light, skeletal elements of the Gothic are introduced. Vaults are nevertheless roughly built, even above carefully profiled ribs. The result is, in effect, a bilingual building. The construction technique speaks of the regional tradition of the masons; in contrast, the ribs and tracery articulate the language of the patron.

Obviously, there must have been European-trained artisans involved in these projects as well, as masons' marks suggest.[39] Trained artisans were necessary for the transfer of tracery patterns and the rib profiles. But the bulk of the labor force must have been local, and the defining characteristics of the building remain indigenous. In French Gothic architecture, the ribs and tracery are integral to the design and structure of the building. By contrast, in the crusader monuments, they form a stylistic overlay, and they can fall off without damaging the structure.

What I conclude from this brief analysis is that continuity in crusader architecture was provided to a large extent by an indigenous workforce. The contacts with the architectural currents of western Europe were neither uniform nor continuous. They were never fully integrated into crusader architecture, and they had little lasting effect on its overall development. Ribbed groin vaults disappeared from the scene with the departure of the crusaders, although other aspects of vault construction continued in the region. Gothic details provided certain specific cultural associations at particular points in time that would have had special meanings to a Eurocentric clientele. Although these sporadic infusions of the Gothic

may have affected the outward appearance of buildings, they did not dramatically alter the development of an architecture that remained primarily a regional architecture.

When crusader architecture is discussed in detail, if it is discussed at all, it is usually placed into a provincial French context.[40] Indeed, the stylistic development of crusader architecture would make no sense at all without periodic French connections. But to get at the essence of the crusader building program, the distinctions set out at the beginning of this essay are worth bearing in mind. Style and construction technique often have different points of origin; and architecture is built by masons, not patrons. This means that the building fabric may tell a very different story than the surviving historical documents. It is standard practice in current art historical studies to privilege the text, and this often results in the writing of art history as the history of patronage.[41] Such studies certainly have their merit, but at the same time, we should also be able to read a building as if it were a historical document—and with the level of nuance we have seen in current manuscript studies. For the architectural historian, the monuments may be the most instructive texts of all. Clearly, we still have much to learn from crusader architecture.

Notes

1. See my *Master Builders of Byzantium* (Princeton, 1999). This chapter originated as a paper presented at the symposium "Frankish Culture at the End of the Crusades: France and the Holy Land," held at the Johns Hopkins University in March 2000. I thank Dan Weiss and Anne Derbes for their encouragement.

2. Michael Davis, "Masons and Architects as Travelers," in *Trade, Travel, and Exploration in the Middle Ages,* ed. John B. Friedman and Kristen Mossler Figg (New York, 2000), 380–82.

3. John Fitchen, *The Construction of Gothic Cathedrals* (Chicago, 1961), 42–85; and James H. Ackland, *Medieval Structure: The Gothic Vault* (Toronto, 1972), 71–89, both give good explanations, perhaps overemphasizing the structural aspects of the ribbed groin vault.

4. See Fitchen, *Construction,* 86–173, for a detailed analysis.

5. As occurs at San Ambrogio in Milan; see Ackland, *Medieval Structure,* 76.

6. As occurs at Speyer Cathedral; ibid., 176.

7. As occurs at St.-Philibert in Tournus and at la Madeleine in Vezelay; ibid., 45, 81.

8. As occurs at Durham Cathedral; ibid., 83.

9. As emphasized by Robert Mark, *Experiments in Gothic Structure* (Cambridge, Mass., 1982), 115.

10. Jaroslav Folda, *The Art of the Crusaders in the Holy Land, 1098–1187* (New York, 1995), 302, with additional bibliography.

11. Virgilio Corbo, *Il Santo Sepolcro di Gerusalemme: aspetti archeologici dalle origini al periodo crociato*, 3 vols. (Jerusalem, 1981–82), 205–7; Folda, *Art of the Crusaders*, 178, who gives the best assessment of the construction history of the crusader phase, places the bulk of the work in the 1140–49 period. The contemporary sources remain curiously silent about the rebuilding of the Holy Sepulchre, and even the patronage goes unmentioned.

12. See Folda, *Art of the Crusaders*, 175–245; and Robert Ousterhout, "Architecture as Relic and the Construction of Sanctity: The Stones of the Holy Sepulchre," *Journal of the Society of Architectural Historians* 62 (2003): 4–23.

13. See Marcel Aubert, "Les plus anciennes croisées d'ogives: leur role dans la construction," *Bulletin Monumental* 93 (1934): 5–67, 137–237, for the early development of ribbed vaulting in France.

14. Hugh Plommer, "The Cenacle on Mount Sion," in *Crusader Art in the Twelfth Century*, BAR International Series 152, ed. Jaroslav Folda (Oxford, 1982), 139–66.

15. Peter Fergusson, "The Refectory at Easby Abbey: Form and Iconography," *Art Bulletin* 71 (1989): 334–51.

16. For illustrations, see M.-Anselme Dimier and Jean Porcher, *L'art cistercien* (Zodiaque, 1962), figs. 8, 41.

17. As with the numerous medieval "copies" of the Holy Sepulchre; see Richard Krautheimer, "Introduction to an 'Iconography of Medieval Architecture,'" *Studies in Early Christian, Medieval, and Renaissance Architecture* (New York, 1969), 115–50.

18. Denys Pringle, *The Churches of the Crusader Kingdom of Jerusalem: A Corpus*, vol. II (Cambridge, 1993), 283–97.

19. Nurith Kenaan-Kedar, "The Cathedral of Sebaste: Its Western Donors and Models," in *The Horns of Hattin*, ed. Benjamin Z. Kedar (Jerusalem, 1992), 99–120; Folda, *Art of the Crusaders*, 309–11.

20. Jacques Henriet, "La Cathédrale Saint-Etienne de Sens: le parti du premier maître, et les campagnes du XIIe siècle," *Bulletin Monumental* 140 (1982): 6–168.

21. Wolfgang Müller-Wiener, *Castles of the Crusaders* (London, 1966), 72–74, 102, and fig. 100.

22. Aubert, "Anciennes croisées," esp. 139–45; Fitchen, *Construction of Gothic Cathedrals*, 69–71.

23. Aubert, "Anciennes croisées," 215.

24. Ibid., 221.

25. Mark, *Experiments in Gothic Structure*, 102–17.

26. Ibid.

27. Aubert, "Anciennes croisées," 139–41; Fitchen, *Construction of Gothic Cathedrals*, 69–71.

28. J. David McGee, "The 'Early Vaults' of Saint-Etienne at Beauvais," *Journal of the Society of Architectural Historians* 45 (1986): 20–31, whose date "as early as the 1070s" may be too early.

29. Corbo, *Il Santo Sepolcro*, III, pls. 174–76.

30. Pringle, *Secular Buildings in the Crusader Kingdom of Jerusalem: An Archaeological Gazeteer* (Cambridge, 1997), 73–75; fig. 39 and pl. LXXV.

31. Ibid., 43–45, and pl. XXXV.

32. Folda, *The Nazareth Capitals and the Crusader Shrine of the Annunciation* (University Park, 1986), pl. 50.

33. Müller-Wiener, *Castles,* 88–90, 105, and fig. 141.

34. Ibid., 59–62, 100–101.

35. Pringle, "Church-Building in Palestine before the Crusades," in *Crusader Art of the Twelfth Century,* 10 and pls 1.7a–b.

36. Müller-Wiener, *Castles,* 59–62, 72–74.

37. Michael Burgoyne, *Mamluk Jerusalem: An Architectural Study* (London, 1987), 273–98.

38. As I have noted elsewhere: "Rebuilding the Temple: Constantine Monomachus and the Holy Sepulchre," *Journal of the Society of Architectural Historians* 48 (1989): 66–78; also Corbo, *Il Santo Sepolcro,* III, figs. 163, 165, for illustrations.

39. Pringle, "Some Approaches to the Study of Crusader Mason's Marks in Palestine," *Levant* 13 (1981): 173–99.

40. As, for example, the classic study of Camille Enlart, *Les monuments de croisés dans la royaume de Jérusalem: architecture religieuse et civile,* 2 vols. (Paris, 1925–28).

41. As, for example, Folda, *Art of the Crusaders.*

PART III

ACRE

AS A CULTURAL CENTER

CHAPTER 6

Society, Culture, and the Arts
in Crusader Acre

David Jacoby

Four momentous events marked the history of Acre in the twelfth
and thirteenth centuries: the crusader conquest of the city in 1104, its occupation
by Saladin in 1187, its recovery by Christian forces in 1191, and its fall to the Mus-
lims in 1291.[1] Each of these events generated abrupt and dramatic changes in the
composition of Acre's population and the nature of its society. Yet, in addition,
this society was subjected during the two centuries of Frankish rule to a continu-
ous influx of new immigrants and a permanent encounter with a fairly large tran-
sient population consisting of merchants, pilgrims, crusaders, and members of the
clergy. The dynamic interaction between residents and nonresidents had a sub-
stantial impact on Acre's evolution. The purpose of this chapter is to consider some
of the factors at play and their connections with the evolving cultural and artistic
trends and creative processes existing in crusader Acre.

Acre became the main port of the Frankish Levant soon after its conquest in
1104, as well as the main destination of merchants and immigrants and the ex-
clusive one of crusaders and pilgrims, except from 1187 to 1191 when it was held
by Saladin.[2] The city fulfilled multiple economic functions as port, market, and
transit station inserted within the Mediterranean trade system and as supplier of
logistical support to the groups just mentioned.[3] Western immigration and settle-
ment in Acre began soon after the crusader conquest and within a short time gen-
erated a major social development: it turned the Latins into the largest and dom-
inant element in the city's population until 1291, except during the four years of
Muslim occupation noted earlier. Western immigration and settlement continued

unabated until the last decades of Frankish rule.[4] They were mainly furthered by Acre's economic growth, which reached its peak in the thirteenth century, although other factors also promoted them, as we shall see below. Individual emigration from the city, primarily by settlers returning to their lands of origin, must have been a permanent demographic feature since the early decades of the twelfth century. Yet this current seems to have gained some strength from the 1260s on, as a result of various unfavorable political and military developments affecting the Kingdom of Jerusalem.[5] The anxiety prevailing in Acre in the last years of Frankish rule is illustrated sometime before 1283 by the decision of the Hospitallers to transfer an important part of their archive and a precious relic to Manosque, France.[6]

Latin society was highly stratified, with a clear legal and social barrier between noblemen and commoners. The nobility mainly hailed from present-day northern France, whereas commoners came from more extensive regions.[7] The mercantile component among the settlers was overwhelmingly of Italian origin. Though small in numbers, it carried particular weight because of its economic activities, its financial capacity,[8] and its role as intermediary in commercial and cultural exchanges.[9] The economic functions assumed by Acre since the early twelfth century largely account for the heterogeneous nature of its Latin population, more pronounced than in any other Frankish city. The multiethnic and multilingual character of that population became even more pronounced after the city's recovery in 1191 when Jerusalem, lost in 1187, remained under Muslim rule and Acre became the focus of Western immigration in the Levant. In addition, the many groups of pilgrims and crusaders arriving in Acre each contributed their modest share to Latin settlement, as evidenced by developments in the new suburb of Montmusard, to which we shall soon return.[10]

The Latins left Acre when the city surrendered to Saladin in 1187, yet returned in 1191 after the Christian reconquest. Acre benefited from a major demographic influx in the following years. It replaced Jerusalem as political and ecclesiastical center of the Kingdom of Jerusalem. It retained this function until its fall to the Muslims in 1291, even during the fifteen years from 1229 to 1244, when the Holy City, with the exception of the Temple Mount, was once more in Frankish hands. The relocation to Acre of the royal court, various ecclesiastical institutions, and numerous refugees from territories remaining under Muslim rule resulted in a substantial concentration in the city of Latin nobility, clergy, and members of an educated elite consisting of notaries, lawyers, practitioners of the medical profession, and some teachers of the liberal arts and theology.[11] This concentration, to an extent unknown in any other Frankish city, had a decisive impact in the twin fields of culture and the arts, as we shall see below. No less important was the growing

cultural fragmentation of Acre's urban space. Even before 1187 each of the privileged quarters of Genoa, Pisa, and Venice was largely or exclusively inhabited by individuals hailing from these cities and their hinterland and speaking their respective dialects. The establishment of the Marseillais or Provençal quarter in 1191 and the creation of the Teutonic order in 1198 added two new linguistic and cultural focuses in the Old City of Acre.[12]

Western immigration after 1191 fostered the creation of additional ethnic and linguistic clusters of population, each grouped around its own church, monastery, hospice, or hospital, especially in the new suburb of Montmusard, which began to expand after 1191. Thus, as a result of the concentration of settlers originating from England, the northern tip of Montmusard came to be known as the English quarter. The hospital and church of St. Thomas Becket were transferred from the Old City to that area in 1227–28, and the hospital named after the Irish St. Bridget of Kildare was established there sometime before 1261. Another institution, the hospice of St. Martin, was founded in 1254 or 1255 in that same urban section to take care of poor pilgrims from Brittany and Touraine.[13] The thirteenth century also witnessed the creation of several "national" confraternities based on common origin, like the Spanish one; that of the Holy Spirit founded by Tuscan merchants hailing from Parma, Bologna, and Florence, the English one dedicated to St. Edward the Confessor, and that of the Nestorian merchants from Mosul.[14]

The presence of a transient population in Acre is worthy of close consideration. The sojourn of traveling merchants in Acre lasted a whole month at most, while that of pilgrims passing through the city was generally shorter, a matter only of days. In both groups, however, some individuals extended their stay in the Holy Land from one sailing season to the other, especially throughout the winter.[15] Crusaders and military contingents were occasionally based in Acre for several months or even longer. Such was the case with the forces of Louis IX from 1250 to 1254 and, after the king's departure, with the French regiment stationed in the city, which was reinforced from time to time until the fall of the city in 1291.[16] Yet, regardless of the time spent by their members in Acre, the conjunction of these groups, their combined numerical strength and especially their continuous flow, in addition to that of new immigrants and members of the clergy,[17] had a substantial impact on Acre's society. They enhanced the circulation of books, the transfer of artifacts, many of which carried social, religious, and aesthetic messages, the movement of artists and craftsmen, and the diffusion of Western social values and attitudes. They infused constant new waves of Western influence and slowed down, as well as limited, the process of orientalization among the Frankish settlers. In addition, they contributed to the shaping of Latin collective and

class identities, culture, and artistic developments in Acre and, to some extent, in the Frankish states in general.[18] The Western visitors passing through Acre also acted as intermediaries in cultural transfers between East and West.[19]

Family, feudal, and geographic ties, as well as common origin, language, and culture fostered cohesion and solidarity among crusaders and pilgrims, as they did among residents. During their stay in Acre visitors displayed a tendency to aggregate in urban areas already inhabited by their former countrymen and around communal or ecclesiastical institutions expressing their collective identity. This tendency fostered patronage, pious donations, and economic support for the maintenance of existing churches, monasteries, hospices, and hospitals and for the foundation of new ones.[20] More generally, the foundation and operation of ecclesiastical and charitable institutions were indirectly enhanced by the economic benefits that Acre derived from trade, pilgrimage, and crusading. Tax revenues, payments for commodities and services, interest on loans, as well as the purchase of devotional objects and souvenirs injected substantial amounts of cash into Acre's economy and stimulated the employment of craftsmen and artists in the city, whether directly or indirectly.[21]

Western pilgrimage warrants particular attention in our context, in view of its importance throughout the Frankish period. It became a mass movement soon after the First Crusade, expanded after 1191, and remained substantial in the following century until the collapse of the Frankish states in 1291, despite Muslim rule over Jerusalem during most of that period.[22] The Dominican friar Riccoldo da Monte Croce claims to have seen more than 10,000 pilgrims on the banks of the river Jordan in January 1289.[23] In accordance with Jewish tradition, Acre was not considered part of the Holy Land by Christians, nor could it boast of any holy sites or shrines. Until 1187, therefore, it functioned exclusively as a transit station for pilgrimage. Conditions changed after 1191, when Jerusalem remained in Muslim hands. Relics salvaged from their previous locations and others acquired elsewhere were brought to Acre. Their accumulation in the course of the thirteenth century gradually turned the city into a sacred space. This process was enhanced after the renewed Christian loss of Jerusalem in 1244 and culminated after the departure of Louis IX from Acre in 1254, which buried all prospects of a Latin recovery of the Holy City. It is illustrated by the establishment of an expiatory pilgrimage in Acre itself, the institution of which was originally intended to offer a substitute to pilgrims compelled to cancel their visit to Jerusalem and other holy sites, due to unfavorable political or military circumstances. A French guide called *Les pardouns dAcre,* compiled between 1258 and 1264, provides the itinerary of this institutionalized pilgrimage linking some forty Latin churches, monasteries, and

hospitals in the city, among the existing sixty or so, and states the indulgences gained at each site.[24]

Before 1187 pilgrims obviously acquired at the major holy sites or in their vicinity, especially in Jerusalem, most of the relics, reliquaries, icons, crosses, and pilgrim flasks or ampullae with which they returned home. Nevertheless, even as a transit station to the holy sites Acre must have produced a certain number of these objects. The expanded function of the city within the framework of pilgrimage after 1191 considerably enhanced its role in the production and supply of devotional objects, souvenirs, and other tourist items.[25] This role became decisive after the renewed loss of Jerusalem and other holy sites in 1244 and was further strengthened after the establishment of the institutionalized pilgrimage in the city mentioned earlier. These developments must have been duly reflected by a growing output of portable icons in Acre. The earliest known depiction of a shop selling icons appears in the manuscript of the *Cantigas de Santa Maria* of King Alfonso X of Castile, illuminated soon after 1265.[26] It illustrates an episode in the story of the Virgin's icon bought in Jerusalem for the Orthodox convent of Our Lady at Saidnaya, located northeast of Damascus.[27] There is good reason to believe that the miniature offers a faithful rendering of an icon shop in the Holy City. In any event, it surely reflects the experience gathered by pilgrims visiting Jerusalem, who purchased icons from existing stock. Moreover, it stresses the nature of icons and other devotional objects as marketable goods and the need to examine their artistic production in an economic context.[28] The depiction and its implications are certainly also valid for thirteenth-century Acre.

The growing output of such objects in Acre in the second half of the thirteenth century is confirmed by the discovery of molds and materials in a recently excavated workshop that mass-produced lead-alloy ampullae, which may be safely assigned to the last years of Frankish rule in the city. Earlier pilgrims' flasks display shrines with distinctive, widely known monumental features, such as those existing in Jerusalem, or religious representations associated with holy sites. By contrast, the ampullae of the Acre workshop and others found at Caesarea bear a standardized decoration consisting of geometric, floral, scale, or cross motifs.[29] Such decorative patterns fitted any holy site and were particularly appropriate in the context of urban pilgrimage in Acre, since the city lacked shrines. Nor were its pilgrimage stations related to holy history or to saints. Flasks decorated with motifs similar to those of Acre and similar in size have been found in Corinth and in Germany. They may well attest to the wide diffusion of Acre's artifacts, unless they are imitations.[30] Except in times of crusades proper, pilgrims were certainly the majority among those visiting Acre. In view of their large numbers and their widely

differing origins, merchants, crusaders, and especially pilgrims returning home fostered a broad dissemination of cultic objects from the Holy Land in the West. In turn this dissemination stimulated Western demand for such objects and, consequently, their production in Acre.

We may now turn to the non-Latin population of Acre. After the city's surrender in 1104 King Baldwin I allowed the Muslim residents to leave; yet they were massacred.[31] During the entire period of Frankish rule, there was no permanent Muslim population in Acre.[32] Exceptionally, however, a few Muslims resided in the city for some time. A tale included in *The Thousand and One Nights,* which appears to reflect an authentic story, records the activity of an Egyptian Muslim who in 1184 rented a shop in Acre to sell his flax and remained there for three years.[33] The small space set aside for Muslim worship in a section of the cathedral of the Holy Cross, formerly the city's main mosque, could accommodate only a limited number of people.[34] It was clearly intended for visiting Muslims, whether peasants bringing their products for sale or merchants coming either by land from cities such as Damascus or by sea from countries such as Egypt.[35] It has been suggested that some Muslims settled in Acre in the 1260s and 1270s, yet this is highly unlikely.[36]

In contrast to the Muslims, many if not most Jews and Oriental Christians appear to have remained in Acre after its surrender in 1104. Their presence in the city is attested throughout the Frankish period, although their numbers are unknown. We shall not deal with the Jews, since they played no part in the cultural and artistic developments on which we focus here.[37] The Oriental Christians, often collectively called "Syrians" in medieval sources, were divided among several religious communities, namely, Greek Orthodox or Melkite, Jacobite, Nestorian, Georgian, and Armenian, each of which retained its own ecclesiastical institutions. It is not clear whether all these communities lost the higher ranks of their clergy after the conquest.[38] In any event, when Jacques of Vitry arrived in Acre in 1216 to serve there as Latin bishop, the first two among them had their own prelates.[39] The local Christian communities included some well-trained Arabic-speaking personnel, whose service proved crucial for the operation of the city's judicial apparatus and fiscal administration and who ensured to some extent the continuity of Fatimid structures and practices in the latter.[40] In addition, we find Oriental Christian merchants, artists, and craftsmen, whose contribution to Acre's culture and arts will be examined below.

Not surprisingly, the number of Oriental Christian churches and monasteries in Acre appears to have been rather small, compared to that of Latin ecclesiastical institutions.[41] It is highly significant, however, that most of those known from

thirteenth-century sources were situated in the suburb of Montmusard, which, as noted earlier, began to develop only after the Latin reconquest of 1191.[42] Their location implies an increase in the size of the Oriental Christian population in Acre, which presumably began shortly after that event. This process was enhanced by specific political and military circumstances, in addition to general economic factors. Indeed, it is probable that, like the Franks, some indigenous Christians abandoned Jerusalem and other cities remaining in Muslim hands after 1187 and resettled in Acre in 1191 or in the following years. A further growth of the Oriental Christian population was apparently generated by the Mongol expansion, destructions, and conquests of 1259–61. Inhabitants of Muslim cities affected by these events found refuge in Acre and other Frankish cities. Those among them who remained in these cities must have been mainly, if not exclusively, Oriental Christians. The same appears likely with respect to merchants and commercial agents hailing from cities in Muslim territory, among them Nestorians from Mosul, who had already been operating in Acre and in other Frankish ports prior to 1259.[43] Documents of 1268 and 1271 record the Arabic names of these merchants, involved in maritime trade.[44] A further wave of Oriental Christians apparently arrived in Acre shortly before 1264, as suggested by a letter from Pope Urban IV from that year. Their migration may have been prompted by the Mongol advance, the renewed Muslim pressure against the Franks after 1263, or both.[45] In any event, the Muslim conquests of Baybars and his successors after 1265 seem to have generated a similar movement. The growing presence of Oriental Christians in Acre from 1191 to 1291 should be taken into account when we deal with their role as cultural and artistic intermediaries.

The Orthodox were apparently the most prominent group among the indigenous Christians in the city. In all likelihood their position was strengthened by the policy of Emperor Manuel I Comnenus toward the Kingdom of Jerusalem. The emperor's niece Theodora married King Baldwin III in 1158.[46] According to a Greek source a cavalry detachment was included in the escort with which she arrived. Two Greeks, Dionisius, *miles,* presumably a member of her bodyguard, and Michael Grifo, *panetarius,* witnessed her grant of a house in Acre in 1161.[47] After the king's death in 1163 Theodora resided in that city, her dower-fief, together with her Greek entourage. She eloped in 1168 with Andronicus Comnenus, the emperor's first cousin, but some members of her suite presumably remained in Acre afterward. In 1167 King Amalric wedded Maria Comnena, a great-niece of Emperor Manuel, whose presence until 1174 at the royal court of Jerusalem must have been beneficial to Orthodox causes.[48] The growing Byzantine involvement in the Kingdom of Jerusalem is illustrated by the readmission of the Greek canons to the

Church of the Holy Sepulchre in 1166 at the latest,[49] the emperor's alliance with King Amalric against Egypt in 1168, his patronage of holy sites, and the redecoration of the Church of the Nativity in Bethlehem, completed by 1169.[50] As noted earlier, Acre lacked shrines. Yet one should not exclude the possibility that the emperor or his female relatives wedded to the kings of Jerusalem financed the construction or decoration of Orthodox churches and monasteries in Acre, especially those offering assistance to Byzantine pilgrims. They may have also donated cash, illuminated manuscripts, and liturgical objects to these institutions. This factor should be duly taken into account when we discuss the Byzantine impact on artistic production in crusader Acre.

The Eurocentric perspective of Mediterranean trade and shipping commonly adopted by scholars has obscured the fact that in the Frankish period there was intense trading between Constantinople and Byzantine provinces, on the one hand, Acre and Egypt, on the other. Acre served as a major transit station in that framework. Byzantine merchants and ships were involved in the traffic in the twelfth century.[51] The Arab chronicler Ibn al-Athir reports that Franks and Rum, respectively Westerners and Byzantines, traded in Acre before its conquest by Saladin in 1187.[52] The continuous connections of the Orthodox Church and community in Acre with Byzantine territories, from neighboring Cyprus to Constantinople, were also enhanced by Byzantine pilgrimage to the Holy Land. This movement continued unabated throughout the two centuries of Frankish presence in the Levant, though on a much smaller scale than Western pilgrimage.[53]

There is good reason to believe that the patronage of Emperor Manuel I and the Greek queens of Jerusalem enhanced the flow of Byzantine pilgrims to the shrines of the Holy Land. In the account of his own pilgrimage, accomplished in 1177, John Phokas refers to those who had preceded and those who would follow him.[54] Further evidence about Byzantine pilgrimage around that time is indirectly provided by the canonist Theodore Balsamon, who resided in Constantinople. While discussing unfulfilled oaths, he reports knowing several individuals who had sworn to go to Jerusalem, yet had refrained from doing so.[55] This implies that others carried out their pledge and that Byzantine pilgrimage to the Holy Land may have been more common than it would seem. It is also likely that it was not limited to the clergy, to which most sources refer. The late-twelfth-century story of the Virgin's icon at the Orthodox convent of Our Lady at Saidnaya confirms the existence of pilgrimage from Constantinople to the shrines of the Holy Land via Acre. According to one variant of the story, a Byzantine patriarch brought the icon to the convent from the Byzantine capital,[56] while according to the second variant, a Byzantine merchant or a monk coming from Constantinople bought

it in Jerusalem, after passing through Acre on his way to the Holy City.[57] In the Frankish period most Byzantine pilgrims, like John Phokas, arrived by sea in Acre.[58] Whether explicit or not, the reference to the city reflects its important role as transit station in the Byzantine pilgrimage of that time.

The Muslim reconquest of Jerusalem in 1187 reinforced the Orthodox clergy in the Holy City at the expense of the Latin Church. The renewed Frankish domination over Jerusalem from 1229 to 1244 did not entirely dislodge the Orthodox from the positions they had gained. Most shrine churches were shared then by both the Orthodox and Latin Churches, and the Greek patriarch Athanasios II, in office from c. 1231 until 1244, when Frankish rule over Jerusalem came to an end, acted independently without being subordinated to the Roman Church.[59] The developments in Jerusalem after 1187 must have furthered Byzantine pilgrimage, the flow of which continued during the period of Frankish rule. This is clearly implied by the many initiatives displayed in these years by Sava, youngest son of the king of Serbia, Stefan Nemanja. Formerly a monk on Mount Athos, he reached an agreement with the Byzantine patriarch Manuel I in Nicaea, by which he became the first primate of Serbia's autonomous Church in 1219. Sava went twice on pilgrimage to the Holy Land, in 1229 and in 1234–35.[60] In Acre he acquired the Latin monastery of St. George, situated in the Old City. He transformed it into an Orthodox institution, the famous monastery of St. Sava, which gave its name to the bloody war fought between the Italian communes in Acre from 1256 to 1258. Sava surely provided the monastery with the liturgical objects and books it needed. His move was clearly intended to ensure assistance and accommodation for pilgrims, functions similar to those performed by Latin ecclesiastical and charitable institutions in the city.[61] Sava's activity in Jerusalem and elsewhere in the Holy Land was also aimed at strengthening the Orthodox Church and furthering Orthodox pilgrimage.[62] A gold coin of John III Vatatzes issued by the mint of Magnesia between 1232 and 1250, thus more or less in the same period, has been found recently in Acre.[63] It is of course not excluded that this stray coin with substantial purchasing power belonged to a merchant, yet the fact that it was not part of a hoard raises the possibility that it was brought by a Byzantine pilgrim from the empire of Nicaea.

The Oriental Christian churches of Acre acted as focuses of distinct collective identities. Their institutions were the depositories of cultic objects, books, and artifacts, and the communities to which they belonged ensured the perpetuation of indigenous artistic traditions. It should be stressed that the continuity of these factors was not affected by the four years of Muslim occupation of the city, from 1187 to 1191. Contrary to the Latin population, the Oriental Christians, or in any

event many of them, remained in Acre during these years.[64] The ongoing inter-
action between the Oriental Christian communities and institutions of the city
with their counterparts in neighboring areas under Frankish, Byzantine, Armen-
ian, or Muslim rule clearly entailed a continuous flow of objects, models, artists,
and craftsmen, which explains to a large extent the vitality and vigor of Christian
artistic creation in the Frankish territories, despite a long period of Muslim rule
prior to the First Crusade.[65] This interaction was enhanced by Byzantine pil-
grimage, which thus far has been entirely overlooked as a cultural factor con-
tributing to the hybrid artistic developments in thirteenth-century Acre. The links
between St. Sava and Mount Athos, Nicaea, and Serbia warrant particular atten-
tion in that context, all the more so since they point to distinctive potential av-
enues of artistic interchange between these centers and Acre. Byzantine imperial
and royal patronage in the twelfth century, the accumulation of books and arti-
facts brought from other Byzantine centers by clerics, pilgrims, and merchants, in
addition to indigenous artistic production, may go far to explain the Byzantine
impact on "crusader" art in Acre. The availability of specific Byzantine works dis-
playing a pictorial or iconographic affinity with illuminated French or Latin man-
uscripts produced in that city cannot be proven. However, the plausibility that
several of them served as models for the illumination of the Arsenal Old Testa-
ment appears to be far greater than the scenario according to which these models
were examined by an illuminator of an Acre atelier working on frescoes in Con-
stantinople, who returned with sketches of them to Acre.[66]

The Frankish presence in the Levant, Western immigration and settlement, as
well as the movement of Latin merchants, crusaders, and pilgrims, entailed an en-
counter on multiple levels with Eastern societies, their physical setting, visual
world, cultures, and artistic traditions. The nature and degree of receptivity dis-
played by Frankish settlers and Western visitors when faced with these elements
depended on the latter's social or religious connotations and on the agents of trans-
mission, especially in the visual arts. More generally, in order to evaluate the com-
plex impact of the Latin encounter with the East in the Levant, it is essential to
consider it within its social and ideological context, to distinguish between indi-
vidual and collective attitudes and responses, not necessarily identical, between
private and public space, and, finally, between material and verbal expressions.

In the Frankish Levant religious affiliation was the basic criterion of social strat-
ification, group identity, and individual status. In order to maintain their politi-
cal rule and their social cohesion the Latins created institutional and legal barri-
ers separating themselves from the indigenous population. The indigenous
communities were relegated to an inferior status, as expressed in the fields of

jurisdiction and taxation. In Acre the non-Frankish population was tried by the *Cour de la Fonde* in noncriminal matters and liable to special payments.[67] Still, members of the indigenous communities could achieve some degree of social promotion by the adoption of the Roman creed,[68] intermarriage with Latins,[69] or naturalization granted by the Italian maritime powers.[70] The social and legal cleavage separating Latins from non-Latins was also expressed in visual terms. Indigenous Christian, Jewish, and Muslim men were bearded, whereas Latin laymen were clean-shaven according to the fashion that had spread in the West by the second half of the eleventh century.[71] Similarly, Latins differed from non-Latins by their distinctive garments. The Council of Nablus, which convened in 1120, issued a regulation forbidding Muslims to dress like Franks.[72] This disposition was not aimed at members of the indigenous Christian or Jewish communities, yet most of these undoubtedly maintained their traditional garb.[73] Shortly after their arrival in Acre in 1290 some crusaders, not acquainted with local mores, attacked and killed several Orthodox Syrians whom they mistook for Muslims because they were bearded and, obviously, clad in Oriental clothes.[74] As for the Franks, one should clearly distinguish between the cloth and cut of their clothes. To be sure, they increasingly used plain and figured Islamic textiles. Silken cloth, wimples, and garments from Antioch, which produced both Byzantine and Islamic silks, as well as silks manufactured in Muslim countries, were available in Acre.[75] Local Franks also purchased the so-called Tartar cloths, as did visiting Latins. Among the latter, Count Eudes of Nevers acquired twenty-three pieces of these textiles in Acre before dying there in 1266.[76] It is also possible that the Franks borrowed some ornamental features from Islamic dress, such as *tiraz* bands adorning sleeves.[77] However, Frankish clothes displayed distinctive characteristics consonant with Western vestimentary fashion.[78] Their function as social markers was particularly important in the multiethnic and multicultural context of the Frankish Levant.

In daily life there was a permanent economic and social intercourse on the individual level between the members of all communities residing in Acre. Contacts were also furthered by the absence of enforced residential segregation, of which there is no trace in Acre, contrary to what has often been claimed.[79] The Latins acquired in that context some spoken Arabic. In addition, Arabic was introduced into Frankish households by the marriage of Latins with baptized Muslim or with Oriental Christian women, as well as by the employment of indigenous servants, wet-nurses, and slaves.[80] Latins spending some time in Muslim captivity presumably also picked up a few words. Yet, with few exceptions, Frankish familiarity with Arabic remained limited to daily usage. Similarly, only a small fraction of the

indigenous population acquired any knowledge of Western tongues on more than a rudimentary level. Such was the case with those serving as officials in the Frankish administration or working as interpreters.[81] In the early thirteenth century, more than a century after the crusader conquest, Jacques of Vitry was compelled to use interpreters when preaching to the Melkite and Jacobite communities, whose members spoke Arabic.[82] The Western clerics who settled in the Frankish Levant were neither interested nor capable of intellectual intercourse with Oriental Christian or foreign Muslim scholars.[83] It is common knowledge that communication between social and ethnic-cultural groups is not merely a matter of language. To a large extent it is also shaped by social as well as cultural attitudes, perceptions, stereotypes, and mentalities. Mutual accommodation between Latin settlers and members of the Oriental communities grew out of necessity, yet restricted only marginally the permanent sense of alterity between them.

The most pronounced accommodation of the Latin settlers to their Levantine surroundings occurred in their lifestyle within their own private space. They enjoyed Oriental baths,[84] occasionally ate Oriental food,[85] and adopted various features of secular domestic architecture suited to the local climate, including some of its furnishing, decorative language, and amenities.[86] A case in point at the highest level is the lavish decoration of the newly built palace of John I of Ibelin, lord of Beirut, visited by Wilbrand of Oldenburg in 1212. It is noteworthy that John I of Ibelin was the son of a Byzantine princess, Maria Comnena, who had married Balian II of Ibelin after the death of her first husband King Amalric.[87] Significantly, with respect to the palace the German imperial envoy remarked that "the Syrians, Saracens and Greeks take pride in the masterly art" displayed in its marble pavement simulating waves, its marble wall panels, and its painted ceiling. In the middle of the palace there was a pool adorned with a floral mosaic and a fountain in the form of a dragon swallowing animals, which spouted a jet of water cooling the air and dispensing humidity.[88] The combination of Byzantine and Islamic elements is obvious and duly illustrates the continuity of indigenous artistic traditions in the Frankish period.

The Franks were also receptive to other elements proper to Eastern material culture. They used Eastern artifacts, such as ceramics,[89] brasses,[90] glassware,[91] jewelry, and textiles,[92] manufactured in line with Oriental traditions in the Levant and farther east, provided these lacked any adverse cultural connotation. Some of these artifacts could easily be inserted within the Frankish setting. Such was the case of ceramic bowls and plates adorned with figures or scenes which, although common to the Iranian-Islamic iconographic repertory and decorative language, could nevertheless be interpreted as a reflection of subject matter proper to con-

temporary French literature and as an expression of knightly lifestyle.[93] Recent excavations in Acre have yielded some proto-Majolica bowls of the thirteenth century imported from southern Italy and polychrome sgraffito ware produced at al-Mina or St. Symeon, the port of Antioch, with similar decoration.[94] These figured artifacts acted primarily as signifiers of the nobility's social standing, yet their presence was not necessarily restricted to the households of its members. Commoners may well have used or displayed them in the presence of guests, or still have offered them as gifts in order to enhance their own social prestige.

The attempts of art historians to categorize artifacts according to ethnic-cultural or geographic origin, that is, "Latin," "Byzantine-Orthodox," or "Islamic," has created rigid mental molds and artificial barriers, which obscure the dynamics of artistic creation and their connection with the economics of artistic production. We have already noted some instances illustrating the perpetuation of indigenous artistic traditions, as in mosaics,[95] paintings, and household items. There can be no doubt that both in Frankish territories and in neighboring Muslim countries the use of "Islamic" techniques, visual vocabulary, iconographic formulas, and styles was not restricted to Muslims and was shared by their indigenous Christian counterparts. The same may be assumed with respect to glass and inlaid brass objects adorned with motifs and scenes which, although Christian, did not include the Crucifixion or the Ascension and were thus not offensive to Muslims. Most of the inscriptions on these objects are of a general nature, convey good wishes, and are not personalized, except for three references to an Ayyubid amir on brass vessels.[96] These market-oriented objects combining Christian and Islamic features could clearly be designed and executed by both Oriental Christian and Muslim artists or craftsmen, whether on their own or in cooperation within the same atelier.[97] Anyone walking today through the Old City of Jerusalem is struck by the side-by-side display of artifacts produced in the same workshops, yet bearing designs and symbols proper to different religious and cultural communities. Moreover, one should not rule out the possibility that various "Islamic" artifacts, including some bearing Christian motifs and iconography, were manufactured by the indigenous workforce in Frankish territories for Christian and Muslim customers living under Muslim rule.[98] Especially in Acre there must have been a keen awareness of the heterogeneous composition of the potential clientele for Oriental artifacts, which included Frankish settlers, Western merchants, pilgrims, and crusaders, in addition to Byzantine and Oriental visitors, the latter either Muslim or Christian.

The attempts to ascribe artifacts to a definite ethnic-cultural and geographic setting, mentioned earlier, has led to the neglect of yet another aspect of artistic

production and its economic context. Too little attention is being paid to the mobility of indigenous artists and expert artisans, attracted by favorable economic prospects or displaced by political and military events. Their mobility entailed a diffusion of technology, designs, iconographic formulas, and styles. It is thus not excluded that various glass vessels attributed to Aleppo or other renowned production centers under Muslim rule in the thirteenth century were in fact manufactured with more or less the same ingredients and decorative features by refugees from that city settled in Frankish ports since 1259.[99] This may have been the case with two "Islamic" glass beakers preserved at the Walters Art Museum in Baltimore, as well as with the brass vessels mentioned earlier.[100] One should also take into account the diffusion of objects and the imitations they prompted, without the need of technology or expertise transfers. At times the movement of skilled workers and goods generated new fashions, new market demands, and the manufacture of new products. This is obvious with respect to the so-called Tartar cloths, which were already available in Acre by the 1260s and were imitated in Italy from the early fourteenth century on.[101] One should not entirely exclude the possibility that some of them were manufactured in the Frankish territories before 1291. In any event, there was ample room for the creative contribution of the members of the Oriental Christian communities, who acted as cultural intermediaries in the context of artistic developments in crusader Acre.

We have already noted the Latin encounter with Byzantine ornamental, iconographic, and stylistic features in objects created by Oriental Christians in the Levant or in Byzantium itself. This is best illustrated by painted panels and small icons, the artistic, geographic, and cultural attribution of which is still not settled after several decades of debate. It is obvious that in the Frankish Levant the religious devotion of Christian worshipers and benefactors, whether local or foreign, cut across religious denominations. The Latins considered all artifacts featuring Christian iconography, imagery, and values, some of which were endowed with imperial prestige, as being devoid of social or political connotations. They could therefore appropriate them, despite the fact that they often reflected the distinctive traditions of Christian indigenous communities. However, this evaluation is not reflected in the investigation of individual icons. As with other artifacts, there is a strong tendency to dwell on patronage and to ascribe each of them to a definite ethnic-cultural and geographic setting by relying upon distinctive signs and attributes in the works themselves, such as iconography, stylistic traits, the depiction of patrons, or heraldry. As a result, relatively few icons can be decisively associated with Latin patrons. In Cyprus the Latin sponsorship of devotional images produced in the Byzantine manner by Orthodox painters and craftsmen is

ascribed to the period after 1291, based on obvious marks such as those just mentioned.[102] Yet how does one explain the absence of Latin sponsorship before 1291, and has this any bearing on the consumption of these images?

It would seem that the art-historical focus on individual pieces and patrons has distorted the perspective with respect to Latin consumption. It too often obliterates the fact that while patronage equates consumption, the reverse is not necessarily true. It is imperative, therefore, to introduce economic considerations into the discussion and, first of all, to view painted panels and icons as marketable goods. Three distinct patterns of marketing may be envisaged. The first one involved patrons who commissioned works that, it is generally assumed, would bear particular features in accordance with their wishes. On the other hand, it is quite possible that some individuals bought icons displayed in a shop and had some distinctive personal marks superimposed upon them. Finally, the vast majority of customers must have been content with the finished product. Once we take these alternatives into account, the Latin consumption of painted panels and icons appears in a new dimension. It is quite conceivable that several thirteenth-century icons considered to be made in Acre for members of the Orthodox community, because they lack distinctive Latin marks, were in fact produced for Latins or in any event were used by them.[103] After all, there was a sizable market in Acre for painted panels and especially small, easily transportable icons. The elasticity of demand was determined by the size of the transient population, rather than by Acre's residents. In addition to individual customers, mostly visitors, the local ecclesiastical and charitable institutions and confraternities, which benefited from continuous financial support, were clearly the destinations of numerous devotional items.[104]

The Latin reception of Oriental elements was far more restricted on the collective level, mainly reflected within the public space. To be sure, outside Acre various churches built in the Frankish period were three-aisled basilicas or cross-in-square domed structures following early Christian and middle-Byzantine models, examples of which existed in the Frankish territories.[105] This was also the case with the Hospitallers' conventual church,[106] and possibly with other churches in Acre. Moreover, there was a limited borrowing of Byzantine, Oriental Christian, and Islamic techniques, styles, and ornamental vocabulary. Thus some twelfth-century churches outside Acre incorporated Islamic components, such as pointed arch openings and godroons.[107] However, since Acre lacked Christian shrines, the impact of indigenous tradition on the city's ecclesiastical architecture must have been less prominent than in Jerusalem or in other holy sites. Refurbished public buildings in Acre presumably retained many of their previous features, although undergoing changes in plan and especially in decoration. On the other hand, ac-

cording to the available material, pictorial, written, and circumstantial evidence, new public buildings in the city, whether Latin churches and monasteries or lay structures, were dominated by a decisive Western imprint. This imprint, expressed in architecture and carved decoration, was largely determined by political, religious, and social considerations, as well as by economic factors and fashion. The building and decoration of these structures was financed by Latin sponsors intent on re-creating to some extent the visual setting to which they were accustomed, while also attentive to new artistic trends in the West and eager to emulate their Western counterparts. Yet the deliberate adoption of Western styles and imagery also had a broader ideological and symbolic meaning. Its imposition on Acre's townscape was a clear affirmation of Frankish political and religious hegemony within the public space. This statement could be more easily achieved in Acre than in Jerusalem, where the material expressions of Muslim religious tradition were far more prominent.

Western architects, sculptors, masons, and other craftsmen arrived in the Levant with the crusading armies, as suggested by the construction of the tomb of Godfrey of Bouillon in Jerusalem in 1100, a year after the city's conquest.[108] They must have also been active in Acre, shortly after that city's conquest in 1104, in the reconversion of Muslim religious buildings, although not all of these were converted into churches. Thus in the Venetian quarter the Commune owned a mosque (*machomaria*) that had been turned into a two-storied lodging house, the apartments of which were being rented out.[109] Acre's main mosque was among the first structures to be adapted to Christian use and became the city's cathedral.[110] A northern portal was added to it before 1135. The church of the Hospitallers is attested in 1149, and the German pilgrim Theodoric, who visited Acre in 1169, saw the massive structures of the Hospitallers and the Templars, which in all likelihood were new buildings.[111] The Italian maritime powers adjusted existing structures to their needs and erected new ecclesiastical and public buildings.[112] Laymen too made alterations in existing dwellings and constructed new ones according to their own requirements and taste.[113] This was clearly the case with noblemen, who had the means to do so and were imbued with Western class attitudes and values. The absence of residential segregation between members of different social classes or ethnic-cultural groups, as well as the urban setting dominated by a monetary economy, must have prompted them to affirm their distinctive standing in the size and style of their dwellings.[114]

It is mainly after the Christian reconquest of 1191 that Acre witnessed large-scale construction, attested by both written sources and archaeological evidence. This activity was urgently required by the relocation and concentration in Acre of in-

stitutions and population from territories occupied by Saladin in 1187 and remaining under his rule, by the establishment of the Teutonic order in 1198, as well as by pressing military needs. Later on demographic growth and patronage, especially by pilgrims and crusaders, in addition to further military requirements, account for the continuation of construction, which went on unabated until the city's fall to the Muslims in 1291. Abundant evidence for building activity in Acre after 1191 is provided by material remains, whether above or below the ground, such as the thirteenth-century sections added to the Hospitaller compound in the Old City, partly excavated in recent years, as well as a church portal and sculptured pieces transferred to Cairo and reused there after 1291.[115] This activity is also illustrated by seals and written sources,[116] in addition to later drawings.[117] The Western impact must have been particularly obvious in the northern suburb of Montmusard, the territory of which lacked an Islamic imprint prior to its development in the wake of the Third Crusade.

Sculptors from the so-called Temple area workshop who had fled from Jerusalem were apparently active in Acre soon after its reconquest in 1191.[118] Yet in the following period it is French Gothic that became dominant in the architecture and monumental sculpture of the city. We may safely assume that in Acre, as elsewhere, its imprint cut across ecclesiastical affiliations and ethnic-cultural ties. This is suggested by the extant thirteenth-century sections of the Hospitaller compound in Acre, the church of St. John of that order depicted with its five aisles on a later drawing,[119] the Templars' Chastel Pelerin, begun in the summer of 1218,[120] and the castle of Montfort, the construction of which was initiated by the Teutonic order in 1226 or 1227 and pursued after a short interruption.[121] To these we may add the church of St. Andrew, also known from a later drawing, and a tombstone of 1290.[122] Neither immigrants established for a few years in Acre nor local Frankish sculptors and architects could have perceived the dynamic evolution and variety of French Gothic sculpture in the first half of the thirteenth century. Only a continuous flow of sculptors trained in France, some of them first-rate artists, may explain the distinctive contemporary and successive trends of French Gothic sculpture reflected in Acre and elsewhere in the Kingdom of Jerusalem.[123] This does not rule out the participation of local artists trained by newcomers, nor the attempt of others to adopt the prevailing style, not always - succesfully.[124] In all likelihood most sculptors resided in Acre, in view of the ongoing building activity in the city, and it is there that they were hired for work in other locations. The diversity in Acre's Gothic must have been partly related to the specific origin of patrons or groups of sponsors and that of the artists whom they employed.[125]

The existence of particular quarters held by the major maritime powers also accounted for some degree of diversity. The six *palacia* or multistoried large buildings in the Genoese quarter recorded in 1248–50 were foreign to indigenous architecture and were presumably similar to those being built around that time in Genoa proper.[126] In 1286 Venice shipped about 72 tons of ashlar and corbels to Acre for the repair and embellishment of the *fondaco* and other public structures located in its quarter.[127] The ashlar obviously lacked the diagonal serrated marks typical of high-quality masonry used in many Frankish structures, as well as the marginal drafting of cornerstones found in more modest Frankish buildings.[128] The carved corbels sent from Venice introduced or added yet other distinctive decorative characteristics to the quarter. It has been argued that some architectural features found in Pisa also appear in the Pisan quarter of Acre.[129] The new churches and monasteries erected by the indigenous Christians in the suburb of Montmusard have disappeared. It is a matter of speculation, therefore, whether they were built and decorated exclusively according to their own traditions or reflected some prevailing Western or indigenous Frankish artistic trends as well.

The cultural orientation of the Latins settled in the Frankish Levant was shaped by their strong bonds with the West and by their determination to maintain their collective social identity. The members of the Latin nobility expressed their affinity with the nobility of the West in social behavior, rituals, attitudes, mentality, the French they spoke, as well as in the courtly literature and legal treatises they read and composed in that language. The social integration of newcomers within the knightly milieu could not be achieved without cultural assimilation, which required the knowledge of French. This is convincingly illustrated by the activity and works of the Italian Philip of Novara, lawyer, chronicler, and occasional poet.[130] In the twelfth century the senior clergy serving in the Frankish territories was initially recruited among members of noble families in the West having kinsmen and acquaintances in the Levant, who would be in a position to promote their careers. French speakers were a majority among them.[131] The Hospitallers used French and before 1187 translated their Latin rule, as well as various Latin documents, into French, which served as their official language.[132] The Rule of the Templars was translated into French around 1140, and this was also the language of the order's regulations issued later.[133] Significantly, Marsilio Zorzi, Venetian bailo in the Frankish Levant from 1242 to 1244, compiled in Acre a memorandum to back Venetian claims in the Kingdom of Jerusalem, in which he preferred to include extracts from the French continuation of William of Tyre's chronicle, rather than from the original Latin text. The so-called *Histoire*

d'Outremer in French was undoubtedly more readily available in Acre and also more accessible to the Frankish noblemen, to whom Zorzi intended to present his claims.[134] However, Levantine French was not uniform and, moreover, was infiltrated by Italian and Arabic lexical elements and features.[135]

The knowledge of French in the Levant was not restricted to the Frankish nobility. Many commoners hailed from French-speaking areas and their offspring presumably continued to speak that language. Significantly, the pilgrimage itinerary in Acre known as *Les pardouns dAcre* was composed in French.[136] Although primarily intended for pilgrims and crusaders, it was also meant to serve Latins established in Acre and in other Frankish locations. A blending of Italian dialects permeated with Arabic and Byzantine elements largely constituted the language of Mediterranean economic life,[137] reflected by notarial documents, commercial manuals, and *portolani*. Some Italians nevertheless understood and may have occasionally used French. A Venetian who escaped from Acre to Famagusta in 1291 had his will drafted in French around three years later, which suggests that he was familiar with that language.[138]

The social and cultural background just examined must be duly taken into account when we consider the production of illuminated manuscripts in thirteenth-century Acre. Hugo Buchthal has ascribed several such manuscripts to Acre by relying on two references to the city, one in the Perugia Missal, which records the "dedicatio ecclesie Acconensis" in the liturgical calendar for 12 July,[139] and the other in a colophon of a copy of the *Histoire Universelle* preserved in the Bibliothèque Royale in Brussels, which will soon be examined. Moreover, he assigned three sumptuous manuscripts, the production of which required substantial resources, to precise historical events and royal commissions or connections, and dated them accordingly. These are the Riccardiana Psalter, the Arsenal Old Testament, and a copy of the *Histoire Universelle* in the British Library in London. In turn his datings, first put forward as hypotheses, became hard facts in the course of his work and served as criteria for his approximate dating of other illuminated manuscripts, considered to have paleographic, stylistic, and iconographic affinities with those already mentioned. These dates have been adopted by other scholars.[140] The manuscripts attributed to Acre are considered to be among the most conspicuous material expressions of aristocratic culture in Frankish Acre. To be sure, Buchthal's work has undoubtedly enriched our knowledge of cultural and artistic life in Acre. Yet his fascination with royal courts and patrons and with luxury items has produced some heavily biased perspectives and propositions and is also responsible for a reductive view of patronage in the Frankish Levant, all com-

mon to this day. Strangely, Buchthal's historical and chronological constructs have never been critically examined, let alone challenged, yet several of them appear to be built on rather weak premises and do not withstand close scrutiny.

We may begin with the Riccardiana Psalter, which Buchthal considered a marriage present offered by Emperor Frederick II to Isabel of England, whom he wedded in 1235.[141] Neither this marital link, nor the execution of the manuscript in Jerusalem or Acre, nor especially its dating to 1235–37 appear plausible. With respect to this dating it will suffice to point to the prayer for the protection of an anonymous count, which appears at the end of the text. Buchthal identified him with Count John of Brienne, former king of Jerusalem, who died in 1237.[142] This connection is totally excluded. Indeed, John's daughter Isabel, Frederick's previous wife, died in 1228. In the following year John and Frederick became mortal enemies when the former invaded the latter's territories at the head of a papal army. Two years later John became Latin co-emperor of Constantinople. No contemporary source refers to him as count.[143] It follows that the *terminus ad quem* of 1235 for the production of the manuscript and the connection with the marriage of Frederick II propounded by Buchthal may be safely discarded. Once the psalter is freed from the constraints of his arguments, its attribution to Italy, already suggested on stylistic grounds, appears even more likely. Opinions differ as to whether its execution took place in Sicily, south Italy, or Pisa.[144] As for the British Library *Histoire Universelle*, it was supposedly commissioned by the barons of the Kingdom of Jerusalem who intended to offer it to Henry II of Lusignan at his coronation in Tyre in August 1286, and its execution is thought to have regenerated aristocratic patronage in Acre.[145] Yet neither the attribution nor the dating of the manuscript is backed by direct or indirect evidence. They remain entirely in the realm of speculation. Only Buchthal's approximate dating of the Arsenal Old Testament appears to be strengthened by recent research, although his attribution of the work to the patronage of Louis IX, though plausible, has not been proven.[146]

Individuals belonging to the upper ranks of the Frankish nobility could clearly afford luxury manuscripts, as implied by their wealth. We have already noted the sumptuous palace built by John I of Ibelin shortly before 1212.[147] Presumably in the first half of 1245 Balian of Ibelin, lord of Beirut and later *bailli* of the Kingdom of Jerusalem, acquired some precious relics from the church of Bethlehem, which had been relocated to Acre.[148] John of Joinville offers a graphic description of the wealth displayed by John of Ibelin-Jaffa, one of the great fief-holders of the Latin Kingdom, both on his galley powered by 300 oarsmen on its way to Egypt in 1249 and for the visit of King Louis IX of France at Jaffa in 1252.[149] In

addition to the wealthy members of the Ibelin clan there were several other Frankish lords established in the Levant, though not necessarily in Acre, as well as in other regions such as Cyprus and Frankish Greece, who shared the same attitudes and values.[150] The Military Orders in Acre also had ample resources, partly spent on illuminated manuscripts.[151] However, it would seem that the clientele for such items was not as limited as is generally assumed.

Illuminated manuscripts have often been examined with respect to their decoration without sufficient regard for their text, the social and economic context in which they were produced, or the specific social and cultural values and the intellectual interests inducing individuals to acquire them. Numerous literary works reflecting class attitudes and values circulated within the ranks of the nobility in the Frankish Levant, which displayed a keen interest both in fictional epic literature and in historical works such as the *Histoire d'Outremer*. This interest was shared by the knightly class in Cyprus and Frankish Greece.[152] Paintings depicting the crusader conquest of the Levant, apparently inspired by the *Histoire d'Outremer*, adorned the walls of the castle of Saint-Omer in thirteenth-century Thebes.[153] Beyond entertainment, this work offered a historical perspective and a justification of Latin presence in the Levant, which enhanced Frankish collective identity.[154] As for the legal works composed in the Kingdom of Jerusalem, also in French, they reflected both the structure and the practical needs of its Frankish society.

However, when we consider the production of illuminated manuscripts in Acre, we should also take into account two weighty factors that have been overlooked so far, namely, the differing quality of manuscripts and the purchasing power of their prospective buyers. Some knights and commoners, such as lawyers, with fairly modest means, compared with those of the higher nobility, were surely content to own manuscripts only sparsely decorated. This is illustrated by two copies of legal texts from the last decades of Frankish rule, one of which is adorned with a single miniature and the other with illuminated initials.[155] In addition, there is good reason to believe that copies of literary and historical works with minimal decoration, as well as unadorned manuscripts, were produced for rather modest customers, more numerous than those acquiring luxury books. It is clear that only a fraction of the manuscripts copied and illuminated in Acre has survived. The continuity of one or several manuscript and illuminator workshops could not have been ensured only by occasional commissions for luxury manuscripts, and clearly depended on a fairly constant stream of demand.[156] One may envisage, therefore, that various works enjoying a fairly wide circulation were copied and stored, like icons, other devotional objects, and tourist items, in anticipation of customers.[157]

Some of these were foreigners who stayed in Acre for a short time only, namely, crusaders, foreign envoys, official representatives of foreign powers, merchants, and especially pilgrims. They would not have been able to acquire the manuscripts they were interested in or had been asked to purchase, unless these were readily available. At his death in Acre in 1266 Count Eudes of Nevers owned a French version of William of Tyre's chronicle.[158] While he had apparently brought it along, other visitors purchased such works in Acre.

We may safely assume that the prospective customers of illuminated manuscripts produced in Acre also included Italian settlers, who thus far have not been taken into account in this respect. Throughout the thirteenth century Venetians belonging to the upper ranks of society displayed much interest in various genres of French literary works, stimulated by their encounter with French culture and literature in Italy as well as overseas, especially but not exclusively in the Frankish Levant.[159] Andrea Bembo was apparently the Venetian who sometime after 1205 returned from Constantinople to Venice with a copy of the *Roman de Troie* composed by Benoît of Sainte-Maure. This work was popular among the French noblemen whom he had met while participating in the Fourth Crusade.[160] It is noteworthy that the main Venetian chronicle of the thirteenth century, composed by Martin da Canal between 1267 and 1275, is written in French, a language that its author considered "la plus delitable a lire et a oire que nule autre."[161] While the reading of this chronicle was limited to governmental circles in Venice, there were other literary works in French enjoying wider circulation there.[162]

Considering this general cultural climate in Venice, it is quite plausible that some Venetians residing in Acre, in continuous relations with Frankish noblemen, both spoke and read French. We have already noted the Venetian from Acre who had his will drafted in French in 1294.[163] There is good reason to believe, therefore, that wealthy and prominent Venetian settlers in this city purchased manuscripts of the *Histoire d'Outremer* composed in French, whether illuminated or not, and that in the 1240s Marsilio Zorzi borrowed one such copy in order to include some of its chapters in his report.[164] Moreover, we may also assume that Venetian settlers either served as intermediaries in the transfer of copies of that work from Acre to Venice, or else brought them along when returning to their city of origin before 1291.[165] This appears far more likely than the scenario according to which a settler fleeing Acre when the city's fall was imminent bothered to take his copy of the *Histoire d'Outremer* with him to Venice.[166]

Buchthal's intense focus on Acre as both production and consumer center of illuminated manuscripts, upheld by scholars to this day, brings us to yet another aspect of his reductive approach. This focus has resulted in the neglect of Cyprus's

interaction with Acre. Buchthal attributed a Brussels copy of the *Histoire Universelle* to Acre on the basis of its colophon, which reads "ce livre escrit Bernart dAcre," and ascribed its execution to c. 1270–80.[167] However, as a rule toponymic surnames indicate the city or region of origin, rather than the place of residence of their respective bearers.[168] It would seem, therefore, that the scribe Bernard d'Acre did not work in Acre, but elsewhere, most likely in Cyprus, where the manuscript is attested in the fifteenth century.[169] Moreover, it is not excluded that its miniatures too were executed in Cyprus.[170] This suggestion is enhanced by the apparent link of the manuscript with the St. Nicholas panel from Kakopetria, executed shortly before 1291 in an indigenous Cypriot workshop. Both depict Frankish knights with similar heraldry and, therefore, were presumably commissioned by the same Frankish patron, identified as a member of the Ravendel family, lords of Maraclea, a fief included in the county of Tripoli.[171] Maraclea was captured by Sultan Qalā'ūn of Egypt in 1289, and it has been suggested that its last lord, Meillor, was identical with Mellorus de Ravendel, attested in Cyprus in 1295.[172] One may wonder, therefore, whether both the St. Nicholas panel and the Brussels copy of the *Histoire Universelle* were not produced in Cyprus.[173] It should be stressed that outside of the attribution to Acre propounded by Buchthal, which appears doubtful, there is neither a decisive argument nor any valid reason to assume that the manuscript reached Cyprus only at the time or after the fall of Acre in 1291.

Some further arguments in favor of the production of illuminated manuscripts in Cyprus may be adduced. The focus on thirteenth-century royal patronage on the island, also illustrated by recent research, has obscured the fact that on the island, as in the Kingdom of Jerusalem, there was a group of wealthy lords who could afford to commission or purchase expensive luxury works and attract artists from abroad. Multiple family, social, and political links existed between the two kingdoms at the aristocratic level, and their knights shared the same ethos, courtly culture, language, and literary taste.[174] We may add a more or less similar attitude with respect to art. Cypriot Gothic architecture and sculpture in the thirteenth century,[175] parallel to that in Acre mentioned earlier, implies that Latin patronage of figural art in Cyprus existed before the last quarter of that century, the period to which its beginnings are generally ascribed.[176] This patronage must have also extended to the production of luxury books prior to that period. One may wonder, therefore, whether some of the manuscripts presently ascribed to Acre were not produced in Cyprus, as suggested above with respect to the Brussels copy of the *Histoire Universelle*. In short, while thirteenth-century Acre was clearly the main center of the Frankish Levant for the copying and illumination of manuscripts and the main market for this commodity, it is by no means certain that it

had a quasi-monopolistic standing in this respect, as generally assumed. It may thus be wise to reassess the geographic attributions of the manuscripts presently ascribed to Acre by taking Cyprus into account.

A final remark regarding the connection between Acre and Cyprus is in order. It is generally assumed that noble patrons from Acre continued to commission works after escaping to Cyprus in 1291.[177] This is not self-evident. Many of these noblemen arrived in Cyprus destitute and in need of financial support, and only a small number of refugees mustered sufficient means of sustenance.[178] One of these was the Savoyard knight Othon I of Grandson, who is attested in Cyprus in 1293 after completing a journey to Cilician Armenia, during which he had access to the royal court, which suggests that he was rather well-off at the time.[179] This knight is supposed to have commissioned an embroidered antependium or altar frontal of silk in Cyprus, produced in the Byzantine manner. It has been suggested that this work was intended as a thank offering to a church for the knight's survival after the fall of Acre. However, its attribution to the Levant is far from secure.[180] Another Frankish refugee of some means was the member of the Ravendel family mentioned earlier.[181]

THIS CHAPTER has examined the complex evolution of Acre's society, its continuous encounter with a multiethnic and multicultural transient population, and their impact on cultural and artistic trends, creative processes, and artistic production in the city during the two centuries of Frankish rule. Although far from being exhaustive, this examination may have provided new insights into the dynamics of Acre's cultural and artistic life. In any event, it suggests new approaches and directions of research. To begin with, some major correctives to an overwhelmingly Eurocentric perspective of culture and art in Acre are indispensable.[182] The investigation of neglected avenues of cultural and artistic contact, diffusion, and exchanges between, on the one hand, the West, Byzantium, the Muslim Levant, and Frankish lands in the eastern Mediterranean, including Cyprus, and Acre on the other underlines the contribution of pilgrimage, trade, and the mobility of objects and skilled workers to the dynamics of artistic creation in that city. With respect to the Byzantine impact, the role of Acre's Orthodox community as a depository of artistic works accumulated over time warrants special attention. It is likely that these works, whether portable or not, in the latter case frescoes and mosaics, had a direct impact on "crusader" art. Not surprisingly, the Byzantine features of that art were particularly prominent in the religious field or religious-related subjects and objects, to which the Latins were receptive.

There is yet another aspect of the relation between society and the arts that

requires a change in perspective. The common preoccupation with single luxury items and their patrons has resulted in a skewed reconstruction of artistic creation, especially with respect to painted panels and icons, manuscripts, and objects displaying inscriptions or distinctive "ethnic-cultural" features. Artistic creation cannot be isolated from the economics of artistic production. In Acre, as elsewhere, it was subject to market forces and to the interplay between demand and supply, which in turn was determined by a set of social, ideological, cultural, and economic variables. The nature and degree of technical, stylistic, and decorative interaction that took place in Acre in various arts and crafts varied according to the media in which they occurred and according to the latter's social function. The discrepancy between private and public space was of particular importance in that respect. The arts and crafts of the Frankish Levant exhibit at times a genuinely original blending and fusion of heterogeneous elements, some indigenous and others imported. It is nevertheless doubtful that they led to the creation of a common material culture, shared by the various communities coexisting in Acre.[183]

Notes

1. For these and other events mentioned below, see Steven Runciman, *A History of the Crusades* (Cambridge, 1953–54), or any other general history of the crusades or of the Kingdom of Jerusalem. On the urban development and the quarters of crusader Acre, see David Jacoby, "Crusader Acre in the Thirteenth Century: Urban Layout and Topography," *Studi medievali* 3a serie, 20 (1979): 1–45; idem, "Montmusard, Suburb of Crusader Acre: The First Stage of its Development," in *Outremer: Studies in the History of the Crusading Kingdom of Jerusalem, presented to Joshua Prawer,* ed. Benjamin Z. Kedar, Hans E. Mayer, and Raymond C. Smail (Jerusalem, 1982), 205–17; idem, "Les communes italiennes et les Ordres militaires à Acre: aspects juridiques, territoriaux et militaires (1104–1187, 1191–1291)," in *État et colonisation au Moyen Age,* ed. Michel Balard (Lyon, 1989), 193–214; idem, "L'évolution urbaine et la fonction méditerranéenne d'Acre à l'époque des croisades," in *Città portuali del Mediterraneo, storia e archeologia: Atti del Convegno Internazionale di Genova 1985,* ed. Ennio Poleggi (Genova, 1989), 95–109. The first two essays are reprinted in D. Jacoby, *Studies on the Crusader States and on Venetian Expansion* (Northampton, 1989), nos. V and VI, respectively; the last two appear in idem, *Trade, Commodities and Shipping in the Medieval Mediterranean* (Aldershot, 1997), nos. VI and V, respectively. See also B. Z. Kedar, "The Outer Walls of Frankish Acre," *'Atiqot* 31 (1997) [=*'Akko (Acre): Excavations Reports and Historical Studies*]: 157–80; Adrian J. Boas, "A Rediscovered Market Street in Frankish Acre?" *'Atiqot* 31 (1997): 181–86, a study dealing with Montmusard; Denys Pringle, "Town Defences in the Crusader Kingdom of Jerusalem," in *Medieval City Under Siege,* ed. Ivy A. Corfis and Michael Wolfe (Woodbridge, 1995), 81–84,

99. I disagree with Kedar's maximalist view regarding Acre's territorial extension and some of Pringle's chronology concerning the fortification of Montmusard, and shall return to these subjects elsewhere.

2. On Acre rapidly replacing Jaffa as the main disembarkation point of pilgrims, see D. Jacoby, "Pèlerinage médiéval et sanctuaires de Terre Sainte: la perspective vénitienne," *Ateneo veneto* 173 (n.s. 24) (1986): 27–30, reprinted in idem, *Studies on the Crusader States,* no. IV; idem, "Il ruolo di Acri nel pellegrinaggio a Gerusalemme," in *Il cammino di Gerusalemme,* ed. M. S. Calò Mariani (Atti del II Convegno Internazionale di Studio, Bari-Brindisi-Trani, 18–22 maggio 1999) (Rotte mediterranee della cultura. 2) (Bari, 2002), 26, 30.

3. D. Jacoby, "The Trade of Crusader Acre in the Levantine Context: An Overview," *Archivio Storico del Sannio* n.s. 3 (1998): 103–20; David Abulafia, "Trade and Crusade, 1050–1250," in *Cross Cultural Convergences in the Crusader Period: Essays Presented to Aryeh Grabois on his Sixty-Fifth Birthday,* ed. Michael Goodich, Sophia Menache, and Sylvia Schein (New York, 1995), 1–20.

4. One example will suffice here. The Venetian Marco Zovene settled in Acre around 1266: D. Jacoby, "L'expansion occidentale dans le Levant: les Vénitiens à Acre dans la seconde moitié du treizième siècle," *Journal of Medieval History* 3 (1977): 244–45, reprinted in idem, *Recherches sur la Méditerranée orientale du XIIᵉ au XVᵉ siècle: peuples, sociétés, économies* (London, 1979), no. VII.

5. On factors of emigration, see D. Jacoby, "Mercanti genovesi e veneziani e le loro merci nel Levante crociato," in *Genova, Venezia, il Levante nei secoli XII–XIV* (Atti del Convegno internazionale di studi, Genova-Venezia, 10–14 marzo 2000), ed. Gherardo Ortalli and Dino Puncuh, Atti della Società Ligure di Storia Patria, n.s. 41/1 (2001), 222–23.

6. On this transfer, see Anthony Luttrell, "The Hospitallers' Early Written Records," in *The Crusades and their Sources: Essays Presented to Bernard Hamilton,* ed. John France and William G. Zajac (Aldershot, 1998), 138–39.

7. Joshua Prawer, *Crusader Institutions* (Oxford, 1980), 379–86; idem, "Social Classes in the Latin Kingdom: The Franks," in *A History of the Crusades,* ed. Kenneth M. Setton, vol. 5, *The Impact of the Crusades on the Near East,* ed. Norman P. Zacour and Harry W. Hazard (Madison, 1969–89), 117–92; Jean Richard, "La noblesse de Terre-Sainte (1097–1187)," *Arquivos do Centro Cultural Português* 26 (1989): 321–36, reprinted in idem, *Croisades et états latins d'Orient* (Aldershot, 1992), no. IX. The documentary evidence is supported by linguistics. According to a recent study, the French spoken by the Frankish elite in thirteenth-century Acre derived from some specific dialects of northern France: see C. Aslanov, "Languages in Contact in the Latin East: Acre and Cyprus, *Crusades* 1 (2002): 156–67, esp. 166–67.

8. See D. Jacoby, "Migration, Trade and Banking in Crusader Acre," in *Balkania kai Anatolike Mesogeios, 120s–170s aiones* (The Balkans and the Eastern Mediterranean, 12th–17th Centuries), ed. Lenos Mavromatis, Byzantium Today, 2 (Athens, 1998), 114–19.

9. On this last aspect, see below, note 19.

10. On the suburb, see D. Jacoby, "Montmusard," 205–17; idem, "Three Notes on

Crusader Acre," *Zeitschrift des Deutschen Palästina-Vereins* 109 (1993): 94–96; Boas, as above, note 1.

11. On some of these elements, see James A. Brundage, "Latin Jurists in the Levant: The Legal Elite of the Crusader States," in *Crusaders and Muslims in Twelfth-Century Syria,* ed. Maya Shatzmiller (Leiden, 1993), 18–42; Mayer, *Die Kanzlei der lateinischen Könige von Jerusalem,* Monumenta Germaniae Historica, Schriftes, 40 (Hannover, 1996), II:1109, s.v. Magister in d. Kanzlei, for further references; idem, "Einwanderer in der Kanzlei und am Hof der Kreuzfahrerkönige," in *Die Kreuzfahrerstaaten als multikulturelle Gesellschaft: Einwanderer und Minderheiten im 12. und 13. Jahrhundert,* ed. Mayer, Schriften des Historischen Kollegs, Kolloquien, 37 (München, 1997), 37–40, on a few physicians with legal training who became chancellors.

12. D. Jacoby, "Crusader Acre," 19–39; idem, "Les communes italiennes," 206–7. See also Marie-Luise Favreau-Lilie, "Die italienischen Kirchen im Heiligen Land (1098–1291)," *Studi veneziani* n.s. 13 (1987): 19–22, 31–44, 75–81.

13. D. Jacoby, "Some Unpublished Seals from the Latin East," *Israel Numismatic Journal* 5 (1981): 85–88; idem, "Il ruolo di Acri," 32.

14. Jonathan Riley-Smith, "A Note on Confraternities in the Latin Kingdom of Jerusalem," *Bulletin of the Institute of Historical Research* 44 (1971): 301–8; Richard, "La confrérie des Mosserins d'Acre et les marchands de Mossoul au XIII^e siècle," *L'Orient syrien* 11 (1966): 451–60, reprinted in idem, *Orient et Occident au Moyen Age: contacts et relations (XII^e–XV^e s.)* (London, 1976), no. XI, yet about this confraternity see below, note 43. *Fraternitas* or *frairie* were the terms used for confraternities in the Frankish Levant. It would seem, therefore, that the Pisan *Societas Vermiliorum* attested in Tyre in 1188 was a commercial or banking company, as suggested by the term *societas* used in that sense in Italy, and not a national confraternity: see D. Jacoby, "Conrad, Marquis of Montferrat, and the Kingdom of Jerusalem (1187–1192)," in *Atti del Congresso Internazionale "Dai feudi monferrini e dal Piemonte ai nuovi mondi oltre gli Oceani," Alessandria, 2–6 Aprile 1990,* ed. Laura Balletto, Biblioteca della Società di Storia, Arte e Archeologia per le province di Alessandria e Asti, N. 27 (Alessandria, 1993), 199–200, reprinted in D. Jacoby, *Trade, Commodities and Shipping,* no. IV. I maintain my interpretation in this respect, despite Mayer, *Die Kanzlei der lateinischen Könige,* II:449–50 and n. 36.

15. D. Jacoby, "Il ruolo di Acri," 29, 36.

16. On that contingent, see Christopher Marshall, *Warfare in the Latin East, 1192–1191* (Cambridge, 1992), 77–83.

17. Bernard Hamilton, *The Latin Church in the Crusader States: The Secular Church* (London, 1980), 113–28; Rudolf Hiestand, "Der lateinische Klerus der Kreuzfahrerstaaten: geographische Herkunft und politische Rolle," in *Die Kreuzfahrerstaaten als multikulturelle Gesellschaft,* ed. Mayer, 43–68.

18. On some of these aspects, see D. Jacoby, "La littérature française dans les états latins de la Méditerranée orientale à l'époque des croisades: diffusion et création," in *Essor et fortune de la chanson de geste dans l'Europe et l'Orient latin: Actes du IXe Congrès international de la Société Rencesvals pour l'étude des épopées romanes (Padoue-Venise,*

1982) (Modena, 1984), 617–46; and idem, "Knightly Values and Class Consciousness in the Crusader States of the Eastern Mediterranean," *Mediterranean Historical Review* 1 (1986): 158–86, reprinted in idem, *Studies on the Crusader States,* nos. II and I, respectively; Laura Minervini, "Outremer," in *Lo spazio letterario del medioevo. 2. Il medioevo volgare,* vol. I, *La produzione del testo,* tomo II, ed. P. Boitani, M. Mancini, and A. Vàrvaro (Roma, 2001), 611–48. On orientalization, see above, pp. 108–10.

19. Annemarie Weyl Carr, "Art in the Court of the Lusignan Kings," in *Cyprus and the Crusades,* ed. Nicholas Coureas and Riley-Smith (Nicosia, 1995), 239, minimizes the role of trade in cultural transfers and in the configuration of cultures. However, various goods in trade, including devotional objects, conveyed symbolic or aesthetic messages. Moreover, merchants as members of a literate group occasionally displayed interest in "high" culture and, in addition, sponsored and financed artistic activity.

20. D. Jacoby, "Il ruolo di Acri," 32–33.

21. Ibid.

22. Ibid., 28.

23. The figure appears in an unpublished manuscript of his *Liber peregrinationis.* It is cited by Emilio Panella, "Ricerche su Riccoldo da Monte di Croce," in *Archivum Fratrum Praedicatorum* 58 (1988): 8. Even if we do not accept the figure at face value, we may assume that several thousand pilgrims were there, which was all the more remarkable in the winter, since Easter was the main pilgrimage season.

24. D. Jacoby, "Pilgrimage in Crusader Acre: The *Pardouns dAcre,*" in *De Sion exibit lex et verbum domini de Hierusalem: Essays on Medieval Law, Liturgy and Literature in Honour of Amnon Lindner,* ed. Yitzhak Hen, Cultural Encounters in Late Antiquity and the Middle Ages, vol. 1 (Turhout, 2001), 105–17.

25. On small pendant crosses and reliquary pendant crosses of metal and other materials worn around the neck, as well as some other devotional objects for private use, see Silvia Rozenberg, "Metalwork and Crosses from the Holy Land," in *Knights of the Holy Land: The Crusader Kingdom of Jerusalem,* ed. Silvia Rozenberg (Jerusalem, 1999), 119–21. Although not found in Acre, these objects obviously reflect those commonly available there.

26. José Guerrero Lovillo, *Las Cántigas: estudio arqueológico de sus miniaturas* (Madrid, 1949), pl. 12, left col., middle. The inscriptions accompanying the six miniatures illustrating Cant. IX appear ibid., 379.

27. On the story and its context, see B. Z. Kedar, "Convergences of Oriental, Christian, Muslim, and Frankish Worshippers: The Case of Saydnaya," in *De Sion exibit lex,* ed. Hen, 59–69. See also above, pp. 104–5.

28. The commercial aspect of the depiction has already been underlined, yet without reference either to Saidnaya or to Jerusalem, in Henk van Os, with Eugène Honée, Hans Nieuwdorp, and Bernhard Ridderbos, *The Art of Devotion in the Late Middle Ages in Europe, 1300–1500,* trans. from the Dutch by Michael Hoyle (London, 1994), 65. However, the contention that such shops served mostly the private devotion of monks is unjustified, since there were clearly also many lay customers.

29. Danny Syon, "Souvenirs from the Holy Land: A Crusader Workshop of Lead

Ampullae from Acre," in Rozenberg, *Knights of the Holy Land*, 112–15. The author's suggestion that after fleeing from Acre in 1291 the workshop's owner possibly worked at Corinth and in Braunschweig may be safely discarded. On earlier ampullae, see Jaroslav Folda, *The Art of the Crusaders in the Holy Land, 1098–1187* (Cambridge, 1995), 294–97.

30. See Syon, as in previous note.

31. Runciman, *A History of the Crusades,* II:88; see also B. Z. Kedar, "The Subjected Muslims of the Frankish Levant," in *Muslims under Latin Rule, 1100–1300,* ed. James M. Powell (Princeton, 1990), 145–46 and n. 20, reprinted in B. Z. Kedar, *The Franks in the Levant, 11th to 14th Centuries* (Aldershot, 1993), no. XVIII.

32. ʿAlī al-Harawī, author of a guide to Muslim pilgrimage sites, visited the Frankish kingdom in the early 1180s. He remarks that in various cemeteries, including that of Acre, "there are many saints and followers whose tombs cannot be recognized": see B. Z. Kedar, "The Subjected Muslims," 150–51, who suggests that the remaining Muslims were too weak or too uninformed to uphold traditions about their exact locations. In my view their ignorance definitely points to the lack of continuity in Muslim urban settlement in Acre.

33. See Robert Irwin, "The Image of the Byzantine and the Frank in Arab Popular Literature of the Late Middle Ages," *Mediterranean Historical Review* 4 (1989): 232–33.

34. *The Travels of Ibn Jubayr,* English trans. by Ronald J. C. Broadhurst (London, 1952), 318. The Franks also displayed religious tolerance toward Muslim religious practices in rural areas: B. Z. Kedar, "Some New Sources on Palestinian Muslims before and during the Crusades," in Mayer, *Die Kreuzfahrerstaaten als multikulturelle Gesellschaft,* 135, 137.

35. On their activity in Acre, see D. Jacoby, "The *Fonde* of Crusader Acre and its Tariff: Some New Considerations," in *Dei Gesta per Francos: Études sur les croisades dédiées à Jean Richard,* ed. M. Balard, B. Z. Kedar, and J. Riley-Smith (Aldershot, 2001), 279–80, 283, 291.

36. See above, p. 103.

37. References to the Jews of Acre in Prawer, *The History of the Jews in the Latin Kingdom of Jerusalem* (Oxford, 1988). The location of their residences, ibid., 103, 262–64, must be rejected. I shall return to that issue elsewhere. In the meantime, see below, note 79.

38. General background in Hamilton, *The Latin Church,* 159–211, with little reference to Acre. On the ambiguous term *Syrian,* see ibid., 159–61.

39. Jacques de Vitry, *Lettres,* new ed. by Robert B. C. Huygens, Corpus Christianorum, Continuatio Mediaevalis, CLXXI (Turnhout, 2000), 563–65, no. 2, lines 124–25, 148–49, 163–65, 169–72. During his stay in Acre in 1229 Frederick II protected from the secular arm a Melkite bishop (*episcopus Surianorum*) who had been excommunicated by the Latin patriarch Gerold: Matthew Paris, *Chronica Majora,* ed. Henry R. Luard, Rolls Series, 57 (London, 1872–84), III:185. According to B. Z. Kedar, "Latins and Oriental Christians in the Frankish Levant, 1099–1291," in *Sharing the Sacred: Religious Contacts and Conflicts in the Holy Land, First–Fifteenth Centuries CE,* ed. Arieh

Kofsky and Guy G. Stroumsa (Jerusalem, 1998), 217–20, the attitude of Latin ecclesiastical circles toward the Orthodox was partly negative, yet the antagonism between the two churches did not prevent some Latin borrowings from the Greeks in ritual and legislation: see B. Z. Kedar, "Latins and Oriental Christians," 209–22; and idem, "On the Origins of the Earliest Laws of Frankish Jerusalem: The Canons of the Council of Nablus, 1120," *Speculum* 74 (1999): 311–24, esp. 321. We may add borrowings in the arts.

40. D. Jacoby, "The *Fonde* of Crusader Acre," 278–80. To the bibliography mentioned there, n. 10, add Samir Khalil Samir, "The Role of Christians in the Fatimid Government Services of Egypt to the Reign of al-Ḥāfiẓ," *Medieval Encounters: Jewish, Christian and Muslim Culture in Confluence and Dialogue* 2 (1996): 177–92, esp. 183–84.

41. This is not only due to the extant documentation, which is heavily Western-biased.

42. D. Jacoby, "Three Notes," 85–87.

43. On the refugees, see Irwin, "The Supply of Money and the Direction of Trade in Thirteenth-Century Syria," in *Coinage in the Latin East: The Fourth Symposium on Coinage and Monetary History,* ed. Peter W. Edbury and David Michael Metcalf, British Archaeological Reports, International Series, LXXVII (Oxford, 1980), 74–75. Richard, "La confrérie des Mosserins d'Acre," 454–57, suggests that the Nestorian confraternity comprised itinerant merchants from Mosul occasionally visiting Acre. Irwin rightly emphasizes that it must have been composed exclusively of merchants settled there: see his study cited above. A further argument in support of this view is provided by the fact that this confraternity appears in Acre only after the events of 1259.

44. Louis de Mas Latrie, ed., *Histoire de l'île de Chypre sous le règne des princes de la maison de Lusignan* (Paris, 1852–61), II:74–79.

45. The pope mentions poor Saracens and Jews who come to Acre in order to convert: B. Z. Kedar, *Crusade and Mission: European Approaches to the Muslims* (Princeton, 1984), 151 and 215, no. 3, edition of the letter. Oriental Christians are not mentioned in that context, which is not surprising since the letter deals with the baptism of Infidels. Yet the fact that those who arrived were destitute and in need of material support seems to point to refugees fleeing from territories affected by military operations. It is reasonable to assume, therefore, that the same circumstances prompted Oriental Christians to find refuge in Acre.

46. On Theodora: Runciman, *History of the Crusades,* II:349–50, 361, 378–79; Hamilton, "Women in the Crusader States: The Queens of Jerusalem (1100–1190)," in *Medieval Women,* ed. Derek Baker, Studies in Church History, Subsidia, 1 (Oxford, 1978), 157–59, 161–62; Ralph-Johannes Lilie, *Byzantium and the Crusader States, 1096–1204,* trans. J. C. Morris and Jean E. Ridings of the revised version of the original German text (Oxford, 1993), 175, 193–95; Paul Magdalino, *The Empire of Manuel I Komnenos, 1143–1180* (Cambridge, 1993), 69–72. See also next note.

47. A. de Marsy, ed., "Fragment d'un cartulaire de l'ordre de Saint Lazare en Terre-Sainte," *Archives de l'Orient latin* II/2 (1884): 138–39, no. XX.

48. Hamilton, "Women in the Crusader States," 161, 163; Lilie, *Byzantium and the*

Crusader States, 196–97; Magdalino, *The Empire of Manuel I Komnenos,* 73–75. After the king's death she withdrew to Nablus, her dower-fief, yet later married Balian II of Ibelin: Hamilton, "Women in the Crusader States," 165; see also next note. In the first half of the twelfth century the royal court displayed a favorable attitude toward the Armenians and Jacobites, both Monophysite groups: B. Z. Kedar, "Latins and Oriental Christians," 210–12. See also Lucy-Anne Hunt, "Art and Colonialism: The Mosaics of the Church of the Nativity in Bethlehem (1169) and the Problem of 'Crusader' Art," *Dumbarton Oaks Papers* 45 (1991): 771–72.

49. Mayer, "Latins, Muslims and Greeks in the Latin Kingdom of Jerusalem," *History* 63 (1978): 190–92, reprinted in idem, *Probleme des lateinischen Königreichs Jerusalem* (London, 1983), no. VI.

50. For the background, see Lilie, *Byzantium and the Crusader States,* 198–202, 309–18; Magdalino, *The Empire of Manuel I Komnenos,* 73–76. On patronage, Carr, "The Mural Paintings of Abu Gosh and the Patronage of Manuel Comnenus in the Holy Land," in *Crusader Art in the Twelfth Century,* ed. Jaroslav Folda, British Archaeological Reports, International Series 152 (Oxford, 1982), 215–34; Hunt, "Art and Colonialism," 69–85; Gustav Kühnel, *Wall Painting in the Latin Kingdom of Jerusalem,* Frankfurter Forschungen zur Kunst, 14 (Berlin, 1988); Folda, *The Art of the Crusaders,* 347–78; and on monumental painting, ibid., 163–65, 313–18, 379–90. See also a recent short survey by G. Kühnel, "Crusader Monumental Painting and Mosaic," in *Knights of the Holy Land,* ed. Rozenberg, 203–15.

51. See D. Jacoby, "The Trade of Crusader Acre," 113–14, and in more detail idem, "Byzantine Trade with Egypt from the Mid-Tenth Century to the Fourth Crusade," *Thesaurismata* 30 (2000): 25–77.

52. Ibn al-Athir, "Kamel Altevarikh," in *Recueil des historiens des croisades: historiens orientaux* (Paris, 1872), vol. I/1, 689.

53. For this period: Alice-Mary Talbot, "Byzantine Pilgrimage to the Holy Land from the Eighth to the Fifteenth Century," in *The Sabaite Heritage in the Orthodox Church from the Fifth Century to the Present,* ed. Joseph Patrich, Orientalia Lovaniensia Analecta, 98 (Leuven, 2001), 97–110, esp. 101–7.

54. I. Troickij, ed., "Ioanna Foki Skazanie vkratce o gorodach i stranach ot Antiochii do Ierusalima," *Pravoslavnyi Palestinskij Sbornik* 8/2, fasc. 23 (1889), 1 (ch. 1), 6 (ch. 9); English trans. in John Wilkinson, ed., with J. Hill and W. F. Ryan, *Jerusalem Pilgrimage, 1099–1185,* Hakluyt Society, Second Series, 167 (London, 1988), 315 and 319, yet with incorrect dating ibid., 22.

55. G. Rhalles and M. Potles, *Syntagma theon kai hieron kanonon* (Athens, 1852–59), IV:249.

56. Account of 1175 by Burchard of Strasbourg in Arnold of Lübeck, *Chronica Slavorum,* ed. J. M. Lappenberg, Monumenta Germaniae Historica, Scriptores, 21 (Hannover, 1869), 239–40; P[aul] D[evos], "Les premières versions occidentales de la légende de Saïdnaia," *Analecta Bollandiana* 65 (1947): 265–66, par. 3. See also above, note 27.

57. For a Western account of 1186 referring to a merchant leaving the Holy Land by sea, see ibid., 272–73, par. 1; around the mid-thirteenth century Matthew Paris,

Chronica Majora, II:485–86, mentions a monk. For a depiction of the monk purchasing the icon, see above, note 26.

58. See above, note 54. Such was not the case with respect to Oriental Christian pilgrims coming from other territories.

59. Richard B. Rose, "The Native Christians of Jerusalem, 1187–1260," in *The Horns of Hattin,* ed. B. Z. Kedar (Jerusalem, 1992), 239–49; Johannes Pahlitzsch, "Athanasios II, a Greek Orthodox Patriarch of Jerusalem (c. 1231–1244)," in *Autour de la première Croisade,* ed. M. Balard, Byzantina Sorbonensia, 14 (Paris, 1996), 465–74.

60. On his life and career, see Dimitri Obolensky, *Six Byzantine Portraits* (Oxford, 1988), 113–72; Mirjana Živojinović, Vassiliki Kravari, and Christophe Giros, eds., *Actes de Chilandar,* Archives de l'Athos, XX (Paris, 1998), I:31–32.

61. D. Jacoby, "Three Notes on Crusader Acre," 83–84.

62. Pahlitzsch, "Athanasios II," 469–71.

63. This is the first find of a Nicaean coin in Israel. I wish to thank hereby Adrian J. Boas, Haifa University, who directed the excavation, and Robert Kool, Coin Department, Israel Antiquities Authority, who identified the coin, for allowing me to mention it here before publication.

64. I shall deal elsewhere with this issue.

65. On the dynamism of provincial art in the Levantine region, see Hunt, "Art and Colonialism," 74–81, 83–85; idem, "A Woman's Prayer to St Sergios in Latin Syria: Interpreting a Thirteenth-Century Icon at Mount Sinai," *Byzantine and Modern Greek Studies* 15 (1991): 96–124; Carr, *Byzantine Illumination, 1150–1250: The Study of a Provincial Tradition,* Studies in Medieval Manuscript Illumination, 47 (Chicago, 1987). On mural paintings in twelfth-century Cyprus and in the first decades following the Latin conquest of 1191, see Robin Cormack, *Writing in Gold: Byzantine Society and its Icons* (London, 1985), 215–51; Carr and Laurence J. Morrocco, *A Byzantine Masterpiece Recovered: The Thirteenth-Century Murals of Lysi, Cyprus* (Austin, 1991), esp. 99–113.

66. The latter is suggested by Daniel H. Weiss, *Art and Crusade in the Age of Saint Louis* (Cambridge, 1998), 151–53. Incidentally, one may wonder whether the same artist would work on frescoes and illuminations, given the substantial differences between the skills and technical means required by the two media, far greater than between frescoes and icons, for which there is evidence: Anthony Cutler, "The Industries of Art," in *The Economic History of Byzantium: From the Seventh through the Fifteenth Century,* ed. Angeliki E. Laiou (Washington, D.C., 2002), II:557 and n. 44.

67. Riley-Smith, *The Feudal Nobility and the Kingdom of Jerusalem, 1174–1277* (London, 1973), 87–91. The status of the Muslims appears to have been inferior to that of the Oriental Christians: B. Z. Kedar, "The Subjected Muslims," 164–65, 168–69. On special taxation, see D. Jacoby, "The *Fonde* of Crusader Acre," 280, 288–89.

68. On two thirteenth-century Oriental Christians of Acre adopting the Latin rite, see B. Z. Kedar, "Latins and Oriental Christians," 220.

69. See Brundage, "Marriage Law in the Latin Kingdom," in *Outremer,* ed. B. Z. Kedar, Mayer, Smail, 262–63.

70. See D. Jacoby, "L'expansion occidentale dans le Levant," 225–64; idem, "The

Rise of a New Emporium in the Eastern Mediterranean: Famagusta in the Late Thirteenth Century," *Meletai kai hypomnemata* (Hidryma archiepiskopou Makariou III) 1 (1984): 160, reprinted in idem, *Studies on the Crusader States,* no. VIII; idem, "La dimensione demografica e sociale," in *Storia di Venezia dalle origini alla caduta della Serenissima,* ed. Giorgio Cracco and Gherardo Ortalli, vol. II, *L'età del Comune* (Roma, 1995), 703–4; D. Jacoby, "Mercanti genovesi e veneziani," 224–26, 239–40.

71. Giles Constable, Introduction to the *Apologia de barbis* in *Apologiae duae. Gozechini epistola ad Walcherum. Burchardi, ut videtur, abbatis Bellevalis Apologia de barbis,* ed. Huygens, Corpus Christianorum, Continuatio Mediaevalis, LXII (Turnhout, 1985), 94–102; B. Z. Kedar, ed., "The *Tractatus de locis et statu sancte terre ierosolimitane,*" in *The Crusades and Their Sources,* ed. France and Zajac, 124, references to shaving and beards in a treatise composed within the two decades preceding 1187; for its dating, see ibid., 119.

72. See the new edition of the Council's canons by B. Z. Kedar, "On the Origins of the Earliest Laws," 331–34, esp. 334, ch. XVI. Kedar, ibid., 323, and "The Subjected Muslims," 165–66, insists that one of the purposes was to prevent inadvertent sexual intercourse between Franks and Muslims, yet the implications of the prohibitions were obviously much broader.

73. Jews wearing traditional Oriental clothes appear in the Job frontispiece of the Arsenal Old Testament, right bottom roundel: see the convincing arguments by Weiss, *Art and Crusade,* 188, and pl. VII.

74. Gaston Raynaud, ed., *Les Gestes des Chiprois: Recueil de chroniques françaises écrites en Orient aux XII^e et XIV^e siècles* (Genève, 1887), 238–40, pars. 480–81; new ed. by Minervini, *Cronaca del Templare di Tiro (1243–1314): La caduta degli Stati Crociati nel racconto di un testimone oculare* (Napoli, 2000), 200, par. 244: "tuerent pluissors Suriens qui porteent barbes et estoient de la ley de Gresse, que pour lor barbes les tuerent en change de Sarazins."

75. D. Jacoby, "Silk Crosses the Mediterranean," in *Le vie del Mediterraneo: idee, uomini, oggetti (secoli XI–XVI),* ed. G. Airaldi, Collana dell'Istituto di storia del medioevo e della espansione europea, 1 (Genova, 1997), 63–64. Imports from Antioch in Acre: Arthur A. Beugnot, ed., *Livre des Assises de la Cour des Bourgeois,* in idem, *Recueil des Historiens des Croisades: Lois,* 2 vols. (Paris, 1841–49), vol. II, 179, ch. 243, pars. 8–9. This section of the Acre tariff belongs to the post-1191 period; for its dating, see D. Jacoby, "The *Fonde* of Crusader Acre," 292–93.

76. Alphonse-Martial Chazaud, ed., "Inventaire et comptes de la succession d'Eudes, comte de Nevers (Acre 1266)," *Mémoires de la Société Nationale des Antiquaires de France* 32 (1870): 187, 191, 203, 206. Ann E. Wardwell, "*Panni tartarici:* Eastern Islamic Silks Woven with Gold and Silver (13th and 14th Centuries)," *Islamic Art* 3 (1988–89): 95–173, offers the broadest and most systematic examination of these silks attempted so far, yet see below, note 101.

77. Depicted in the frontispieces to Proverbs 2 and 3 in the Arsenal Old Testament: see Weiss, *Art and Crusade,* 184, and 100–101, figs. 47 and 48. The evidence adduced is not decisive, since the two miniatures clearly reflect Islamic models.

78. On Frankish dress, see Urban T. Holmes, "Life Among the Europeans in Palestine and Syria in the Twelfth and Thirteenth Centuries," in *A History of the Crusades,* ed. K. M. Setton, vol. 4, *The Art and Architecture of the Crusader States,* ed. H. W. Hazard (Madison, 1977), 22–23. In 1184 Ibn Jubayr saw in Tyre a Frankish bride "most elegantly garbed in a beautiful dress from which trailed, according to their custom, a long tail of golden silk," that is, gold-interwoven silk: *The Travels of Ibn Jubayr,* 320.

79. D. Jacoby, "The *Fonde* of Crusader Acre," 287–89; evidence on the scattered residence of non-Franks in Acre can be found in Jacoby, "Three Notes on Crusader Acre," 83–88, esp. 87–88.

80. Fulcher of Chartres, *Historia Hierosolymitana (1095–1127),* ed. Heinrich Hagenmeyer (Heidelberg, 1913), 747–49 (Book 3, ch. 37, pars. 2–5), on intermarriage; the presence of Muslim servants and slaves in Frankish homes is illustrated by canons XII–XV of the Council of Nablus: see text in B. Z. Kedar, "On the Origins of the Earliest Laws," 333–34; idem, *Crusade and Mission,* 79.

81. See Minervini, "Les contacts entre indigènes et croisés dans l'Orient latin: le rôle des drogmans," in *Romania arabica: Festschrift für Reinhold Kontzi zum 70. Geburtstag,* ed. Jens Jüdtke (Tübingen, 1996), 57–62. On Syrians in the Frankish administration, see above, p. 102.

82. Jacques de Vitry, *Lettres,* 563–65, no. 2, lines 124–69.

83. B. Z. Kedar, "The Subjected Muslims," 174. The Muslim scholars living in the territories conquered by the Christians in the early twelfth century had been massacred or had abandoned their homes.

84. Usāma Ibn Munqidh, *Les enseignements de la vie.* Kitāb al-I'tibār. *Souvenirs d'un gentilhomme syrien du temps des Croisades,* French trans. by André Miquel (Paris, 1983), 299, on a public bath in Tyre. There were several baths in Acre, one of them belonging to the Hospitallers and another in private hands: D. Jacoby, "Les communes italiennes," 201–2. See also Holmes, "Life Among the Europeans," 18–19.

85. Ibid., 17–18; Usāma Ibn Munqidh, *Les enseignements de la vie,* 304–5, mentions a Frankish knight who had Egyptian female cooks.

86. On housing, for the time being see Holmes, "Life Among the Europeans," 9–13.

87. See above, note 48.

88. Testimony of Wilbrand of Oldenburg: J.C.M. Laurent, ed., *Peregrinationes medii aevi quatuor: Burchardus de Monte Sion, Ricoldus de Monte Crucis, Odoricus de Foro Julii, Willebrandus de Oldenburg* (Leipzig, 1864), 166–67; English trans. by Prawer, *The Latin Kingdom of Jerusalem: European Colonialism in the Middle Ages* (London, 1972), 451–52.

89. Edna J. Stern, "Ceramic Ware from the Crusader Period in the Holy Land," in *Knights of the Holy Land,* ed. Rozenberg, 259–65.

90. Eva Baer, *Ayyubid Metalwork with Christian Images,* Studies in Islamic Art and Architecture, Supplements to Muqarnas, vol. IV (Leiden, 1989), 41–48.

91. High-quality glassware was produced in Antioch, Beirut, Tyre, and Acre: see Wilhelm Heyd, *Histoire du commerce du Levant au moyen âge* (Leipzig, 1885–86),

I:179–80; Riley-Smith, *The Feudal Nobility,* 81 and 266, n. 147; Baer, *Ayyubid Metalwork,* 44; Yael Gorin-Rozen, "Excavation of the Courthouse Site at 'Akko: Medieval Glass Vessels (Area TA)," *'Atiqot* 31 (1997): 75–85; Na'ama Brosh, "Between East and West: Glass and Minor Arts in the Crusader Kingdom," in *Knights of the Holy Land,* ed. Rozenberg, 267–70. See also below, note 100.

92. See above, p. 107.

93. Véronique François, "Une illustration des romans courtois: La vaisselle de table chypriote sous l'occupation franque," *Cahiers du Centre d'études chypriotes* 29 (1999): 59–80, argues for a direct impact of French literature. A different interpretation is offered by Marie-Louise von Wartburg, "'Hochzeitpaare' und Weintrinker: Zur Bildmotiven der Mittelalterlichen Keramik Cypern," *Antiquitas,* 3rd ser., 42 (2001) (= *Zona archeologica: Festschrift für Hans Peter Isler zum 60. Geburtstag,* ed. Sabrina Buzzi et al.): 457–65, who stresses the Oriental tradition. Both views can be reconciled, as presented here.

94. See figures in Rozenberg, *Knights of the Holy Land,* 60, 66, 127–28. I also rely on a personal communication from Edna J. Stern, Israel Antiquities Authority, regarding unpublished material.

95. See Folda, *The Art of the Crusaders,* 347–78, and about the identity of the mosaicists, ibid., 350–57; see also above, note 50.

96. On the nature of the inscriptions: Oleg Grabar, "The Crusades and the Development of Islamic Art," in *The Crusades from the Perspective of Byzantium and the Muslim World,* ed. Laiou and Roy Parviz Mottahedeh (Washington, D.C., 2001), 239–41.

97. Baer, *Ayyubid Metalwork,* 49, suggests that the high degree of specialization in brass extended to the execution of types of decorative motifs by different artisans, which would imply that only Christians worked on Christian motifs; this, however, does not seem convincing. Maria Georgopoulou, "Orientalism and Crusader Art: Constructing a New Canon," *Medieval Encounters: Jewish, Christian and Muslim Culture in Confluence and Dialogue* 6 (2000): 295, rightly points to multiethnic partnerships in Egypt, including in industrial ventures: see Shlomo D. Goitein, *A Mediterranean Society: The Jewish Communities of the Arab World as Portrayed in the Documents of the Cairo Geniza* (Berkeley, 1967–88), I:72, 85, 124, 365, no. 17; III:330; V:4.

98. Strangely, this hypothesis has never been raised until now. An argument supporting its plausibility will soon be adduced. Among the customers, one should also take into account the Copts coming from Egypt. This is suggested by an Arabic-Old French phrase-book of the thirteenth century written in Coptic characters, apparently intended for Coptic visitors to Acre: see Aslanov, "Languages in Contact," esp. 157–58.

99. On these refugees, see above, p. 103. Raschid-Eldin, *Histoire des Mongols de la Perse,* ed. and trans. E. Quatremère (Paris, 1836), 337–39, reports that the il-khan of Persia, Hülagü, deported the artisans he found in Aleppo after capturing the city in 1260, yet does not specify in which crafts they worked. It is likely, however, that some artisans fled earlier.

100. Georgopoulou, "Orientalism and Crusader Art," 301–18, esp. 315, considers that the beakers were made "in the market of a Muslim city for Christian patrons." However, she refrains from dealing with the composition of the workshop, nor does

she envisage the scenario suggested here. See also John Carswell, "The Baltimore Beakers," in *Gilded and Enamelled Glass from the Middle East,* ed. Rachel Ward (London, 1998), 61–63. On Aleppo as a glass center, see Georgopoulou, "Orientalism and Crusader Art," 296–99, with references to previous bibliography; also Irwin, "A Note on Textual Sources for the History of Glass," in *Gilded and Enamelled Glass,* ed. Ward, 24–26.

101. On "Tartar cloths," see above, p. 107. Wardwell's argumentation is weakened by two factors. She assumes absolute continuity in the nature of raw materials, weave composition, and type of decoration in each of the regions to which she assigns the silks, and completely disregards the mobility of expert workers and the transfers they could generate. On the imitation of "Tartar cloths" in Italy, see D. Jacoby, "Silk Economics and Cross-Cultural Artistic Interaction: Byzantium, the Islamic World and the Christian West," *Dumbarton Oaks Papers* 58 (2004) (in press). I shall deal elsewhere with the role of Acre as a silk market.

102. Carr, "Art in the Court of the Lusignan Kings," 242–44; Folda, "Crusader Art in the Kingdom of Cyprus," 216–19.

103. In addition to Acre, this may also apply to Cyprus before 1291. In that case one would have to explain why the distinctive marks of Latin patronage appear only after 1291. It is quite possible, however, that earlier pieces have simply not survived. We deal at any rate with a small number of objects, compared with what must have been a sizable output.

104. On these institutions, see above, p. 99.

105. Bianca Kühnel, *Crusader Art of the Twelfth Century: A Geographical, an Historical, or an Art Historical Notion?* (Berlin, 1994), 23–29, 155–58; Folda, *The Art of the Crusaders,* 136.

106. See below, note 117.

107. B. Kühnel, *Crusader Art of the Twelfth Century,* 47.

108. On which see Folda, *The Art of the Crusaders,* 37–40. Interestingly, there was a painter in the Christian army that captured Damietta in 1218 during the Fifth Crusade. At the request of an English knight, he depicted St. Edmund's passion on a wall of the church that had been dedicated to the saint: Walter of Coventry, *Memoriale,* ed. William Stubbs, Rolls Series, 58 (London, 1872–73), II:242–43.

109. Gottlieb L. Fr. Tafel and Georg M. Thomas, eds., *Urkunden zur älteren Handels- und Staatsgeschichte der Republik Venedig* (Wien, 1856–57), II:396; new ed. by Oliver Berggötz, *Der Bericht des Marsilio Zorzi: Codex Querini-Stampalia IV3 (1064),* Kieler Werkstücke, Reihe C: Beiträge zur europäischen Geschichte des frühen und hohen Mittelalters, herausgegeben von Hans E. Mayer, 2 (Frankfurt am Main, 1990), 178.

110. The identity of the building is secured by Ibn Jubayr's testimony regarding Muslim worship in Acre: see above, p. 102.

111. D. Jacoby, "Les communes italiennes," 200, 204, yet for the dating of Theodoric's journey, see now Huygens, ed., *Peregrinationes tres: Saewulf, John of Würzburg, Theodericus,* Corpus Christianorum, Continuatio Mediaevalis, CXXXIX (Turnhout, 1994), 28.

112. D. Jacoby, "Crusader Acre," 19–20, 24–25.

113. I shall deal with this topic elsewhere.

114. On the absence of residential segregation, see above, p. 107.

115. Zehava Jacoby, "Crusader Sculpture in Cairo: Additional Evidence on the Temple Area Workshop of Jerusalem," in *Crusader Art in the Twelfth Century,* ed. Folda, 121–38. See also below, note 117.

116. D. Jacoby, "Crusader Acre," 25–26, 28–29, 33–36; idem, "Les communes italiennes," 200–204; see also above, notes 10 and 13.

117. Camille Enlart, *Les monuments des croisés,* Album, vol. I, pls. 51–52, figs. 162–64. The full panoramic drawing of Acre made by Gravier d'Orcières c. 1686, on which the church of St. John of the Hospitallers is depicted, is reproduced in B. Z. Kedar, "The Outer Walls of Frankish Acre," 165, fig. 7, unfortunately on a very small scale. The 1681 drawing of the church of St. Andrew, once located in the southwest corner of the Old City, appears in Cornelis de Bruyn (Le Brun), *Voyage au Levant* (Delft, 1700), between 312 and 313. Part of the first drawing and the entire second one are reproduced in Benvenisti, *The Crusaders in the Holy Land* (Jerusalem, 1970), 96 and 112, respectively. According to Enlart, *Les monuments des croisés,* II:20, the Gothic portal inserted in the *madrasah* of Sultan al-Malik an-Nāṣir in Cairo originally belonged to the church of St. Andrew in Acre, yet this attribution is not backed by any evidence or plausible argument.

118. Z. Jacoby, "Crusader Sculpture in Cairo," 122–26.

119. See above, note 117.

120. Hiestand, "*Castrum Peregrinorum* e la fine del dominio crociato in Siria," in *Acri 1291: La fine della presenza degli ordini militari in Terra Santa e i nuovi orientamenti nel XIV secolo* (Porta San Giovanni, Perugia, 1996), 24–27, and 25 for the dating. On the castle, see Pringle, *The Churches of the Crusader Kingdom of Jerusalem* (Cambridge, 1993–98), I:69–80, s.v. 'Atlit; idem, "Town Defences," 91–92.

121. Pringle, *The Churches of the Crusader Kingdom,* II:40–43.

122. See above, note 117; and Prawer, "A Crusader Tomb of 1290 from Acre and the Last Archbishops of Nazareth," *Israel Exploration Journal* 24 (1974): 241–51.

123. Z. Jacoby, "The Impact of Northern French Gothic on Crusader Sculpture in the Holy Land," in *Il medio oriente e l'occidente nell'arte del XIII secolo,* Atti del XXIV Congresso internazionale di storia dell'arte, Bologna, 1975, vol. II, ed. Hans Belting (Bologna, 1982), 123–27. Note also a crocket capital from Acre in Rozenberg, "Sculptural Fragments," in *Knights of the Holy Land,* ed. Rozenberg, 188, fig. 7, and an additional head from Montfort, 190, fig. 11.

124. With respect to the latter, see ibid., 190, figs. 14 and 16, and 191, fig. 20.

125. On this diversity, see above, p. 113.

126. These buildings appear in inventories of the mid-thirteenth century, Cornelio Desimoni, ed., "Quatre titres des propriétés des Génois à Acre et à Tyr," *Archives de l'Orient latin* 2/2 (1884): 215–18.

127. See D. Jacoby, "Crusader Acre," 36.

128. On these two distinctive features, see Ronny Ellenblum, "Construction Methods in Frankish Rural Settlements," in *The Horns of Hattin,* ed. B. Z. Kedar, 170–72.

129. Piero Pierotti, *Pisa e Accon: L'insediamento pisano nella città crociata. Il porto. Il fondaco* (Pisa, 1987), 85–98.

130. See above, note 18. On the origin of the knights, see above, note 7.

131. Hamilton, *The Latin Church,* 123, 125; for Acre, see Hiestand, "Der lateinische Klerus," 52.

132. Luttrell, "The Hospitallers' Early Written Records," 139–43, 146–47, 151, 153. See also Keith V. Sinclair, ed., *The Hospitaller's "Riwle"* (*Miracula et Regula Hospitalis Sancti Johannis Jerosolimitani*), Anglo-Norman Texts, 42 (London, 1984).

133. Luttrell, "The Earliest Templars," in *Autour de la première Croisade,* ed. Balard, 201; Malcolm Barber, *The New Knighthood: A History of the Order of the Temple* (Cambridge, 1994), 182.

134. D. Jacoby, "The Venetian Privileges in the Latin Kingdom of Jerusalem: Twelfth and Thirteenth-Century Interpretations and Implementation," in *Montjoie: Studies in Crusade History in Honour of Hans Eberhard Mayer,* ed. B. Z. Kedar, J. Riley-Smith, and R. Hiestand (Aldershot, 1997), 167–68.

135. Minervini, "La lingua franca mediterranea: plurilinguismo, mistilinguismo, pidginizzazione sulle coste del Mediterraneo tra tardo medioevo e prima età moderna," *Medioevo Romanzo* 20 (1996): 246–48; Aslanov, "Languages in Contact," 166–75.

136. See above, pp. 100–101.

137. See Minervini, "La lingua franca mediterranea," 237–39, 244–45. The predominance attained by Venetian among Italian dialects as the primary economic language in the eastern Mediterranean was the result of a long process, which began in the thirteenth century and was completed only after the fall of the Frankish Levant.

138. Valeria Bertolucci Pizzorusso, "Testamento in francese di un mercante veneziano (Famagosta, Gennaio 1294)," *Annali della Scuola Normale Superiore di Pisa* ser. III, 18 (1988): 1011–33, esp. 1031–32. See also above, p. 118.

139. Hugo Buchthal, *Miniature Painting in the Latin Kingdom of Jerusalem, with Liturgical and Palaeographical Chapters by Francis Wormald* (Oxford, 1957), esp. XXXII, 48, 97, n. 2, 116, 188.

140. See Buchthal, as in the previous note. Folda, *Crusader Manuscript Illumination at Saint-Jean d'Acre, 1275–1291* (Princeton, 1976), who relies on Buchthal, ascribes additional manuscripts to Acre. See also his studies cited below, notes 151, 155.

141. Buchthal, *Miniature Painting,* 39–46, esp. 40–41, on the marriage.

142. Ibid., 144: "ut famulum tuum N. comitem *nostrum* [my emphasis] custodias" (fol. 174v). Buchthal, ibid., 41, speaks of "the popular ex-king," yet he was certainly not popular with Frederick II: see below.

143. A more detailed treatment of this subject will appear elsewhere.

144. Gigetta Dalli Regoli, "Il salterio di San Giovanni d'Acri della Riccardiana di Firenze," in *Federico II: immagine e potere,* ed. Maria Stella Calò Mariani and Raffaella Cassano (Venezia, 1995), 442, 444–45, basically follows Buchthal while pointing to other attributions.

145. Buchthal, *Miniature Painting,* 68–69, 79–87; Folda, *Crusader Manuscript Illumination,* 26, 77–80, 102; idem, "Crusader Art in the Kingdom of Cyprus,

1275–1291: Reflections on the State of the Question," in *Cyprus and the Crusades,* ed. Coureas and Riley-Smith, 212–13.

146. See Weiss, *Art and Crusade,* 202–4, who adds an alternative hypothesis, namely, that the manuscript was commissioned as a gift to the king after his arrival in Acre. This hypothesis is clearly inspired by Buchthal's scenario regarding the British Library *Histoire Universelle,* on which see previous note.

147. See above, p. 108.

148. See D. Jacoby, "Pilgrimage in Crusader Acre," 115–16.

149. Jean sire de Joinville, *Histoire de Saint Louis: Credo et lettre à Louis X,* ed. Natalis de Wailly (Paris, 1874), 86–88, par. 157, and 282–84, par. 516.

150. D. Jacoby, "Knightly Values," 160–61.

151. Folda, *Crusader Manuscript Illumination,* 42–116, 163; "The Hospitaller Master in Paris and Acre: Some Reconsiderations in Light of New Evidence," *Journal of the Walters Art Gallery* 54 (1996): 51–59, 269–72; also below, note 155. However, the appellation *Hospitaller Master* is a misnomer, since there is no indication that this artist was a Hospitaller, nor did he exclusively work for the Hospitallers.

152. D. Jacoby, "Knightly Values," 164–78. On Cyprus, see also above, pp. 118–19.

153. Note similar paintings in English royal castles: D. Jacoby, "La littérature française," 637–39; idem, "Knightly Values," 169–70.

154. On this particular aspect, see ibid., 178–79.

155. Edbury and Folda, "Two Thirteenth Manuscripts of Crusader Legal Texts from Saint-Jean d'Acre," *Journal of the Warburg and Courtauld Institutes* 57 (1994): 243–54.

156. On one or several *scriptoria* in Acre, see Minervini, "Produzione e circolazione di manoscritti negli stati crociati: biblioteche e *scriptoria* latini," in *Medioevo romanzo e orientale: Il viaggio dei testi,* III Colloquio internazionale Medioevo Romanzo e Orientale, Colloqui 4 (Soveria Mannelli, 1999), 88–96. Yet see my reservations about the attribution of certain manuscripts to Acre, above, pp. 116, 118–19.

157. On the sale of icons from an existing stock, see above, p. 101.

158. D. Jacoby, "La littérature française," 620–22; idem, "Knightly Values," 165.

159. This is suggested by Gianfranco Folena, "La Romània d'Oltremare: francese e veneziano nel Levante," in idem, *Culture e lingue nel Veneto medievale* (Padova, 1990), 271–72 and n. 5.

160. D. Jacoby, "La littérature française," 633–34.

161. Martin da Canal, *Les estoires de Venise: cronaca veneziana in lingua francese dalle origini al 1275,* ed. Alberto Limentani (Firenze, 1972), 2, and for the dating, ibid., Introduzione, xviii–xxxii.

162. See Alberto Limentani, "Cultura francese e provenzale a Venezia nei secoli XIII e XIV," in *Componenti storico-artistiche e culturali a Venezia nei secoli XIII e XIV,* ed. Michelangelo Muraro (Venezia, 1981), 64–70. On Franco-Italian and Franco-Venetian, see also John Critchley, *Marco Polo's Book* (London, 1992), 19–20.

163. See above, p. 115.

164. Some settlers belonging to families of the Venetian elite were quite wealthy, as

illustrated by their ownership of several houses in Acre: D. Jacoby, "L'expansion occidentale dans le Levant," 239. Although late, these pieces of evidence clearly reflect conditions also existing in the 1240s. On Marsilio's memorandum, see above, pp. 114–15.

165. On the return of settlers to Venice after many years in the Levant, see D. Jacoby, "Mercanti genovesi e veneziani," 221–23.

166. As suggested by Folda, *Crusader Manuscript Illumination*, 115–16, 138–41, esp. 139, and 192–96 (catalogue, no. 12).

167. Buchthal, *Miniature Painting*, 69–70 and n. 2; repeated in Folda, *Crusader Manuscript Illumination*, 17 and 25, n. 114.

168. B. Z. Kedar, "Toponymic Surnames as Evidence of Origin: Some Medieval Views," *Viator* 4 (1973): 123–29, esp. 127. A similar problem arises with respect to the location at which the scribe Jaquemin d'Acre worked in 1270. His name appears in the colophon of an illuminated manuscript reproducing the second version of a work by Gossuin de Metz, entitled *Image du monde*. Minervini, "Produzione e circolazione di manoscritti," 92–93, speaks of an "opera copiata probabilmente ad Acri." This version was supposedly based on a Latin book found in Acre in the library of the relocated church of Mount Zion, yet there is no indication where the translation into French or the copy of the latter was made.

169. In 1432 it belonged to Phoebus of Lusignan: Buchthal, *Miniature Painting*, 69. On this member of the royal family, see Wilpert H. Rudt de Collenberg, "Les Lusignan de Chypre: généalogie compilée principalement selon les registres de l'Archivio Segreto Vaticano et les manuscrits de la Biblioteca Vaticana," *Epeteris tou Kentrou Epistemonikon Ereunon* 10 (Nicosia, 1979–80): 190–92.

170. Folda, "Crusader Art in the Kingdom of Cyprus," 218, fails to take into account the problem posed by the name of the scribe and, since the manuscript was later in Cyprus, postulates that the latter was commissioned by a Frankish patron of the island from a workshop in Acre.

171. Folda, ibid., 216–19, 221, dates the panel on the basis of a comparison with another icon ascribed to the 1280s; see also idem, "Reflections on the Mellon Madonna as a Work of Crusader Art: Links with Crusader Art on Cyprus," in *Dei Gesta per Francos*, ed. Balard, B. Z. Kedar, and Riley-Smith, 366–68; Carr, "Art in the Court of the Lusignan Kings," 242, proposes a dating after the fall of Acre in 1291, apparently following Buchthal's contention that the manuscript reached Cyprus at the time.

172. Folda, "Crusader Art in the Kingdom of Cyprus," 227, n. 49; and Norman Housley, "Charles II of Naples and the Kingdom of Jerusalem," *Byzantion* 54 (1984): 527–35.

173. Susan Young, *Byzantine Painting in Cyprus during the Early Lusignan Period* (Ph.D. diss., University of Pennsylvania, 1983), 395–96, points to the affinity between some miniatures of this manuscript and the Sacrifice of Isaac depicted on a wall of the church of St. Herakleidios in Kalopanagiotis, executed before 1291. However, the instance is too isolated to allow for any broader conclusions. On the church, see Andreas Stylianou and Judith Stylianou, *The Painted Churches of Cyprus: Treasures of Byzantine Art* (London, 1985), 294–305.

174. D. Jacoby, "Knightly Values," 160–67, 174.

175. See Enlart, *Gothic Art and the Renaissance in Cyprus,* trans. and ed. by David Hunt (London: Trigraph/A. G. Leventis Foundation, 1987); T.S.R. Boase, "The Arts in Cyprus: Ecclesiastical Art," in *A History of the Crusades,* ed. Setton, vol. 4, *The Art and Architecture of the Crusader States,* ed. Hazard, 167–74; Michael D. Willis, "The Larnaca Tympanum," *Kypriakai Spoudai* 45 (1981): 15–28, on a piece dated to the second decade of the thirteenth century; see also next note. And, recently, J. B. de Vaivre, "Sculpteurs parisiens en Chypre autour de 1300," in *Dei Gesta per Francos,* ed. Balard, B. Z. Kedar, and Riley-Smith, 373–88. According to that author, two statues discovered in Nicosia display a strong affinity with those made by an atelier active at Notre-Dame in Paris around 1260: ibid., 376–80. However, he ascribes their carving by a sculptor from that workshop in Nicosia to the reign of King Philip IV of France (1285–1314), thus several decades later. This late dating apparently derives from the common misconception that there must have been a lag of many years between the diffusion of new artistic trends in the West and in the "colonial" Frankish Levant, respectively.

176. For example, by Folda, "Crusader Art in the Kingdom of Cyprus," 221–22; and Carr, "Art in the Court of the Lusignan Kings," 242–44, 251.

177. As suggested by Carr, "Art in the Court of the Lusignan Kings," 242–43, 251.

178. Favreau-Lilie, "The Military Orders and the Escape of the Christian Population from the Holy Land in 1291," *Journal of Medieval History* 19 (1993): 219, 225–26.

179. He commanded English troops during the siege of Acre and managed to escape to Cyprus: Marshall, *Warfare in the Latin East,* 82; Raynaud, *Les Gestes des Chiprois,* pars. 491, 499, 542, and new ed. by Minervini, *Cronaca del Templare di Tiro,* pars. 255, 263, 306.

180. Michael Stettler and Paul Nizon, *Bildteppiche und Antependien im historischen Museum Bern* (Bern, 1966), 34–37, 49, refer to the provenance of the piece from the cathedral of Lausanne, with a question mark, and as donor one of the lords of Grandson, that is, not necessarily Othon I. According to an undated folder published by the same museum this knight was buried in 1328 in the cathedral of Lausanne after having granted it a number of precious church objects. The antependium was attested there in 1538. It is mentioned by Folda, "Crusader Art in the Kingdom of Cyprus," 216, and examined more in detail by Carr, "Art in the Court of the Lusignan Kings," 243. In a personal communication after the colloquium Annemarie Weyl Carr has expressed some hesitancy regarding the attribution to the Levant, which is mainly based on circumstantial evidence, namely, the presence of Othon in Cyprus.

181. See above, p. 119.

182. Carr, "Art in the Court of the Lusignan Kings," 240–41, 242–43, 250–51, has made a similar point with respect to the origin of Western influences in the art of Cilician Armenia and Cyprus.

183. As suggested for the Levant by Georgopoulou, "Orientalism and Crusader Art," 291.

Before Louis IX: Aspects of Crusader Art at St. Jean d'Acre, 1191–1244

Jaroslav Folda

In a discussion devoted to Frankish culture in the Latin Kingdom of Jerusalem during the second half of the thirteenth century, it is evident that the figure who exerted the most influence on the crusader East was King Louis IX of France.[1] In my chapter, the fact of his towering stature and his enormous patronage is, however, precisely the problem. In effect, it is difficult to see back beyond his time in the Holy Land, because, as modern scholars have shown, Hugo Buchthal and now Daniel Weiss, among others, Louis IX had such a major impact on the Latin Kingdom, during his residence there (1250–54) and in the aftermath, until Acre fell in 1291.[2] Yet that is the very object of my inquiry, to pose the question: what do we know of Acre and the Latin Kingdom as a center for the art of the crusaders between the Third Crusade and the mid-thirteenth century, before Louis IX?

The fifty-five-year period from 1189 to 1244 contains by far the largest number of crusades—eight—when compared to the preceding ninety-two years. From 1095 to 1187, there were essentially only two crusades, and in the subsequent period of forty-seven years, 1244 to 1291, in the Latin East, there were also basically two. Calling and organizing these eight crusades between 1189 and 1244 were some of the most important popes in the high Middle Ages, among whom Innocent III (1198–1216) stands as far and away the most significant figure. Leading these eight crusades, some of the most important princes of Europe were involved, including Richard I Lionheart, king of England, Philip II Augustus, king of France, Frederick II, Holy Roman Emperor, Thibaut IV of Champagne, king of Navarre, and

Richard Plantagenet, earl of Cornwall. In the Latin Kingdom of Jerusalem itself, King John of Brienne also played an important role in the Fifth Crusade (1217–22), and others, especially John I of Ibelin, count of Beirut, played a major role during the crusade of Frederick II in 1228–29, as well as in the civil war following, from 1229 to 1236.

In these years, the city of Acre became the de facto capital of the Latin Kingdom.[3] With the loss of Jerusalem in 1187 and the failure of the Third Crusade to regain the Holy City, Acre effectively served as the political and military, the economic and commercial, the ecclesiastical and, I would argue, the artistic capital of the Latin Kingdom for the hundred years between 1191 and 1291. Acre was, of course, the most important crusader port on the coast of Syria-Palestine. Most of the organs of government and the ecclesiastical institutions and religious and military orders, which had been forced to leave Jerusalem in 1187, had relocated to Acre in 1191. Furthermore, they stayed there even during the period from 1229 to 1244, when partial access to Jerusalem for pilgrims had been regained by treaty, as initially arranged by Frederick II.

Acre became the capital city principally because Jerusalem was no longer available. Acre was the royal residence and the seat of government, although Tyre was now the place of coronation. Acre was also the residence for the patriarch of Jerusalem, who used the cathedral of the Holy Cross of the bishop of Acre as his co-cathedral. It was the location of the headquarters of the Knights Hospitaller and the Knights Templar, and the Teutonic Knights had a major house there. Acre was also the wealthiest crusader city, because of its commerce and the financial resources of its major residents. What Acre lacked compared to Jerusalem as capital was the latter's unparalleled spiritual heritage and authority, and its unsurpassed number of major holy sites. Jerusalem was the center of the Christian world, and Acre could never claim that honor. What Acre possessed that Jerusalem lacked was its important harbor and dynamic commerce, a major system of defensive fortifications that expanded all through the thirteenth century, and a growing population that made it the largest city in the Latin Kingdom. As capital of the Latin Kingdom, Acre was the leading site from which the various attempts to recapture the Holy City were repeatedly, if unsuccessfully, launched.

The issue for us to consider here is what evidence there is that Acre was also a center of artistic activity during these years, 1191 to 1244, and if so, what that meant. What kind of art was produced and when, sponsored by whom? It is well known, following the important publications by Hugo Buchthal and Kurt Weitzmann in the 1950s and 1960s, to what extent Acre is argued to be the artistic capital of the Latin Kingdom, at least in terms of crusader painting, from c. 1250 to

1291.[4] But what do we know about Acre prior to that time, as a center for the arts between 1191 and the middle of the thirteenth century?

Before focusing on the figural arts in the main part of my discussion, there are three points I would like to make about Acre that pertain to its artistic production in this period. Looking back to the historiography of the study of the art of the crusaders before 1940, that is, before numerous manuscripts, panel paintings, and even fresco paintings had been identified as crusader and attributed to the period between 1250 and 1291, many produced in Acre, we find that Emmanuel Rey and Camille Enlart argued that Acre occupied an important role as a center for the arts in the thirteenth century.[5] It was not the only center—Antioch, Tripoli, and even Tyre also played a role in these discussions—but Acre was the most important artistic center. So, to some extent, we need to follow up on Rey's and Enlart's hypotheses, which predate the Buchthal and Weitzmann publications that shifted our attention to the 1250s and beyond.

Second, if we inquire as to the identity and location of the major patrons of the arts in the thirteenth century as we have recognized them in the twelfth century, namely, ecclesiastical, courtly, aristocratic, and possibly also patrons among the wealthy merchants, as well as Christian pilgrims, there can be no doubt that Acre is the most important site to consider, for what appear to be obvious reasons. Moreover, artistic patronage developed and spread to other segments of the population in the thirteenth century. For example, we must consider the role of the new confraternities in Acre and Tyre,[6] the city communes in Acre and Antioch, the increasingly wealthy members of the military orders, as well as laymen of means among the burgesses, educated knights, and lay women, not all of whom were necessarily members of the aristocracy. We expect to find the most art produced where there were patrons with the means to commission it. Acre was the largest and wealthiest crusader city with the most patrons possessing the wealth to commission works of art. It was here that artistic workshops were apparently established after 1191 and developed to meet their needs, however invisible they may seem according to the evidence currently available before c. 1250.

Third, when we investigate the investment of time, manpower, and financial resources in artistic production during the thirteenth century in the Latin Kingdom—before 1244 as well as after—we cannot but recognize the immensely important role that architecture played in crusader activity, at Acre and elsewhere. To some extent Acre is today an archaeological museum of thirteenth-century crusader architecture; but although a well-known fact, its status as such has only begun to be studied. We must not forget that architecture more than any other medium was a focus of crusader artistic and military activity in this period. Even

though it is difficult to recognize architectural survivals from the period 1191 to 1244, because of later demolitions, rebuilds, and repairs, architecture played a pivotal role, both at Acre and at other major sites. Much work was done in terms of reconstruction at well-established fortified cities and castles, as well as in terms of new construction at older fortresses, or the siting and building of entirely new and significant fortifications. In this last category we have the castles of Chastel Pelerin at 'Atlit (1217–18), of Montfort (1228–29), and of Safad (1228–40), as well as the sea castle of Sidon (1227–28, 1253–54), in this period. At Acre we can identify the major construction of the first wall system enclosing the Montmusard suburb to the north of the main city walls, begun after the earthquake of 1202 and completed by c. 1210. Furthermore, when the current excavations underway in the old city of 'Akko are complete, we shall know a great deal more about crusader urban architecture in St. Jean d'Acre. Archaeologists are shedding light on the Hospitaller and Templar headquarters, both of which received major construction in this period, as well as the location and dating of various parts of the city wall system.[7]

Compared to architecture, when we attempt to identify major extant works of figural art which belong to this period and which can also be related in some way to Acre, it appears at first that the evidence is comparatively slim. Nonetheless there was important crusader work done and, if we look carefully, we can see that apparently some of it was produced in Acre in this period. Indeed, we can fruitfully reconsider some of these works in attempting to regain a sense of Acre's role as an artistic center, prior to the advent of Louis IX.

My hypothesis is that Acre was a flourishing center of the arts before Louis IX arrived there in 1250, with a variable output. But if this is the case, why, comparatively speaking, is there so little evidence in the form of extant work? Does this mean that, although much art was produced, a greater percentage of it was lost because of the turmoil and destruction caused by so many crusades, losses greater than those during the periods before and after? Indeed, how can we explain the apparent current situation that much more art has been attributed to the 1250–91 period than to the fifty years preceding it? In this brief chapter, I cannot discuss all aspects of the problem alluded to above, so I propose to focus on issues pertaining to certain extant works of figural art, mostly painting. When were these works done and for whom?

As a matter of historical context we should observe that in contrast to the period from 1250 to 1291, Acre and the Latin Kingdom in general was characterized by a strong German presence from 1191 to 1244. We are, of course, all aware of the major German pilgrims who came to the Holy Land in the last third of the twelfth century—Theodorich and John of Würzburg in the 1160s and 1170s—as well as

Wilbrand of Oldenburg and Thietmar in the 1210s. We remember that the military order of the Teutonic Knights grew out of the German hospital established in Acre during the Third Crusade, and that it built its headquarters castle at Montfort in the nearby hills east of Acre, during and after 1226. Furthermore, three German emperors took the cross between 1187 and 1228. Even though Frederick I died in Cilicia in 1189, and Henry VI died before he could sail to the East in 1197, their armies, or remnants thereof, arrived in the crusader states: some to fight, some to build, some to go on pilgrimage, and some to do all three. Frederick II, the most famous—or perhaps the most infamous—crusader in this period, took the cross in 1215 and vowed to lead the Fifth Crusade in 1217–21, even though in the end he never left western Europe to command the army at Damietta. Finally, of course, he personally led his own "crusade" from 1228 to 1229, a remarkable act considering he was under a sentence of excommunication. Frederick II was not only a somewhat irregular crusader, but also the king of Jerusalem from 1225 to 1228 by virtue of his marriage to Isabel of Brienne. After 1228 his young son, Conrad, was king *in absentia,* but Frederick attempted to rule the crusader kingdom as regent with imperial bailiffs, especially Richard Filangieri in Tyre. Even though the emperor and his supporters eventually lost the civil war in the crusader states, the so-called Lombard or Imperialist Wars fought between 1229 and 1236 against the Ibelins and their supporters,[8] nonetheless a Hohenstaufen king claimed the crown of the Latin Kingdom from 1225 to the death of Frederick II in 1250 and beyond, until the death of Conradin in 1268.

There is a certain irony in the fact that the very year Louis IX arrived in the Holy Land, Frederick II died. But why is it that King Louis IX, who resided in the Holy Land from 1250 to 1254 but could not recapture or even visit the Holy City and was never king of Jerusalem, apparently left a much greater artistic legacy to the crusader states visible to us today than Frederick II, who did regain access to Jerusalem and even wore his imperial crown in the Church of the Holy Sepulchre? Why is this the case, even though—again, ironically—a Hohenstaufen was king of Jerusalem while Louis resided in the Latin Kingdom! In fact, what artistic impact did the German presence leave on the crusader states before Louis IX arrived?

What evidence is there? There are a few works of painting, all of which seem to reflect some aspect of German artistic presence between 1191 and 1244. The most important examples are the Freiburg Leaf, the episcopal miter of Jacques de Vitry, and an icon fragment from the castle of Montfort. The first monument to consider is, however, the best-known work from this turbulent period, namely, the Riccardiana Psalter.

The Riccardiana Psalter was apparently made in Acre in the first half of the thirteenth century.[9] It is a luxury manuscript comparable to the Melisende Psalter, made in Jerusalem c. 1135, in that it was a private prayerbook also produced for a noble lady. Otherwise, it is only minimally and mostly indirectly related to the earlier manuscript. For example, the Riccardiana codex received a calendar reflecting its Jerusalem origin that has only certain generic parallels with Melisende's psalter. The Riccardiana Psalter also has a litany of prayers written for a Benedictine nun at the Convent of St. Anne in Jerusalem.[10] Since the nuns of this convent transferred to Acre at the time of Saladin's invasion, however, it is clear evidence that this litany is based on a manuscript taken from the convent that was apparently available in Acre in the early thirteenth century. Besides references to Benedict and Anne, the litany contains other entries that are of interest, however, including one to Elizabeth, mother of John the Baptist, and several others that are French, mostly female saints from northern France. The reference to Elizabeth has been taken to be an allusion to Isabel, one of the wives of Frederick II, a point to which we will return.

In contrast to the earlier codex, the main decoration of the Riccardiana Psalter consists of a series of scenes of the life of Christ, showing some interest in the contemporary *loca sancta,* but omitting the Crucifixion, starting with a full-page historiated and illuminated initial (fig. 7.1). The remainder of the scenes are found in smaller panel miniatures inserted at the beginning of each of the eight divisions of the psalter, such as an image of the Adoration of the Magi, which alludes directly to Bethlehem (fig. 7.2).[11] This variation on the format for psalter decoration, found in Saxony and Thuringia at this time, is unusual and is the sole explicit "German" aspect of this codex. By contrast, the painting is characterized by a strongly Italo-Byzantine crusader style, apparently made by a crusader painter of Sicilian ancestry or training.

Among other important features of this codex is a prayer, "Pro Comite . . . ," interpreted by Buchthal to refer to King John of Brienne, formerly a count of Champagne. This and the commemoration of Elizabeth in the litany, as an allusion to Isabel, were factors that led him to propose that this manuscript was commissioned by Frederick II for his third wife, Isabel, princess of England, between 1235 and 1237. In fact, the idea that this manuscript was made for Isabel and that the prayer did refer to John of Brienne may be correct, but historical considerations make it clear that, if so, the manuscript could not possibly have been made in the mid-1230s. Instead, it is far more likely that the Riccardiana Psalter was commissioned for Frederick II's second wife, also named Isabel, who was Isabel of Brienne, King John's daughter, at the time of her marriage in 1225. Consider that by

Fig. 7.1. The Riccardiana Psalter, fol. 14v, initial "B," with Annunciation and Nativity. Photo by courtesy of the Biblioteca Riccardiana, Florence.

1235 John of Brienne and Frederick II had become mortal enemies on the battle-field, Acre was in Ibelin crusader control and not open to imperial representatives or artistic commissions from them, and John had now become the co-emperor of the Latin Empire of Constantinople. On the other hand, in 1225 John of Brienne was regent for his daughter Isabel before her marriage to Frederick; the various prayers referred to above would have been appropriate for her, and this manuscript could have been commissioned by John or one of his representatives in Acre as a wedding gift before Isabel sailed to Brindisi to be married to the emperor, leaving her homeland forever.

The details of this argument and the many questions it raises are not relevant for us to explore in this chapter. What is important for us to realize, however, is that the Riccardiana Psalter, while most likely made in Acre as Buchthal argued, probably had nothing to do with Frederick II's patronage. Indeed, the German as-

Fig. 7.2. The Riccardiana Psalter, fol. 36r, panel miniature, with Adoration of the Magi. Photo by courtesy of the Biblioteca Riccardiana, Florence.

pect identifiable in the book was more likely a reflection of the German crusader presence in Acre in this period, part of the crusader city's multicultural diversity, rather than any direct result of imperial artistic patronage by Frederick. In 1225, of course, the German emperor had not yet come to the Holy Land, despite having taken the cross ten years earlier.

What other more substantial evidence do we have for the presence of German artistic activity in the Holy Land? The Freiburg Leaf is a familiar work with two handsome drawings on the recto of the third of three extant leaves (fig. 7.3).[12] The upper register of the Freiburg Leaf depicts Christ and Zachaeus (Luke 19:1–10) in silverpoint. Christ gestures to Zachaeus, depicted only half as large as himself, in keeping with the story. Zachaeus is standing in a sycamore tree before him, with Peter behind Christ looking back, presumably to other apostles who are lost where the vellum has been cut off at the left. A later hand has written the inscription "Christ" and "Zachaeus" in brown ink above the relevant figures. The upper scene seems to have been drawn first because the red lances held by the two soldier saints below, as well as the halo of the saint on the right, overlap elements of the upper scene.

The lower image executed as a sepia pen drawing consists of two mounted soldier saints holding lances, each with a halo. Inscriptions by the same later hand in brown ink indicate a "consodalis" at the left, and at the right, "Theodorus." To the far right of Theodorus's head is the number "lxxv" in red ink, referring to the

Fig. 7.3. The Freiburg Leaf, fol. 1c recto, Christ and Zachaeus (upper register), Sts. George and Theodore (lower register). Photo by courtesy of the Augustinermuseum, Freiburg im Breisgau.

entry of this image on folio 1a, recto. The two figures are surely the youthful, beardless St. George at the left—the inscription simply indicates a "companion soldier"—and the bearded St. Theodore at the right, a typical Byzantine pairing. It is notable that the idea of mounted soldier saints, while not unknown in Byzantium, was of particular interest to crusader artists in the thirteenth century. Furthermore, although the figure of St. George is dressed in recognizable Byzantine military costume, the figure of St. Theodore, with a long tunic reaching all the way down to his ankles, appears to be wearing crusader dress. Both figures also wear a diadem, which is a frequent feature in the crusader iconography of these mounted saints.

Scholars have interpreted the Freiburg Leaf to be an example of a motif or

model book, in which an artist collected sketches of interesting images that he observed during his travels. Everyone seems to agree that the artist in question is a German from the Upper Rhineland, who was traveling c. 1200 when he executed these drawings. Otto Demus also suggested he was an Augustinian monk.[13] Everyone seems to agree as well that the same artist was responsible for both drawings, but the models he used were quite different, and he drew them from different media and in different locations.

It is clear that the style of the two drawings is somewhat different, just as the techniques are distinct. The upper silverpoint drawing is quite refined with sensitive attention to the soft draperies flowing over the figures, the naturalistic tree with fluffy leaves, and the gently shaded components. The lower sepia drawing is more decisive with bold linear definition, strongly stated patterns in the armor, horses' manes, the tack, and the draperies. Nonetheless the artist's basic conventions are the same in both drawings, for example, in the rendering of the faces, demonstrating that this is the same person employing different models. The Freiburg Leaf is worth a fuller discussion elsewhere, but to make our point here, let us focus only on the possible models for the lower drawing.

The lower scene is clearly different from a pair of mounted secular soldiers drawn by Villard de Honnecourt c. 1230 in northern France;[14] indeed, Villard's image helps us to realize that the Freiburg drawing of paired soldier saints must have been based on icon painting. The question is, what kind of an icon and where? Because of the special iconographic features of the lower drawing, referencing characteristics of crusader painting, Weitzmann proposed that the artist had "recourse to a crusader icon as a model," and that he "travelled to the Holy Land, where, in the established crusader ateliers, he must have been exposed to a great variety of copies from Byzantine models."[15] In fact, Weitzmann has published several crusader icons with paired soldier saints, but all of his examples are dated 1250 and later.[16] The Freiburg Leaf clearly dates to c. 1200, however. Therefore, the fact that we have relatively few crusader icons that have been securely attributed to this early period, the years around 1200, suggests one of several possibilities: few icons were made in this period; many were made but none survive from the early thirteenth century due to later destruction, a more likely scenario; or some early-thirteenth-century icons do in fact survive but are currently dated after 1250, which may also be possible. Whatever we eventually decide the case may be, the lower drawing of the Freiburg Leaf clearly seems to indicate, indirectly of course, that there was considerable interest in icons and that such crusader icons did exist.

Where might the artist have traveled to see what Weitzmann called "established crusader ateliers"? The most likely place is, of course, Acre.[17] And the obvious and

most likely reason for this artist to have been in the Holy Land is that he came with the crusaders in 1197–98, the remnants of Henry VI's ill-fated expedition, what we now call the German Crusade. Moreover, he might well have stayed in the Holy Land for a year or two after the other crusaders went home. In any case, his sojourn in Acre could very likely have been facilitated by the newly established house of the Teutonic Knights, which appeared in Acre at the time of the Third Crusade and which opened formally in 1198 at the end of the German Crusade.[18]

In sum, it is not surprising to find that the Freiburg Leaf can be seen quite plausibly as the work of a German artist in the Holy Land. After all, Weitzmann had already suggested this idea in principle in 1966.[19] But it is important to realize that the Freiburg Leaf may help us to see crusader works that existed then, but do not survive today. It has the additional significance of being a rare exemplar of an artist's sketch sheet. The quality of the drawings is, moreover, extraordinarily high and it is our great good fortune that this work has survived even fragmentarily to help us understand more about the way knowledge of crusader art was transmitted back to western Europe. It also suggests that pilgrim artists could have been active in this manner at other times during the crusader period. But it is most interesting to find such a work dating to this period (c. 1197–1200), a period considered to be lacking in the production of crusader objects and their visibility to visiting pilgrims. The Freiburg Leaf is evidence of important artistic work in the crusader kingdom that the pilgrim-painter was apparently able to see, but which has since been destroyed.

Finally, if we ask the question whether the Freiburg Leaf artist is unique in doing this kind of work, the answer is no. We can see possible parallels in a much later crusader diptych containing bust-length images of the Virgin and Child Kykkotissa and the soldier saint Procopius, dating c. 1280.[20] Clearly, the crusader painter of this work, who may have been Cypriot and working at Acre (or even at St. Catherine's monastery on Mount Sinai) could well have seen the great Virgin Kykkotissa icon at the Monastery of the Kykkotissa on Cyprus. Furthermore, he apparently also visited the site sacred to "St. Procopius 'O PERIBOLITES,'" as specified in the inscription, where he saw a special venerated icon of Procopius with this title. Weitzmann proposes to see the church of St. Procopius Peribolites at Siloam, just outside Jerusalem, as the likely site. It was there "where a 'peribolos,' i.e. a sacred precinct, may have given rise to the epithet," where the icon could have been seen.[21] It is there, in any case, where excavations have indicated that the crusaders were interested in the cult of this soldier saint, Procopius, as known from other evidence. Like the Freiburg Leaf artist, the painter of this magnificent diptych was apparently visiting important centers and copying icon models.

Fig. 7.4. The Miter of Jacques de Vitry (front), Christ, Mary, and a bishop with Evangelists and six Apostles. Photo by courtesy of the Soeurs de Notre Dame de Namur, Trésor d'Oignies.

What other works can we consider that relate to a German artistic presence in the Latin Kingdom? There are two other examples that, each in its own way, provide evidence for this phenomenon.

One of the most interesting and unusual objects we have encountered, which seems to show links to the crusader East, is an episcopal miter now in the Treasury of Oignies, in the care of the sisters of Notre Dame de Namur, Belgium (figs. 7.4 and 7.5).[22] This treasury is of capital interest to us because it contains a number of objects bequeathed to it by the famous and outspoken former bishop of Acre, Jacques de Vitry. Jacques lived in Acre from 1216 to 1225 before he returned to Liege and then went to Rome, where Pope Gregory IX made him a cardinal. Eventually, when Jacques de Vitry died in 1240, he willed his property to the Augustinian priory of Oignies, where he had been a regular canon before going to Acre. The miter in question was part of that bequest. It is made of parchment, with a remarkably detailed program of miniature painting executed on the front and back. The question is, where was it made?

Everything about this miter is unusual, its materials, its iconography, and its style. In conjunction with the twelve seated apostles under arches that decorate the base of the miter, we see three medallions on the front vertical element which include Christ, the Virgin Mary, and, at the bottom, a bishop (fig. 7.4). It is an ambitious program that placed the bishop who wore this liturgical headdress directly in the line of latter-day apostles. Furthermore, in the triangular interstices

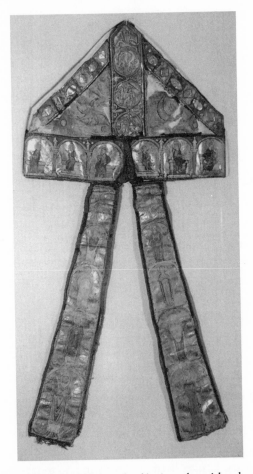

Fig. 7.5. The Miter of Jacques de Vitry (back), Apostles with celestial bodies. Photo by courtesy of the Soeurs de Notre Dame de Namur, Trésor d'Oignies.

we also note a remarkable ensemble of the four evangelist symbols, notable because they apparently bring together different iconographic traditions for this venerable imagery: seated figures, winged animals, and winged human figures. Taken separately these types are all identifiable in western Europe, but this appears to be a unique example of the three types joined together in one grouping. Finally, on the lappets we note the presence of ten additional saints, half of which are women, and two saints who conspicuously carry palms as pilgrims to Jerusalem.

On the basis of the unique character of this miter, on its distinctive program, and on the completely unusual style of the figures, I propose that Jacques de Vitry

commissioned this work for his personal use in Acre, before his departure in 1225. The use of parchment for the painting is entirely extraordinary, such that P. Courtoy and other scholars of liturgical vestments, like Josef Braun, have remarked on its unique character.[23] Such an experimental medium with the lavish use of painted gold and the simulation of precious and semiprecious gems would seem very possible in Acre, far away from the more traditional production of such liturgical headdress in western Europe. The rare iconography also seems unlikely for any known center in the West. But it does correspond to the crusader interest in blending different traditions in Near Eastern workshops; in this case, obviously, most likely in Acre, where Jacques de Vitry was bishop between 1216 and 1225.

Finally, the style is also clearly not what we would expect in the period between 1215 and 1230. It is full of saturated color, characterized by strong, dark outlines and simple modeling, but nowhere do we see the trough folds, the hairpin loops, or other drapery conventions that we would expect to find in the Meuse Valley at this time in the West, as seen in the metalwork of Nicholas of Verdun and related manuscript illumination. More specifically, it is not comparable to the work of Hugo d'Oignies, the greatest metalworker and painter in the Meuse Valley at the time, and the exact contemporary of Jacques de Vitry. Hugo is documented as making two of his chefs d'oeuvres, the Oignies Evangeliary and the St. Peter reliquary, between 1228 and 1230 for the priory of Oignies, just when Jacques de Vitry is recorded as consecrating an altar there in 1228 or 1229.[24] Had this miter been commissioned in Oignies, Hugo would have been the obvious artist to make it, but the style of the miter is clearly not that of Hugo, nor even influenced by Hugo. Viewed from an Eastern perspective, it may be a style that seems rather strongly Western and only mildly Byzantine influenced for Acre at this time, but we certainly seem to have evidence of other Western-trained painters, with varying degrees of Byzantine influence, working in Acre both before and after this period. The problem with localizing the creation of this object in the Latin Kingdom, however, lies in the fact that nothing like it has been found to be the product of a crusader workshop.

Given that few works have been firmly attributed to the crusader kingdom at the time of the Fifth Crusade and before Frederick II arrives in 1228, it is difficult as yet to place this miter within a context of comparanda from the crusader East. Nonetheless I think it is highly probable that this miter was executed in Acre, not in the northwestern lands of the German empire in Europe. Even though its artist may have been partly trained in the region of the Meuse Valley, or by an artist from that region, he may have worked elsewhere in the Latin East before coming to the Latin Kingdom.[25] In any case, the miter seems to offer us a glimpse of what

is perhaps an unrecognized aspect of crusader painting in the Holy Land at the time. Certainly it is hardly unexpected that Western painters would have come to the Holy Land, as pilgrims and to ply their trade. We have already seen above the case of the German artist of the Freiburg Leaf in the late 1190s, and, of course, there is the much later case of the Hospitaller Master from Paris, an artist we now call the "Paris-Acre Master," who came to Acre in the late 1270s.[26] As we investigate these developments further, I am convinced the miter will gradually take its rightful place as an important example of crusader production between 1216 and 1225 from Acre.

The final work I wish to present as part of the evidence of German artistic activity and/or patronage in Acre during these years is an icon fragment from Montfort (fig. 7.6).[27] Montfort, or Starkenberg, the new castle of the Teutonic Knights, was built substantially in the years 1226–29, and was mostly completed by 1240, although some work may have continued into the 1260s. In 1926, during the excavations carried out by Bashford Dean on the site for the Metropolitan Museum of Art, a slender fragment of a painted panel, measuring 22 cm × 2.5 cm, was found in the room identified as the chapel. On the section that remains we can see the sandaled feet of a standing male figure at the left, and to the right a fragmentary pair of imperial buskins also belonging to a standing male figure. Given the position of the feet and the size of the fragment, it is likely that the panel contained only two frontally standing figures.

It is difficult to say exactly what this evidence may indicate, but we can at least make a proposal. Comparing our fragment to extant icons from the Monastery of St. Catherine on Mount Sinai,[28] the sandaled feet may have belonged to an image of St. John the Baptist, to an apostle, or to a prophet. The feet with buskins might have been a figure of St. Michael the Archangel, another saintly figure, or even David or Solomon, but it was clearly not a female figure. The admittedly slender evidence of the extant painted section further indicates, by similar comparisons, that such an icon is related to examples said to have been made in Acre. Furthermore, even though the type and the style point to an artist from Acre, its place of execution could have been Acre, St. Catherine's, or even Montfort.

It is important to point out that with this fragment we have a bit of archaeological evidence indicating the presence of panel paintings in the form of an icon in a crusader castle very near Acre presumably in the first third of the thirteenth century, independent of the large collection at St. Catherine's monastery. Second, apparently icons like this were being used by these knights, either for their corporate worship services, for individual devotional activities, or for both. The question of exactly how the crusaders were using these panel paintings is a large and

Fig. 7.6. Fragment of an icon from the castle of Montfort, two sandaled feet and one foot with a red buskin with pearls. Photo by courtesy of the Metropolitan Museum of Art, Gift of Clarence Mackay, Archer M. Huntington, Stephen H.P. Pell, and Bashford Dean, 1928 (28.99.54).

important issue that we cannot attempt to address here, but this fragment is a significant bit of evidence that raises important questions about such use.

This is not the place to explore the possibility that a number of other icons—all found in the large collection at St. Catherine's monastery on Mount Sinai—may also be attributed to Acre or to Sinai in this period. Suffice it to say that however many there are, none of the possible candidates seem to add any significant further evidence to the presence of German crusader artistic activity, either as products of painters or commissions of German patrons in this period.

It remains then to draw a few conclusions. The evidence presented above seems to indicate clearly that Acre was an important center of crusader art in the Holy Land between 1191 and 1244, not necessarily the only center, but the major center. Furthermore, there is clearly some evidence for German artistic patronage and presence at Acre as an essential part of crusader developments in this period. The evidence of German crusader artists and patronage is quite diverse, and therefore has been largely overlooked in the past. We have a wide variety of examples, to summarize:

a. A pilgrim from the upper Rhineland who sketches icons no longer extant in the Holy Land c. 1198–1200 while traveling in Palestine

b. A Western painter partly trained in Europe and partly crusader- and/or Byzantine-influenced who paints an episcopal miter in Acre, c. 1220, for Bishop Jacques de Vitry

 c. A crusader miniaturist working in an Italo-Byzantine crusader style whose ancestry was possibly Sicilian and who incorporates aspects of Saxon/Thuringian psalter decoration into a luxury prayerbook for a royal crusader patron in Acre, c. 1225

 d. Crusader icon painters working for the Teutonic Knights at Montfort, and conceivably in Acre, in the late 1220s, after c. 1226

Other evidence may come to light. The fact is, however, that despite the impact of German crusader patronage, and the presence of German crusader artists, there is no clear or direct evidence of German imperial patronage in the medium of painting on the part of Frederick II, despite the fact that he did commission important architectural building activity. This means that the crucial aspect of royal patronage, which is central to the impact of Louis IX immediately after the period in question, is largely absent with regard to Frederick II. Just as he was a somewhat mysterious and certainly an independent force as an art patron in western Europe, Frederick II's role in the Latin East is equally difficult to identify.

In sum, we should recognize that before the advent of Louis IX in 1250, the German crusader presence was an important factor in the artistic developments in the capital city of Acre, and elsewhere in the crusader states. I propose that in this period, 1191–1244, Acre was not only the most important crusader artistic center, but also that German crusader work was one of its most significant products and German patrons among the most important sponsors. In this regard it is important to note that the German related artistic activity is mainly to be seen, however, before the civil war of 1229 to 1236, which pitted the Ibelin crusaders centered in Acre against the imperial supporters located especially in Tyre. When these "Lombard Wars" broke out in the Latin Kingdom following the departure of Frederick II for western Europe in 1229, the lack of Hohenstaufen imperial presence in the Latin Kingdom left a certain void in crusader cultural and artistic leadership. It was the coming of King Louis IX to the Holy Land in 1250 that changed this situation most dramatically!

Notes

 1. This chapter is a revised version of a talk given at the symposium, "Frankish Culture at the End of the Crusades: France and the Holy Land," held at the Johns Hopkins University, 24–25 March 2000. I would like to thank the organizers, Anne Derbes, Mark Sandona, and Daniel Weiss, for the invitation to speak and to contribute to this publication of the *Acta* of the conference.

2. Hugo Buchthal, *Miniature Painting in the Latin Kingdom of Jerusalem* (Oxford, 1957), 54–68, 95–97; Daniel H. Weiss, *Art and Crusade in the Age of Saint Louis* (Cambridge, 1998).

3. For a recent historical discussion of this period, 1189–1244, see J. Richard, *The Crusades, c. 1071–c. 1291,* trans. J. Birrell (Cambridge, 1999), 216–331.

4. Buchthal, *Miniature Painting,* 39–105; Kurt Weitzmann, "Thirteenth Century Crusader Icons on Mount Sinai," *Art Bulletin* 45 (1963): 179–203; and idem, "Icon Painting in the Crusader Kingdom," *Dumbarton Oaks Papers* 20 (1966): 49–83.

5. Emmanuel G. Rey, *Les colonies franques de Syrie aux XIIe et XIIIe siècles* (Paris, 1883); and Camille Enlart, *Les monuments des croisés dans le Royaume de Jérusalem: architecture religieuse et civile,* vol. 1 (Paris, 1925), vol. 2 (Paris, 1928), atlas in two albums (Paris, 1926).

6. Jonathan Riley-Smith, "A Note on Confraternities in the Latin Kingdom of Jerusalem," *Bulletin of the Institute of Historical Research* 44 (1971): 301–8. Just as in Italy, the confraternities in the Latin Kingdom merit further study to examine their role as patrons of the arts.

7. For recent developments in the archaeological and historical study of crusader Acre, see Moshe Hastal, Edna J. Stern, et al., "Akko (Acre): Excavation Reports and Historical Studies," *'Atiqot* 31 (1997): 1–207. We expect further information on the architecture at Acre by Denys Pringle in vol. 3 of *The Churches of the Crusader Kingdom of Jerusalem,* being published by Cambridge University Press, which will deal with Acre and is in preparation.

8. The Lombard or Imperialist Wars introduced serious factionalization into the crusader states, with certain parallels to the Guelf-Ghibelline dispute in western Europe. The imperial supporters included troops commanded by the Filangieri brothers, the Teutonic Knights, the Pisans, and certain crusader lords. They controlled Tyre and Sidon. The Ibelin family formed the core of their opponents, claiming the allegiance of forty-three major crusader lords and the majority of the baronage, the commune of Acre, the Genoese, and King Henry of Cyprus. The Ibelin party held Acre, Beirut, and Cyprus. Other major groups, such as the Hospitallers and the Templars, the Venetians, many members of the clergy, and a few lords, originally sought to keep the peace without taking sides, but eventually were forced to join the Ibelins. See Steven Runciman, "The Crusader States, 1192–1143," in *A History of the Crusades,* ed. Kenneth M. Setton, vol. 2, *The Later Crusades, 1189–1311,* ed. Robert L. Wolff and Harry W. Hazard (Madison, 1969), 546–51.

9. Buchthal, *Miniature Painting,* 39–48, 143–44, with older bibliography. I am enormously grateful to Dr. Cathleen Fleck for having generously shared her unpublished research on the Riccardiana Psalter with me. Hers is the most probing discussion of the various problematic issues concerning this important codex. Most reviews of Buchthal's book and comments on the Riccardiana Psalter by other scholars have accepted his interpretations, even if provisionally. Dr. Fleck's detailed unpublished discussion and H. Bober's comments in his review of Buchthal's book in the *Art Bul-*

letin 43 (1961): 65–68, have raised serious questions about Buchthal's attributions in regard to this manuscript. For another discussion and further bibliography see G. D. Regoli, "Il salterio di San Giovanni d'Acri della Riccardiana di Firenze," *Federico II: immagine et potere* (Venice, 1995), 441–45.

10. For the calendar and the litany, see Buchthal, with liturgical and palaeographical chapters by Francis Wormald, *Miniature Painting*, 107–8, 110–21, 129–30.

11. Ibid., pls. 52–54.

12. The Freiburg Leaf is in Freiburg-im-Breisgau, Augustinermuseum, inv. No. G. 23/fols. 1a–c. Recent bibliography includes Jaroslav Folda, "The Freiberg Leaf: Crusader Art and Loca Sancta around the Year 1200," in *The Experience of Crusading*, vol. 2. *Defining the Crusader Kingdom*, ed. P. Edbury and J. Phillips (Cambridge, 2003), 113–34; Robert W. Scheller, *Exemplum: Model-Book Drawings and the Practice of Artistic Transmission in the Middle Ages (ca. 900–ca. 1470)* (Amsterdam, 1995), 136–43, cat. No. 8; E. Sebald, "Blätter aus einem Musterbuch," *Ornamenta Ecclesiae*, vol. 1 (Cologne, 1985), 316–18, no. B 89, all with additional older bibliography.

13. Otto Demus, *The Mosaics of Norman Sicily* (London, 1950), 446.

14. Hans R. Hahnloser, *Villard de Honnecourt: Kritische Gesamtausgabe des Bauhüttenbuches, ms. fr. 19093 der Pariser Nationalbibliotek* (Vienna, 1935), pl. XVI, or Theodore Bowie, ed., *The Sketchbook of Villard of Honnecourt*, 2d ed. (New York, 1959), pl. 19.

15. Weitzmann, "Icon Painting in the Crusader Kingdom," 80–81.

16. See, for example, ibid., 79–81.

17. Acre is the most likely source, but we cannot eliminate St. Catherine's on Mount Sinai as an important possibility as well. This is an important issue that should be mentioned, but will have to be discussed at some other opportunity.

18. I. Sterns, "The Teutonic Knights in the Crusader States," in *A History of the Crusades*, ed. Kenneth M. Setton, vol. 5, *The Impact of the Crusades on the Near East*, ed. N. P. Zacour and H. W. Hazard (Madison, 1985), 315–27.

19. Weitzmann, "Icon Painting in the Crusader Kingdom," 80–81.

20. Ibid., 66–69.

21. Ibid., 67. Questions have been raised about this reading of the inscription. M. Aspra-Vardavakis, "Diptych: A. St. Procopios, B. The Virgin Kykkotissa, and Saints," in *Mother of God: Representations of the Virgin in Byzantine Art*, ed. Maria Vassilaki (Athens, 2000), 444–46, proposes that the reading of this word should be interpreted as "noised abroad," or, in effect, "famous" or "well known." Whatever the final outcome of this issue, the fact is that our artist could still have visited a sanctuary of St. Procopius, at Jerusalem or elsewhere, where he was inspired by an icon of the saint, which is our point here.

22. P. Courtoy, *Le trésor du Prieuré d'Oignies aux soeurs de Notre-Dame à Namur et l'Oeuvre du Frère Hugo* (Brussels, 1953), 100–102, no. XXVII, and 136.

23. Ibid., 100; and J. Braun, "Die Paramente im Schatz der Schwestern U.L. Frau Namur," *Zeitschrift für Christliche Kunst* 19 (1907): cols. 293–94.

24. Courtoy, *Le trésor du Prieuré d'Oignies,* 16–24, figs. 1–3 (Evangeliary covers); 30–36, figs. 12–17 (St. Peter's reliquary).

25. The artist could have come to the Latin Kingdom by way of the Latin Empire. The artistic developments of the Latin Empire (1204–61) require serious study to shed light on possible links with the crusader states in Syria-Palestine. We know there were such links, as indicated by the later stylistic connections between the Arsenal Old Testament made in Acre and the St. Francis frescoes in Constantinople.

26. On the Hospitaller Master, whom we are now calling the "Paris-Acre Master," see Folda, "The Hospitaller Master in Paris and Acre: Some Reconsiderations in Light of New Evidence," *Journal of the Walters Art Gallery* 54 (1996): 51–59, 269–72, and idem, "The Figural Arts in Crusader Syria and Palestine, 1187–1291: Some New Realities," *Dumbarton Oaks Papers* 58 (2004): forthcoming.

27. B. Dean, "The Exploration of a Crusaders' Fortress (Montfort) in Palestine," *Bulletin of the Metropolitan Museum of Art, New York* 22, pt. II (1927): 36, fig. 52; 39–40, accession no. 28.99.54.

28. Consider comparanda from Mount Sinai published by Weitzmann. For example, the icon with the Virgin of the Burning Bush with Moses, Elijah, and St. Nicholas or the icon with the Virgin of the Burning Bush flanked by St. John the Baptist and Moses shows figures with sandaled feet (cf. Weitzmann, "The Icons of the Period of the Crusades," *The Icon* [New York, 1982], 217, 228). They also show the long robes of the Virgin partly covering her buskins. Icons depicting St. Michael the Archangel, other saintly figures, like St. Stephen, or the worthies of the Old Testament, such as David and Solomon, show how their pearl-decorated buskins are not covered by their outer robes (cf. ibid., 225).

PART IV

THE USES
OF SECULAR HISTORY

The Perception of History
in Thirteenth-Century Crusader Art

Bianca Kühnel

WHAT STRIKES ONE MOST in examining the Acre manuscripts[1] is the discrepancy between the ambitious historical perspective, from Creation to the crusades, offered by the texts copied and illuminated in Acre and the precarious political and military situation of the time and place that engendered these manuscripts. The thought arises that the richly illuminated manuscripts produced by the Acre scriptorium were meant to evade embarrassing circumstances for the sake of adhesion to a glorious ideal, and this is indeed an idea proposed by Daniel Weiss in his study of the Arsenal Old Testament.[2] The so-called *Histoire Universelle* and *Histoire d'Outremer* manuscripts illuminated in the scriptorium some ten to thirty years after the Arsenal Old Testament are even more revealing in this direction, first because the copying of their texts and their illumination were contemporary with the most critical period of crusader Acre, and second, because they deal with texts and topics that have a meager and comparatively shorter career in Christian iconography than the Bible. Biblical *exempla* were constantly associated with early Christian and medieval rulers, East and West, whether to provide them with a perhaps lacking legitimacy or to glorify them and strengthen their position through propaganda. The manipulation of mythology and history, however, occurs only sporadically in Christian iconography before the thirteenth century, having been substantially promoted by the development of secular historiography and vernacular literature.[3] Since this was a relatively new field, it was more open to innovation than biblical iconography, being from the outset able to reflect immediate political realities in a more direct way.[4] The fact that the crusader preoccu-

pation with secular works is part of the general contemporary interest in such texts cannot in itself explain the particular weight accorded by the crusaders to secular historiography between mid-thirteenth century and the year 1291. Indeed, the majority of illuminated manuscripts produced in Acre between 1250 and 1291 were either of the *Histoire ancienne jusqu'à César*[5] (abbreviated to "*Histoire Universelle*," the oldest French chronicle of the world, that actually ends with Caesar) or the French, updated version of William of Tyre's *History of Deeds Done Beyond the Sea,* equally inaccurately abbreviated to "*Histoire d'Outremer.*"[6] Whatever the significance of such statistics, it is the iconographical study of these secular illuminations that brings us further in our understanding of crusader mentality during the last decades of the Latin Kingdom. The iconography of these manuscripts has great importance for the study of thirteenth-century book illumination in general, but especially for its contribution to the reconstruction of the crusaders' self-image at the waning of an almost 200–year occupation of the Holy Land.

It seems to me that what most characterizes the attitude toward history, whether remote or close, of the thirteenth-century crusaders in Acre was a consistent attempt to draw from it those *exempla,* which, while being highly relevant to the present, have an intrinsic capacity to emphasize continuity. This feature is suggested first of all by visual composition and context, which imply a continuous flow from one period or situation to another, based on the typically weak medieval sense of chronology.[7] The evidential value of the scenes to be discussed here is increased by the fact that they contain iconographical details appearing only in copies of the chronicles from the local-Byzantine group of Acre manuscripts, and not shared by the local-Gothic or the Western illuminated copies of the same texts.[8] The manuscripts that belong to the local-Byzantine group produced in Acre are, in chronological order:

1. The *Histoire Universelle* in Dijon, Bibliothèque Municipale, MS. 562,[9] contemporary with the *Histoire d'Outremer* manuscript in Paris, Bibliothèque Nationale, MS. fr. 2628,[10] and dated by Hugo Buchthal to 1260–70.[11]

2. The *Histoire Universelle* in Brussels, Bibliothèque Royale, MS. 10175,[12] contemporary with the *Histoire d'Outremer* manuscripts in Lyon, Bibliothèque Municipale, MS. 828,[13] and St. Petersburg, M.E. Saltykov-Shchedrin State Public Library, MS. fr. fol. v.IV.5,[14] produced ten to twenty years after the previous group.

3. The *Histoire Universelle* in London, British Library, MS. Add. 15268,[15] and the first five illuminations of the *Histoire d'Outremer* manuscript in Paris, Bibliothèque Nationale, MS. fr. 9084.[16] Though not equal in qual-

Fig. 8.1. Dijon, Bibliothèque Municipale, MS. 562, fol. 170v.
Photo: F. Perrodin.

ity, these two manuscripts are considered contemporaneous by Buchthal, dating probably to the very last years of crusader Acre, shortly before its collapse in 1291.[17]

The *Histoire Universelle* manuscript in Dijon has on folio 170v an exceptional depiction of Alexander the Great kneeling before the high priest in front of the Temple, shown as a domed centralized building (fig. 8.1).[18] The building is unique in design, not only among the *Histoire Universelle* manuscripts but also when compared with Western illuminated copies of the *Alexandreis,* the medieval romances recounting the deeds of Alexander the Great.[19] Also unique in the iconography of this scene is the object held by the high priest in his covered hands: a polygonal pyxis with pointed lid and the letter *S* standing for the Trisagion Sanctus, Sanctus, Sanctus, inscribed three times on the visible faces of the casket. At least one version of the Alexander story includes a detail on which the Dijon miniature was probably based: the high priest, welcoming Alexander in front of

a group of priests and other people, all clad in full ceremonial, liturgical costume, holds a golden plate on which the four letters of the name of God are written. When asked by the Syrian kings why it is that he adores the Jewish high priest, he who is adored by all, Alexander answers that he is not adoring the priest but the God represented and served by the high priest. This episode figures in the text of an Alexander manuscript from the late thirteenth century in Leipzig, belonging to the Orosius recension.[20] This very detailed illuminated manuscript (of 215 miniatures) contains a depiction of Alexander kneeling before a high priest with miter and crozier,[21] but omits the golden plate altogether. A further miniature, showing the two protagonists seated, is concerned with a related episode, that of the high priest giving Alexander the Book of Daniel,[22] which contains the prophecy that a Greek will interrupt the hegemony of the Persians. The Book of Daniel features as the gift presented by the high priest to Alexander in illuminated manuscripts of other recensions of the Alexander text, even when only one illumination is devoted to the meeting between Alexander and the high priest, as, for example, in a probably contemporary French manuscript in Berlin, a copy of Walter of Châtillon's 5000–hexameter-long poem, *Alexandreis,* of 1184.[23] The only miniature coming closest to representing the "golden plate" with inscription mentioned in at least one Alexander recension is a crusader manuscript of Acre, the *Histoire Universelle* in Brussels, folio 216v, which shows the high priest within the city gate of Jerusalem displaying a banner with three rows of inscription on it.[24]

It seems that the inscribed golden plate of the medieval Alexander texts found no visual echo in Western illuminated manuscripts. The transformation of the golden plate of the text into a pyxis has no parallel. The Acre context seems to have generated a special interest in an Alexander episode where the Jerusalem Temple was involved, the Temple whose tradition had been appropriated by the crusaders. The unusual introduction of a pyxis, a possible container of relics, can also be understood in crusader terms, particularly since the Latin conquest of Constantinople, accompanied by a great transfer of relics to the West, established an equivalence between success in obtaining a relic and active participation in the crusade. A most striking expression of this equation is the rule saying that the person who brought home a relic was exempt from the obligation to contribute to the conquest of Jerusalem.[25] In this context we should also recall the special emphasis relics gained under Saint Louis: his translation of relics from Jerusalem to France caused him to be considered the true Solomon, his people the new Chosen People, the Sainte-Chapelle the new Temple of Jerusalem, and Paris the new Holy Land.[26] Against this background, we may understand the depiction of Alexander the Great kneeling before the high priest in the Dijon *Histoire Universelle* as a

Fig. 8.2. Dijon, Bibliothèque Municipale, MS. 562, fol. 204v.
Photo: F. Perrodin.

symbolical transmission of relics from the Holy Land, standing for the transfer of
authority, legitimacy, and continuity to the New Solomon, the crusader king.

The *Histoire Universelle* in London also uses unusual Alexander iconography
in order to emphasize the crusader king's prowess in war. On folio 203, the meet-
ing between Alexander the Great and the queen of the Amazons is depicted in
such a way as to make clear the superiority of Alexander, seated on an elaborate
throne, significantly larger than the queen, who visibly recognizes his sovereignty.[27]
The courtly, ceremonial character of this representation is as unusual as the one
showing Alexander in front of the high priest in the Dijon and Brussels manu-
scripts of the *Histoire Universelle*. The Western illuminated manuscripts of the
Alexander text are on the contrary balanced in the depiction of the two parties,
Alexander and the Amazons, in spite of differences in iconography and style. The
French manuscript in Berlin, while showing the two opposed armies facing each
other, even allows the Amazons some superiority, letting the victory of Alexander
appear not at all secure.[28]

The temple of Janus is another theme that provided the Acre crusaders with a
basis for unusual iconography. The Dijon *Histoire Universelle* shows on folio 204v
(fig. 8.2) a statue of the naked two-headed god perched on a column in a sort of
arched niche between two different buildings with open entrances of equal height.

The emphasis on the open entrances undoubtedly reflects the classical story of Janus, the double-faced god, who gazed toward the two opposite doors of the temple arch, facing east and west; they were locked in peacetime and opened during war. However, the Dijon illuminator, while displaying his knowledge of the classical tradition, transformed it so as to incorporate a message of his own time and place: the two entrances of Janus's temple arch are translated into two different buildings, one centralized (square) and domed, the other longitudinal, two-storied, narrow, and tall, topped by a gabled roof, possibly suggesting Eastern and Western architecture, respectively.

This version of the temple of Janus in the Dijon manuscript departs not only from the classical legend of the god, but also from the medieval paraphrase in the text of the *Histoire Universelle*. The medieval version has the statue of Janus placed on an altar and the temple transformed into an armory. The two doors kept open in wartime are assigned appropriate functions: one is for the soldiers to collect their arms before battle, the other to deposit them after victory.[29] The corresponding illumination in the Brussels *Histoire Universelle*, folio 254v,[30] is entirely faithful to this version of the Janus story, as are the illuminations of the copies belonging to the local-Gothic group or produced outside Acre.[31] They all show Janus on an altar, soldiers pacing inside and outside the building, which is a Gothic church. Unlike all these, and the Brussels manuscript, the Dijon illustration ignores the neighboring text, which harks back to the classical story, but adapts the element of continuity (between war and peace, East and West) to its own, contemporary purposes. The reference to the Temple of Jerusalem, identified by the lily above the entrance as the crusader Templum Domini, evidently extends the element of continuity in the figure of Janus to the Kingdom of Jerusalem and to the French monarchy.[32] Manipulating the Janus iconography for this purpose invests the crusader message with historical depth and universal authority.

The London *Histoire Universelle* shows on folio 242v a different but equally original depiction of Janus (fig. 8.3).[33] The temple of the god is reduced to an enclosure wall, with two window-like openings encircling an elaborate column, which supports a relatively small statue of the naked god. This representation of the temple of Janus takes up no more than one-third of the frame, the rest being occupied by what Buchthal calls "the Roman Senators' feast":[34] five dignitaries, clad in medieval costume, are banqueting, seated behind a richly furnished table, and engaged in lively discussion. A servant approaches the table from the left, carrying a bottle and a beaker. The architecture behind the feasting figures is most interesting: an elaborate centralized domed building whose four visible arches identify it as an octagon, recalling the Dome of the Rock. Buchthal thought the

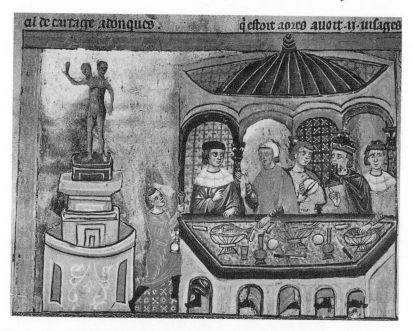

al de cartage adonques . q estoit adrees auoit .ij. uisages

Fig. 8.3. London, British Library, MS. Add. 15268, fol. 242v. By permission of the British Library.

building belonged to "a well-known type of classical Roman architecture" and supposed a classical model for the scene.[35]

However, the unique crusader interpretation of the ancient Janus legend in the London *Histoire Universelle* cannot be grasped without the medieval iconography of Janus. During the Middle Ages the two-headed Janus was depicted only as a personification of the month of January, usually placed at the beginning of cycles of the months. As such he already appears in the tenth century (c. 975) on the frontispiece of the Calendar of Fulda in Berlin.[36] During the twelfth century the motif seems to have become very popular in this particular context, since we find it in monumental art, in painting, as in the Panteon de los Reyes of the Colegiata San Isidoro in Leon, c. 1130, as well as in sculpture, on the west façade, left portal, of the Cathedral of Chartres, where one head is of a young and the other of an old man. There can be no doubt that these representations reflect the medieval understanding of the double-headed god Janus as a symbol of temporal continuity: one face directed toward the new year, the other to the old one.

In late medieval art the representation of the month of January as the double-headed god Janus became a basis for variations and additions of different nuances,

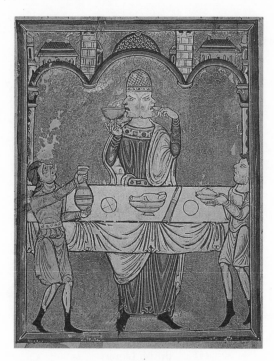

Fig. 8.4. The Hague, Koninklijke Bibliotheek, MS. 76 F 13, fol. 1v

reflecting local, particular interests or tastes. For example, in the fourteenth-century Luttrell Psalter, on folio 206v, a baboon with two human heads and a hat is depicted in a marginal illustration to a page that shows at the foot the act of roasting meat, complementing the representation of January with activities typical for the month; the scene certainly looks, says Michael Camille, like a folk image of a pseudo-liturgical feast.[37] Camille quotes a medieval author, Bonvesin de Riva (1240–1315), who wrote a *contrasto* performed by peasants dressed as months, in which January reigns harshly over his brother months and exploits their labor: "Wicked January who lives without working."[38] These two examples may illustrate the flexibility of our motif during the late medieval period in western Europe and its association with a popular festivity.

An illustration of this late medieval concept of January-Janus, closer, earlier, and therefore more directly relevant to the crusader illumination in London, is the frontispiece of the Fécamp Psalter from c. 1180 in The Hague (fig. 8.4).[39] The Fécamp Psalter has been attributed to northeastern France and compared from a stylistic and iconographical point of view to English psalter illumination of the

end of the twelfth and the beginning of the thirteenth centuries.[40] The psalter opens with a calendar cycle (1v–12v), with a full page dedicated to each month, followed by a New Testament cycle and historiated initials. The frontispiece shows Janus as the personification of January, seated (no stool is visible) at a table: one of his two heads is eating, the other one is drinking. The table is attended by two servants, one brings a bowl, the other a plate. The scene takes place within an architectural frame.

The crusader miniature in the London *Histoire Universelle* evidently originated in a model similar to the Fécamp Psalter. The northeastern French origin of the Fécamp Psalter brings us near the royal French ambiance of the Acre scriptorium. It seems as if the crusader illuminator of the London *Histoire Universelle* was torn between what we may call "the local tradition" of depicting Janus as a column-statue of a god, a tradition that whatever its roots were had already been established in the Acre scriptorium by the earlier Dijon and Brussels *Histoire Universelle* manuscripts, and the western European representation of the feasting Janus. The illuminator found an ingenious solution separating the column-god from the feast. The servant approaching the table from the left illustrates the compromise that must have been reached in terms close to those described above: he is the lone remnant of the pair depicted in the Fécamp illumination. Since Janus is no longer feasting, the anecdote of the double action to occupy his two heads is superfluous, so that a single servant from the symmetrical composition of the Fécamp Psalter was retained in the economy of a different composition in Acre. Details such as the bowls with fishes (in Acre) and pork head (in Fécamp), or the diagonal arrangements of the knives, enhance the similarity between the two manuscripts, making the supposition of a direct influence acceptable.[41]

The question arises whether the process described above was due to merely trivial circumstances, to the compilation of several models, to the lack of understanding of one or of all the models available, or to deliberate choice. My own opinion is that whoever was responsible for the decoration of the Acre manuscripts, whether the artists themselves or their sponsors, was aware of what they were doing. The key to our understanding of these representations lies in the depiction of the two-headed god Janus in connection with a temple (therefore its separation from the feast scene), that is, the temple of Janus associated in Acre with the Temple of Jerusalem. Preserving the association to a temple, although the medieval iconography of Janus shows no sign of one, suggests that the Acre illuminators, while aware of the medieval iconography of Janus-January, were nevertheless still interested in the original connotations of Janus as a Roman god. The importance of the pagan Janus must have been substantially greater than is indi-

cated by the bits of information that have reached us. Modern research has paid little attention to the interpretation and correlation of the extant ancient sources, which are at times extremely controversial; the most recent study (by Robert Schilling of the Ecole française de Rome) is already forty years old.[42] Even so the classical Janus can consider himself lucky when compared to the total neglect of his medieval counterpart: the medieval redaction of ancient sources referring to Janus, such as that appearing in the *Histoire Universelle,* has not yet been explored, and the Christian implications assigned to the ancient god have not yet been taken into consideration. The most explicit extant classical source is Ovid, *Fastes,* I, 63-288, 317-36.[43] Many other ancient sources concerning Janus were collected and transmitted to the medieval and modern eras through Macrobius at the beginning of the fifth century C.E. I shall here outline only a few aspects of Janus's complex and changeable identity, as documented by the available sources, aspects that seem relevant to the crusader representations discussed here.

The god Janus was most probably a Roman creation of the sixth century B.C.E. resulting from a conflation between a function and a foreign deity with two heads. The function is etymologically documented by the Latin *ianus,* one of the words used to designate an arched porch in addition to *fornix* and *arcus,* these last two being later and limited to architectural terminology. *Ianus* is not only the oldest term for an arch, but also the only one to refer to the content, the concept of *transitio* through the porch, and not to the form alone. This definition and interpretation is based on Cicero, *De natura deorum,* II, 27, 67: "transitiones per viae iani nominantur."[44] Ovid pinpoints the difference between *ianus* and the god Janus: in *Fastes* I, 257, he asks how it is that in spite of the fact that there are so many *iani,* only one is dedicated to Janus.[45] He was of course reflecting a contemporary circumstance.

During the sixth century B.C.E. this function of *transitio* materialized into a *bifrons* deity, whose shape was most probably borrowed either from the Etruscans or from the ancient Middle East.[46] The two heads were essential for a deity presiding over the cult of passage, and believed to keep an eye on the vulnerable axis of the city, that of the east-west. To understand the importance and longevity of Janus in ancient Rome, we must keep in mind the weight given to the passage cult as part of the protection system of the city. The ancient city was protected not only physically by a wall, but also by a magical barrier called a *pomerium,* supposed to keep hostile supernatural forces at bay. The arched porches, guarded by deities, are therefore essential parts of this protection system, in which Janus occupied a key position. Entry within the walls of the city was forbidden to armed soldiers. The Janus statue was placed at the north gate and the two heads supervised the

east-west axis. Since the axial arrangement of a city was believed to be magical, predetermined, and reflecting the order of the universe, Janus was known as the author of the order of the universe, the *custos mundi*, the guardian of heaven.[47] This aspect was related to another typical Janus function, that of being, together with Juno, the deity of the *calendae*, the dates that through their periodical return make the other divisions of time possible. Already in the third century B.C.E. he was considered to be the master of Time.[48] Nigidius Figulus, the most important exponent of first-century B.C.E. neo-Pythagorism, knew of Janus as a solar god, a belief that must have developed much earlier. It was only natural that once the reform of the twelve-month year was introduced (by Numa, as traditionally believed) Januarius became the name of the first month.

Under Augustus one very important aspect of Janus's personality seems to have prevailed: he was mainly Janus Quirinus, the god of peace, not only of the *pax Romana*,[49] but also of the universal notion of peace, of eternal peace; not every peace, of course, but the victorious peace. In the official version of Augustus's testament we read: "Ianum Quirinum, quem clausum esse maiores nostri voluerunt, cum per totum imperium populi Romani terra marique esset parta victoriis pax."[50] Horatius, in one of his *Epistles*, II, 1, 255, names him *"custodem pacis . . . Ianum."*[51] Through Dio Cassius we know that Augustus intended to close the temple of Janus (as a sign of peace) in the year 10 B.C.E., the year when he built altars and statues to *Concordia*, to the *Salus Populi Romani*, and to *Pax*, but was prevented from doing so by the uprising of the Dacians.[52]

The most ancient temple of Janus was a double arch above Argiletum, the street leading from the Republican Forum Romanum to the *suburba*. The double-headed statue of the god stood in the middle of the arch, supervising the entrances. Under the empire and the construction of new *fora*, this monument became too modest. Domitian built a new temple to Janus, an arch with four openings in the cardinal directions, the still standing Janus Quadrifons, with key location in the middle of the Forum transitorium, on the way from the temple of Mars Ultor in the Forum Augustae to the temple of peace of the Forum of Vespasian.[53] Thus, Janus practically became the exponent of imperial Rome, the incarnation of its concept of universal, victorious peace.

The story of the medieval armory attached to the temple of Janus in the text of the *Histoire Universelle* indicates that the idea of victorious peace attributed to Janus in imperial Rome was revived in the late Middle Ages. The illustration of the month of January with the aid of the double-headed god shows that the other important aspect of the ancient Roman Janus was still alive in the late Middle Ages; in effect, according to the extant monuments, it seems clear that this was

THE USES OF SECULAR HISTORY

the main aspect of Janus represented in Christian art, possibly based on the Christian exegesis that insists on the initial character of Janus's passage attributes. Thus, for example, Augustine, in the seventh chapter of his *Civitas Dei,* writes: "ad Ianum pertinent initia factorum"[54] or "respondetur omnium initiorum potestatem habere Ianum."[55] Isidor of Seville's *Etymologiae* was instrumental in transmitting the identification of the god Janus with the month of January to the Middle Ages: "Ianuarius mensis a Jano dictus, cuius fuit a gentilibus consecratus; vel quia limes et ianua sit anni. Unde et bifrons idem Janus pingitur, ut introitus anni et exitus demonstraretur."[56]

The adherence of the Dijon and London *Histoire Universelle* manuscripts to the representation of Janus as a double-headed god associated with the city of Rome through column and temple shows the direction of crusader preferences, namely, for the message of peace emanating from imperial Rome; the additional connotations to the personification of January stand for continuity. The Frankish Kingdom of Jerusalem is implied in the continuity schema and is thus associated with Augustus's Rome through references to the Templum Domini. Nothing was more essential to the crusaders at the end of the thirteenth century than a message of victorious peace; its absence in the real world, the precarious existence of Acre, intensified the search for historical *exempla* capable of offering both deeper roots in the past and guarantees for the future.

The image of the construction of Rome on folio 156 of the *Histoire Universelle* manuscript in London also suggests an association with the Temple of Jerusalem.[57] The scene with Romulus and Remus supervising the building strongly recalls depictions of the construction of the Temple under the supervision of King Solomon in manuscripts of the *Bible moralisée,* as in Vienna, Österreichische Nationalbibliothek, MS. 2554, folio 50.[58] This visual similarity must have been due to an aspiration to equate Rome and Jerusalem, with the intention of using the glory of ancient Rome to strengthen the precarious Kingdom of Jerusalem. Similar, probably, was the role of other representative scenes with no textual basis appearing especially in the London *Histoire Universelle* in addition to the council accompanying the Janus statue, as, for example, the council of the Roman senators under Brutus on folio 161v,[59] or the statue of a mounted emperor in the construction of Rome on folio 156. The mounted emperor could be an allusion to the statue of Hadrian in Rome, placed at the Lateran during the Middle Ages and known as Constantine the Great, or the statue of the emperor Justinian in Constantinople, identified during the thirteenth century with the emperor Heracles.[60] These references to imperial and early Christian Rome (or New Rome) were perhaps motivated by an endeavor to extend the genealogy of crusader kingship.[61]

The so-called *Histoire d'Outremer* manuscripts[62] document the search for genealogical roots not in distant but in closer history, namely, in crusader history of the twelfth century as formulated by William of Tyre, his translators and continuators. The side-by-side depictions of the death of a king of the Godfrey of Bouillon dynasty and the early coronation (or appointment)[63] of his successor reflect more than any other illuminations in these manuscripts the Acre crusaders' approach to history. These scenes form a large and consistent group, representing about one-third of all the illuminations in the *Histoire d'Outremer* manuscripts produced in Acre. The repeated appearance of this sequence of two scenes is mentioned by both Buchthal[64] and Jaroslav Folda[65] as an argument of poor quality and lack of imagination. The deliberate novelty and uniqueness of this iconography went unnoticed, as did its significance.

Let us first of all observe that the consistency referred to in the depictions of the crusader kings' deaths and coronations can be observed only in those three manuscripts, closely related to each other, that belong to the "local-Byzantine" department of the Acre scriptorium: Paris, Bibliothèque Nationale, MS. fr. 2628, St. Petersburg, M.E. Saltykov-Schedrin State Public Library, MS. fr. fol. v.IV.5, and Lyon, Bibliothèque Municipale, MS. 828.[66] Only there is the death of a king and the coronation of his successor depicted in close juxtaposition, on superimposed registers, either in initials or beside them, always at the beginning of a chapter. These three manuscripts depict exactly the same six pairs of twelfth-century kings of Jerusalem, from the death of Godfrey of Bouillon to the accession of Baldwin V. The two-episode representations are unique in every possible aspect: they consistently associate death and appointment or early coronation by patriarch and barons in historical sequence, with no compulsive symmetry in the composition. Paris 2628 shows on folio 79 the death of Godfrey and the coronation of Baldwin I (fig. 8.5),[67] while on folio 124 the death of Baldwin II and the coronation of Fulk[68] are very similarly depicted. All the other *Histoire d'Outremer* manuscripts, those of the local-Gothic group as well as the French or Italian examples, show only coronations of some of the crusader kings, in symmetrical compositions centered upon the seated figure of the king (as, for example, Paris 9084, folio 112, with the coronation of Baldwin I, or folio 169 with the coronation of Fulk).[69] Even if the death of a king is occasionally depicted in the manuscripts of this group, it is done independently, on a separate folio, as demonstrated by the illumination on folio 290v of Paris 9084, showing the death of Amalric.[70]

The linkage that the "local-Byzantine" crusader manuscripts of Acre insist on preserving between the death of a king and the accession of his successor is an anachronism from both a historical and an art historical point of view.

Fig. 8.5. Paris, Bibliothèque Nationale, MS. fr. 2628, fol. 79. Courtesy of the
Bibliothèque Nationale.

There are only a few instances in crusader twelfth-century history when the coronation of a successor at the deathbed of a crusader king is mentioned, and always dictated by extraordinary circumstances: Baldwin II, count of Edessa, a relative of Baldwin I, was "coronatus autem et consecratus" on the day of Baldwin I's death, 2 April 1118, in Egypt;[71] Fulk and Melisende were appointed by the ailing Baldwin II; the five-year-old Baldwin V was anointed and crowned by his cousin, the leper king, Baldwin IV.[72] All the other crusader kings were elected by the barons' and churchmen's councils and were crowned a long time after their forerunners' death.

In the two great Western monarchies, that of France and England, during the thirteenth century, the heir began to rule with full power and authority on the day of his accession, which was the day of his father's burial and before his coronation.[73] In France, it was with Philip Augustus, 1180–1223, that the use of two coronation and consecration ceremonies ceased. For six generations before that, the Capetians used to consecrate the successor during the lifetime of the old king, in

any convenient place, dictated by circumstances. A second, public coronation ceremony took place later, always at Rheims, when the new king was already in office. After 1223, early appointments (consecrations) of the son through the father took place only when extraordinary circumstances required this. The two most famous such thirteenth-century exceptions involved Saint Louis: he was appointed by his father Louis VIII, fallen ill in Auvergne during a crusade against the Albigensians; his son, Philip III, was appointed by Louis IX on his deathbed in Tunis. These acts were intended to ensure the succession and to avoid periods with no king, a situation that was impossible from a constitutional point of view.

The crusader examples quoted above as exceptional early appointments show that their usage in the Latin Kingdom was as rare as in thirteenth-century France and was practiced as such already during the twelfth century: Baldwin I died unexpectedly in Egypt, with no direct successors, therefore the urgent coronation of Baldwin II; the early appointment of Fulk by Baldwin II was meant to ensure the unusual succession of a son-in-law, while the coronation of five-year-old Baldwin V was intended to avoid the loss of lineage.

It is obvious, then, that the crusader depictions of death and appointment or early coronation in the *Histoire d'Outremer* manuscripts consistently turned an exceptional historical reality into the rule. Moreover, they also made use of a rare visual formula. In fact, no other depictions exist of the death and the coronation of kings in a single frame, not elsewhere and not in Acre. The manuscript of the French coronation Ordo (Paris, Bibliothèque Nationale, MS. lat. 1246), written and illustrated in Paris shortly before 1250 when Saint Louis took the cross, a long and detailed illuminated depiction of the coronation rite de passage with all its stages, makes no association between death and coronation.[74] Furthermore, this manuscript shows no interest whatsoever in vertical compositions, which were considered suited to the supernatural, but clearly prefers "earthly," ceremonial compositions developing horizontally.[75] In those rare instances where a death scene was included in the same frame as a coronation in the local-Gothic manuscripts of Acre, they were also arranged horizontally, one beside the other, as in Paris 9084 on folio 197.[76] Even if biblical manuscripts sometimes place depictions of death and coronation in a vertical arrangement, the chronological order is the opposite of that followed by the crusader manuscripts: the death scene is depicted in the lower panel, while the coronation is placed above. This is the case with depictions of the Virgin Mary's death and coronation,[77] or David's death and Solomon's anointing.[78]

It thus seems that our manuscripts, in their endeavor to stress the connection between royal deaths and coronations, drew inspiration from a different visual

Fig. 8.6. Göttingen, Niedersächsische Staats- und Universitätsbibliothek, MS. Jurid 27, fol. 28v

source. Significantly closest to them are illuminated legal manuscripts of the thirteenth and fourteenth centuries when they consider various possible alternatives to the inheritance law. Such, for example, is folio 28v of a thirteenth-century manuscript in Göttingen (Niedersächsische Staats- und Universitätsbibliothek, MS. Jurid 27) (fig. 8.6), discussing the possible theoretical outcomes of a succession with no written will (*De hereditatibus quae ab intestato deferuntur*):[79] above, the unction before death of the central character, surrounded by his family, that is, his legal successors, is depicted. In the lower register, the executor (judge or ruler) with sword and raised finger in a teaching gesture performs the two possible variants of the resolution: the execution *ex maleficio* and the execution *ex contractu*. A comparison with folio 122v of the Acre manuscript in Lyon (MS. 828) (fig. 8.7),[80] where the death of Baldwin I and the early coronation of Baldwin II are depicted, shows the similar arrangement of the two scenes, an arrangement that emphasizes the succession and dependence of one scene upon the other. The resemblance between the frame corner decorations, the similarity in the way the figures relate to

Fig. 8.7. Lyon, Bibliothèque Municipale, MS. 828, fol. 122v. Photo courtesy of the Bibliothèque Municipale, Lyon, Didier Nicole.

the frame, in the way of emphasizing hierarchies within the frame, in the gestures at the deathbed, all suggest that a direct link may have existed between the two manuscripts. Not only were there legal books in the Acre libraries, but some were also produced in Acre itself, as attested by two manuscripts published by Peter Edbury and Folda in 1994.[81] The monumental depiction of the *haute cour* of the Latin Kingdom meeting in Jerusalem on the frontispiece of one of these codices, that containing the *Livre des assises* of John of Ibelin in Venice,[82] confers additional authority upon legal codices and shows what importance was attached to them in crusader Acre. The purposeful use of legal imagery by the crusaders in nonlegal manuscripts throws light on the emphasis they wanted to place on succession and continuity and the great part played by jurisprudence in formulating these principles during the thirteenth and fourteenth centuries.

In view of the exceptional nature of our representations, unique in their historical as well as iconographical lineage, we can hardly be wrong in assuming that the authors of this program consciously compiled a new iconography, in order to

emphasize Godfrey of Bouillon's succession as a coherent dynasty. The reason was beyond simple nostalgia, although this must have been a sentiment certainly experienced by the Acre crusaders toward the end of their hold on the Latin Kingdom. However, the glorification of the twelfth-century crusader dynasty ruling in Jerusalem probably had a more selfish ground: the dynastic continuity was repeatedly made visible in order to provide a solid basis for Acre royalty and an argument in favor of the ideal continuation of the crusader state, beyond and in spite of vicissitudes encountered on the battlefield.

This interpretation, primarily based on observations raised by visual depictions and their iconography, is well anchored in the changes undergone by the concept of state during the thirteenth and fourteenth centuries in the two European monarchies in England and France. At the peak of a long process in which both Church and Empire were involved, a fruitful meeting between the spiritual resources of scholasticism, jurisprudence, and the institution of royalty led to the crystallization of a theory of royalty to support the European myth of kingship.[83] In France, the third quarter of the thirteenth century was decisive in this development, and Saint Louis, who was to take the cross and become a crusader king, acted as the main source of inquiries destined to define theoretically the meaning and scope of royalty in theological, philosophical, and juridical terms.[84]

The key notions of this change were succession and perpetual continuity. The most tangible political symptoms of these changes were the abolition of the successor's coronation during his father's lifetime and the abolition of the "little interregnum," the time between the accession and the coronation, both steps preparing for the formal recognition, in 1270 in France and in 1272 in England, that the succession to the throne was the birthright of the eldest son.[85] These changes covered many aspects, but it cannot be doubted that their most central message was particularly appealing to the crusaders in Acre shortly before 1291: the new concept of rulership made a clear distinction between the person of the ruler, be he an emperor, a king, or a princeps, and his office (*officium* and *dignitas*);[86] the person might die, the office is eternal. This concept was embedded in, although not engendered by, the revival, after the middle of the thirteenth century, of the Aristotelian doctrine of the eternity of the world, distinct from the traditional Augustinian concepts of Time and Eternity.[87] Indeed, what happened in the second half of the thirteenth century was a process leading to the secularization of the Christian concept of continuity, a transfer of the angelic *aevum* to earth and man.[88] Even if philosophy did not directly influence governmental practice, the coincidence of parallel developments in philosophical and political thought shows that techniques of government certainly found support in theoretical thought, es-

pecially when dictated by practical needs. Thus, the philosophical concept of perpetual continuity was translated into institutional continuity, which touched upon the most prosaic of institutions such as taxation and diplomatic representation.[89] However, the most central of all institutions affected by the new concept of eternity and continuity, and the one concerning us here, was the monarchy. The principle of dynastic continuity became so self-evident during the thirteenth century that appointments/coronations of the eldest son during the lifetime or immediately after the death of the predecessor were no longer necessary, practically beginning in France with Philip Augustus and becoming law in 1270, as already mentioned. The continuous succession of individuals was only one component of the principle of dynastic continuity. The second component, or notion, was the perpetuity of the collective body politic symbolized by the crown in its two significances (*corona visibilis et invisibilis*): the invisible crown, "encompassing all the royal rights and privileges indispensable for the government of the body politic," made visible by the "exterior crown, that demands an imposition of the hand and the solemnity of offices."[90] The invisible, immaterial crown, which refers to the sovereignty of the whole collective body of the realm, is perpetual. It is probably this quality of the invisible crown that is made visible in the extraordinary deathbed coronations of the crusader representations, which confers on them a generally symbolical character and not a specifically ceremonial one. The third notion with which dynastic continuity operates is the *dignitas,* which although not exactly identical to the *officium regis,* largely coincides with the royal office, the sovereignty of the king. At the beginning of the thirteenth century (c. 1215) a canonist called Damasus formulated the doctrine that must have lain at the basis of the repeated succession ceremonies in the manuscripts of the *Histoire d'Outremer* illuminated in Acre: "the Dignity never perishes, although individuals die every day."[91] To conclude this interpretation of the crusader representations, we may add the very explicit commentary in Bernard of Parma's *Glossa ordinaria* of about 1245: "predecessor and successor are understood as one person, since the Dignity does not die."[92] It is of course not my intention to ascribe the Acre representations directly to this or that text, but rather to rely on specific relevant quotations as illustrations of ways of thinking that were largely known and even typical for the time and place that generated these representations. The sentence formulated by Damasus at the beginning of the thirteenth century became one of those most often used by glossators and postglossators for generations to come, expressing a concept of royalty that was generally known and accepted in the Western monarchies, and also in the crusader state with a capital in Acre.

The concept of Western monarchy made extensive use of Rome and the Roman

Empire, which brings us back to our interpretation of the crusader iconography of Alexander the Great and Janus. It seems that when considered in connection with the legal and political notion of Western monarchy that was focused on continuity during the thirteenth and fourteenth centuries, the crusader relation to Rome as reflected by the representations discussed at the beginning of this chapter takes on an additional dimension.

Common to Christianity during the Middle Ages was the belief that Rome is eternal and that the fourth world monarchy, that of the Romans, will last until the end of the world, an idea based on St. Jerome's identification of Daniel's vision of the Four World Monarchies.[93] During the late Middle Ages, philosophical and legal writings attest the transformation of the fourth monarchy into the monarchy of Christ, "the true lord and monarch of the world, whose first vicar was . . . the Emperor Augustus."[94] This switch was understood as an argument in favor of immanent continuity. The interpreters of Roman Law stressed the principle of "identity despite changes" or "identity within changes."[95] This principle was clearly formulated with respect to the continuity of a law court, in the case that a judge has died and been replaced by a substitute, in the *Glossa ordinaria* of Accursius from c. 1227 to 1240.[96] Directly relevant to our discussion is the perpetual identity of forms despite changes, the "cascading" (as Ernst Kantorowicz calls it) effect the Roman Empire and people had during the Middle Ages: their permanent duration was translated into the perpetuity of kingdoms and peoples. It was therefore important to the crusaders in Acre to stress their own connection to Rome, in order to draw consolation for the future from this association. More than fifty years later Baldus de Ubaldis (c. 1327–1400) formulated the concept on which the crusader representations appear to have been based: "A realm contains not only the material territory, but also the peoples of the realm because those peoples collectively are the realm . . . And the totality or commonweal (*universitas seu respublica*) of the realm does not die, because a commonweal continues to exist even after the kings have been driven away . . . and for that reason it is said that the 'commonweal has no heir' because in itself it lives for ever."[97]

The crusader representations discussed in this chapter show that the Acre producers of illuminated manuscripts were aware of the latest developments in philosophical and legal thought shaping the concept of royalty in the second half of the thirteenth century and wanted to apply them to their own state. Therefore they translated these thoughts into unique visual images, meant to enable the high-positioned sponsors of these manuscripts to come to terms with their precarious political and military situation and especially with the prospect of being driven from the Holy Land in a near future. The concept of continuity and immortal

dignitas helped them detach the existence of their realm from themselves and pro-long it into the distant future. Eternity for their state, eternity for their cause, this is what the crusaders of Acre claimed, by using "the authority of the eternal yesterday,"[98] by creating bonds between their own time and selected episodes of the past, and especially by stressing elements of continuity, able to provide their menaced state with an ideal future; unable to overcome in the battlefield, they wished to defeat time.

Notes

1. Hugo Buchthal, *Miniature Painting in the Latin Kingdom of Jerusalem* (Oxford, 1957); Jaroslav Folda, *Crusader Manuscript Illumination at Saint-Jean d'Acre, 1275–1291* (Princeton, 1976).

2. Paris, Bibliothéque de l'Arsenal, MS. 5211; Daniel H. Weiss, *Art and Crusade in the Age of Saint Louis* (Cambridge, 1998).

3. Gabrielle M. Spiegel, *Romancing the Past: The Rise of Vernacular Prose Historiography in Thirteenth-Century France* (Berkeley, 1993).

4. On the "secularization of typology," see Spiegel, "Political Utility in Medieval Historiography: A Sketch," *History and Theory: Studies in the Philosophy of History* 14 (1975): 315–25, esp. 321f.

5. This was the name given to the compilation by Paul Meyer, who first published it; see Meyer, "Les premiers compilations françaises d'histoire ancienne," *Romania* 14 (1885): 1–85; Guy Raynaud de Lage, "L'histoire ancienne jusqu'à César et les Faites des Romains," *Le Moyen Age* 55 (1949): 5–16; idem, "Les romans antiques dans l'Histoire ancienne jusqu'à César," *Le Moyen Age* 63 (1957): 267–309; Doris Oltrogge, *Die Illustrationszyklen zur "Histoire ancienne jusqu'à César" (1250–1400)*, Europäische Hochschulschriften, Series 28, vol. 94 (Frankfurt am Main, 1989), 9ff.

6. For the original version of William of Tyre's chronicle, see the critical, updated edition by Robert B. C. Huygens and Hans E. Mayer, *Willelmi Tyrensis Archiepiscopi Chronicon*, Corpus Christianorum, Series Latina, 63–63A, 2 vols. (Turnholt, 1986); for an English translation, see Emily A. Babcock and August C. Krey, eds., *William Archbishop of Tyre: A History of Deeds Done Beyond the Sea*, 2 vols. (New York, 1943); for the continuations and translations of William's Chronicle, see *Recueil des historiens des croisades: historiens occidentaux*, Académie Royale des Inscriptions et Belles-lettres, vol. 2 (Paris, 1859), no. 23ff.; Margaret R. Morgan, *The Chronicle of Ernoul and the Continuations of William of Tyre* (Oxford, 1973); and Peter W. Edbury, *William of Tyre: Historian of the Middle East* (Cambridge, 1988).

7. This approach is presented by Spiegel as apparent in the Chronicles of St. Denis; see Spiegel, "Political Utility in Medieval Historiography," 323f.

8. The features discussed in this chapter fit the attributions to the Acre scriptorium as made by Buchthal, *Miniature Painting*, esp. 68–93, thus enhancing his "min-

imalistic" approach, which is mainly based on stylistic observations, with icono-
graphical arguments. The manuscripts added by Folda, *Crusader Manuscript Illumi-
nation,* to the Acre scriptorium, those allegedly produced by the "Hospitaller Mas-
ter" in Acre, do not share the features discussed here. See also the critical review of
Folda's book by Harvey Stahl in *Zeitschrift für Kunstgeschichte* 43 (1980): 416–23; and
Folda, "The Hospitaller Master in Paris and Acre: Some Reconsiderations in Light
of New Evidence," *Journal of the Walters Art Gallery* 54 (1996): 51–272.

9. Buchthal, *Miniature Painting,* pls. 82–129.

10. Ibid., pls. 130–35.

11. Ibid., 71ff. and 88f.

12. Ibid., pls. 82–129.

13. Ibid., pls. 130–35; Folda, *Crusader Manuscript Illumination,* pl. 23.

14. Folda, *Crusader Manuscript Illumination,* 176ff., pls. 3–22.

15. Buchthal, *Miniature Painting,* 68ff., pls. 82–129.

16. Ibid., pl. 136.

17. Ibid., 89.

18. Ibid., 76 and pl. 122a.

19. David J. A. Ross, *Alexander Historiatus: A Guide to Medieval Illustrated Alexan-
der Literature,* Warburg Institute Surveys, 1 (London, 1963); idem, *Illustrated Medieval
Alexander-Books in Germany and the Netherlands: A Study in Comparative Iconography,*
Publications of the Modern Humanities Research Association, 3 (London, 1972).

20. Leipzig, Universitätsbibliothek, MS. Rep. II. 4°. 143. W. Kirsch, ed., *Das Buch
von Alexander dem edlen und weisen König von Makedonien, mit den Miniaturen der
Leipziger Handschrift* (Leipzig, 1991), 39ff. The manuscript is attributed to south Italy.

21. Ibid., fig. p. 40.

22. Ibid., fig. p. 41.

23. *Walter von Châtillon, Alexandreis, Das Lied von Alexander dem Grossen,* trans.
and ed. G. Streckenbach, intro. W. Berschin (Heidelberg, 1990), 46, fig. 8.

24. Buchthal, *Miniature Painting,* pl. 122b.

25. C. de Riant, *Des dépouilles religieuses enlevées à Constantinople au XIIIe siècle
par les Latins,* Mémoires de la Société nationale des Antiquaires de France, 36 (Paris,
1875), 42 and 100ff.; idem, *Exuviae Sacrae Constantinopolitanae,* vol. 1 (Genève, 1877),
19ff.; Hans Belting, "Die Reaktion der Kunst des 13. Jahrhunderts auf den Import von
Reliquien und Ikonen," in *Il medio oriente e l'occidente nell'arte del XIII secolo,* ed. Hans
Belting, Atti del XXIV Congresso Internazionale di Storia dell'Arte (Bologna, 1979),
35–53.

26. Weiss, *Art and Crusade,* esp. 11–32.

27. Buchthal, *Miniature Painting,* pl. 121c.

28. *Walter von Châtillon, Alexandreis,* 142, fig. 21.

29. Ibid., 77.

30. Ibid., pl. 128b.

31. Paris, Biblothèque Nationale, MS. fr. 20125, fol. 279r, and MS. fr. 686, fol. 321r.
Ibid., pls. 153b and c.

32. The lily became the heraldic device of the French monarchy at the end of a process that was completed around 1200. See Percy E. Schramm, *Der König von Frankreich: Das Wesen der Monarchie vom 9. Zum 16. Jahrhundert. Ein Kapitel aus der Geschichte des abendländischen Staates* (Darmstadt, 1960), esp. vol. 1, 214–15 ("Die Lilie als Wappenfigur").

33. Buchthal, *Miniature Painting*, pl. 128c.

34. Ibid., 83.

35. Ibid.

36. MS. Theol. lat. 192, fol. 19.

37. Michael Camille, *Mirror in Parchment: The Luttrell Psalter and the Making of Medieval England* (London, 1998).

38. Piero Camporesi, "Two Faces of Time," in *The Magic Harvest: Food, Folklore and Society*, trans. Joan Krakover Hall (Cambridge, 1993), 35–50.

39. Royal Library, MS. 76 F 13, fol. 1v. See Walter Cahn, *Romanesque Manuscripts: The Twelfth Century*, A Survey of Manuscripts Illuminated in France, exh. cat., vol. 2 (London, 1996), no. 134, 160ff., fig. 328.

40. Ibid., 161; see also Olga Kosellef Gordon, "The Calendar Cycle of the Fécamp Psalter," in *Studien zur Buchmalerei und Goldschmiedekunst des Mittelalters: Festschrift für Karl Hermann Usener*, ed. Frieda Dettweiler (Marburg, 1967), 209–24.

41. Another, similar example is found in a psalter manuscript in Paris, Bibliothèque Nationale, MS. n.a.l.1392, from the first half of the thirteenth century. See Reiner Haussherr, "Ein Pariser martyrologischer Kalender der 1. Hälfte der 13. Jahrhunderts," in *Festschrift Matthias Zender* (Bonn, 1972), 1076–1103, fig. 3. For the same type in French, Flemish, German, and English calendars of the thirteenth century, see K.B.E. Carlvant, "Thirteenth-century Illumination in Bruges and Ghent" (Ph.D. diss. Columbia University, 1978 [Ann Arbor, 1983]), pl. 4. See also Oltrogge, *Die Illustrationszyklen*, n. 595.

42. Robert Schilling, "Janus, le dieu introducteur, le dieu des passages," *Mélanges d'archéologie et d'histoire* 72 (1960): 89–131. See also the more recent resumé by K. Thraede, "Ianus," in *Reallexikon für Antike und Christentum* (Stuttgart, 1994), cols. 1259–82.

43. *P. Ovidi Nasonis Fastorum libri sex*, ed. E. H. Alton, D.E.W. Wormell, and E. Courtney, Bibliotheca Scriptorum Graecorum et Romanorum Teubneriana, Book I (Berlin, 1997), 63–288, 317–36.

44. Cicero, *De natura deorum*, II, 27 and 67, in Cicero, *De Natura Deorum: Academica*, with an English translation by Harris Rackham, Loeb Classical Library Series, vol. 19 (London, 1956), 188f. and 282f.

45. Pierre Grimal, "Le dieu Janus et les origines de Rome," *Lettres d'humanité* 4 (1945): 85.

46. For the different opinions in scholarship, see Grimal, "Le dieu Janus"; P. Ackerman, "Origines orientales de Janus et d'Hermès," *Bulletin of the American Institute for Persian Art and Archaeology* 5 (1937–38): 216–25.

47. Ovid, *Nasonis Fastorum*, Book I, 103ff., 119, 125, 139f.; Schilling, "Janus," 95.

48. John of Lydia, *De mensibus*, IV, 2, after Grimal, "Le dieu Janus," 113.

49. Virgil, *Georgics*, III, 22–39, after Schilling, "Janus," 128, n. 2.

50. Theodor Mommsen, ed., *Res gestae divi Augusti: ex monumentis Ancyrano et Apolloniensi* (Berlin, 1865), 13; Schilling, "Janus," 127.

51. Horatius, "Epistles," II, 1, 255, in Horatius, *Satires, Epistles, and Ars Poetica*, with an English translation by H. Rushton Fairclough, Loeb Classical Library Series (Cambridge, Mass., 1966), 416ff.

52. Dio Cassius, *Roman History*, LIV, 35, 2 and 36, in Cassius Dio Cocceianus, *Roman History*, with an English translation by Earnest Cary, on the basis of the version of Herbert B. Foster, Loeb Classical Library Series, vol. 6 (London, 1969), 374f.

53. The circumstances of the building of the new Janus temple are depicted by Virgil's commentator, Servius. See Filippo Coarelli, *Guida Archeologica di Roma* (Verona, 1974), 61f.; see also Schilling, "Janus," 130.

54. Augustine, *Civitas Dei*, VII, 9, in Augustine, *The City of God Against the Pagans*, ed. and trans. R. W. Dyson (Cambridge, Mass., 1998), 279–81.

55. Ibid., VII, 3:271.

56. Isidor of Sevilla, *Etymologiae*, V, 33, *PL* 82, col. 219f. See Oltrogge, *Die Illustrationszyklen*, 105f., esp. n. 594.

57. Buchthal, *Miniature Painting*, pl. 117c.

58. Haussherr, *Bible moralisée (Österreichische Nationalbibliothek, Mss. 2554)*, Codices Selecti, 40 (Graz, 1973). Oltrogge, *Die Illustrationszyklen*, 106.

59. Buchthal, *Miniature Painting*, pl. 118b.

60. Oltrogge, *Die Illustrationszyklen*, 142, n. 924, quoting, among other sources, Robert of Clari, "Conquête de Constantinople, 1216."

61. Creating genealogies out of political reality and utility is a feature occurring in the written chronicles, as, for example, the Chronicles of St. Denis. See Spiegel, "Political Utility in Medieval Historiography," esp. 325.

62. See above, note 6.

63. The so-called deathbed coronations are probably appointment scenes, as has been recently convincingly demonstrated by I. Gerlitz, "'The King is Dead—Long Live the King': The Representations of Death and Appointment of Crusader Kings in the *Eracles* Manuscripts Produced in Acre" (in Hebrew) (M.A. thesis, The Hebrew University, Jerusalem, 2000). The English term adopted here is deliberately not one linked to a specific stage of the coronation ceremony, in order to stress the general symbolic meaning of the act depicted in the Acre manuscripts. On the coronation stages according to the French and the crusader uses, see respectively Schramm, *Der König von Frankreich*, esp. vol. 1, 197–204; János M. Bak, ed., *Coronations: Medieval and Early Modern Monarchic Ritual* (Berkeley, 1990); Anne D. Hedeman, *The Royal Image: Illustrations of the Grandes Chroniques de France, 1274–1422* (Berkeley, 1991); and H. E. Mayer, "Das Pontifikale von Tyrus und die Krönung der Lateinischen Könige von Jerusalem: Zugleich ein Beitrag zur Forschung über Herrschaftszeichen und Staatssymbolik," *Dumbarton Oaks Papers* 21 (1967): 143–232.

64. Comparing the Paris 2628 *Histoire d'Outremer* manuscript with its contem-

porary *Histoire Universelle* in Dijon, Buchthal wrote: "The cycle is even more indiscriminate in its repetitions than that of the Dijon manuscript. Illustrations of the deaths of the Latin kings and of the coronations of their successors, for instance . . . recur frequently with very little variation." *Miniature Painting*, 89.

65. See, for example, Folda, *Crusader Manuscript Illumination*, 30: "the monotonous iconography of the deathbed-coronation sequence is reintroduced yet another time," or ibid., 114: "Bored, no doubt, with the repetitious coronation scenes which are such a monotonous feature of many Acre *History of Outremer* cycles."

66. To the three *Histoire d'Outremer* manuscripts attributed by Buchthal, *Miniature Painting*, 87–93 and catalogue numbers 12–21, to Acre, Folda added five more (*Crusader Manuscript Illumination*, esp. 27–41 and 77–116, catalogue numbers 2, 3, 7, 8, and 12).

67. Buchthal, *Miniature Painting*, pl. 132a.

68. Ibid., pl. 132h.

69. Folda, *Crusader Manuscript Illumination*, pls. 105 and 107.

70. Ibid., pl. 114.

71. He was probably designated even earlier, on 1 April. Baldwin I was buried on 7 April in Jerusalem. Baldwin II, count of Edessa, came immediately to Jerusalem and was received by clergy and barons. The official coronation took place on 25 December in Bethlehem.

72. The text mentions *unctio* and *coronatio* and no consecration.

73. Ernst Kantorowicz, *The King's Two Bodies: A Study in Medieval Political Theology* (Princeton, 1957), 328f.

74. Jacques LeGoff, "A Coronation Program for the Age of Saint Louis: The Ordo of 1250," in *Coronations*, ed. Bak, 46–57; Jean-Claude Bonne, "The Manuscript of the Ordo of 1250 and Its Illuminations," in *Coronations*, ed. Bak, 58–71. See also Hedeman, *The Royal Image*, esp. 1–29.

75. Luc de Heusch, "Introduction à une ritologie générale," in *L'unité de l'homme: pour une anthropologie fondamentale*, ed. Edgar Morin and Massimo Piattelli-Palmarini (Paris, 1974); Bonne, "The Manuscript of the Ordo," 69f.

76. Folda, *Crusader Manuscript Illumination*, pl. 109.

77. It seems that such was the usual arrangement in northern European psalter manuscripts at the beginning of the thirteenth century, as documented by Paris, Bibliothéque Nationale, MS. lat. 238, fol. 62v and Chantilly, Musée Condé, cod. 1695 (Ingeborg Psalter), fol. 34v; Gertrud Schiller, *Ikonographie der christlichen Kunst*, vol. 4, 2: *Maria* (Gütersloh, 1980), figs. 617 and 618.

78. See, for example, folio 122 of a Bible of uncertain provenance from the end of the twelfth century in Oxford, Bodleian MS. Laud. Misc. 752 (opening initial to 1 Kings): David Diringer, *The Illuminated Book: Its History and Production*, rev. ed. (New York, 1967), 229 and fig. IV-34.

79. F. Ebel, A. Fijal, and G. Kocher, *Römisches Rechtsleben im Mittelalter: Miniaturen aus den Handschriften des Corpus iuris civilis* (Heidelberg, 1988).

80. Buchthal, *Miniature Painting*, pl. 132f.

81. Edbury and Folda, "Two Thirteenth-Century Manuscripts of Crusader Legal Texts from Saint-Jean d'Acre," *Journal of the Warburg and Courtauld Institutes* 57 (1994): 243–54.

82. Venice, Biblioteca Marciana, MS. fr. app. 20 (=265), fol. 1; Folda, "The Hospitaller Master," fig. 5.

83. Schramm, *Der König von Frankreich,* esp. vol. 1, 188ff.

84. Ibid., 191–92; Joseph R. Strayer, "France, the Holy Land, the Chosen People and the Most Christian King," in *Action and Conviction in Early Modern Europe,* ed. Theodore K. Rabb and Jerrold E. Seigel (Princeton, 1969), 3–16.

85. Kantorowicz, *The King's Two Bodies,* 328ff.

86. See above, note 83.

87. Kantorowicz, *The King's Two Bodies,* 273ff.

88. Scholastic philosophy distinguished between *aeternitas* (belonging to God alone), *tempus* (belonging to man), and *aevum* (belonging to the angels, who are eternal beings, bodiless, immortal, and outlasting the Last Judgment); ibid., 280–81.

89. Ibid., 286ff.

90. Ibid, 336ff.

91. "quia dignitas nunquam perit, individua vero quotidie pereunt." Quoted after Kantorowicz, *The King's Two Bodies,* 385, n. 234.

92. "[praedecessor et successor] pro una persona intelliguntur: quia dignitas non moritur." Ibid., 386, n. 236.

93. Schramm, *Kaiser, Rom und Renovatio: Studien zur Geschichte des römischen Erneuerungsgedankens vom Ende des karolingischen Reiches bis zum Investiturstreit,* vol. 1, Studien der Bibliothek Warburg, 17 (Berlin, 1929), 244f.

94. After Kantorowicz, *The King's Two Bodies,* 293, nn. 40 and 41.

95. Ibid., 294, n. 47.

96. Ibid., 295.

97. Ibid., 299.

98. Spiegel, "Political Utility in Medieval Historiography," 315, n. 5.

Amazons and Crusaders: The *Histoire Universelle* in Flanders and the Holy Land

Anne Derbes and Mark Sandona

OF THE TEXTS copied and illustrated in the crusader states in the thirteenth century, one of the most popular was the *Histoire ancienne jusqu'à César*, also known as the *Histoire Universelle*. Written for Roger IV, castellan of Lille, in the early thirteenth century, the *Histoire Universelle* is a richly detailed account of world history that weaves together biblical narrative, Greek mythology, and Roman history. Dozens of copies of the text survive, most of them illustrated, and most of them produced in western Europe in the fourteenth and fifteenth centuries.[1] But a small group dates to the second half of the thirteenth century; although most of these early copies were produced in western Europe, some of the most intriguing examples have been assigned to Acre.[2]

What especially interests us in these manuscripts—both the western European and the crusader examples—are their narrative cycles depicting the Amazons. The warring women appear in about half of the western European copies, and all of the crusader copies. The cycles are fascinating in their own right, for the warring women appear only rarely in medieval visual culture. Although earlier depictions of individual Amazons occur, especially in Byzantine art, even there they are exceptional—and narrative cycles depicting the women are almost unknown. The images in the *Histoire Universelle* thus seem to form the first extensive narrative cycle of these women to survive since antiquity.[3]

These Amazon cycles are also noteworthy in their diversity. The selection of episodes varies considerably from one copy to the next; even images of the same scene often differ substantially. In fact, text and images are often only loosely con-

nected; as we shall see, the designers of the narrative cycles apparently felt free to embellish, disregard, or even contradict the very text that the images purport to illustrate. Although this sort of independence of text and image occurs elsewhere, it is especially striking in these instances.[4]

At the center of our inquiry is a remarkable, and highly controversial, copy of the *Histoire,* today in Paris (Bibliothèque Nationale, MS. fr. 20125). It was Hugo Buchthal, in his pioneering study of crusader manuscript illumination, who brought this codex to scholarly attention. Buchthal focused on three copies of the text, today in Dijon (Bibliothèque Municipale, MS. 562), Brussels (Bibliothèque Royale, MS. 10175), and London (British Library, MS. Add. 15268), which he attributed to Acre, and dated to the 1260s, 1270s, and 1280s, respectively.[5] He then discussed the Paris copy; though he recognized its kinship with the three that he ascribed to crusader scriptoria, he considered it a copy of a *Histoire Universelle* from Acre and argued that it was produced in France, probably about 1300. However, Jaroslav Folda, citing both stylistic and codicological considerations, attributed this manuscript to Acre itself, dating it c. 1287.[6]

The response to Folda's arguments has been mixed. Doris Oltrogge rejected Folda's attribution of the manuscript, assigning it instead to northern France and dating it 1250–75; and recent scholars have followed her.[7] A close look at the Amazon cycle in the contested manuscript, and in copies of the *Histoire* from western Europe and the Levant, may shed some light on this issue. As we will see, in its Amazon cycle, the Paris codex shares very little with the copies from western Europe. In the format of the miniatures, the narrative selection, the iconography of individual scenes, and the ideology that informs the images, the cycle is far closer to the three copies attributed to Acre.

In the first section of our essay, then, we seek to make two distinctions: the first obtains between the Acre manuscripts and their western European counterparts, the second between the three Acre manuscripts and the Paris codex. The crusader manuscripts foreground the Amazons in clear contrast with those produced on the European continent; and of the crusader manuscripts, Paris 20125 is not only more concerned with them, but concerned in an extraordinary way.

Most intriguing, for us, are the ideological implications of the warring women in the Acre manuscripts. We will argue that these images are not merely curiosities, chosen for their exotic appeal, but that they are politically charged images intimately linked with the crusades. We will then turn to the circumstances surrounding the initial commissioning of the text in early-thirteenth-century Flanders—a region deeply invested in the crusades, and governed for much of the century by two powerful women, Joan of Constantinople and her sister Margaret.

As we will argue, it was perhaps through members of this family that the *Histoire Universelle* first made its way to the Holy Land. Finally, we will suggest that the Paris copy of the text may have been commissioned by a specific patron whom we can place in Acre in the late 1280s.

Narrative Choices and Iconography in the Histoire Universelle*'s* Amazon Cycles

We begin by comparing the Amazon cycle in Paris 20125 with the same cycle in two groups of manuscripts: the three crusader copies of the text and those made about the same time in western Europe. Relying on Oltrogge's study, we have complied a list of eleven manuscripts that are securely ascribed to western Europe (specifically France and south Italy) and dated to the later thirteenth century.[8] The two groups differ fairly significantly. First, the percentage of the narrative cycle devoted to the Amazons diverges sharply: the women occupy far more of the pictorial cycle in the crusader works than in the western European copies of the text.[9] As the table below indicates, in these western European copies, the Amazons figure only minimally, if at all. Five of the 11 omit them entirely, and in the others, the warring women comprise between 2 percent and 6 percent of the secular narrative scenes. For instance, in a copy from Naples now in Paris (Bibliothèque Nationale, MS. fr. 1386), 2 of the 112 secular scenes, just under 2 percent, depict the Amazons, while in a codex in Pommersfelden (Gräflich-Schönborn'sche Schlossbibliothek, MS. 295) from northern France the Amazons are featured in 2 of the 59 secular scenes, or 3 percent. By contrast, the 3 crusader copies devote between 18 percent and 21 percent of their secular narratives to the women: 4 of 22 scenes in the Brussels copy, 6 of 33 in the Dijon copy, and 6 of 29 in the London codex. The Paris copy reveals much the same preoccupation with the women: 6 of its 33 secular scenes, or 18 percent, depict Amazons. One final manuscript now in Paris (Bibliothèque Nationale, MS. fr. 9682) is especially interesting for us, for it was produced in France from a crusader copy of the *Histoire*.[10] It devotes the same proportion of the cycle to the women (5 episodes of 24, about 21 percent).

The two groups of manuscripts, crusader and western European, differ not only in the relative importance of the Amazons but also in the selection of specific episodes from the Amazon cycle and in the iconography of the scenes that they have in common. The text introduces the Amazons with the story of the Kingdom of Scythia, legendary home of the women; as the rubric explains: "Here begins [the history] of Athens and the isle of Crete . . . where begins the reign of the Amazons."[11] The saga opens with the story of the male warriors of Scythia,

TABLE 9.1. *Comparison of Manuscripts of the Histoire Universelle.*

Manuscript	Number of Images	Number of Amazon Images	Percentage of Amazon Images
Brussels 18295	14	0	0
Carpentras	38	0	0
Paris 9685	35	0	0
Vatican	48	0	0
Tours	17	0	0
Paris 1386	112	2	1.7
Pommersfelden	59	2	3.4
The Hague	72	3	4.2
London 19669	85	4	4.7
Chantilly	65	4	6.2
Brussels 10175	22	4	18.2
Dijon	33	6	18.2
Paris 20125	33	6	18.2
London 15268	29	6	20.6

who had set out to war with Egypt. The men remained away for such a long time that the women of Scythia became concerned. The women sent messages to the warriors, then dispatched two of their sons to retrieve them. But the mission ended in disaster; the two young men and the warriors were all killed. At this point, the women took action. The text reads: "Do you know what they did? They assembled and decided to arm themselves and avenge their husbands and their sons and their brothers against those who had killed them."[12] The text then describes two queens, Merpesia and Lampetho, setting off on horseback (*chivauchier*) with the other Scythian women.

All three copies of the text from Acre signal the introduction of the Amazons with a miniature. Each appears above, or near, a rubric: "The women of Scythia go forth with sharp swords drawn to avenge their sons and their friends."[13] In the copies now in Dijon and Brussels, which generally resemble each other closely, the women are shown mounted, battling their Egyptian foes; their necks and arms are protected by chain mail.[14] The London copy—a *de luxe* product distinguished from the other two by its size, its panoramic narratives, and its sharply observed vignettes (fig. 9.2)—differs considerably. Though it, too, depicts a battle, the women are neither mounted nor dressed for combat. Instead, they hurl rocks at soldiers in the tower above, and one hacks at the tower door with a pick-ax—the traditional weapon of Amazons. The only figures equipped for combat are the women's heavily armed and well-protected male antagonists in the tower above, and their male allies—mounted, armed to the teeth, and sheathed in metal from head to toe. The image is all the more surprising when we consider the text, which

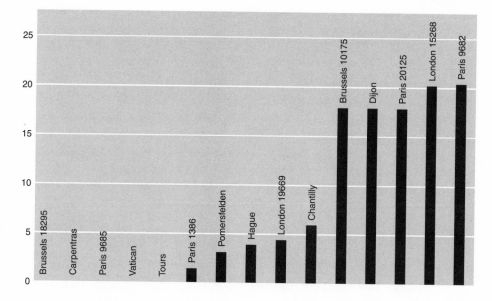

Fig. 9.1. Comparison of manuscripts of the *Histoire Universelle:* Percentage of Amazon Images

merely describes the women's victory, and makes no mention of either surviving male Scythians or male allies who suddenly materialize to fight with the women.[15]

Not one of the western European copies of the texts depicts the tale of the Scythian women. In Paris 20125, however, just as in the copies from Acre, a miniature of the Amazons accompanies the text, and the rubric is much the same. Although the image in the Paris codex (fig. 9.3) depicts a different moment—the journey of the women rather than the battle—it follows the text more closely than the other three.[16] In contrast to the Brussels and Dijon copies, where Merpesia and Lampetho are not distinguished from the others, here the two crowned queens lead a group of nine women; as the text specifies, all are mounted. They are equipped for battle, carrying banners and shields and wearing chain mail, which can be seen emerging from their tunics.

The next image of the Amazons is unique to the Paris codex (fig. 9.4). It illustrates the next passage of the text, which describes the women's decision to live independently; they raised their daughters with "grant diligence" and trained them in the arts of warfare.[17] The passage also explains the traditional etymology of the word *Amazon,* "without breast," noting that the women removed a breast for easier handling of the bow and arrow. The miniature that appears at this point

Fig. 9.2. The Scythian women avenging their loved ones, London, British Library, MS. Add. 15268, fol. 101v. By permission of The British Library.

Fig. 9.3. The Scythian women avenging their loved ones, Paris, Bibliothèque Nationale, MS. fr. 20125, fol. 119r. Courtesy of the Bibliothèque Nationale.

Fig. 9.4. The Amazons dispatch their foes with bows and arrows, Paris, Bibliothèque Nationale, MS. fr. 20125, fol. 119v. Courtesy of the Bibliothèque Nationale.

vividly illustrates the Amazons' prowess with the bow. Under a barrage of arrows, the Amazons' male opponents flee; one of them, wounded, collapses against his horse. (The rubric here, "How the Amazons founded Ephesus," refers to the passage that follows.) One other copy of the text—the Dijon codex from Acre—includes an image at this rubric; here, however, the women appear not in battle but on a leisurely ride.[18] None of the western European copies illustrate this passage.

The text goes on to describe the Amazons' subsequent military victories in Asia and Europe. As the group grew, they conquered much of Asia and Europe, destroying some cities and founding others. Merpesia, however, met an unhappy end. While guarding the Amazons' territory in Asia, her army was attacked by the Assyrians, who killed them all. This episode, interestingly, is not illustrated by any of the three texts usually ascribed to Acre, nor in the disputed Paris copy. However, it does appear in a Western manuscript—a copy of about 1290 from Naples

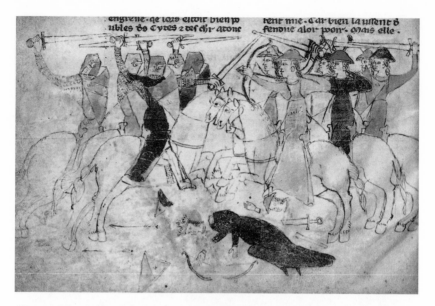

Fig. 9.5. The death of Marpesia, Paris, Bibliothèque Nationale, MS. fr. 1386, fol. 22v. Courtesy of the Bibliothèque Nationale.

(fig. 9.5).[19] Here, with the battle still raging behind, Merpesia's body lies in the foreground, not only lifeless but mutilated: she has been beheaded and had one hand severed. More Amazonian body parts—a head and hand—lie just behind her. Though the text describes the queen's death, it says nothing of decapitation or dismemberment.[20]

All three crusader copies—as well as the Paris copy—next depict the battle of two Amazons (Menalippe and Hippolyta, the sisters of Queen Antiope) against Hercules and Theseus, who invaded the Amazons' land. The text is forthright about the prowess of the Greek males: Hercules is another Samson, the two are the best knights in the world.[21] But it is clear, too, in stressing the valor of the sisters, who fought with all their might; they even succeeded in unseating Hercules and Theseus for a moment before their fellow Greeks rushed to the rescue. Finally, with the help of these troops, Hercules and Theseus disarmed the sisters; after making peace with the Amazons, Theseus took Hippolyta to Greece and married her.[22]

None of the crusader copies explicitly depicts the ultimate outcome of the struggle. Instead, in all three, the Greeks and Amazons appear fairly evenly matched. In the Dijon and Brussels copies, the illustrator has given no indica-

Fig. 9.6. The sisters of Antiope fight Hercules and Theseus, London, British Library, MS. Add. 15268, fol. 103r. By permission of The British Library.

tion of which side will prevail; in the Dijon image, both groups are wounded, and in the Brussels image, neither is.[23] In the London codex, too (fig. 9.6), all four combatants have clearly been wounded, and sprawl precariously on the backs of their horses.

The Paris codex, by contrast, would appear to depict a rout—but, remarkably, it portrays the *Amazons,* not the Greeks, as victors (fig. 9.7). The Amazons serenely charge at their sprawling opponents, who flail about in midair in the split-second before they tumble to the ground. This illuminator has clearly represented the point of the Amazons' near-victory, before the Greeks' reinforcements turned the tide of battle; nowhere does the image even hint that the men would finally triumph.

The designer of the narrative program, then, has singled out the one moment in the text in which the Amazons almost prevail. In a sense, this image nearly contradicts the text, suggesting an Amazonian victory that never transpired. In fact, it does contradict the rubric below, which reads: "Que li diu chivalier valliant o l'aie de lor gens pristrent les ·ii. puceles" [How the two *knights* conquer, with the aid of their people, and take the two young women (italics added).]

Moreover, we can detect a certain suggestive playfulness in both this image and the same scene in the London codex. In the London copy, the women lie against

Fig. 9.7. The sisters of Antiope fight Hercules and Theseus, Paris, Bibliothèque Nationale, MS. fr. 20125, fol. 121r. Courtesy of the Bibliothèque Nationale.

their horses almost flat on their backs, with their legs spread; the men, too, ride with legs wide apart. These curious positions, awkward but erotic, seem to fore-shadow the denouement of the struggle here, which will conclude with the mar-riage of two of the antagonists. In the Paris copy, it is Hercules and Theseus who are supine, with their legs spread; now the women are securely in control of the proceedings. Indeed, if we look more closely at this image, we note a surprising detail that seems to make the implied eroticism explicit. Not only are the Greek heroes about to be unhorsed, they are also about to be unmanned, as the posi-tion of the Amazons' spears would indicate: they are directed just between the legs of the two Greeks. Apparently a man defeated by the Amazons stood to lose more than face.[24]

But the light-hearted playfulness of this image vanishes when we turn to other copies of the text. Although this episode is absent in almost all of the thirteenth-century Western copies, it is illustrated in a copy of the text that was produced in Bologna in about 1330 (fig. 9.8).[25] Here, too, image and text seem at cross-purposes. Now, in contrast with the crusader copies and the Paris copy, Hercules and Theseus have clearly triumphed over the Amazons, in keeping with the text—but the Amazons fare far worse than the text states: the women sprawl across their

Fig. 9.8. The sisters of Antiope fight Hercules and Theseus, Paris, Bibliothèque Nationale, MS. fr. 686, fol. 136v. Courtesy of the Bibliothèque Nationale.

horses almost lifeless, bleeding copiously, their throats slit—hardly an auspicious beginning to the marriage promised by the text.

The text next takes up the story of the Trojan War, which it recounts in considerable detail. Here, again, we note the apparent fascination with the warring women in the crusader copies of the text. Initially the tale unfolds for many pages with minimal illustration;[26] but when the story turns to the Amazon queen, Penthesilea, two images follow in quick succession. First, Penthesilea and the Amazons come to aid the Trojans—an episode seen in two of the three crusader manuscripts and in the disputed Paris copy, but in only two of the eleven Western copies.[27] In contrast to virtually all the other Amazon episodes illustrated in these manuscripts, the depiction of the women's journey in the two groups of manu-

scripts, crusader and Western, does not differ greatly. In almost all of them, the women are shown riding forthrightly ahead, poised for battle (as in the Paris copy, fig. 9.9); only the London codex again elaborates, depicting the women's arrival in Troy and the Trojans' welcome (fig. 9.10).

The next image in most copies, regardless of provenance, depicts the battle of Penthesilea with Achilles's son Pyrrhus, a showdown that would end with the queen's death. The battle must have appealed to patrons in both western Europe and the Levant: of all the episodes featuring the Amazons, this one is represented most often in both Western and crusader copies. As we will show, however, the emphasis differs significantly in the two groups, and the differences are telling. All three crusader copies, and the disputed Paris codex, depict an early moment in the battle, before the queen has been wounded. In the Dijon and Brussels copies, there is no suggestion of the queen's final fate.[28] In the London codex, some of the Amazons have been killed, but Penthesilea herself rides valiantly forth, as yet untouched by the enemy (fig. 9.11). The version of the scene in the Paris copy (fig. 9.12) most closely resembles those in Dijon and Brussels: though it does not depict the armies accompanying Penthesilea and Pyrrhus, the two combatants face each other early in the battle, and there is no indication of Pyrrhus's ultimate victory.

In almost all of the western European copies—and the scene occurs in five of the eleven—the moment chosen differs significantly: instead of showing an early phase of the battle, all but one depict its finale, the death of the queen. A codex in London (British Library, MS. 19669), dated c. 1250–75 and ascribed to northern France (fig. 9.13), features a two-tier, four-scene miniature—a format that is found often in the early Western copies of the text, but never in the crusader copies. Here, the scenes of the Amazons' arrival and early stages of the battle appear in the upper register; to the lower left, Pyrrhus administers the coup de grace. As Pyrrhus's lance pierces Penthesilea in the side, she topples from her mount, her crowned head and upper torso projecting beyond the frame and thus italicizing her demise. In the northern French codex in Pommersfelden, also c. 1250–75, Pyrrhus thrusts his sword in the queen's throat.[29] A closely related northern French manuscript, now in The Hague (Konklijke Bibliothek, MS. 78 D 47), depicts not only Penthesilea's death—in which the queen is shown bleeding from the head and torso—but also the moment in which the Amazons appeal to Priam for the queen's corpse, which lies, still bloody under its blue drape, in the foreground (fig. 9.14). This episode, which appears in other Western examples but in none of the crusader group, drives home the brutal death of the queen.

Fig. 9.9. Penthesilea and the Amazons go to the aid of Troy, Paris, Bibliothèque Nationale, MS. fr. 20125, fol. 141v. Courtesy of the Bibliothèque Nationale.

Fig. 9.10. Penthesilea and the Amazons go to the aid of Troy, London, British Library, MS. Add. 15268, fol. 122r. By permission of The British Library.

Fig. 9.11. The battle of Pyrrhus and Penthesilea, London, British Library, MS. Add. 15268, fol. 123r. By permission of The British Library.

Fig. 9.12. The battle of Pyrrhus and Penthesilea, Paris, Bibliothèque Nationale, MS. fr. 20125, fol. 142r. Courtesy of the Bibliothèque Nationale.

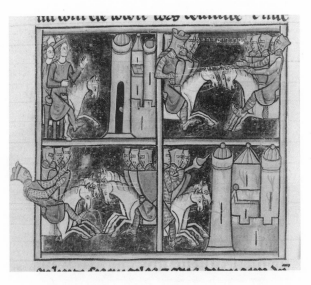

Fig. 9.13. The death of Penthesilea, London, British Library, MS. Add. 19669, fol. 89r. By permission of The British Library.

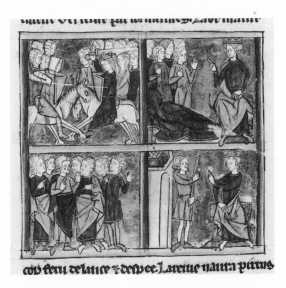

Fig. 9.14. The death of Penthesilea, The Hague, Koninklijke Bibliotheek, 78 D 47, fol. 72v

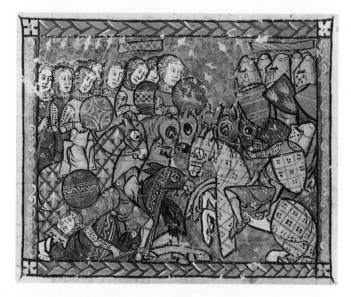

Fig. 9.15. The death of Penthesilea, Paris, Bibliothèque Nationale, MS. fr. 9682, fol. 126v. Courtesy of the Bibliothèque Nationale.

Perhaps most suggestive is the manuscript now in Paris (MS. fr. 9682) that was copied in France from a manuscript produced in Acre (fig. 9.15). Here the miniature resembles the Acre codices, particularly the copy in Brussels, in the panel format of the miniature and in certain details, such as the dotted pattern on Penthesilea's tunic. But for the illuminator of this French copy, the Acre image was only a point of departure: in stark contrast to the crusader manuscripts, here Penthesilea is clearly dying; both she and her horse collapse as Pyrrhus rides his rearing mount in triumph.

Finally, seven copies of our text—the three crusader manuscripts, the Paris copy (20125), and three of the eleven Western manuscripts—also include another warring woman: Camilla, the legendary Roman princess who was considered an Amazon in the Middle Ages.[30] While the London copy (fig. 9.16) depicts Camilla meeting her allies in the camp of Turnus, the Latin king under whose command she fought, the other six depict her encounter with Aeneas—still another battle that would prove fatal for the female protagonist. Just as we noted in the depictions of Penthesilea and Pyrrhus, neither the crusader manuscripts nor the Paris codex hint at Camilla's death. In the Dijon and Brussels copies, Camilla and Aeneas are shown in combat, but both depict an evenly matched struggle, with no sign of Aeneas's victory.[31] One of the western European copies also depicts an early mo-

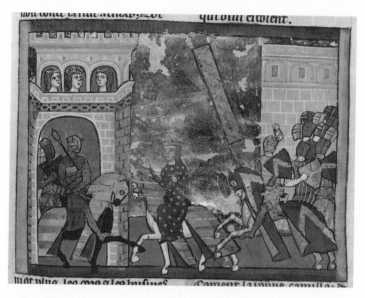

Fig. 9.16. Camilla meeting her allies in the camp of Turnus, London, British Library, MS. Add. 15268, fol. 149r. By permission of The British Library.

ment of the battle, with Camilla unharmed, but the other two instead show Aeneas striking the fatal blow.[32]

The image in the Paris codex (fig. 9.17) offers, again, a singular interpretation of the encounter. Superficially, it resembles those in the Brussels and Dijon copies, though the moment differs slightly: now we see the two armies poised for battle, though not yet in combat. The illuminator of the Paris copy has made Camilla's Amazonian affiliations explicit by the horizontal stripes of her banner and tunic and her horse's caparison, which link her visually with Penthesilea in folio 141 (fig. 9.9).[33] What is most striking, however, is the pronounced emphasis on Camilla and her entourage. In contrast with the Brussels and Dijon copies, where the men and women share the pictorial field equally, here the women clearly dominate, occupying almost two-thirds of the composition. Aeneas and his men, by contrast, seem wedged into their space. Other visual cues similarly signal the women's greater importance: the impressively large lance Camilla wields (which dwarfs the weapon held by Aeneas) and her richly caparisoned horse (Aeneas's horse is almost unadorned). Even the Amazons' horses gallop forward, in contrast with the rather listless and tentative mounts of Aeneas and his men.

Again, the version of the scene in Paris 9682, the copy made in France from a crusader manuscript, is especially revealing (fig. 9.18). Though here Camilla and

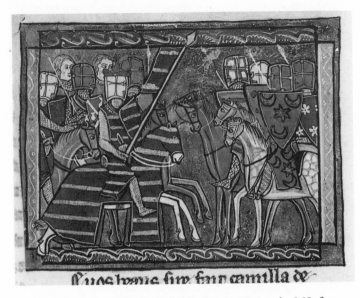

Fig. 9.17. Camilla and Aeneas, Paris, Bibliothèque Nationale, MS. fr. 20125, fol. 172r. Courtesy of the Bibliothèque Nationale.

Aeneas closely resemble the image in Paris 20125 (fig. 9.17) in several respects—the composition, the format, the obsessive heraldry, and even the decoration of the borders—clearly the emphasis has shifted. Now it is Camilla and her army who are dwarfed by Aeneas and his force, for the men dominate in almost every way: their size (they tower over the women); their sheer number (they ride at least two deep, unlike the women); their spears that thrust beyond the border (the women's are both fewer and smaller); even their massive standard, emblazoned with a menacing dragon (the women's standards are slender, and delicately dotted). Outnumbered and outmuscled, the women clearly are doomed to defeat.

To summarize: the crusade copies of the *Histoire Universelle* manuscripts—and the disputed Paris copy—reveal a consistent fascination with the Amazons; none of the copies securely attributed to western Europe even approaches them in the proportion of the narrative cycle devoted to the women. At least as significantly, the crusader manuscripts consistently avoid representing the Amazons in defeat: the death of Merpesia is studiously omitted; the sisters of Antiope hold their own against the Greeks; Penthesilea battles on, unharmed, before the fatal blow; Camilla is either equally matched with her opponent or entirely unscathed in combat. The pro-Amazon tenor of these manuscripts is most striking in the Paris copy, in which the images never hint at the Amazons' defeat. Several miniatures in par-

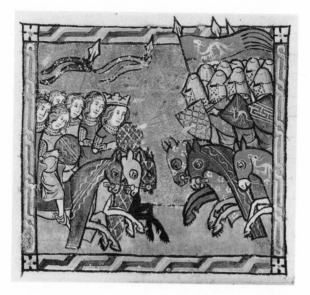

Fig. 9.18. Camilla and Aeneas, Paris, Bibliothèque Nationale, MS. fr. 9682, fol.155v. Courtesy of the Bibliothèque Nationale.

ticular proclaim the women's thematic importance and military prowess: only here do the Amazons dispatch their foes with ease (fig. 9.4); only here do they topple Hercules and Theseus (fig. 9.7); only here is Camilla more formidable than her male opponents (fig. 9.17).

In striking contrast to the crusader copies and the Paris codex, the copies of the *Histoire* produced about the same time (or a little later) in western Europe often omit the women entirely. When they do include them, they not only depict the Amazons in defeat, but at times do so in a way that seems gratuitously grisly—featuring a decapitated and dismembered Merpesia, the sisters of Antiope with their throats slit, and Penthesilea's and Camilla's violent deaths.

Amazons and Crusading Ideology

How are we to understand the dramatic differences that separate the Western and crusader groups? What, in particular, should we make of Paris 20125, with its uncompromising insistence on the Amazons' victories? In a sense, the western European examples seem to require little explanation, for they conform to a long pictorial tradition that emphasizes the subjugation of the Amazons. In particular, they recall the earliest images of the women, those from ancient Greece, where

the Amazons are routinely stabbed, clubbed, speared, or otherwise subdued. Given Greek legends about the women's murderous ways, their fate is not surprising; these images assert the inevitable response to such social and sexual transgression.[34]

The Western images are consistent, too, with the views of some of the earliest Christian writers to describe the women, for these authors consistently condemn the women as pagan, savage, and lustful. Clement of Alexandria, for instance, says the Amazons are "like animals"; Orosius notes that they "destroyed the greater part of the earth with boundless slaughter."[35] For Dictys of Crete, the Amazon queen Penthesilea "transgressed the boundaries of nature and her sex."[36] Hostility to the Amazon surfaces, as well, in the later Middle Ages; for example, according to the fourteenth-century author Hugh of Strasburg, the queen of the Amazons was a worshiper of the Antichrist.[37]

But the three crusader copies of the *Histoire Universelle,* and especially the Paris copy, are clearly informed by a different sensibility: now the women are no longer transgressive threats to the social order but rather its defenders, avenging their sons and husbands, and coming to the aid of the Trojans. This shift in attitude is clearly felt in the text of the *Histoire Universelle* as well as its images, but the shift does not begin here; rather, we find similarly positive evaluations of the women as early as the late eleventh century. At times, prominent women—some of whom took arms to defend family and property—are compared with legendary exemplars. For instance, at the end of the eleventh century, Orderic Vitalis praises Isabelle of Conches, likening her to Camilla, Hippolyta, Penthesilea, "and other warrior-queens of the Amazons."[38] Hugh of Fleury's *Historia ecclesiastica,* written in 1110 for Countess Adele of Blois, includes the Amazons in a lengthy discussion of exemplary women leaders.[39]

It is especially in the context of the crusades that writers begin to stress the women's courage and military prowess. A connection between Amazons and crusaders is explicit by the Second Crusade, when Eleanor of Aquitaine, accompanied by a sizable entourage of women, went with her husband to the Holy Land. Legends claim that the queen identified with the Amazon queen Penthesilea.[40] In fact, one Byzantine chronicler, Nicetas Choniates, describes the women participating in the Second Crusade and compares them with Amazons:

> Females were numbered among them, riding horseback in the manner of men, not on coverlets sidesaddle but unashamedly astride, and bearing lances and weapons as men do; dressed in masculine garb, they conveyed a wholly martial appearance, more mannish than the Amazons. One stood out from the rest as another Penthesilea [with] embroidered gold which ran around the hem and fringes of her garment.[41]

The richly clad woman noted by the chronicler is widely thought to have been Eleanor.[42] Another link between Eleanor and the Amazons is implied by Benoît de Sainte-Maure's twelfth-century *Roman de Troie,* which the poet dedicated to Eleanor.[43] Benoît's romance is unusual in its lengthy, and admiring, treatment of Amazons; for instance, he praises the Amazons' beauty, wisdom, and valor.[44]

Crusaders and Amazons appear again in the spurious letter of Prester John, generally dated 1165. In the letter "Prester John," the legendary Nestorian Christian, offered to lead a crusade against the Saracens and described his vast territory. The letter reads:

> We have a country . . . called the "Great Femenie." Do not think it is in the land of the Saracens. . . . In that land there are three queens and many other ladies who hold their lands from them. And when these three queens wish to wage war, each of them leads with her 100,000 armed women. . . . And know that they fight bravely like men.[45]

This implicit offer of the Amazons' help in fighting the Turks is significant, for it will become explicit later. Rumors of Prester John circulated at least twice after 1165—in 1192 and again at the time of the Fifth Crusade (c. 1213–21), when word of his imminent rescue of the Franks fanned crusaders' hopes.[46] Significantly, women were officially recognized as *crucesignatae* at just this time. Though women had participated earlier, their presence had been discouraged and at times prohibited. However, Pope Innocent III reversed previous policy when he launched the Fifth Crusade and allowed women to make the crusading vow.[47] The new policy was intended to benefit crusading in two ways. First, it was a fund-raising effort; the pope noted that any crusaders deemed "not suitable or able to fulfill the vow" could redeem it for money,[48] and this category was apparently intended to remove most women from the ranks. However, the policy also stipulated that wealthy women could hire an entourage of soldiers to accompany them to Palestine; at this juncture, military assistance from any quarter was welcomed. The women who took the cross did not merely fund the services of mercenary soldiers; many played active roles themselves. At times, female crusaders were limited to gendered tasks such as preparation of food or tending the wounded. But at other times, they took on the responsibilities of male soldiers. We know, for instance, that women participated fully in the siege of Damietta in 1219. Like the men, they stood guard over tents at night, and sources tell us a group of Muslims attempting to foil the crusaders' siege were killed by the women of the camp.[49] In the image of Amazons at the siege of a city in the London *Histoire Universelle* (fig. 9.2), the women launch rocks against their antagonists in the tower, and one wields a

pick-ax to break down the door. It is not hard to imagine that the women who actually fought in the crusades may have had similar roles. Not unexpectedly, tales of women's military prowess and valor appear in literature written during these years; for instance, the story of Arabel, written about 1220, describes the heroine's courage in battle.[50]

In the crusader East, the Amazons were believed to be one of many groups of exotic races living in the region, and crusading chronicles refer to the warring women fairly often. William of Tyre's *History of Outremer* refers to the warring women; like the spurious letter of Prester John, he notes their homeland in Femenie. Guibert of Nogent, in his *Gesta Dei per Francos,* mentions them as well.[51] Jacques de Vitry, bishop of Acre in the 1220s, devotes considerable attention to the Amazons in his *Historia Orientalis,* where he observes that they were stronger than men since their strength was not "consumed in frequent copulation."[52] The anonymous author of the *Histoire Universelle* was likely a crusader himself, as Raynaud de Lage has suggested; his text is laced with allusions to specific sites in the Levant. His travels in the East may have fanned his interest in the Amazons.[53]

All of these references, and the presence of actual warring women in record numbers, help to frame the foregrounding of the Amazons in the *Histoire.* But the most interesting link—particularly significant for the images in the Acre manuscripts—occurs in the Flemish writer Thomas of Cantimpré's *De Naturis Rerum,* completed around 1240. The suggested possibility of Amazonian assistance in Prester John's letter now becomes overt: according to Thomas, the Amazons were military allies of the crusaders. Thomas cites Jacques de Vitry, the bishop of Acre, as his source, even claiming that Jacques referred to the Amazons as Christians— and thus logical allies of the crusaders against the forces of Islam.[54]

Even more curious than Thomas's description of the Amazonian alliance is the way the idea of these warring women entered into the sensibility of the crusader military orders. For example, a fourteenth-century chronicle describes the coronation festivities in Acre in 1286 for the king of Jerusalem, wherein the Knights of St. John "enacted the feats of the round table and imitated the Queen of Femenie"; it states that the "chevaliers" were "dressed as ladies."[55] In the fifteenth century, this same order, the Knights of St. John, quarrying stone from a Greek temple near Halicarnassos, selected and preserved friezes depicting a battle of the Amazons in the walls of their castle at Bodrum.[56]

The Halicarnassos frieze reminds us that Amazons were far more common in the visual culture of the Byzantine East than in the Latin West. Late Roman mosaics at sites like Antioch, Apamea, and Zippori, silver plates from Constantinople or Asia Minor, and textiles from Egypt and Syria all represented the women,

most often as mounted hunters.[57] Presumably images like these, which highlight the women's martial prowess, would have further sparked crusaders' interest in the warring women and perhaps reinforced some notion of their utility as military allies.

Thus a confluence of cultural phenomena—the gradual rehabilitation of the Amazons beginning around the time of the First Crusade and continuing into the thirteenth century; the greater participation of women in the crusades in the early thirteenth century; the Franks' increased exposure to Amazonian images and lore in the crusader states—all must have contributed to the new perspective on the Amazons seen in these crusader copies of the *Histoire*.

The prospect of Amazons as allies illuminates specific aspects of the miniatures—such as the Amazons' zeal in avenging "their sons and their friends" and their effortless shows of strength, seen especially in the Paris copy, where they rain arrows at fleeing opponents and unhorse Hercules and Theseus (figs. 9.4, 9.7). Perhaps the most topical images, however, are those that depict the Amazons eagerly hastening to the defense of others: "Penthesilea, Queen of Femenie, goes to the aid of the Trojans" (figs. 9.9, 9.10). Such images would have held particular resonance for the crusaders. The Franks identified strongly with the Trojans, and in fact traced their origins to ancient Troy. Though this appropriation of Trojan ancestry can be traced to the seventh century, it was popularized by Benoît de Saint-Maure in his *Roman de Troie*.[58] But it was especially apt in the wake of the Fourth Crusade, when it became a convenient justification for the sack of Constantinople. As Colette Beaune has observed, "it was the crusade of 1204 that transformed the crusaders definitively into Trojans, as their battle with the Greeks . . . became a fitting revenge for the pillage of Troy."[59] Scenes of Penthesilea coming to the aid of the Trojans presumably evoked crusaders' hopes for a similar rescue.[60]

The Franks' identification with the Trojans, and thus their claim to Amazonian assistance, seems to be visually asserted in crusader manuscripts through distinctive heraldry: crusader leaders often wear a lion (at times, but not always, rampant) with jaws open and tail furled, an armorial that was associated with the Trojan hero Hector.[61] Heraldry is again a key to the ideological cast of these illuminations in the miniature of Aeneas with Camilla in Paris 20125 (fig. 9.17). We have already noted the privileged status of Camilla and her entourage, signaled by the space they occupy, the size of their weapons, and so on. One other aspect of the miniature explicitly asserts the identity of her adversaries: Aeneas's shield and tunic are emblazoned with stars and crescents, the emblems of Islam. The overt identification of the Trojan hero Aeneas with the Saracen foes of the Franks is, at first, startling. But there can be little doubt that the stars and crescents signified the Saracens. The star and crescent, or *hilāl*, appeared early in Islamic history,

but became especially popular among the Seljuk Turks in the twelfth and thirteenth centuries; it is not surprising that the emblem would be familiar to the Franks in crusader Palestine. In fact, the crusaders' enemies are often identified with stars, crescents, or both, in the manuscripts attributed to Acre.[62] The explanation for the star and crescent labeling Aeneas in the Paris *Histoire Universelle* is an alternate view of him that coexisted with that of Virgil's pious Aeneas in the Middle Ages: to some medieval writers, Aeneas was a turncoat, the betrayer of the Trojans. Dares's *History of the Fall of Troy*—an important source for both Benoît and the *Histoire Universelle*—tells us that Aeneas conspired in a plot with the Greeks that resulted in the Greeks' victory.[63] Interestingly, the author of the *Histoire Universelle* was more ambivalent; he presents two versions of the tale, one implicating, the other exonerating Aeneas.[64] Little ambivalence is felt in the Paris illumination, however: clearly it is the treacherous Aeneas who wears the insignia of Islam.

Daniel Weiss has demonstrated convincingly that crusading ideology profoundly informs an important product of the Acre ateliers, the Arsenal Old Testament;[65] it seems to us that we find much the same phenomenon here. These encounters—between Amazon and Greek, between Camilla and Aeneas—seem thinly disguised references to actual encounters between Christian and Muslim. The particular relevance of the Amazon narratives to the circumstances of crusader Palestine may suggest that this cycle first gained prominence in crusader workshops. As Weiss has argued, the inventiveness of the cycle in shaping visual language to crusading ideology is characteristic of the Acre ateliers.

The ideological underpinnings of these three copies of the *Histoire Universelle*—the codices in Dijon, Brussels, and London—corroborate their attribution to the crusader East. Ideologically, the Paris codex seems akin to the other three; if anything, it seems still more deeply infused with crusading rhetoric than the others. It is in the Paris codex that the Amazons' military skills—and thus their utility as allies of the Trojans/Franks—are most emphatically asserted. It is there, too, that the relevance of these tales to the crusaders is most explicit, in the identification of Aeneas, the enemy of the Amazonian Camilla, as a treacherous Muslim. Even the use of the star and crescent to signify Islam may link the manuscript with the Levant; though the insignia and its meaning were apparently known in western Europe as well, they would have been most familiar to the Franks of crusader Palestine.[66] Thus these observations may add further weight to the stylistic and codicological arguments that Folda has already marshaled in his attribution of the Paris codex to a crusader atelier. Considering all the available evidence, the codex seems to us most convincing as a product of crusader Acre.

Crusading Women in Flanders and the Holy Land: Issues of Patronage

Finally, the Amazon images in the Acre manuscripts lead us to revisit the circumstances surrounding the initial commissioning of the text. Though the precise date of the *Histoire Universelle* is unknown, it must have been written sometime between 1208, when Roger IV took office as castellan of Lille, and 1229–30, when he died.[67] While it was written for a man, the text was intended to be read at court, inevitably to a male and female audience. Raynaud de Lage and Mary Coker Joslin have already noted aspects of the narrative that were inserted to please female listeners.[68] The Amazons are not the only exemplars of female valor: the Genesis portion includes references to female rulers who "govern well"; to Io, "considered so wise that she was worshiped as the goddess Isis in Egypt"; to Pallas, also hailed as a goddess for her discoveries of wool and silk.[69] The scriptural portions of the text also present women, and those who treat them respectfully, in a sympathetic light. For instance, as Joslin notes, in the tale of Rebecca at the well, when Isaac's servant asks for Rebecca's hand, the author "tells us that this is the first time that a woman's consent was asked before a marriage agreement was concluded."[70] The author also approvingly describes Rachel's heroic deeds to save her people, and Jacob's great devotion to his wife, for whom he waited fourteen years.[71] The author likewise takes note of the punishment meted out to those who harm women: the tale of Dinah, who was raped, and the fierce revenge exacted by her brothers on the rapist; the two evil husbands of Tamar, both stricken down by God because of their marital failings.[72]

We suspect that such references were not merely gracious gestures to anonymous female listeners, but were strategic insertions intended to curry favor with the two most powerful women in Flanders: the countesses Joan and Margaret. The sisters, who ruled Flanders for much of the thirteenth century (Joan from 1212 to 1244; Margaret from 1244 to 1278), were well known in Lille, which had been a comital residence since the eleventh century, its castellan serving the counts as local official and administrator. The countesses spent several years in Lille as children, in the care of an aunt; as adults, both sisters lived there regularly and endowed it generously. Indeed, the comital castle became Margaret's favorite residence.[73] Surely the sisters must have been at times among the audience at Lille when the *Histoire* was recited at court; and surely the author of the text was well aware of the sisters when he composed it.

If the countesses approved of the *Histoire*'s references to women as wise leaders and rulers, they would have similarly appreciated its references to the crusades, for they came from a family in which both men and women were deeply com-

THE USES OF SECULAR HISTORY

mitted to crusading. The counts of Flanders had engaged in holy warfare for over a century.[74] The sisters' father, Baldwin IX, was the first Latin emperor of Constantinople. Their mother, Mary, counted equally distinguished crusaders among her forebears, and she herself took the cross, dying in Acre in 1204. Margaret, the younger of the two sisters, was an especially stalwart supporter of the crusading enterprise. She contributed substantially to Louis IX's crusades, and both of her surviving sons accompanied the French king to the Holy Land: the elder from 1248 to 1250; the younger in 1270. Although she did not make the journey herself, Margaret also took the cross, in 1267, when she was sixty-five.[75]

Margaret's continuing commitment to crusading prompts us to speculate further about the text and its journey to Acre. Buchthal, followed by Folda and Harvey Stahl, proposed on stylistic grounds that the Acre copies of the *Histoire* stem from an illustrated copy made just before 1250.[76] This dating accords well with the crusading activities of the comital family: when Margaret's son William of Dampierre traveled with Louis IX to Acre in 1248, he almost certainly took books with him, as Louis did; the *Histoire,* a chronicle written by a Flemish crusader at his mother's favorite residence, would have been an apt choice.[77] We know that members of the Dampierre family were important patrons of French vernacular texts, often commissioning manuscripts with crusading themes.[78] As Rebecca Corrie has shown, the same family is responsible for the transmission of the *Histoire* to Angevin Naples.[79]

This particular history raises questions about the patronage of the Paris copy of the *Histoire Universelle*. As we have seen, this manuscript stands apart from all the other surviving copies of the text in its insistence on the Amazons' military prowess: only there do the women rout hapless male adversaries (fig. 9.4), topple Hercules and Theseus in defiance of the very rubric above (fig. 9.7), and even seem to intimidate Aeneas (fig. 9.17). This remarkable emphasis on women's valor suggests to us the possibility of a female patron. While we have argued that the ideology of the crusades might in part explain such images, we know no other copy of our text that portrays the women as such astonishing exemplars of martial force. Perhaps the gender reversals embodied by the Amazons stirred anxieties in some patrons, as the brutal dismemberments and deaths of the women in so many copies of the text suggest (figs. 9.5, 9.8, 9.13, 9.14, 9.15). Even the crusader copies at times betray some ambivalence about the women's military exploits. For instance, the London copy of the *Histoire Universelle* tends to undercut the women's stature, depicting them as decorative helpmates to the male fighters (fig. 9.2) rather than warriors in their own right.[80] Such ambivalence is not surprising; surely the notion of martial women must have unsettled many a knight, even those hoping

for outside assistance from any quarter.[81] But no ambivalence is seen in the Paris codex, where the women fight alone, apparently invincible.

If the Amazon images in the Paris codex seem to suggest a female patron, so too does the Genesis cycle—indeed, Joslin, the author of the only extensive study of the Genesis cycle, has already raised such a possibility.[82] First, as she notes, in the image of Jacob receiving Isaac's blessing, Rebecca is given a prominence unprecedented in the Acre manuscripts. Here Rebecca, a towering presence, occupies the center of the composition, and directs her obedient younger son to disguise himself as his brother. Her size, her position, and her commanding action all establish her as the dominant character here. In the other three copies of the text, by contrast, her role is minimal; in two instances she does not participate, but appears only as a diminutive figure watching from afar, and in a third she is omitted entirely.[83]

Following Buchthal, Joslin also points to the anomalous treatment of Joseph and Potiphar's wife in the Paris codex.[84] The illustrations in the three other codices from Acre emphasize the titillating aspects of the drama. In each, Potiphar's wife is shown stark naked and lying in bed, in a manner that makes her intentions explicit.[85] In the Paris codex, however, she stands, fully and discreetly dressed; the bed is nowhere in sight. Further, in the other Acre manuscripts as well as the comparable French examples of the scene, Joseph is shown trying to escape; here he faces her calmly.[86] The change in action and tenor seems significant: Potiphar's wife has been transformed from a threatening seductress to a stately, regal figure. Only her gesture—she is shown grasping Joseph's cloak—gives any indication of the struggle between them. Finally, as Joslin has also noted, the Paris codex's image of the death of Isaac is unique among the Acre copies in its inclusion of two female mourners; in the others, the mourners are all male.[87] Moreover, the two women are among the most prominently placed of the mourners, standing near the head of the dead man.

All of these manipulations of more typical iconography, in both the Amazon cycle and the Genesis cycle, cannot be fortuitous. This consistent foregrounding of women implies the intervention of a patron who issued clear instructions to the illuminator responsible for the images here.[88] We know that medieval female patrons made their wishes clear to artisans in their employ. The twelfth-century countess Adele of Blois (d. 1137) supervised work on the tapestries that would hang in her room in the palace, "showing [the weavers] with her drawing stick what they should do";[89] Christine de Pizan also directed the illuminators of her own texts.[90] It seems likely that similar direction was provided here.

We can only speculate about the specific patron responsible for this remarkable

codex. A number of women wealthy and powerful enough to commission such a manuscript lived in the crusader states in the waning years of the Latin Kingdom. Further, we have evidence of one noble woman who was a patron of an Acre scriptorium in the 1270s: Eleanor of Castile, who accompanied her husband, Edward of England, to Acre in 1271, commissioned a translation of a text, and presented the manuscript to her husband.[91]

But an especially intriguing possibility deserves our attention: Alice, countess of Blois. Alice left for Acre in 1287—close to the likely date of the Paris codex. The countess had taken her crusading vow some twenty years earlier and succeeded in reaching Acre only as a widow, bringing with her a "grant compagnie de gens d'arms."[92] Like Penthesilea, then, Alice brought military reinforcements to embattled friends. Moreover, she was not merely a visitor to the Holy Land but a settler, who remained in Acre for over a year and died there in 1288. Alice took an active interest in the life of the city and invested in it heavily: she had a tower constructed on the wall of the city and also endowed a chapel. Furthermore, her daughter, Joan, joined her in Acre, spending two years in the city.[93] Given Joan's presence there, the emphasis in the Paris manuscript on *pairs* of women—the two queens who set out to rescue their loved ones (fig. 9.3), the victorious sisters of Antiope (fig. 9.7), and the two women prominently mourning the death of Isaac—is especially suggestive.

In fact, there are reasons why Alice might have had a particular interest in the *Histoire Universelle,* and in the specific version of the text that survives in Paris 20125. This copy of the text is distinctive not only in its images but also in its text, which includes a verse prologue and moralizations omitted in all but one other copy.[94] It is only in the prologue that we find references to Flanders, and to Lille as the origin of the text. Later in the moralization the text refers to the counts of Flanders, to the father of Joan and Margaret, Baldwin, the first emperor of Constantinople, and to Baldwin's mother, Margaret, a good and distinguished woman ("bone dame eslite").[95] If the prologue and the moralization were included at the Acre patron's request, should we not assume some sort of affiliation with Flanders? We know that long-standing ties linked the comital families of Blois and Flanders. Count Louis of Blois had been a close companion of Margaret's father, Baldwin IX, on the Fourth Crusade;[96] and the old allegiance between the two families was strengthened by the marriage, in 1287 or 1288, of Alice's husband's nephew, the new count of Blois, Hugh II of Châtillon, to Beatrice, the daughter of Guy of Dampierre—the youngest son of Margaret.[97] At this point, of course, our evidence remains circumstantial at best. But the possibility of a female patron asso-

ciated with the Flemish countesses seems worth exploring, and Alice of Blois fits the description.

Tempting as it may be to assume a proto-feminist sensibility here, we should be cautious concerning the many possibilities in the interpretation of this manuscript's images. The Paris codex's illustration of the confrontation between the sisters of Antiope and Hercules and Theseus is a striking case in point (fig. 9.6). Though the images suggest gender reversal—female warriors are erect and aggressive, males supine and submissive—this confrontation seems to be tinged with a sense of humor. Female lances are poised precariously near male "lances." Like the festival in which the Knights of St. John dressed as Amazons, this particular illustration challenges us to interpret its tone. The Knights of St. John and the patron of this manuscript were undoubtedly affected by both the legendary Amazons and the actual crusading women in the Levant. Although David Jacoby suggests that the festive Knights were satirizing the sexual reversals,[98] perhaps the term *satire* is an overstatement. Could it be that in both cases there was an attempt to understand a potentially troubling disruption of social norms by offering a comic version of a realized threat? The laughter of satire implies that an abnormal state of affairs (gender reversal) requires a corrective (return to socially sanctioned roles). The laughter of comedy does not necessarily assign a solution; it is an interrogation of sorts—as if the Knights and the patron used this sexual "play" as a heuristic device, playing the game of "what if women were like men, and men like women?"

In conclusion, our ambition for this essay is double-edged. We hope to have shown that the illuminated manuscripts of the *Histoire Universelle* from Acre attest to the rehabilitation of the Amazons that took place in the twelfth and thirteenth centuries, especially in the context of the crusades. But we also hope to have offered a plausible interpretation of this unusual interest in these (ordinarily) subversive figures. That interpretation is, of necessity, a tentative one. We believe that patronage could explain both the emphasis on the Amazons and the manner in which they are represented. We know that the text's European origins are embedded in a court society dominated by two women referred to in Flanders (to this day) as "les bonnes comtesses." And since the manuscripts were produced in Acre, a destination for military women (like Eleanor of Aquitaine or Alice of Blois), the simplest explanation is that just such a woman directed the program of a manuscript like Paris 21025. But, whatever the sexual identity of the patron, the product seems deeply influenced both by the legendary Amazons who moved in the cultural imagination of the Latin Kingdom, and by the female crusaders who made their way east in the later thirteenth century.

Notes

We are grateful to Jaroslav Folda, Sharon Gerstel, Mary Coker Joslin, Ellen Schwartz, and Daniel Weiss for their comments on earlier drafts of the text, and to Mary Coker Joslin for her generosity in sharing a transcription of the *Histoire Universelle* with us. Our thanks as well to Penelope Adair, Emilie Amt, Jeffrey Anderson, Julie Badiee, Cristelle Baskins, Anne-Marie Bouché, Annemarie Weyl Carr, Rebecca Corrie, John Block Friedman, Joan Holladay, David Jacoby, Genevra Kornbluth, Marcia Kupfer, Eunice Maguire, Henry Maguire, Julia Miller, Jonathan Riley-Smith, Pamela Sheingorn, and Diane Wolfthal for suggestions and comments, and to Jane Moncure and Robert Schwab for their assistance. The research for this project was supported by a Beneficial-Hodson Faculty Fellowship from Hood College.

1. The seminal work on this text is the study by Paul Meyer, "Les premières compilations françaises d'histoire ancienne," *Romania* 14 (1885): 1–81. Portions have been edited: for Genesis, see Mary Coker Joslin, "A Critical Edition of the Genesis of Rogier's *Histoire ancienne* based on Paris, BN MS fr. 20125" (Ph.D. diss., University of North Carolina, 1980); idem, *The Heard Word: A Moralized History. The Genesis Section of the Histoire Ancienne in a Text from Saint-Jean d'Acre,* Romance Monographs, 45 (University, Miss., 1986); for Assyria, Thebes, the Minotaur, the Amazons, and Hercules, see Marijke de Visser-van Terwisga, ed., *Histoire ancienne jusqu'à César (Estoires Rogier),* 2 vols. (Orleans, 1995, 1999); for a portion of the section on Rome, see Christophe Pavlides, *L'Histoire ancienne jusqu'à César (première rédaction). Étude de la tradition manuscrite. Étude et édition partielle de la section d'histoire romaine* (thesis, École Nationale des Chartes, 1989). De Visser-van Terwisga (*Histoire*, II, 12–17) provides the most recent list of the known manuscripts of the first redaction. For a cogent overview of the literary genre and its ideological roots, see Gabrielle M. Spiegel, *Romancing the Past: The Rise of Vernacular Prose Historiography in Thirteenth-Century France* (Berkeley, 1993); for the *Histoire Universelle* specifically, see ibid., 107–11, 116–17. For the most comprehensive recent study of the illuminated copies, see Doris Oltrogge, *Die Illustrationszyklen zur "Histoire ancienne jusqu'à César" (1250–1400)* (Frankfurt am Main, 1989); see also Joslin's review in *Speculum* 68 (1993): 544–47.

2. For the attribution of these copies to Acre, see Hugo Buchthal, *Miniature Painting in the Latin Kingdom of Jerusalem* (Oxford, 1957) and Jaroslav Folda, *Crusader Manuscript Illumination at Saint Jean d'Acre, 1275–1291* (Princeton, 1976), esp. 77–82 and 93–102. Though the attribution is widely accepted, David Jacoby has questioned it; see, most recently, his contribution to this volume, "Society, Culture, and the Arts in Crusader Acre."

3. Two Amazons appear in an illumination from a thirteenth-century copy of Thomas of Cantimpré, *De Naturis Rerum* (Valenciennes, Bibliothèque Municipale, MS. 320, fol. 44r); see John B. Friedman, *The Monstrous Races in Medieval Art and Thought* (Cambridge, Mass., 1981), fig. 1. Thomas's text will be discussed below.

The women appear occasionally in *mappaemundi:* the Ebstorf *Mappamundi,* a late-thirteenth-century manuscript consisting of thirty joined sheets (now in Hannover,

Mus. Hist. Ver. Niedersachsen), depicts two women, one with a sword, the other with a spear, inscribed AMAZONES; they stand on an island in the Black Sea. See Gotz Pöchat, *Der Exotismus während des Mittelalters und der Renaissance* (Stockholm, 1970), fig. 85, 203; see also his chapter 9, "Die Exotismus in der Kartographie." On *mappaemundi*, see John Moffitt, "Medieval *Mappaemundi* and Ptolemy's *Chorographia*," *Gesta* 32 (1993): 59–68; Marcia Kupfer, "The Lost *Mappamundi* at Chalivoy-Milon," *Speculum* 66 (1991): 540–71.

Amazons may also have appeared in early copies of the *Roman de Troie*—another important text for this study. Buchthal, *Historia Troiana: Studies in the History of Mediaeval Secular Illustration,* Studies of the Warburg Institute, 32 (London, 1971), 61, states that the episode of the queen of the Amazons "must have been illustrated" in early copies, as it appears in later versions of the text. As Buchthal notes (9), the earliest extant illustrated copy, from 1264, is in Paris, Bibliothèque Nationale, MS. fr. 1610. Though the Paris copy does include small illuminations of battle scenes at or near the points in the text that discuss Penthesilea (e.g., fols. 138r, 141v), it is impossible to determine the sex of the combatants, as they wear helmets that cover their faces and hair.

4. See Sandra Hindman, "The Role of Author and Artist in the Procedure of Illustrating Late Medieval Texts," in *Text and Image,* ed. David W. Burchmore (Binghamton, 1986), 27–62. We are grateful to Diane Wolfthal for this reference.

5. Buchthal, *Miniature Painting,* 69–87.

6. Ibid., 70; Folda, *Crusader Manuscript Illumination,* 95–102. Folda has returned to the atelier responsible for this manuscript and a number of related works in two more recent studies: "Two Thirteenth-Century Manuscripts of Crusader Legal Texts from Saint-Jean d'Acre" (with Peter Edbury), *Journal of the Warburg and Courtauld Institutes* 57 (1994): 243–54; "The Hospitaller Master in Paris and Acre: Some Reconsiderations in Light of New Evidence," *Journal of the Walters Art Gallery* 54 (1996): 51–59.

7. Oltrogge, *Die Illustrationzyklen,* 22; followed by Barbara Zeitler, "'Sinful Sons, Falsifiers of the Christian Faith': The Depiction of Muslims in a 'Crusader' Manuscript," *Mediterranean Historical Review* 12 (1997): 25–50, and de Visser-van Terwisga, *Histoire,* II, 39. In her *Speculum* review of Oltrogge's study, Joslin noted that Oltrogge's attribution of the Paris copy to France was made "without full codicological consideration" (546). Reservations about Folda's arguments were expressed first by Harvey Stahl in his review of *Crusader Manuscript Illumination* in *Zeitschrift für Kunstgeschichte* 43 (1980): 416–23. For Folda's response to other points raised by Stahl in his review, see "The Hospitaller Master," 52–55.

8. The manuscripts are in The Hague, Koninklijke Bibliothèque, MS. 78 D 47; London, British Library, Add. MS. 19669; Pommersfelden, Gräflich-Schönborn'sche Schlossbibliothek, MS. 295 (all three are tentatively ascribed by Oltrogge, *Die Illustrationzyklen,* 13, to the same workshop in northern France, c. 1250–75); Paris, Bibliothèque Nationale, MS. fr. 17177 (northern French, c. 1280–1300; Oltrogge, 22–23); Brussels, Bibliothèque Royale, MS. 18295 (Paris, c. 1250–75; Oltrogge, 24–25); four ascribed to Naples, c. 1290: Carpentras, Bibliothèque Inguimbertine, MS. 1260; Rome,

Vatican, MS. 5895; Paris, Bibliothèque Nationale, MS. fr. 1386; Paris, Bibliothèque Nationale, MS. fr. 9685 (for these, see Bernhard Degenhart and Annegrit Schmidt, *Corpus der Italienischen Zeichnungen, 1300–1450* [Berlin, 1980], cat. 665, 667, 668, and 666; Oltrogge, 36–39); Chantilly, Musée Condé, MS. 726, Naples, c. 1275–1300 (on which see Rebecca Corrie's article in this volume, "Angevin Ambitions: The Conradin Bible Atelier and a Neapolitan Localization for Chantilly's *Histoire ancienne jusqu'à César*"); Tours, Bibliothèque Nationale, MS. 953 (Italian, c. 1300; Oltrogge, 315). De Visser-van Terwisga adds another thirteenth-century manuscript (Aylsham, Norfolk, Blickling Hall, MS. 6931) that Oltrogge did not include in her study (*Histoire,* II, 12). We also exclude from the list of western European examples a manuscript in Paris (Bibliothèque Nationale, MS. fr. 9682) that was copied in France at the end of the thirteenth century from a crusader copy. It offers an instructive look at the issues discussed here, and we consider its Amazon images at some length above, but it is not representative of the western European copies.

9. Our analysis relies on Oltrogge's extensive tables, which list a total of 298 secular episodes in thirty-three of the manuscripts. In our calculations, we include Camilla, the Roman maiden often associated with the Amazons in medieval lore. We have excluded one of the thirteenth-century Western copies, Paris, Bibliothèque Nationale, MS. fr. 17177, from our table, because its pictorial cycle is incomplete, and we thus cannot calculate the percentage of episodes dedicated to the Amazons.

10. See Buchthal, *Miniature Painting,* 70; Folda, *Crusader Manuscript Illumination,* 128–29. Buchthal dates the manuscript c. 1300 ; Folda prefers a date of c. 1291–95 (102).

11. For the full rubric ("Ci commence de ceus d'athenes et de ceus de l'isle de Crete, qui en celui tans se guerreoient et dou comencement dou regne d'Amazone"), and subsequent text, see de Visser-van Terwisga, *Histoire,* I, 76–a. The text refers to the land of the Amazons even in the Genesis portion; see Joslin, *The Heard Word,* 291, n. 103.

12. The text reads: "savés vos qu'eles firent? Eles s'asemblerent *et* si pristrent conseill qu'eles s'armeroient *et* si iroient vengier lor barons *et* lor fiz *et* lor freres de ceaus qui ocis les avoient" (de Visser-van Terwisga, *Histoire,* I, 80).

13. "Des dames de Sithe, qui alerent vengier lor fiz *et* lor amis as armes esmolues" (ibid., I, 80). Herodotus places the Amazons in Scythia, but the tale of their presence there is rather different. He describes a group of Amazons at sea, taken captive by the Greeks, who murdered their captors and landed in Scythia. See Herodotus, *The History,* trans. David Grene (Chicago, 1987), Book 4, 110; and Abby W. Kleinbaum, *The War Against the Amazons* (New York, 1983), 6–8.

14. See Buchthal, *Miniature Painting,* pl. 107a (Dijon), b (Brussels). The copy in Paris, MS. fr. 9682, resembles these two fairly closely.

15. The text reads: "as espees esmolues destruirent eles ceaus qui lor amis ocis avoient." Just as the images in the Paris and London copies differ, the rubrics differ correspondingly: the rubric in the London codex drops the phrase "as armes esmolues" ("with sharp swords drawn"), and in the London miniature, the women are largely unarmed.

16. As Joslin has noted ("The Illustrator as Reader: Influence of Text on Images in the *Histoire ancienne*," *Medievalia et Humanistica*, n.s., 20 [1993]: 85–121, esp. 90–99 and 110–11), details in the illustrations to Genesis in the Paris copy also reveal an unusually close correspondence with the text.

17. For the full passage, see de Visser-van Terwisga, *Histoire*, I, 81.

18. See Buchthal, *Miniature Painting*, pl. 109a.

19. Bibliothèque Nationale, MS. fr. 1386, fol. 22v; Degenhart and Schmidt, *Corpus der Italianischen Zeichnungen*, vol. 2, part 2, cat. 668.

20. de Visser-van Terwisga, *Histoire*, I, 81: "Cele roïne fist merveilles por ses compaignesses qu'ele veoit devant li ocire. Mais ne valut rien en la fin, quar la fu ocise la roïne *et* totes ses puceles, qui bien s'i furent vengees." Amazonian mutilation does, however, occur in the *Roman de Troie* by Benoît de Saint-Maure (in the passage describing the death of Penthesilea; see Kleinbaum, *The War Against the Amazons*, 56).

21. The text reads: "il fu samblans a Sanson de proece *et* de force." The two are described as "les meillors dou monde."

22. For the passage (fols. 121r and v), see de Visser-van Terwisga, *Histoire*, I, 84.

23. See Buchthal, *Miniature Painting*, pls. 108a, b.

24. Greek images of these heroes battling the Amazons also were at times tinged by eroticism, as Ellen Reeder has observed (*Pandora: Women in Classical Greece* [Princeton, 1995], 373–74).

25. Oltrogge, *Die Illustrationzyklen*, 285.

26. The foregrounding of the Amazons in the Troy portion of the manuscripts was noted by Buchthal, who stressed that parts of the Troy story that are far better known were left unillustrated. He noted the manuscripts' omission of what he called "the characteristic scenes" of the Troy story (*Miniature Painting*, 70–71) and observed again on page 75: "Most of the numerous chapters referring to the story of Troy are not illustrated at all." In *Historia Troiana*, 16, he again noted the limited illuminations, stating: "This choice cannot be called particularly apt or happy, for with the exception of the death of Hector, the miniatures all illustrate secondary or uncharacteristic episodes. The most likely reason for this is in all probability that when the *Histoire ancienne* was first compiled at the beginning of the thirteenth century, no narrative cycle illustrating the story of Troy existed. . . . Thus the illuminator of the archetype had no obvious models at his disposal. He was content to insert a few colorless miniatures repeating standard formulas, and later copyists followed suit."

27. The Amazons come to the aid of the Trojans in the manuscript in Chantilly and in London (Add. MS. 19669); see Oltrogge's chart, *Die Illustrationzyklen*, no. 161. For other episodes at times depicted in copies of the *Histoire*, again see Oltrogge's chart, nos. 128–60.

28. See Buchthal, *Miniature Painting*, pls. 114a, b.

29. See Oltrogge, *Die Illustrationzyklen*, fig. 111.

30. On Camilla as an Amazonian figure, see A. Petit, "Le traitement courtois du thème des Amazones d'après trois romans antiques: *Éneas, Troie*, et *Alexandre*," *Le Moyen Age* 89 (1983): 63–84, esp. 65–67; Kleinbaum, *The War Against the Amazons*,

27–30. As Petit notes, Virgil compared Camilla to the Amazons Hippolyta and Penthesilea (66).

31. See Buchthal, *Miniature Painting,* pls. 116a, b. In the Dijon codex, both principal antagonists appear wounded, and in the Brussels manuscript, neither is—just as in the battle of the sisters of Antiope against Hercules and Theseus in each manuscript: there, too, both male and female combatants are wounded in the Dijon copy, neither in the Brussels copy.

32. A manuscript in London, Add. MS. 19669, depicts an early moment of the battle (fol. 104r); in a copy in Paris, MS. fr. 17177, fol. 71v, Aeneas strikes Camilla across the chest. The Pommersfelden copy, fol. 95r, similarly depicts the death of the princess (Oltrogge, *Die Illustrationzyklen,* fig. 136).

33. The colors differ, however: Penthesilea wears a red tunic with gold stripes (as does Hector, her ally, in folio 133v; Folda, *Crusader Manuscript Illumination,* pl. 75); Camilla's tunic, also with gold stripes, is blue. The roses that Penthesilea wears in the battle against Pyrrhus also appear in later manuscripts; see Laura Dufresne, "Woman Warriors: A Special Case from the Fifteenth Century," *Women's Studies* 23 (1994): 120–31, esp. 126–27. We are grateful to Pamela Sheingorn for a copy of this article.

34. There is considerable literature on Amazons in antiquity. See, for instance, Donald J. Sobol, *The Amazons of Greek Mythology* (South Brunswick, 1972); Kleinbaum, *The War Against the Amazons,* 5–36; Page duBois, *Centaurs and Amazons: Women and the Pre-History of the Great Chain of Being* (Ann Arbor, 1982); William Blake Tyrrell, *Amazons: A Study in Athenian Mythmaking* (Baltimore, 1984).

35. Clement: see Kleinbaum, *The War Against the Amazons,* 39; Orosius: *Paulus Orosius: The Seven Books of History against the Pagans,* trans. Roy J. Deferrai, The Fathers of the Church, 50 (Washington, D.C., 1964), 37 (1.16); Vincent DiMarco, "The Amazons and the End of the World," in *Discovering New Worlds: Essays on Medieval Exploration and Imagination,* ed. Scott D. Westrem, Garland Medieval Casebooks 2, Garland Reference Library in the Humanities 1436 (New York, 1991), 69–90, 77.

36. *The Trojan Way: The Chronicles of Dictys of Crete and Dares the Phrygian,* trans. R. M. Frazer Jr. (Bloomington, 1966), 88.

37. DiMarco, "The Amazons and the End of the World," 79–80.

38. *Historia Ecclesiastica,* part III, book VIII; see also Petit, "Le traitement courtois," 80. For similar examples, see the entry "Amazons" by Adam Kosto in *Travel, Trade, and Exploration in the Middle Ages: An Encyclopedia,* ed. John Block Friedman and Kristen Mossler Figg (New York, 2000). We are grateful to Professor Friedman for providing us with a copy of this entry before the publication of the encyclopedia.

39. Joan M. Ferrante, "Women's Role in Latin Letters," in *The Cultural Patronage of Medieval Women,* ed. June Hall McCash (Athens, 1996), 73–104, esp. 95–96. Ferrante cites an unpublished paper by Kimberly LoPrete on Adele.

40. Amy Kelly, *Eleanor of Aquitaine and the Four Kings* (Cambridge, Mass., 1950), accepted the legend, arguing that "the tale is in character, and later allusions to Amazons en route, found in Greek historians, give some substance to it" (35); indeed, she referred to Eleanor and her entourage as "Amazons" throughout (e.g., 38–39, 41, 47–48, 50). How-

ever, D.D.R. Owen, *Eleanor of Aquitaine: Queen and Legend* (Oxford, 1993), 148–52, viewed the legend more cautiously. See also F. Chambers, "Some Legends Concerning Eleanor of Aquitaine," *Speculum* 16 (1941): 459–68; Petit, "Le traitement courtois," 80.

41. *O City of Byzantium: Annals of Niketas Choniates,* trans. Harry J. Magoulias (Detroit, 1984), 35; see also *Chronicles of the Crusades,* ed. Elizabeth Hallam (New York, 1989).

42. Desmond Seward, *Eleanor of Aquitaine: The Mother Queen* (London, 1978), 44, takes Choniates's reference to the "lady of the golden boot" as a reference to Eleanor. In addition, see Owen, *Eleanor of Aquitaine,* 149, who also notes that Choniates "surely had Eleanor in mind."

43. For Amazons in the *Roman de Troie,* see Petit, "Le traitement courtois," 67–68; Kleinbaum, *The War Against the Amazons,* 51–58; Alison Taufer, "From Amazon Queen to Female Knight: The Development of the Woman Warrior in the *Amadis Cycle*" (Ph.D. diss., UCLA, 1988), 66–71. The basic edition of the text is Leopold Constans, ed., *Le roman de Troie,* 6 vols. (Paris, 1904–22). See Owen, *Eleanor of Aquitaine,* 38, for the "riche dame" as Eleanor, and for a translation of lines 23426–97 on the Amazons. For illustrated copies of Benoît's romance, see Buchthal, *Historia Troiana,* chapter 2. The earliest extant illustrated copy dates from 1264 (Paris, Bibliothèque Nationale, MS. fr. 1610); Buchthal believes that the first illustrated copies would have been executed about ten or twenty years earlier (13).

44. For instance, about Penthesilea he writes:

Proz e hardie e bele e sage
De grant valor, de grant parage (lines 23362–63)

On the other hand, Benoît also describes the mutilation of Penthesilea, suggesting lingering ambivalence about martial females.

45. Quoted in Vsevolod Slessarev, *Prester John: The Letter and the Legend* (Minneapolis, 1959), 70. On the legend, see also C. F. Beckingham, "The Achievements of Prester John," in his collected essays, *Between Islam and Christendom: Travellers, Facts and Legends in the Middle Ages and the Renaissance* (London, 1983), 3–24. Beckingham noted that the first reference to the legend appears in Otto of Freising's *Two Cities* (book VII, chapter 3); Otto cited as his source the bishop of Jabala, ancient Byblos in Lebanon. See also the discussion by B. Hamilton, "Prester John and the Three Kings of Cologne," in *Studies in Medieval History Presented to R.H.C. Davis,* ed. Henry Mayr-Harting and R. I. Moore (London, 1985), 177–91, esp. 178–80, for the origins of the legend. For a discussion of this passage referring to the Amazons, see Beckingham, "The Achievements of Prester John," 4–8. Beckingham, ibid., 10–13, cautiously dated the letter 1143–80 (the reign of Manual Komnenus, to whom the letter was addressed); it is more often dated 1165. On Prester John and the Amazons, see also Kleinbaum, *The War Against the Amazons,* 73–75.

46. Slessarev, *Prester John,* 33–34; Igor de Rachewiltz, *Prester John and Europe's Discovery of East Asia* (Canberra, 1972), 5.

47. For women's increasing participation, see James W. Powell, "The Role of Women in the Fifth Crusade," in *The Horns of Hattin,* ed. Benjamin Z. Kedar

(Jerusalem, 1992); L. Brady, "Essential and Despised: Images of Women in the First and Second Crusades, 1095–1148" (master's thesis, University of Windsor, 1992); Helen Penrose, "Constructing Medieval Identity: Women in the Crusades" (master's thesis, University of Melbourne, 1992). We have not been able to consult Penrose's thesis, but we are grateful to her for corresponding with us about it. For the prohibition against female crusaders, see Elizabeth Siberry, *Criticism of Crusading, 1095–1274* (Oxford, 1985), 44–46 (on the Third Crusade); James A. Brundage, *Medieval Canon Law and the Crusader* (Madison, 1969), 76–77 (on changes at the time of Innocent III); H. Solterer, "Figures of Female Militancy in Medieval France," *Signs* 16 (1991): 522–49, esp. 535–41. For *Quia maior,* Innocent's encyclical of 1213, see Jonathan Riley-Smith, *The Crusades: A Short History* (New Haven, 1987), 143. On female crusaders, see also Taufer, "From Amazon Queen to Female Knight," 109–15; M. Purcell, "Women Crusaders: A Temporary Canonical Aberration?" in *Principalities, Powers and Estates: Studies in Medieval and Early Modern Government and Society,* ed. L. O. Frappell, Papers presented at the Fifth Conference of Australian Historians of Medieval and Early Modern Europe, Sydney, 23–26 May 1978 (Adelaide, 1979), 57–64; Ronald C. Finucane, *Soldiers of the Faith: Crusaders and Moslems at War* (New York, 1983), 174–79; M. McLaughlin, "The Woman Warrior: Gender, Warfare and Society in Medieval Europe," *Women's Studies* 17 (1990): 193–209. We are indebted to Cristelle Baskins for the references to Solterer's and McLaughlin's studies and for generously sharing her work on Amazons with us.

48. Riley-Smith, *The Crusades,* 144.

49. Powell, "The Role of Women," 161–62.

50. The tale appears in Wolfram von Eschenbach's Willehalm epic of about 1220; we are grateful to Joan Holladay for a copy of her paper, "The Heroine as Holy Woman: Arabel in Armor," presented at the Thirteenth Annual Sewanee Medieval Colloquium, April 1986, University of the South, Sewanee, Tenn. See also *Li tournoiement as dames,* from the thirteenth century; Solterer, "Figures of Female Militancy," esp. 535–42, discusses this text in light of women's increasing participation in the crusades.

51. For William: *Recueil des historiens des croisades: historiens occidentaux,* II, 504. For Guibert: *Recueil des historiens des croisades: historiens occidentaux,* IV, 191 (book 5, IX). According to Taufer ("From Amazon Queen to Female Knight," 114), William also refers to women in Syria with Conrad as Amazons.

52. Trans. in Friedman, *Monstrous Races,* 170–71.

53. Raynaud de Lage, "Les 'romans antiques' et la représentation de l'antiquité," *Le Moyen Age* 67 (1961): 281; he noted "un echo de la 4ᵉ Croisade." See also page 291, where he raises the issue again. The Genesis portion of the text contains some support for his suggestion. It includes references to holy sites that, according to Joslin, are not found in any of the author's sources; these also tend to suggest a firsthand knowledge of the Holy Land. For instance, he notes the location of the tombs of Hebron, near Jerusalem on Damascus road (Joslin, "Critical Edition," cvii), and cites the epitaph on the tomb of Rachel, which he says is "found today" (ibid., cxviii).

54. See John B. Friedman, "Thomas of Cantimpré, *De Naturis Rerum:* Prologue, Book III, and Book XIX," in *La science de la nature,* Cahiers d'études medievales, 2 (Montreal, 1974), 88–90, 125; *Monstrous Races,* 171. Friedman notes (107–8, 110) that Thomas studied with Jacques as a boy in Liège, 1206–12.

55. *Les gestes des chiprois: recueil des chroniques françaises écrites en Orient aux XIIIe et XIVe siècles,* ed. Gaston Raynaud (Geneva, 1887), 220; Buchthal, *Miniature Painting,* 86. Jacoby has suggested that the play—in itself a fascinating gender reversal, mirroring the gender reversal of the Amazons themselves—was likely satirical; see "La litterature française dans les états latins de la Mediterranée orientale a l'époque des croisades: diffusion et creation," in *Studies on the Crusader States and on Venetian Expansion* (Northampton, 1989), 617–46, esp. 631–32; idem, "Knightly Values and Class Consciousness in the Crusader States of the Eastern Mediterranean," *Mediterranean Historical Review* 1 (1986): 159–86, esp. 167. We are grateful to Professor Jacoby for copies of these articles.

56. For the castle at Bodrum, see T.S.R. Boase, "The Arts in Frankish Greece and Rhodes," in *A History of the Crusades,* ed. Kenneth M. Setton, vol. 4, *The Art and Architecture of the Crusader States,* ed. Harry W. Hazard (Madison, 1977), 208–50, esp. 240–51.

57. See, for instance, Doro Levi, *Antioch Mosaic Pavements,* 2 vols. (Princeton, 1947) vol. 1, 282; vol. 2, pl. LXIVb; C. Dulière, *La mosaique des Amazones* (Brussels, 1968); Ehud Netzer and Zeev Weiss, *Zippori* (Jerusalem, 1994), 52–53; a silver plate in Dumbarton Oaks (Marvin C. Ross, *Catalogue of the Byzantine and Early Medieval Antiquities in the Dumbarton Oaks Collection,* vol. 1: *Metalwork, Ceramics, Glass, Glyptics, Painting* [Washington, D.C., 1962], no. 4, 3–4); J.-L. Laporte, "Tissus de Faremoutiers," in *L'Ile-de-France de Clovis à Hugues Capet, du Ve siècle au Xe siècle,* exh. cat., Musée Archéologique Départemental du Val-d'Oise et Service Régional de l'Archéologie d'Ile-de-France, 112–13. Many thanks to Sharon Gerstel, Eunice Maguire, and Henry Maguire for these references. Finally, the legend of the Amazons appears in the twelfth-century Byzantine poem, *Digenis Akritas,* 6. 720s f, but illustrations of the women in copies of the text are not known. For the Amazons in this text, see U. Moennig, "Digenes = Alexander? The Relationships between *Digenis Akrites* and the Byzantine *Alexander Romance* in their Different Versions," in *Digenis Akrites: New Approaches to Byzantine Heroic Poetry,* ed. Roderick Beaton and David Ricks (Brookfield, Vt., 1993), 103–15, esp. 110–12. We are grateful to Jeffrey Anderson for calling our attention to this text.

58. Buchthal, *Historia Troiana,* 3–4. On Dares and Dictys as the sources of the *Roman de Troie,* see Buchthal, *Historia Troiana,* 3; idem, "Hector's Tomb," *De Artibus Opuscula,* XL: *Essays in Honor of Erwin Panofsky,* ed. Millard Meiss (New York, 1961), vol. 1, 29–36. The compiler of the *Histoire Universelle* took the Troy portion largely from Dares; for the strongly pro-Trojan tenor of Dares, see Buchthal, *Historia Troiana,* 3–4.

59. *The Birth of an Ideology: Myths and Symbols of Nation in Late-Medieval France* (Berkeley, 1991), 237.

60. The notion of the Amazons as allies of the Trojans does not appear in Homer,

and it is only minimal in Virgil; it is, however, found in Aretinus of Miletus. See Klein-baum, *The War Against the Amazons,* 22–26.

61. For this image as the heraldry of Hector, see Christine Van der Bergen-Pantens, "Guerre de Troie et heraldique imaginaire," *Revue belge d'archéologie et d'histoire d'art* 52 (1983): 3–21; for images of Hector with the lion, see her figs. 1–4, 6. She traces the rampant lion as Hector's emblem to Benoît de Sante-Maure in his *Roman de Troie* (6–7).

Examples of the rampant lion worn by crusader leaders include several images in a *History of Outremer,* Paris, Bibliothèque Nationale, MS. fr. 9084; Folda, *Crusader Manuscript Illumination,* 77–92, and cat. no. 7, 182–84. Folio 307v (Folda, pl. 115) de-picts Bohemond of Antioch and Raymond of Tripoli arriving before Jerusalem; Bo-hemond was specifically compared with Hector by Radulf of Caen (Beaune, *The Birth of an Ideology,* 236). Another example that is equally suggestive appears in another copy of the *History of Outremer* (Boulogne-sur-Mer, Bibliothèque Municipale, MS. 142, fol. 16r; Folda, pl. 119). This miniature depicts Godfrey of Bouillon, who was also com-pared with Hector (Beaune, *The Birth of an Ideology,* 238).

The rampant lion was, however, very popular, and appears fairly often on the her-aldry of Flemish nobility; for typical examples, see E. Warlop, *The Flemish Nobility before 1300,* 4 vols. (Kortrijk, 1975–76), vol. 2, pt. 2, pls. 204, 207. It is conceivable that its popularity is due to its associations with the Trojan king; the Flemish claimed Tro-jan ancestry from c. 1120 (Beaune, *The Birth of an Ideology,* 236). Moreover, there are inconsistencies in its depiction. As noted above, the lion is usually rampant, but not always; in a French copy of the *Roman de Troie,* dated 1264 (Paris, Bibliothèque Na-tionale, MS. 1610, fol. 17v; Buchthal, *Historia Troiana,* pl. 2a), Hector wears a lion, but it is shown walking. And at times, the rampant lion is the emblem not of the Trojans but of the Greeks. For instance, this odd misunderstanding occurs in the Dijon *Histoire Universelle* (Buchthal, *Miniature Painting,* pls. 114a, 107a), and at times in Paris 1610 (Buchthal, *Historia Troiana,* pls. 5a, b). These images may be early examples of the fairly frequent errors in representing Hector's heraldry, described by R. Loomis, "The Heraldry of Hector or Confusion Worse Confounded," *Speculum* 42 (1967): 32–35.

62. See R. Ettinghausen, "Hilāl in Islamic Art," in *The Encyclopedia of Islam,* vol. 3 (London, 1979), 381–85. For the early appearance of the crescent, with a five- or six-pointed star, on Arab-Sasanian coins from the end of the seventh century, see page 381. For the motif as a bronze ornament worn by horses, see ibid., fig. 10. By the sixteenth century, and possibly earlier, the star and crescent appeared on Turkish flags; see ibid., fig. 17.

For the star or the crescent in crusader manuscript illumination, see, for instance, Folda, *Crusader Manuscript Illumination,* pls. 13, 130, 142, 144, 145; Buchthal, *Minia-ture Painting,* pl. 136d. In each case, the emblem identifies the Turks. The motifs are not confined to actual Turks, however. The army of Holofernes, Nebuchadnezzar's general, is shown carrying two flags, one with a star and the other with a crescent, in

the Arsenal Old Testament (Buchthal, *Miniature Painting*, pl. 73); for Nebuchadnezzar as proto-Turk, see Anne Derbes, "Crusading Ideology and the Frescoes of S. Maria in Cosmedin," *Art Bulletin* 77 (1995): 460–78. In the image from the Arsenal Old Testament, the flag is much the same shape as the sixteenth-century example illustrated by Ettinghausen, "Hilāl in Islamic Art," fig. 17. Similarly, the crescents seen in the crusader manuscripts reproduce exactly the shape of the motif in the Islamic objects illustrated in the same article (figs. 10, 17).

Finally, in one manuscript apparently produced outside crusader Palestine the star and crescent also appear. Both stars and crescents identify the Greek foes of the Trojans in the *Roman de Troie* manuscript in Paris, MS. fr. 1610 (Buchthal, *Historia Troiana*, fig. 2).

63. See Buchthal, *Historia Troiana*, 2–3; and Meyer Reinhold, "The Unhero Aeneas," *Classica et Medievalia* 27 (1966): 195–207. Reinhold notes (198) that the accusation against Aeneas appeared as early as the fifth to fourth century B.C.E., in Menecrates of Xanthus, and that it was repeated by Servius (199) and Tertullian (201), among others. For Dares, see Reinhold, "The Unhero Aeneas," 203–5; for Dares and Benoît, ibid., 204.

64. Thus he cites both Livy, who "dist qu'il dui la traïrent, Eneas e Anthenor," and Sisenna, "qui dist qu' Eneas ne la traï mie, mais Anthenor" (Raynaud de Lage, "Les 'romans antiques,'" 292).

65. Daniel H. Weiss, *Art and Crusade in the Age of Saint Louis* (Cambridge, 1998).

66. As mentioned in note 62, the star and crescent appear in Paris 1610, a manuscript thought to have been produced in France. Clearly the illuminator was familiar with the insignia, however; both appear there exactly as they do in Islamic art, such as the Turkish flag mentioned in note 62. According to Ettinghausen ("Hilāl in Islamic Art," 384), the motifs were not commonly understood in the West as Turkish symbols until the middle of the fifteenth century.

67. The range of opinion on the dating varies fairly widely. Several scholars have linked the date of the text with its premature end (the author intended to continue through the history of Flanders, but stops abruptly with the section on ancient Rome). Meyer ("Les premières compilations françaises," 57) dated it to the end of Roger's life, arguing that the project was abandoned when Roger died (1229–30). Raynaud de Lage ("'L'Histoire ancienne jusqu'à César' et les 'Faits des Romans,'" *Le Moyen Age* 55 [1949]: 5–16, esp. 14–15) proposed a narrower dating, 1208–13. He argued that the text was not completed because the patron learned of the *Faits de Romans*, which covers the same material as the last portion of the *Histoire* (one manuscript of the *Faits de Romans* dates 1213–14); he noted further that the text must predate 1213, the year of the catastrophic defeat of the Flemish at Bouvines, for it refers to conditions of peace. Joslin follows Raynaud de Lage (*The Heard Word*, 14). Oltrogge dates the text more broadly, between 1212 and 1229–30 (*Die Illustrationzyklen*, 11). De Visser-van Terwisga prefers a date of c. 1212–14 (*Histoire*, II, 223–24), argues that the writing ended with the Battle of Bouvines (1213), and suggests Wauchier de Denain as its author. We would note that cer-

tain passages in the text may point to a later date. Several references to Damietta (for which, see Joslin, "Critical Edition," 14, 263–64) may suggest that the text postdates the capture of Damietta during the Fifth Crusade (crusading forces took the city in 1219). The reference to the prevailing peace (fol. 327v in the Paris copy) could well allude to the final resolution of a long crisis, the imprisonment of Ferrand (husband of Joan, countess of Flanders), and the briefer crisis precipitated by the episode of the "False Baldwin," which resulted in civil war (1225). Both crises were resolved through the intervention of King Louis VIII, who rejected the claims of the False Baldwin and supported Joan. With the Treaty of Melun in 1226, Joan ransomed Ferrand and resumed control of Flanders (for these events, see Robert Lee Woolf, "Baldwin of Flanders and Hainaut, First Latin Emperor of Constantinople: His Life, Death, and Resurrection, 1172–1225," *Speculum* 27 [1952]: 281–322). The text also refers to a French king, whose identity has been much discussed by scholars (see de Visser-van Terwisga, *Histoire*, 223–24); the king in question could be Joan's supporter Louis VIII, who died in 1226.

68. Raynaud de Lage, "Les 'romans antiques,'" 283, 302, notes the author's awareness of the female audience for whom the *Histoire Universelle* was intended. He notes also that in the Paris codex, the author repeatedly addresses his audience, "Segnor e dames"—and that this appellation is for the most part omitted in other copies (268, n. 3). Joslin, "Critical Edition," cxvii, observes one comment "perhaps calculated to please the ladies among his listeners."

69. For Semiramis, the wife of Ninus, who "governs well," see Joslin, "Critical Edition," xxv. For Io, ibid., xxxiv, xxxvi; for Pallas, ibid., xli.

70. Ibid., xxxiii.

71. Ibid., xliii, for Rachel's theft of the idols of Laban to save her people; ibid., xl, for Jacob's love of Rebecca.

72. For Dinah: ibid., xlvi ; for Tamar's husbands: ibid., liii.

73. For the countesses, see Karen S. Nicholas, "Countesses as Rulers in Flanders," in *Aristocratic Women in Medieval France*, ed. Theodore Evergates (Philadelphia, 1999), 111–37. We are grateful to Emilie Amt for this reference. For the countesses' youth in Lille, see ibid., 128; for Joan's residence at Lille as an adult, see Gérard Sivéry, "Histoire économique et sociale," in *Histoire de Lille*, I, ed. Louis Trenard (Lille, 1970), 183; de Visser-van Terwisga, *Histoire*, 222. For Lille as Margaret's favorite residence, see David Nicholas, *Medieval Flanders* (London, 1992), 163; for its importance as a comital residence, ibid., 119. For Roger IV and Countess Joan, see Théodore Leuridan, *Les châtelains de Lille: cartulaire des châtelains de Lille*, Société des sciences, de l'agriculture et des arts de Lille. Memoires. 3d series, x. 481; xi. 109 (Lille, 1873), 231, 237.

74. For the crusading tradition in Flanders, see Leopold A. Warnkoenig, *Histoire de la Flandre et de ses institutions civiles et politiques, jusqu'à l'année 1305*, I (Brussels, 1835), 261.

75. For the countesses' mother, Mary, on crusade, see Woolf, "Baldwin of Flanders and Hainaut," 288. For Margaret's son, William, as a close ally of Louis IX, and his involvement with the crusades, see William Chester Jordan, *Louis IX and the Challenge*

of the Crusade: A Study in Rulership (Princeton, 1979), 45, 67, 102, 124. For Margaret taking the cross, see Jean Richard, *Saint Louis: Crusader King of France* (Cambridge, 1992), 305. For her financing of Guy's crusade in 1270–71, see Ellen E. Kittell, *From Ad Hoc to Routine: A Case Study in Medieval Bureaucracy* (Philadelphia, 1991), 16.

76. Buchthal, *Miniature Painting*, 70–71; Folda, *Crusader Manuscript Illumination*, 98; Stahl, review, 420.

77. For the books that Louis IX took with him on crusade, see Weiss, *Art and Crusade*, 146–47; for secular works taken on crusade, see Jacoby, "Knightly Values," 165–66; see also the essay by Riley-Smith, "The Crown of France and Acre, 1254–1291," in this volume.

78. M. D. Stanger, "Literary Patronage in the Medieval Court of Flanders," *French Studies* 9 (1957): 214–29; Diane Tyson, "Patronage of French Vernacular History Writers in the Twelfth and Thirteenth Centuries," *Romania* 100 (1079): 180–222. On the Dampierre family, see esp. Stanger, "Literary Patronage," 222–24; Tyson, "Patronage," 209.

79. See her essay in this volume, "Angevin Ambitions."

80. The London codex also contains one image that is omitted by the other three crusader copies: it illustrates the meeting of Alexander with the Amazon queen Thalestris (Buchthal, *Miniature Painting*, pl. 121c). This tale, however, is not a saga of female valor but a romance. As the story goes, the Amazon queen Thalestris learns of Alexander's military might and presents herself to him, hoping to seduce the king and thereby bear his child. The image depicts a looming Alexander who dominates half the composition; the queen and her attendants are compressed into a small space to the right. Here the queen—dwarfed by the enormous monarch and even by the man escorting her—wears a dress and daintily lifts the hem of her skirt, suggesting the seduction to come.

81. Ambivalence about crusading women continues into the seventeenth century. Thomas Fuller, writing c. 1640, compares female participants in the crusades with Amazons: "And which was more, women (as if they would make the tale of the Amazons truth) went with weapons in men's clothes; a behavior at the best immodest" (*The Historie of the Holy Warre*, 2d ed., Cambridge), quoted in Brady, "Essential and Despised," 7.

82. Joslin, "The Illustrator as Reader," 111: "we can only guess about the patron from the nature of the elegant book he (or she) possessed."

83. Joslin, "The Illustrator as Reader," esp. 91–94. For an image, see ibid., fig. 3; Buchthal, *Miniature Painting*, pl. 150c.

84. Joslin, "The Illustrator as Reader," 95–97, fig. 5; Buchthal, *Miniature Painting*, pl. 150d.

85. See Buchthal, *Miniature Painting*, pls. 94a, b, c.

86. Joslin, "The Illustrator as Reader," 97.

87. "Critical Edition," iv–v. For a reproduction, see Folda, *Crusader Manuscript Illumination*, pl. 57.

88. On patrons' instructing illuminators, see, for instance, Jonathan J. G. Alexander, *Medieval Illuminators and their Methods of Work* (New Haven, 1992), 52ff., 84–85;

idem, "Art History, Literary History, and the Study of Medieval Illuminated Manuscripts," *Studies in Iconography* 18 (1997): 51–66, esp. 56–59.

89. The quotation is from a contemporary poem, *Adelae comitissae,* about Countess Adele of Blois (d. 1137); see Joachim Bumke, *Courtly Culture: Literature and Society in the High Middle Ages* (Berkeley, 1991), 117. Interestingly, the episodes in the tapestry described here correspond closely to the episodes described, and usually illustrated, in the *Histoire Universelle:* the poem mentions Genesis scenes on the first wall, Old Testament scenes on the second, scenes from Greek mythology, the story of Troy, and early Roman history on the third, and more recent events on the last (reminding us that the *Histoire Universelle* was not completed). As Bumke notes, these monumental cycles (in tapestry or fresco) based on themes from world history were not uncommon; he cites four other examples known from textual descriptions (117–19). Some depicted exactly the same figures seen in our manuscripts (the Babylonian king, Ninus; Alexander the Great). The *Histoire Universelle* manuscripts thus seem to replicate in miniature the sorts of scenes that often decorated the walls of nobles' palaces—perhaps making them especially attractive to crusading knights far from home.

90. Sandra Hindman, *Christine de Pizan's "Epistre d'Othea": Painting and Politics at the Court of Charles VI* (Toronto, 1986). Interestingly, Christine included the tale of Antiope's sisters battling Hercules and Theseus in her *City of Ladies.* As Dufresne has observed ("Woman Warriors," 127), she minimized the outcome of the battle, and stressed the women's heroism instead. A manuscript of c. 1465–70 (Brussels, Bibliothèque Royale, MS. 9235-7, fol. 24v)—commissioned by a woman, Walburge de Meurs—resembles Paris 20125 in that it, too, stresses the one moment in which the sisters almost prevail. Here, the women unseat Hercules and Theseus in the foreground; the Greeks' capture of the Amazons appears as a tiny vignette in the distance (Dufresne, "Women Warriors," fig. 10).

91. Important women living in the Levant at the time the Paris codex was produced include Margaret of Tyre; Eschiva of Beirut, wife of Guy of Lusignan; Sibyl of Tripoli; and Lucy of Tripoli. For all, see Steven Runciman, "The Crusader States, 1243–1291," in *A History of the Crusades,* ed. Kenneth M. Setton, vol. 2, *The Later Crusades, 1189–1311,* ed. R. L. Wolff and H. W. Hazard (Madison, 1969), 557–98. For Eleanor of Castile, see Folda, *Crusader Manuscript Illumination,* 16. The manuscript was a translation of Vegetius, *De Re Militari.* For the role of women in the culture of the crusader states in the twelfth century, see Bernard Hamilton, "Women in the Crusader States: The Queens of Jerusalem, 1100–1190," in *Medieval Women,* ed. Derek Baker (Oxford, 1978), 143–74. For the most important crusader manuscript owned by a woman, the Melisende Psalter, see Jaroslav Folda, "A Twelfth-Century Prayerbook for the Queen of Jerusalem," *Medieval Perspectives* 8 (1993): 1–12; we thank Professor Folda for a copy of this article. See also Folda, *The Art of the Crusaders in the Holy Land, 1098–1187* (Cambridge, 1995), 137–63.

92. *Archives de l'Orient latin,* II: *Archives de Terre Sainte,* 459–60; Purcell, "Women Crusaders," 60.

93. Jean Caplat, *Histoire de Blois* (Blois, 1954), 95–97.

94. For the verse prologue and moralizations in the Paris copy, see Joslin, *The Heard Word,* 27–29, and de Visser-van Terwisga, *Histoire,* II, 39. The prologue and parts of the moralization are found only in one other manuscript, now in Vienna, from the middle of the fourteenth century.

95. See de Visser-van Terwisga, *Histoire,* II, 223; this passage occurs at folio 252v.

96. For the friendship of the count of Flanders and the count of Blois, see Wolff, "Baldwin of Flanders," 297.

97. Stanger, "Literary Patronage," 229, n. 64. Folda has noted a castle among the heraldry in the Paris codex; this may suggest an owner among the Châtillon, for one family seal includes a castle. For the castle in Paris 20125, see Folda, *Crusader Manuscript Illumination,* 101, n. 131. For the castle in the seal of the Châtillon family, see *l'Archives de l'Orient latin,* I, 663.

98. See note 55.

Angevin Ambitions: The Conradin Bible Atelier and a Neapolitan Localization for Chantilly's *Histoire ancienne jusqu'à César*

Rebecca W. Corrie

A FEW YEARS AGO, as she was studying the manuscripts of the *Histoire Universelle,* also known as the *Histoire ancienne jusqu'à César,* Anne Derbes asked me what I thought of Doris Oltrogge's suggestion that one of the two painters who divided the decoration of the *Histoire ancienne,* MS. 726, in the Musée Condé at Chantilly might have belonged to the atelier that produced the Conradin Bible, MS. 152 in the Walters Art Museum, a topic I had worked on for more than a decade.[1] Her question sent me to Oltrogge's essential book and then to Chantilly in April 1999.[2] There I found one of the approximately fifty-nine profusely illuminated versions of the *Histoire ancienne,* an example of what Christopher de Hamel has called "romantic histories," which were composed in the twelfth and thirteenth centuries, and combined biblical texts and ancient history and mythology.[3] These histories were particularly popular in the courts of France, Flanders, and the Frankish states of the Mediterranean, and the *Histoire ancienne* itself was composed between 1211 and 1230 for Roger IV, castellan of Lille, a leading city in the county of Flanders.[4] A day with the Chantilly codex convinced me that Oltrogge was correct, and I began to investigate the connections between the *Histoire ancienne* and the Conradin Bible in the hope of finding insights into the history of that south Italian atelier, which have eluded us thus far.

Indeed, there are three points that I would like to make. The first is to support the connection between the Chantilly manuscript and the Conradin Bible that Oltrogge offered and to argue that this confirms a south Italian or Neapolitan localization for the Conradin Bible, a conclusion which Angela Daneu Lat-

Fig. 10.1. Scenes from the story of Dido and Aeneas, *Histoire ancienne jusqu'à César,* Chantilly, Musée Condé, MS. 726, fol. 55r. Photo: courtesy of Dr. Doris Oltrogge.

Fig. 10.2. Genesis, *Histoire ancienne jusqu'à César,* Chantilly, Musée Condé, MS. 726, fol. 1r. Photo: courtesy of Dr. Doris Oltrogge.

tanzi maintained and which Hélène Toubert and I have promoted for two decades, and one now generally accepted by other scholars.[5] The second is to build upon Oltrogge's proposal that the manuscript was made for a member of the Angevin family who ruled at Naples after 1266 in order to characterize the clients of the illuminators of the Conradin Bible and to argue that the Angevins, like those with whom they went on crusade in the Levant, North Africa, and southern Italy, understood that specific political and personal messages could be conveyed by the possession of particular manuscripts.[6] Finally, I will argue that the Frankish culture that produced Chantilly 726 was not merely a generally shared aristocratic culture but emerged at least in part in response to the needs and ambitions of a close network of relatives and allies.

Oltrogge made her astute connection primarily on the basis of the gold dots that are the leading characteristic of the Conradin Bible itself, as well that of Chantilly 726, and some observations on drapery (figs. 10.1–10.6). In fact, she described

Fig. 10.3. Scenes from the history of King Cyrus, *Histoire ancienne jusqu'à César,* Chantilly, Musée Condé, MS. 726, fol. 72v. Photo: courtesy of Dr. Doris Oltrogge.

Fig. 10.4. Scenes from the history of King Pyrrhus, *Histoire ancienne jusqu'à César,* Chantilly, Musée Condé, MS. 726, fol. 109r. Photo: courtesy of Dr. Doris Oltrogge.

aspects of the drapery painting in terms reminiscent of those that Toubert and I have used to describe the Conradin Bible group.[7] Close inspection reveals that the head types and palette in the Chantilly codex also match those of the Conradin Bible. But writing in 1987, Oltrogge was tentative about what her comparison with the Conradin Bible might mean.[8] Most important she was not certain about the localization of the production of the Conradin Bible atelier. Since the publication of her book, however, the scholarship on this difficult manuscript group has expanded and now a more interesting and powerful case for both the association and the localization can be made.

The Conradin Bible takes its name from the last Hohenstaufen claimant to the throne of Sicily, who marched his army down across the Alps and challenged Charles I of Anjou, who had defeated Conradin's uncle, King Manfred of Sicily,

Fig. 10.5. Execution of the Amalekite, 2 Kings, Conradin Bible, The Walters Art Museum, Baltimore, MS. 152, fol. 152r

Fig. 10.6. Nehemiah as cupbearer to Artaxerxes, 2 Ezra, Conradin Bible, The Walters Art Museum, Baltimore, MS. 152, fol. 155r

in 1266. Losing to Charles at the Battle at Tagliacozzo, Conradin was beheaded at Naples in 1268 at the age of sixteen. The connection between the tragic Conradin and the Walters Art Museum Bible is based upon the report of a now-lost note, described in the nineteenth century by Leopold Delisle as glued to the inside cover of the Bible, which claimed that the manuscript had been made for Conradin in 1268 and sent to him in the north.[9] Four decades ago, when this tradition came into question, much of the discussion of its localization focused on comparisons between the Walters Bible and fresco and panel painting. But since then other manuscripts have been attributed to the same painter and his associates. For example, the so-called Bassetti Bible in the Biblioteca Comunale in Trento has the same ropey drapery we find in the Conradin Bible as well as the

Chantilly manuscript (figs. 10.1, 10.3, 10.5, 10.6).[10] Other manuscripts, including an antiphonary in Pisa and a number of separated leaves from other chorale manuscripts, have also surfaced.[11] Over the past two decades the group of manuscripts associated with the painter or, more likely, painters who produced the Conradin Bible has expanded. To the Baltimore and Trento Bibles, Toubert added a Bible in the Bodleian Library, a second in the Bibliothèque Ste.-Geneviève in Paris, and a third in Palermo originally attributed by Daneu Lattanzi to the group associated with the south Italian Manfred Bible, as well as a manuscript of an ode to the Virgin dedicated to the powerful, Ghibelline-leaning Cardinal Ottaviano degli Ubaldini who died in 1272, all convincing attributions.[12] Subsequently, I added yet another Bible in the Vatican Library and an antiphonary in the collection of the Colchester Castle museum, for a total of six Bibles, two antiphonaries, and possible fragments of one or two others, and the Ubaldini text.[13] In addition, in her last publication on the subject Daneu Lattanzi added two manuscripts of the al-Hāwī medical encyclopedia, made for Charles I in 1282 at Naples, to the work of these painters.[14] Despite differences in the figure types, the character of the ornamentation substantiates her proposal.

In fact, this manuscript group has been exceedingly difficult to handle. While the manuscripts themselves are usually easy to recognize, and figure style, ornamentation, palette, palaeography, and iconography are the very elements that tie the group together, there are variations in quality and ornamentation, and a split in palaeography between clear examples of a Neapolitan chancellory hand and something much more in keeping with the Bolognese script style that came to dominate Italy in the second half of the thirteenth century. Yet despite recent attempts to pull the manuscript group apart, it holds together irrevocably.

Although we have tended to use the Conradin Bible as the touchstone, the one-volume Bible, MS. Vat. lat. 4195, in the Vatican Library, in particular, holds the group together. It has many of the figure types, albeit less accomplished, that we find in the Conradin Bible, and the inelegant figure type of the Colchester antiphonary and the Bodleian Bible. But it also shares ornament with other manuscripts, for example, the Palermo and Paris Bibles.[15] Perhaps even more convincing is the single folio in the Cini Foundation in Venice, which has the lively figure type of the Paris Bible and the same ornamental flowers used as finials found in the Palermo, Vatican, and Paris Bibles.[16] In other words, the group cannot be pulled apart. Indeed, it is actually quite difficult to separate hands or produce a chronology, for while the Palermo Bible seems likely to be the earliest and, like the Vatican Bible, shares ornamental elements with manuscripts in the so-called Manfred Bible group, produced in southern Italy in the 1250s and 1260s, the rest

bunch together as the production of an atelier in which painters shared a varying yet distinctive repertoire of motifs over the course of at least three decades, beginning in the 1260s and concluding in Naples in 1282.

At the very least, assembling this manuscript group supports the nineteenth-century idea that the atelier of the Conradin Bible was located in southern Italy, a localization that was questioned a few decades ago.[17] While some of the manuscripts have ornament that resembles that of the Manfred Bible group, several of the codices also have secure south Italian provenances. The Palermo Bible is documented in Palermo in the seventeenth century. A coat of arms in the Bodleian Bible places it in the possession of the Auria of Lucera, a south Italian family closely allied to the Hohenstaufen cause in the thirteenth century. The Vatican Bible was a gift to the Vatican library in 1600 from a Neapolitan scholar. Finally, the two copies of the al-Hāwī medical encyclopedia were made for Charles of Anjou in Naples in 1282.

Adding the Chantilly manuscript to the group enhances the association of the atelier of the Conradin Bible with aristocratic circles in the cities of southern Italy. Oltrogge identified two painters, one who provided illuminations found between folios 1 and 98, as well as folio 175, and a second who provided illuminations between folios 108 and 157 and between 188 and 273, an assessment with which I entirely agree.[18] As I noted at the start, she proposed the possibility that the first painter might have belonged to the Conradin Bible atelier and, after looking at the manuscript myself, I have no doubt that she was correct. Indeed, it seems likely that this Chantilly painter, whose work is closest in some details to that of the Conradin Bible itself of any of the manuscripts gathered in the group thus far, worked on that very project as an assistant. For example, if we compare an image from the story of Dido and Aeneas with one from the margin of 2 Kings in the Conradin Bible we find the same cloud of gold dots covering the entire background field, a motif not found in other Italian manuscripts and a profuseness not found even in those few English and French manuscripts that do use dots on background fields (figs. 10.1, 10.5). Moreover, the painter, or painters, of the Conradin Bible often uses contrasting color fields of blue and dusty rose, usually with white pen-sketch ornament on the field (fig. 10.5). Both are elements found in the Chantilly manuscript (fig. 10.1). Also in Chantilly 726 are figures with ropey draperies that band across the legs of seated male as well as youthful male figures dressed in short tunics and shoeless stockings, just as in the Conradin Bible (figs. 10.1, 10.3, 10.5, 10.6, 10.8). Comparison with an image from 2 Kings in the Conradin Bible reveals other similarities. Oltrogge noted that the painter she called Hand I used broad black outlines as well as fine white and yellow lines for highlighting in drap-

Fig. 10.7. St. Jerome with a scribe, Prologue, Bassetti Bible, Trento, Biblioteca Comunale di Trento, MS. 2868, fol. 7. Photo by permission of the Biblioteca Comunale di Trento.

ery, a method found throughout the Conradin Bible and other manuscripts produced by the same painters (fig. 10.5).[19] Quite striking too is the similarity in script style, so close that I am inclined to assign the Conradin Bible and the Chantilly manuscript to the same scribe, and argue that the two manuscripts must be very close in date (figs. 10.1, 10.4, 10.5, 10.6).

Yet more telling are small, blunt heads with flat brown hair picked out in small black dots along the brow line, and large, smudgy eyes. This figure type appears most clearly in those manuscripts or portions of manuscripts that seem to be less detailed or accomplished versions of those in the Conradin Bible, for example, the creator figures in the Genesis initial of the Bodleian Bible and in the Trento Bible (figs. 10.1, 10.3, 10.7, 10.8). Similarly, the Chantilly manuscript has the round-headed dragons found in the Palermo, Vatican, and Trento Bibles and the al-Hāwī

Fig. 10.8. Creation scenes, Genesis, Bible, The Bodleian Library, University of Oxford, MS. Canon. Bibl. Lat. 59, fol. 4r. Photo by permission of The Bodleian Library, University of Oxford.

codices (figs. 10.1, 10.7). It also has initials of the type that appear in some of the less facile portions of manuscripts in the group, for example, a scale pattern in the stems of the initials of the center third of the Bodleian Bible, and in the Paris and Trento Bibles (fig. 10.7).[20] Other details, such as architecture and horses, are painted in the same manner as those in the Conradin Bible and the Trento Bible (figs. 10.1, 10.3).[21]

On the other hand, the ornament in the borders of the Chantilly manuscript is not entirely typical of that in other manuscripts of the Conradin Bible atelier (figs. 10.2, 10.4). But these variations can be explained and in fact help us place it within the history of manuscript illumination at Naples or another major center, such as Foggia. In the first place, as Oltrogge's survey demonstrates, the illumination layouts of the Chantilly manuscript, with scenes in windowpane panels,

must come from its model and its text and illustration recension in northern France, and is a format typical of French secular manuscripts (figs. 10.1, 10.3).[22] Another indication of the adherence of the Chantilly manuscript to this particular recension is its Genesis page, executed by Hand I, our painter from the Conradin Bible atelier (fig. 10.2). The Creation scenes are set in a ring of roundels, as they are in versions now in The Hague, Pommersfelden, and elsewhere.[23] Some aspects of the ornament on this folio that are not found in the northern French versions do occur in the Conradin Bible, for example, the gold dots and the cusping that even extend around portions of the marginal vines, just as the cusping does in the Conradin Bible itself (figs. 10.5, 10.6). As with the flaking found in the Conradin Bible, these details suggest that this ornament was executed by the same painter responsible for the figures. But there is a difference between this cusped ornament and that of the lower and right margins of the Creation page, which resembles that in some of the manuscripts in the Conradin Bible group and is in keeping with the style that emerged in Bologna in the 1260s and 1270s with thin vines with half leaves, and knots and balls (fig. 10.2).[24] The same vine motifs appear in the portions of the codex where the scenes are painted by Hand II.

In fact, the presence of Bolognese ornamental elements in a manuscript painted at least in part by a painter trained in the Conradin Bible atelier is consistent with the apparent stylistic development of that atelier. In the Conradin Bible itself we do see some vines with balls and leaves (fig. 10.6). And when we turn to other manuscripts from the group, the influence of Bolognese illumination seems to become increasingly profound, especially in the Trento Bible and the medical manuscripts of al-Hāwī, commissioned by Charles I in 1282 at Naples (fig. 10.7).[25] I would certainly argue that these painters, while working in southern Italy, most likely at Naples, had become familiar with the work of Bolognese painters whose style began to dominate manuscript illumination throughout Italy in the second half of the thirteenth century, much as the Bolognese script style had spread beginning in the time of Frederick II.

Indeed, in the Chantilly manuscript we appear to be able to watch a painter working in the style of the Conradin Bible along with a painter trained at Bologna, for Hand II, whose work begins on folio 109, gives every evidence of being a Bolognese painter (fig. 10.4). In fact, Oltrogge compared the figure style of Hand II to that of the Bolognese illuminator of around 1270, called the Master of 1285 by Alessandro Conti.[26] Because of the Bolognese character of the ornament and the likelihood that Hand II was a painter from Bologna, Oltrogge hesitated in attributing this manuscript to Naples, stating that, although most likely painted

in Naples, it was also possible that an Angevin prince had commissioned this French manuscript at Bologna.[27]

Yet not only does the most recent study of the Conradin Bible atelier itself point to the south, but so does what we know about the general development of illumination in Naples. Bolognese ornament can be found in a number of well-known manuscripts produced in that region, including those in the possession of the abbot of the Badia at Cava di Tirreni, in the early fourteenth century, the brother of the Angevin king Robert, and a missal now at Naples, made for use in the Angevin court in the later part of the thirteenth century.[28]

However, although she identified the similarity of Hand I's style to that of the Conradin Bible, what finally led Oltrogge to attribute the Chantilly manuscript to the south was her association of the manuscript with the Angevin house and her identification of its possible recipient. She noticed heraldic devices on folio 109r, the most elaborate page in the manuscript: a silver lion on a red field and gold lilies on a blue field, the latter of which can be identified as the arms of the Angevins at Naples (fig. 10.4). She also noticed that the folio singled out for the coats of arms and for the most elaborate decoration of the entire manuscript was folio 109, an unusual position since it is deeply embedded within the codex. In addition, she argued that the text illustrated here also points to an Angevin patron or recipient.

The elaborately decorated folio 109r depicts the story of King Pyrrhus of the Molossians and ancient Epiros.[29] In 281 B.C.E. in the course of his extensive military career, Pyrrhus allied with Taranto in southern Italy in a successful battle against the Romans, eventually taking even the title of king of Sicily. Certainly this heroic tale provides a precedent for a new alliance between southern Italy and Greece and an occasion for the celebration of a new southern kingdom. This fits the history of Angevin Naples. Following the Battle of Benevento in 1266, when Charles of Anjou defeated and killed the last Hohenstaufen ruler of southern Italy, Manfred of Sicily, the Angevin house assumed not only the south Italian kingdom but also the imperial ambitions of both the Normans and the Hohenstaufens for control of the Aegean region.[30] Through the various events of their reigns, including the loss of Sicily in 1282, the Angevin rulers focused much of their political and military policy on the possibility of recapturing Constantinople, and control of Epiros was a crucial step toward that end.[31] Moreover, not only do we find the arms of the Angevins in the lower margins, but heraldic motifs used to identify the battling armies in the small scenes above stress the identification between the thirteenth-century leaders and the ancient heroes. Here we find the strategic

employment of the lily of the Angevins and the eagle. The use of heraldic motifs in the illumination of such texts is not unusual, as Jaroslav Folda has shown in his study of crusader manuscripts of the thirteenth century.[32] But he also pointed out that, like other heraldic motifs, the eagle is ambiguous, and here we might add, more so than usual. Folda noted that the eagle is often associated with the Byzantine Empire, as well as with the Roman Empire, perhaps leaving the lily of the Angevins here to represent the ancient Epirotes, Tarantans, and the king of Sicily. But it also seems impossible to overlook an association that would further underline the success of the Angevin house, the use of the eagle by the Hohenstaufen Holy Roman Empire, which the Angevins had so recently defeated. In a sense, then, the eagles of the Romans defeated by Pyrrhus might call to mind both the Byzantine rulers at Constantinople, whom the Angevins hoped to defeat, and the Hohenstaufens they had defeated just a few years before. Building on the Taranto and Epiros connections and the coats of arms, Oltrogge proposed that the Chantilly manuscript was made for the fourth and favorite son of Charles II of Naples, Philip, prince of Taranto, for in 1294 the military and marital policies of the Angevins produced a marriage between Philip and Thamar, daughter of the despot of Epiros.[33]

Certainly Philip of Taranto and his bride would be ideal recipients of such a manuscript. Oltrogge, however, urged caution because she was not able to identify the second coat of arms with a particular family or kingdom. Indeed, scholars have noted that working with coats of arms in the thirteenth century is extremely difficult, for they appear to have been a relatively new phenomenon, particularly popular among the crusading Europeans and their Islamic opponents.[34] The rampant lion appears almost randomly in crusader manuscripts, including the *Histoire ancienne* and histories of the crusades, but its employment may have been intended to suggest associations between Ancient Greece, especially Thebes, and Frankish Greece, especially Epiros or Achaea.[35] Significantly, the rampant silver or white lion on a red field occurs in the Angevin frescoes at San Gimignano right beside the fleur-de-lis, but here too, aside from the Angevin context, there is no identification of the lion's meaning.[36] As a result, I am inclined to follow Oltrogge's cautionary guidance and look for another appropriate recipient or client at an earlier date consistent with the history of the Conradin Bible atelier. Indeed, Philip was not the first prince of Taranto married to a princess of Epiros. King Manfred of Sicily, undoubtedly the favorite of his father, Frederick II, was named prince of Taranto and Manfred's second wife and widow in 1266 was Helena of Epiros.[37] But there is nothing to indicate that the Angevin arms are later additions and, therefore, I would be more inclined to look for efforts to marry

Angevins to heirs of the crusader kingdom. Certainly, such alliances were a major aspect of Charles's policy directed toward control of those states. For example, in 1267 Charles I had provided an elaborate wedding for his daughter Beatrice and Philip of Courtenay, titular Latin emperor by 1273.[38] An even more likely candidate is Philip, a son of Charles I, who died in 1277. In 1271, this Philip married Isabelle of Villehardouin, princess of Achaea, who was the daughter of William, prince of Achaea, and Anna Doukaina of Epiros, and thus the granddaughter of William II, despot of Epiros.[39] Associating the Chantilly manuscript with an Angevin–Epirote marriage of 1271 puts it into the same period as some of the other manuscripts belonging to the Conradin Bible atelier. On the other hand, the 1267 Treaty of Viterbo that arranged this marriage also set up a line of inheritance that brought Achaea directly to Charles of Anjou himself, who became prince of Achaea in 1278, yet another occasion that could have been celebrated by the commission of Chantilly 726.[40] In contrast, a date in the 1290s would put approximately twenty-five years between Chantilly 726 and the Conradin Bible, which both the decoration and the script style discourage. Moving the date of the Conradin Bible as far as the 1290s seems equally difficult, since the other Bibles, especially that now in Palermo, are tied to the Manfred group, which is dated to the 1250s and 1260s.[41] Moreover, the Ubaldini ode to the Virgin, the *Liber Annayde*, must have been made for the cardinal before his death in 1272. And the al-Hāwī manuscripts of 1282 seem to be the farthest from the others in style and therefore likely to be the latest. Furthermore, nothing in the Chantilly manuscript suggests that it was made in anything but a single campaign. And like the uniform script style and ornament, a small motif of crowns appears throughout the manuscript. The crowns are different from those in the Conradin Bible, but similar to those in other Angevin manuscripts, and point to a project carried out during the reign of Charles I (figs. 10.1, 10.5).[42]

Placing the Chantilly manuscript among those painted by illuminators working in the atelier that produced the Conradin Bible provides a new vision of the atelier's activity, as does connecting the Chantilly manuscript with the patronage and political life of the early decades of the Angevin dynasty. With the exception of the al-Hāwī manuscripts, the Ubaldini ode, and the legend of the Conradin Bible as the intended gift for the young prince, the impression left by the other manuscripts in the group is of generic commissions such as luxury, one-volume Bibles made for well-to-do clients, with decoration depending on their taste and pocketbook. Such commissions seem to parallel the production of manuscript ateliers of Paris and Bologna, with several painters of varying ability working together with a shared repertoire of drawings and models.

But the Chantilly manuscript provides an example of collaboration between client and painters to produce a work that follows a particular agenda, a single, distinctive project, similar to the commission for the al-Hāwī codices finished in 1282. De Hamel is undoubtedly correct in his assertion that the crusaders used manuscripts like the *Histoire ancienne* to read up on their ancient history while they were in the Middle East, where he notes, "Even Troy cannot have seemed far away," or to read to those back home on their return.[43] He observes, however, that some commissions must have been more personal, and here we find such a focused commission. In other words, these manuscript projects were not always simply generic types, but were projects commissioned by specific individuals that asserted their self-conceptions and ambitions or promoted a particular family agenda. Undoubtedly, both the extensive use of heraldry in the illuminations and the subject matter of the texts here are related to the needs of these individuals. Scholars interested in heraldry have connected its use not only to the crusades, but also to the pressure exerted by the emerging royal houses on local Flemish counts, who became particularly interested in tracing their genealogy both to the Trojans and to Charlemagne. Indeed, it was Baldwin, count of Hainault and Flanders and king of Constantinople, who commissioned a search for a history of Charlemagne around 1200, which resulted in the production of editions for the same court circles in which the *Histoire ancienne* was written.[44] It is clear that commissioning and owning luxurious copies of these so-called romantic histories and the very act of crusading to reclaim what Colette Beaune has characterized as their perceived Trojan heritage became a means of asserting family political and territorial positions during this period of shifting power.[45]

If we look more closely at the background of the manuscripts of the *Histoire ancienne* and the history of the Angevin court during the reign of Charles I of Anjou, we may be able to provide an explanation for the production of the Chantilly manuscript. Oltrogge, like Derbes and Sandona, noted that the text of the *Histoire ancienne* was probably composed at Lille in Flanders, and that the commissioning of some of the extant illuminated manuscripts of this text was at the behest of members of the Flemish aristocracy, in particular the family of Margaret, countess of Flanders, who was raised at Lille, and her heirs, especially those from her second marriage to William III of Dampierre.[46] The Dampierre family, which from this period on included the counts of Flanders, was connected by marriage to most of the royal houses of Europe.[47] The family tree of the thirteenth-century Dampierres is extremely full, including Margaret's father, Baldwin, count of Hainault and Flanders and king of Constantinople. Even Charles of Anjou's second wife, Margaret of Tonnerre, was descended from a different branch of the

Dampierre family. But of particular interest to us are Guy of Dampierre, Margaret of Flanders's son who fought on crusade with Saint Louis in 1248 and was with him at Tunis in 1270, and Guy's son Robert.[48] Guy was also at Naples with Charles of Anjou, who between 1253 and 1256 had sided with Margaret, Guy, and his brother William in their fight over the county of Hainault against Margaret's sons from her first marriage to Bouchard of Avesnes.[49] Of even more interest is Guy's son, Robert of Béthune, from Guy's first marriage to Mathilda of Béthune.[50] Robert fought with Charles of Anjou in his crusade against King Manfred of Sicily and married Charles's daughter Blanche in 1265, living through the 1270s at Naples where he functioned as what Jean Dunbabin has called a "pillar of his government."[51] Toubert has recently argued that it was through Robert of Béthune that Manfred's copy of the Frederick II's *Art of Hunting with Birds,* confiscated at Benevento, found its way to Champagne and into the hands of yet another member of the Dampierre family, John II of Dampierre, and Saint Dizier, who was Robert of Béthune's half-brother, perhaps because John was married to a descendant of John of Brienne, king of Jerusalem, a title Frederick II had claimed, providing through the manuscript a parallel between John of Dampierre and his son William and Frederick and Manfred.[52] Indeed, in a family that claimed descent from Charlemagne, such a comparison to another Holy Roman Emperor, Frederick II, might seem appropriate.

Certainly we have evidence that at least one collector in Sicily owned manuscripts of French romantic histories in the 1280s, and we have several slightly later copies of the *Histoire ancienne* produced at Naples in a very different style and format.[53] But Dunbabin recently attributed at least part of the intense interest in historical and chivalric texts in Charles's court to the Dampierre presence there.[54] The Dampierre family, indeed, Margaret of Flanders's entire family, was among the most important patrons of manuscript illumination that we know from this period, and embody what appears to be a family ethos of using both intellectual and artistic patronage to assert political and dynastic position. In addition to Margaret's interest in the *Histoire ancienne,* as proposed in this volume by Derbes and Sandona, we know from inventories that Robert of Béthune owned a *Lancelot* manuscript, as did his brother, William of Tenremonde, who commissioned an important version now at Yale.[55] Similarly, de Hamel has noted that among other important owners of courtly manuscripts in the thirteenth century, including another *Lancelot* manuscript, were John and William of Avesnes.[56] As Margaret's sons from her first, annulled marriage to Bouchard of Avesnes, they were Robert of Béthune's uncles.[57] Despite the persistent feud between Margaret's Avesnes and Dampierre heirs, they apparently shared an interest in courtly manuscripts. Since

the *Histoire ancienne* was written at Lille in the court in which Margaret was raised, it is likely that members of her family owned copies of it and we would not be amiss in considering the possibility that it was Robert of Béthune who provided the model for the Chantilly copy produced in Naples. Indeed, it is entirely possible that it was Robert of Béthune himself who commissioned the Chantilly codex as a gift for a member of his wife's family on the occasion of one of the many Angevin marriages that took place in the 1260s and 1270s. While this attribution is speculative, there is no doubt that both the execution of this manuscript at Naples and the presence of members of the Dampierre family in the Angevin Court at Naples brings the Angevins into the circle of crusaders who understood the manner in which these biblical and classical histories could validate contemporary lives and ambitions, paralleling Dunbabin's characterization of Charles's patronage of "northern French lyrical poets."[58]

Finally, the addition of Chantilly 726 to the group of manuscripts produced by the painters trained and working in the Conradin Bible atelier tells us something interesting about the production of manuscripts in southern Italy and perhaps about the organization of manuscript ateliers in Italy altogether. It seems quite reasonable to assume that the painter Oltrogge identified as Hand I was one of the secondary painters of the Conradin Bible atelier, but one very close to the primary master. To see such a painter collaborating with a Bolognese painter and perhaps appropriating further elements of Bolognese ornament from him helps us to understand the spread of Bolognese style among Neapolitan painters in general. Furthermore, watching two very different painters work side by side on a single project provides a vision of the relationships that the Angevins had with their painters. Scholars have noted the difficulty the Angevins had recruiting manuscript illuminators. For example, Cornelia Coulter's 1944 article chronicles Charles I's search for painters for the al-Hāwī codices, during which he was advised to hire either the monk, Giovanni da Montecassino, in residence with the archbishop, or Mainardo Teutonico.[59] Certainly, Bolognese painters could also fill such needs, and it seems likely that the variation in style and the resultant adoption of Bolognese elements was in part the product of the Angevin failure to support local, luxury manuscript ateliers. This raises another question: since there is no evidence at Naples or Foggia of the massive production of manuscripts we see at Paris or Bologna, just how many painters were there in the so-called atelier of the Conradin Bible, even at its height? Could the Conradin Bible be a sort of art historical red-herring, a spectacular and unusual commission leading us to envision a large and sophisticated atelier, when, in fact, we may be looking at the work of just a few painters, who made a living by working perhaps at Naples for a variety

of clients on a variety of projects? Chantilly 726, like the al-Hāwī codices, suggests that even the Angevins, who appreciated the political and personal significance of such illuminated histories, did not support court ateliers, but by and large used available painters.

The fact that the commissions for a number of these manuscripts appear to be connected to political self-conceptions and ambitions argues that some of the changes in style within the Conradin Bible atelier may have been similarly driven. Perhaps the shifting identities of the clientele present in southern Italy within the Hohenstaufen and Angevin courts accounts for the corresponding shifts in the visual repertoire of the Conradin Bible atelier, from south Italian inhabited vines to Byzantine figure types demonstrably close in style to those at Monreale, to French cusping and contrasting pink and blue fields and diappered grounds, and to the increasingly dominant Bolognese style, a painting repertoire that functions as a witness to the role that both image and text played in the expression of identities in the fluid Mediterranean political situation.

Notes

1. I would like to express my gratitude to Bates College for providing funding for my travel to Chantilly in 1999 through McGinty and Schmutz faculty support grants, to Nicole Garnier, Conservateur du Musée Condé and its staff, to Anne Derbes, Mark Sandona, and Daniel Weiss for organizing the symposium that inspired this anthology, and to Doris Oltrogge for her generosity in providing the photographs of MS. 726 of the Musée Condé at Chantilly. In most cases her selection of photographs makes the points I think are crucial. But during my visit to Chantilly in April 1999, I found several illuminations not reproduced that utterly convinced me that she is correct in her stylistic analysis of the manuscript. I have not been able to obtain photographs of these additional images. Hopefully, without them I will still be able to offer a convincing case for the accuracy of both our observations.

2. Doris Oltrogge, *Die Illustrationszyklen zur "Histoire ancienne jusqu'à César" (1250–1400)* (Frankfurt am Main, 1989), 39–41, 142–43, 243–46, figs. 82–88, 118, 123, 126.

3. This number is provided by Oltrogge, *Die Illustrationszyklen,* 9; Christopher de Hamel, *A History of Illuminated Manuscripts,* 2d ed. (London, 1994), 165.

4. Gabrielle M. Spiegel, *The Past as Text: The Theory and Practice of Medieval Historiography* (Baltimore, 1997), 178–94, and *Romancing the Past: The Rise of Vernacular Prose Historiography in Thirteenth-Century France* (Berkeley, 1993), 12, 23–29, 44–54, 107–20; Guy Raynaud de Lage, *Les premiers romans français et autres études littéraires et linguistiques* (Geneva, 1976), 6 and 12; Oltrogge, *Die Illustrationszyklen,* 9.

5. Ibid., 173, n. 282; Angela Daneu Lattanzi, "Una 'Bella Copia' di al-Hāwī tradotto dall'arabo da Farag Moyse per Carlo I d'Angiò (Ms. Vat. Lat. 2398–2399)," *Miscellanea*

di studi in memoria di Anna Saitta Revignas, Biblioteca di bibliografia italiana, 86 (Florence, 1978), 149–69; Hélène Toubert, "Autor de la Bible de Conradin: trois nouveaux manuscrits enluminés," *Mélanges de l'Ecole française de Rome* 91 (1979): 729–84; Rebecca W. Corrie, "The Conradin Bible: Since 'Since de Ricci,'" *Journal of the Walters Art Gallery* 40 (1982): 13–24; idem, "The *Conradin Bible:* East Meets West at Messina," in *The Meeting of Two Worlds: Cultural Exchange between East and West during the Period of the Crusades,* ed. Vladimir P. Goss and Christine Verzar Bornstein (Kalamazoo, 1986), 295–307, figs. 41–47; idem, "The Conradin Bible, MS. 152, the Walters Art Gallery: Manuscript Illumination in a Thirteenth-Century Italian Atelier" (Ph.D. diss., Harvard University, 1986); idem, "The Antiphonaries of the Conradin Bible Atelier and the History of the Franciscan and Augustinian Liturgies," *Journal of the Walters Art Gallery* 51 (1993): 65–88; idem, "The Conradin Bible and the Problem of Court Ateliers in Southern Italy in the Thirteenth Century," in *Intellectual Life at the Court of Frederick II Hohenstaufen,* ed. William Tronzo, Studies in the History of Art, 44 (1994): 17–39. A great deal of ink has been spilled on this subject; including the articles cited above and in subsequent notes, the following have weighed in on the different sides of the localization issue: Marina Bernasconi and Lorena dal Poz, *Codici miniati della Biblioteca Comunale di Trento* (Florence, 1985), 69–120; Pierluigi Leone de Castris, *Arte di corte nella Napoli angioina* (Florence, 1986), 104–5; Larry Ayres, "Bibbie italiane e Bibbie francesci: il XIII secolo," in *Il Gotico europeo in Italia,* ed. Valentino Pace and Martina Bagnoli (Naples, 1994), 361–74; Maria Stella Calò Mariani and Raffaella Cassano, eds., *Federico II e l'Italia: Percorsi, Luoghi, Segni e Strumenti* (Rome, 1995), 260–78; Andrea Bacchi, ed., *Dalla Bibbia di Corradino a Jacopo della Quercia: sculture e miniature italiane del Medioevo e del Rinascimento* (Milan, 1997), 110–11.

6. Oltrogge, *Die Illustrationszyklen,* 40–41, 142–43, 243; on the Angevin campaigns against the Hohenstaufen and Aragonese in the south as crusades, see Norman Housley, *The Italian Crusades: The Papal-Angevin Alliance and the Crusades against Christian Lay Powers, 1254–1343* (Oxford, 1982), 71–75.

7. Oltrogge, *Die Illustrationszyklen,* 40.

8. Ibid., 41, 173.

9. Auguste and Emile Molinier and Leopold Delisle, *La collection Spitzer* (Paris, 1892), inv. No. 5: 124–26, 141–43. I have discussed the history of MS. 152 at length elsewhere: Corrie, "The Problem of Court Ateliers," 33; idem, "Since 'Since de Ricci,'" 13–15; idem, "The Conradin Bible, MS. 152, the Walters Art Gallery," 27–69.

10. The Bassetti Bible is MS. 2868 in the Biblioteca Comunale in Trento. See Daneu Lattanzi, *Lineamenti di storia della miniatura in Sicilia* (Florence, 1968), 61–64.

11. For additional bibliography, see Corrie, "The Antiphonaries."

12. Toubert, "Autour." For a review of these attributions and bibliography, see Corrie, "The Problem of Court Ateliers," esp. 36. The manuscripts are: MS. Canon. Bibl. Lat. 59 in the Bodleian Library, MS. 14 in the Bibliothèque Ste. Geneviève in Paris, and MS. I.C.13 in the Biblioteca Centrale della Regione Siciliano in Palermo, and the *Liber Annayde,* MS. lat. 8114 in the Bibliothèque Nationale in Paris.

13. Corrie, "The Problem of Court Ateliers," 19–28; idem, "The Antiphonaries." The additional manuscripts are MS. Vat. lat. 4195 in the Vatican Library, MS. 222.32 in the Colchester and Essex Museum, and the antiphonary leaf, 65.1952, in the St. Louis City Museum.

14. Daneu Lattanzi, "Una 'Bella Copia,'" 149–69.

15. Corrie, "The Problem of Court Ateliers," figs. 3–16.

16. Pietro Toesca, *Miniature di una Collezióne Veneziana* (Venice, 1958), pl. LXXVII; Toubert, "Autour," figs. 3–12; Corrie, "The Problem of Court Ateliers," figs. 3–5.

17. While Naples as the primary capital of the Angevins seems a likely localization for manuscript production, it is also possible that manuscripts were produced in another center, especially in the early years of Charles I's reign. Foggia, which had been a primary seat for both Frederick II and Manfred, must be considered since it was also used extensively by Charles I. See Lorenz Enderlein, *Die Grablegen des Hauses Anjou in Unteritalien: Totenkult und Monumente 1266–1343* (Worms, 1997), 11. Jean Dunbabin notes that it was at Foggia that Charles held the elaborate wedding for his daughter. On the other hand, it was at Naples that the multiple households of Charles and his children were established as his reign continued: Dunbabin, *Charles I of Anjou: Power, Kingship and State-Making in Thirteenth-Century Europe* (London, 1998), 188–89, 202. Extensive research has appeared in the past few years on Angevin Naples, including some publications that will be cited below and others including: *L'État Angevin: pouvoir, culture et société entre XIIIe et XIVe siècle,* Actes du Colloque international organisé par l'American Academy in Rome, et al "Federico II" Rome-Naples, 7–11 novembre 1995 (Rome, 1998); and Alessandro Tomei, ed., *Roma, Napoli, Avignone: arte di curia, arte di corte 1300–1377* (Turin, 1995).

18. Oltrogge, *Die Illustrationaszyklen,* 246.

19. Ibid., 40.

20. For the Paris Bible, see Toubert, "Autor," figs. 40, 42, 47, pl. D. The initials referred to in the Bodleian Bible (MS. Canon. Bibl. Lat. 59) have not been published, but include an initial on folio 200v, executed by the least accomplished hand in the manuscript, which illuminated folios 200r to 231v.

21. The examples shown in the figures here find parallels in folios illustrated in Corrie, "The Conradin Bible, MS. 152, The Walters Art Gallery," figs. 20, 231, for the Conradin Bible and the Trento Bible, respectively.

22. de Hamel, *Illuminated Manuscripts,* 167; Oltrogge, *Die Illustrationszyklen,* figs. 7–21.

23. Oltrogge, *Die Illustrationszyklen,* figs. 3 and 5. MS. 295 in the Gräflich-Schönborn'sche Schlossbibliothek, Pommersfelden, fol. 1r and MS. 78 D47 in the Koninklijke Bibliotheek, The Hague, fol. 1r.

24. Alessandro Conti, *La miniature Bolognese: scuole e botteghe, 1270–1340* (Bologna, 1981), figs. 19, 61.

25. Corrie, "The Problem of Court Ateliers," fig. 17.

26. Oltrogge, *Die Illustrationszyklen,* 41; Conti, *La miniature bolognese,* 25, figs. 29–32.

27. Oltrogge, *Die Illustrationszyklen*, 41.

28. Mario Rotili, *Miniatura francese a Napoli* (Benevento, 1968), pls. XIII, XIV; and Rotili, *La miniatura nella Badia di Cava: Volume Primo, Lo scritto, i corali miniati per l'abbazia* (Naples, 1976), 45–79, 113–18, pls. XXXVII–LXII.

29. "Pyrrhus," *Encyclopedia Britannica*, vol. 18 (Chicago, 1967), 904.

30. Dunbabin, *Charles I of Anjou*, 55–98.

31. Peter Lock, *The Franks in the Aegean* (London, 1995), 92–95.

32. Jaroslav Folda, *Crusader Manuscript Illumination at Saint-Jean d'Acre, 1275–1291* (Princeton, 1976), 83–84, 101, 114, 136.

33. Lock, *The Franks*, 97. On this marriage and title, see Andreas Kiesewetter, *Die Anfänge der Regierung König Karls II. von Anjou (1278–1295): das Königreich Neapel, die Grafschaft Provence und der Mittelmeerraum zu Ausgang des 13. Jahrhunderts* (Husum, 1999), 255, 259, 351–56.

34. Thomas Woodcock and John Martin Robinson, *The Oxford Guide to Heraldry* (Oxford, 1988), 1–14; William Leaf and Sally Purcell, *Heraldic Symbols: Islamic Insignia and Western Heraldry* (London, 1986), 44–62.

35. Rampant lions are found in numerous crusader manuscripts. See Daniel H. Weiss, *Art and Crusade in the Age of Saint Louis* (Cambridge, 1998), fig. 49 for the Arsenal Old Testament, fol. 339r; Folda, *Crusader Manuscript Illumination*, fig. 88 for the *Histoire Universelle* (or *Histoire ancienne*), Paris, Bib. Nat., MS. fr. 20125, fol. 249r, and elsewhere, figs. 99, 108, 115, 144, 165. In the *Histoire Universelle*, London, British Library, MS. Add. 15268, the white rampant lion on red ground can be found in images of Polyneices and Tydeus in battle in the courtyard of King Adrastus (fol. 81v), part of the history of Thebes, and elsewhere in the history of Crete (fol. 136v), and in the history of Pyrrhus, he has a gold lion on red (fol. 226r).

36. Enderlein, *Die Grablegen*, fig. 100.

37. Dunbabin, *Charles I of Anjou*, 89.

38. Ibid., 184, 202.

39. Ibid., 91.

40. Lock, *The Franks*, 84–86; Dunbabin, *Charles I of Anjou*, 91–93.

41. For recent comments and bibliography, see Toubert, "Influences gothiques sur l'art frédéricien: le maître de la Bible de Manfred et son atelier," in *Federico II e l'arte del Duecento italiano*, ed. Angiola Maria Romanini, Atti della III settimana di studi di storia dell'arte medievale dell'universita di Roma, 15–20 maggio 1978 (Rome, 1980), 59–76; and Toubert, "Trois nouvelles Bibles du maître de la Bible de Manfred et de son atelier," *Mélanges de l'Ecole française de Rome* 89 (1977): 777–810.

42. In the Paris copy of the medical encyclopedia of al-Hāwī, for example, the crown is shown on Charles of Anjou. See Leone de Castris, *Arte di corte*, fig. 16. In the Angevin court missal, Naples Biblioteca Nazionale, MS. IB22, fol. 218r for a Roman emperor, see Rotili, *Miniatura francese*, pl. VIII.

43. de Hamel, *Illuminated Manuscripts*, 165.

44. Georges Duby, *France in the Middle Ages 987–1460: From Hugh Capet to Joan of Arc* (Oxford, 1987), 205. Interestingly, it is also Baldwin to whom recent scholars

have attributed the spread of heraldry of the sort found throughout these manuscripts. See Woodcock and Robinson, *Oxford Guide,* 4–7; and Beryl Platts, *Origins of Heraldry* (London, 1980), 23–48, who notes especially the Flemish leaders' interest in their descent from Charlemagne.

45. Colette Beaune, *The Birth of an Ideology: Myths and Symbols of Nation in Late-Medieval France* (Oxford, 1991), 236–43.

46. Anne Derbes and Mark Sandona, "Amazons and Crusaders: The *Histoire Universelle* in Flanders and the Holy Land," in this volume; Karen S. Nicholas, "Countesses as Rulers in Flanders," in *Aristocratic Women in Medieval France,* ed. Theodore Evergates (Philadelphia, 1999), 111–37; Evergates, *Feudal Society in the Bailliage of Troyes under the Counts of Champagne, 1152–1284* (Baltimore, 1975), 101–13, 177; M. l'Abbé Maistre, *Histoire de la Maison de Dampierre* (Paris, 1884), 107–9, 119.

47. Ibid., 51, 67, 107.

48. Salvatore Romano, "Un Viaggio del conte di fiandra, Guido di Dampierre, in Sicilia nel 1270," *Archivio storico siciliano* 26 (1905): 285–309.

49. Dunbabin, *Charles I of Anjou,* 37–38; Abbé Maistre, *Maison de Dampierre,* 110–13.

50. Ibid., 137, 140, 143–44.

51. Dunbabin, *Charles I of Anjou,* 18, 184.

52. Toubert, "Les enluminures du manuscrit fr. 12400," in *Federico II: DE ARTE VENANDI CUM AVIBUS. L'art de la chace des oisiaus, Facsimile ed edizione critica del manoscritto fr. 12400 della Bibliotheque Nationale de France* (Naples, 1995), 387–93.

53. Berhard Degenhart and Annegrit Schmidt, "Frühe angiovinische Buchkunst in Neapel: Die Illustrierung französischer Unterhaltungsprosa in neapolitanischen Scriptorien zwischen 1290 und 1320," in *Festschrift Wolfgang Braunfels,* ed. Friedrich Piel and Jörg Traeger (Tübingen, 1978), 71–92; Dunbabin, *Charles I of Anjou,* 208.

54. Dunabin, *Charles I of Anjou,* 209.

55. Derbes and Sandona, "Amazons and Crusaders"; Abbé Maistre, *Maison de Dampierre,* 148–49. On Yale, Beinecke Library, MS. 229, see M. Alison Stones, "Secular Manuscript Illumination In France, " in *Medieval Manuscripts and Textual Criticism,* ed. Christopher Kleinhenz, North Carolina Studies in Romance Languages and Literatures, 173 (Chapel Hill, 1976), 87.

56. de Hamel, *Illuminated Manuscripts,* 150.

57. Abbé Maistre, *Maison de Dampierre,* 122–30.

58. Dunbabin, *Charles I of Anjou,* 207.

59. Cornelia C. Coulter, "The Library of the Angevin Kings at Naples," *Transactions and Proceedings of the American Philological Association* 75 (1944): 141–55.

PART V

CULTURAL EXCHANGE
IN THE AGE
OF THE CRUSADES

CHAPTER II

Everywhere and Nowhere:
The Invisible Muslim and Christian Self-Fashioning
in the Culture of Outremer

Anthony Cutler

IN THE FIRST CHAPTER of his first volume on the history of crusader art in the Holy Land, Jaroslav Folda remarked on the amount of this material that has been lost, "a higher percentage perhaps than almost anywhere else in the medieval world."[1] This may well be so, even if, on the one hand, Byzantine art, partly as a result of Frankish depredation, may give crusader production a good run for its money in this respect; and even though, on the other, crusader works continue to turn up, as in the case of two little-known objects, the publication of which I shall come to later in this essay. Before reaching that point, however, it is necessary to remark that there are different sorts of loss, of which physical destruction— Folda cites "Crusader cities and castles . . . razed as a matter of policy by certain Moslem conquerors"—is only one. An object all but disappears, for example, when it is assigned to a society to which it does not belong: as a result it may be "written out" of both scholarly consideration and the broader treatment of a culture undertaken by authors who depend, to a greater or lesser extent, on the work of specialists. Conversely, something is lost when a complex object is treated unquestioningly as the product of a single society—a monolith within a monoculture—mindless of the many strands that make up its fabric and the multitude of responses that this very diversity would have evoked.

It is precisely this complexity to which I wish to draw attention. My main concern is with the virtual exclusion of Muslims, the ethnic, religious, and demographic majority in the lands where the Frankish enterprises under consideration

took place, invisible save where they appear as the objectification and ultimately the very essence of what the Franks were not.

True, the imaginary world in which Islam had no role except as the occasional hostile walk-on was a construction of the Franks themselves;[2] and true, as Carole Hillenbrand has pointed out, those Islamic authors who can help us redress the balance all lived the greater part of their lives outside the Frankish states.[3] But neither of these facts provides sufficient reason to ignore the extent to which the Muslim environment shaped crusader undertakings in general,[4] or affected crusader art in particular. In the first half of this chapter I shall describe some of the circumstances that allowed, and others that actually stimulated, intercourse between Franks and Muslims. Then I shall try, first, to recover the Arab dimensions within a work of art that I believe to have been made in the crusader states. And, second, using this complexity as a paradigm for the consequences of overlooking the multifaceted character of works produced in this multicultural region,[5] I shall suggest the nature of another object made, in my view, not in the Holy Land itself but directly under the impact of one of the cults that long before the states of Outremer existed, and long after they ceased to exist, made the region a site of intense acrimony and, at the same time, an incubator of cultural affinities that qualify an otherwise bleak picture.

Circumstances of Exchange

It would be easy, and for our present purposes pointless, to dwell on the gulf that divided crusaders from Muslims in the twelfth and thirteenth centuries. The ethos of the former is by now so well known that it is taken as a given, a universal "truth" that only lately has been subjected to subtle distinction.[6] On the other hand, in keeping with the much slighter Western awareness of (and interest in) things Islamic, Muslim attitudes toward those who repeatedly invaded their territory were until recently little known. We now possess a huge survey of the Arab sources on all aspects of this confrontation, depressing in its extent but a necessary supplement and correction to earlier studies largely limited to matters of ideology.[7] With the passage of time comes an increase in understanding, a development no less true of the Franks who settled in Outremer than of their modern historians. Around the year 1100, it has been noted, Fulcher of Chartres thought that the Muslims had worshiped an idol "set up in the name of Mohammed" in the Templum Domini. Early crusader authors did not "know much about the Islamic proscription of religious images, nor indeed much about Islam at all"; yet by 1147 Otto of Freising was aware that Muslims worshiped one god and did not

have idols.[8] Such "progress" is evident also in other spheres of activity: less than a century later Latin residents of the Levant had clearly adopted local practices, at least in the realm of diplomacy. "Le bon seigneur de Baruth," as Philip of Novara calls John of Ibelin—whose family had been in Outremer for over a hundred years—gave typical Arab presents of horses, garments, and arms to Frederick II when he concluded a temporary peace with the emperor's Lombard forces on Cyprus.[9]

Gifts, of course, are shaped as much by the expectations of the recipient as by those of the donor and offer an index to the extent to which the performance of the parties to the transaction, and thus the societies they represent, can be seen to converge. The Arab, Greek, and Latin reports that we have of presents and the occasions on which they were offered are naturally colored by the interests of the reporter[10] and his stance in matters of ethnicity and belief.[11] But descriptions of the objects themselves are less susceptible to distortion and suggest not only parallels across different cultures but infection—behavior picked up from the environment inhabited by the protagonists in such exchanges. Thus legates of the "king of Jerusalem" (who could be Amalric I or Baldwin IV, since the event is recorded *sub anno* 1174) are said to have brought Frederick I "many gifts," among which the chronicler singles out for attention golden apples filled with musk.[12] The fashion for such pomanders is confirmed by John of Joinville in his account of a mission of the "Old Man of the Mountain" (the head of the Isma'īlī sect) to Louis IX. On this occasion, in addition to gaming boards and chess sets, the present included figurines of an elephant, a giraffe, and apples all carved of rock crystal adorned with amber and gold. When the messengers opened the caskets containing these pieces, the entire chamber was filled with sweet perfume.[13]

Wedding gifts, especially those of royal origin, were certainly no less closely examined and widely reported, as we learn from William of Tyre's narrative of the ill-fated match between Manuel Komnenos and Melisende, sister of Raymond II of Tripoli, proposed in 1159 by Baldwin III: in the archbishop's telling phrase the Greeks scrutinized each detail of the virgin's trousseau (and her physical characteristics) *ad unguem*.[14] Her mother and aunt prepared for her a wardrobe of personal adornment described in loving detail (and an arcane vocabulary), along with silver services of immense size intended for her table and her toilet.[15] These last paraphernalia are of great interest in that they lay stress on precious-metal objects intended for secular use, an emphasis that recurs in the exactly contemporary account of an "Arab-Syrian gentleman's" accoutrements by Usama ibn Munqidh[16] in a manual written for didactic purposes. The king was surely thinking of the huge dowry of "gold and gems, garments and pearls, tapestries and

silken stuffs, as well as precious vessels"[17] that the emperor had sent with his niece, Theodora, when she married Baldwin in the previous year. But if it is fair to infer from these instances that the Byzantines and Franks drew, in principle and in detail, on a shared gift culture, then Ayyūbid practice in this respect should not be ignored. When Ḍayfa, the daughter of the sultan al-'Adil, set out from Damascus to marry her cousin, al-Ẓāhir, prince of Aleppo in 1212 she went equipped, as al-Maqrīzī recalls, with

> cloths, instruments, and manufactured goods borne on fifty mules, two hundred Bactrian camels, and three hundred [one-humped] camels. Attendant maidens traveled on a hundred camels, among them one hundred singers who could play a variety of instruments, and another hundred who could execute the most remarkable handicrafts. The day of her entry into Aleppo was a great occasion. Al-Ẓāhir presented her with his gifts which included five strings of jewels that cost 150,000 *dīnārs,* a diadem of gems without equal, five amber necklaces ornamented with gold and five without such, 170 gold and silver objects, twenty linen bags filled with vestments, twenty hand-maidens, and ten slaves.[18]

All sorts of pedantic objections can be raised against the use of Maqrīzī's *Sulūk* as a historical document: it was written 200 years after the event just described, during his retirement in Cairo (c. 1425–44), and the old man seems to have been obsessed with gift lists. The fact remains that the book constitutes the fullest witness to Arab presents after the *Kitāb al-hadāyā wa al-Tuhaf,*[19] compiled in the late eleventh century and therefore of no use if we wish to assess analogies between Muslim and Frankish giving. True to his preoccupation with acts of egregious largesse, al-Maqrīzī goes on to catalogue the gifts that al-Ẓāhir lavished on the son that Ḍayfa gave him in Aleppo in April 1213. The "objects of all shapes and kinds . . . fashioned for him in hundredweights" included

> ten cradles . . . of gold and silver, not counting those which were made of ebony, sandalwood, and aloes-wood and such like. For the boy himself three dresses were woven from pearls, each dress having also forty rubies, sapphires and emeralds; two breastplates, two helmets, and two embroidered horse-cloths, all set with pearls, three jeweled saddles, each saddle having a set of gems of astonishing beauty and rubies and emeralds; three swords with their precious attachments and handles studded with a variety of precious stones, and a set of golden lances with jeweled heads.[20]

Muslim birth-gifts could likewise cross ethnic and confessional lines. When Louis IX was in prison after the disaster at al-Manṣūra, news reached al-Mu'aẓẓam that the French queen had borne Louis a son. "Bar Hebraeus" reports that the Ayyūbid

sultan immediately sent the infant "ten thousand red *dīnārs* and a golden cradle, together with royal raiment."[21]

Even without consideration of larger-scale and more protracted exchanges,[22] perhaps enough has been said to indicate symmetries of both content and circumstance in the gifts that moved between crusaders, Muslims, and Byzantines. These were only one of many vehicles that transported imagery and craft skills across the region in the period with which we are concerned, movements that at once expressed and abetted aspects of the cultural exchange that lie concealed beneath layers of political and religious contest. Before turning to these other mechanisms, however, it is worth noting the extent to which gifts themselves could be emblems of such competition. The best-known instance is perhaps Louis IX's response to the envoys he received on Cyprus from Güyük, a shadowy figure to the Franks (as to many modern Western historians),[23] and known to Joinville only as "le grant roy des Tartarins."[24] It was surely not only because the Mongol signaled his readiness to help Louis deliver Jerusalem from the hand of the Saracens that the French king sent him "a tent arranged for use as a chapel—a very costly gift indeed, for it was made throughout of fine scarlet cloth. To see if he could attract them to our belief, the king had carved for the chapel a series of images representing the Annunciation of Our Lady and all the other points of faith."[25] Muslim leaders in their turn knew well the sorts of artifact by which Christians in the Holy Land defined their mission and themselves. In 1238, in order to relieve John II Komnenos' siege of Shayzar, Zangī of Mosul sent the emperor Christian antiquities, "sacramental vessels of gold and silver, crosses of gold obtained in victories over the emperors and preserved by them from the days of their fathers."[26]

After he had finally conquered the city, John took away what Niketas Choniates was content to call "gifts." These consisted not only of such customary plunder as

> highly bred horses with arched necks and objects fashioned from the most precious materials: silk garments interwoven with gold and a table well worth looking at

but an inscribed cross of Parian marble,

> a most beautiful and unusual work of art rivaling in beauty the sacred image, a feast for the eyes; this the emperor received with his own hands and preferred to all others. The Saracens of Shayzar related that the cross of glistening marble and the costly and dazzling table from among the gifts offered to the emperor had been taken by their ancestors long ago when they had captured the emperor Romanos Diogenes.[27]

Choniates's lexical distinction between the objects taken by the Seljuks at Mantzik-ert in 1071, referred to in this last phrase, and the "gifts" received by John Kom-nenos is of course quite specious. Both hauls were plunder, a mechanism no less productive than presents in the dissemination of visual ideas and technical know-how. Precisely because of the political significance attached to loot it could con-stitute a fund of potent models for its new possessors. The nature of its compo-nents, where these are known, and the occasions on which they were seized, therefore merit some attention.

As opposed to its obvious economic value, the art historical importance of precious-metal booty has been little considered. Easily melted down, the worth of gold and silver objects is immediately apparent when, as so often, their weight is indicated in the sources. But their broader significance lies in the fate they enjoyed before reaching the foundry, that is to say, their movements into one culture and out of another. Al-Mufaẓẓal reports, for example, that when the Mamluks took the citadel of Cairo in 1291 their loot included "an immense quantity of copper vessels with silver inscriptions, silver vases and pieces of goldsmiths' work made by the Franks."[28] And the Chronicle of Magnus Presbyter, written a century ear-lier, makes clear that Western weapons, even those more utilitarian than ornate, remained a gift highly regarded in the eyes of the Arabs. In the course of the flurry of presents exchanged between Isaac II Angelos and Saladin the former sent the latter "four hundred excellent breastplates, four thousand iron lances and five hun-dred swords, which he had from the king of Sicily"[29]—a reference probably to the loot which Isaac had taken from the troops of William II when, after the Normans had taken Thessalonike, the invading army was defeated in November 1185.

Weapons of Byzantine manufacture likewise traveled widely. Joinville observes that when Louis IX was fortifying Sidon "messengers came to him from a great noble from the depths of Greece who called himself the great Komnenos and lord of Trebizond," bringing the king jewels and especially bows made of cornel wood, on the construction and excellence of which the crusader historian dwells at length.[30] We shall see below evidence of crusaders' fondness for Muslim bows and quivers. In their turn, the Arabs especially prized Latin spears. With no hint of the irony involved in taking coals to Newcastle, an anonymous Syriac chronicler records that Najm al-Dawla Malik, lord of Qal'at Ja'bar on the Euphrates, pre-sented Joscelin with "clothes, a fine horse [and] Frank[ish] arms,"[31] and the Turks who defeated Bohemund of Antioch in Cilicia in 1130 sent not only the dead prince's skull but Frankish spears and saddles to Ghiyath al-Dīn, "the great sultan of Ispahan."[32] The esteem that these arms enjoyed is noteworthy given the estab-lished reputation of Damascus as a source of tempered steel. Indeed, by 1240–41

the Franks themselves were acquiring weaponry by purchase in that city, a practice permitted by the Ayyūbid sultan over the protests of the 'ulamā', the divines who removed his name from among the pleas for intercession (*khuṭba*) uttered in the Great Mosque.[33] Clearly, the demand for munitions of quality triumphed over ideology. Weapons originating in Genoa arrived in Egypt where shields described as *janawiya* appear in texts of the twelfth and thirteenth centuries.[34] Like modern arms merchants, the Italians supplied strategic materials and goods (wood, ships, and weapons) to competing powers in the Near East.[35]

One reason, then, for interconnections between the various societies of the Levant is that they drew on common sources of supply. But goods that traveled in commerce were only one such mechanism and it may be that, insofar as artistic resemblances are concerned, booty was no less important than trade. Nor were such transfers confined to armies that saw in their plunder the reward for defeating an opposing faith. 'Imād al-Dīn al-Isfahānī, Saladin's panegyrist if not his hagiographer, remarks on the valuables looted from their compatriots by other Franks who had joined Saladin's side in 1191. And while the sultan's secretary obviously rejoices in this example of Latin treachery, so specific is his account of part of the plunder that his list cannot be made up out of whole cloth. Following vessels worked in gold, silver ewers, ingots, plaques, bowls, plates, and the like that the turncoats took from their co-religionists and in turn presented to Saladin, al-Isfahānī describes in detail a large silver table with a high cover (?) of great value and a platter of similar weight, which, he says, one might find only with difficulty in a king's treasure and which, were it to be weighed, would measure one *qintar*.[36]

Some especially precious metal objects were removed from circulation by virtue of their political connotations. Maqrīzī reports that "the crown of the King of the Franks and the cross on top of the Dome of the Rock, as well as many other objects" seized by Saladin when Jerusalem was taken, were sent as trophies to the 'Abbasid caliph al-Nāṣir. The cross "which was of copper and coated with gold was buried beneath the threshold of the Bab al-Nūbī [in Baghdad] and thus was trodden upon."[37] Much may have been melted down in the rush to sell before the value of gold and silver, reduced by the sudden glut that followed the looting of cities, fell too low, as "Bar Hebraeus" seems to suggest when he writes of Seljuk plunder taken from the Franks at the time of the Second Crusade.[38] But the very survival of crusader silver objects, some of which are discussed in the second section of this chapter, implies that a fair number of pieces escaped this fate. The very fact that objects of gold and silver were assessed by weight speaks against their conversion into coin, the treatment bestowed by the Latins on the ancient bronzes of Constantinople.[39] Moreover, where we have detailed accounts of the disposi-

tion of booty, as we do in the case of Baybars' division of the spoils of Antioch in 1268, the careful separation of crafted vessels from specie[40] further argues against their immediate and total obliteration. Naturally, Christian writers stress the loss of sacred objects taken from church treasuries and delivered to the Tatars.[41] Yet in light of the number of examples of secular pieces of crusader silver found at a variety of sites in Russia,[42] it is not likely that all precious-metal objects that fell into Mongol hands were converted to other ends.

It is sometimes forgotten that the Mongols, who took Damascus in 1260, raided as far south as Hebron and Gaza and are thus more relevant to cultural exchange in the region than is normally supposed. By design the focus of this chapter is on Frankish relations with Islam, a faith to which only one of the Tatar khans (Berke of the Golden Horde) belonged.[43] Yet even if collaboration between Franks and Mongols (at least until the defeat of the latter by the Mamluks at 'Ayn Jalūt in 1260) was, as is often maintained, a natural alliance, this exotic bond has over-shadowed the extent and recurrence of more or less harmonious relations between Latin Christians and Muslims in the Holy Land. Two examples, nearly a century and a half apart, must suffice to demonstrate that the battlefield was not the only occasion on which the crusaders encountered Arab warriors. When Adelaide, the widow of Count Roger of Sicily, arrived at Acre in August 1113 as the bride of Bald-win I, she was accompanied, according to Albert of Aachen,[44] by a thousand men-at-arms in two Sicilian warships, other vessels laden with gold, silver, and purple silks, and a splendidly clad contingent of "Saracen" archers, all of which she pre-sented to her new husband. An inversely proportional ethnic mixture occurred in 1244–45 when al-Manṣūr, prince of Himṣ, led an army from Damascus against the Khwarazmians at Gaza that included a troop of Latins, ever ready to exploit Mus-lim factionalism. "The Franks raised crosses over the army from Damascus and over the head of al-Manṣūr; and their priests made the sign of the cross while bear-ing vessels of wine from which they gave their knights to drink," wrote Maqrīzī some 200 years later but still perceptibly shocked. The battle at Gaza proved a dis-aster for the Franks. The Khwarazmians fell upon Jerusalem, killing many Chris-tians, destroying much of the Church of the Resurrection, and ransacking the tombs of the Latin kings.[45]

Both medieval and modern discourse on the crusades emphasizes this sort of vandalism at the expense of evidence that points to another aspect of relations be-tween Christians and Muslims. Precisely because it is concerned with process, that is, practices in the *longue durée,* rather than event, such testimony is less dramatic and therefore less often remarked. As against the looting of shrines and the seizure of artifacts, sacred and profane, in the private possession of individuals, both of

which, as we have seen, were steps that redistributed among the predators goods marked with the signs of their prey, established modes of behavior tended to reduce the gulf between self-consciously opposed cultures. Not least of these was the commingling represented by the shared veneration of such sites as Saidanya, near Damascus.[46] The best-known source of information on this convent's most revered object is that of Gerard of Strasbourg, Frederick Barbarossa's envoy to Saladin in 1175, as incorporated into Arnold of Lübeck's early-thirteenth-century chronicle. Reversing what by the twelfth century had become the direction normally attributed to wonder-working icons—from the Holy Land to Constantinople—Gerard declares that this panel had been made in the capital, brought to the East by a patriarch of Jerusalem, and then obtained in 870 by the abbess of Saidanya. To this day, he reports, "on the Feast of the Assumption and at Christmas all the Saracens of that province [Damascus] gather as one with the Christians to pray and the Saracens perform ceremonies with the highest devotion" to the image; "from it there exudes an incessant flow of oil that heals the ailments of many Christians, Saracens and Jews."[47] The account is repeated all but verbatim by the Rothelin continuator of William of Tyre,[48] but more striking testimony to the icon's universal appeal is the fact already reported in an Arabic manuscript of 1183 that there "gather to this place Christians, Muslims, Nestorians, Melkites, Syrians and others approximately four or five thousand people."[49] This constitutes independent witness to Gerard's description of the cult.

If the importance of this account of the Saidanya icon has by now been recognized by historians, it does not stand alone as an example of co-veneration. Writing more like an ethnographer than a propagandist, in the context of Egypt's natural products he observes the balsam that is collected drop by drop in glass vessels, stored for six months in pigeon excrement, and then decanted. This harvest is gathered at the spring where the Virgin and Child rested during the Flight from Herod and where she washed her son's clothes. The Saracens, Gerard notes, venerate the site, bringing to "it candles and incense when they bathe there."[50] Higher up the social ladder examples of tolerance are harder to come by, yet even these are not unknown. One instance is offered by a Syrian chronicler, whom one might imagine to be hostile to the Franks. Ibn Wāṣil is a primary source for the negotiations over Jerusalem and the subsequent treaty of Jaffa (February 1229) between Louis IX and the Ayyūbid sultan al-Kāmil; reporting the French king's arrival in Jerusalem, restored to the Latins with the exception of the Dome of the Rock and al-Aqṣā, the Arab tells of Louis's admiration for the construction of these holy places and especially for the *minbar* at the Aqṣā, to the top of which he climbed. On leaving, the king encountered a priest, Gospel book in hand, seeking to enter

the mosque. No doubt mindful that the treaty ceded to the Franks the Holy Sepulchre, where he had just appeared wearing his crown and anxious to maintain the delicate balance of power, Louis upbraided the cleric, threatening to blind any Christian who transgressed this boundary of mutual respect.[51]

However ephemeral some might have been, courtesies of this sort were extended to each other by Arab, Greek, and Latin élites. A renegade Byzantine aristocrat and his royal Frankish lover, traveling with their possessions, were welcomed in Damascus.[52] Over the course of several centuries Byzantine emperors went on campaign equipped with fine goods "for distinguished refugees and for sending to distinguished and powerful foreigners."[53] These stores probably supplied the brocades and other items that Manuel Komnenos sent from Cicilia to Nūr al-Dīn in March 1159, and possibly the "rare pearls, a brocade tent of considerable value, and magnificent horses from the Jebel" that in part made up the emperor's next gift in response to the *atabeg*'s release of prisoners of war.[54] Eleven years later, when the shoe was on the other foot and Amalric of Jerusalem came to Constantinople to seek the emperor's help against Nūr al-Dīn, and a treaty to this effect had been signed, Manuel lavished on the Frankish king and his retinue "inmensa . . . auri pondera, olosericorum quoque multitudinem simul et peregrinarum eximia dona divitiarum."[55] What these "foreign wares" were William of Tyre does not say, but it seems reasonable to suppose that some were of Muslim origin or manufacture. Whether or not this is so, it is clear that the eastern Mediterranean was covered by a gift network, following or even preceding patterns of commercial exchange, that brought luxuries to all who participated in the diplomatic game and independent of their confessional affiliation or ethnic origin. All in all, the range and purposes of precious gifts far exceeded the ethical notion that "Bar Hebraeus" puts into the mouth of Richard I Lionheart when he communicated with Saladin through his ambassador:

> I have sent to thee that, if thou wilt permit, I may send to thee presents. For it is not right for kings to cut off gifts, and embassies, and words of affection from each other, even though war is being carried on between them. For thus do the laws of our fathers the kings of olden time, teach us.[56]

Exchanging Visual Ideas: Two Examples

Several inferences, I believe, may be drawn from the material presented up to this point. First, the social, economic, and diplomatic circumstances in which the states of Outremer found themselves allowed and seem to have encouraged the movement of artifacts within and across their changing borders. Second, unlike

the rigid ideological systems with which the partners to these transactions sought to define themselves, these borders were permeable, not least to the Arab and other Islamic societies that inhabited or surrounded crusader lands. Third, the movement of objects and with them the visual ideas that they carried was achieved through various means, above all gifts and loot. Lastly, and most important for what follows, nothing in these circumstances requires us to identify any specific object as a crusader product: I have been speaking in terms of generalities, and while generalities may be necessary to the understanding of an artifact, they are never sufficient to identify its peculiarities. A definition of its nature can come only from recognition of those qualities that set it apart, even (or especially) from things that superficially resemble it.

To the best of my knowledge, there are no good analogues for the two objects considered below when they are regarded as totalities. The absence of "parallels"— an unhappy term for any work made before the era of hard-edge painting—means that we shall have to take them apart, particularly if the extent of their Muslim content and context is to become visible. There is nothing new about such a procedure. It is true that, so far as metalwork is concerned, study of the absorption of Christian themes into Islamic objects has yielded more positive results[57] than any assimilation in the opposite direction. But especially in the field of manuscript illumination, since Hugo Buchthal's pioneering investigation of iconographical elements nearly half a century ago,[58] the identification in crusader books of iconographic elements derived from the Muslim world has become progressively more sophisticated.[59] On the other hand, we cannot rely on iconography alone. Essential as the analysis of their constituents may be to an understanding of the objects in question, the problems each poses depend as much on the way these are put together, modifying the diverse sources employed, and thus forming unique wholes that are more than the sum of their parts.

Initially, the claim for uniqueness of our first object (fig. 11.1) may be questioned by those familiar with many Western medieval, Byzantine, and Islamic pieces that have as their principal motif the image of a mounted hunter or warrior (fig. 11.2). Yet, depending on their area of specialization (and I have tested this empirically), experts are likely to cite very different comparanda. This disagreement is of course part of the problem and a witness to the object's prima facie hybridity. A footed silver bowl, belonging to the Stanford Place collection in Faringdon, Oxfordshire, it is at present on loan to the Metropolitan Museum of Art.[60] Within its chased rim, worked partly à jour in a sort of egg-and-dart molding, there runs a circumferential frieze made up of running quadrupeds separated by discrete leaf-like forms. The animals include one with long horns (a gazelle?), at least two hares (?),

Fig. 11.1. Faringdon, Stanford Place collection (on loan to the Metropolitan Museum of Art), silver bowl. By permission of the Trustees of the Stanford Place Collection.

several shorter-eared creatures (rabbits?), and dogs. Particularly in light of the central motif, I see no reason not to interpret this zone as a hunt, or rather part of a hunt, much as we find it on the edge of the lip of the late-thirteenth- or early-fourteenth-century Mamluk vessel known as the Baptistère de Saint-Louis (fig. 11.3).[61] Unlike this basin, however, which on both its exterior and interior is covered with successive bands of ornament highlighted with precious-metal inlay, the Stanford Place bowl displays a broad swath of undecorated silver that at once exploits its basic raw material and directs the eye outward toward the just-described animal frieze and especially inward toward the rider at the vessel's hub.

The interval between periphery and center is further emphasized by rings, heightened in niello, that define a broad border of leafy ornament. Where the fretted leaves of the outer frieze are occasional and subordinate to the animals, in this larger zone the vegetation rules uncluttered by zoomorphic inhabitants and is organized as a continuous, carefully delineated rinceau, each leaf of which is uniform in size and shape. Given this lack of realism—in this respect the scroll looks more "romanesque" than "gothic"—there is little point in assigning the ornament the name of a particular species. It may be better simply to call it an arabesque, as Robert Nelson did with similar decoration that he found on a number of Egyptian woodcarvings and in Coptic book illumination.[62] Only within the central

Fig. 11.2. Detail of fig. 11.1, central medallion. By permission of the Trustees of the Stanford Place Collection.

Fig. 11.3. Paris, Musée du Louvre, "Baptistère de Saint-Louis," detail. Copyright Réunion des Musées Nationaux / Art Resource, NY

Fig. 11.4. Berlin, Kunstgewerbemuseum, Demetrios plaque. By permission of the Staatliche Museen zu Berlin, Kunstgewerbemuseum.

medallion (fig. 11.2) is this botanical restraint abandoned: here regularity and simplicity are replaced by a riot of often intertwining tendrils that seem to fill every interstitial space, leaving room only for the lioness's tail which is itself converted into a leaf.

"All over" ornament that occupies virtually every inch of a panel not reserved for the figure occurs on a variety of Byzantine works depicting rider saints, notably on the enameled Demetrios plaque from the Welf treasure in Berlin (fig. 11.4)[63] and on the now well-known crusader icon of St. George in London (fig. 11.8).[64] But neither resembles the decoration on our bowl, and on both, each in its own way but especially that in the Kunstgewerbemuseum, the vegetation is distributed in a much more disciplined fashion,[65] creating a less luxuriant impression. For rife, "all over" ornament it is to the Islamic art of the thirteenth and fourteenth centuries that we must turn, be it to the grounds of the roundels on the Louvre "Baptistère" (fig. 11.3), of a glazed Syrian bowl in the Museum of Islamic Art in Berlin,[66] or especially to those of the medallions inhabited by horsemen on a Persian candlestick in Edinburgh (fig. 11.5).[67]

The last two of these examples likewise conform to our rider not only in that they show hunters, but also in that in both cases the figures brandish a sword above their heads while turning to confront their prey.[68] On the Stanford Place bowl this is the already-mentioned lioness that leaps up to bite the crupper of the horse; the

Fig. 11.5. Edinburgh, Royal Scottish Museum, Persian candlestick, detail

bear on the candlestick medallion is similarly engaged even if it stands erect on its hind feet.[69] The rump-biting beast is a familiar motif in Late Antiquity,[70] yet in the period with which we are concerned more common in Muslim representations than in those of either Byzantium or the West. So, too, it is in the body of Muslim rather than Latin or Greek imagery that the vignette of a foal or, as on our bowl, a cub suckling at its mother's teat is best preserved.[71] Neither these observations nor, of course, the absence of any overtly Christian aspect to the iconography require that our object was made by an Islamic silversmith. Yet they reinforce the likelihood that it was the product of a region in which, as Boris Marshak proposed of two silver vessels in the Hermitage Museum, again decorated with purely secular imagery among fretted tendrils akin to those on the Stanford Place bowl, Byzantine, Latin, and native craftsmen encountered Muslim visual traditions. Such an area, it has recently been observed of the same two vessels, could have been the county of Edessa, lost by the crusaders to Nūr al-Dīn in 1140.[72] Found several thousand kilometers apart, but both in regions raided by the Tatars (the first near Tartu in Estonia, the second in the Nenets region of western Siberia),

they could have been gifts to Mongol leaders or fruits of their pillaging in the Holy Land.[73]

Certainly there is nothing Mongol or Mamluk about the facial features of the rider on our bowl. The "Gothic swing" of his somewhat disjointed body, his long fleshy nose and somewhat petulant expression can be found in Western manuscript illumination toward the middle of the twelfth century,[74] but his uncovered head and thick lips recall Byzantine saints on the order of Demetrios on the Berlin icon (fig. 11.4). Yet the closely observed stubble on his chin and jowels[75] distinguish him as much from the youthful Demetrios, George, and Sergios as from pictures of the full-bearded Theodore. In this respect it is one of the hunters on the Baptistère de Saint-Louis (fig. 11.3) whom the Stanford Place horseman most closely resembles. His costume, it must be said, can be no guide in localizing the image. Even when a rider wears armor, as on the crusader St. George in London (fig. 11.8), this may be fanciful;[76] even if, as on our bowl, his garb is far from military, on at least one silver casket, likewise said to be crusader work, a hunter is shown wearing the armor of a cavalryman.[77] Given these ambiguities born of the hybrid situation in which the bowl came about, what is needed is one distinct, diagnostic sign that can point to its origin. This is available in a detail carefully recorded, it would seem, by the silversmith. Each of the horse's boots is shown attached with four studs to the walls of its hooves. This feature appears, perhaps without precedent, on two crusader icons on Mount Sinai[78] before reaching the crusader-occupied Morea in the late thirteenth century and Lusignan Cyprus shortly thereafter,[79] before spreading to western Europe where horse boots attached in this way are still evident in paintings by Rubens. Apart from a small group of Georgian objects in metal,[80] I know of no work, Eastern or Western, in which this feature is observed save for two icons at Mount Sinai that are surely the work of a crusader painter.[81]

If, for us, so small a detail as boot studs is sufficient to indicate where the Stanford Place bowl was made, it is highly improbable that it would have been noticed by the object's original audience. Like the arabesque decoration, the rider's sword-wielding gesture, the rump-biting lioness, and its suckling cub, all of which we can find in Muslim art, the design as a whole would not have been read in the twelfth or thirteenth century as anything but "natural," that is to say, as neither "Eastern" nor "Western." Just as important elements in the scene reveal their Islamic affiliations only upon close, retrospective analysis, so the bowl would not have announced a specifically Latin, Greek, or crusader identity, for it is in the nature of the hybrid to be ordinarily unselfconscious. Only when an artist, in response to the demands of his clientèle, fashions iconographies that proclaim po-

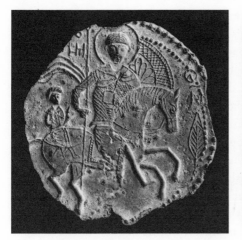

Fig. 11.6. The Art Museum, Princeton University, pilgrim token, obverse. Museum purchase, gift of the Judy and Michael Steinhardt Foundation. Photo: Bruce M. White.

Fig. 11.7. Reverse of fig. 11.6

litical, ethnic, or religious distinctions—as happened in the case of the Arsenal Old Testament[82] or the literally flag-waving or cross-bearing saints on icons[83]— are we entitled to recognize exceptions to this rule. In normal apolitical practice,[84] of which our bowl is an instance, the craftsman's purpose and achievement was to mask, if he was not entirely unaware of, the origins of the signs that he employed.

OUR SECOND EXAMPLE, a small, bilateral lead object of the type conventionally called a pilgrim token, offers the very antithesis of the political quiescence suggested by the Stanford Place bowl. Acquired by the Princeton University Art Museum in 1997,[85] it insists upon its Christian character both in the identification of figures as "holy" on its obverse (fig. 11.6) and the depiction of a cross that dominates its reverse (fig. 11.7). Even so, we shall see that its immediate iconographic sources are concealed, just as its Islamic, or rather anti-Islamic, content is covert if not entirely "invisible." The saint's pose—turning toward the beholder while sitting astride his mount—and his accoutrements—notably his fluttering chlamys and shield disposed vertically, to be read as carried on his back—are generically those of a number of crusader panels,[86] although most common on representations of St. George. To this point, there has been no reason to question the fragmentary inscription that supplies the name Demetrios. Where this label seems

to go awry, however, is in the depiction of the youth seated far back on the horse's crupper.[87] No explanation for this comparison is offered by the body of myth surrounding Demetrios, but his presence becomes comprehensible as soon as the token is compared with images such as that in figure 11.8.

The legend of St. George's rescue of the boy of Mitylene from Arab captivity is too well known to require repetition here.[88] Suffice it to recall that in its fullest elaboration, in response to his mother's prayer the boy is carried across the sea to his island home, still holding the wine glass that he was offering to the emir of Crete at the moment of his salvation. The dimensions of the token prevent a precise reading of the youth's right hand, although he appears to point to the saint rather than hold a glass. Similarly, the abraded condition of the lower portion of our object makes it difficult to interpret this area as water—an identification made certain by the fish that inhabit this zone in other representations[89]—although the large leaf to the right of the token could be taken as an indication of the dry land that is the riders' destination. Notwithstanding these problems, there can be little doubt that the token borrows a celebrated aspect of the George legend and applies it to Demetrios.

The problem posed by our object, then, is where this appropriation occurred. The cult of St. George, best known to scholars at Lydda,[90] was widespread in crusader Palestine and Syria. A fresco of the saint on horseback survives at Crac des Chevaliers[91] and an Arab chronicler reports a "large idol" of "Abū Jurj" venerated by the Franks at Ṣafad; this was torn out when the citadel was captured by Baybars in 1266 and its site turned into a *miḥrab*.[92] In this light, one might presume that the token was made in the Holy Land.[93] Yet the object itself suggests good reasons for an alternative reading. The image of St. Demetrios in itself is insufficient to support the hypothesis of a Thessalonican origin since, apart from his appearance on numerous crusader icons, he appears among the wall paintings at Abū Ghosh less than 25 km from the Holy Sepulchre.[94] Nonetheless, he is presented in the company of St. Nestor, whose abbreviated name is inscribed on the obverse just above the large leaf,[95] the figure with whom Demetrios was jointly martyred in Thessalonike and whose feast day (27 October) he shares.[96]

Again, it might be supposed that the large cross on steps, set between wiry vines sprouting sparse flowers on the reverse of the token, points to a connection with Jerusalem. Double-barred crosses appear on the necks of two lead ampullae, now in Berlin, which in their main fields display images of the Holy Sepulchre and the Marys at the Tomb.[97] But the True Cross had long been an established motif in Thessalonike,[98] as elsewhere, and there is no reason to associate it exclusively with the Holy City. The "patriarchal" (i.e., double-barred) cross, moreover, was a fea-

ture of Thessalonican money in the late eleventh century and, by the twelfth, held between St. Demetrios and the emperor, regularly appeared on the city's coinage.[99] More to the point, the cross, like the adaptation of the Frankish type of St. George, speaks to the power of crusader themes to affect the content of images far from the Holy Land.[100] The strongly Frankish elements on the token could be explained by the possibility that it reached Thessalonike during the rule of Boniface of Montserrat (1204–26) or that it was made in the city under the impact of an object that arrived during these years of crusader occupation.[101] If this second scenario obtained, then its recontextualization in the situation of Thessalonike parallels a phenomenon familiar in Frankish painting whereby one saint's name is applied to a type normally used in the depiction of another. (In Byzantium, more usually, one epithet for the Mother of God is sometimes applied to a type that normally carries a different designation.)

This tendency has led to some scholarly confusion, as in the case of an icon at Mount Sinai, first identified by George and Maria Soteriou as St. George but then rechristened as Sergios by Kurt Weitzmann on the basis of an inscription.[102] Philologically the revision is well founded and, in terms of reception, it surely defines how the panel was perceived. But to treat this instance as an "error" amended by a "correction" conceals not only the mechanism of the image's transmission, but also the cognitive stance of its maker. And as much is true of the Princeton token: refashioned as Demetrios, the saint took on some of the aura previously attached to George. This would be a value *added to* rather than supplanting the power that had accrued to the Thessalonican saint through legend and its representation in art and literature. The transfer of the miracle of Mitylene to a new "host" could also account for the lesser attention paid to the boy who was its beneficiary. In comparison with a Frankish icon where he is embraced by Demetrios (fig. 11.8), he sits farther removed from the saint and, as we have seen, seems to lack the wine glass, the key iconographic marker of the event at the hands of a painter working in the Holy Land. But in light of the scene's mobility we should expect variant forms. A late-twelfth- or early-thirteenth-century icon at Mount Sinai of St. Nicholas surrounded by scenes of his posthumous miracles attributes to this saint the boy's salvation from Arab enslavement and his return to his parents.[103]

The anti-Muslim content of the myth is somewhat softened in the token, an attenuation not out of keeping with an object apparently produced in a city less subject to Arab threats in the Frankish era than the land where the St. George panel was made. But to interpret the object solely according to the degree of animosity that it displays is to fall into the trap set by the rhetoric of those who contested the possession of Outremer. Just as the Stanford Place bowl is best read as

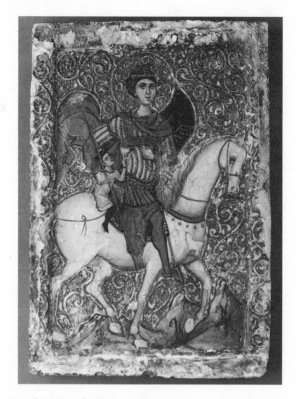

Fig. 11.8. London, British Museum, St. George icon. By permission of the
British Museum.

the work of a Frankish silversmith familiar with several Muslim motifs, so the
icons that depict the holy warriors of Christendom as heroes of the struggle against
Islam[104] can be recognized as incorporating elements borrowed from the Muslim
world. Quite remarkable, for example, is the manner in which art historians have
ignored the bows and quivers depicted on such panels as the St. Sergios and the
Sergios and Bacchus at Mount Sinai, other than to suppose the painter was in-
spired by a "Persian model."[105] In all likelihood the model was much closer to
hand. These were normal weapons of the turcopoles, the light cavalry troops of
crusader and Byzantine armies that used Islamic equipment. Muslim archers, and
those who learned from them, drew their bows with their thumb inserted into a
ring not with their finger as was the practice in Europe. On the Sergios and Bac-
chus icon this ring is still on the bow, while on that of Sergios alone it is evident
at the junction of his thumb and right hand.[106]

Of course the significance of such details, be it on the painted panels or the ex-

amples of metalwork that we have considered above, can be exaggerated: these are, as I have said, complex objects and we have no way of knowing the extent to which those who saw them perceived the Islamic nature of some of their constituent parts. So, too, it would be absurd to read the presence of these motifs as evidence of ever-harmonious relations between Muslims and Christians in Outremer, the "symbiose pacifique" of which Jules Leroy wrote when describing the conditions under which Arabs and Copts produced their books in medieval Egypt.[107] Yet to neglect these signs is akin to treating them like Michel Foucault's outlaws, traces of whose existence become visible only at the moment of their intersection with authority.[108] The hybrid horsemen of the Stanford Place bowl and the Princeton token, their equipment and their settings, have a part in the Christian culture of Outremer and something to say to those who write its history.

AFTER THIS CHAPTER was submitted there appeared a brief discussion of the Princeton token and a similar piece excavated at Novgorod in 1999 by V. N. Zalesskaya, "Thessalonikskie ikon'i-eulogii i obraski epokhi latinsko imperii," in *Pilgrim'i, istoriko-kulturnaia rol'palomnichestva,* a volume produced by the State Hermitage Museum for the 20th International Congress of Byzantine Studies, Paris, 19–25 August 2001, St. Petersburg, 2001, 78–82. The token is there described as being in a private collection in New York, following its initial publication in a dealer's checklist, *Engraved Gems and Rings of the Middle Byzantine Period,* [Michael] Ward and Company, New York, 1997, no. 23. Naturally, I was glad to see that Zalesskaya assigns it to the same date and place of origin as I do.

Notes

1. *The Art of the Crusaders in the Holy Land, 1098–1187* (Cambridge, 1995), 16. The author's definition of the term *crusader* (3) should be noted: it includes "not only those who came on the various expeditions but also the Frankish settlers, merchants and church officials, and all generations of these laypersons and ecclesiastics *in the Holy Land* between 1089 and 1291" (Folda's italics). One can accept the inclusiveness of this characterization, even while recognizing that it is precisely what it excludes that has provoked much of the debate about this and similar definitions of the past twenty-five years. For discussion, see ibid., 3–4, 474–80.

2. The most astute insight into this mental universe remains the study by David Jacoby, "Knightly Values and Class Consciousness in the Crusader States of the Eastern Mediterranean," *Mediterranean Historical Review* 1 (1986): 158–86.

3. *The Crusades: Islamic Perspectives* (Chicago, 1999), 358.

4. Recognition of their intertwined destinies is especially apparent in the Arab

sources. Writing of the earthquake that destroyed much of Damascus, Ḥimṣ, and Aleppo in late June 1170, Ibn al-Athīr notes that "as for the land of the Franks, the earthquake caused similar disasters there" and observed its consequences for both sides: "Each of the two peoples was thus occupied with rebuilding its cities out of fear of the other." See his *Al-Kāmil fī'l-tarīkh,* trans. W. McGuckin de Slane in *Recueil des historiens des croisades: historiens occidentaux* 1 (Paris, 1872), 573.

5. A model corrective to oversimplifications of this sort is provided by Lucy-Anne Hunt, "Art and Colonialism: The Mosaics of the Church of the Nativity in Bethlehem (1169) and the Problem of 'Crusader' Art," *Dumbarton Oaks Papers* 45 (1991): 69–85. Similarly, on the implications of Ayyūbid glass beakers with Christian figures in enamel, see Maria Georgopoulou, "Orientalism and Crusader Art: Constructing a New Canon," *Medieval Encounters* 5 (1999): 289–321.

6. Thus, Jacoby, "Knightly Values," 174–75, has pointed out that while the French in the West indulged themselves in both fierce hatred of, and fanciful stories about, the Muslims, a more sober and realistic picture of their neighbors was drawn by the knights of Outremer, "grown accustomed to a continuous cycle of warfare alternating with peaceful coexistence."

7. Survey of sources: Hillenbrand, *The Crusades: Islamic Perspectives;* Emmanuel Sivan, *L'Islam et la Croisade: Idéologie et propagande dans les réactions musulmanes aux Croisades* (Paris, 1968). For a useful account of Islamic historiography on the crusades, see Françoise Micheau, "Le crociate nella visione degli storici arabi di ieri e di oggi," in *Le crociate: l'Oriente e l'Occidente da Urbano II a San Luigi, 1096–1270,* exh. cat., ed. Monique Rey-Delqué (Milan, 1997), 63–75.

8. I derive the contrast from Folda, *Art of the Crusaders,* 44, 49.

9. Philippe de Novare, *Mémoires, 1218–1243,* ed. Charles Kohler (Paris, 1970), 51. Philip himself also adopted the Arab habit of interspersing his chronicle with appropriate verses, his own and others, that he had picked up from reading.

10. Thus the *rara et preciosa munera,* left undescribed by the anonymous author of the Chronicle of Cologne and sent to Manuel I by the *rex Babyloniae* when in 1173 Saladin sought to marry his son to the emperor's daughter, are said to have been accompanied by the pledge that, if the match were consummated, the sultan would embrace the emperor's faith and release all Christian prisoners. See *Chronica regia coloniensis,* ed. Georg Waitz, *MGH ScriptRerGerm* 18 (Hanover, 1880), 124.

11. Thus Niketas Choniates explains Manuel I's lavish offering of gold and silver vessels, coins, garments, and "other choice ornaments which were easily procured by the Romans but rare among the barbarians and hardly ever seen by them" as due to the emperor's awareness that "no barbarian is able to resist the temptation of gain." See Choniates, *Historia,* ed. Jan Louis van Dieten (Berlin, 1975), 120 line 94–121 line 7. I cite the translation of Harry Magoulias, *O City of Byzantium* (Detroit, 1984), 68. Significantly, the offer is corroborated by the Syriac "Bar Hebraeus" (see *The Chronography of Gregory Abū'l Faraj,* 2 vols. [Oxford, 1932], 1:287), but without the ethnic slur.

12. *Chronica regia coloniensis,* 125.

13. *L'Histoire de Saint Louis.* ed. Natalis de Wailly (Paris, 1867), 304.

14. *Chronicon,* bk. 18, ch. 31, ed. R.B.C. Huygens. Corpus Christianorum. Continuatio Medievalis, 63A (Turnhout, 1986), 856 line 19.

15. Ibid., 856 lines 8–18.

16. *Kitāb al-i'tibār* (The Book of Learning by Example), trans. Philip K. Hitti as *An Arab-Syrian Gentleman and Warrior in the Period of the Crusades* (New York, 1929), 117–18.

17. *Chronicon,* 843 lines 20–25, and in the translation by Emily A. Babcock and August C. Krey, *A History of Deeds Done Beyond the Sea,* 2 vols. (New York, 1943), 1:274. On Baldwin himself Manuel bestowed garments, silks, and precious vases (*Chronicon,* 847 lines 52–57). I omit mention of the specie lavished on the couple by the emperor. On this and the economic significance of the gifts as a whole, see Anthony Cutler, "Gifts and Gift Exchange as Aspects of the Byzantine, Arab and Related Economies," *Dumbarton Oaks Papers* 55 (2001): 247–78.

18. *Kitāb al-Sulūk li-ma'rifat duwal al-mulūk,* partially trans. R. J.C. Broadhurst as *A History of the Ayyūbid Sultans of Egypt* (Boston, 1980), 156–57.

19. Trans. Ghada al-Hijjāwī al-Qaddūmī as *Book of Gifts and Rarities* (Cambridge, Mass., 1996).

20. *Sulūk,* trans. Broadhurst, 157–58.

21. *Chronography,* 415. Another reason to suppose a cordial relationship between the sultan and the king is offered by Godfrey of Beaulieu in his *Life of St. Louis.* The sultan, having shown Louis his library, offered to have as many books copied as the king might wish. According to Godfrey, the "sons of darkness" thereby showed themselves to be as "sons of light" since Louis then conceived the idea of building a collection of books for distribution to monastic libraries where they could be studied by *viri litterati ac religiosi familiares.* See *Vita Ludovici Noni* in *Recueil des historiens des Gaules et de la France* 20 (Paris, 1840), 15 B. On the further intellectual repercussions of this, see Daniel H. Weiss, *Art and Crusade in the Age of Saint Louis* (Cambridge, 1998), 208–9.

22. The most extensive evidence derives from records of the diplomatic exchanges of, first, Manuel Komnenos, Amalric of Jerusalem, and Nūr al-Dīn; second, Saladin and Isaac II Angelos; and lastly al-Kāmil and Frederick II. These are treated briefly in my article, "Gifts and Gift Exchange," and more fully in my forthcoming study, *The Empire of Things: Gifts and Gift Exchange in Byzantium, the Arab World, and Beyond.*

23. But see Thomas T. Allsen, *Commodity and Exchange in the Mongol Empire* (Cambridge, 1997), index s.v. Güyüg.

24. *L'Histoire de Saint Louis,* 88. Similar unfamiliarity with the names of foreign rulers is widespread among Arab chroniclers. Louis IX, for example, is regularly called "Raidafrans" by Ibn al-Furāt (as in note 40).

25. *L'Histoire de Saint Louis,* 88–89. At 314, Joinville reverts to the subject of the chapel, expanding the list of images to include the Nativity, the Baptism, "the entire Passion and the Ascension," and the Descent of the Holy Spirit. Included, too, were chalices, books, and all that was necessary for the two accompanying "freres Preescheurs pour chanter les messes devant eulz."

26. Arthur S. Tritton and Hamilton A. R. Gibb, "The First and Second Crusades from an Anonymous Syriac Chronicle," *Journal of the Royal Asiatic Society* (1933): 279.

27. *Historia,* 30 line 90–31 line 4; Magoulias, *O City of Byzantium,* 18.

28. *Histoire des sultans Mamlouks,* ed. and trans. E. Blochet, *Patrologia orientalis,* XIV (Paris, 1920), 535–36.

29. *Chronicon Magni Presbyteri,* ed. W. Wattenbach, *MGH, Scriptores,* XVII (Hanover, 1861), 512 lines 5–7. Although there is no reason to see them as gifts rather than items of commerce, the Danish axes carried by the Arabs who boarded his ship clearly terrified Joinville, *L'Histoire de Saint-Louis,* 234.

30. *L'Histoire de Saint Louis,* 396.

31. Tritton and Gibb, "The First and Second Crusades," 81.

32. Ibid., 99.

33. *Sulūk,* trans. Broadhurst, 262–63.

34. Claude Cahen, *Orient et occident au temps des Croisades* (Paris, 1983), 133, 176.

35. David Abulafia, "Trade and Crusade, 1050–1250," in *Cross Cultural Convergences in the Crusade Period: Essays Presented to Aryeh Grabois on his Sixty-Fifth Birthday,* ed. Michael Goodich, Sophia Menache, and Silvia Schein (New York, 1995), 17.

36. *Al-Fath al-qussī fi'l-fath al-Qudsī,* trans. Henri Massé as *Conquête de la Syrie et de la Palestine par Saladin* (Paris, 1972), 278–79. The weight of the Islamic *qintar* varied over time and space. When applied to coins it was the equivalent of 100,000 *dīnārs* or 42.33 kg of gold. See Walther Hinz, *Islamische Masse und Gewichte* (Leiden, 1955), 19–20.

37. *Sulūk,* trans. Broadhurst, 89–90.

38. *Chronography,* 274: "And the countries of the Turks were filled with the spoils of the Franks, and talents of silver were sold as if they were lead in Melitene." Alternatively, the figure of speech could refer only to the abundance of the loot.

39. Michael Hendy, *Coinage and Money in the Byzantine Empire, 1081–1261* (Washington, D.C., 1969), 206.

40. Ibn al-Furāt, *Ta'rīkh al-duwal wa'l-mulūk,* trans. U. and M. C. Lyons as *Ayyubids, Mamlukes and Crusaders,* 2 vols. (Cambridge, 1971), 2:125: "So the Muslims brought the money and the gold and silverwork. The weighing took a long time and coins were divided out in cups and drinking vessels."

41. *Chronography,* 409: "And the governor [of Melitene] collected a very large amount of money, *zūze,* and *dīnārs,* and chains (i.e., jewelry), and vessels of gold and silver, which was equal [in value] to forty thousand *dīnārs* of gold. And he stole also the vessels of the sanctuary, and he brought out chalices, and phials, and censers, and lamp-stands, and the coffins (funerary caskets) of the saints from the treasury of the great church, and gave them to the Tātārs."

42. See the survey by Boris I. Marshak, "Zur Toreutik der Kreuzfahrer," in *Metallkunst von der Spätantike bis zum ausgehende Mittelalters,* ed. Arne Effenberger (Berlin, 1982), 166–86.

43. For this neglected chapter in Levantine history, see Peter M. Holt, *The Age of the Crusades: The Near East from the Eleventh Century to 1517* (London, 1986), 87–95;

and on Baybars' gifts to Berke, including, it is said, a Koran written by the caliph 'Uthman, ibid., 94.

44. *Historia hierosolymitana,* bk. 12, ch. 13, *Recueil des historiens des croisades: historiens occidentaux* 4 (Paris, 1879), 696–97.

45. *Sulūk,* trans. Broadhurst, 273–74.

46. For knowledge of this cult and the medieval literature on it, I am greatly indebted to Annemarie Weyl Carr.

47. *Chronica slavorum,* bk. VII, ch. 8, ed. J. M. Lappenberg in *MGH Scriptores* 21 (Hanover, 1869), 239 line 36–240 line 12. The Saidnaya image was perhaps reproduced in enamel on the rarely reproduced sliding lid of an eleventh-century staurothèque removed from the convent of this name by a patriarch of Antioch in 1914 and now in the Hermitage Museum. See *Sinai, Byzantium, Russia,* exh. cat., ed. Yuri Piatnitsky and Oriana Baddeley et al. (London, 2000), no. B38. The enamel is now lost and replaced with a relief in silver gilt. Below the image are a well and compartments perhaps for the thaumaturgic oils in question.

48. In *Itinéraires à Jérusalem et descriptions de la Terre Sainte,* ed. Henri Michelant and Gaston Raynaud (Geneva, 1882), 173–74.

49. Daniel Baraz, "The Incarnated Icon of Saidnaya Goes West," *Le Muséon* 108 (1995): 181–91.

50. *Chronica slavorum,* 237 line 41–238 line 9. In a genuine attempt to reconcile the alien faiths Gerard goes on to say that the Saracens believe that the Virgin conceived Christ through the medium of an angel and adds that, although they deny that he was the son of God, they are circumcised and hold in veneration many apostles, prophets, and martyrs.

51. *Mufarrij al-kurūb fī akhbār Banī Ayyūb,* 4, ed. Hassanein Rabie (Cairo, 1972), 244–45, trans. Holt, *Age of the Crusades,* 65.

52. The flight from Beirut of Andronikos Komnenos, first cousin of Manuel I and eventually emperor, and Theodora, dowager queen of Baldwin III, is only one of several examples. See William of Tyre, *Chronicon,* bk. 20, ch. 2, in *Recueil des historiens des croisades: historiens occidentaux,* 993–94. For discussion, see Bernard Hamilton, "Women in the Crusader States: The Queens of Jerusalem," in *Medieval Women,* ed. Derek Baker (Oxford, 1978), 162.

53. *Constantine Porphyrogennetos: Three Treatises on Imperial Military Expeditions,* ed. and trans. John F. Haldon (Vienna, 1990), 110 lines 247–49. Cf. 108 lines 225–32.

54. Abū Shāma, *Kitāb al-rawdatayn fī akhbār al-dawlatayn al-Nūriyya wa'l-Salāhiyya,* ed. and trans. A.-C. Barbier de Meynard, as *Le livre des deux jardins* in *RHC Hist. or.* 4 (Paris, 1898), 104–5.

55. William of Tyre, *Chronicon,* bk. 20, ch. 24, ed. Huygens, 946 lines 29–34; trans. Babcock and Krey, *A History of Deeds Done Beyond the Sea,* 383.

56. *Chronography,* 334. Noting that three envoys from the Franks were with Saladin at the same time as Richard's ambassadors, Gregory Abū'l Faraj evidently understood the obfuscatory nature of the English king's overture. He concludes his narration of the incident by noting that "it is said that the king of England had no other

object in the dispatch of ambassadors time after time with these empty stories, except to obtain exact knowledge about the strength of Ṣalāḥ al-Dīn and of the kings who were with him." Ibid., 335.

57. See, for example, the groundbreaking paper by Ranee E. Katzenstein and Glenn D. Lowry, "Christian Themes in Thirteenth-Century Islamic Metalwork," *Muqarnas* 1 (1983): 53–68.

58. *Miniature Paintings in the Latin Kingdom of Jerusalem* (Oxford, 1957), esp. 65, 85.

59. Writing of books that he suggests were made at Acre, Jaroslav Folda, *Crusader Manuscript Illumination at Saint-Jean d'Acre, 1275–1291* (Princeton, 1976), 79–80, already notes that the Hospitaller Master's repertoire was "no longer confined to an occasional turbaned figure." In a copy of the *Histoire d'Outremer* in Paris (MS. fr. 9084) that he believes to have been painted in 1286, the Syrian defenders of Antioch (Buchthal, *Miniature Paintings,* pl. 136a) are shown as "totally Near Eastern in physiognomy, costume and weaponry." Following these leads, Weiss, *Art and Crusade,* has pointed to an even greater and more diverse repertoire of Muslim themes and the reasons for their incorporation into the Arsenal Old Testament. See esp. 120, 164, pl. VII and fig. 49.

60. The bowl measures 5.45 cm. high × 28.06 cm. diameter with a central medallion of 13.07 cm. I am indebted to the trustees of Stanford Place for permission to publish this object, which is reputed to have been in the collection of Horace Walpole (d. 1797). It is not mentioned in either Walpole's *Description of the Villa of Mr. Horace Walpole . . . with an Inventory of the Furniture, Pictures, Curiosities, Etc.* (Strawberry-Hill, 1784), or *A Catalogue of the Classic Contents of Strawberry Hill collected by Horace Walpole* (London, 1842). For more than forty years, before it was acquired by its present owner, it was in a private collection in Birmingham. I would also like to thank Helen Evans and Rob Hallman of the Metropolitan Museum for photographs and for their kind assistance.

61. *Renaissance of Islam: Art of the Mamluks,* ed. Esin Atil (Washington, D.C., 1981), no. 21. As against the creatures on the rim of this vessel, those on its two friezes are much more diverse and include leopards, panthers, stags, and elephants.

62. "An Icon at Mount Sinai and Christian Painting in Muslim Egypt during the Thirteenth and Fourteenth Centuries," *Art Bulletin* 65 (1983): 206 and figs. 6, 7, 9–11.

63. Dietrich Kötzsche, *Der Welfenschatz in Berliner Kunstmuseum* (Berlin, 1973), 21–22, 65 no. 2, and fig. 3.

64. Robin Cormack and Stavros Mihalarias, "A Crusader Painting of St George: 'Maniera greca' or 'Lingua Franca'?" *Burlington Magazine* 126 (March 1984): 132–41.

65. Clearly, the orderly distribution of multipetaled vegetation on the enamel takes advantage of the polychrome potential of the medium, while (even with the loss of pigment) the projecting brackets of gesso on the London icon enhance the reflectivity of its original silver decoration.

66. *Islamische Kunst in Berlin: Katalog, Museum für Islamische Kunst, Staatliche Museen Preussischer Kulturbesitz* (Berlin, 1971), no. 385 (Johanna Zick-Nissen) and fig.

8. The author of the entry describes the shield held by the rider as of "Norman" type and sees in this an allusion to the wars with the crusaders.

67. Conveniently reproduced in detail in Eva Baer, *Metalwork in Medieval Islamic Art* (Albany, N.Y., 1983), 230–31 and figs. 130, 190. Cf. figs. 22, 40.

68. The combination of the turned head and raised sword is found also on the D'Arenberg basin of c. 1240 in the Freer Gallery (Baer, *Metalwork in Medieval Islamic Art*, fig. 100).

69. Ibid., 231, sees the creature as biting the rider's [left] arm. The horseman's left hand is, however, still higher than the bear's head, while its open jaw is above the horse's rump.

70. Thus the lion attacking a quadruped in the Bacchus mosaic at El-Jem (Irving Lavin, "The Hunting Mosaics of Antioch and their Sources: A Study of Compositional Principles in the Development of Early Medieval Style," *Dumbarton Oaks Papers* 17 [1963]: fig. 92), and another assailing a horse at Cherchel (Katherine M. D. Dunbabin, *The Mosaics of Roman North Africa: Studies in Iconography* [Oxford, 1978], 59 and pl. XVIII, fig. 39).

71. Cf., for example, the nursing camel on an 'Abbāsid lustre bowl in the Louvre (Ernst Kühnel, *Islamic Art and Architecture* [Ithaca, N.Y., 1966], pl. 16a). See also note 77 below.

72. Marshak, *Silberschätze des Orients: Metalkunst des 3.-13. Jahrhunderts und ihre Kontinuität* (Leipzig, 1986), 115–18; *Sinai, Byzantium, Russia*, no. B81 (V. N. Zalesskaya). For large-scale photos of the two vessels in question, see Alice Bank, *Byzantine Art in the Collections of Soviet Museums* (Leningrad, 1977), figs. 220–26. I am obliged to Avinoam Shalem for useful discussion of the ornament on these pieces.

73. See the first section of this chapter.

74. Cf. the image of the evangelist Luke in the Gospels from Liessies written in 1146 (Charles R. Dodwell, *Painting in Europe, 800–1200* [Baltimore, 1971], 179 and fig. 211).

75. Arab writers of the period such as al-Qazwīnī (see the translation by Bernard Lewis in Hillenbrand, *The Crusades: Islamic Perspectives*, 272) remarked on the clean-shaven faces of the Franks.

76. Cormack and Mihalarias, "A Crusader Painting," 132, n. 1.

77. Thus on the casket in the Wawel in Cracow. See Marshak, "Zur Toreutik des Kreuzfahrer," fig. 20. The hunter is shown spearing a lioness, which, in turn, is suckling a cub.

78. Sergios (Cormack and Mihalarias, "A Crusader Painting," fig. 3); Sts. Sergios and Bacchus (*Sinai, Byzantium, Russia*, no. S63 [Yuri Piatnitsky]). More clearly seen in this second panel, two pairs of studs are driven into the horny walls of the hooves of both saints' horses.

79. As in the wall paintings of St. George at Vrontomas and Geraki, on which see Sharon E. J. Gerstel, "Art and Identity in the Medieval Morea," in *The Crusades from the Perspective of Byzantium and the Muslim World*, ed. Angeliki E. Laiou and Roy P. Mottahedeh (Washington, D.C., 2001), figs. 9, 13.

80. *Sinai, Byzantium, Russia,* no. B108 (A. S. Mirzoyan).

81. Sergios (Cormack and Mihalarias, "A Crusader Painting," fig. 3); Sts. Sergios and Bacchus (*Sinai, Byzantium, Russia,* no. S63 [Yuri Piatnitsky]).

82. Weiss, *Art and Crusade.*

83. Cormack and Mihalarias, "A Crusader Painting," fig. 3.

84. The distinction between images that are inherently political and the political uses to which images may be put seems to me important, not least in the context of the Holy Land. The act and presence of Christian painting were in themselves ideological statements, as Ibn al-Furāt, *Ta'rīkh al-duwal wa'l-mulūk,* 31, attests when he cites a report on one response to the disaster at al-Manṣūra in 1221: "I heard that the Christians at Baalbek blackened the faces of the portraits in their church and put soot on them out of sorrow for what had happened to the Franks in Egypt. When the governor heard of that he fined them."

85. See the acquisition notice in *Record of the Art Museum, Princeton University* 57 (1998, published 1999), 169. The maximum diameter of the token, a gift of the Judy and Michael Steinhardt Foundation, is 5.4 cm. I am indebted to Dr. Betsy Rosasco for the photographs and permission to publish them.

86. For example, Cormack and Mihalarias, "A Crusader Painting," figs. 1, 3 (vertical shield but held in three-quarter view), 8. It will be noted that our figure lacks the diadem in his hair, often but not always an attribute of rider saints. For an exception, see an early-fourteenth-century icon at Vatopedi (*Treasures of Mount Athos,* exh. cat., 2d ed., Thessalonike, 1997, 76, no. 2.13) where the framed square enkolpion (?) prominent on our saint's chest, is also to be found.

87. Whether the boy sits astride the horse or rides side-saddle is difficult to ascertain. But what might be read as his legs, dangling below the horse's girth strap, I take to be ornaments on that strap as variously rendered in the panels cited in note 86 and other examples.

88. For the story, its textual sources, and modern scholarship on the topic, see Jaroslav Folda, "Crusader Frescoes at Crac des Chevaliers and Marqab Castle," *Dumbarton Oaks Papers* 36 (1982): 177–210 and esp. 194 with n. 63a; and Cormack and Mihalarias, "A Crusader Painting," 137–38.

89. Cormack and Mihalarias, "A Crusader Painting," fig. 8.

90. Ibid., 138–39.

91. Folda, "Crusader Frescoes," 194.

92. Ibn al-Furāt, *Ta'rīkh al-duwal wa'l-mulūk,* 105.

93. This localization is suggested for a lead-alloy pilgrim flask in London depicting Sts. Demetrios and George on one side and the Holy Sepulchre on the other by Christopher Entwistle and David Buckton in *Byzantium: Treasures of Byzantine Art and Culture from British Collections,* exh. cat. (London, 1994), no. 202.

94. Gustav Kühnel, *Wall Painting in the Latin Kingdom of Jerusalem* (Berlin, 1988), 172 and pl. L, fig. 88.

95. Ⓐ Ñ.

96. For their martyrdom, see the *Bibliotheca hagiographica graecorum* 3, nos.

2290–92; for their joint feast, *Synaxarion urbis Constantinopolitanae,* 167. I have benefited here from the advice of John Nesbitt and Brigitte Pitarakis. Sts. Demetrios and Nestor are associated on such objects as an enkolpion at Halberstadt (*The Glory of Byzantium: Art and Culture of the Middle Byzantine Era, A.D. 843–1261,* ed. Helen Evans and William D. Wixom, exh. cat. [New York, 1997], no. 108 [William D. Wixom]). Our medallion evidently extends into the thirteenth century the cult of Demetrios and Nestor found on tenth- to twelfth-century reliquaries and parallels lead, myrrh-containing ampullae of the late twelfth to fifteenth centuries studied by Ch. Bakirtzis, "Byzantine Ampullae from Thessaloniki," in *The Blessings of Pilgrimage,* ed. Robert Ousterhout (Urbana, 1990), 140–49.

97. Folda, *Art of the Crusaders,* 294–97 and pl. 8B, figs. 8, 9.

98. For example, on a closure slab now in the Vlatadon monastery. See E. Kourkoutidou-Nikolaidou and A. Tourta, *Wandering in Byzantine Thessaloniki* (Athens, 1997), fig. 118, here dated to the tenth to eleventh centuries.

99. Hendy, *Coinage and Money,* 41–46, 110, 125–26, and pls. 1, nos. 9–12; 2, no. 17; 11, nos. 15–17; 14, nos. 7–9.

100. Folda, *Crusader Manuscript Illumination,* 119–58, has demonstrated the impact of crusader and particularly Hospitaller painting at a much greater distance, in both Parisian and other western European book production.

101. In which case the twelfth-century date assigned to the token in the Princeton *Record* entry (as in note 85) would need revision.

102. For the literature and commentary, see Cormack and Mihalarias, "A Crusader Painting," 133.

103. Nancy Ševčenko, *The Life of Saint Nicholas in Byzantine Art* (Turin, 1983), 29–31 and fig. 3.16.

104. See note 81 above.

105. Kurt Weitzmann, "Icon Painting in the Crusader Kingdom," *Dumbarton Oaks Papers* 20 (1966): 71–72.

106. Ahmad Y. al-Hassan and Donald R. Hill, *Islamic Technology, an Illustrated History* (Cambridge, 1986), 98–99 and fig. 4.5.

107. *Les manuscrits coptes et coptes-arabes illustrés* (Paris, 1974), 228.

108. *Power (The Essential Works of Foucault, 1954–1984,* vol. 3), ed. James D. Faubion (New York, 2000).

On *Sāqīs* and Ceramics: Systems of Representation in the Northeast Mediterranean

Scott Redford

IN THIS ESSAY, I would like to employ figural and nonfigural imagery on sgraffito ceramics from the Principality of Antioch and the Kingdom of Armenian Cilicia to address issues faced by students of the Latin states of Outremer and the medieval eastern Mediterranean. In the tug-of-war over the cultural allegiance of the states of Outremer, this imagery can be used to examine cultural literacy, autonomy, intentionality, and distinctions between religious and perhaps more widespread nonreligious traditions. Here, I would like to propose coherent and distinct, but overlapping, systems of visual representation not only found in the Principality of Antioch and the Kingdom of Armenian Cilicia, but also shared between these states and their neighbors, the Lusignans, Mongols, Ayyūbids, Mamluks, and Seljuks of Rum. In my opinion, these systems represent an overlapping of cultures in the Levant no less than the creative dynamism of the Christian littoral states themselves.

The vehicle for discussion in this essay is the incised, polychrome glazed pottery commonly known as Port Saint Symeon (henceforth PSS) ware. It was so-named after the thirteenth-century port of Antioch, also known as al-Mina, where quantities and kiln wasters of these ceramics were recovered by Sir Leonard Woolley's excavations in 1936 and 1937.[1] In the years since, sherds of PSS ceramics have been found all around the Mediterranean.[2] More recently, multiple production centers for this kind of glazed ceramic have been uncovered.

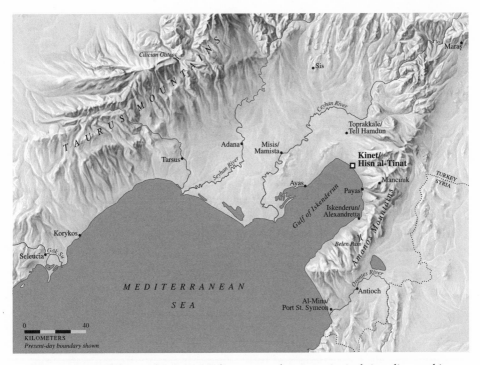

Fig. 12.1. Map of the northeastern Mediterranean showing principal sites discussed in the text. Map by Jerome Cookson.

Excavations at Medieval Kinet

The site of Kinet is well situated to address issues common to both the Principality of Antioch and the Kingdom of Armenian Cilicia. Medieval Kinet was located in a border zone between them (fig. 12.1). The site, the ancient port of Issos,[3] lies at the edge of the narrow coastal plain linking Syria through Antioch with Cilicia. The mound of Kinet was reoccupied for the first time since the fourth century B.C.E. in the late twelfth century C.E. At the time, a fortified, orthogonally planned settlement was laid on top of the ancient tell and surrounding areas, perhaps by the Templars.[4] One reason for the refounding of Kinet seems to have been the booming commerce of the era, as well as the need for secure ports away from the southern frontier of the Principality of Antioch, which had lost its main port, Lattakieh, and its land bridge to the southern Latin states with Saladin's conquests of 1188.

Kinet can be identified with the port of al-Tīnāt, or Ḥiṣn al-Tīnāt, the "Castle of the Figs" mentioned by Arabic-language geographers between the late ninth

and early thirteenth centuries. These sources mention it as a port between Payas (Bayyās) and Misis (al-Maṣṣīṣa) exporting pine from the nearby Amanos mountains (Jabal al-Lukkām).[5] Ḥiṣn al-Tīnāt is explicitly tied by geographers Ibn Khurdādhbeh, Ibn Ḥawqal, al-Iṣṭakhrī, and others to the exploitation of timber resources; the earlier medieval settlement may have been located several kilometers to the south of the present-day mound near the mouth of the Deli Çayı, the river that would have been used to float logs down from the Amanos mountains. That earlier medieval settlement is likely buried under the alluvium and the recent commercial and industrial development along the Mediterranean coast.[6]

Despite its refoundation or relocation in the twelfth century, the site continued to be referred to as al-Tīnāt in Ayyūbid and Mamluk sources, which record its burning by Mamluk troops in 1266.[7] The archaeological record indicates that this thirteenth-century settlement lasted less than a century. Kinet was burned thrice; the third sack, in the early fourteenth century, led to its abandonment.

Compared to Iskenderun/Alexandretta to the south and Ayas/Lajazzo to the north and west, Kinet was a port of lesser magnitude. And yet its medieval ceramics testify to the fact that it was a thriving harbor town with far-flung connections. Excavations have yielded ceramics from around the Mediterranean littoral: proto-Majolica from southern Italy and/or Sicily, punctate ceramics from Venice, so-called Zeuxippus and early-thirteenth-century Aegean wares from Cyprus and/or the Aegean,[8] and underglaze painted ceramics from Egypt, Tripoli, Lebanon, and Frankish Palestine. Add to this ceramic assemblage enameled and other glass vessels and the finest-quality underglaze painted artificial paste body ceramics from the Syrian interior, and a picture results of thirteenth-century Kinet as a lively port and transshipment center participating in the commercial boom that shifted north to this region. This trend accelerated with the Mamluk reduction of the Levantine coast farther south after mid-century and the Armenian alliance with the Mongols. It even continued despite increasing Mamluk raids into Cilicia after 1266 and the fall of Antioch in 1268. Marco Polo's disembarkment at nearby Ayas in 1271 at the beginning of his trip to China is the best-known example of the attention this corner of the Mediterranean gathered in the late thirteenth century.[9]

It would be misleading, however, to characterize Kinet simply as a trade and transshipment port. It was also a manufacturing center in its own right, producing textiles, iron implements, and ceramics. Excavations at Kinet have uncovered spindle whorls, sheep/goat bones, and cotton seeds. While the evidence is circumstantial, it indicates weaving activity at the site. A blacksmithy has also been discovered, and an iron ingot in its ceramic mold. Kilos of slag, hundreds of nails,

and dozens of implements of agriculture and warfare found during excavation also attest to a prodigious local production of iron objects.

Decentralized Ceramic Production

Most relevant to the topic of this chapter is the recovery of multiple indices for the manufacture of glazed sgraffito ceramics at Kinet. While the inhabitants of medieval Kinet would have utilized a certain number of these vessels (overwhelmingly bowls), large quantities of PSS ceramics have been recovered, more than would have met the needs of the settlement. Proof for on-site manufacture comes in the form of two kiln furniture trivets, one with glaze adhering to it, and two sherds of slip incised, bisque fired, but unglazed sgraffito bowls. The neighboring site of Epiphaneia/Kanīsat al-Sawdā', some 25 km to the north of Kinet, has also yielded kiln furniture associated with sgraffito sherds,[10] and the nearby port of Misis, too, has produced evidence of glazed sgraffito earthenware production.[11]

These locally produced sgraffito ceramics are identical to the PSS ware first identified by Arthur Lane at al-Mina. Since PSS ceramics have been found around the Levant and eastern Mediterranean littoral, it stands to reason that this kind of ceramic was not made solely at the small port of Antioch at the mouth of the Orontes River. In fact, evidence for the manufacture of sgraffito ceramics at Antioch itself was uncovered by the 1930s excavations there.[12]

Cupbearers, Bowls, and Markets

If excavation and survey have produced evidence for the manufacture of sgraffito ceramics at Kinet, Epiphaneia, Port Saint Symeon, and Antioch, then what of the other towns and cities of this region? A small army of *sāqīs* or cupbearers can help answer this question. PSS sgraffito bowls bearing depictions of this so-called Oriental figure have been recovered at Tarsus, Misis, Adana, Antioch, Port Saint Symeon, Kinet, Hama (in central Syria), and Acre (in northern Israel). Even though relatively immobile (they are seated cross-legged, dressed in fine caftans, and proffer goblets of wine), this regiment of *sāqīs* dispersed far and wide (figs. 12.2, 12.3, and 12.4)![13]

Three points can be made from this coincidence of cupbearers. The first is the certainty of decentralization of ceramic production in the medieval Levant and eastern Mediterranean. If Kinet, Epiphaneia, Antioch, Port Saint Symeon, and Misis were all producing PSS ceramics in the thirteenth century, as the evidence indicates, then certainly the medieval Cilician towns of Tarsus, Sis, Korykos/Kiz

Fig. 12.2. Drawing of sgraffito bowls with representations of cupbearers, Port St. Symeon and Hama (Florence Day's review of Arthur Lane, "Medieval Finds at Al Mina in North Syria," in *Ars Islamica* 6 [1939]: fig. 1)

Kalesi, Ayas, and points in between were, too. This decentralization of glazed ceramic production parallels the situation in inland Syria and Anatolia and the decentralized nature of governance in both Armenian Cilicia and in Ayyūbid Syria, as I have argued elsewhere.[14]

The second point concerns mass production and markets. Zeuxippus ware from the Byzantine world, luster ceramics from the Islamic world, and proto-Majolica ceramics from Italy are still considered by most art historians to be luxury wares. However, there is such a quantity of them, so many examples of these ceramics have been found in nonelite archaeological settings, and so many centers of production and imitation have been recently uncovered or posited as the result of chemical analysis, that it is impossible to consider them as such.[15] Qualitative factors such as hardness of glaze and fineness of drawing may place PSS ceramics below the finest medieval ceramics such as those mentioned. However, as vessels such as the Dumbarton Oaks amphora (figs. 12.5 and 12.6) indicate, the artistic distance is not so great as to be unbridgeable. Decentralization and imitation provide the key to this issue, with Cyprus probably playing a key role in the imitation and dissemination of both "authentic" and "imitation" Zeuxippus, PSS, and "early thirteenth-century Aegean" ceramics. Complete analysis of ceramics from medieval Cypriot sites like Saranda Kolones will go a long way toward establishing this role.[16]

The third issue raised by these peripatetic cupbearers is, appropriately enough, that of taste, and with it cultural allegiance. The Mediterranean-wide distribution

Fig. 12.3. Drawing of a sgraffito bowl base with a representation of cupbearer, Kinet, late thirteenth century (KT #7373). Light brown/orange fabric. Cream slipped with incised decoration. Clear glaze with brown and green highlights around figure (not shown in drawing). Base diameter = 7.5 cm.

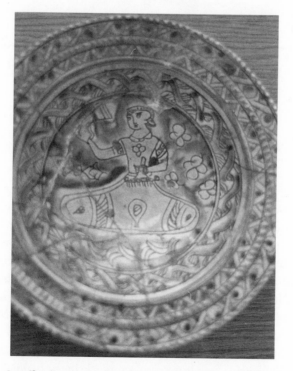

Fig. 12.4. Sgraffito bowl with representation of cupbearer: Adana Museum (Accession #BY1)

Fig. 12.5. Drawing of the Dumbarton Oaks amphora (D.O. Accession #67.8). Drawing by Karen Rasmussen.

of PSS ceramics, like the medieval Mediterranean koiné that makes portable objects as diverse as ivories, silks, and metalwork so difficult to attribute, can certainly be tied to the fluid Italian-dominated world of maritime commerce. But a commercial argument only carries the distribution of these objects so far. The ubiquity and mutual resemblance of our exemplary cupbearers bespeak standardization that goes together with mass production and export. The presence of kilns and cupbearers in *port* cities in the northeast corner of the Mediterranean denotes that that product was largely Italian-borne and the market destination Christian.[17] But the cupbearer bowls found in the citadel at Hama demonstrate that this kind of figural ceramic was also acceptable in the Islamic world.

Fig. 12.6. Drawing of the Dumbarton Oaks amphora (D.O. Accession #67.8).
Drawing by Karen Rasmussen.

Indeed, since Lane's 1938 publication of the Port Saint Symeon finds, the pose, subject matter, and garb of the cupbearer has been labeled "Islamic," "oriental," or "orientalizing," without explanation.[18] In the tug-of-war over cultural allegiance in the crusader states, do these ceramics, which are first found in early-thirteenth-century Christian contexts, bespeak Islamic cultural influence due to the isolation of Antioch and Armenian Cilicia from Acre and other centers of Frankish culture? Do they indicate mounting Levantine Christian influence over the material culture of the states of Outremer? And, remembering that our cupbearers were found in both "crusader" and "Armenian" contexts, can we talk about a difference be-

tween the material culture of Antioch, the crusader capital, and Sis, the Armenian capital in the thirteenth century? In terms of Kinet, can the archaeologist tell the crockery from a Templar table from that of an Arab Christian or an Armenian? These issues are paramount not only in determining cultural allegiance, but also the governance of the Latin states, with their demographically tiny ruling elites.

"High" and "Low" or Religious and "Secular" Artistic Traditions

The study of the visual culture of the world of the crusades has traditionally focused on religious objects. Like the writing of history, the making of art was largely controlled by the Church or was ecclesiastically related. Some scholars of the (ecclesiastical) art of medieval Armenian Cilicia have pinpointed varieties of Byzantine and Italian models for painters and illuminators of manuscripts and icons.[19] Similar efforts to distinguish "influence" on the art and culture of Armenian Cilicia from its more proximate Islamic neighbors have been few and far between.[20] Thus, while one prominent scholar of Armenian art noted a Chinese dragon on the silk lining of a depiction of the robe of Bishop John, brother of King Hetoum I, in a manuscript dated 1289, its exotic nature seems to have rendered it immune from larger issues of cultural borrowing from or affiliation with non-Christian societies. In the same opus, the striking similarity of a pattern on a silk robe in a 1262 depiction of Prince Levon and his bride to coinage from the neighboring Rum Seljuk state was ignored. The fact that the Seljuk sultan who issued the coinage, Giyaseddin Keyhüsrev II, had an Armenian mother through whom he was related to the highest noble family in Armenian Cilicia, and that he himself was married to a Georgian princess active in Christian patronage, has not helped bridge a seemingly insuperable confessional and cultural divide.[21] Nonreligious imagery, such as the lion and sun on the coinage and wedding dress, is harder to pin down, and because it does not relate to the "high" artistic—for which read, religious—tradition of the culture, it is discounted or ignored.[22]

The figural ceramics from Kinet and other sites help address issues of a *totality* of figural representation in the Kingdom of Armenian Cilicia and the Principality of Antioch. They adduce new evidence to a familiar debate concerning the nature of the nonreligious artistic culture of eastern Mediterranean Christian societies. This debate has centered on the early assumption of images and motifs from Sasanian Iran along with the baggage of Late Antiquity or "Islamicizing" trends that seem to surface as early as the Macedonian dynasty in the tenth century.[23]

Imagery as Anthropology

In 1098, during the First Crusade when the French count Baldwin of Boulogne gained co-regency with Toros, the Armenian ruler of Edessa, he did so by a public adoption ceremony in which the two donned the same shirt. This ritual was then repeated with Baldwin and Toros's wife.[24] To my knowledge, this ceremony of adoption is not Byzantine, and seems to be an Armenian tradition practiced also in wedding ceremonies, where it was commemorated in depictions on sgraffito ceramic vessels. In fact, the depiction is widespread enough on ceramics of medieval Cyprus for these vessels to be called "wedding bowls."[25] The rite, as well as its depiction, may have been adopted by Lusignan Cyprus from Armenian Cilicia, if its presence on a thirteenth-century Cilician jug in Dumbarton Oaks is any indication (fig. 12.7). This jug shows a couple sharing a garment and accompanied by animals signifying fertility and happiness as well as other scenes that may depict wedding celebrations.[26] This Cypriot connection reminds us of the close links between the courts and ports of these two kingdoms in the thirteenth and fourteenth centuries, bonds spreading far beyond the practice of intermarriage and alliance between royal families.

More than the marriage of Levon depicted in the miniature of the Jerusalem Gospel, the anonymous marriage celebrated or commemorated by a contemporaneous jug allows us to link the rarefied circles surrounding the Armenian king in Sis or the patriarch in Hromkla with the legion of figural ceramics produced at every town in Cilicia and the Principality of Antioch. I am not proposing a link between separate "high" and "low" traditions; rather a rationale for the production of figural ceramics: first, as opposed to the vast majority of sgraffito ceramics that are not figural and, second, as opposed to vague invocations of "market" destinations.

Since examples of the cupbearer bowls were found in late-thirteenth- or fourteenth-century levels inside the citadel of a central Syrian city, most patently there was a polyvalence to much of the figural imagery on PSS ceramics, the majority of which consist of birds, just as the geometric and vegetal interlace speak to different constituencies alike. More strikingly, it is evidently too easy to talk of blazon-like depictions of crosses in these bowls as intended solely for a "Frankish market," since a PSS bowl with shield-inscribed cruciform decoration was excavated in the royal Seljuk palace at Kubadabad. "High" art parallels exist, of course, for this coincidence of Christian imagery and Islamic context, most notably in late Ayyūbid metalwork. Islamic imagery is also found in a Christian royal context in Lusignan Cyprus.[27]

Instead, the Dumbarton Oaks jug (fig. 12.7) gives us an idea linking social prac-

0 5 cm

Fig. 12.7. Drawing of the Dumbarton Oaks jug (D.O. Accession #58.92). Drawing by Karen Rasmussen.

tice with ceramic production, an idea of occasion and imitation. If Cypriot potters were to imitate and popularize an Armenian Cilician tradition, then can we not think of local potters creating their own commemorative commissions for other occasions? To give other potential examples of this practice: at Kinet, a PSS sgraffito bowl has been found in late-thirteenth- or early-fourteenth-century levels that bears the depiction of a mounted knight in chain mail grasping a shield and reins (fig. 12.8). This kind of heraldic depiction on ceramics has been recovered elsewhere in the greater crusader arena, including Port Saint Symeon.[28]

From an earlier, early-thirteenth-century level at Kinet come fragments of another glazed ceramic vessel that also depicts fully outfitted warriors (fig. 12.9). Un-

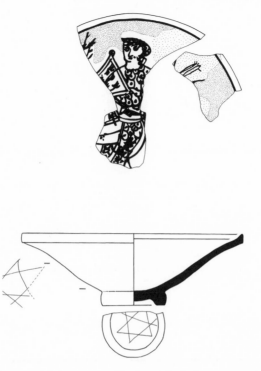

Fig. 12.8. Drawing of polylchrome sgraffito bowl depicting mounted knight with shield, Kinet, late thirteenth or early fourteenth century (KNH #144). Brown fabric with cream slip and incised representation under green glaze with brown accents. Rim diameter = 24 cm.

like the sgraffito bowl, these unusual figures, to my knowledge unique in the medieval eastern Mediterranean, are freestanding: tiny helmeted foot soldiers grasp broadsword and shield. The material used in this vessel is the red clay of brittle "frying pans" found throughout the medieval Levant, a qualitative step down from sgraffito. However, the very fact of a tradition of depicting warriors may have spurred the production of this local piece in commemoration of a particular person or battle. To my mind, decentralized production contributed an intimate social dimension to the iconography of medieval ceramics, bringing potters of glazed ceramics into contact with many segments of the population in many regions. Another potential example of a vessel with a commemorative function is a bowl in the Adana Museum said to come from Misis (fig. 12.10). Its celebratory, perhaps personal, iconography merits closer study.[29]

My arguments concerning PSS ceramics can be summarized in four basic

Fig. 12.9. Drawing of ceramic figurines of warriors attached to a vessel, Kinet, early thirteenth century (KNH #146). Brittle reddish brown fabric slip painted with cream slip and glazed with clear glaze. Length of fragment depicted = 21.5 cm.

points. First of all, they, along with other fine, glazed ceramics from medieval Islamic or Christian societies, were not luxury items produced and consumed mainly in major urban centers. Second, as nautical and land-based archaeology have demonstrated, PSS ceramics, along with other glazed ceramics, seem to have been a major item of trade, and most of their production and international distribution argue for specifically maritime trade.[30] But the very multiplicity of production sites meant that inland distribution was also possible. Although breakage rates were, of course, higher in the overland caravan carrying trade, PSS ceramics have been found at inland Islamic sites as scattered as Kubadabad, west of Konya in central Anatolia, Samsat in the northern Jazira, Hama, Qal'at al-Ja'bar, and other sites in inland Syria.[31]

Third, this production is not directly imitative of Islamic pottery. There are no contemporaneous Islamic ceramics with similar depictions of cupbearers or any of the other figural or nonfigural decoration that form the chief subject matter of these bowls.[32] If this were indeed simply a ceramic tradition imitating Islamic art, as most would have us believe, why did the major export markets of this ware, with allegedly Oriental Islamic figures, seem to have been Occidental Christian societies?

Fourth and finally, alongside a commodity-based argument for the standardization of production, I would like to propose an anthropological one. According to this argument, a portion of the statistically negligible number of all glazed

Fig. 12.10. Polychrome sgraffito bowl in Adana Museum said to come from Misis
(Accession #BY3)

sgraffito ceramics that bear figural decoration can be connected with ritual, be it gifting, weddings, baptisms, or other celebrations or rituals of the social order.

Heraldry and Astrology

The Dumbarton Oaks amphora (figs. 12.5 and 12.6) constitutes a good point of departure for a consideration of taste and subject matter. Since Lane's publication of the Port Saint Symeon finds, if not earlier, the depiction of composite beasts on medieval ceramics from Syria and Cilicia has been labeled merely grotesque or fantastical, while similar depictions on Aegean sgraffito bowls have been related directly to either Greek myth or epic, in the case of creatures like the centaur or Akritas-like warriors, or, paradoxically, outside Islamic influence.[33]

A recent study of another kind of long-distance trade at this time in the Mongol Empire provides a good summary of issues of "influence." In this work, Thomas Allsen argues that the act of borrowing, or "coming under the influence," is not a passive one.[34] In discussing PSS ceramics, I, too, would like to restore

the active element to this act. Part of this animation of the act of borrowing is the realization that the thing, or image, or design borrowed corresponds to a particular aspect of the society that is borrowing it. Something that does not fit into a social receptor is rejected. This idea restores a social dynamic to the act of borrowing, or the mystifying "influences" in accounts of Byzantine, Islamic, and crusader art that blow from east to west like so many bouts of "influenza": from the Orient, (culture-debilitating) illness.

This argument also centers on modes of presentation. Most of the figures on medieval sgraffito ceramics are presented in a heraldic fashion, either *regardant* or *passant.* Just as significant is the fact that the vast majority of scenes is composed of single figures. Is there an implied narrative in these figures, as one scholar has argued concerning some contemporaneous Iranian ceramic vessels and tiles?[35] In the case of the Dumbarton Oaks amphora, I do not think so; I would argue for viewing the confrontation or procession of the composite figures on this vessel as a response to its circular form rather than any narrative function. If there is any epitomization here, it is of greater cycles of astrological depiction, but images conflate as much as they epitomize.

Creatures similar to those on the Dumbarton Oaks amphora can be found on the ceramics from Kinet and Port Saint Symeon. These and others argue for the pervasive presence of astrological imagery on medieval sgraffito ceramics from Antioch and Armenian Cilicia. The fantastic composite beasts can be seen as astrological symbols, with the centaur/cupbearer as a composite of representations of Sagittarius and Aquarius and the confronted, winged human-headed felines as combinations of moon and sun figures. The numerous parallels to be made with contemporaneous Islamic metalwork, coinage, silks, and architectural decoration do not necessarily argue for direct appropriation from neighboring Islamic realms. The visual universe of the inhabitants of Kinet or other towns of the region would have included these astrological representations in visual validations of elements of their society alongside representations of valor and/or chivalry and marriage, and symbols of Christian faith. This combination is common and not mutually exclusive. The finest manufactured artifact found so far at Kinet demonstrates this. It is a fragment of an ivory comb from late-thirteenth- or early-fourteenth-century levels with a feline *passant* and crosses (figs. 12.11 and 12.12). While the feline is not necessarily astrological, it does belong to a different referential system than the cross. Similar combinations of heraldic and religious imagery are common on contemporaneous Antiochene and Armenian Cilician coins.

The figures on the Dumbarton Oaks amphora speak to multiple meanings and figurations. The two confronted composite beasts are presented in a heraldic man-

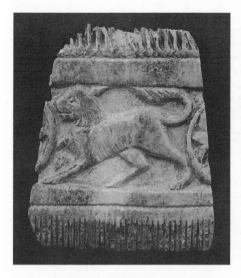

Fig. 12.11. Ivory comb fragment (KNH #720), Kinet, late thirteenth to early fourteenth centuries, obverse, incised decoration depicting feline *passant* between two crosses. Photo: Tuğrul Çakar.

Fig. 12.12. Reverse of fig. 12.11, showing inscribed incised cross

ner. Their crescent moon-shaped wings recall lunar symbolism common on coins of this period and objects like a ceramic fountain head from thirteenth-century Syria. In addition to contemporary representations of Sagittarius and the cupbearer, the spotted bodies of the centaur and feline are reminiscent of another composite creature first depicted in this era, the Prophet Muhammad's human-headed steed, Burāq. A depiction of Burāq in an Ilkhanid Mongol manuscript dated 1314 shows her with an animated tail. A contemporaneous astrological manuscript, produced in central Anatolia between 1272 and 1273, depicts a griffin very much that on the Dumbarton Oaks amphora. In this manuscript, this figure is called a *djinn* of the appearance of the passage of the sun from Aquarius to Pisces. The miniatures of this manuscript promiscuously mix Byzantine, western European, and Islamic models.[36] This kind of conflated or recombinant meaning is a natural byproduct of the very ubiquity of production and consumption of these vessels. In this respect the cupbearer, too, can be seen as a simple terpnopoietic (pleasure bearing) figure, or a representation of a comely youth, but one that also bears associations with both the astrological figure of Aquarius and the common depiction of monarchs bearing cups in contemporaneous Islamic societies.[37]

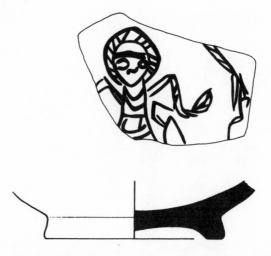

Fig. 12.13. Monochrome sgraffito bowl base with representation of Scorpio, Kinet, early fourteenth century (KT #11345). Orange fabric with lime inclusions. Interior, cream slip with incised decoration under dark green glaze. Base diameter = 8 cm.

Astrological imagery, I would argue, was part of a series of polyvalent systems representing the celebration and validation of the powers of rule, fate, and faith in all medieval Mediterranean societies. The heraldic mode of depiction noted above has its roots in this cultural koiné. Those Kinet sgraffito ceramics that depict astrological themes—representations of Cancer and Scorpio (figs. 12.13 and 12.14)—limit the scene to single figures, part of the epitomized or heraldic mode of presentation found in Byzantine, Anatolian, Egyptian, and Levantine medieval ceramic traditions alike.[38] A heraldic mode of presentation is not limited to PSS or Aegean figural ceramics: it is also found in simple charge ceramics found at 'Atlit, Port Saint Symeon, Kinet, and elsewhere in the Levant.

Many scholars are happy to argue against a non-Western origin to the European science of heraldry. They correctly note that this allegiance is genealogical in the West.[39] This tradition is in contrast with the ostensibly first manifestation of heraldic symbolism in the Islamic world: the Mamluk dynasty, which arose from the Ayyūbid dynasty in the middle of the thirteenth century. In the Mamluk system, blazons are only occasionally hereditary, and usually represent office. Despite the prevalence of opinion supporting the existence of two different, separate heraldic systems, I would like to emphasize that in the thirteenth century the Frankish and Mamluk traditions were not the only (quasi- or proto-) heraldic systems operative.

Fig. 12.14. Polychrome sgraffito bowl with representation of Cancer, Kinet, late thirteenth century (KT #7763/7921). Light brown fabric cream slipped and glazed to line on exterior. Interior incised decoration splashed with brown and dark green on clear light green glaze. Rim diameter = 22.5 cm.

In order to illustrate this, I would like to support my discussion of the emblematic mode of depiction above by returning to the Seljuks of Anatolia. As discussed above, the early-thirteenth-century Seljuk sultan Alaeddin Keykubad used both the color crimson and the double-headed eagle as his personal coat of arms, fabricating silks with his name and emblem. His son did the same with the lion and sun image, which he had displayed on his coinage and buildings and, if my surmise is correct, on silks as well. The wedding silk used by Prince Levon may demonstrate another instance of the passing of valuable objects from court to court. One Seljuk tent was given by the king of Armenian Cilicia to King Louis IX of France while he was on Cyprus in 1248.[40]

Heraldic imagery was not confined to figural/astrological imagery in any system. In the art of the Seljuks, the same simple charges (also called "ordinaries") found on Frankish, Ayyūbid, and Mamluk blazons can be found juxtaposed with devices, writing, figures, and *tamghas*.[41] Seljuk coins and building inscriptions bear

Fig. 12.15. Polychrome sgraffito bowl with representation of rosette. Orange fabric. Interior: cream slip with incised design under clear glaze. Design elements splashed with diluted brown and green glaze in such a fashion to form two crosses from petals of the rosette, one brown, one green (not shown on drawing) (KT #11476), late thirteenth century. Base diameter = 7.5 cm.

the same knotted *tamgha* design or rosette and mottos. Writing, figural imagery, abstract design (and color, although that could not be duplicated on ceramics) co-exist as validators of the realm.

Examples from the Seljuk domain illustrate the differing valences of astrological figural and nonfigural imagery, its participation in a heraldic mode of depiction that would have been found on banners, tents, walls, and gates, and its association with the ruling dynasty. Astrological and heraldic meaning and depiction overlap in Seljuk Anatolia, and I would argue for a similar cultural weight for the imagery in Armenian Cilicia, if not Antioch as well. The most famous example of this kind of astrological-cum-heraldic imagery from Armenian Cilicia is the early-to mid-thirteenth-century relief above the entrance to Yilan Kalesi.[42] But PSS ceramics from Kinet and PSS also provide examples of overlap between systems of representation, both modal and cultural.

Two examples recovered from Kinet (figs. 12.15 and 12.16) depict the rosette and knot, the two most widespread emblems, found in all these contexts. Rosette and knot emblems found in royal Seljuk contexts, on Armenian royal inscriptions, Mongol coins, Ayyūbid and Mamluk ceramics and clothing, and on crusader coins, caparisons, and other objects can also be found on PSS ceramics.[43] The

Fig. 12.16. Sgraffito bowl with representation of knot *tamgha,* Kinet, early fourteenth century (KT #12214). Orange fabric with lime inclusions. Interior: cream slip with incised design under clear glaze. One knot roughly infilled with brown glaze and one with green (not shown on drawing). Base diameter = 7.5 cm.

Armenian-Mongol alliance may provide a historical justification for this, but I would prefer to argue for a polyvalent meaning in which the context of an object gave cultural meaning to a rosette—as a blazon, astrological sign, historic referent (similar symbols would have been present on the ruins of antiquity found at the time), or a knot pattern, for which cultural antecedents can be found in all eastern Mediterranean cultures.

In this context, figural and nonfigural, religious and nonreligious imagery are all found together on a widely produced and distributed type of ceramic. Crosses, *tamgha*s, astrological imagery, and heraldic imagery are given equal prominence. A very similar situation would have applied in contemporaneous Syria. The ceramics from Danish excavations at Hama show a similar mix of blazon-like heraldic patterns (figural and nonfigural), astrological imagery, and excerpted scenes of cycles of princely privilege.

The biggest difference between the totality of imagery presented at Hama and that at Kinet, Port Saint Symeon, or Antioch, is the prevalence of Arabic writing.

The glassware at Hama, especially, bears long passages of titles of anonymous rulers. The extensive use of pseudoepigraphic decoration on the ceramics from Ayyūbid and Mamluk Syria *and* Antiochene and Cilician ceramics underscores the polyvalence of the imagery discussed above. That which could bear apotropaic or talismanic meaning for a user of the Arabic script (Muslim or Christian) could be seen as simple decoration by a consumer who knew the Latin alphabet. As for the use of Arabic titles on glassware, the employment of standardized titulature can be seen as another aspect of the proliferation, willy-nilly, of signifiers of power and privilege on portable objects in the heady days of the commercial boom of the thirteenth century.

Physical and Cultural Proximity

The line of reasoning I have followed in this essay parallels that implicit in a recent book concerning the twelfth-century Kingdom of Jerusalem. In it, geographer Ronnie Ellenblum extrapolates an allegiance between Latin and Levantine Christians from dense settlement patterns of Franks in areas around Jerusalem, Nablus, and Acre, largely populated by local Christians.[44] I would expand Ellenblum's geographic and demographic allegiance into the cultural domain. By the thirteenth century, at least in the northern tier, the material culture of Latin and Levantine Christians on an archaeological level is indistinguishable. Not only Armenians participated in this "fantastic," "hybrid" cultural creation, but also Arabic-speaking Christians more prominent in the southern tier states of Outremer. Only two bowls, one from Port Saint Symeon, the other presumably from Antioch, have the Arabic word for parrot written below the depiction of (very dissimilar and very un-parrot-like) birds,[45] perhaps demonstrating the ethnicity of at least some of the PSS potters. Otherwise, the archaeological record is silent concerning the ethnicity of the inhabitants of settlements like Antioch, Port Saint Symeon, and Kinet.

In this essay, I have tried to suggest multiple meanings and cultural valences for the figural ceramics of the Kingdom of Armenian Cilicia and the Principality of Antioch. Together with the ceramics of Cyprus and the Aegean, Syria, and Anatolia, they share a heraldic or emblematic mode of representation and subject matter that included astrological and other systems. I have linked the subject matter of the figural ceramics to both export markets and local consumption and practice. Ethnic affiliation is not expressed save in two words scrawled in Arabic, which itself is as enigmatic as the birds represented. But one thing is certain: the figural ceramics of Antioch and Cilicia did not parrot Islamic art. They created a distinct taste in the fluid and profitable world of thirteenth-century commerce, pertain-

ing to, but distinct from, objects in allied media and from allied and inimical neighboring states. They were far from passive transmitters of wealth from East to West. Despite their small size, polities like the Principality of Antioch and the Kingdom of Armenian Cilicia, and within them ports like Kinet, actively manufactured a variety of goods for local consumption and for export. The cupbearer is particularly suited to the task of celebrating and encouraging consumption, of these bowls and their contents.

Notes

1. See Arthur Lane, "Medieval Finds at Al Mina in North Syria," *Archaeologia* 87 (1938): 46, for the term *Port St. Symeon ceramics* in connection to the thirteenth-century sgraffito ceramics found there.

Support for the preparation of materials illustrated in this chapter came from Georgetown University. The site of Kinet, which yielded many of the ceramics discussed here, is being excavated by a team of archaeologists from Bilkent University, Ankara, Turkey, under the direction of Prof. Marie-Henriette Gates. The author is director of medieval operations at Kinet, whose excavation is supported by Bilkent University, Georgetown University, the Fondation Max van Berchem, The Tarbell Foundation, and other donors. I would like to thank Prof. Gates, Stephen Album, Lee Avdoyan, Veronica Kalas, and Stephen Zwirn. This essay was completed in December 2000.

For Kinet excavations, see Marie-Henriette Gates, "1997 Archaeological Excavations at Kinet Höyük (Yeşil-Dörtyol, Hatay)," *20. Kazi Sonuçlari Toplantisi,* vol. 1 (Ankara, 1999), 259–81; idem, "1998 Excavations at Kinet Höyük (Yeşil-Dörtyol, Hatay)," *21. Kazi Sonuçlari Toplantisi,* vol. 1 (Ankara, 2000), 193–208. Since this essay was completed, the following article has appeared: Scott Redford, Salima Ikram, Elizabeth Parr, and Timothy Beach, "Excavations at Medieval Kinet, Turkey: A Preliminary Report," *Journal of Ancient Near Eastern Studies* 38 (2001): 59–139.

2. Denys Pringle, "Pottery as Evidence for Trade in the Crusader States," in *The Italian Communes in the Crusading Kingdom of Jerusalem,* ed. Gabriella Airaldi and Benjamin Kedar (Genoa, 1986), 454 for examples found in Pisa, 458–59 and pl. 1 for Levantine distribution. In this essay, I employ the conventional designation of Port Saint Symeon ceramics even though one of my theses is that PSS sgraffito ceramics were produced throughout the region, and not just at the port of Antioch.

3. Hansgerd Hellenkemper, "Das wiedergefundene Issos," in *Aus dem Osten des Alexanderreiches,* ed. J. Ozols and V. Thewalt (Cologne, 1984), 43–50.

4. This refounding may be associated with the Templars, who, at various times, built and manned castles in the region of the Amanos mountains. A document dating to a period after 1215 records the granting of the revenues of the port of "Calamella" for two years to the Hospitallers by the king of Armenia. The crusaders had associated

this region with the name Canamella/Calamella since the time of the First Crusade. For the identification of this site with Canamella, see Claude Cahen, *La Syrie du nord* (Paris, 1940), 150. Hansgerd Hellenkemper and Friedrich Hild, *Neue Forschungen in Kilikien* (Vienna, 1986), 104–8, assuming that the geomorphology of the two sites was the same in the medieval period as it is today, argue that Canamella be identified with Payas. King Levon may have returned the site to the Templars following 1216, when his great-nephew assumed the throne of Antioch, as he allowed the Templars to reoccupy some of their former castles elsewhere at the time. The Templars are recorded as being in possession of the site by Ibn al-Furat in 1266. For the grant to the Hospitallers, see Jonathan Riley-Smith, "The Templars and the Teutonic Knights in Cilician Armenia," in *The Cilician Kingdom of Armenia,* ed. T.S.R. Boase (New York, 1978), 107–8.

5. See Guy Le Strange, *Palestine under the Moslems* (reprint, Beirut 1965), 455; Georgette Cornu, *Atlas du monde arabo-islamique à l'époque classique* (Leiden, 1985), 13. Yāqūt, *Mu'jam al-Buldān,* vol. 2 (Beirut, n.d.), 68, is the last of these, and he, too, notes the export of timber by sea (to Egypt) as the activity of the port town (furḍa), which he refers to simply as "Tīnāt."

6. The Deli Çayı is an unstable river, classified as a spasmodic torrent. The study of its changes of course, along with the rest of the geomorphology of the area surrounding Kinet, are being undertaken by a team under the direction of Timothy Beach of Georgetown University and Sheryl Luzzadder Beach of George Mason University. According to Prof. Beach, another possibility is that the river's medieval course was far different from its present one.

7. See 'Izz al-Dīn ibn Shaddād, *Al-A'lāq al-Khaṭīra,* ed. and trans. Anne-Marie Eddé-Terrasse as *Description de la Syrie du Nord* (Damascus, 1984), 100, for a brief description of "al-Tīnāt." The destruction of the site during the Mamluk invasion of Armenian Cilicia in 1266 is mentioned by Ibn Furāt in his *Tārīkh al-Duwal wa'l Mulūk;* see U. and M. C. Lyons, eds. and trans., *Ayyubids, Mamlukes, and Crusaders: Selections from the Tarikh al Duwal wa'l Muluk of Ibn Furat,* 2 vols. (Cambridge, 1971), 1:99, 217; 2:126.

8. See A.H.S. Megaw, "An Early Thirteenth-Century Aegean Glazed Ware," in *Studies in Memory of David Talbot Rice,* ed. Giles Robertson and George Henderson (Edinburgh, 1975), 34–45, for the first naming of this ceramic and its attribution to Greece. Boas, below note 16, argues for a Cypriot imitation.

9. For the importance of commerce in this area at the time, see Eliyahu Ashtor, *Levant Trade in the Later Middle Ages* (Princeton, 1983), 43–44 and 55–57; Paul Bedoukian, *Coinage of Cilician Armenia* (New York, 1962), 25–42; and W. Heyd, *Histoire du commerce du Levant* (reprint, Leipzig, 1936), 73–92.

10. This production at Kinet is associated with the last two phases of medieval occupation in the late thirteenth and early fourteenth centuries. I am indebted to Prof. Jennifer Tobin for showing me medieval sgraffito sherds and kiln furniture in the area north of the bath building at Epiphaneia. The presence of monochrome and polychrome sgraffito sherds (but not kiln furniture) here was noted by Hellenkemper and Hild, *Neue Forschungen,* 103.

11. Friedrich Hild and Hansgerd Hellenkemper, *Tabula Imperii Byzantini,* vol. 5, *Kilikien und Isaurien* (Vienna, 1990), 358, fig. 312. Hild and Hellenkemper publish kiln wasters in the Adana Museum that were found at Misis and claim to have discovered a kiln there, too.

12. Frederick Waagé, ed., *Antioch-on-the-Orontes,* vol. 4, pt. 1 (Princeton, 1949), 101–2.

13. For the cupbearer from Port Saint Symeon, see Lane, "Medieval Finds," 50, pl. 24, 1a. For the figures from Hama, see P. J. Riis and Vajn Poulsen, *Hama fouilles et recherches 1931–1938,* vol. 4, pt. 2 (Copenhagen, 1957), 233, figs. 804 and 805. Figure 804 was drawn and reproduced as pl. 5. Excavations in late-thirteenth-century crusader levels at Acre have uncovered a PSS bowl base with part of a representation of a cupbearer; see Edna Stern, "Excavation of the Courthouse Site at 'Akko: The Pottery of the Crusader and Ottoman Periods," *'Atiqot* 31 (1997): 56 and fig. 13, # 96. For examples from Misis in the Adana Museum, see Hild and Hellenkemper, *Tabula Imperii Byzantini,* fig. 313; and Özden Süslü, *Tasvirlere Göre Anadolu Selçuklu Kiyafetleri* (Ankara, 1989), fig. 145. Süslü, 98, fig. 147, also illustrates an example in the Erdemli Museum said to have been found in the Adana region. For the example found in Tarsus, see Gönül Öney, "Human Figures on Anatolian Seljuk Sgraffiato and Champlevé Ceramics," in *Essays in Islamic Art and Architecture in Honor of Katharina Otto-Dorn,* ed. Abbas Daneshvari (Malibu, 1982), 114–15 and fig. 1. Öney publishes this piece as "Seljuk" and the example from PSS as an example of "So-called 'Byzantine' wares that are probably Seljuk" (117). The retrieval of so many examples of the same type of ceramic from an area that was never under Seljuk control argues strongly for attribution to the region in which these pieces were found: namely, the Kingdom of Armenian Cilicia and the Principality of Antioch. The example from Kinet was uncovered in thirteenth-century levels in 1997.

14. Redford, "Medieval Ceramics from Samsat, Turkey," *Archéologie islamique* 5 (1995): 65–67; Redford and M. James Blackman, "Luster and Fritware Production and Distribution in Medieval Syria," *Journal of Field Archaeology* 24 (1997): 244–46.

15. For luster ware, see Redford and Blackman, note 14 above. For the production of Zeuxippus ware in general and especially the proliferation of "Zeuxippus-derived" ceramic production in the thirteenth century, see Stella Patitucci, "'Zeuxippus Ware' Novità da Kyme Eolica (Turchia)," *Corso di cultura sull'arte ravennate e bizantina* 42 (1995): 739ff. For the multiple production centers of proto-Majolica ceramics in southern Italy and Sicily, see idem, "La nuova ceramica dell'età federiciana: la protomaiolica," in *Federico II e l'Italia* (Rome, 1995), 111–23; and Stella Patitucci Uggeri, "La protomaiolica del mediterraneo orientale in rapporto ai centri di produzione italiani," *Corsi di cultura sull'arte ravennate e bizantina* 32 (1985): 337–402.

16. For preliminary reports on excavations at Saranda Kolones, see Megaw, "Supplementary Excavations on a Castle Site at Paphos, Cyprus, 1970–1971," *Dumbarton Oaks Papers* 26 (1972): 322–43; and John Rosser, "Excavations at Saranda Kolones, Paphos, Cyprus, 1981–1983," *Dumbarton Oaks Papers* 39 (1985), 81–97. For preliminary analysis concerning the mediatory/imitative role played by Cypriot potters in the thir-

teenth century, see Adrian Boas, "The Import of Western Ceramics to the Latin King-dom of Jerusalem," *Israel Exploration Journal* 44 (1994): 118ff. On page 120 Boas argues for a Cypriot-produced "Pseudo-PSS ware" based on his chemical analysis. He also maintains that his analysis revealed that the same clays were used in the production of local Zeuxippus and thirteenth-century Aegean ceramics. As early as 1968, Megaw argued for a thirteenth-century Cypriot production of Zeuxippus derived ceramics; see idem, "Zeuxippus Ware," *Annual of the British School at Athens* 63 (1968): 86. Demetra Papanikola-Bakirtzis, "La céramique à glaçure dans la Chypre du Moyen-Age," in *La France aux portes de l'Orient Chypre XIIème–XVème siècle,* ed. Jacques Charles-Gaffiot (Paris, 1991), 169, notes that three centers of medieval glazed ceramic production have been found in Cyprus, one on the west coast, one on the east coast, and one on the north coast, all near major ports.

17. Late-thirteenth-century floor tiles from the Benedictine Abbey of St. Peter in Chertsey in Surrey, England, also depict seated cupbearers remarkably similar to this figure. These tiles are on display in the Victoria and Albert Museum, London, as well as at the Chertsey Museum, Chersey, Surrey. See http://www.surreyweb.net/StPeters/history/index.htm.

18. Lane, "Medieval Finds," 50, "The oriental element is most marked in the small bowl with a squatting human figure, of indeterminate sex. The personage wears a tur-ban, a collar resembling a bow-tie, a short caftan, and trousers; round the arm is bound an ornamental ribbon (*tiraz*)." Boas, "The Import of Western Ceramics," 107–8, typ-ifies PSS ware as follows: "Although perhaps not manufactured by Frankish potters (there is an Arabic inscription on one vessel from al-Mina and *Islamic subject matter on some examples* [emphasis added]), occasional examples of Christian motifs leaves [*sic*] no doubt that this class of ware was intended for the Frankish market." In describing the Dumbarton Oaks amphora (fig. 12.5), Nancy Ševčenko ("Some Thirteenth-Century Pottery at Dumbarton Oaks," *Dumbarton Oaks Papers* 28 [1974]: 360) writes that "the Franco-Syrians were known for their exotic coinage and dress, and our amphora is yet another witness to the orientalizing taste which prevailed in the Principality of Antioch during its last half-century of existence."

In nearby Cappadocia, for instance, donor portraits of the eleventh century con-sistently depict the Byzantine aristocracy there in turbans and kaftans; see Thomas Mathews and Annie-Christine Daskalakis Mathews, "Islamic-Style Mansions in Byzantine Cappadocia and the Development of the Inverted T-Plan," *Journal of the Society of Architectural Historians* 56 (1997): 310–11. If the aristocracy of the Eastern Christian world shared a style of dress with the Islamic elite, and this style of dress is depicted on PSS ceramics, it is hard to argue that it is Islamicizing; surely its allure or "selling point" was as an index of elite culture.

19. See, for example, Anne Derbes, "Siena and the Levant in the Later Dugento," *Gesta* 28 (1989): 190–204; Annemarie Weyl Carr, "Icon-Tact: Byzantium and the Art of Cilician Armenia," in *Treasures in Heaven Armenian Art, Religion, and Society,* ed. Thomas Mathews and Roger Wieck (New York, 1998), 73–102.

20. A notable exception is Priscilla Soucek, "Armenian and Islamic Manuscript

Painting: A Visual Dialogue," in *Treasures in Heaven,* ed. Mathews and Wieck, 115–31, although the scope of this article is limited to manuscript illustration and some architectural decoration and mainly concerns Armenian-Mongol relations, not those with Syria or Anatolia.

21. See Speros Vryonis, "Another Note on the Inscription of the Church of St. George of Beliserama," *Byzantina* 9 (1977): 13–22, for a consideration of the career of this Princess Tamar.

22. Sirarpie Der Nersessian, *Miniature Painting in the Armenian Kingdom of Cilicia from the Twelfth to the Fourteenth Century,* 2 vols. (Washington, D.C., 1993), 1:154–55, 158; 2: fig. 645 for the portrait of Bishop John, fig. 640 for the double portrait of Prince Levon and his wife Keran. Der Nersessian goes out of her way to emphasize Italian and Armenian connections with these and other silks depicted in these portraits, while virtually ignoring Islamic examples.

The emblem of Alaeddin Keykubad, Seljuk sultan and father of Giyaseddin Keyhüsrev II, was a double-headed eagle, and this was depicted on Seljuk crimson and gold silks, the tiles of the sultan's palaces, and the city walls of his capital, Konya. Addorsed lions were also portrayed on his silks; see Gönül Öney, *Anadolu Selçuklu Mimarisinde Süsleme ve El Sanatları* (Ankara, 1978), 133, fig. 114, for an image of a silk in Berlin bearing a double-headed eagle inside a shield-shaped medallion and 134, fig. 115, for an image of a silk in Lyon bearing addorsed lions inside medallions. This latter silk also carries an inscription tying it to the reign of Alaeddin Keykubad. His son, Sultan Giyaseddin Keyhüsrev II, seems to have adopted the lion and sun as his emblem, as it is depicted on his coinage and figures on some of the buildings he erected. See Joachim Gierlichs, *Mittelalterliche Tierreliefs in Anatolien und Mesopotamien* (Tübingen, 1996), 117–18 (double headed eagle) and 119–20 (lion and sun) for the most recent summary of this issue.

As far as the silk depicted in the 1262 wedding portrait of King Levon is concerned, its representation of the lion and sun within a roundel on a crimson/purple silk leads me to posit the existence of a silk of Sultan Giyaseddin Keyhüsrev II similar to his coinage, and continuing his father's practice of producing emblematic silks. The lion and sun roundel is more evident in another portrait of Levon as crown prince; see Claude Mutafian, *La Cilicie au carrefour des empires,* vol. 2 (Paris, 1988), fig. 164. To my knowledge, no such silk has survived. Its use by Armenian royalty would not be anomalous; Marco Polo records the production of crimson silks by Greeks and Armenians in Sivas, Kayseri, and Konya, Seljuk cities very close to the Kingdom of Armenian Cilicia; see Marco Polo, *The Travels,* trans. Ronald Latham (London, 1958), 47. In addition, there were gifts exchanged between Seljuk and Armenian monarchs. It is this association of emblems with silks that causes me to propose a Seljuk connection. Otherwise, the lion and sun imagery, seemingly copied from its use on Rum Seljuk silver coinage, was widely imitated in the copper coinage of the Artuqids, Ilkhanids, and Mamluks.

23. See Redford, "How Islamic Is It? The Innsbruck Plate and its Setting," *Muqarnas* 7 (1990): 131–32, for a brief summary of this debate.

24. Steven Runciman, "The First Crusade: Constantinople to Antioch," in *A History of the Crusades.* ed. Marshall Baldwin, vol. 1 (Philadelphia, 1958), 303.

25. See, for example, Papanikola-Bakirtzis, "La céramique à glaçure," 172. Dr. Papanikola-Bakirtzis has dated the earliest Cypriot wedding bowls to the fourteenth century on stylistic grounds.

26. David Talbot Rice, "Late Byzantine Pottery at Dumbarton Oaks," *Dumbarton Oaks Papers* 20 (1966): 212–13; figs. 4 and 5. Despite discussing the depiction of "Orientals" on the vessel, the author tentatively ascribes it to thirteenth-century Greece, largely on the basis of resemblance to vessels from Corinth and Athens that allegedly depict the epic of Dighenis Akritas. Even though the subject matter is unique, complicated, and perhaps ultimately personal, in technique, shape, and decoration the closest parallels to this jug are from Cilician Armenia. The figural imagery on only one side of this vessel is depicted here; its current display precluded a complete rendering.

27. See Öney, *Anadolu Selçuklu,* 108, fig. 91, for this bowl, whose crosses are inscribed in triangular, shield-like lozenges. Boas, "The Import of Western Ceramics," 108, when describing PSS ceramics, falls prey to the tendency to ascribe anything with heraldic and/or cruciform decoration to its production for "the Frankish market." This tradition began at least as far back as C. N. Johns, "Medieval Slip-Ware from Pilgrim's Castle, 'Atlit, 1930–1," 139–40, in *Pilgrims' Castle ('Atlit), David's Tower (Jerusalem), and Qal'at ar-Rabad ('Ajlun)* (Aldershot, 1997), who unsuccessfully tried to correlate the schematic devices found on shields on PSS ceramics found at 'Atlit with known coats of arms, Frankish and Mamluk, and to attribute the ceramics to the respective periods of sovereignty. For inlaid Syrian vessels with Christian imagery, see Eva Baer, *Ayyubid Metalwork with Christian Images* (Leiden, 1989). For the art of the court of Hugh IV of Lusignan (r. 1324–59), see Carr, "Art in the Court of the Lusignan Kings," in *Cyprus and the Crusades,* ed. Nicholas Coureas and Jonathan Riley-Smith (Nicosia, 1995), 246ff., for the Mamluk basin with Arabic and Latin inscriptions praising King Hugh.

28. See Lane, "Medieval Finds," 51, pl. 24 for this bowl. "He is clothed in chainmail with *hauberk* and *chausses,* brandishes a sword (missing) in his left hand, but has no helmet or shield; from behind him appear the ends of his scabbard and, probably, the handle of his dagger. The horse is draped in starred 'housings,' with a green shoulder-band, a saddle-cloth, and an ornamental strap over the hindquarters with tassels." In short, a very exact depiction of trappings, especially the star-spangled caparison and the helmet-less knight, argues for a kind of portrait different from more generic depictions. Another Armenian or Antiochene ceramic depiction of a mounted knight out hunting has recently been displayed; see Helen Evans and William Wixom, eds., *The Glory of Byzantium* (New York, 1997), 401.

29. For this bowl, see Hild and Hellenkemper, *Tabula Imperii Byzantini,* pl. 312. It is interesting to note that the central figure in this bowl is holding an object similar to that grasped by the seated cupbearer in fig. 12.4.

30. See Véronique François, "Sur la circulation des céramiques byzantines en Méditerranée orientale et occidentale," in *La céramique médiévale en Méditerranée* (Aix-en-Provence, 1997), 235, concerning the shipment of glazed ceramics in the medieval

Mediterranean, with specific reference to the shipwrecks of Kastellorizo off south-west Anatolia and those near the islands of Pelagonnisos and Skopelos in the Aegean. All of these shipwrecks bore cargos of glazed bowls of twelfth- and thirteenth-century Aegean wares. A shipwreck with a cargo of PSS ceramics awaits its discoverer.

31. See Redford, "Medieval Ceramics from Samsat," 67, for PSS ceramics found at Samsat. Cristina Tonghini, *Qal'at Ja'bar Pottery: A Study of a Syrian Fortified Site of the Late 11th–14th Centuries* (Oxford, 1998), 60–61, summarizes the evidence for PSS ceramics found in Syria.

32. Riis and Poulsen, *Hama fouilles,* 187, illustrate a bowl (not found at Hama) de-picting a cupbearer using the underglaze painted technique. This bowl directly imi-tates imports of *minā'i* (under- and overglazed painted) ceramics from contemporary Iran in both subject matter and technique. No examples exist of this figure in sgraffito or other techniques of medieval Syrian ceramics to the best of my knowledge. In its depiction of headgear and physiognomy it also differs markedly from PSS cupbearers. In fact, Riis and Poulsen posit a local school of sgraffito production at Hama in imi-tation of PSS ceramics, not the other way around. Priscilla Soucek, in *The Meeting of Two Worlds: The Crusades and the Mediterranean Context,* ed. Christine Bornstein and P. P. Soucek (Ann Arbor, 1981), 39–41, attempts to link PSS ceramics to both earlier Egyptian-derived luster ceramics and contemporaneous underglaze painted frit ce-ramics from Syria with figural decoration. While single figures are found in both these and PSS ceramics, their style, palette, and technique are very different from PSS ce-ramics. Add to this their relative rarity, and it is hard to draw a direct connection with PSS ceramics. Lane, "Medieval Finds," 50, notes the similarity between the PSS cup-bearer and contemporary depictions on Syrian glassware. While this is true, the fact remains that these similarities derive not from copies of Islamic ceramics, but figures in other media that are extracted and reinterpreted.

33. M. Alison Frantz, "Akritas and the Dragons," *Hesperia* 10 (1941): 13, on slen-der to nonexistent evidence, linked depictions of warriors fighting dragons on twelfth-to thirteenth-century sgraffito bowls found at Athens to the epic of Dighenis Akri-tas. Declaring that "the longevity of the Greek tradition, which extends from the days of Mycenae to modern Greece, is such that we can see in it certain recurrent patterns," James Notopoulos ("Akritan Ikonography [*sic*] on Byzantine Pottery," *Hesperia* 33 [1964]: 108) took the ball and ran with it. A well-known champ-levé plate excavated at Corinth and dated to the early thirteenth century has also been consistently linked with Dighenis Akritas (although its latest commentator suggests another meaning); see Evans and Wixom, eds., *The Glory of Byzantium,* 270–71. To my mind, this plate, which shows a man and woman wearing the same garment, depicts or commemorates a wedding.

34. Thomas Allsen, *Commodity and Exchange in the Mongol Empire: A Cultural History of Islamic Textiles* (Cambridge, 1997), 101–2.

35. Marianna Shreve Simpson, "Narrative Allusion and Metaphor in the Decora-tion of Medieval Islamic Objects," in *Pictorial Narrative in Antiquity and the Middle Ages,* ed. Herbert Kessler and M. S. Simpson (Washington, D.C., 1985), argues for

"epitomized image" (136) and "abbreviated narrative significance" (140) in depictions of stories from the *Shahname* on medieval Iranian ceramics and tilework.

36. See Marianne Barrucand, "The Miniatures of the *Daqā'iq al-Ḥaqā'iq* (Bibliothèque Nationale Pers. 174): A Testimony to the Cultural Diversity of Medieval Anatolia," *Islamic Art* 4 (1991), pl. 2c for the image, and 117–18 for a discussion of the various sources for the manuscript's imagery. I disagree with the author's conclusion that the diversity of sources and styles was a conscious choice, preferring to relate it to the promiscuous borrowing between Islamic, Levantine Christian, and Frankish traditions at the time and, like the production of other works, the decentralization of artistic production that went with a multiplicity of small courts in the eastern Mediterranean in general, and, specifically in Seljuk Anatolia, within the state. The manuscript's two colophons, appropriately enough, were written in two different central Anatolian cities, Aksaray and Kayseri.

37. For the ceramic fountain figure, see Kjeld von Folsach, *Islamic Art: The David Collection* (Copenhagen, 1990), fig. 129, where this figure is dated to the late twelfth century, too early in my opinion. The other fountain figures in this series are a rooster (also in Copenhagen) and a mounted knight (in the National Museum in Damascus). Depictions of both figures are found on Kinet sgraffito ceramics. For depictions of Burāq, see Thomas Arnold, *Painting in Islam* (reprint, New York, 1965), 117–22. Arnold derives the depiction of Burāq from the sphinx. Tufted, spotted, composite creatures are represented on the ceramics of both Kinet and Port Saint Symeon. Oleg Grabar, *The Mediation of Ornament* (Princeton, 1992), 37, coined the neologism *terpnopoietic* to describe a function of a work of art.

38. For the identification of this seemingly abstract "winged" disc as a representation of the crab, Cancer, grasping the moon, see Esin Atil et al., *Islamic Metalwork in the Freer Gallery of Art* (Washington, D.C., 1985), 150. The depiction is on a metal candlestick ascribed to late-thirteenth-century Turkey, close both chronologically and geographically to medieval Kinet. However, the division of the central orb into three parts, typical of heraldry, on the sgraffito bowl serves as another example of the mixing of representational systems.

39. For example, Thomas Woodcock and John Martin Robinson, *The Oxford Guide to Heraldry* (Oxford, 1988), 4–6, following Beryl Platts's *Origins of Heraldry*, argue for a strictly European evolution of Western heraldic symbols from the civil personal mark (or seal device) through the standard to representation on the shield. William Leaf and Sally Purcell, *Heraldic Symbols: Islamic Insignia and Western Heraldry* (London, 1986), 44, maintain that Western European heraldry was becoming established by the middle of the twelfth century and employ a chronological scheme to argue for the influence of Western heraldry on later, thirteenth-century Islamic (i.e., Ayyūbid and Mamluk) usage.

40. Jean de Joinville, *The Life of Saint Louis* in *Joinville and Villehardouin Chronicles of the Crusades,* trans. M.R.B. Shaw (Harmondsworth, 1963), 200. The Armenians of Cilicia were vassals of the Seljuks of Anatolia until 1243. It is possible that silk robes of the Seljuks were obtained by the Armenian kings as part of that relation.

41. Neither the rosette nor the knot is found in the lists of medieval Anatolian *tamgha*s, which are considered to be the marks or emblems of Turkic tribes; see A. Riza Yalgin, *Anadoluda Türk Damgalari* (Bursa, 1943). However, their prevalence and prominence on Rum Seljuk and other contemporaneous Mongol and Turkic coinage and emblematic quality cause me to consider them as such.

42. See Robert Edwards, *The Fortifications of Armenian Cilicia* (Washington, D.C., 1987), 272–73 for a description of this relief, which combines a cross-legged, seated crowned monarch, fleur de lys, and rampant lions. Edwards comments on the pose of the figure in the following way: "Armenian kings sitting in an oriental fashion would not be unusual, considering that under Het'um I and his successors Cilicia frequently became a vassal of its Moslem neighbors to the north and of the Mongols." Another heraldic relief, of a man flanked by two rampant lions, is located in a similarly prominent position above the entrance to the Cilician Armenian castle of Çem, see ibid., 115; although it seems to be in reuse.

43. Fig. 12.15 is paralleled by another sgraffito bowl with a knotted design found at Port Saint Symeon; see Lane, "Medieval Finds," pl. 24, 1 B. The rosette is depicted on many Seljuk royal inscriptions and monuments, see, for example, the mihrab of the Alaeddin Mosque in Niğde (1223) depicted in Albert Gabriel, *Monuments turcs d'Anatolie*, vol. 1 (Paris, 1931), pl. 36, and Seljuk inscriptions published by Seton Lloyd and D. S. Rice, *Alanya (Alā'iyya)* (London, 1958), pls. 5c and d (rosette), 8a (knot and rosette), and 13d (rosette). A painted knotted *tamgha* appears above the entrance to the Seljuk palace at Aspendos. Both emblems are found on many issues of silver dirhams of the Rum Seljuks.

Rosettes as star/asterisks are found on the coinage of the princes of Antioch together with moons; see D. M. Metcalf, *Coinage of the Crusades and the Latin East* (London, 1995), pl. 16 for the star and crescent moon to either side of the helmeted knight on silver deniers, and page 146 for a coin bearing an emblematic "pound sign" similar to the knotted *tamgha*. Star rosettes are also found on Armenian Cilician royal inscriptions, for instance, the 1290 repair inscription to the castle of Mancınık near Kinet. This inscription is discussed in Edwards, *Fortifications*, 186, but not illustrated. Similar asterisk-like stars are depicted on the silver coinage of thirteenth-century Georgia; see, for example, Evans and Wixom, eds., *The Glory of Byzantium*, 349 for a 1230 coin of Queen Rusudan of Georgia.

Both rosettes and knotted *tamgha*s are found on the early-fourteenth-century coinage of the Ilkhanid Mongols. To my knowledge, these emblems or *tamgha*s have not been recognized as significant; Sheila Blair, "The Coins of the Late Ilkhanids: Mint Organization, Regionalism, and Urbanism," *American Numismatic Society Museum Notes* 27 (1982): 221, calls the knotted *tamgha* a "looped diamond" but does not otherwise discuss it or the rosette. Both emblems are extremely common on the metalwork and other minor arts of the Ayyūbid and Mamluk dynasties as well as dynasties farther east.

For Ayyūbid and Mamluk examples, see L. A. Mayer, *Saracenic Heraldry* (Oxford, 1933), 24–25 for the rosette; also see J. W. Allan, "Mamluk Sultanic Heraldry and the

Numismatic Evidence: A Reinterpretation," *Journal of the Royal Asiatic Society* n.s. 2 (1970): 104–5: "Rosettes are also of course used in Mamluk decoration purely for decorative purpose and this somewhat confuses their position as heraldic devices, but although we shall never know for certain what symbolism or decorative the rosette . . . had for a particular coin designer, some overtones of authority and power might be fairly assumed"; and Paul Balog, "New Considerations on Mamluk Heraldry," *American Numismatic Society Museum Notes* 22 (1977): 200–201 (for the rosette, which he rejects as an Ayyūbid blazon, while accepting it for the Mamluks). For a rosette embroidered on a piece of Mamluk clothing, see Bethany Walker, "The Social Implications of Textile Development in Fourteenth-Century Egypt," *Mamluk Studies Review* 4 (2000): 215, fig. 16.

Unlike Mayer, Balog, Allan, and most writers on this issue, I am not addressing the specific identification of emblem or blazon with office or sultan. Rather, I am broadening the argument by insisting that by addressing the presence of blazons/emblems/*tamgha*s found (a) on Christian-produced ceramics at Kinet and (b) "on thousands of pottery fragments" (Balog, "New Considerations on Mamluk Heraldry," 183) and on subroyal Mamluk copper coins (Allan, "Mamluk Sultanic Heraldry," 103ff.) we are not dealing with a precise system of heraldic allegiance/identification/production, but rather with symbols of favor and power that become part of a generalized vocabulary of auspicious images. The issue of the origins of these symbols, and the Mamluk heraldic system, has been partially addressed by Estelle Whelan, "Representations of the *Khāṣṣikīyah* and the Origins of Mamluk Emblems," in *Content and Context of Visual Arts in the Islamic World,* ed. Priscilla Soucek (University Park, 1988), 219–43, but it is too vast and varied a topic to enter into here.

44. Ronnie Ellenblum, *Frankish Rural Settlement in the Latin Kingdom of Jerusalem* (Cambridge, 1998), 283: "The impression created from the conclusions I draw in my thesis is that the distribution of [rural] Frankish settlements, their degree of intensivity, and the rate at which they were developed, is in direct proportion to the distribution, degree of intensivity, and rate of development of the local Christian settlements which still existed during the Frankish period."

I disagree heartily with Ellenblum's statement on page 286, however, in which he attributes the depopulation of Christian agriculturalists to the invasion of Turkish tribes, citing textual evidence from Anatolia for this view. For a different view of this issue based on both textual and archaeological evidence, see my *Landscape and the State in Medieval Anatolia: Seljuk Gardens and Pavilions of Alanya, Turkey* (Oxford, 2000).

45. Lane, "Medieval Finds," pls. 22 1D and 25 1. The first bowl fragment is explicitly identified as having been excavated at Port Saint Symeon; the second is complete and is listed as being in the Antioch Museum. They spell the Arabic word for parrot differently.

The Holy Icons: A Lusignan Asset?

Annemarie Weyl Carr

JONATHAN RILEY-SMITH urged contributors to this publication to pursue a paradox.[1] The late crusaders, he argued, were more fully in touch than their predecessors had been with the culture not of their European or their adopted Levantine homelands, but with the cultures of both simultaneously. This chapter seeks to understand Lusignan Cyprus in this way. It does so by studying artifacts within the contexts of their local use, not of their divergent derivations.

Such localized viewing might be exemplified by the chapel of St. Catherine, Pyrga.[2] Exit 11 on the A1 in eastern Cyprus signals both Pyrga and Stavrovouni. Pyrga is familiar to crusader historians for its tiny stone chapel, scarcely bigger than a sentry box, known today as St. Catherine's but dedicated initially to the Passion of Christ (fig. 13.1).[3] Its ribbed vaults are painted with the arms of the Lusignans, the dynasty of French kings implanted on Cyprus by the crusades. A Passion cycle on the eastern wall is dominated by a large Crucifixion in which the Lusignan king of Cyprus, Janus (1398–1432), and his wife Charlotte (+1422) are portrayed among the New Testament onlookers, kneeling at the foot of the cross with their heads at the level of Jesus' pierced feet (fig. 13.2). As king of Cyprus, Janus also wore the crown of the Kingdom of Jerusalem. Thus, his incorporation into a cycle of the events commemorated by pilgrims in Jerusalem might be seen to evoke his other kingdom, conjuring the many bonds that tied Cyprus to that kingdom's myths and catastrophes. The very palladion of the kings of Jerusalem, after all, had been the wood of Christ's Crucifixion. The continuity of Lusignan Cyprus and the crusader states on the mainland seems concretized in the paintings.

Fig. 13.1. Pyrga, Chapel of St. Catherine and view to Stavrovouni. Photo: author.

Over Pyrga, however, looms Stavrovouni (fig. 13.1). Stavrovouni, the "mountain of the Cross," is a dramatically isolated, 2260-foot peak that dominates Cyprus's southeastern littoral.[4] It is named for relics of the cross brought to Cyprus in mythic antiquity by the empress Helena. There were two of these: a large cross composed of one beam from the Good Thief's cross and one from the Bad Thief's, in which a chunk of the True Cross had been lodged; and a cruciform piece of the footrest of Christ's own cross that Helena had installed in a separate monastery in Tochni below Stavrovouni.[5] These crosses were embedded in Cypriot pride and legend already long before the crusades, and they remained focal points of identity in the new Lusignan regime. Stavrovouni itself, colonized by Benedictine monks, was a site of contentious mutual possessiveness, but it retained its preeminent symbolic status within the island and served as its dominant pilgrim attraction.[6] The Tochni relic, in turn, became a bridge between Cypriots and crusaders. Lost when its gem-studded reliquary was stolen by a Latin priest but miraculously recovered in 1340, it was welcomed by the Cypriots with a fervor that quite overwhelmed Latin clerical efforts at skepticism.[7] Forced to respond, the Latin archbishop ordered an ordeal by fire; the relic not only triumphed in the ordeal, but healed the Latin queen, Alix, of a dumbness imposed upon her three years earlier by another Orthodox holy object, the icon of Makhairas Monastery.

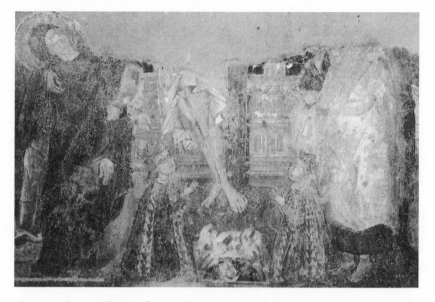

Fig. 13.2. Pyrga, Chapel of St. Catherine, east wall, Crucifixion: King Janus and Queen Charlotte at the feet of Christ. Photo: author.

In gratitude for her cure, the queen's Catholic aunt installed the cross in a new Greek church with icons, clergy, and Orthodox vestments, and it was venerated thenceforth by both communities.

Were Janus and Charlotte invoking through their portraits the long-lost Kingdom of Jerusalem? Or were they, with their eyes and faith fixed upon the footrest of the cross, invoking the protection of Cyprus's own palladia: the "mountain of the Cross" and the Tochni relic? Were their images pointing across the sea? Or weren't they rather—as the signs on the A1 still intimate—weaving a fabric of invocation across the loom of Cyprus's own landscape, binding Pyrga to Stavrovouni?

Pyrga is a useful introduction to a discussion of Cyprus in the Latin culture of the late crusades, for it shows how readily things regarded as "crusader" can turn out in fact to be local: products of a chemistry of confrontation that bound the crusaders' artifacts to the circumstances of their local setting and its own, deeply rooted traditions. Cyprus was, indeed, Jerusalem's heir. One looks to it automatically and with full justification to probe the afterlife of the crusader culture found on the mainland before 1291.[8] Cyprus had its own triumphant last crusade in 1365, led by King Peter I de Lusignan (1359–69). Peter promoted his crusade in the

courts of Europe with spectacular visits, conjuring Outremer's exotic splendor by giving gifts of gem stones and relics of the cross, and his chivalric elegance was immortalized in Guilhaum de Machaut's *La prise d'Alexandrie*.[9] But Cyprus was also a world of its own. Both people and artifacts transported from the mainland were quickly absorbed in an environment with its own long history, social patterns, and artistic traditions. The chemistry of their confrontation generated new and site-specific compounds. In the realm of art especially, it quickly becomes impossible to follow the styles and images known from the mainland, and rather than artistic forms, it is habits of use that speak to us about the textures of the cultures spawned by the crusades.

It is to an aspect of local use that this chapter turns. Its concern is with cult icons of the Mother of God. Named icons of Mary that served as the object of local and even long-distance pilgrimage are among the religious artifacts that we most readily associate with Orthodox Christianity. The period of the crusades saw the incubation of several such icon cults. They developed in Orthodox monasteries and served the Orthodox population. Yet Latin travelers, too, cite Marian icons. Thus, it is the German pilgrim, Ludolph von Suchem, around 1350, who gives us our earliest reference to an icon of Mary, painted by St. Luke the Evangelist, that he venerated in the city of Antalya on the southern coast of Asia Minor.[10] A generation after he saw it, the panel was brought to Cyprus.[11] It would soon vanish, but it lived on in the legends of other great holy images, still figuring in the eighteenth-century narrative of the icon of Mary at Megaspilaion Monastery in the Peloponnesus.[12] The miraculous icon at Megaspilaion, too, is first documented in the mid-fourteenth century, as are the icons of Soumela and Kykkos with which it traditionally shares priority as one of Luke's first three icons of Mary.[13] In Cyprus, also, the fourteenth century yields our first documentary evidence of several major Marian icon cults: the Virgin Phaneromene, the Makhairiotissa, the Kykkotissa. These fourteenth-century records are not the first reports of named cult panels—the earliest go back to the late eleventh century. But they are symptomatic of a heightened visibility of such panels in the fourteenth century. Lusignan Cyprus shares in this vitality and offers a site to examine it.

Insights into the actual formation of icon cults is rare. An exception occurs on Cyprus itself, in the case of the Makhairiotissa, the icon of Makhairas Monastery that was cited above in the story of the Tochni Cross and Queen Alix.[14] The Makhairiotissa is first documented in the *Chronicle* of Leontios Makhairas, composed in Cyprus in the 1430s. It appears, precisely, in the story of Queen Alix.[15] During a royal visit to Makhairas in around 1340, the *Chronicle* reports, Alix in-

sisted upon entering the church, off-limits to women since it was a male monastery. The icon struck her with dumbness, the dumbness that was then healed by the Tochni Cross. The icon still exists, though it is rarely seen: it is one of Cyprus's covered icons. In the late 1980s it was briefly removed for conservation. It proved to be a superb painting of the late eleventh or twelfth century.[16] As such, it is quite old enough to have belonged to Makhairas from its foundation, which occurred in 1172. We still have the monastery's original Typikon, or consuetudinary, compiled in 1210.[17] The Typikon, however, says nothing at all about a major icon of the Mother of God. A cult icon was apparently not part of the monastery's initial persona. The cult must have emerged only later—perhaps before the episode with Queen Alix around 1340, surely before the version of that episode penned by Leontios Makhairas around 1430. It emerged, then, in the Lusignan era, in much the period of the reports inventoried above. The same seems to be true of the rain-making icon belonging to the convent of the Virgin Phaneromene in Nicosia. The panel—which still bears on its frame a petition for rain—is of fourteenth-century date.[18] The same is true of the icon of Kykkos, as will be shown. These icons point to an efflorescence of cults, not only reported, but actually incubated in late Byzantium. A number of these cults appear in areas that were—like Cyprus—under alien control, and they must have responded to the conditions to which Orthodox institutions were exposed in the aftermath of the crusades: of economic exigency due to the impoverishment of their traditional patrons, and of increased religious tourism. Thus they raise the question of the relation of these cults to the presence of the Latins.

This chapter will explore the relations of Latin-rite Christians to the icons of the Greeks by examining a particular icon cult in Lusignan Cyprus, the cult of the icon of Mary at Kykkos Monastery in the Troodos mountains.[19] It will concentrate on the decades between King Peter I and Leontios Makhairas. Peter was the son of Queen Alix. He maintained a very cosmopolitan court that proclaimed its parity among the great powers of the Mediterranean by cultivating the styles of all of them: high Palaeologan, as in the paintings surrounding the crest of his brother, Jean, at Pelendri; High Gothic, as in the cathedral porch readied for his coronation in Nicosia; High Mamluk, as in the damascened bronzes of his parents.[20] Leontios Makhairas, in turn, was the contemporary and confidant of King Janus, whose artistic patronage is attested at Pyrga. The art of each king responds to the distinctive conditions of his realm. Did they respond, as well, to the icons?

In approaching the relation of Latin-rite Christians to the cult icons of their Greek-rite neighbors, historians have moved a good distance from the assumption still felt in Kurt Weitzmann's great pioneering works, that the icon remained in

some fundamental way inaccessible to Latin Christians, who always transformed it in the process of embracing it.[21] Yet we remain reticent to believe that Latin-rite Christians really could embrace the icon without remaking it. This is seen in Hans Belting's probing thesis of the Latin invention of the devotional panel, akin in form to the icon but distinct in function from it;[22] it is seen again in Jaroslav Folda's belief that the famous icon with the portrait of a donor-knight from St. Nicholas of the Roof on Cyprus cannot have been equivalent to the votive icon of St. Nicholas with the portrait of an Orthodox donor-monk inside the church (figs. 13.11, 13.12), but must have been an altarpiece, instead—once again akin in form, but distinct in function from the icon.[23] We presume this despite the fact that the West nurtured flourishing cults of panel paintings of Mary at just this period,[24] and that Latin-rite pilgrims are a major source of information about the cult icons of the Greeks.[25] Don't these bespeak, instead, a virtual parity in purpose and response, at least in the case of these major cult icons?

Certainly the two generations from Peter I's accession in 1359 to the Chronicle of Makhairas in the 1430s were punctuated with events in Cyprus in which icons played a public role—events that embraced the Latin-rite as well as the Greek-rite populace. Queen Alix's run-in with the Makhairiotissa was the first of these that we know, and it exposes an unexpected insight into Lusignan courtly behavior: the court apparently made periodic visits to the rich Orthodox monastery of Makhairas. The retributive tone of the Makhairiotissa's response to Alix was exceptional, and its retributive edge was softened three years later when the queen was cured by that other Greek holy object, the Tochni relic. Then her son Peter's reign saw several events in which icons functioned not as minatory voices of an alien native populace, but rather as holy objects of a Lusignan polity. In 1360 Peter's capture of the city of Korykos on the southern coast of Asia Minor was abetted by a miracle-working icon of Mary.[26] This icon had previously blinded—and later been induced by his many gifts to cure—the father of Peter's opponent, the Turkish Great Karaman. That the icon's protection was considered meaningful not only to Turks and Greeks but to Franks, as well, is suggested by the Franks' celebration a year later when Antalya fell to them: they raided nearby Myra and "liberated" its miracle-working icon of St. Nicholas, installing it with fanfare in the Latin cathedral in Famagusta.[27] Antalya was the home of the icon of Mary that Ludolph von Suchem had described as having been painted by Saint Luke. Twelve years later in 1373, when Peter II lost Antalya, he had this icon brought back to Cyprus along with its jeweled throne, and installed them in a church in Kyrenia.[28] Outbreaks of bubonic plague and the first plagues of locusts from 1351 on unsettled the conscience of Peter's successors, prompting them to organize penitential

icon processions,[29] and in the plague of 1398 when the court fled to the safety of Makhairas Monastery, the then queen, Heloise, insisted upon returning to her suffering subjects, and was met at the walls of Nicosia by all of the icons of the city.[30] Triumphant or *triste*, the public events of the Lusignans were punctuated with icons.

The most frequently replicated of the cult icons in Cyprus by the end of the Lusignan era was that of Kykkos Monastery. Like Makhairas, Kykkos was a twelfth-century foundation, and its cult icon, too, is first documented by Leontios Makhairas around 1430.[31] But unlike Makhairas, Kykkos was far from the capital, and we know almost nothing about it until 1365, when it was devastated by a forest fire. Only its icon of Mary survived. Kykkos appealed to the king, Peter I, and his queen, Eleanor of Aragon, agreed to support the rebuilding. It was an apt moment for an appeal, on the brink of Peter's crusade, at a time when public sentiment found a ready focus in holy images and holy happenings. Kykkos and the crusade share the crucial date of 1365. We know virtually nothing of the icon's earlier life, but we can assert that 1365 marked a stage in its cult, for the earliest cluster of icons that clearly reflect it comes from the generations between 1365 and the chronicle of Leontios Makhairas. Seven examples can be assigned to these decades.

Among the earliest is a large and very beautiful icon in the shrine of the Virgin Theoskepaste just outside Kalopanagiotis in the Marathasa Valley (figs. 13.3, 13.8).[32] The facial features, folds, pale gold ground, and finely incised haloes are so closely akin to those of an icon of St. Michael from around 1400 in Nicosia that I have given the same date to the Virgin.[33] The icon displays the posture that is so readily identified now as that of the Kykkotissa: wearing a heavy red veil over her maphorion, Mary holds on her left arm a bare-legged, kicking Child; as he turns from her, she lays her cheek against the curls of his averted head and supports his right hand, which holds a rolled scroll. The icon exhibits, as well, a cluster of particularly fine iconographic details that recurs in the panels of the Kykkos type attributable to the generations after 1365 and unites them as a distinguishable group. They include the heavy crimson veil falling at a canted angle over the maphorion on the Virgin's head; the lozenge pattern on the veil; the spill of folds from the Child's tunic that falls over his mother's hand; his broad, "x"-knotted sash; the angular folds of her maphorion, rising at a right angle to follow her upraised right arm; and perhaps above all the extended index finger of her right hand along the Christ Child's arm. Precisely the same details—albeit in a different style—appear in a small icon now in Nicosia (figs. 13.4, 13.7): the lozenge pattern on the veil, the broad sash and spilling folds, the angular folds of the maphorion, and the extended index finger.[34] This icon is no earlier than the fourteenth-century style of the figures in its border of scenes, and its porcelain-

Fig. 13.3. Kalopanagiotis, "Latin Chapel," Monastery of St. John Lampadistes, icon from the shrine of the Panagia Theoskepaste. Photo: author.

Fig. 13.4. Nicosia, Byzantine Museum, icon from the church of the Chrysaliniotissa. Photo: courtesy of the Archbishop Macarios III Foundation Cultural Centre.

like linearity seems to me to belong to the fifteenth century. Different yet again in style, though consistent in iconography, is the third of this group, a large icon that remained until recently in the church of the Virgin Theotokos in Kalopana-giotis (figs. 13.5, 13.6).[35] Its sweet freshness resembles that of the icon from the nearby shrine of the Theoskepaste, and suggests a date not far different. Distinctive to it are the golden crosslets that pye the sleeves of the Virgin; the same crosslets appear again on the largest and originally the most magnificent of the icons from this period. Largely illegible today, this panel comes from the church of St. Marina in Kalopanagiotis.[36] It was restored, disastrously, in the sixteenth century, when the name, *He Athanasiotissa*, was inscribed on its pale golden ground. Its original manner seems to have been that of the superb, late-fourteenth-century Deposition from the Cross that adorns its reverse.[37] The fifth icon of this group, just found by Stelios Perdikes in the western Cypriot village of Pyrgos, echoes the motifs of the other four.[38]

Fig. 13.5. Kalopanagiotis, Shrine of the Panagia
Theoskepaste, icon from the church of the
Panagia Theotokos. Photo: author.

Fig. 13.6. Detail of fig. 13.5

These five paintings constitute the core of the icons of the Kykkotissa from the decades between Peter I and Leontios Makhairas. Somewhat later, though probably not yet from the sixteenth century, is a remarkable unfinished icon now in Lemythou, in which the lozenges of the veil have been rendered in pastiglia relief.[39] The pose has been reversed—something not unusual in the history of such images—but the extended index finger, the full folds of the Child's tunic, and the angular play of the maphorion are consistent, and affirm once again the group of details that lace the icons together.

A final icon that might have belonged to this group survives only as a ghost, but a very provocative one. This is the Chryseleousa icon in Praitori (fig. 13.9).[40] What survives of it are the panels of its gilded silver cover, now nailed in a phantasmagoric hotchpotch on the surface of its overpainted image. The components clearly bespeak the posture of the Kykkotissa, as seen in the discernable contour

Fig. 13.7. Detail of fig. 13.4

of the child's arm, and in the veil. But what are extraordinary are the Gothic figures—an unidentified kneeling male near Mary's head and the saints from the frame—and the western European translucent enamels that appear in the medallions, integral to the whole, in the upper corners. Clearly enough made for an icon of the Kykkos type, the cover was very Gothic in taste. It is difficult to date, but it clearly adorned an icon of the type and phase we have been following, echoing the fine chrysography of the icons in Kalopanagiotis, and it may itself belong to the fifteenth century.

These are the icons associable with the period that concerns us. They reflect such a close kinship in their iconographic details—a kinship lost again in the looser, more generic repetitions of the type in the sixteenth century—that they seem to be intended to recall a specific model. With their meticulous fidelity to details, they imply a phase in which the icon of Kykkos was especially well known and its details recognized. This would accord with the decades after the fire and

Fig. 13.8. Detail of fig. 13.3

miracle, when the icon was both an important focus of fund-raising and a local sacred celebrity.

The iconographic consistency of this group is made the more striking by two somewhat earlier variants of this posture on Cyprus. One is in the church of Saints Barnabas and Hilarion in Peristerona (fig. 13.10).[41] It shows a red-veiled Virgin holding a Child in much the posture seen hitherto, but with her right hand supporting his waist; the Child's waist, in turn, is wrapped not with a simple belt, but with a halter with straps over the shoulders. The second is a well known icon, initially from Asinou but now in the Byzantine Museum in Nicosia.[42] It is consistently called a Kykkotissa; in fact, however, it looks rather different. Mary does not have the red veil; she holds the Child on her right arm and extends a scroll to him with her left hand; and he wears both a red halter and blue cape over his tunic. While the icon at Peristerona might be seen as a modest variation of the established pose, the icon from Asinou is less a variant than a free improvisation. One

Fig. 13.9. Praitori, Church of the Panagia Chryseleousa, gilded silver cover of the icon of the Chryseleousa. Photo: author.

wonders whether such a freely imaginative version would have been made once the posture had been canonized. One might gather from the Asinou panel that, though known, the iconographic type of the Kykkotissa had not yet attained its canonical status at the time that it was made. The date of the painting is debated but generally placed in the later thirteenth century; as such, it would underscore the impression given above, that—at a point in the fourteenth century—the icon associated with Kykkos went from being one of many icons to being a canonical cult object.

The Kykkotissa's posture is not a trivial one. With greater or lesser exactitude, it appears in a number of examples outside Cyprus. The earliest surviving example is the famous twelfth-century icon on Mount Sinai.[43] We can only speculate about the significance of the image in this case, but almost all of the ensuing examples are themselves miracle-workers. The most famous—along with the Kykkotissa—

Fig. 13.10. Peristerona, Church of SS. Barnabas and Hilarion, icon of the Mother of God. Photo: author.

is the still very active Axion Estin on Mount Athos, recently published as an early-fourteenth-century painting, somewhat earlier than the icon from the Theoskepaste Shrine, which it resembles.[44] Earlier still is the late-thirteenth-century Madonna del Vessillo in Piazza Armerina in Sicily, reputed by legend to have been the battle standard of the Norman duke Roger who invaded Sicily in 1059, and a miracle-worker from the Black Death through the years of the Second World War.[45] Four other icons of this type with cults in Apulia and Lazio are known.[46] The Italian examples show the Kykkos icon's posture except that Mary holds the Child's waist, and he wears a halter: very nearly the posture, that is, of the icon at Peristerona. The Italian examples appear in Aragonese territory, governed by the family of King Peter's queen, Eleanor. Eleanor rebuilt Kykkos. Was its icon a type that she recognized and espoused? Did she adopt it as a Lusignan asset?

That the cult at Kykkos was in origin anything but Greek is implausible. This is clear in the first place from the places for which the replicas were made. The church of the Virgin Theotokos in Kalopanagiotis is a modern building and serves

as the main village church, but the other sites we have mentioned are little buildings located outside their mountain villages and unlikely ever to have been of interest to Latin-rite Christians. The icons' sites are thoroughly local.

Along with the sites, the styles of the icons are notable. They are stylistically extremely diverse. Iconographically similar as they are, they are very different in style (compare figs. 13.6, 13.7, and 13.8). In this respect, they differ fundamentally from the icons of the Kykkotissa that come from the Ottoman period.[47] In the Ottoman period Kykkos itself disseminated the replicas of its great palladion, actively propagating its cult. A very different pattern is suggested by the medieval replicas. These seem to have arisen from their own locales, as if their patrons had themselves chosen the form of a local and exceptionally successful icon. This does not convey the impression of a cult spawned with the focused backing of a royal enclave. It suggests local, Cypriot attention.

This suggestion is reinforced by what we know of the financing of Kykkos and its icon. We learn this from an account of the icon's legend dictated at some time before his death in 1422 by an aged Kykkos monk named Gregorios who remembered the fire of 1365.[48] In its earliest surviving manuscript copy, his account includes two insights into Kykkos's funding that vanish from later versions. First, after telling us that Queen Eleanor agreed to fund the rebuilding in 1365, Gregorios adds that her contribution was followed by a flood of contributions by Cypriots, both rich and poor, so that the new monastery was finished within six months.[49] A royal donation, then, if scratched, reveals extensive local contributions, as well. The same pattern emerges more strikingly in the second royal donation that Gregorios relates.[50] This was made by Queen Heloise, the queen who had left the safety of Makhairas Monastery during the plague of 1398. Heloise came from the Brunswick family, a Frankish family long established on Cyprus. Her benefaction concerned St. Nicholas at Peganion, a small monastery in western Cyprus. A Cypriot serf of one of her relatives had built the monastery with his own hands, endowed it with fields, herds, and vineyards, and at his death had willed it to Kykkos. Since he was a serf, however, Kykkos still owed one-third of the land's produce to his lord. The lord had returned his third to Kykkos in the form of gifts for the feasts of Mary and her icon, but Queen Heloise made them a gift in perpetuity. Behind her gift, then, lay the gift of a native Cypriot. It was he who had singled out Kykkos.

Localities, styles, and funding imply that the cult of the Kykkos icon took momentum at the instigation not of royal support, but of widespread local interest as patrons in Greek-rite villages decided, one by one, to adopt for an icon the type of the icon that had proved so effective at Kykkos. It was a Greek cult. The con-

clusion is unsurprising: as we have seen, similar cults were assuming prominence elsewhere in Orthodoxy, too. But why were they doing so? Was the cult of Kykkos a self-consciously Greek one, announcing its difference from Latin-rite devotion? The vengeful behavior of the Makhairiotissa, striking King Peter's mother with dumbness, suggests that icons were, indeed, a banner of Greek and Cypriot identity. Leontios Makhairas himself tends to support this idea, emphasizing that it was another holy object of the Greeks that cured the queen's dumbness.[51] But the icons of the Kykkotissa tend to dispute this view.

They do so first in their territorial distribution. They are found in little churches high in the mountains, but an exceptional number of them are in the Marathasa Valley. Three of the six icons of our group come from the one village of Kalopanagiotis in Marathasa, and seven of the sixteen pre-Ottoman icons come from Marathasa. Marathasa was a rich valley in the Lusignan era, as attested by its many medieval churches. Kalopanagiotis seems to have been its medieval hub.[52] It was royal land—Peter I gave it as a wedding gift to Eleanor[53]—and Latin lords surely came there, for their heraldic devices still adorn the medieval woodwork of two churches: the church of St. Herakleidios in the monastery of St. John Lampadistes in Kalopanagiotis itself, and the church of the Archangel at Pedoulas.[54] Marathasa's villages were solidly Greek, but their prosperity was clearly fed by the Frankish presence. One sees this in the sheer quality of its icon painting, and most conspicuously in its Kykkotissas. These display the styles not of Cyprus's native mountain masters, but of cosmopolitan painters from the cities who worked, inter alia, for the Frankish nobles: the Deposition on the reverse of the Athanasiotissa, for instance, resembles closely the hand of the superb painter who worked at Pelendri, where the heraldic crest of Jean de Lusignan is seen.[55] If local in their distribution, variety, and funding, then, the early icons of the Kykkotissa also bespeak a locale that fed on the Frankish presence. Frankish lords both hunted and worshiped in Marathasa, and they encouraged the cult at Kykkos with their contributions, contributions that were direct, as in the cases of the two queens, and perhaps more interestingly indirect, as in the case of Queen Heloise's relative, who returned his third of the proceeds of the little monastery of St. Nicholas to Kykkos. In the story of Heloise's relative, we watch what had been Latin profits on the land slowly reverting—first by gift and then in perpetuity—to the Cypriot institution and its cult.

The Deposition on the icon of the Athanasiotissa shows us a Palaeologan painter who may also have worked for Latin patrons. But Greek-rite patrons did not spurn Latin manners, either. The evidence for this is far scarcer than the reverse, but the Kykkotissa itself offers one of the rare examples. This is in the icon

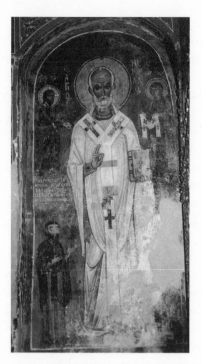

Fig. 13.11. Kakopetria, Church of St. Nicholas of the Roof, mural icon of
St. Nicholas with donor-monk. Photo: author.

cover of the Chryseleousa at Praitori (fig. 13.6). It is hard to defend a self-conscious
proclamation of Greek identity in an image that acquired so Gothic a cover as this
one. Rather, it bespeaks the same fluidity that the Athanasiotissa does.

This fluidity is reinforced, in the third place, by the icons that share the pos-
ture and charismatic veneration of the Kykkotissa's type in Italy. One cannot sug-
gest that the kinship of the icon at Peristerona to those in Italy indicates that
Eleanor of Aragon implanted the icon type espoused at Kykkos. But this kinship
can tell us that the audience embraced by this iconographic type—and respon-
sive to its charismatic reputation—was not limited to the Middle East, but in-
cluded the Mediterranean West, as well. It was not alien to Latin Christians in
Italy, and nothing in the Latin response to the emergence of the Kykkos cult sug-
gests that it was alien to Latin-rite Christians in Cyprus, either. Greek and Latin,
Cypriots responded to its emergence.

The cult of the Kykkotissa emerged into broad visibility in the era between
Peter I and Leontios Makhairas, in the very decades in which we can watch icons

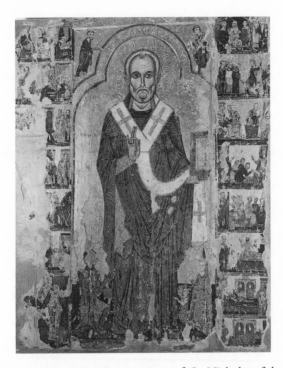

Fig. 13.12. Nicosia, Byzantine Museum, icon of St. Nicholas of the Roof with donor-knight and his family. Photo: courtesy of the Archbishop Macarios III Foundation Cultural Centre.

being woven deeply into the fabric of Lusignan public life. In the growing number of events that laced the populace of the island together in this period—triumphant conquest, foreign defeat, violent domestic invasion, bubonic plague, and the dreadful invasion of locusts—icons were integral to everyone's public response. The public cults—of the Makhairiotissa, the Phaneromene, the Kykkotissa—were cults of the Greeks. But they relied, as well, on Latin-rite Christians, who abetted their support, reinforced their institutions, and created the contexts of public ritual to which the icons responded with their healing, rain-bringing, or consoling interventions. Greek as the tradition was that they represented, this tradition was woven, as well, into the habits of public ritual and responsibility that the Latin lords developed to reinforce their power. There was no need to remake the icons, except as they responded to the shared conditions of that society.

What is meant by such a response might be illustrated by returning to the icons at the church of Saint Nicholas of the Roof in Kakopetria (figs. 13.11, 13.12). They

were juxtaposed earlier—the mural icon of a Greek monk of the twelfth century in the naos; the panel-painted icon of a Latin knight from around 1300 in the narthex.[56] Both, I believe, are simply icons. What distinguishes them is not the adaptation of the later one to serve as an altarpiece, but the elaboration of its donor portrait to emphasize its distinctive content, as the family portrait of a man identified by his blood: by his inherited armorial bearings. This produced an emphasis on the donor that was exceptional by both Greek and Latin conventions. But that very emphasis upon the donor rapidly became one of the signature characteristics of Cypriot icons as a whole, regardless of the ethnic identity of the donor. Just how we are to read the content of the knightly portrait from Kakopetria— as an aggressive imposition of his hegemony over the church, or an affirmation of his pious participation in its congregation—has become extraordinarily difficult for us to guess, because we have been so very accustomed to scrutinizing icons in the crusader kingdoms as sites of difference. The Kykkotissa shows us, however, that there were also large tracts of public life in which icons functioned as instruments of unity. It is this aspect of icons' lives in the late crusader states that this chapter recommends to our attention.

Notes

1. This chapter was first drafted as a paper for the conference "Frankish Culture at the End of the Crusades: France and the Holy Land," held at the Johns Hopkins University on 24 and 25 March 2000. I am indebted to the National Humanities Center, the Cyprus American Archaeological Research Institute, and the Dumbarton Oaks Center for Byzantine Studies for support in pursuing research on this material, which emerges from my work on the history of the Kykkotissa.

2. On the chapel of St. Catherine, see Andreas Stylianou and Judith A. Stylianou, *The Painted Churches of Cyprus: Treasures of Byzantine Art*, 2d ed. (Nicosia, 1997), 428–32; Athanasios Papageorgiou, "Vasiliko Parekklesi," in *Pyrga: Hodegos* (Nicosia, n.d.); idem, "L'Art byzantin de Chypre et l'art des croisés: influences réciproques," *Report of the Department of Antiquities, Cyprus, 1982* (Nicosia, 1982), 221–22, pls. XLIX, 4; L, 1–4.

3. Camille Enlart, *Gothic Art and the Renaissance in Cyprus*, trans. D. Hunt (London, 1987), 328, recorded the following, much abraded inscription on the west wall beneath the window: ai / l'an de Nostre-Sei-/ gneur M. CCCC et XXI / s. III. . . . s de / s. ncoumësée / ceste chappele / ..'onor de Dieu et de / l..a . . . on de nostre / . . . Mar en sui / e / ere. He read it as follows: "L'an de Nostre Seigneur M. CCCC et XXI . . . s. . . . Ill jours dee'enousesee, ceste chappele en l'onor de Dieu et de la Passion de nostre Seigneur. . . . en sul." Papageorgiou, *"Vasiliko Parekklesi,"* 4, questions Enlart's conclusion that the chapel was

dedicated to the Passion of Christ because the murals devote as much space to the life of the Mother of God as to the Passion narrative. If not to the Passion as such, however, the chapel was probably devoted in some way to the Passion, for the same balance of Marian and Passion imagery characterizes the church at Pelendri, which was dedicated to the True Cross.

4. On Stavrovouni, see "Staurovouni, Monasteri," in *Megale Kypriake Enkyklopaideia*, 16. vols. (Nicosia, 1990), 12:306–11; Rupert Gunnis, *Historic Cyprus* (London, 1936), 428–32; John Hackett, *A History of the Orthodox Church of Cyprus* (London, 1901), 439–51.

5. Thus they were described in the 1430s by Leontios Makhairas, *Recital Concerning the Sweet Land of Cyprus Entitled 'Chronicle,'* trans. and ed. R.M. Dawkins, 2 vols. (Oxford, 1932), 1:§8. We know of earlier visitors—the Abbot Daniel in 1106, Willibrand of Oldenburg in 1211, Jacobus da Verona in 1335—but none describes the relics in more than generic terms. For Abbot Daniel, see "The Pilgrimage of the Russian Abbot Daniel," in *Library of the Palestine Pilgrims Text Society*, vol. 4 (London, 1897), 8. For Willibrand and Jacobus da Verona, see Claude Delaval Cobham, *Excerpta Cypria: Materials for a History of Cyprus* (Cambridge, 1908), 14 and 18.

6. Stavrovouni's significance at the time of King Janus is shown by the Mamluks' triumphant symbolic devastation of it in the wake of their triumph over Janus at Khirokitia in 1426. Makhairas asserts that the "Cross of Olympas, that is, Great Cross" came down of its own accord from Stavrovouni at this time and thus was saved from Muslim destruction: Makhairas, *Recital*, 1:§68.

7. This story is related at length by Makhairas, *Recital*, 1:§67–77. In the course of its narration he interjects (1:§68) the assertion cited above, that the "Cross of Olympas, that is, Great Cross" came down of its own accord from Stavrovouni at the time of King Janus's disastrous defeat by the Mamluks at Khirokitia in 1426, and thus was saved from Muslim destruction.

8. See in particular Papageorgiou, "L'Art byzantin de Chypre et l'art des Croisés"; Nicholas Coureas and Jonathan Riley-Smith, eds., *He Kypros kai hoi Stavrophories: Cyprus and the Crusades* (Nicosia, 1995); Krijne Ciggaar, "Manuscripts as Intermediaries: The Crusader States and Literary Cross-Fertilization," in *East and West in the Crusader States: Context—Contacts—Confrontations,* Orientalia Louvaniensia Analecta 75, ed. Krijne Ciggaar, Adelbert Davids, and Herman Teule (Leuven, 1996), 131–51.

9. On Peter I's crusade, see Peter W. Edbury, *The Kingdom of Cyprus and the Crusades, 1191–1374* (Cambridge, 1991), 166–68; idem, "Cyprus and Genoa: The Origins of the War of 1373–1374," in *Praktika tou deuterou diethnous kyprologikou Synedriou*, 3 vols. in 4 (Nicosia, 1986), 2:109–26; Nicholas Iorga, *Philippe de Mézières 1327–1405 et la Croisade au XIVe siècle,* Bibliothèque de l'Ecole des hautes études, sciences philosophiques et historiques, 110 (Paris, 1896). Peter's itinerary on his recruitment journey is reconstructed by Louis de Mas Latrie, *Histoire de l'île de Chypre sous le règne des princes de la maison de Lusignan,* 3 vols. (Paris, 1855), 2:2339, n. 1; see also idem, "Guillaume de Machaut et la prise d'Alexandrie," *Bibliothèque de l'Ecole des chartes* 37 (1876): 1–26. On Peter's gift of relics of the cross, see Franz Machilek, "Privat-

frömmigkeit und Staatsfrömmigkeit," in *Kaiser Karl IV: Staatsmann und Mäzen,* exh. cat., Kaiserburg, Nürnberg, 1978 (Munich, 1978), 93.

10. Ludolph von Suchem, *Description of the Holy Land, and of the Way Thither, Written in 1350,* trans. Aubrey Stewart (London, 1895), 45.

11. Hackett, *A History,* 340; Makhairas, *Recital,* 1:§368.

12. *Ktitorikon: He Proskynetarion tes hieras kai vasilikes Mones tou Megalou Spilaiou, Epidiorthen psepho kai spoude tou hierou Monasteriou en etei 1840,* ed. K. Oikonomos, 3d ed. (Athens, 1932), 90.

13. The Megaspilaiotissa is first cited in a chrysobull of the emperor John VI Kantakouzenos from 1350, published in Franz Miklosich and Iosephus Müller, *Acta et Diplomata Monasteriorum et Ecclesiarum Orientis,* 6 vols. (Vienna, 1887), 5:191. The Soumeliotissa is first cited in a chrysobull of the Grand Komnenos Alexios III in 1364: see Raymond Janin, *Les eglises et les monastères des grands centres byzantins (Bithynie, Hellespont, Latros, Galèsios, Trébizonde, Athènes, Thessalonique)* (Paris, 1975), 274–76; Maria K. Chaireti, "Soumela, Mone," *Threskeutike kai ethike Enkyklopaideia,* 12 vols. (Athens, 1966), 11:291–95.

14. On Makhairas Monastery, see most recently the introduction by Anastasius Bandy to his translation of the Makhairas Typikon in John Thomas and Angela Hero, eds., *Byzantine Monastic Foundation Documents: A Complete Translation of the Surviving Founder's Typika and Testaments* (Washington, D.C., 2000; also available online at http://www.doaks.org/typo46.pdf), 1107–20, with earlier bibliography, in particular Ioannes P. Tsiknopoullos, *Kypriaka Typika* (Nicosia, 1969), 3–68; idem, *He hiera vasilike kai stauropegiake Mone tes hyperagias Theotokou Makhaira* (Nicosia, 1967); S. Menardos, *He en Kypro hiera Mone tes Panagias tou Makhaira* (Piraeus, 1929); Hackett, *A History,* 345–48.

15. Makhairas, *Recital,* 1:§67–77.

16. Papageorgiou, *Icons of Cyprus* (Nicosia, 1992), pl. 3; Sophocles Sophocleous, *Icons of Cyprus, 7th to 20th Century* (Nicosia, 1994), pl. 4.

17. The Typikon is kept at the monastery. See note 14 above for bibliography.

18. Papageorgiou, *Icons of Cyprus,* pls. 47 a–b.

19. On Kykkos Monastery, see A. Paulides, "Kykkou, Panagias Monasteri," in *Megale Kypriake Enkyklopaideia,* 16 vols. (Nicosia, 1987), 11:350–61; His very Reverence the Abbot of Kykko Chrysostomos, *The Holy, Royal Monastery of Kykko founded with a Cross* (Limassol, 1969); N. G. Kyriakes, *Historia tes hieras Mones Kykkou* (Larnaca, 1949). On the icon, see especially Olga Gratziou, "Metamorphoseis mias thaumatourges Eikonas: Semeioseis stis opsimes Parallages tes Panagias tou Kykkou," *Deltion tes christianikes archaiologikes Hetaireias* 4, no. 17 (1993–94): 317–29 (English summary on 330); George A. Soteriou, "He Kykkiotissa," *Nea Hestia* (Christmas issue, 1939): 3–6.

20. On the court art of the fourteenth-century Lusignans, see Annemarie Weyl Carr, "Art in the Court of the Lusignan Kings," in *He Kypros kai hoi Staurophories: Cyprus and the Crusades,* ed. Coureas and Riley-Smith, 239–74.

21. See in particular Kurt Weitzmann, "Crusader Icons and Maniera Greca," in

Byzanz und der Westen: Studien zur Kunst des europäischen Mittelalters, ed. Irmgard Hutter (Vienna, 1984), 143–70; and idem, "Icon Painting in the Crusader Kingdom," *Dumbarton Oaks Papers* 20 (1966): 51–83, and "Thirteenth-Century Crusader Icons on Mount Sinai," *Art Bulletin* 45 (1963): 179–204, both reprinted in idem, *Studies in the Arts at Sinai* (Princeton, 1982).

22. Hans Belting, *The Image and Its Public in the Middle Ages: Form and Function of Early Paintings of the Passion,* trans. Mark Bartusis and Raymond Mayer (New Rochelle, 1989).

23. Jaroslav Folda, "Crusader Art in the Kingdom of Cyprus, 1275–1291: Reflections on the State of the Question," in *He Kypros kai hoi Staurophories: Cyprus and the Crusades,* ed. Coureas and Riley-Smith, 209–38.

24. Note the cult of the Tuscan Madonna of Impruneta, like the Kykkotissa a covered icon famous as a rain-maker (*Impruneta: Una pieve, un paese,* Convegno di studi [Impruneta, 1982]), the Madonna della Ghiara near Bologna (V. Benassi et al., *La Madonna della Ghiara in Reggio Emilia* [Reggio Emilia, 1983]), the south Italian cults treated by Pina Belli d'Elia, *Icone di Puglia e Basilicata dal medioevo al Settecento,* exh. cat., Bari, Pinacoteca Provinciale, 1988 (Bari, 1988), or for that matter the cult of the Freising Madonna (C. Wolters, "Beobachtungen am Freisinger Lukasbild," *Kunstchronik* 17 [1964]: 85–91). Though it was devoted to a statue, one might cite, as well, the cult at Walsingham in England (J. C. Dickinson, *The Shrine of Our Lady of Walsingham* [Cambridge, 1956]).

25. Along with Ludolph von Suchem cited in note 10 above, see Willibrand of Oldenburg's account of a rain-making icon in Antioch in J.M.C. Laurent, *Peregrinatores Medii Aevi Quatuor: Burchardus de Monte Sion, Ricoldus de Monte Crucis, Odoricus de Foro Julii, Wilibrandus de Oldenborg* (Leipzig, 1864), 172, ll. 18–19; Nicholas de Martoni's account of the Atheniotissa in L. Le Grand, "Relation du pèlerinage à Jérusalem de Nicolas de Martoni, notaire italien (1394–1395)," *Revue de l'Orient latin* 3 (1895): 652; or the Latin accounts of the icon of Saidnaya, for which see Paul Peeters, "La légende de Saidnaia," *Analecta Bollandiana* 25 (1906): 137–55 and more recently Daniel Baraz, "The Incarnated Icon of Saidnaya Goes West: A Re-examination of the Motif in the Light of New Manuscript Evidence," *Muséon* 108 (1995): 181–91.

26. Makhairas, *Recital,* 1:§115–16.

27. Ibid, 1:§127.

28. Ibid., 1:§368; Hackett, *A History,* 340.

29. Makhairas, *Recital,* 1:§623.

30. Ibid., 1:§624.

31. Ibid., 1:§37.

32. Papageorgiou, *He Autokephalos Ekklesia tes Kyprou: Katalogos tes Ektheses. Exhibition at the Byzantine Museum of the Archbishop Makarios III Cultural Foundation* (Nicosia, 1995), 143. The icon has been removed from its church and now is placed for veneration in the so-called Latin Chapel in the monastery of St. John Lampadistes in Kalopanagiotis.

33. Papageorgiou, *Icons of Cyprus,* pl. 46.

34. Papageorgiou, *Byzantine Icons of Cyprus,* exh. cat., Benaki Museum (Athens, 1976), 78–79, no. 27 (though the description has been interchanged with that of no. 29); idem, *Icons of Cyprus* (Geneva, 1969), pl. on page 48.

35. The icon is currently in the shrine of the Panagia Theoskepaste, from which the title icon has been removed as noted in note 32 above.

36. Papageorgiou, *Byzantine Icons of Cyprus,* 84–87, no. 30.

37. Ibid., 86–87, and in color in idem, *Icons of Cyprus,* pl. 49. The contemporaneity of the Deposition with the original version of the Virgin on the panel's obverse is based on the little angels in the upper corners of the obverse, which were not affected by the later overpainting.

38. *Hiera Metropolis Morphou. 2000 Chronia Technes kai Hagiotetos,* exh. cat., Cultural Foundation of the Bank of Cyprus (Nicosia, 2000), 282–83, no. 19.

39. Sophocles Sophocleous, "He Eikona tes Kykkotissas ston Hagio Theodoro tou Agrou," *Epeterida Kentrou Meleton hieras Mones Kykkou* 2 (1993): 329–37, pls. 10–12.

40. Papageorgiou, *Icons of Cyprus,* pl. 17.

41. Andreas Stylianou and Judith A. Stylianou, *Peristerona (Morphou)* (Peristerona, 1974), fig. 10; *Hiera Metropolis Morphou,* 254–55, no. 6, showing it in its current, rather violently restored condition.

42. Papageorgiou, *Byzantine Icons of Cyprus,* 82–82, no. 29; idem, *Icons of Cyprus,* pl. 35.

43. Helen C. Evans and William W. Wixom, *The Glory of Byzantium: Art and Culture of the Middle Byzantine Era, A.D. 843–1261,* exh. cat., Metropolitan Museum of Art (New York, 1997), 372–73, no. 244, with earlier bibliography.

44. Giannes Tavlakes, "He Panagia Axion Estin: He Eikona," in Kriton Chrysochoides, Giannes Tavlakes, and Giota Oikonomake-Papadopoulou, *To Axion Estin: Panagia he Karyotissa, he ephestia Eikona tou Protatou* (Athos, 1999), 19–23, pl. on page 18.

45. Paola Santa Maria Mannino, "Vergine 'Kykkotissa' in due icone Laziali del Duecento," in *Roma Anno 1300, Atti del Congresso internazionale di Storia dell'Arte medievale (Roma, 19–24 Maggio 1980)* (Rome, 1983), 487–92, pl. 5.

46. Ibid. They are the Madonna delle Vergini from Bitonto and now in the Museo Provinciale in Bari, the Madonna dell'Orto in the church of San Martino, Velletri, a panel in the Museo Civico in Viterbo, and the Madonna dell'Isola in a private collection in Naples. See also Pina Belli d'Elia, *Icone di Puglia e Basilicata,* 126–28, nos. 30 (Madonna delle Vergini) and 31 (Madonna dell'Isola).

47. This is especially clear in the seventeenth century when the international basis for the Kykkotissa's cult was set in place. This will constitute a chapter in my book on the Kykkotissa.

48. The account survives in several manuscript copies, of which two have been published: Costas Chatzepsaltes, "To anekdoto Keimeno tou Alexandrinou Kodikos 176 (366): Paradoseis kai Historia tes Mones Kykkou," *Kypriakai Spoudai* 14 (1950): 39–69; K. Spyridakes, "He Perigraphe tes Mones Kykkou epi te Basei anekdotou Cheirographou," *Kypriakai Spoudai* 13 (1950): 1–28. The earliest version, in Vatican, gr. 2123, has just been published by Costas Constantinides, *He Diegesis tes thauma-*

tourges Eikonas tes Theotokou Eleousas tou Kykkou, Peges tes Historias tes Hieras Mones Kykkou 4 (Nicosia, 2002). The manuscript was copied in 1661 by the monk Barnabas of Kykkos Monastery.

49. Vatican, gr. 2123, fol. 27r, ll. 6–15: "The rebuilding being underway, the common people of Marathasa saw the queen's urgent desire for the monastery's renewal. They, too, joined in with full heart and spirit, and built the church and monastery completely as you see it today, between the beginning of July and the month of December." See also Chatzepsaltes, "To anekdoto Keimeno," 67, ll. 21–25.

50. Vatican, gr. 2123, fol. 27v, line 8 to the end of the text; Chatzepsaltes, "To anekdoto Keimeno," 67, line 30 to the end of the text.

51. Makhairas's narration of the whole story of the Tochni relic is notable, for he makes of it an occasion to counterpose the efficacy of "Greek" holy objects with "Latin" ones, noting at one point (1:§72) that "because the Latins envy the Greeks, they hide the miracles that are worked by the icons and by the pieces of the Holy Wood in the churches of the Greeks: not because they disbelieve, but because they are envious. For this reason the Latin churchmen used to say that the Cross is not of the Holy Wood, but the miracles are worked by craft."

52. On Kalopanagiotis, see "Kalopanagiotis," *Megale Kypriake Enkyklopaideia,* 16 vols. (Nicosia, 1983), 6:215–16; Louis de Mas Latrie, *L'Ile de Chypre: sa situation présente et ses souvenirs du Moyen-age* (Paris, 1879), 355.

53. Chatzepsaltes, "To anekdoto Keimeno," 67, ll. 13–14.

54. For St. John Lampadistes, see Stylianou and Stylianou, *The Painted Churches,* pl. 182; and idem, "He Vyzantine Techne kata ten Periodo tes Phrankokratias (1191–1570)," in *Historia tes Kyprou, Tomos E': Mesaionikon Basileion, Enetokratia, Meros B': Pneumatikos Bios, Paideia, Grammatologia, Vyzantine Techne, Gothike Techne, Nomismatokopia, Bibliographia,* ed. Theodore Papadopoullos, 2 vols. (Nicosia, 1996), 2: pls. 148–56. On the Archangel Church in Pedoulas, see idem, "He Vyzantine Techne," 2: pls. 164–65; George A. Soteriou, *Ta Vyzantina Mnemeia tes Kyprou* (Athens, 1935), pls. 147–48.

55. Compare the Deposition (Papageorgiou, *Icons of Cyprus,* pl. 49), with the dome at Pelendri (Annemarie Weyl Carr, "Italians and Byzantines on Cyprus: Images from Art," *Dumbarton Oaks Papers* 49 [1995]: 345, pl. 10).

56. Stylianou and Stylianou, *The Painted Churches,* pl. 25.

Bibliography

l'Abbé Maistre, M. *Histoire de la Maison de Dampierre*. Paris: Victor Palmé, Libraire-Éditeur, 1884.

Abulafia, David. "Trade and Crusade, 1050–1250." In *Cross Cultural Convergences in the Crusade Period: Essays Presented to Aryeh Grabois on his Sixty-Fifth Birthday*, edited by Michael Goodich, Sophia Menache, and Silvia Schein, 1–20. New York: Verlag Peter Lang, 1995.

Ackerman, Phylis. "Origines orientales de Janus et d'Hermès." *Bulletin of the American Institute for Persian Art and Archaeology* 5 (1937–38): 216–25.

Ackland, James H. *Medieval Structure: The Gothic Vault*. Toronto: University of Toronto Press, 1972.

Ainalov, Dmitrii V. *The Hellenistic Origins of Byzantine Art*. New Brunswick: Rutgers University Press, 1961.

Airaldi, Gabriella, ed. *Le vie del Mediterraneo: idee, uomini, oggetti (secoli XI–XVI)*. Collana dell'Istituto di storia del medioevo e della espansione europea, 1. Genoa: Università degli studi di Genova, 1997.

Alexander, Jonathan J. G. "Art History, Literary History, and the Study of Medieval Illuminated Manuscripts." *Studies in Iconography* 18 (1997): 51–66.

———. *Medieval Illuminators and Their Methods of Work*. New Haven: Yale University Press, 1992.

Allan, J. W. "Mamluk Sultanic Heraldry and the Numismatic Evidence: A Reinterpretation." *Journal of the Royal Asiatic Society* n.s. 2 (1970): 99–112.

Allsen, Thomas T. *Commodity and Exchange in the Mongol Empire: A Cultural History of Islamic Textiles*. Cambridge: Cambridge University Press, 1997.

Amadi, Francisco. *Chroniques de Chypre d'Amadi et de Strambaldi*. Edited by René de Mas-Latrie. 2 vols. Paris, 1891–93.

Anglade, Joseph. *Las leys d'amors*. Toulouse: Privat, 1919.

Archives de l'Orient latin. Sociètè de l'Orient latin. 2 vols. Paris: E. Leroux, 1881–84.

Arnold of Lübeck. *Chronica slavorum*. Edited by Johann M. Lappenberg. Monumenta Germaniae historica: scriptores, 21. Hanover: Anton Hiersemann, 1869.

Arnold, Thomas. *Painting in Islam*. Reprint, New York: Dover, 1965.

Ashtor, Eliyahu. *Levant Trade in the Later Middle Ages*. Princeton: Princeton University Press, 1983.

Aslanov, Cyril. "Languages in Contact in the Latin East: Acre and Cyprus." *Crusades* 1 (2002): 155–81.

Atil, Esin, et al. *Islamic Metalwork in the Freer Gallery of Art*. Washington, D.C.: Freer Gallery of Art, 1985.

Atil, Esin, ed. *Renaissance of Islam: Art of the Mamluks*. Washington, D.C.: Smithsonian Institution Press, 1981.

Aubert, J. Lafond, and J. Verrier. *Les vitraux des Notre-Dame et de Sainte-Chapelle de Paris*. Paris, 1950.

Aubert, Marcel. "Les plus anciennes croisées d'ogives: leur role dans la construction." *Bulletin Monumental* 93 (1934): 5–67, 137–237.

Augustine. *The City of God against the Pagans*. Edited and translated by R. W. Dyson. Cambridge, Mass.: Harvard University Press, 1998.

Ayres, Larry. "Bibbie italiane e Bibbie francesci: il XIII secolo." In *Il Gotico europeo in Italia*, edited by Valentino Pace and Martina Bagnoli, 361–74. Naples: Electa Napoli, 1994.

Babcock , Emily A., and August C. Krey, eds. *William Archbishop of Tyre: A History of Deeds Done Beyond the Sea*. 2 vols. New York: Columbia University Press, 1943.

Bacchi, Andrea, ed. *Dalla Bibbia di Corradino a Jacopo della Quercia: sculture e miniature italiane del Medioevo e del Rinascimento*. Milan: Galleria nella Longari, 1997.

Baer, Eva. *Ayyubid Metalwork with Christian Images*. Studies in Islamic Art and Architecture. Supplements to Muqarnas, 4. Leiden: Brill, 1989.

——. *Metalwork in Medieval Islamic Art*. Albany: State University of New York Press, 1983.

Bak, János M., ed. *Coronations: Medieval and Early Modern Monarchic Ritual*. Berkeley: University of California Press, 1990.

Balard, Michel, ed. *Autour de la première Croisade*. Byzantina Sorbonensia, 14. Paris: Publications de la Sorbonne, 1996.

Balard, Michel, Benjamin Z. Kedar, and Jonathan S. C. Riley-Smith, eds. *Dei gesta per Francos: Études sur les croisades dédiées à Jean Richard*. Aldershot: Ashgate, 2001.

Balog, Paul. "New Considerations on Mamluk Heraldry." *American Numismatic Society Museum Notes* 22 (1977): 183–211.

Bank, Alice. *Byzantine Art in the Collections of Soviet Museums*. Leningrad: Aurora Art Publishers, 1977.

Baraz, Daniel. "The Incarnated Icon of Saidnaya Goes West: A Re-examination of the Motif in the Light of New Manuscript Evidence." *Muséon* 108 (1995): 181–91.

Barber, Malcolm. *The New Knighthood: A History of the Order of the Temple*. Cambridge: Cambridge University Press, 1994.

Bar Hebraeus. *The Chronography of Gregory Abū'l Faraj*. 2 vols. Oxford: Oxford University Press, 1932.

Barolini, Teodolinda. *Dante's Poets: Textuality and Truth in the Comedy*. Princeton: Princeton University Press, 1984.

Barrucand, Marianne. "The Miniatures of the *Daqā'iq al-Haqā'iq* (Bibliothèque Na-

tionale Pers. 174): A Testimony to the Cultural Diversity of Medieval Anatolia." *Islamic Art* 4 (1991): 113–42.

Bartsch, Karl. *Chrestomathie Provençale.* 4th ed. Elberfeld: R. L. Friederichs, 1880.

Beaune, Colette. *The Birth of an Ideology: Myths and Symbols of Nation in Late-Medieval France.* Berkeley: University of California Press, 1991.

Beckingham, Charles F. *Between Islam and Christendom: Travellers, Facts and Legends in the Middle Ages and the Renaissance.* London: Variorum Reprints, 1983.

Bedoukian, Paul. *Coinage of Cilician Armenia.* New York: American Numismatic Society, 1962.

Belli d'Elia, Pina. *Icone di Puglia e Basilicata dal medioevo al Settecento.* Exh. cat. Bari: Mazzotta, 1988.

Belting, Hans. *The Image and Its Public in the Middle Ages: Form and Function of Early Paintings of the Passion.* Translated by Mark Bartusis and Raymond Mayer. New Rochelle, N.Y.: Aristide D. Caratzas Publisher, 1989.

Belting, Hans. "Die Reaktion der Kunst des 13. Jahrhunderts auf den Import von Reliquien und Ikonen." In *Ornamenta Ecclesiae: Kunst und Künstler der Romanik,* edited by Anton Legner, 3:173–83. Katalog zur Ausstellung des Schnütgen-Museums. Cologne: Schnütgen-Museum der Stadt Köln, 1985.

Belting, Hans, ed. *Il medio oriente l'occidente nell'arte del XIII secolo.* Atti del XXIV Congresso internazionale di storia dell'arte, Bologna, 1975. Bologna: Editrice CLUEB, 1982.

Benassi, Vincenzo, et al. *La Madonna della Ghiara in Reggio Emilia.* Reggio Emilia: Comunita dei Servi di Maria del Santuario della B.V. della Ghiara, 1983.

Benvenisti, Meron. *The Crusaders in the Holy Land.* Jerusalem: Israel Universities Press, 1970.

Berggötz, Oliver. *Der Bericht des Marsilio Zorzi: Codex Querini-Stampalia IV3 (1064).* Edited by Hans E. Mayer. Kieler Werkstücke, Reihe C: Beiträge zur europäischen Geschichte des frühen und hohen Mittelalters, 2. Frankfurt am Main: Verlag Peter Lang, 1990.

Bernasconi, Marina, and Lorena dal Poz. *Codici miniati della Biblioteca Comunale di Trento.* Florence: Alinari, 1985.

Bertolucci Pizzorusso, Valeria. "Testamento in francese di un mercante veneziano (Famagosta, Gennaio 1294)." *Annali della Scuola Normale Superiore di Pisa* ser. 3, 18 (1988): 1011–33.

Blair, Sheila. "The Coins of the Late Ilkhanids: Mint Organization, Regionalism, and Urbanism." *American Numismatic Society Museum Notes* 27 (1982): 295–317.

Boas, Adrian J. "The Import of Western Ceramics to the Latin Kingdom of Jerusalem." *Israel Exploration Journal* 44 (1994): 102–22.

———. "A Rediscovered Market Street in Frankish Acre?" *'Atiqot* 31 (1997): 181–86.

Boffa, Serge. "Les soutiens militaires de Jean Ier, duc de Brabant, à Philippe III, roi de France, durant les expéditions ibériques (1276–1285)." *Revue du Nord* 78 (1996): 7–33.

Bornstein, Christine, and Priscilla P. Soucek, eds. *The Meeting of Two Worlds: The Crusades and the Mediterranean Context.* Ann Arbor: The University of Michigan Museum of Art, 1981.

Borrelli de Serres, Léon L. "Compte d'une mission de prédication pour secours à la Terre Sainte (1265)." *Mémoires de la société de l'histoire de Paris et de l'Ile-de-France* 30 (1903): 243–80.

Bowie, Theodore, ed. *The Sketchbook of Villard of Honnecourt.* 2d ed. Bloomington: Indiana University Press, 1959.

Brady, L. "Essential and Despised: Images of Women in the First and Second Crusades, 1095–1148." Master's thesis, University of Windsor, 1992.

Branner, Robert. *Manuscript Painting in Paris during the Reign of Saint Louis.* Berkeley: University of California Press, 1977.

Braun, Joseph. "Die Paramente im Schatz der Schwestern U. L. Frau Namur." *Zeitschrift für Christliche Kunst* 19 (1907): cols. 289–304.

Breckenridge, James D. "Drawing of Job and His Family Represented as Heraclius and his Family." In *Age of Spirituality: Late Antique and Early Christian Art, Third to Seventh Century,* edited by Kurt Weitzmann, 35–36. New York: The Museum, 1979.

Brenk, Beat. "The Sainte-Chapelle as a Capetian Political Program." In *Artistic Integration in Gothic Buildings,* edited by Virginia C. Raguin, Kathryn Brush, and Peter Draper, 195–213. Toronto: University of Toronto Press, 1995.

Brisch, Klaus, et al. *Islamische Kunst in Berlin: Katalog, Museum für Islamische Kunst, Staatliche Museen Preussischer Kulturbesitz.* Berlin: B. Hessling, 1971.

Brundage, James A. *Medieval Canon Law and the Crusader.* Madison: University of Wisconsin Press, 1969.

Bruyn, Cornelis de. *Voyage au Levant.* Delft: H. de Kroonevelt, 1700.

Buchthal, Hugo. "Hector's Tomb." In *De Artibus Opuscula, XL: Essays in Honor of Erwin Panofsky,* edited by Millard Meiss, 1:29–36. New York: New York University Press, 1961.

———. *Historia Troiana: Studies in the History of Medieval Secular Illustration.* London: Warburg Institute, University of London, 1971.

———. *Miniature Painting in the Latin Kingdom of Jerusalem.* Oxford: Clarendon Press, 1957.

Buckton, David, ed. *Byzantium: Treasures of Byzantine Art and Culture from British Collections.* Exh. cat. London: British Museum Press, 1994.

Bulst-Thiele, Marie Luise. *Sacrae Domus Militiae Templi Hierosolymitani Magistri.* Göttingen: Vandenhoeck und Ruprecht, 1974.

Bumke, Joachim. *Courtly Culture: Literature and Society in the High Middle Ages.* Berkeley: University of California Press, 1991.

Burgoyne, Michael. *Mamluk Jerusalem: An Architectural Study.* London: World of Islam Festival Trust, 1987.

Bustron, Florio. *Chronique de l'Île de Chypre.* Edited by René de Mas-Latrie. Paris, 1886.

Cahen, Claude. *Orient et Occident au temps des Croisades.* Paris: Aubier Montaigne, 1983.

———. *La Syrie du nord.* Paris: Paul Geuthner, 1940.

Cahn, Walter. *Romanesque Manuscripts: The Twelfth Century.* Exh. cat. A Survey of Manuscripts Illuminated in France. London: H. Miller, 1996.

Calò Mariani, Maria Stella, and Raffaella Cassano, eds. *Federico II e l'Italia: percorsi, luoghi, segni e strumenti.* Rome: Edizióni de Luca-Editalia, 1995.

Camille, Michael. *Mirror in Parchment: The Luttrell Psalter and the Making of Medieval England.* London: Reaktion Books, 1998.

Camporesi, Piero. "Two Faces of Time." In *The Magic Harvest: Food, Folklore and Society,* translated by Joan Krakover Hall, 35–50. Cambridge, Mass.: Polity Press, 1993.

Caplat, Jean. *Histoire de Blois.* Blois, 1954.

Carlvant, Kerstin B. E. "Thirteenth-century Illumination in Bruges and Ghent." Ph.D. diss., Columbia University, 1978.

Carolus-Barré, Louis. "Les enquêtes pour la canonisation de Saint Louis—de Grégoire X à Boniface VIII—et la bulle *Gloria laus,* du 11 Août 1297." *Revue de l'histoire de l'église de France* 57 (1971): 19–29.

Carr, Annemarie Weyl. *Byzantine Illumination, 1150–1250: The Study of a Provincial Tradition.* Studies in Medieval Manuscript Illumination, 47. Chicago: University of Chicago Press, 1987.

———. "Icon-Tact: Byzantium and the Art of Cilician Armenia." In *Treasures in Heaven: Armenian Art, Religion, and Society,* edited by Thomas Mathews and Roger Wieck, 73–102. New York: The Pierpont Morgan Library, 1998.

———. "Italians and Byzantines on Cyprus: Images from Art." *Dumbarton Oaks Papers* 49 (1995): 339–57.

Carr, Annemarie Weyl, and Laurence J. Morrocco. *A Byzantine Masterpiece Recovered: The Thirteenth-Century Murals of Lysi, Cyprus.* Austin: University of Texas Press / Menil Foundation, 1991.

Cassius Dio Cocceianus. *Roman History.* Translated by Earnest Cary on the basis of the version of Herbert B. Foster. Loeb Classical Library Series, 6. Cambridge, Mass.: Harvard University Press, 1969.

Chambers, Frank. "Some Legends Concerning Eleanor of Aquitaine." *Speculum* 16 (1941): 459–68.

Chatzepsaltes, Costas. "To anekdoto Keimeno tou Alexandrinou Kodikos 176 (366): Paradoseis kai Historia tes Mones Kykkou." *Kypriakai Spoudai* 14 (1950): 39–69.

Chazaud, Alphonse-Martial, ed. "Inventaire et comptes de la succession d'Eudes, comte de Nevers (Acre 1266)." *Mémoires de la Société Nationale des Antiquaires de France* 32 (1870): 164–206.

Chronicon Magni Presbyteri. Edited by Wilhelm Wattenbach. Monumenta Germaniae historica: scriptores, 17. Hanover, 1861.

Chronica regia coloniensis. Edited by Georg Waitz. MGH ScriptRerGerm, 18. Hanover, 1880.

Chrysostomos, His very Reverence the Abbot of Kykko. *The Holy, Royal Monastery of Kykko founded with a Cross.* Limassol: Kykko Monastery, 1969.

Cicero. *De Natura Deorum: Academica.* Translated by Harris Rackham. Loeb Classical Library Series, 19. Cambridge, Mass.: Harvard University Press, 1956.

Ciggaar, Krijne, Adelbert Davids, and Herman Teule, eds. *East and West in the Crusader States: Context—Contacts—Confrontations.* Orientalia Louvaniensia Analecta, 75. Leuven: Peeters, 1996.

Clement IV. *Registre.* Edited by Edouard Jordan. Paris, 1893–1945.

Coarelli, Filippo. *Guida Archeologica di Roma.* Verona: A. Mondadori, 1974.

Cockerell, Sydney C., and John Plummer. *Old Testament Miniatures.* New York: George Braziller, 1969.

Cole, Penny J. *The Preaching of the Crusades to the Holy Land, 1095–1270.* Cambridge, Mass.: Medieval Academy of America, 1991.

Constans, Leopold, ed. *Le roman de Troie.* 6 vols. Paris: Firmin Didot, 1904–22.

Constantine Porphyrogennetos: Three Treatises on Imperial Military Expeditions. Edited and translated by John F. Haldon. Vienna, 1990.

Constantinides, Costas N. *He* Diegesis *tes thaumatourges Eikonas tes Theotokou Eleousas tou Kykkou.* Peges tes Historias tes Hieras Mones Kykkou, 4. Nicosia: Kentro Meleton Hieras Mones Kykkou, 2002.

Conti, Alessandro. *La miniature Bolognese: scuole e botteghe, 1270–1340.* Bologna: Edizióne ALFA, 1981.

Corbo, Virgilio. *Il Santo Sepolcro di Gerusalemme: aspetti archeologici dalle origini al periodo crociato.* 3 vols. Jerusalem: Franciscan Print. Press, 1981–82.

Cormack, Robin. *Writing in Gold: Byzantine Society and its Icons.* London: George Philip, 1985.

Cormack, Robin, and Ernest J. W. Hawkins. "The Mosaics of St. Sophia at Istanbul: The Rooms above the Southwest Vestibule and Ramp." *Dumbarton Oaks Papers* 31 (1977): 175–251.

Cormack, Robin, and Stavros Mihalarias. "A Crusader Painting of St George: 'Maniera greca' or 'Lingua Franca'?" *Burlington Magazine* 126 (1984): 132–41.

Cornu, Georgette. *Atlas du monde arabo-islamique à l'époque classique.* Leiden: E. J. Brill, 1985.

Cornut, Gautier. *Historiae susceptionis Coronee spinee.* In *Exuviae Sacrae Constantinopolitanae,* edited by C. de Riant, 1:45–56. Geneva, 1877.

Corrie, Rebecca W. "The Antiphonaries of the Conradin Bible Atelier and the History of the Franciscan and Augustinian Liturgies." *Journal of the Walters Art Gallery* 51 (1993): 65–88.

———. "The Conradin Bible, MS. 152, the Walters Art Gallery: Manuscript Illumination in a Thirteenth-Century Italian Atelier." Ph.D. diss., Harvard University, 1986.

———. "The Conradin Bible and the Problem of Court Ateliers in Southern Italy in the Thirteenth Century." In *Intellectual Life at the Court of Frederick II Hohenstaufen,* edited by William Tronzo, 16–39. Studies in the History of Art, 44. Washington, D.C.: National Gallery of Art, 1994.

————. "The Conradin Bible: Since 'Since de Ricci.'" *Journal of the Walters Art Gallery* 40 (1982): 13–24.

Cosmas Indicopleustès. *Topographie chrétienne.* Edited by Wanda Wolska-Conus. Sources Chrétiennes, 159. Paris: Les Éditions du Cerf, 1970.

Coulter, Cornelia C. "The Library of the Angevin Kings at Naples." *Transactions and Proceedings of the American Philological Association* 75 (1944): 141–55.

Coureas, Nicholas, and Jonathan Riley-Smith, eds. *He Kypros kai hoi Stavrophories: Cyprus and the Crusades.* Nicosia: Cyprus Research Centre, 1995.

Courtoy, Ferdinand. *Le trésor du Prieuré d'Oignies aux soeurs de Notre-Dame à Namur et l'oeuvre du Frère Hugo.* Brussels: Editions de la librairie Encyclopèdique, 1953.

Critchley, John. *Marco Polo's Book.* London: Variorum, Ashgate, 1992.

Cutler, Anthony. "Gifts and Gift Exchange as Aspects of the Byzantine, Arab and Related Economies." *Dumbarton Oaks Papers* 55 (2001): 247–78.

————. "The Industries of Art." In *The Economic History of Byzantium: From the Seventh through the Fifteenth Century,* edited by Angeliki E. Laiou, 2:555–87. Washington, D.C.: Dumbarton Oaks, 2002.

da Canal, Martin. *Les estoires de Venise: cronaca veneziana in lingua francese dalle origini al 1275.* Edited by Alberto Limentani. Florence: Leo S. Olschki Editore, 1972.

Dalli Regoli, Gigetta. "Il salterio di San Giovanni d'Acri della Riccardiana di Firenze." In *Federico II: immagine e potere,* edited by Maria Stella Calò Mariani and Raffaella Cassano, 440–45. Venice: Marsilio Editori, 1995.

Daneu Lattanzi, Angela. "Una 'Bella Copia' di al-Hāwī tradotto dall'arabo da Farag Moyse per Carlo I d'Angiò (Ms. Vat. Lat. 2398–2399)." In *Miscellanea di studi in memoria di Anna Saitta Revignas,* 149–69. Biblioteca di bibliografia italiana, 86. Florence: Leo S. Olschki, 1978.

————. *Lineamenti di storia della miniatura in Sicilia.* Florence: Leo S. Olschki, 1968.

Dante Alighieri. *The Divine Comedy.* Translated, with a commentary by Charles S. Singleton. Bollingen Series, 80. Princeton: Princeton University Press, 1970.

Davis, Michael. "Masons and Architects as Travelers." In *Trade, Travel, and Exploration in the Middle Ages,* edited by John B. Friedman and Kristen Mossler Figg, 350–82. New York: Garland, 2000.

Dean, Bashford. "The Exploration of a Crusaders' Fortress (Montfort) in Palestine." *Bulletin of the Metropolitan Museum of Art, New York* 22 (1927): 91–97.

Degenhart, Bernhard, and Annegrit Schmidt. *Corpus der Italianischen Zeichnungen, 1300–1450.* Berlin: Mann, 1980.

————. "Frühe angiovinische Buchkunst in Neapel: Die Illustrierung französischer Unterhaltungsprosa in neapolitanischen Scriptorien zwischen 1290 und 1320." In *Festschrift Wolfgang Braunfels,* edited by Friedrich Piel and Jörg Traeger, 71–92. Tübingen: Verlag Ernst Wasmuth, 1978.

de Hamel, Christopher. *A History of Illuminated Manuscripts.* 2d ed. London: Phaidon Press Limited, 1994.

de Heusch, Luc. "Introduction à une ritologie générale." In *L'unité de l'homme: pour*

une anthropologie fondamentale, edited by Edgar Morin and Massimo Piattelli-Palmarini, 679–87. Paris: Éditions du Seuil, 1974.

Deichmann, Friedrich W. *Ravenna: Hauptstadt des spätantiken Abendlandes*. Wiesbaden: F. Steiner, 1969 and 1976.

Delaval Cobham, Claude. *Excerpta Cypria: Materials for a History of Cyprus*. Cambridge: Cambridge University Press, 1908.

Delaville Le Roulx, Joseph. *Cartulaire général de l'ordre des Hospitaliers de St-Jean de Jérusalem (1100–1310)*. 4 vols. Paris: E. Leroux, 1894–1906.

Delbrück, Richard. *Die Consulardiptychen und verwandte Denkmäler*. Studien zur spätantiken Kunstgeschichte, 2. Berlin: W. de Gruyter, 1929.

Demus, Otto. *The Mosaics of Norman Sicily*. London: Routledge & Kegan Paul, 1950.

de Rachewiltz, Igor. *Prester John and Europe's Discovery of East Asia*. Canberra: Australian National University Press, 1972.

Derbes, Anne. "Crusading Ideology and the Frescoes of S. Maria in Cosmedin." *Art Bulletin* 77 (1995): 460–78.

———. "Siena and the Levant in the Later Dugento." *Gesta* 28 (1989): 190–204.

de Riant, C. *Des dépouilles religieuses enlevées à Constantinople par les Latins*. Mémoires de la Société nationale des Antiquaires de France, 36. Paris: Imprimerie Gouverneur, 1875.

———. *Exuviae Sacrae Constantinopolitanae*. Geneva, 1877.

Der Nersessian, Sirarpie. *Miniature Painting in the Armenian Kingdom of Cilicia from the Twelfth to the Fourteenth Century*. 2 vols. Washington, D.C.: Dumbarton Oaks, 1993.

de Visser-van Terwisga, Marijke, ed. *Histoire ancienne jusqu'à César (Estoires Rogier)*. 2 vols. Orleans: Paradigme, 1999.

Devos, Paul. "Les premières versions occidentales de la légende de Saïdnaia." *Analecta Bollandiana* 65 (1947): 245–78.

Dickinson, John C. *The Shrine of Our Lady of Walsingham*. Cambridge: Cambridge University Press, 1956.

Digard, Georges. *Philippe le Bel et le Saint-Siège*. 2 vols. Paris: Librairie du Recueil Sirey, société anonyme, 1936.

DiMarco, Vincent. "The Amazons and the End of the World." In *Discovering New Worlds: Essays on Medieval Exploration and Imagination*, edited by Scott D. Westrem, 69–90. Garland Medieval Casebooks, 2. Garland Reference Library in the Humanities, 1436. New York: Garland, 1991.

Dimier, M.-Anselme, and Jean Porcher. *L'art cistercien*. Paris: Zodiaque, 1962.

Diringer, David. *The Illuminated Book: Its History and Production*. Rev. ed. New York: Frederick A. Praeger, 1967.

Dodwell, Charles R. *Painting in Europe, 800–1200*. Harmondsworth, Eng.: Penguin Books, 1971.

duBois, Page. *Centaurs and Amazons: Women and the Pre-History of the Great Chain of Being*. Ann Arbor: University of Michigan Press, 1982.

Duby, Georges. *France in the Middle Ages, 987–1460: From Hugh Capet to Joan of Arc.* Oxford: Blackwell Publishers Limited, 1987.

Dufresne, Laura. "Woman Warriors: A Special Case from the Fifteenth Century." *Women's Studies* 23 (1994): 120–31.

Dulière, Cécile. *La mosaique des Amazones.* Brussels: Centre belge de recherches archéologiques à Apamée de Syrie, 1968.

Dunbabin, Jean. *Charles I of Anjou: Power, Kingship and State-Making in Thirteenth-Century Europe.* London: Addison Wesley Longman Limited, 1998.

Dunbabin, Katherine M. D. *The Mosaics of Roman North Africa: Studies in Iconography.* Oxford: Clarendon Press, 1978.

Ebel, Friedrich, Andreas Fijal, and Gernot Kocher. *Römisches Rechtsleben im Mittelalter: Miniaturen aus den Handschriften des Corpus iuris civilis.* Heidelberg: C. F. Müller Juristischer Verlag, 1988.

Edbury, Peter W. "Cyprus and Genoa: The Origins of the War of 1373–1374." In *Praktika tou deuterou diethnous kyprologikou Synedriou,* 2:109–26. 3 vols. in 4. Nicosia: Hetaireia Kypriakon Souden, 1986.

———. *The Kingdom of Cyprus and the Crusades, 1191–1374.* Cambridge: Cambridge University Press, 1991.

———. *William of Tyre: Historian of the Middle East.* Cambridge: Cambridge University Press, 1988.

Edbury, Peter W., and Jaroslav Folda. "Two Thirteenth Manuscripts of Crusader Legal Texts from Saint-Jean d'Acre." *Journal of the Warburg and Courtauld Institutes* 57 (1994): 243–54.

Edbury, Peter W., and David M. Metcalf, eds. *Coinage in the Latin East: The Fourth Symposium on Coinage and Monetary History.* British Archaeological Reports, International Series, 77. Oxford: B.A.R., 1980.

Edwards, Robert. *The Fortifications of Armenian Cilicia.* Washington, D.C.: Dumbarton Oaks, 1987.

Ellenblum, Ronnie. *Frankish Rural Settlement in the Latin Kingdom of Jerusalem.* Cambridge: Cambridge University Press, 1998.

Enderlein, Lorenz. *Die Grablegen des Hauses Anjou in Unteritalien: Totenkult und Monumente 1266–1343.* Worms: Wernersche Verlagsgesellschaft, 1997.

Enlart, Camille. *Gothic Art and the Renaissance in Cyprus.* Translated and edited by David Hunt. London: Trigraph / A. G. Leventis Foundation, 1987.

———. *Les monuments des croisés dans le royaume de Jérusalem: architecture religieuse et civile.* 2 vols. Paris: P. Geuthner, 1925–28.

L'État Angevin: pouvoir, culture et société entre XIIIe et XIVe siècle. Actes du Colloque international organisé par l'American Academy in Rome, et al "Federico II" Rome-Naples, 7–11 novembre 1995. Rome: Ecole française de Rome & Istituto storico italiano per il Medio Evo, 1998.

Evans, Helen C., and William W. Wixom, eds.. *The Glory of Byzantium: Art and Culture of the Middle Byzantine Era, A.D. 843–1261.* Exh. cat. New York: The Metropolitan Museum of Art, 1997.

Evergates, Theodore. *Feudal Society in the Bailliage of Troyes under the Counts of Champagne, 1152–1284*. Baltimore: Johns Hopkins University Press, 1975.

Favier, Jean. *Philippe le Bel*. Paris: Fayard, 1978.

Favreau-Lilie, Marie-Luise. "Die italienischen Kirchen im Heiligen Land (1098–1291)." *Studi veneziani* n.s. 13 (1987): 15–101.

———. "The Military Orders and the Escape of the Christian Population from the Holy Land in 1291." *Journal of Medieval History* 19 (1993): 201–27.

Fergusson, Peter. "The Refectory at Easby Abbey: Form and Iconography." *Art Bulletin* 71 (1989): 334–51.

Ferrante, Joan M. "Women's Role in Latin Letters." In *The Cultural Patronage of Medieval Women*, edited by June Hall McCash, 73–104. Athens: University of Georgia Press, 1996.

Filangieri, Riccardo, et al. *I registri della cancelleria angioina*. 30 vols. Naples: L'Accademia, 1950–71.

Finucane, Ronald C. *Soldiers of the Faith: Crusaders and Moslems at War*. New York: St. Martin's Press, 1983.

Fitchen, John. *The Construction of Gothic Cathedrals*. Chicago: University of Chicago Press, 1961.

Folda, Jaroslav. *The Art of the Crusaders in the Holy Land, 1098–1187*. Cambridge: Cambridge University Press, 1995.

———. "Crusader Frescoes at Crac des Chevaliers and Marqab Castle." *Dumbarton Oaks Papers* 36 (1982): 177–210.

———. *Crusader Manuscript Illumination at Saint-Jean d'Acre, 1275–1291*. Princeton: Princeton University Press, 1976.

———. "The Freiburg Leaf: Crusader Art and *Loca Sancta* around the Year 1200." In *The Experience of Crusading*. Vol. 2. *Defining the Crusader Kingdom*, edited by Peter Edbury and Jonathan Phillips, 113–34. Cambridge: Cambridge University Press, 2003.

———. "The Hospitaller Master in Paris and Acre: Some Reconsiderations in Light of New Evidence." *Journal of the Walters Art Gallery* 54 (1996): 51–59, 269–272.

———. *The Nazareth Capitals and the Crusader Shrine of the Annunciation*. University Park: Pennsylvania State University Press, 1986.

———. "A Twelfth-Century Prayerbook for the Queen of Jerusalem." *Medieval Perspectives* 8 (1993): 1–12.

Folda, Jaroslav, ed. *Crusader Art in the Twelfth Century*. British Archaeological Reports, International Series, 152. Oxford: B.A.R., 1982.

Folena, Gianfranco. "La Romània d'Oltremare: francese e veneziano nel Levante." In *Culture e lingue nel Veneto medievale*, 269–86. Padua: Editoriale Programma, 1990.

Forey, Alan J. "The Military Order of St Thomas of Acre." *English Historical Review* 92 (1977): 481–503.

Foucault, Michel. *The Essential Works of Foucault, 1954–1984*. Vol. 3. *Power*. Edited by James D. Faubion. New York: New Press, 2000.

France, John, and William G. Zajac, eds. *The Crusades and their Sources: Essays Presented to Bernard Hamilton*. Aldershot: Ashgate, 1998.

François, Véronique. "Une illustration des romans courtois: la vaisselle de table chypriote sous l'occupation franque." *Cahiers du Centre d'études chypriotes* 29 (1999): 59–80.

―――. "Sur la circulation des céramiques byzantines en Méditerranée orientale et occidentale." In *La céramique médiévale en Méditerranée*, 231–55. Aix-en-Provence: Narration Éditions, 1997.

Frantz, M. Alison. "Akritas and the Dragons." *Hesperia* 10 (1941): 9–13.

Frazer, Richard M. Jr., trans. *The Trojan War: The Chronicles of Dictys of Crete and Dares the Phrygian.* Bloomington: Indiana University Press, 1966.

Friedman, John B. *The Monstrous Races in Medieval Art and Thought.* Cambridge, Mass.: Harvard University Press, 1981.

―――. "Thomas of Cantimpré, *De Naturis Rerum:* Prologue, Book III, and Book XIX." In *La science de la nature: theories et pratiques.* Cahiers d'études mediévales, 2. Montreal: Bellarmin, 1974.

Friedman, John B., and Kristen Mossler Figg, eds. *Travel, Trade, and Exploration in the Middle Ages: An Encyclopedia.* New York: Garland, 2000.

Frolow, A. *Les reliquaires de la vraie croix.* Paris: Institut français d'études byzantines, 1965.

Fulcher of Chartres. *Historia Hierosolymitana (1095–1127).* Edited by Heinrich Hagenmeyer. Heidelberg: Carl Winters Universitätsbuchhandlung, 1913.

―――. *A History of the Expedition to Jerusalem, 1095–1127.* Knoxville: University of Tennessee Press, 1969.

Gabriel, Albert. *Monuments turcs d'Anatolie.* Vol. 1. Paris: E. de Boccard, 1931.

Gates, Marie-Henriette. "1997 Archaeological Excavations at Kinet Höyük (Yeşil-Dörtyol, Hatay)." *20. Kazı Sonuçları Toplantısı.* Vol. 1 (Ankara: Ministry of Culture, 1999): 259–81.

―――. "1998 Excavations at Kinet Höyük (Yeşil-Dörtyol, Hatay)." *21. Kazı Sonuçları Toplantısı.* Vol. 1 (Ankara: Ministry of Culture, 2000): 193–208.

Gatien-Arnoult, Adolphe Félix, ed. *Las flors del gay saber* estier dichas *Las leys d'amors.* Toulouse: Privat, 1849[?].

Gautier d'Arras. *Eracle.* Edited by Guy Raynaud de Lage. Les classiques français du Moyen Age. Paris: Champion, 1976.

Georgopoulou, Maria. "Orientalism and Crusader Art: Constructing a New Canon." *Medieval Encounters: Jewish, Christian and Muslim Culture in Confluence and Dialogue* 5 (1999): 289–321.

Gerlitz, Iris. "'The King is Dead—Long live the King': The Representations of Death and Appointment of Crusader Kings in the *Eracles* Manuscripts Produced in Acre" (in Hebrew). Master's thesis, The Hebrew University, Jerusalem, 2000.

Gesta Dei per Francos. Edited by Jacques Bongars. 2 vols. Hannau, 1611.

Gesta Francorum et aliorum Hierosolimitanorum. Edited by Louis Bréhier. 2d ed. Paris: Les Belles Lettres, 1964.

Les gestes des chiprois: recueil des chroniques francaises ecrites en Orient aux XIIIe et XIVe siecles. Edited by Gaston Raynaud. Geneva: Jules-Guillaume Fick, 1887.

Gierlichs, Joachim. *Mittelalterliche Tierreliefs in Anatolien und Mesopotamien*. Tübingen: Ernst Wasmuth Verlag, 1996.

Goitein, Shlomo D. *A Mediterranean Society: The Jewish Communities of the Arab World as Portrayed in the Documents of the Cairo Geniza*. Berkeley: University of California Press, 1967–88.

Goodich, Michael, Sophia Menache, and Sylvia Schein, eds. *Cross Cultural Convergences in the Crusader Period: Essays Presented to Aryeh Grabois on his Sixty-Fifth Birthday*. New York: Verlag Peter Lang, 1995.

Gorin-Rozen, Yael. "Excavation of the Courthouse Site at 'Akko: Medieval Glass Vessels (Area TA)." *'Atiqot* 31 (1997): 75–85.

Goss, Vladimir P., and Christine Verzar Bornstein, eds. *The Meeting of Two Worlds: Cultural Exchange between East and West during the Period of the Crusades*. Kalamazoo, Mich.: Medieval Institute Publications, 1986.

Grabar, André. *L'iconoclasme byzantin: dossier archéologique*. Paris: College de France, 1957.

Grabar, Oleg. *The Mediation of Ornament*. Princeton: Princeton University Press, 1992.

Gratziou, Olga. "Metamorphoseis mias thaumatourges Eikonas: Semeioseis stis opsimes Parallages tes Panagias tou Kykkou." *Deltion tes christianikes archaiologikes Hetaireias*, 4 (1993–94): 317–29, English summary 330.

Grimal, Pierre. "Le dieu Janus et les origines de Rome." *Lettres d'humanité* 4 (1945): 15–121.

Guerrero Lovillo, José. *Las Cántigas: estudio arqueológico de sus miniatures*. Madrid: Consejo Superior de investigaciones científicas. Istituto Diego Velazquez—Sección de Sevilla, 1949.

Guiraud, Jean, and Léon Cadier, eds. *Les registres de Grégoire X (1271–1276) et de Jean XXI (1276–1277): recueil des bulles de ces papes*. Paris, 1892–1960.

Gunnis, Rupert. *Historic Cyprus*. London: Methuen and Co., Ltd., 1936.

Hackett, John. *A History of the Orthodox Church of Cyprus*. London: Methuen and Co., Ltd., 1901.

Hahnloser, Hans R. *Villard de Honnecourt: Kritische Gesamtausgabe des Bauhüttenbuches, ms. fr. 19093 der Pariser Nationalbibliotek*. 2d ed. Graz: Akademische Druck- und Verlagsanstalt, 1972.

Hallam, Elizabeth, ed. *Chronicles of the Crusades*. New York: Weidenfeld and Nicolson, 1989.

Hamilton, Bernard. *The Latin Church in the Crusader States: The Secular Church*. London: Variorum Publications, 1980.

———. "Prester John and the Three Kings of Cologne." In *Studies in Medieval History Presented to R. H. C. Davis*, edited by Henry Mayr-Harting and R. I. Moore, 177–91. London: Hambledon Press, 1985.

———. "Women in the Crusader States: The Queens of Jerusalem (1100–1190)." In *Medieval Women*, edited by Derek Baker, 143–74. Studies in Church History, Subsidia,1. Oxford: Blackwell, 1978.

al-Hassan, Ahmad Y., and Donald R. Hill. *Islamic Technology: An Illustrated History.* Cambridge: Cambridge University Press, 1986.

Hastal, Moshe, Edna J. Stern, et al. "'Akko (Acre): Excavation Reports and Historical Studies." *'Atiqot* 31 (1997): 1–207.

Hatcher, Anna G. "Marcabru's *A la fontana del vergier.*" *Modern Language Notes* 79 (1964): 284–95.

Haussherr, Reiner. *Bible moralisée (Österreichische Nationalbibliothek, Mss. 2554).* Codices Selecti, 40. Graz: Akademische Druck- und Verlagsanstalt, 1973.

———. "Ein Pariser martyrologischer Kalender der 1. Hälfte der 13. Jahrhunderts." In *Festschrift Matthias Zender,* edited by Ennen and Günter Wiegelmann, 1076–103. Bonn: Ludwig Röhrscheid Verlag, 1972.

Hazard, Harry W., ed. *A History of the Crusades.* Vol. 4. *The Art and Architecture of the Crusader States.* Madison: University of Wisconsin Press, 1977.

Hedeman, Anne D. *The Royal Image: Illustrations of the Grandes Chroniques de France, 1274–1422.* Berkeley: University of California Press, 1991.

Heintze, Helga von. "Ein spätantikes Mädchenporträt in Bonn: Zur stilistischen Entwicklung des Frauenbildnisses im 4. und 5. Jahrhundert." *Jahrbuch für Antike und Christentum* 14 (1971): 61–91.

Hellenkemper, Hansgerd. "Das wiedergefundene Issos." In *Aus dem Osten des Alexanderreiches,* edited by Jakob Ozols and Volker Thewalt, 43–50. Cologne: Dumont Buchverlag, 1984.

Hellenkemper, Hansgerd, and Friedrich Hild. *Neue Forschungen in Kilikien.* Vienna: Verlag der Österreichischen Akademie der Wissenschaften, 1986.

Hen, Yitzhak, ed. *De Sion exibit lex et verbum domini de Hierusalem: Essays on Medieval Law, Liturgy and Literature in Honour of Amnon Lindner.* Cultural Encounters in Late Antiquity and the Middle Ages. Turhout: Brepols, 2001.

Hendy, Michael. *Coinage and Money in the Byzantine Empire, 1081–1261.* Washington, D.C.: Dumbarton Oaks Center for Byzantine Studies, trustees for Harvard University, 1969.

Henriet, Jacques. "La Cathédrale Saint-Etienne de Sens: le parti du premier maître, et les campagnes du XIIe siècle." *Bulletin Monumental* 140 (1982): 6–168.

Herodotus. *The History.* Translated by David Grene. Chicago: University of Chicago Press, 1987.

Herzog zu Sachsen, Johann Georg. "Konstantin der Grosse und die hl. Helena in der Kunst des christlichen Orients." In *Konstantin der Grosse und seine Zeit: Gesammelte Studien,* edited by Franz Dölger, 257–58. Supplementheft der Römischen Quartalschrift, 19. Freiburg, 1913.

Heyd, Wilhelm. *Histoire du commerce du Levant au moyen âge.* Leipzig: Otto Harrassowitz, 1885–86.

Hiera Metropolis Morphou: 2000 Chonia Technes kai Hagiotetas. Exh. cat. Nicosia: Cultural Foundation of the Bank of Cyprus and the Holy Archbishopric of Morphou, 2000.

Hiestand, Rudolf. "*Castrum Peregrinorum* e la fine del dominio crociato in Siria." In

Acri 1291: la fine della presenza degli ordini militari in Terra Santa e i nuovi orientamenti nel XIV secolo, edited by Francesco Tommasi, 23–41. Porta San Giovanni, Perugia: Quattroemme, 1996.

Hild, Friedrich, and Hansgerd Hellenkemper. *Tabula Imperii Byzantini*. Vol. 5. *Kilikien und Isaurien*. Vienna: Verlag der Österreichischen Akademie der Wissenschaften, 1990.

Hillenbrand, Carole. *The Crusades: Islamic Perspectives*. Chicago: Fitzroy Dearborn Publishers, 1999.

Hindman, Sandra. *Christine de Pizan's "Epistre d'Othea": Painting and Politics at the Court of Charles VI*. Toronto: Pontifical Institute of Mediaeval Studies, 1986.

———. "The Role of Author and Artist in the Procedure of Illustrating Late Medieval Texts." In *Text and Image*, edited by David W. Burchmore, 27–62. Binghamton: State University of New York Press, 1986.

Hinz, Walther. *Islamische Masse und Gewichte*. Leiden: E. J. Brill, 1955.

Holt, Peter M. *The Age of the Crusades: The Near East from the Eleventh Century to 1517*. London: Longman, 1986.

Horatius. *Satires, Epistles, and Ars Poetica*. Translated by H. Rushton Fairclough. Loeb Classical Library Series. Cambridge, Mass.: Harvard University Press, 1966.

Horn, Elzear. *Iconographiae monumentorum Terrae Sanctae (1724–1744)*. With English version by Eugene Hoade and Preface and Notes by Bellarmino Bagatti. 2d ed. Jerusalem: Franciscan Press, 1962.

Housley, Norman J. "Charles II of Naples and the Kingdom of Jerusalem." *Byzantion* 54 (1984): 527–36.

———. *The Italian Crusades: The Papal-Angevin Alliance and the Crusades against Christian Lay Powers, 1254–1343*. Oxford: Clarendon Press, 1982.

———. *The Later Crusades*. Oxford: Oxford University Press, 1992.

Hunt, Lucy-Anne. "Art and Colonialism: The Mosaics of the Church of the Nativity in Bethlehem (1169) and the Problem of 'Crusader' Art." *Dumbarton Oaks Papers* 45 (1991): 69–85.

———. "A Woman's Prayer to St Sergios in Latin Syria: Interpreting a Thirteenth-Century Icon at Mount Sinai." *Byzantine and Modern Greek Studies* 15 (1991): 96–145.

Hutter, Irmgard, ed. *Byzanz und der Westen: Studien zur Kunst des europäischen Mittelalters*. Vienna: Österreichische Akademie der Wissenschaften, 1984.

Huygens, Robert B. C., ed. *Apologiae duae: Gozechini epistola ad Walcherum. Burchardi, ut videtur, abbatis Bellevalis Apologia de barbis*. Corpus Christianorum, Continuatio Mediaevalis, 62. Turnhout: Brepols, 1985.

———. *De constructione castri Saphet*. Amsterdam: North-Holland, 1981.

———. *Peregrinationes tres: Saewulf, John of Würzburg, Theodericus*. Turnholt: Brepols, 1994.

Ibn al-Furāt. *Tārīkh al-Duwal wa'l Mulūk*. Edited and translated by Ursula and Malcolm C. Lyons, *Ayyubids, Mamlukes and Crusaders: Selections from the Tarikh al Duwal wa'l Muluk of Ibn Furat*. 2 vols. Cambridge: W. Heffer and Sons, 1971.

Ibn Jubayr. *The Travels of Ibn Jubayr*. Translated by Ronald J. C. Broadhurst. London: Jonathan Cape, 1952.

Ibn Shaddād, 'Izz al-Dīn. *Al-A'lāq al-Khaṭīra*. Edited and translated by Anne-Marie Eddé-Terrasse, *Description de la Syrie du Nord*. Damascus: Institut Français, 1984.

Impruneta: una pieve, un paese. Convegno di studi "Impruneta: una pieve, un paese" (Impruenta, 1982). Florence: Salimbeni, 1983.

Iorga, Nicholas. *Philippe de Mézières 1327–1405 et la croisade au XIVe siècle*. Bibliothèque de l'Ecole des hautes études, sciences philosophiques et historiques, 110. Paris: Emile Bouillon, 1896.

Irwin, Robert. "The Image of the Byzantine and the Frank in Arab Popular Literature of the Late Middle Ages." *Mediterranean Historical Review* 4 (1989): 226–42.

al-Isfahanī, Imad al-Dīn. *Al-Fath al-qussī fi'l-fath al-Qudsī*. Translated by Henri Massé, *Conquête de la Syrie et de la Palestine par Saladin*. Paris: Paul Geuthner, 1972.

Itinéraires à Jérusalem et descriptions de la Terre Sainte. Edited by Henri Michelant and Gaston Raynaud. Geneva: Jules-Guillaume Fick, 1882.

Jacoby, David. "Byzantine Trade with Egypt from the Mid-Tenth Century to the Fourth Crusade." *Thesaurismata* 30 (2000): 25–77.

———. "La dimensione demografica e sociale." In *Storia di Venezia dalle origini alla caduta della Serenissima*. Vol. 2. *L'età del Comune*, edited by Giorgio Cracco and Gherardo Ortalli, 681–711. Rome: Istituto della Enciclopedia Italiana, 1995.

———. "Knightly Values and Class Consciousness in the Crusader States of the Eastern Mediterranean." *Mediterranean Historical Review* 1 (1986): 158–86.

———. "Migration, Trade and Banking in Crusader Acre." In *Balkania kai Anatolike Mesogeios, 120s–170s aiones* (The Balkans and the Eastern Mediterranean, 12th–17th Centuries), edited by Lenos Mavromatis, 105–19. Byzantium Today, 2. Athens: The National Hellenic Research Foundation, Institute for Byzantine Research, 1998.

———. *Recherches sur la Méditerranée orientale du XIIe au XVe siècle: peuples, sociétés, economies*. London: Variorum Reprints, 1979.

———. "Il ruolo di Acri nel pellegrinaggio a Gerusalemme." In *Il cammino di Gerusalemme*, edited by Maria Stella Calò Mariani, 25–44. Atti del II Convegno Internazionale di Studio (Bari-Brindisi-Trani, 18–22 maggio 1999). Rotte mediterranee della cultura, 2. Bari: Mario Adda Editore, 2002.

———. "Some Unpublished Seals from the Latin East." *Israel Numismatic Journal* 5 (1981): 83–88.

———. *Studies on the Crusader States and on Venetian Expansion*. Northampton: Variorum Reprints, 1989.

———. "Three Notes on Crusader Acre." *Zeitschrift des Deutschen Palästina-Vereins* 109 (1993): 83–96.

———. *Trade, Commodities and Shipping in the Medieval Mediterranean*. Aldershot: Variorum, Ashgate, 1997.

———. "The Trade of Crusader Acre in the Levantine Context: An Overview." *Archivio Storico del Sannio* n.s. 3 (1998): 103–20.

Jacques de Vitry. *Lettres*. Edited by Robert B. C. Huygens. Corpus Christianorum, Continuatio Mediaevalis, 171. Turnhout: Brepols, 2000.

Janin, Raymond. *Les eglises et les monastères des grands centres byzantins (Bithynie, Hellespont, Latros, Galèsios, Trébizonde, Athènes, Thessalonique)*. Paris: Institut français d'études byzantines, 1975.

John of Joinville. *L'histoire de Saint Louis: credo et lettre à Louis X*. Edited by Natalis de Wailly. Paris: Firmin Didot, 1874.

———. *The Life of Saint Louis*. In *Joinville and Villehardouin: Chronicles of the Crusades*, translated by Margaret R. B. Shaw. Harmondsworth: Penguin, 1963.

———. *Vie de Saint Louis*. Edited by Jacques Monfrin. Paris: Dunod, 1998.

Johns, C. N. "Medieval Slip-Ware from Pilgrim's Castle, 'Atlit, 1930–1." In *Pilgrims' Castle ('Atlit), David's Tower (Jerusalem), and Qal'at ar-Rabad ('Ajlun)*, edited by Denys Pringle, 136–44. Aldershot: Ashgate, 1997.

Jordan, Alyce A. "Narrative Design in the Stained Glass Windows of the Ste Chapelle in Paris." Ph.D. diss., Bryn Mawr College, 1994.

Jordan, A. *Visualizing Kingship in the Windows of the Sainte-Chapelle*. Turnhout: Brepols, 2002.

Jordan, W. "The Psalter of Saint Louis (BN MS lat. 10525): The Program of the Seventy-Eight Full Page Illustrations." In *Acta: The High Middle Ages*, vol. 7, edited by Penelope C. Mayo, 65–91. Binghamton: The Center for Medieval and Early Renaissance Studies, State University of New York, 1983.

Jordan, William C. *Louis IX and the Challenge of the Crusade: A Study in Rulership*. Princeton: Princeton University Press, 1979.

Joslin, Mary Coker. "A Critical Edition of the Genesis of Rogier's *Histoire ancienne* based on Paris, BN MS fr. 20125." Ph.D. diss., University of North Carolina, 1980.

———. *The Heard Word: A Moralized History. The Genesis Section of the Histoire Ancienne in a Text from Saint-Jean d'Acre*. Romance Monographs, 45. University, Miss.: Romance Monographs, Inc., 1986.

———. "The Illustrator as Reader: Influence of Text on Images in the *Histoire ancienne*." *Medievalia et Humanistica* n.s. 20 (1993): 85–121.

Kantorowicz, Ernst. *The King's Two Bodies: A Study in Medieval Political Theology*. Princeton: Princeton University Press, 1957.

Katzenstein, Ranee E., and Glenn D. Lowry. "Christian Themes in Thirteenth-Century Islamic Metalwork." *Muqarnas* 1 (1983): 53–68.

Kautzsch, R. "Die Herakliusbilder zu Fraurombach." In *Studien aus Kunst und Geschichte: Friedrich Schneider zum 70. Geburtstag*, edited by Joseph Sauer. Freiburg im Breisgau, 1906.

Kedar, Benjamin Z. *Crusade and Mission: European Approaches to the Muslims*. Princeton: Princeton University Press, 1984.

———. *The Franks in the Levant, 11th to 14th Centuries*. Aldershot: Variorum, Ashgate, 1993.

———. "On the Origins of the Earliest Laws of Frankish Jerusalem: The Canons of the Council of Nablus, 1120." *Speculum* 74 (1999): 310–35.

———. "The Outer Walls of Frankish Acre." *'Atiqot* 31 (1997): 157–80.

———. "Toponymic Surnames as Evidence of Origin: Some Medieval Views." *Viator* 4 (1973): 123–29.

Kedar, Benjamin Z., ed. *The Horns of Hattin*. Jerusalem: Israel Exploration Society / Yad Izhak Ben-Zvi Institute, 1992.

Kedar, Hans E. Mayer, Jonathan S. C. Riley-Smith, and Rudolf Hiestand. *Montjoie: Studies in Crusade History in Honour of Hans Eberhard Mayer*. Aldershot: Ashgate, 1997.

Kedar, Hans E. Mayer, and Raymond C. Smail, eds. *Outremer: Studies in the History of the Crusading Kingdom of Jerusalem, presented to Joshua Prawer*. Jerusalem: Yad Izhak Ben-Zvi Institute, 1982.

Kelly, Amy. *Eleanor of Aquitaine and the Four Kings*. Cambridge, Mass.: Harvard University Press, 1950.

Kessler, Herbert L. "Pictures as Scripture in Fifth-Century Churches." *Studia Artium Orientalis et Occidentalis* 2 (1985): 17–31.

Kiesewetter, Andreas. *Die Anfänge der Regierung König Karls II. von Anjou (1278–1295): Das Königreich Neapel, die Grafschaft Provence und der Mittelmeerraum zu Ausgang des 13. Jahrhunderts*. Husum: Matthiesen Verlag, 1999.

Kirsch, Wolfgang, ed. *Das Buch von Alexander dem edlen und weisen König von Makedonien, mit den Miniaturen der Leipziger Handschrift*. Leipzig: Reclam-Verlag, 1991.

Kitāb al-hadāyā wa al-Tuhaf. Translated by Ghada al-Hijjāwī al-Qaddūmī, *Book of Gifts and Rarities*. Cambridge, Mass.: Harvard University Press, 1996.

Kittell, Ellen E. *From Ad Hoc to Routine: A Case Study in Medieval Bureaucracy*. Philadelphia: University of Pennsylvania Press, 1991.

Kleinbaum, Abby W. *The War Against the Amazons*. New York: New Press, 1983.

Kofsky, Arieh, and Guy G. Stroumsa, eds. *Sharing the Sacred: Religious Contacts and Conflicts in the Holy Land, First–Fifteenth Centuries CE*. Jerusalem: Yad Izhak Ben Zvi, 1998.

Kosellef Gordon, Olga. "The Calendar Cycle of the Fécamp Psalter." In *Studien zur Buchmalerei und Goldschmiedekunst des Mittelalters: Festschrift für Karl Hermann Usener*, edited by Frieda Dettweiler, 209–24. Marburg: Verlag des Kunstgeschichtlichen Seminars der Universität Marburg, 1967.

Kötzsche, Dietrich. *Der Welfenschatz in Berliner Kunstmuseum*. Berlin, 1973.

Kourkoutidou-Nikolaidou, Eutychia, and A. Tourta. *Wandering in Byzantine Thessaloniki*. Athens: Kapon Editions, 1997.

Krautheimer, Richard. "Introduction to an 'Iconography of Medieval Architecture.'" In *Studies in Early Christian, Medieval, and Renaissance Architecture*, 115–50. New York: New York University Press, 1969.

Kühnel, Bianca. *Crusader Art of the Twelfth Century: A Geographical, an Historical, or an Art Historical Notion?* Berlin: Gebr. Mann Verlag, 1994.

Kühnel, Ernst. *Islamic Art and Architecture*. Ithaca, N.Y.: Cornell University Press, 1966.

Kühnel, Gustav. "Kreuzfahrerideologie und Herrscherikonographie: Das Kaiserpaar

Helena und Heraklius in der Grabeskirche." *Byzantinische Zeitschrift* 90 (1997): 396–404.

―――. "Das restaurierte Christusmosaik der Calvarienberg-Kapelle und das Bild-programm der Kreuzfahrer." *Römische Quartalschrift* 92 (1997): 45–71.

―――. *Wall Painting in the Latin Kingdom of Jerusalem*. Frankfurter Forschungen zur Kunst, 14. Berlin: Gebr. Mann Verlag, 1988.

Kupfer, Marcia. "The Lost *Mappamundi* at Chalivoy-Milon." *Speculum* 66 (1991): 540–71.

Kurz, Otto. "An Alleged Portrait of Hercalius." *Byzantion* 16 (1942–43): 162–64.

Kyriakes, Neokles G. *Historia tes hieras Mones Kykkou*. Larnaca: Chairmonides, 1949.

Laiou, Angeliki E., and Roy P. Mottahedeh, eds. *The Crusades from the Perspective of Byzantium and the Muslim World*. Washington, D.C.: Dumbarton Oaks, 2001.

Lane, Arthur. "Medieval Finds at Al Mina in North Syria." *Archaeologia* 87 (1938): 19–78.

Laporte, J.-L. "Tissus de Faremoutiers." In *L'Ile-de-France de Clovis à Hugues Capet, du Ve siècle au Xe siècle*, 112–13. Exh. cat. Musée Archéologique Départemental du Val-d'Oise et Service Régional de l'Archéologie d'Ile-de-France. Saint-Ouen-l'Aumône: Editions du Valhermeil, 1993.

Laurent, J.M.C., ed. *Peregrinatores Medii Aevi Quatuor: Burchardus de Monte Sion, Ricoldus de Monte Crucis, Odoricus de Foro Julii, Wilibrandus de Oldenborg*. Leipzig: J. C. Hinrichs Bibliopola, 1864.

Lavin, Irving. "The Hunting Mosaics of Antioch and their Sources: A Study of Compositional Principles in the Development of Early Medieval Style." *Dumbarton Oaks Papers* 17 (1963): 179–286.

Leaf, William, and Sally Purcell. *Heraldic Symbols: Islamic Insignia and Western Heraldry*. London: Victoria & Albert Museum, 1986.

Le Grand, L. "Relation du pèlerinage à Jérusalem de Nicolas de Martoni, notaire italien (1394–1395)." *Revue de l'Orient latin* 3 (1895): 566–669.

Leone de Castris, Pierluigi. *Arte di corte nella Napoli angioina*. Florence: Cantini, 1986.

Leroy, Jules. *Les manuscrits coptes et coptes-arabes illustrés*. Paris: P. Geuthner, 1974.

Le Strange, Guy. *Palestine under the Moslems*. Reprint, Beirut: Khayat's, 1965.

Leuridan, Théodore. *Les châtelains de Lille: cartulaire des châtelains de Lille*. Société des sciences, de l'agriculture et des arts de Lille. Memoires. 3d series. Lille, 1873.

Levi, Doro. *Antioch Mosaic Pavements*. 2 vols. Princeton: Princeton University Press, 1947.

Library of the Palestine Pilgrims Text Society. London: Committee of the Palestine Exploration Fund, 1897.

Ligato, Giuseppe. "Fra Ordine Cavallereschi e crociata: 'milites ad terminum' e 'confraternitates' armate." *Militia Christi e crociata nei secoli XI–XIII*, 645–97. Milan: Vita e pensiero, 1992.

Lilie, Ralph-Johannes. *Byzantium and the Crusader States, 1096–1204*. Translated by J. C. Morris and Jean E. Ridings. Oxford: Clarendon Press, 1993.

Lloyd, Seton, and David S. Rice. *Alanya (Alā'iyya)*. London: British Institute of Archaeology at Ankara, 1958.

Lloyd, Simon. *English Society and the Crusade, 1216–1307.* Oxford: Clarendon Press, 1988.

Lock, Peter. *The Franks in the Aegean.* London: Longman, 1995.

Loomis, Roger S. "The Heraldry of Hector or Confusion Worse Confounded." *Speculum* 42 (1967): 32–35.

Ludolph von Suchem. *Description of the Holy Land, and of the Way Thither, Written in 1350.* Translated by Aubrey Stewart. London: Palestine Pilgrim Text Society, 1895.

Lunt, William E. *Financial Relations of the Papacy with England.* 2 vols. Cambridge, Mass.: Medieval Academy of America, 1939–62.

Machilek, Franz. "Privatfrömmigkeit und Staatsfrömmigkeit." In *Kaiser Karl IV: Staatsmann und Mäzen,* edited by Ferdinand Seibt, 87–101. Exh. cat. Kaiserburg, Nürnberg, 1978. Munich: Prestelverlag, 1978.

Magdalino, Paul. *The Empire of Manuel I Komnenos, 1143–1180.* Cambridge: Cambridge University Press, 1993.

Maguire, Henry. *Art and Eloquence in Byzantium.* Princeton: Princeton University Press, 1981.

Makhairas, Leontios. *Recital Concerning the Sweet Land of Cyprus Entitled 'Chronicle'.* Translated and edited by R. M. Dawkins. 2 vols. Oxford: Clarendon Press, 1932.

al-Maqrīzī, Taqī al-Dīn Abū'l 'Abbās. *Kitāb al-Sulūk li-ma'rifat duwal al-mulūk.* Partially translated by R.J.C. Broadhurst, *A History of the Ayyūbid Sultans of Egypt.* Boston: Twayne Publishers, 1980.

Marco Polo. *The Travels.* Translated by Ronald Latham. London: Penguin, 1958.

Mark, Robert. *Experiments in Gothic Structure.* Cambrige, Mass.: MIT Press, 1982.

Marshak, Boris I. *Silberschätze des Orients: Metalkunst des 3.-13. Jahrhunderts und ihre Kontinuität.* Leipzig: Seemann, 1986.

———. "Zur Toreutik der Kreuzfahrer." In *Metallkunst von der Spätantike bis zum ausgehende Mittelalters,* edited by Arne Effenberger, 166–84. Berlin: Staatliche Museen zu Berlin, 1982.

Marshall, Christopher J. "The French Regiment in the Latin East, 1254–91." *Journal of Medieval History* 15 (1989): 301–7.

———. *Warfare in the Latin East, 1192–1191.* Cambridge: Cambridge University Press, 1992.

Mas Latrie, Louis de. "Guillaume de Machaut et la prise d'Alexandrie." *Bibliothèque de l'Ecole des chartes* 37 (1876): 1–26.

———. *L'Ile de Chypre: sa situation présente et ses souvenirs du Moyen-age.* Paris: Librairie de Firmin-Didot et Companie, 1879.

Mas Latrie, Louis de, ed. *Histoire de l'Île de Chypre sous le règne des princes de la maison de Lusignan.* 3 vols. Paris: Imprimerie Impériale, 1852–61.

Matthew Paris. *Chronica Majora.* Edited by Henry R. Luard. Rolls Series, 57. London: Longman, 1872–84.

Mathews, Thomas, and Annie-Christine Daskalakis Mathews. "Islamic-Style Mansions in Byzantine Cappadocia and the Development of the Inverted T-Plan." *Journal of the Society of Architectural Historians* 56 (1997): 294–315.

Mayer, Hans E. "Henry II of England and the Holy Land." *English Historical Review* 97 (1982): 721–39.

———. *Die Kanzlei der lateinischen Könige von Jerusalem.* Monumenta Germaniae historica: schriftes, 40. Hanover: Hahnsche Buchhandlung, 1996.

———. "Das Pontifikale von Tyrus und die Krönung der Lateinischen Könige von Jerusalem: Zugleich ein Beitrag zur Forschung über Herrschaftszeichen und Staatssymbolik." *Dumbarton Oaks Papers* 21 (1967): 143–232.

———. *Probleme des lateinischen Königreichs Jerusalem.* London: Variorum Reprints, 1983.

Mayer, Hans E., ed. Die Kreuzfahrerstaaten als multikulturelle Gesellschaft: Einwanderer und Minderheiten im 12. und 13. Jahrhundert. Kolloquien, 37. Munich: Schriften des Historischen Kollegs, 1997.

Mayer, Leo A. *Saracenic Heraldry.* Oxford: Clarendon Press, 1933.

McGee, J. David. "The 'Early Vaults' of Saint-Etienne at Beauvais." *Journal of the Society of Architectural Historians* 45 (1986): 20–31.

McLaughlin, Megan. "The Woman Warrior: Gender, Warfare and Society in Medieval Europe." *Women's Studies* 17 (1990): 193–209.

Megaw, Arthur H. S. "An Early Thirteenth-Century Aegean Glazed Ware." In *Studies in Memory of David Talbot Rice,* edited by Giles Robertson and George Henderson, 34–45. Edinburgh: Edinburgh University Press, 1975.

———. "Supplementary Excavations on a Castle Site at Paphos, Cyprus, 1970–1971." *Dumbarton Oaks Papers* 26 (1972): 323–43.

———. "Zeuxippus Ware." *Annual of the British School at Athens* 63 (1968): 67–88.

Menardos, Simos. *He en Kypro hiera Mone tes Panagias tou Makhaira.* Piraeus: n.p., 1929.

Metcalf, David M. *Coinage of the Crusades and the Latin East.* London: Royal Numismatic Society, 1995.

Meyer, Paul. "Les premières compilations françaises d'histoire ancienne." *Romania* 14 (1885): 1–81.

Micheau, Françoise. "Le crociate nella visione degli storici arabi di ieri e di oggi." In *Le Crociate: l'Oriente e l'Occidente da Urbano II a San Luigi, 1096–1270,* edited by Monique Rey-Delqué, 63–75. Exh. cat. Milan: Electa, 1997.

Michelet, Jules. *Le procès des Templiers.* 2 vols. Paris: Impr. royale, 1841–51.

Miklosich, Franz, and Iosephus Müller. *Acta et diplomata monasteriorum et ecclesiarum Orientis.* 6 vols. Vienna: Carolus Gerold, 1887.

Minervini, Laura. "Les contacts entre indigènes et croisés dans l'Orient latin: le rôle des drogmans." In *Romania arabica: Festschrift für Reinhold Kontzi zum 70. Geburtstag,* edited by Jens Jüdtke, 57–62. Tübingen: Gunter Narr Verlag, 1996.

———. "La lingua franca mediterranea: plurilinguismo, mistilinguismo, pidginizzazione sulle coste del Mediterraneo tra tardo medioevo e prima età moderna." *Medioevo Romanzo* 20 (1996): 231–301.

———. "Outremer." In *Lo spazio letterario del medioevo. 2. Il medioevo volgare,* vol. 1. *La produzione del testo,* tomo 2, edited by Piero Boitani, Mario Mancini, and Alberto Vàrvaro, 611–48. Rome: Salerno, 2001.

———. "Produzione e circolazione di manoscritti negli stati crociati: biblioteche e *scriptoria* latini." In *Medioevo romanzo e orientale: il viaggio dei testi*, edited by Antonio Pioletti and Francesca Rizzo Nervo, 79–86. III Colloquio internazionale Medioevo Romanzo e Orientale. Colloqui, 4. Soveria Mannelli: Rubbettino, 1999.

Minervini, Larua, ed. *Cronaca del Templare di Tiro (1243–1314): la caduta degli Stati Crociati nel racconto di un testimone oculare.* Naples: Liguori Editore, 2000.

Moennig, Ulrich. "Digenes = Alexander? The Relationships between *Digenis Akrites* and the Byzantine *Alexander Romance* in their Different Versions." In *Digenis Akrites: New Approaches to Byzantine Heroic Poetry*, edited by Roderick Beaton and David Ricks, 103–15. Brookfield, Vt.: Variorum, 1993.

Moffitt, John. "Medieval *Mappaemundi* and Ptolemy's *Chorographia*." *Gesta* 32 (1993): 59–68.

Molinier, Auguste, Emile Molinier, and Leopold Delisle. *La collection Spitzer.* Paris: Maison Quantin and Libraire Centrale, 1892.

Mommsen, Theodor, ed. *Res gestae divi Augusti: ex monumentis Ancyrano et Apolloniensi.* Berlin: Weidemann, 1865.

Morgan, Margaret R. *The Chronicle of Ernoul and the Continuations of William of Tyre.* Oxford: Oxford University Press, 1973.

Mostra storica nazionale della miniatura: Palazzo Venezia, Roma. Catalogue. 2d ed. Florence: Sansoni, 1954.

al-Mufazzal, ibn Abi 'l-Fazāil. *Histoire des sultans Mamlouks.* Edited and translated by Edgar Blochet. Patrologia orientalis, 14. Paris, 1920.

Müller, Matthias. "Paris, das neue Jerusalem? Die Ste-Chapelle als Imitation der Golgatha-Kapellen." *Zeitschrift für Kunstgeschichte* 59 (1996): 325–35.

Müller-Wiener, Wolfgang. *Castles of the Crusaders.* London: Thames & Hudson, 1966.

Muraro, Michelangelo, ed. *Componenti storico-artistiche e culturali a Venezia nei secoli XIII e XIV.* Venice: Ateneo Veneto, 1981.

Murphy, James J., ed. *Three Medieval Rhetorical Arts.* Berkeley: University of California Press, 1971.

Mutafian, Claude. *La Cilicie au carrefour des empires.* Vol. 2. Paris: Société d'Édition Les Belles Lettres, 1988.

Nelson, Robert. "An Icon at Mount Sinai and Christian Painting in Muslim Egypt during the Thirteenth and Fourteenth Centuries." *Art Bulletin* 65 (1983): 201–18.

Netzer, Ehud, and Zeev Weiss. *Zippori.* Jerusalem: Israel Exploration Society, 1994.

Nicholas III. *Registre.* Edited by Jules Gay and Suzanne Vitte. Paris, 1898–1938.

Nicholas IV. *Registre.* Edited by Ernest Langlois. 2 vols. Paris, 1886–93.

Nicholas, David. *Medieval Flanders.* London: Longman, 1992.

Nicholas, Karen S. "Countesses as Rulers in Flanders." In *Aristocratic Women in Medieval France*, edited by Theodore Evergates, 111–37. Philadelphia: University of Pennsylvania Press, 1999.

Niketas Choniates. *Historia.* Edited by Jan Louis van Dieten. Berlin: de Gruyter, 1975.

———. *O City of Byzantium: Annals of Niketas Choniates.* Translated by Harry J. Magoulias. Detroit: Wayne State University Press, 1984.

Noel, William, and Daniel Weiss, eds. *The Book of Kings: Art, War, and the Morgan Library's Medieval Picture Bible*. London: Third Millennium, 2002.

Notopoulos, James. "Akritan Ikonography on Byzantine Pottery." *Hesperia* 33 (1964): 108–33.

Obolensky, Dimitri. *Six Byzantine Portraits*. Oxford: Clarendon Press, 1988.

Oikonomos, K., ed. *Ktitorikon: He Proskynetarion tes hieras kai vasilikes Mones tou Megalou Spilaiou, Epidiorthen psepho kai spoude tou hierou Monasteriou en etei 1840*. 3d ed. Athens: Athanasios A. Papaspyrou, 1932.

Oltrogge, Doris. *Die Illustrationszyklen zur "Histoire ancienne jusqu'à César" (1250–1400)*. Europäische Hochschulschriften. Frankfurt am Main: Verlag Peter Lang, 1989.

Öney, Gönül. *Anadolu Selçuklu Mimarisinde Süsleme ve El Sanatları*. Ankara: İş Bankası, 1978.

―――. "Human Figures on Anatolian Seljuk Sgraffiato and Champlevé Ceramics." In *Essays in Islamic Art and Architecture in Honor of Katharina Otto-Dorn*, edited by Abbas Daneshvari, 113–25. Malibu: Undena, 1982.

Ordericus Vitalis. *Historia Ecclesiastica*. Translated and edited by Marjorie Chibnall. 6 vols. Oxford: Clarendon Press, 1968–80.

Orosius. *Paulus Orosius: The Seven Books of History against the Pagans*. Translated by Roy J. Deferrai. The Fathers of the Church, 50. Washington, D.C.: Catholic University Press of America, 1964.

Ortalli, Gherardo, and Dino Puncuh, eds. *Genova, Venezia, il Levante nei secoli XII–XIV*. Atti del Convegno internazionale di studi, Genova-Venezia, 10–14 marzo 2000. Genoa: Società Ligure di Storia Patria, 2001.

Ostrogorsky, Georgije. *History of the Byzantine State*. 2d ed. New Brunswick: Rutgers University Press, 1968.

Ousterhout, Robert. "Architecture as Relic and the Construction of Sanctity: The Stones of the Holy Sepulchre." *Journal of the Society of Architectural Historians* 62 (2003): 4–23.

―――. *The Blessings of Pilgrimage*. Urbana: University of Illinois Press, 1990.

―――. *Master Builders of Byzantium*. Princeton: Princeton University Press, 1999.

―――. "Rebuilding the Temple: Constantine Monomachus and the Holy Sepulchre." *Journal of the Society of Architectural Historians* 48 (1989): 66–78.

Ovid. *P. Ovidi Nasonis Fastorum libri sex*. Edited by E. H. Alton, D.E.W. Wormell, and E. Courtney. Bibliotheca Scriptorum Graecorum et Romanorum Teubneriana. Berlin: B. G. Teubner, 1997.

Owen, Douglas D. R. *Eleanor of Aquitaine: Queen and Legend*. Oxford: Blackwell Publishing, 1993.

Paden, William D., Jr., Tilde Sankovitch, and Patricia H. Stäblein, eds. *The Poems of the Troubadour Bertran de Born*. Berkeley: University of California Press, 1986.

Panella, Emilio. "Ricerche su Riccoldo da Monte di Croce." *Archivum Fratrum Praedicatorum* 58 (1988): 5–85.

Papageorgiou, Athanasios. "L'art byzantin de Chypre et l'art des croisés: influences ré-

ciproques." *Report of the Department of Antiquities, Cyprus, 1982*, 217–26. Nicosia: Department of Antiquities, 1982.

———. *He Autokephalos Ekklesia tes Kyprou: Katalogos tes Ektheses. Exhibition at the Byzantine Museum of the Archbishop Makarios III Cultural Foundation.* Nicosia: Holy Archiepiscopate of Cyprus, 1995.

———. *Byzantine Icons of Cyprus.* Exh. cat. Athens: Benaki Museum, 1976.

———. *Icons of Cyprus.* Geneva: Nagel, 1969.

———. *Icons of Cyprus.* Nicosia: Holy Archiepiscopate of Cyprus, 1992.

———. *"Vasiliko Parekklesi."* In *Pyrga: Hodegos*, 1–11. Nicosia: Zavalles, Ltd., n.d.

Papanikola-Bakirtzis, Demetra. "La céramique à glaçure dans la Chypre du Moyen-Age." In *La France aux portes de l'Orient Chypre XIIème–XVème siècle*, edited by Jacques Charles-Gaffiot, 169–75. Paris: Centre Culturel du Panthéon, 1991.

Patitucci, Stella. "'Zeuxippus Ware' Novità da Kyme Eolica (Turchia)." *Corso di cultura sull'arte ravennate e bizantina* 42 (1995): 721–46.

———. "La nuova ceramica dell'età federiciana: la protomaiolica." In *Federico II e l'Italia*, 111–23. Rome: Edizioni Deluca, 1995.

Patitucci Uggeri. "La protomaiolica del mediterraneo orientale in rapporto ai centri di produzione italiani." *Corsi di cultura sull'arte ravennate e bizantina* 32 (1985): 337–402.

Pavlides, Christophe. *L'Histoire ancienne jusqu'à César (première rédaction): Étude de la tradition manuscrite. Étude et edition partielle de la section d'histoire romaine.* Thesis, École Nationale des Chartes, 1989.

Peeters, Paul. "La légende de Saidnaia." *Analecta Bollandiana* 25 (1906): 137–55.

Penrose, Helen. "Constructing Medieval Identity: Women in the Crusades." Master's thesis, University of Melbourne, 1992.

Petit, Aimé. "Le traitement courtois du thème des Amazones d'après trois romans antiques: *Éneas, Troie*, et *Alexandre*." *Le Moyen Age* 89 (1983): 63–84.

Philippe de Novare. *Mémoires, 1218–1243.* Edited by Charles Kohler. Paris: H. Champion, 1970.

Piatnitsky, Yuri, and Oriana Baddeley et al., eds. *Sinai, Byzantium, Russia.* Exh. cat. London: Saint Catherine Foundation in association with The State Hermitage Museum, St. Petersburg, 2000.

Pierotti, Piero. *Pisa e Accon: l'insediamento pisano nella città crociata. Il porto. Il fondaco.* Pisa: Pacini Editore, 1987.

Platts, Beryl. *Origins of Heraldry.* London: Procter Press, 1980.

Pöchat, Gotz. *Der Exotismus während des Mittelalters und der Renaissance.* Stockholm: Almqvist & Wiksell, 1970.

Powell, James M., ed. *Muslims under Latin Rule, 1100–1300.* Princeton: Princeton University Press, 1990.

Prawer, Joshua. *Crusader Institutions.* Oxford: Clarendon Press, 1980.

———. "A Crusader Tomb of 1290 from Acre and the Last Archbishops of Nazareth." *Israel Exploration Journal* 24 (1974): 241–51.

———. *The History of the Jews in the Latin Kingdom of Jerusalem*. Oxford: Clarendon Press, 1988.

———. *The Latin Kingdom of Jerusalem: European Colonialism in the Middle Ages*. London: Weidenfeld and Nicolson, 1972.

Pringle, Denys. *The Churches of the Crusader Kingdom of Jerusalem: A Corpus*. Cambridge: Cambridge University Press, 1993–98.

———. "Pottery as Evidence for Trade in the Crusader States." In *The Italian Communes in the Crusading Kingdom of Jerusalem*, edited by Gabriella Airaldi and Benjamin Z. Kedar, 451–75. Genoa: Collana Storica di Fonti e Studi, 1986.

———. *Secular Buildings in the Crusader Kingdom of Jerusalem: An Archaeological Gazeteer*. Cambridge: Cambridge University Press, 1997.

———. "Some Approaches to the Study of Crusader Mason's Marks in Palestine." *Levant* 13 (1981): 173–99.

———. "Town Defences in the Crusader Kingdom of Jerusalem." In *Medieval City Under Siege*, edited by Ivy A. Corfis and Michael Wolfe, 69–121. Woodbridge: The Boydell Press, 1995.

Puckett, Jaye. " 'Reconmenciez novele estoire': The Troubadours and the Rhetoric of the Later Crusades." *Modern Language Notes* 116 (2001): 844–89.

Purcell, Maureen. "Women Crusaders: A Temporary Canonical Aberration?" In *Principalities, Powers and Estates: Studies in Medieval and Early Modern Government and Society*, edited by L. O. Frappell, 57–64. Papers presented at the Fifth Conference of Australian Historians of Medieval and Early Modern Europe, Sydney, 23–26 May, 1978. Adelaide: Adelaide University Union Press, 1979.

Quaresmius, Franciscus. *Historica, theologica et moralis Terrae Sanctae elucidatio*. Antwerp, 1639.

Raschid-Eldin. *Histoire des Mongols de la Perse*. Edited and translated by E. Quatremère. Paris: Imprimerie royale, 1836.

Raynaud de Lage, Guy. "'L'histoire ancienne jusqu'à César' et les 'Faites des Romans.'" *Le Moyen Age* 55 (1949): 5–16.

———. *Les premiers romans français et autres études littéraires et linguistiques*. Geneva: Librarie Droz, 1976.

———. "Les romans antiques dans l'Histoire ancienne jusqu'à César." *Le Moyen Age* 63 (1957): 267–309.

Recueil des historiens des croisades: historiens occidentaux. 5 vols. Paris, 1844–95.

Recueil des historiens des croisades: historiens orientaux. 5 vols. Paris: Académie des Inscriptions et Belles-Lettres, 1872–1906.

Recueil des historiens des croisades: lois. 2 vols. Paris: Imprimerie royale, 1841–43.

Recueil des historiens des Gaules et de la France. 24 vols. Paris: Aux dépens des libraires associés, 1738–1904.

Redford, Scott. "How Islamic Is It? The Innsbruck Plate and its Setting." *Muqarnas* 7 (1990): 119–35.

———. *Landscape and the State in Medieval Anatolia: Seljuk Gardens and Pavilions*

of Alanya, Turkey. British Archaeological Reports, International Series, 893. Oxford: Archaeopress, 2000.

———. "Medieval Ceramics from Samsat, Turkey." *Archéologie islamique* 5 (1995): 55–80.

Redford, Scott, and M. James Blackman. "Luster and Fritware Production and Distribution in Medieval Syria." *Journal of Field Archaeology* 24 (1997): 233–47.

Redford, Salima Ikram, Elizabeth Parr, and Timothy Beach. "Excavations at Medieval Kinet, Turkey: A Preliminary Report." *Journal of Ancient Near Eastern Studies* 38 (2001): 59–139.

Reeder, Ellen. *Pandora: Women in Classical Greece*. Princeton: Princeton University Press, 1995.

Regesta regni Hierosolymitani. Compiled by Reinhold Röhricht. Innsbruck, 1893–1904.

Reinhold, Meyer. "The Unhero Aeneas." *Classica et Medievalia* 27 (1966): 195–207.

Rey, Emmanuel-Guillaume. *Les colonies franques de Syrie aux XIIe et XIIIe siècles*. Paris: A. Picard, 1883.

Rhalles, G., and M. Potles, ed. *Syntagma theon kai hieron kanonon*. Athens, 1852–59.

Riant, Paul E. D. "Déposition de Charles d'Anjou pour la canonisation de Saint Louis." In *Notices et documents publiés pour la société de l'histoire de France à l'occasion du cinquantième anniversaire de sa fondation*, 155–76. Paris, 1884.

Richard, Jean. *Croisades et Etats latins d'Orient*. Aldershot: Variorum, Ashgate, 1992.

———. *The Crusades, c. 1071–c. 1291*. Translated by Jean Birrell. Cambridge: Cambridge University Press, 1999.

———. *The Latin Kingdom of Jerusalem*. Translated by Janet Shirley. Amsterdam: North-Holland, 1979.

———. *Orient et Occident au Moyen Age: contacts et relations (XIIe–XVe s.)*. London: Variorum Reprints, 1976.

———. *Saint Louis: Crusader King of France*. Cambridge: Cambridge University Press, 1992.

———. "Saint Louis dans l'histoire des croisades." *Bulletin de la société d'emulation du Bourbonnais* (1970): 229–34.

———. *Saint Louis: roi d'une France féodale, soutien de la Terre Sainte*. Paris: Fayard, 1983.

Riis, P. J., and Vajn Poulsen. *Hama: fouilles et recherches, 1931–1938*. Vol. 4. Copenhagen: Nationalmuseet, 1957.

Riley-Smith, Jonathan S. C. *The Crusades: A Short History*. New Haven: Yale University Press, 1987.

———. *The Feudal Nobility and the Kingdom of Jerusalem, 1174–1277*. London: Archon Books, 1973.

———. *The First Crusaders, 1095–1131*. Cambridge: Cambridge University Press, 1997.

———. "A Note on Confraternities in the Latin Kingdom of Jerusalem." *Bulletin of the Institute of Historical Research* 44 (1971): 301–8.

———. "The Templars and the Teutonic Knights in Cilician Armenia." In *The Cilician Kingdom of Armenia*, edited by Thomas S. R. Boase, 92–117. New York: St. Martin's, 1978.

Riqueur, Martín de. *Los trovadores*. Barcelona: Planeta, 1975.

Romano, Salvatore. "Un viaggio del conte di fiandra, Guido di Dampierre, in Sicilia nel 1270." *Archivio storico siciliano* 26 (1905): 285–309.

Ross, David J. A. *Alexander Historiatus: A Guide to Medieval Illustrated Alexander Literature*. Warburg Institute Surveys, 1. London: Trinity Press, 1963.

———. *Illustrated Medieval Alexander-Books in Germany and the Netherlands: A Study in Comparative Iconography*. Publications of the Modern Humanities Research Association, 3. Cambridge: Modern Humanities Research Association, 1972.

Ross, Marvin C. *Catalogue of the Byzantine and Early Medieval Antiquities in the Dumbarton Oaks Collection*. Vol. 1. *Metalwork, Ceramics, Glass, Glyptics, Painting*. Washington, D.C.: Dumbarton Oaks Research Library and Collection, Trustees for Harvard University, 1962.

Rosser, John. "Excavations at Saranda Kolones, Paphos, Cyprus, 1981–1983." *Dumbarton Oaks Papers* 39 (1985): 81–97.

Rotili, Mario. *La miniatura nella Badia di Cava: Volume Primo, Lo scritto, i corali miniati per l'abbazia*. Naples: Mauro Editore, 1976.

———. *Miniatura francese a Napoli*. Benevento: Museo del Sannio, 1968.

Rozenberg, Silvia, ed. *Knights of the Holy Land: The Crusader Kingdom of Jerusalem*. Jerusalem: Israel Museum, 1999.

Rudt de Collenberg, Wilpert H. "Les Lusignan de Chypre: généalogie compilée principalement selon les registres de l'Archivio Segreto Vaticano et les manuscrits de la Biblioteca Vaticana." *Epeteris tou Kentrou Epistemonikon Ereunon* 10 (Nicosia, 1979–80): 85–319.

Runciman, Steven. *A History of the Crusades*. Cambridge: Cambridge University Press, 1953–54.

Rutebeuf. "La complainte de monseigneur Joffroi de Sergines." In *Onze poèmes de Rutebeuf concernant la croisade*, edited by Julia Bastin and Edmond Faral, 22–27. Paris: P. Geuthner, 1946.

Samir Khalil Samir. "The Role of Christians in the Fatimid Government Services of Egypt to the Reign of al-Ḥāfiẓ." *Medieval Encounters: Jewish, Christian and Muslim Culture in Confluence and Dialogue* 2 (1996): 177–92.

Santa Maria Mannino, Paola. "Vergine 'Kykkotissa' in due icone Laziali del Duecento." In *Roma Anno 1300*, edited by Angiola Maria Romanini, 487–92. Atti del Congresso internazionale di Storia dell'Arte medievale (Roma, 19–24 maggio 1980). Rome: l'Erma di Bretschneider, 1983.

Schein, Sylvia. "Philip IV and the Crusade: A Reconsideration." In *Crusade and Settlement*, edited by Peter W. Edbury, 121–26. Cardiff: University College Cardiff Press, 1985.

Scheller, Robert W. *Exemplum: Model-Book Drawings and the Practice of Artistic Transmission in the Middle Ages (ca. 900–ca. 1470)*. Translated by Michael Hoyle. Amsterdam: Amsterdam University Press, 1995.

Schilling, Robert. "Janus, le dieu introducteur, le dieu des passages." *Mélanges d'archéologie et d'histoire* 72 (1960): 89–131.

Schramm, Percy E. *Kaiser, Rom und Renovatio: Studien zur Geschichte des römischen Erneuerungsgedankens vom Ende des karolingischen Reiches bis zum Investiturstreit.* Studien der Bibliothek Warburg, 17. Leipzig: B. G. Teubner, 1929.

———. *Der König von Frankreich: Das Wesen der Monarchie vom 9. zum 16. Jahrhundert. Ein Kapitel aus der Geschichte des abendländischen Staates.* Darmstadt: Wissenschaftliche Buchgesellschaft, 1960.

Sebald, Eduard. "Blätter aus einem Musterbuch." In *Ornamenta Ecclesiae: Kunst und Künstler der Romanik,* edited by Anton Legner, 1:316–18. Katalog zur Ausstellung des Schnütgen-Museums. Cologne: Schnütgen-Museum der Stadt Köln, 1985.

Servois, Gustave. "Emprunts de Saint Louis en Palestine et en Afrique." *Bibliothèque de l'école des Chartes* sér. 4, 4 (1858): 113–31, 283–93.

Ševčenko, Nancy. *The Life of Saint Nicholas in Byzantine Art.* Turin: Bottega d'Erasmo, 1983.

———. "Some Thirteenth-Century Pottery at Dumbarton Oaks." *Dumbarton Oaks Papers* 28 (1974): 354–60.

Seward, Desmond. *Eleanor of Aquitaine: The Mother Queen.* London: David & Charles, 1978.

Shatzmiller, Maya, ed. *Crusaders and Muslims in Twelfth-Century Syria.* Leiden: Brill, 1993.

Shirley, Janet. *Crusader Syria in the Thirteenth Century: The Rothelin Continuation of the History of William of Tyre with Part of the Eracles or Acre Text.* Aldershot and Brookfield: Ashgate, 1999.

Siberry, Elizabeth. *Criticism of Crusading, 1095–1274.* Oxford: Clarendon Press, 1985.

Simpson, Marianna Shreve. "Narrative Allusion and Metaphor in the Decoration of Medieval Islamic Objects." In *Pictorial Narrative in Antiquity and the Middle Ages,* edited by Herbert Kessler and Marianna Shreve Simpson, 131–49. Studies in the History of Art, 16. Washington, D.C.: National Gallery of Art, 1985.

Sinclair, Keith V., ed. *The Hospitaller's "Riwle" (Miracula et Regula Hospitalis Sancti Johannis Jerosolimitani).* Anglo-Norman Texts, 42. London: Anglo-Norman Text Society, 1984.

Sivan, Emmanuel. *L'Islam et la Croisade: idéologie et propagande dans les réactions musulmanes aux Croisades.* Paris: Librairie d'Amérique et d'Orient, 1968.

Sivéry, Gérard. "Histoire économique et sociale." In *Histoire de Lille.* Vol. 1. *Des origines à l'avènement de Charles Quint,* edited by Louis Trenard, 111–270. Lille: Librairie Giard, 1970.

Slessarev, Vsevolod. *Prester John: The Letter and the Legend.* Minneapolis: University of Minnesota Press, 1959.

Sobol, Donald J. *The Amazons of Greek Mythology.* South Brunswick: A. S. Barnes, 1972.

Solterer, Helen. "Figures of Female Militancy in Medieval France." *Signs* 16 (1991): 522–49.

Sophocleous, Sophocles. "He Eikona tes Kykkotissas ston Hagio Theodoro tou Agrou." *Epeterida Kentrou Meleton hieras Mones Kykkou* 2 (1993): 329–37.

———. *Icons of Cyprus, 7th to 20th Century*. Nicosia: Museum Publications, 1994.

Soteriou, George A. "He Kykkiotissa." *Nea Hestia*, Christmas issue (1939): 3–6.

———. *Ta Vyzantina Mnemeia tes Kyprou*. Athens: Academy of Athens, 1935.

Soucek, Priscilla. "Armenian and Islamic Manuscript Painting: A Visual Dialogue." In *Treasures in Heaven: Armenian Art, Religion, and Society*, edited by Thomas Mathews and Roger Wieck, 115–31. New York: The Pierpont Morgan Library, 1998.

Spain, Alexander S. "Hercalius, Byzantine Imperial Ideology, and the David Plates." *Speculum* 52 (1977): 217–37.

Spatharakis, Iohannis. *The Portrait in Byzantine Illuminated Manuscripts*. Leiden: E. J. Brill, 1976.

Speck, Paul. *Das geteilte Dossier*. Bonn, 1981.

Spiegel, Gabrielle M. *The Past as Text: The Theory and Practice of Medieval Historiography*. Baltimore: Johns Hopkins University Press, 1997.

———. "Political Utility in Medieval Historiography: A Sketch." *History and Theory: Studies in the Philosophy of History* 14 (1975): 314–25.

———. *Romancing the Past: The Rise of Vernacular Prose Historiography in Thirteenth-Century France*. Berkeley: University of California Press, 1993.

Spufford, Peter. *Handbook of Medieval Exchange*. London: Offices of the Royal Historical Society, 1986.

Spyridakes, Konstantinos. "He Perigraphe tes Mones Kykkou epi te Basei anekdotou Cheirographou." *Kypriakai Spoudai* 13 (1950): 1–28.

Stahl, Harvey. "The Iconographic Sources of the Old Testament Miniatures, Pierpont Morgan Library, M.638." Ph.D. diss., New York University, 1974.

Stammler, Wolfgang, ed. *Deutsche Philologie im Aufriss*. 2d ed. Berlin: E. Schmidt, 1962.

Stanger, Mary D. "Literary Patronage in the Medieval Court of Flanders." *French Studies* 9 (1957): 214–29.

Stern, Edna. "Excavation of the Courthouse Site at 'Akko: The Pottery of the Crusader and Ottoman Periods." *'Atiqot* 31 (1997): 35–70.

Stettler, Michael, and Paul Nizon. *Bildteppiche und Antependien im historischen Museum Bern*. Bern: Verlag Stämpfli, 1966.

Stones, Alison. "Illustrating Lancelot and Guinevere." In *Lancelot and Guinevere: A Casebook*, edited by Lori J. Walters, 125–57. New York: Routledge, 1996.

———. "Sacred and Profane Art: Secular and Liturgical Book-Illumination in the Thirteenth Century." In *The Epic in Medieval Society*, edited by Harold Scholler, 100–112. Tübingen: Niemeyer, 1977.

———. "Secular Manuscript Illumination In France." In *Medieval Manuscripts and Textual Criticism*, edited by Christopher Kleinhenz, 81–102. North Carolina Studies in Romance Languages and Literatures, 173. Chapel Hill: University of North Carolina, 1976.

Stork, Hans-Walter. *The Bible of Saint Louis: Complete Facsimile Edition in the Original Format of MS 240 from the Pierpont Morgan Library, New York*. Graz: Akademische Druck- und Verlagsanstalt, 1996.

Strayer, Joseph R. "France, the Holy Land, the Chosen People and the Most Christian King." In *Action and Conviction in Early Modern Europe*, edited by Theodore K. Rabb and Jerrold E. Seigel, 3–16. Princeton: Princeton University Press, 1969.

———. *The Reign of Philip the Fair*. Princeton: Princeton University Press, 1980.

Streckenbach, Gerhard, ed. and trans. *Walter von Châtillon, Alexandreis, Das Lied von Alexander dem Grossen*. Heidelberg: Schneder, 1990.

Stylianou, Andreas, and Judith A. Stylianou. *The Painted Churches of Cyprus: Treasures of Byzantine Art*. 2d ed. Nicosia: A.G. Leventis Foundation, 1997.

———. *Peristerona (Morphou)*. Peristerona: Church Committee of the Church of SS. Barnabas and Hilarion, 1974.

———. "He Vyzantine Techne kata ten Periodo tes Phrankokratias (1191–1570)." In *Historia tes Kyprou, Tomos E': Mesaionikon Basileion, Enetokratia, Meros B': Pneumatikos Bios, Paideia, Grammatologia, Vyzantine Techne, Gothike Techne, Nomismatokopia, Bibliographia*, edited by Theodore Papadopoullos, 2:1229–1407. 2 vols. Nicosia: Archbishop Makarios III Cultural Foundation, 1996.

Süslü, Özden. *Tasvirlere Göre Anadolu Selçuklu Kıyafetleri*. Ankara: Atatürk Kültür, Dil ve Tarih Yüksek Kurumu, 1989.

Tafel, Gottlieb L. Fr., and Georg M. Thomas, eds. *Urkunden zur älteren Handels- und Staatsgeschichte der Republik Venedig*. Vienna: Kaiserliche Akademie der Wissenschaften, Historische Kommission, 1856–57.

Talbot, Alice-Mary. "Byzantine Pilgrimage to the Holy Land from the Eighth to the Fifteenth Century." In *The Sabaite Heritage in the Orthodox Church from the Fifth Century to the Present*, edited by Joseph Patrich, 97–110. Orientalia Lovaniensia Analecta, 98. Leuven: Peeters, 2001.

Talbot Rice, David. "Late Byzantine Pottery at Dumbarton Oaks." *Dumbarton Oaks Papers* 20 (1966): 211–19.

Taufer, Alison. "From Amazon Queen to Female Knight: The Development of the Woman Warrior in the *Amadis Cycle*." Ph.D. diss., U.C.L.A., 1988.

Tavlakes, Giannes. "He Panagia Axion Estin: He Eikona." In *To Axion Estin: Panagia he Karyotissa, he ephestia Eikona tou Protatou*, edited by Kriton Chrysochoides, Giannes Tavlakes, and Giota Oikonomake-Papadopoulou, 19–23. Athos: Holy Community of Mount Athos, 1999.

The Templar of Tyre. *Cronaca del Templare di Tiro (1243–1314)*. Edited by Laura Minervini. Naples: Liguori, 2000.

Teteriatnikov, Natalia. "The True Cross flanked by Constantine and Helena: A Study in the Light of the Post-Iconoclastic Re-evaluation of the Cross." *Deltion tes Christianikes archaiologikes etaireias* 19 (1995): 169–88.

Teulet, Auguste, Jean de Laborde, Elie Berger, and Henri F. Delaborde. *Les layettes du Trésor des Chartes*. 5 vols. Paris, 1863–1909.

Thomas, Antoine. *Poésies completes de Bertran de Born*. Toulouse: Privat, 1888.

Thomas, John, and Angela Hero, eds. *Byzantine Monastic Foundation Documents: A Complete Translation of the Surviving Founder's Typika and Testaments*. Washington, D.C.: Dumbarton Oaks, 2000.

Thomas, Marcel. *Le Psautier de Saint Louis.* Graz: Akademische Druck- und Verlagsanstalt, 1970.

Toesca, Pietro. *Miniature di una Collezióne Veneziana.* Venice: Fondazione Cini, 1958.

Tomei, Alessandro, ed. *Roma, Napoli, Avignone: arte di curia, arte di corte, 1300–1377.* Turin: SEAT-Divisione STET, 1995.

Tonghini, Cristina. *Qal'at Ja'bar Pottery: A Study of a Syrian Fortified Site of the Late 11th–14th Centuries.* Oxford: Oxford University Press, 1998.

Toubert, Hélène. "Autor de la Bible de Conradin: trois nouveaux manuscrits enluminés." *Mélanges de l'Ecole française de Rome* 91 (1979): 729–84.

———. "Les enluminures du manuscrit fr. 12400." In *Federico II: DE ARTE VENANDI CUM AVIBUS. L'art de la chace des oisiaus, Facsimile ed edizione critica del manoscritto fr. 12400 della Bibliothèque Nationale de France,* 385–416. Naples: Electa Napoli, 1995.

———. "Influences gothiques sur l'art frédéricien: le maître de la Bible de Manfred et son atelier." In *Federico II e l'arte del Duecento italiano,* edited by Angiola Maria Romanini, 2:59–83. Atti della III settimana di studi di storia dell'arte medievale dell'universita di Roma, 15–20 maggio 1978. Rome: Congedo Editore, 1980.

———. "Trois nouvelles Bibles du maître de la Bible de Manfred et de son atelier." *Mélanges de l'Ecole française de Rome* 89 (1977): 777–810.

Treadgold, Warren. *A History of the Byzantine State and Society.* Stanford: Stanford University Press, 1997.

Treasures of Mount Athos. Exh. cat. 2d ed. Thessalonike: Ministry of Culture/Museum of Byzantine Culture, 1997.

Trilling, James. "Myth and Metaphor at the Byzantine Court." *Byzantion* 48 (1978): 249–63.

Tritton, Arthur S., and Hamilton A. R. Gibb. "The First and Second Crusades from an Anonymous Syriac Chronicle." *Journal of the Royal Asiatic Society* (1933): 69–101, 273–305.

Tsiknopoullos, Ioannes P. *He hiera vasilike kai stauropegiake Mone tes hyperagias Theotokou Makhaira.* Nicosia: Makhairas Monastery, 1967.

———. *Kypriaka Typika.* Nicosia: Cyprus Research Centre, 1969.

Tyrrell, William Blake. *Amazons: A Study in Athenian Mythmaking.* Baltimore: Johns Hopkins University Press, 1984.

Tyson, Diane. "Patronage of French Vernacular History Writers in the Twelfth and Thirteenth Centuries." *Romania* 100 (1979): 180–222.

Urban IV. *Registre.* Edited by Jean Guiraud. 4 vols. Paris, 1901–58.

Usāma ibn Munqidh. *An Arab-Syrian Gentleman and Warrior in the Period of the Crusades.* Translated by Philip K. Hitti. New York: Columbia University Press, 1929.

———. *Les enseignements de la vie.* Kitāb al-I'tibār. *Souvenirs d'un gentilhomme syrien du temps des Croisades.* Translated into French by André Miquel. Paris: Collection orientale de l'Imprimerie Nationale, 1983.

Van der Bergen-Pantens, Christine. "Guerre de Troie et heraldique imaginaire." *Revue belge d'archéologie et d'histoire d'art* 52 (1983): 3–21.

van Os, Henk. *The Art of Devotion in the Late Middle Ages in Europe, 1300–1500.* Translated from the Dutch by Michael Hoyle. London: Merrell Holberton/Rijksmuseum Amsterdam, 1994.

Vassilaki, Maria, ed. *Mother of God: Representations of the Virgin in Byzantine Art.* Milan: Skira Editore, 2000.

von Folsach, Kjeld. *Islamic Art: The David Collection.* Copenhagen: Davids Samling, 1990.

von Simson, Otto G. *Sacred Fortress: Byzantine Art and Statecraft in Ravenna.* Princeton: Princeton University Press, 1987.

Vryonis, Speros. "Another Note on the Inscription of the Church of St. George of Beliserama." *Byzantina* 9 (1977): 13–22.

Waagé, Frederick, ed. *Antioch-on-the-Orontes.* Vol. 4. Princeton: Princeton University Press, 1949.

Walker, Bethany. "The Social Implications of Textile Development in Fourteenth-Century Egypt." *Mamluk Studies Review* 4 (2000): 167–217.

Walter of Coventry. *Memoriale.* Edited by William Stubbs. Rolls Series, 58. London: Her Majesty's Stationery Office, 1872–73.

Wander, Steven H. "The Cyprus Plates: The Story of David and Goliath." *Metropolitan Museum Journal* 8 (1973): 89–104.

Ward, Rachel, ed. *Gilded and Enamelled Glass from the Middle East.* London: British Museum Press, 1998.

Wardwell, Ann E. "*Panni tartarici*: Eastern Islamic Silks Woven with Gold and Silver (13th and 14th Centuries)." *Islamic Art* 3 (1988–89): 95–173.

Warlop, Ernest. *The Flemish Nobility before 1300.* Kortrijk: G. Desmet-Huysman, 1975–76.

Warnkoenig, Leopold A. *Histoire de la Flandre et de ses institutions civiles et politiques, jusqu'à l'année 1305.* Brussels: M. Hayez, 1835.

Wartburg, Marie-Louise von. "'Hochzeitpaare' und Weintrinker: Zur Bildmotiven der Mittelalterlichen Keramik Cypern." *Antiquitas* 3d ser., 42 (2001): 457–65.

al-Wasil, Muhammad ibn Sālim. *Mufarrij al-kurūb fī akhbār Banī Ayyūb.* Edited by Hassanein Rabie. Cairo: Matba'at Jāmi'at Fu'ād al-Awwal, 1972.

Weiss, Daniel H. *Art and Crusade in the Age of Saint Louis.* Cambridge: Cambridge University Press, 1998.

———. "Biblical History and Medieval Historiography: Rationalizing Strategies in Crusader Art." *Modern Language Notes* 108 (1993): 710–37.

———. *The Morgan Crusader Bible: Commentary.* Lucerne: Faksimile Verlag, 1999.

Weitzmann, Kurt. "Icon Painting in the Crusader Kingdom." *Dumbarton Oaks Papers* 20 (1966): 49–83.

———. "The Icons of the Period of the Crusades." In *The Icon*, edited by Kurt Weitzmann et al., 201–35. New York: Alfred A. Knopf, 1982.

———. "Thirteenth Century Crusader Icons on Mount Sinai." *Art Bulletin* 45 (1963): 179–203.

Wessel, Klaus. "Konstantin und Helena." *Reallexikon der byzantinischen Kunst* 4 (1989): cols. 357–66.

Whelan, Estelle. "Representations of the *Khāṣṣikīyah* and the Origins of Mamluk Emblems." In *Content and Context of Visual Arts in the Islamic World*, edited by Priscilla Soucek, 219–43. University Park: Pennsylvania State University Press, 1988.

Wiegel, Karl Adolf. "Die Darstellungen der Kreuzauffindung bis zu Piero della Francesca." Ph.D. diss., Cologne University, 1973.

Wilkinson, John, ed. *Jerusalem Pilgrimage, 1099–1185*. 2d series, 167. London: Hakluyt Society, 1988.

William of Nangis. *Chronique*. Edited by P. H.J.F. Géraud. 2 vols. Paris, 1843.

William of Tyre. *Chronicon*. Edited by Robert B. C. Huygens and Hans E. Mayer. Corpus Christianorum, Continuatio Mediaevalis, 63 and 63 A. 2 vols. Turnholt: Brepols, 1986.

———. *A History of Deeds Done Beyond the Sea*. Translated by Emily A. Babcock and August C. Krey. 2 vols. New York: Columbia University Press, 1943.

Willis, Michael D. "The Larnaca Tympanum." *Kypriakai Spoudai* 45 (1981): 15–28.

Wolff, Robert L. "Baldwin of Flanders and Hainaut, First Latin Emperor of Constantinople: His Life, Death, and Resurrection, 1172–1225." *Speculum* 27 (1952): 281–322.

Wolff, Robert L., and Harry W. Hazard, eds. *A History of the Crusades*. Vol. 2. *The Later Crusades, 1189–1311*. Madison: University of Wisconsin Press, 1969.

Wolters, Christian. "Beobachtungen am Freisinger Lukasbild." *Kunstchronik* 17 (1964): 85–91.

Woodcock, Thomas, and John Martin Robinson. *The Oxford Guide to Heraldry*. Oxford: Oxford University Press, 1988.

Yalgın, A. Rıza. *Anadoluda Türk Damgaları* Bursa: Yeni Basımevi, 1943.

Yāqūt al-Rūmī. *Mu'jam al-Buldān*. Vol. 2. Beirut: Dar Sader, n.d.

Young, Susan. "Byzantine Painting in Cyprus during the Early Lusignan Period." Ph.D. diss., University of Pennsylvania, 1983.

Zacour, Norman P., and Harry W. Hazard, eds. *A History of the Crusades*. Vol. 5. *The Impact of the Crusades on the Near East*. Madison: University of Wisconsin Press, 1985.

Zeitler, Barbara. "'Sinful Sons, Falsifiers of the Christian Faith': The Depiction of Muslims in a 'Crusader' Manuscript." *Mediterranean Historical Review* 12 (1997): 25–50.

Živojinović, Mirjana, Vassiliki Kravari, and Christophe Giros, eds. *Actes de Chilandar*. Archives de l'Athos, 20. Paris: Lethielleux, 1998.

Contributors

ANNEMARIE WEYL CARR, University Distinguished Professor of Art History, Southern Methodist University

REBECCA W. CORRIE, Phillips Professor of Art, Chair of the Division of Humanities, Bates College

ANTHONY CUTLER, Research Professor of Art History, Pennsylvania State University

ANNE DERBES, Professor of Art History, Hood College

JAROSLAV FOLDA, N. Ferebee Taylor Professor of the History of Art, University of North Carolina, Chapel Hill

DAVID JACOBY, Department of History, Hebrew University, Jerusalem

BIANCA KÜHNEL, Professor of History of Art, Hebrew University, Jerusalem

GUSTAV KÜHNEL, Professor, The Yolanda and David Katz Faculty of the Arts, Tel Aviv University

LISA MAHONEY, Mellon Dissertation Fellow in the Humanities, The Johns Hopkins University

STEPHEN G. NICHOLS, James M. Beall Professor of French and Humanities, The Johns Hopkins University

ROBERT OUSTERHOUT, Professor of Architectural History, School of Architecture, University of Illinois, Urbana-Champaign

SCOTT REDFORD, Associate Professor, Division of Culture and Politics, Walsh School of Foreign Service, Georgetown University

Contributors

JONATHAN RILEY-SMITH, Dixie Professor of Ecclesiastical History, University of Cambridge

MARK SANDONA, Professor of English, Hood College

DANIEL WEISS, James B. Knapp Dean and Professor of Medieval Art, The Johns Hopkins University

Index